Catalogue of European Sculpture in the Ashmolean Museum

Catalogue of European Sculpture in the Ashmolean Museum

1540 to the Present Day

VOLUME I: Italian

NICHOLAS PENNY

CLARENDON PRESS · OXFORD

For Jon Whiteley

Oxford University Press, Walton Street, Oxford OX2 6DP

Oxford New York Toronto
Delhi Bombay Calcutta Madras Karachi
Kuala Lumpur Singapore Hong Kong Tokyo
Nairobi Dar es Salaam Cape Town
Melbourne Auckland Madrid
and associated companies in
Berlin Ibadan

Oxford is a trade mark of Oxford University Press

Published in the United States
by Oxford University Press, New York

First published 1992
Reprinted 1993

Published in co-operation with the Visitors
of the Ashmolean by the Delegates of the Press

British Library Cataloguing in Publication Data

(Data available)

Library of Congress Cataloging in Publication Data

Penny, Nicholas, 1949
Catalogue of European sculpture in the Ashmolean Museum, 1540 to the
present day/Nicholas Penny.
Contents: v. 1. Italian sculpture—v. 2. French and other European
sculpture (excluding Italian & British)—v. 3. British sculpture.
1. Sculpture, European—Catalogs. 2. Sculpture, Modern—Europe—
Catalogs. 3. Sculpture—England—Oxford—Catalogs. 4. Ashmolean
Museum—Catalogs. I. Title.
NB454.P46 1992
735'.074'42574—dc20 92–21820
ISBN 0–19–951329–5 (Volume I)
ISBN 0–19–951356–2 (Three volume set)

Printed and bound in Great Britain by
Butler & Tanner Ltd, Frome and London

Acknowledgements

THIS catalogue was compiled during my five years as Keeper of the Department of Western Art in the Ashmolean Museum. I was encouraged by my directors, successively Sir David Piper and Dr Christopher White; also by my successor as Keeper, Dr Timothy Wilson, who read the entire catalogue in typescript and made numerous improvements. The Museum generously made occasional grants towards the cost of travel, as did Balliol College, but most of the overseas research was possible because it could be combined with courier duty—a compensation for the disproportionate administrative burden placed on the Department by the relentless loans to foreign exhibitions.

I had the benefit of the notes assembled by predecessors and by colleagues in the Department of Western Art. Christopher Lloyd, who had planned to catalogue the earlier Renaissance bronzes and plaquettes, also took a special interest in many of the pieces included in these volumes and I have benefited both from his knowledge and from his correspondence with other scholars. Gerald Taylor's memory was essential to me, as was his expert knowledge in the applied arts, and Catherine Whistler was unfailingly helpful. The sculpture's debt to Jon Whiteley's indefatigable housekeeping and my debt to, and admiration for, his critical sensitivity and historical curiosity are inadequately acknowledged in the dedication of these volumes.

Without the assistance and kindness of Dorothy Money, my secretary for most of my time in the Department, the task of combining scholarly work with administration would have been impossible. The Department benefited from having as its photographic archivists and secretaries (for the post is a clerical one) Noelle Brown and, after her retirement, Vera Magyar, whose exceptional linguistic abilities, zeal for research, and wide intellectual interests saved me from numerous errors. Without them of course the huge campaign of photographing, for the first time, about 600 of the sculptures catalogued here would have been impossible. The skill of Michael Dudley and the Museum's other photographers will, I hope, speak for itself but I must thank them for their patience and good humour. The catalogue was much improved by the copy-editing of Jackie Pritchard and I am deeply grateful to both Anne Ashby and Nick Clarke at Oxford University Press for all the special attentions which they have given to the editing and design.

A succession of volunteers helped with sorting out the Department's archives, cleaning the sculptures, reordering the reserve collection, translating and pursuing comparative material—Emily Black, Katie Butler, Christine Gormley, Laura Gowing, Lore Ostwald, Julia Parker, Louise Sykes, Bridget Virden, Alexandra West among them. Aline Berlin carried out essential research in the Chantrey ledgers in the Royal Academy library which has been incorporated in the entries of the Chantrey plasters in the third volume. Research for this part of the catalogue was also carried out in the Conway Library of the Courtauld Institute of Art.

Colleagues in other Departments have been unfailingly helpful: in particular, Ann Brown, Michael Vickers, and Helen Whitehouse in the Department of Antiquities, Andrew Topsfield in the Department of Eastern Art, and Nick Mayhew in the Heberden Coin Room. I obtained much assistance in the technical examination of the sculpture from David Armitage, the conservator in the Department of Eastern Art, and from Mark Norman and

Kathleen Kimber in the Department of Antiquities. By kind permission of the Director of the Oxford University Research Centre for Art and Archaeology, Doreen Stoneham undertook thermo-luminescence (TL) analysis of many of the terracottas.

Scholars who generously agreed to spend many hours in the Museum being quizzed by me about the sculpture include Malcolm Baker, Volker Krahn, Alastair Laing, Jennifer Montagu, and Anthony Radcliffe. Michael Maclagan examined many coats of arms and heraldic devices. I have, I hope, recorded their opinions accurately. Anthony Radcliffe also extended exceptional hospitality to me on my visits to the Victoria and Albert Museum— a hospitality which continued under his successor Paul Williamson. The opportunity to place pieces from the Ashmolean side by side with those in the Victoria and Albert Museum was of special value. Thanks to John Ingamells I was also able to do this in the Wallace Collection. I must also record my gratitude to Iona Bonham-Carter and Charles Avery at Christie's, Elizabeth Wilson at Sotheby's, Gordon Balderston first at Christie's and then at Sotheby's, and Paul Davidson at Phillip's for granting me special access, sending photographs, forwarding enquiries, and generally sharing their knowledge and enthusiasm. Among the London art dealers who have been helpful in similar ways I must thank Tony Roth and Pat Wengraf especially.

The following curators generously permitted me to visit reserve collections or to handle sculpture normally on display in their museums, taking much time and trouble to organize this. Robin Crighton in the Fitzwilliam Museum, Cambridge, James Draper in the Metropolitan Museum, New York, Peter Fusco in the J. Paul Getty Museum, Henry Hawley in the Cleveland Museum of Art, Corey Keeble in the Royal Ontario Museum, Toronto, Volker Krahn in the Staatliche Museen, Berlin-Dahlem, Donald La Rocca in the Philadelphia Museum of Art, Amaury Léfebure in the Louvre (Département des Objets d'Art), Katherine Lochnan and David McTavish in the Art Gallery of Toronto, Anne Poulet in the Museum of Fine Arts, Boston, Eliot Rowlands in the Nelson Atkins Museum, Kansas City, Lorenz Seelig in the Bayerisches Nationalmuseum, Munich, Hugh Tait in the British Museum, Christian Theuerkauff in the Staatliche Museen, Berlin-Dahlem, Ian Wardropper in the Art Institute of Chicago, John Wilson in the Spencer Museum of Art, University of Kansas, Eric Zafran in the Walters Art Gallery, Baltimore. Many of these curators also went to great trouble to respond to requests for opinions, information, and photographs—as did Michael Knuth in the Staatliche Museen, East Berlin, Jean-René Gaborit in the Louvre (Département des Sculptures), and Anne Pingeot in the Musée d'Orsay. I must also thank one private collector, Sir Brinsley Ford, for his exceptional help and hospitality.

My last special word of thanks must go to Francis Haskell who has read this catalogue in its entirety and suggested many improvements to it. With him and Larissa Haskell and with Mary Wall I have over several years discussed the merits of the objects catalogued here as if they were common friends.

The following have helped me or my colleagues in a variety of ways, generally by answering postal enquiries or adding information to the files: Mary Ajunta, Teresa Ruiz Alcón, C. J. Anderson, Ray Ansty, Chloe Archer, Kenneth Armitage, Johannes Auersberg, P. M. Baker, Nicole Barbier, Pierre Bazin, Stella Beddoe, Malka Ben Josef, Ursel Berger, Bernard Black, Bruce Boucher, Alan Braham, John Brasier, W. W. S. Breem, the late James Byam Shaw, Andrew Ciechanowiecki, Carol Clark, Pamela Clark, Dick Coats, Patricia Collins, Ruth Cornett, Raymond Courtier, C. P. Courtney, Caroline Cuthbert, Catherine Dalton, John Davis, Peter Day, Anne Donald, Bernard Dragesco, Alan Fausel, Eric Freeman, Carmen Diaz Gallegos, Charlotte Gere, John Gere, Philippa Glanville, Alvar González-Palacios, Nicholas Goodison, David Green, Jasper Griffin, John Hardy, Johanna

Hecht, Detlef Heikamp, Emma Hicks, Terence Hodgkinson, Hugh Honour, Carolyn Hopkins, Viviane Huchard, Irene Hueck, Sabine Jacob, Simon Jervis, Ceri Johnson, Jean Jacques Journet, Daniel Katz, Herbert Keutner, Kathleen Kimber, Brian Kneale, Peggy Kraay, Klaus Lankheit, Geneviève Le Duc, Sarah Levitt, Ronald Lightbown, Hugh Macandrew, Julie Mckeny, John Maddicott, John Mallet, Peter Meller, Jeremy Montagu, Philip Morgan, Hugo Morley-Fletcher, Veronica Murphy, Nick Norman, Andrew Penny, Lucy Penny, Carlo Pietrangeli, Sandra Pinto, Julia Poole, Tamara Préaud, Paul Quarrie, Robin Reilly, Aileen Ribeiro, Crispin Robinson, Antoinette le Normand Romaine, Herta Simon, Robert Skelton, Peyton Skipwith, Joanne Soden, Lindsey Stainton, Sheena Stoddart, Anne Thorold, W. F. Toporowski, Charles Truman, David Udy, Piero Verado, Clive Wainwright, Philip Ward-Jackson, Malcolm Warner, Norma Watt, Robert Williams, Edwin Willson, Carolyn Wilson, H. I. R. Wing, Patrick de Winter, Federico Zeri.

Contents

Works Catalogued

Notes on the Scope and Presentation
of the Catalogue

THE catalogue includes some metal work and *objets d'art* that are not generally classed as sculpture. I have made this decision partly because of the difficulty of devising clear distinctions, but chiefly out of a concern that items in the Museum's collections might otherwise never be catalogued at all—enamelled ormolu candles, a cup fashioned out of mother-of-pearl, an obelisk of blue-john, a steel purse holder are examples. I have also included some furniture, especially that which incorporates marble slabs or inlay or that adorned by notable ormolu mounts or carved ornament. Those pieces which I have not catalogued are listed in appendices to each volume. I have not included any of the musical instruments in the Hill Collection which has already been catalogued by Boyden (in 1969) but it is worth pointing out here that the heads and figures carved on some of these— in particular the head on the bass viol by John Rose of Bridewell and the Moor's head of ebony inlaid with ivory on the Venetian cittern—are sculptures of very high quality. I have included some items of continental plate with an obviously sculptural character. Ceramics are included when they are likely either to reflect a prototype in bronze, terracotta, or marble, or to have been modelled by an artist much of whose work was on a larger scale. Thus there are entries for a biscuit porcelain figure after a statue by Pajou, for a pair of *terraglia* figures deriving from bronzes by Foggini, and for vases with a speckled granite finish or of a shape inspired by stone bodies with ormolu mounts. But porcelain figurines from the great German factories (of which the Museum has a fine collection mostly given by L. R. Abel Smith in 1963), together with the few which it has from French and British ones, are excluded.

Those sculptures which can be associated with a particular artist or craftsman have been listed alphabetically. Priority is given to modellers or carvers, then to the creator of the prototype, then to the founder or to the supplier or factory-owner. Thus, if there was a bronze cast by the Barbedienne foundry after a model by Houdon which was derived from a work by Bernini it would be catalogued under Houdon. If it was not certain by whom the model was made it would be catalogued under Bernini. If, in addition, the connection with Bernini was conjectural it would be catalogued under Barbedienne.

Works which cannot be associated with a particular artist or craftsman are listed in chronological order (which can of course only be approximate) after the alphabetical catalogue of the national group to which they belong. In the case of the first volume, devoted to Italian sculpture, a distinction has been made between independent figure sculpture and utensils and fittings, which are grouped under types (inkstands, candlestands, door-knockers, seals, and so on), which will I hope make the catalogue easier to consult. The second volume groups the anonymous French sculpture after the alphabetical section devoted to that school. This section is followed by an alphabetical section devoted to European (and colonial) schools other than the Italian, French, and British with a corresponding anonymous section after it. The second volume concludes with two sections: one devoted to the sculpture the origin of which has seemed to me impossible to determine and another devoted to trifles and rubbish reluctantly received or inadvertently acquired. The third volume is devoted to British sculpture— little of which is anonymous. I have catalogued separately and only briefly the remnants of the large collection of plaster casts by Sir Francis Chantrey given to the University Galleries by his widow.

Artists will be found listed under the country where most of their mature work seems to have been made. Thus Giambologna, Duquesnoy, and Thorwaldsen will be found under Italy and Fanelli, Roubiliac, and Guelfi under Britain. Not every artist can easily be placed by this means. Marochetti presents a particularly tricky case: he will be found among the British because the only work by him catalogued here was made in Britain. The sculpture by Marochetti has in fact been lost but I have still catalogued it, as I have a few other items which are clearly recorded as having once been in the collection.

Although I have included copies in bronze and terracotta and marble after the antique—this indeed accounts for a very large part of the collection—I have not catalogued plaster casts of the antique of which there is a large and important collection in the Ashmolean Museum. Those few plaster casts of subsequent sculpture in the collection have been included because of their historical interest—the cast of the frieze from S. Maria dei Miracoli and the cast of the death-mask of Lorenzo de' Medici are examples. These casts are catalogued either under the name of the artist responsible for the object reproduced or among the anonymous sculpture at the period the original was made.

Forgeries I have placed in the catalogue as if they were genuine. A possibility that some of these works are genuine cannot be excluded and they seem to me best placed where this possibility will be most frequently reassessed. However, when I believe that an innocent imitation of a work in an earlier style, or even a work merely influenced by earlier sculpture, has been sold as an earlier sculpture I have not classed it with the earlier sculpture. I have not included forgeries of Greek and Roman antiquities.

In some respects my method will be found to differ from that of other museum catalogues including those devoted to the paintings and to the Old Master drawings in the Ashmolean. Above all I have not supplied that type of description which was originally devised as a substitute for illustrations. (Every

item in this catalogue is illustrated.) On the other hand I have tried to provide fuller technical information and a fuller account of the physical condition of each work than is usual and also more information under provenance.

In fact I have deliberately given more information than is likely to be required by any one reader: information on such matters as the size and colour of the modern plinth, the manner in which a bronze from Fortnum's collection was displayed in his house, the number of chaplet pins visible in the interior of a cast, and the price of the object. But it is as easy to skip what is not of interest as it is hard to discover what has been omitted in a catalogue. All the same I hope that I have avoided the obvious: separate artists' biographies, for example, are not given. Readers who want an outline of the careers of Michelangelo, Bernini, or Canova can find these more easily elsewhere. On the other hand, in the case of an artist such as

Grandi who is little known in this country there is a good deal of biographical material which has been incorporated into the relevant catalogue entry.

In cataloguing bronzes I have departed in a couple of ways from conventional language. I have avoided the verb 'to chase' except in the case of silver where it has a precise meaning—to work in the metal with a sharp tool without losing any of the metal surface. Generally when used of bronzes 'chasing' is simply an impressive word for tooling—usually punching or chiselling. 'Patina' is used here to mean the colour which belongs to the metal (as sun-tan or a sickly pallor belong to the skin) and is distinguished from varnishes which are applied to the metal (as face paint is to the skin).

A description of the catalogues of Fortnum's collection, to which reference is frequently made in this catalogue, is given in the Preliminary Essay in the first volume.

PRELIMINARY ESSAY:

The Fortnum Collection

THE Ashmolean Museum houses one of the most important groups of small Italian sculpture in the world because it incorporates the collection of Charles Drury Edward Fortnum, a collection most distinguished for its bronzes (many of them Etruscan, Greek, or Roman or of the early sixteenth or late fifteenth century and so not included in this catalogue), for its ceramics, and especially its Italian maiolica, and for its finger rings, but also including important terracottas, carvings in stone, marble, jet, ivory, and wood. Not much has been written about Fortnum, but what there is has a value which is not diminished by what follows. All students of his collection must refer to John Mallet's articles 'C. D. E. Fortnum and Italian Maiolica of the Renaissance', *Apollo* (1978), 396–404, and 'Storico e storicismo: Fortnum, Cantagalli e Castellani', *Faenza* (1978), 37–47; and also to Christopher Lloyd's 'Two Large Plaquettes in Oxford from the Collection of C. D. E. Fortnum', in the symposium papers on Renaissance plaquettes, edited by Alison Luchs, published by the National Gallery of Art in Washington in 1989 as No. 22 in their Studies in the History of Art. What I have attempted is a fuller description of his activity as a collector, with special reference to his sculpture, and brief accounts, never previously attempted, of the manner in which the collection passed into the care of the University of Oxford, and the ways in which it has been displayed there.

1. *The Growth and Shape of the Collection*

Drury Fortnum, as he was known, was born on 2 March 1820, the only surviving legitimate son of Charles Fortnum—the latter was aged 50 when Drury Fortnum was born and died aged 90 in 1860. Privately educated on account of delicate health, Fortnum nevertheless sailed to Australia in 1840, where he acquired a cattle ranch. His illegitimate half-brother Charles William Stuart was already settled in Australia. Fortnum is said to have discovered the Montacute Copper Mine ten miles outside Adelaide and he is known to have formed a collection of birds, reptiles, and insects some of which later found their way into the British Museum and others of which, as part of the collection of his friend F. W. Hope, went to the University Museum in Oxford.

Fortnum and Mason in Piccadilly, the grocery store established in the late eighteenth century by a Charles Fortnum who had been a footman to George III, prospered and expanded steadily throughout the early nineteenth century, especially under the management of Richard Fortnum, who died in 1846 leaving legacies of over £50,000. His share of the business was inherited by his nephew Frederick Keats and part of his fortune by his niece Fanny Matilda Keats. Drury Fortnum returned to England in 1845 and in 1848 he married this cousin Fanny. She was then aged forty. Her fortune made it possible for him to live as a gentleman and it enabled him to collect. Given Mrs Fortnum's age it must soon have been apparent that they would have no children. During the 1860s, Miss Keats, an orphan niece, lived with them and she was (as Mrs John Holland) to be a major beneficiary of Fortnum's will; but Fortnum jocularly referred to his bronzes and his pots as his babies and Mrs Fortnum may have felt tenderly towards them too. They went to Italy, perhaps for the first time in the year of their marriage and Mrs Fortnum seems to have accompanied her husband on many of his subsequent continental travels. By the 1860s her rheumatism and colds provided them with an additional motive for spending the winter abroad. We do not know what part she played in her husband's collecting but some items in his catalogue are specified as having been presented to her and it is significant that the earliest purchases of works of art of which he kept a record include none, however modest, made before his marriage.

The Fortnums were able to buy a substantial if plain brick Georgian house, the Hill House, at Great Stanmore, Middlesex, probably in the year of their marriage, and some of the works of art acquired soon afterwards must have been furniture for their new home. Fortnum's eighteenth-century French ormolu—his candlestands, urns, and clocks—were probably thought of in this way, even though, with typical scrupulosity, he included them in his catalogues. His two pairs of white marble busts after the antique (Nos. 3, 20, 514, 515) bought from studios in Rome and a statuette bought at auction in Paris (No. 292) must also have been thought of as ornaments—they were certainly displayed in the drawing room at the Hill House (Plate A). Also in that room were his three mosaic marble table tops—the largest of them by Michelangelo Barberi (No. 10)—although even here something of Fortnum's systematic and scientific turn of mind is apparent, for Barberi's table top is not only a work of art but a display of mineral samples; the two smaller table tops (which are not in the Ashmolean Museum) were selected to illustrate the different branches of a related art, one an example of the stone marquetry pictures made by the Florentine workers in *pietra dura*, the other an example of the micro-mosaic work of the Roman craftsmen.

The earliest bronzes which Fortnum is recorded as buying came from a Genoese dealer called Maggi in 1848. They were statuettes of a *Centaur*, a *Bull*, a *Jupiter* (Nos. 162, 164, and 337)—all French or Italian works of the seventeenth or eighteenth century—and an inkstand of a nude figure of Pan pausing with his pipes poised as if enraptured by the repetitions of Echo, a work long attributed to Riccio, which is one of the most poetic works of the Italian Renaissance (Plate B). Two

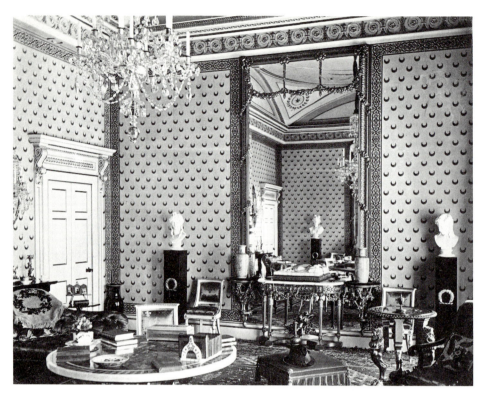

A. The drawing-room in the Hill House, Stanmore. The circular marble specimen table by Barberi (No. 10) is in the foreground. The sleeping nude by or after Mignot (No. 292) is in front of the looking-glass, which reflects the marble bust by Amici (No. 4) and is flanked with busts by Gott (Nos. 514 and 515).

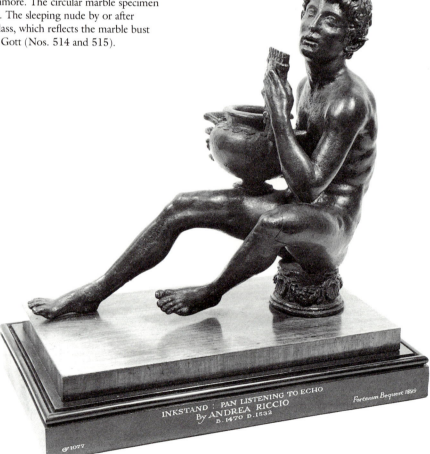

B. *Pan Listening to Echo*. Bronze. *c*.1500, sometimes attributed to Riccio. Ashmolean Museum.

years later Fortnum bought in Bologna the mysterious, beautiful statuette of a half-draped *Venus*, and in 1855 he bought from the antique and reproduction furniture and ormolu dealer Forrest, in the Strand, the statuette of *St John the Baptist* for £15 (he later refused £500 for it) which is now recognized as the early masterpiece by Severo de Ravenna, dating probably from the end of the fifteenth century. Fortnum did not know to whom the *John the Baptist* should be attributed (he hesitated to accept the suggestion of Donatello) but he was aware that 'in action, in expression, in the management of the drapery, in the delicate execution of the extremities, particularly the hands' it possessed the 'highest excellence'. It is indeed remarkable how Fortnum, at a time when there was hardly any scholarly interest in the small bronze statuettes of the late fifteenth century, should have so soon secured three of the dozen most beautiful examples to have survived (all three too early in date to be included in this catalogue). It should not, however, make us suppose that Renaissance art was his only, or even his chief, interest during his first decade of collecting.

The *Centaur*, *Bull*, and *Jupiter*, the three other bronzes acquired from Maggi in 1848, were more expensive than the Pan inkstand. Two of them were copies after antique sculptures and the third was inspired by such a sculpture. In this respect they resemble the marble heads which Fortnum bought in Rome, and indeed the table top by Barberi, which has in its centre a micro-mosaic copy of a famous antique mosaic. Fortnum's first catalogue of his collection made in 1857 reveals that he also bought modern bronzes which were replicas of Roman lamps and cups and modern terracotta copies of large bronzes and marbles in the Museo Borbonico in Naples (preliminary catalogue, pp. 55, 56, 93)—items which he seems later to have disposed of.

The relative importance of different parts of a collection cannot be settled by counting, but it is nevertheless noteworthy that in 1857 Fortnum had 48 bronze statuettes of ancient Egyptian, Greek, Roman, and Etruscan origin as against 23 'Italian, French &c Bronzes & figures'. The ancient miscellaneous implements also greatly outnumbered the Renaissance and modern medallions, door-knockers, and so on, and there were more ancient vases and terracotta lamps than pieces of majolica and modern faience. It is fair to say that there were few items among his ancient works to compare with the Renaissance ones in quality, but there was no Renaissance work which Fortnum pursued as keenly as the corroded but perfectly intact Greek bronze *Venus* holding a twisted wreath in her raised right hand (Plate C). This statuette was sold in 1841 to Edward O'Meilly RN (the name is given incorrectly by Michaelis in his *Ancient Marbles in Great Britain*) in Moglia, near Stratonikeia in Karia, and subsequently obtained by B. Hertz, at whose sale at Sotheby's in 1859 Fortnum bought it for £135—a higher price than he paid for any Renaissance statuette.

Emily Mary Hall recorded in her manuscript diary (Kent Record Office, U923,F2/11, II, pp. 121–2) a visit to the Fortnums in Rome on 9 March 1866:

Mr F. talked of £30 or £40 for a tiny gem as big as a sixpence! he told us a curious story of a Bronze antique figure now in his collection.

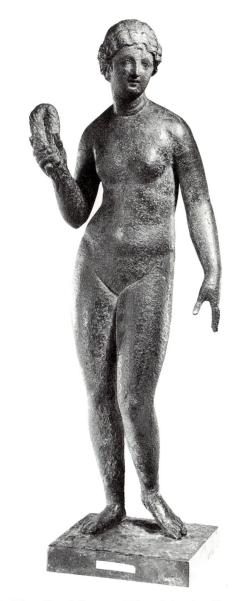

C. The 'Hertz Venus'. Bronze. *c.*200 BC. Ashmolean Museum.

A young Englishman: I forget his name went with some companions yachting to the coast of Greece: & whilst on shore shooting a peasant bought him a bronze figure & some coins dug up in the neighbourhood. The gentleman gave him a sovereign for them & the man was very greatly elated. The yachter knew nothing whatever of art & brought the things to Engd. only to sell them again. The coins he carried to a small dealer who immediately gave him £35 for them & would have bought the bronze but had not the money by him— eventually someone gave him £15 for it & soon after sold it to Herz the Jew collector for £50. In his shop window Mr F. saw it & heard the story: & desired to buy the figure but Herz wd not sell it. It was one of his treasures which he desired to keep for his especial enjoyment. Mr F. asked him to put a price upon it—'the least I wd take wd be £300—but I repeat I do not mean to sell it'—so things went on & Mr F. used to go & ogle his young lady thro' the window for all she never ogled him or took any notice of his admiration. Meanwhile the people of Liverpool impelled by Mr Mayer the collector agreed to buy Herz's collection in one lot to add to Mayer's which

he most generously presented to the city & in consideration of getting it in one lot Herz consented to sell for 10 what otherwise he wd not have parted with under £12 000. The Liverpool merchants bound themselves to subscribe various sums & so make up all that was required. But unfortunately for human hopes, bef: the purchase was completed a great crisis took place in the commercial world. Several American houses failed & with them failed sundry Liverpool houses also; & were consequently unable to fulfil their promise in subscribing towards the purchase of the Herz collection: Mayer had spent so much on his own that he could not do more, than he had originally engaged to do—so, finally to the regret of all who cared for such things the Herz collection came into the market. Mr Fortnum heard of it, tho' abroad & wrote to a friend giving him 'carte blanche' to buy it: only begging that he might not be ruined—& now it is the joy and pride of his heart: & his collection—I longed, but did not venture, to ask what he gave for it.

In addition to this bronze we might cite two other antiquities in Fortnum's collection of great beauty and rarity—a large iron ring set with an intaglio gold portrait of Berenice, consort of the first Ptolemy Soter (318–297 BC), and a terracotta head of a youth with boldly modelled hair and an expression of great pathos (Plate D), which was excavated in Rome in 1882 on the Esquiline near via Paolina and bought by him in the same year from his friend the sculptor Francesco Fabi-Altini. The head Fortnum believed to be from a recumbent or seated tomb effigy by an artist of the Italo-Greek or Greco-Etruscan school. He was inclined to date it between 250 and 300 BC and in reading a paper to the Society of Antiquaries (*Archaeologia*, 49 (1885), 453–5) on 26 March 1885 he cited the opinions of 'Dr Helbig, Mr Newton and the late Sig Alessandro Castellani' in support of this. A few scholars seem to have doubted the antiquity of the work but Evans 'pronounced' the clay to be genuine and detected on part of it a 'deposit which proved its age'. L. R. Farrell gave it prominence in an article 'On Some Works of the School of Scopas', in *Journal of Hellenic Studies* (7 (1886) 114–25), finding in it 'a high pathetic and dramatic emotion free of all morbid consciousness, and wrought in large and satisfying forms'. It is certainly one of the most powerful ancient sculptures in Britain and deserves to be far better known.

In 1858 Fortnum was elected a Fellow of the Society of Antiquaries. In subsequent years he addressed several learned papers to the Society and he was elected its Vice-President in 1886, 1891, and 1894. He also served as Honorary Vice-President of the Archaeological Institute. By 1859 he had commenced correspondence with Henry Cole of the South Kensington Museum (now the Victoria and Albert Museum) mostly concerning possible acquisitions (the letters are in Box 16 55 BB of the Cole correspondence in the National Art Library). His close association with the South Kensington Museum was reflected in his catalogue of maiolica there which was published in 1873. This was followed in 1876 by his catalogue of the bronzes—both books were landmarks, not only because of the exact scholarship and the commendable caution of their entries but because of the lucid introductory historical surveys which were both more comprehensive and more reliable than any previously published. During the 1860s Fortnum had come to concentrate his attention chiefly on the Renaissance and his work on these catalogues during the 1870s and his involvement with the South Kensington Museum

generally must have done much to confirm him in this.

His correspondence with Cole is not however confined to Renaissance sculpture and ceramics. He drew Cole's attention to old silk and velvet in Florence (on 15 March 1859), to olivewood marquetry made in Nice by an Italian who refused to show his work as an example of French manufacture at the international exhibitions (on 24 February 1862), to fine modern bronzes by Righetti (see Nos. 79–81) in the possession of Righetti's son in Rome (on 2 February 1870), to a marble chimney-piece made for Pius VI in 1775 (on 4 March 1870), to a new papal medal featuring St Peter's (on 19 March 1870), to a collection of engraved gems (31 March 1870), to the merit of a pair of late seventeenth-century bronze vases belonging to C. C. Black (15 October 1870—these were bought by the Museum and are 843 and 843a–1870). He also displayed great confidence. 'I flatter myself that I know quite as much or more about them as any man in Europe', he wrote about the Della Robbia on 15 March 1871, and on 31 March 1870 he pointed out that he had 'given some attention to engraved stones, particularly this winter during my stay here [in Rome]' and 'candidly' confessed that he would back his judgement against that 'of any English connoisseurs whom I know of including all the tall talkers and writers on the subject'.

Fortnum contributed generously to the loan exhibition mounted in the South Kensington in 1862, and in 1883 he

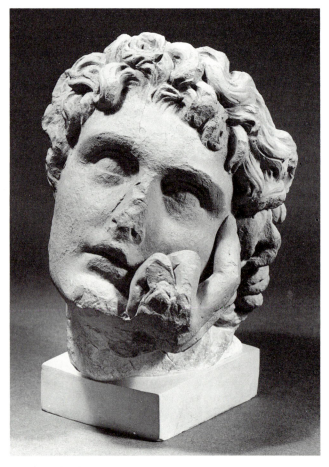

D. Heroic head. Terracotta. *c*.200 BC. Ashmolean Museum.

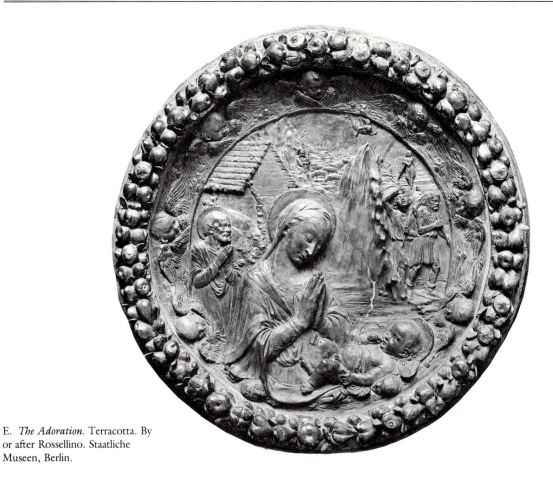

E. *The Adoration*. Terracotta. By
or after Rossellino. Staatliche
Museen, Berlin.

permitted a large part of his collection to go on display there,
in two large glass cases to right and left of the entrance to the
Court of Italian Art—one case contained examples of maiolica,
and Della Robbia ware, his examples of Medici porcelain, his
terracotta bust by Bandinelli (then attributed to Cellini), and
his *pietra serena* relief thought to be by Desiderio da Settignano
(Nos. 8, 27), and the other case contained 'upwards of thirty'
small bronzes some of which Fortnum had also exhibited in
1879 in the rooms of the Burlington Fine Arts Club. Many
people, including for instance Wilhelm Bode, director of the
great Museum of Berlin, who began his correspondence with
Fortnum in 1886, assumed that Fortnum would bequeath his
collection—or at least this part of it—to South Kensington.

Whilst acting as adviser for the South Kensington Museum
Fortnum accepted consultancy fees and his expenses, but he
had never taken a commission on any work of art which he had
reserved for, or directed to, the Museum. 'I am anxious to
maintain my position as an *amateur* and not to be looked upon
as a *dealer*,' he wrote to Cole on 5 April 1865. Some of the
items which he persuaded the Museum to buy—for instance
the large fifteenth-century Florentine archway in *pietra serena*
(62–1866)—would not have been easy to accommodate at
Stanmore. But he must have often reflected on those pieces
which he might have picked up for his own collection but which
he had honourably recommended to the Museum instead. In
one case, a terracotta tondo of the *Adoration* (Plate E) which

was a variation on the celebrated marble by Antonio Rossellino,
Fortnum actually bought the work himself in the winter of
1864 for the high price of £200 in order to secure it for them.
The terracotta had been with Louis Hombert, a leading
Florentine dealer who had acquired it from a member of the
Dolfi family in 1858. The Museum's Board turned it down.
They had in fact recently come to the conclusion that they had
devoted enough of their resources in recent years to Italian
sculpture, but the excuse that they gave to Fortnum was that
J. C. Robinson regarded the piece as a 'surmoulage'.

John Charles Robinson had been made curator of the
Museum of Ornamental Art when it was established in 1853
in Marlborough House and had become superintendent of the
division of the South Kensington museum which corresponded
with this in 1857. In 1863 he had been relegated to the position
of 'Art Referee' but there was no question about his authority.
He was the greatest connoisseur of his day in Britain—indeed
perhaps the greatest this country has ever known—and his
opinion was not easily dismissed. It was, however, wrong:
doubts have been expressed concerning the status of the
terracotta (it is in East Berlin, where I have not studied it) but
it is certainly not an aftercast. Robinson had been a close friend.
He and Fortnum had travelled together, they had corresponded
on their collecting in all fields, and Robinson had even
presented Fortnum with some minor pieces in his collection.
So it is most surprising that he had dismissed the tondo so

hastily. Fortnum was able to secure from Professor Emilio Santarelli, the Florentine sculptor and dealer, a certificate of its authenticity and, more importantly, he had letters from Sir Charles Eastlake and Charles Perkins in its favour. Fortnum let the relief stay on loan at South Kensington and gave them what he said would be a 'last chance' to buy it on 20 May 1868— 'Mind I have no great wish to part with it & once fixed at home certainly shall not do so.' (Robinson had by then resigned.)

C. F. Bell who knew Fortnum and discussed his collection with him added a marginal note in the large manuscript catalogue to the effect that it was because of this incident that Fortnum decided not to leave his collection to the South Kensington Museum, and the strength of Fortnum's feelings over the affair is clear from the manner in which he did eventually part with the relief. 'Amongst all your pieces,' Bode wrote on 1 February 1886, 'one that strucked me the most by its artistic value is the study of the adoration by Antonio Rossellino'. He knew that doubts had been expressed concerning it but 'you know my opinion; and I say that I would appreciate it extremely in our collection'—that is to say in the Museum in Berlin—'and that I would be glad to have it one day for a thousand of £'. Fortnum offered it again to South Kensington, this time for £800, to be paid, if need be, in stages, explaining that he was sorely tempted by Bode's offer 'the more so as I want to make some alterations to my home'. The Museum refused, he accepted Bode's offer in a letter of 14 December 1886, and it was sent to Berlin the following March. The transaction had the effect of both snubbing South Kensington and endorsing his own judgement.

It is unlikely that Fortnum really needed the money and he sold no other works from his collection even though Bode was desperate to acquire the inkstands signed by Peter Vischer (bought by Fortnum in Paris and Geneva)—for those he said Fortnum could 'name his own price'. Even as late as August 1896 Bode was still hoping for them and mentioned that in the delirium of a recent illness 'I am always thinking to see one of the P. Vischer's inkstands in our collection'. Bode also wished to acquire 'the pretty little St Jerome by Basaiti', now often regarded as by Giovanni Bellini, which was by far the finest of the old Italian paintings in Fortnum's collection. This painting, a *Virgin and Child* by Pintoricchio, and an *Entombment*, then attributed to Giottino but now to the Master of San Martino alla Palma (A.302, A.300, A303 in the Ashmolean Museum), were all bought by Fortnum in Florence in 1864 from the heirs of the dealer Francesco Lombardi. The only other notable old master painting Fortnum owned was a Vittorio Crivelli of *St Catherine* (A.301) bought by him at Castellani's sale in Rome in 1884 for his cousin Mary who presented it to him after she became his second wife in 1891.

If Fortnum took decisively against the South Kensington Museum on the strength of the refusal of the Rossellino relief, as Bell claimed, then it is surprising that he continued to retain close relations with the Museum authorities, not only placing works of art on loan there but also agreeing to act as agent for them, and indeed continuing to advise them on purchases. He was annoyed about the Rossellino but still more so, to judge from his letters to Cole between February and April 1870, by

the Museum's reluctance to accept his advice in the purchase of Cellini's great bust of Bindo Altoviti then for sale in Rome. He refers to muddles and missed opportunities. There is no correspondence with Cole after 1870 in the National Art Library but a number of papers survive in the Ashmolean Museum archives concerning the superb terracotta sketch of a river god (Victoria and Albert Museum 250–1876). This belonged in 1876 to Emilio Santarelli, the Florence sculptor and dealer whom we have mentioned as furnishing a certificate for the terracotta tondo by Rossellino. He was described by Fortnum as an 'elderly man' who 'no longer works in his studio, but with comfortable means devotes himself to his camelia garden & his collection of autographs'. Santarelli had formed an extensive collection of old master drawings which he presented to the Uffizi and items from his sculpture collection had already found their way to South Kensington via the remarkable collection of Ottavio Gigli which had been bought by the Marchese Campana, sequestrated by the Papal Government, and purchased for South Kensington by Robinson when (together with Fortnum) he was in Italy in the troubled winter of 1860–1. Fortnum had himself made two important acquisitions from Santarelli in 1870 including his spectacular head by Bandinelli (No. 8). Santarelli proposed that the river god was the work of Michelangelo, and other Florentine sculptors, Dupré and Romanelli, had testified in favour of this attribution. Fortnum was convinced, and although he could have bought it for himself, urged the Museum to do so, which they did for £131. The sculpture is now regarded as an extremely important model by Giambologna for a colossal sculpture of the river Nile projected for the Medici villa at Pratolino. With it came an interesting group of lesser and earlier Renaissance works in terracotta and plaster (251, 252, 253–1876) bought for £51, £11, and £7.

Fortnum did eventually come to share the disillusion with the management of the South Kensington Museum that Robinson had expressed to him on 5 March 1869. Robinson felt that it was pointless working on catalogues of collections that were kept in 'a state of disgraceful confusion' (he would no doubt otherwise have compiled the catalogues of the majolica and bronzes). Certainly by 1 March 1888 Fortnum wrote to Arthur Evans that he regarded South Kensington as 'now under such incompetent direction', and as 'so niggardly & miserable in some ways, and ignorantly wasteful in others, that one wonders at nothing illiberal or wasteful that they may do'. He expanded on his objection to the way the Museum was organized in another letter to Evans of 23 October 1894:

I am afraid I have but small belief in republics and committees particularly as regards the management of institutions of this nature . . . The South Kensington Museum I was indirectly & as an amateur connected with from its first formation—In its early days under able departmental heads it worked merrily & with good effect— later when these heads were represented by committees or councils (the which I was asked but refused to join) error and disaster came thick and fast—The British Museum of which I have the honour to be a Trustee is a better model.

In a paper published in the *Archaeological Journal* (1892: 288) he lamented its excessively heterogeneous character—'it has

become such a crowded "omnium gatherum" of ill-arranged and ill-assorted specimens that one loses oneself as in a maze'.

There is no proof that Fortnum had ever intended that his collection should go to the South Kensington Museum, but these very attacks are best explained as justifications for what might have been regarded as betrayal. The more his collection is studied the more it looks as if it was formed along the same lines as those in the South Kensington Museum and as if designed to fit into it. The emphasis of his collection is on illustrations of the history of technology as well as art—he may have preferred works which have been cast, forged, fired, or blown rather than carved or painted—and this is reminiscent of the priority placed on 'industrial art' by the founders of the South Kensington Museum.

A superficial acquaintance with his collection would not suggest that Fortnum took much interest in modern art. But, as has been mentioned, he purchased table tops and marble copies from sculptors in Rome in his early years as a collector. He also bought in London in 1851 a couple of decorative bronzes of nude women (an *Eve* and a 'female caressing a dove') after the Belgian sculptor Charles-Auguste Fraikin (1817–93) which the Ashmolean did not deem worthy of collection after his death. In his letters to Cole he often refers to modern works and in one long letter of 10 March 1862 he offered his views on the projected Albert Memorial, urging that it take the form of a gothic tower with sculpture and mosaic which would express popular and national sentiment. With an architect such as Scott or Street 'a lovely thing might be safely looked for.' He took a special interest in the revival by modern craftsmen of the Renaissance work he studied. He commissioned spectacular serpent-handled majolica vases of sixteenth-century form, decorated with grotesques and with his own arms, from the Cantagalli factory of Florence in 1882 and he was presented in 1887 by the same factory with a plate, splendidly decorated by Ulderigo Grillanti, dedicated to him by the workshop as 'their guide in the art' (reproduced in Mallet's article in *Faenza* and in the latter case in Timothy Wilson's *Maolica: Italian Renaissance Ceramics in the Ashmolean Museum* (Oxford, 1989)). He commissioned work from a modern Roman foundry (No. 87) and we know that he had many contacts with Hatfields, the leading London 'bronzist'. He also seems to have commissioned from Pomeroy a copy of a small Renaissance bronze (No. 561) cast by the lost-wax method then being revived in London.

When compared with earlier collectors in similar fields, most notably perhaps Matthew Uzielli of Hanover Lodge, Regent's Park (whose enamels, glass, majolica, bronzes, and gems Robinson had catalogued in 1860), Fortnum's collection is remarkable for its comprehensive character, including works from periods which he regarded as inferior, and works which were obviously minor but which shed light on the history of a technique or the importance of even the most mundane article of applied art (his collection of bronze door-handles is the best example of this). Presenting a large part of the collection to Oxford, and proposing the eventual bequest of the remainder, Fortnum wrote, in a letter to the Vice-Chancellor of 24 November 1888, that it was 'illustrative of the rise and development of the sculptor's art, as applied to smaller objects, as also of that of the potter, from antique Egyptian to recent times' and hoped that it 'would be made useful by promoting study of the history and archaeology of various branches of the applied arts'. The fact that it had this didactic character must have been due at least in part to the influence of the South Kensington Museum.

In addition to being influenced by the ideals of the South Kensington Museum Fortnum's collecting was shaped by the special interests of some of the dealers from whom he bought. This course is generally true of collectors, although seldom admitted. Although Fortnum bought works both at auction and from dealers in London the majority of his collection was formed on the continent and above all in Italy, where he travelled frequently. He bought many pieces—antique and Renaissance—from Alessandro Castellani and evidently enjoyed cordial relations with him, citing his opinion (for example, of the ancient terracotta head already discussed) and recording gifts received from him to himself and to his wife. Alessandro was the son of Fortunato Pio Castellani (1794–1865), who had been the leading goldsmith in Rome in the period between 1830 and 1855, collecting and excavating antique jewellery of which he made a careful study and which he reproduced in his own work. Alessandro (1823–83) had left Rome for political reasons and resided in Paris and London, where Fortnum would certainly have first met him, before returning to Italy (at first to Naples and then to Rome) in 1862. He continued with his father's work as a jeweller, collector, and dealer but was a more serious scholar and more extensive in his antiquarian interests. The idea of forming a collection of finger rings of all ages is one which Alessandro must have encouraged and indeed he enlarged this part of Fortnum's collection by a number of presents. Alessandro's son Torquato (1846–1931) and brother Guglielmo (1836–96) were involved in the study and revival of Italian majolica, the field in which Fortnum was perhaps most expert. Fortnum commissioned a plate decorated with arms from Torquato's factory in 1880. The Castellani were also sympathetic to the formation of public collections. They not only sold some of their own collections *en bloc* to European museums (including the South Kensington and British Museums) but presented their most important collections to the Italian state—and Alessandro's brother Augusto became Director of the Capitoline Museums. From Augusto Castellani Fortnum purchased an important group of bronzes; he noted of one of them, a salt-cellar in the form of a triton carrying a shell (No. 245), that Augusto's silversmiths made imitations of it. His bronze triton and tortoise inkstand came from the same source. Were the modern imitations of this piece which Fortnum knew of made by the Castellani?

The Castellani were not the only scholarly and public-spirited Italian dealers known by Fortnum: there was the sculptor and dealer Francesco Fabi-Altini in Rome and the sculptor, collector, and dealer Emilio Santarelli in Florence, who have already been mentioned, and Alessandro Foresi, a Florentine dealer in ceramics and the scholar who first drew attention to the importance and beauty of the soft-paste porcelain made for Francesco de' Medici in late sixteenth-century Florence. (Fortnum owned three of these rare pieces, two of which he presented to the British Museum.) Foresi dealt in bronzes as

well and Fortnum bought a small group (No. 46) and a candlestand from him. Nevertheless the Castellani did have a special significance for Fortnum and it may have been partly because of them that he thought of Oxford as a home for his collection. During the 1870s a collection of Etruscan antiquities had been purchased from Alessandro Castellani for the University Galleries; he had also presented a similar collection to the University, but the latter had been placed in a different institution, the Ashmolean Museum, then still in its original building next to the Sheldonian Theatre. This suggested some serious confusion within the University, with which Fortnum was unlikely to have had much patience.

2. *Fortnum and Oxford*

When a young man in Australia Fortnum sent specimens to the Revd Frederick Williams Hope (1797–1862). He seems to have given him more on his return to England and Mrs Hope is recorded as giving him a few items in his collection of bronzes and terracottas. He was actively involved in helping Hope with his endeavour to persuade the University of Oxford to accept on reasonable terms his great zoological collections, to endow a chair in entomology, and to care for his vast collection of engraved portraits, and letters of 1857 show that by then Fortnum was acting as his friend's agent in dealings with the University. This was the period when the University was founding its museum of natural history, against considerable opposition. This foundation entailed the reorganization of the old Ashmolean Museum, many of whose curiosities of natural history now had a new home. There was soon to be pressure for the rationalization and extension of the University's archaeological holdings.

The Keeper of the Ashmolean was John Henry Parker. He had met Fortnum in Rome in 1869 and Fortnum had mentioned the possibility of his collection coming to Oxford. They had met a couple of times since then, as Parker recalled in a letter to the Vice-Chancellor of 9 March 1881. He enclosed a letter which he had received from Fortnum dated 27 February (quoted in full in R. F. Ovenall, *The Ashmolean Museum 1683–1894* (Oxford, 1986), 243): 'There are many and valuable works of art and archaeology in the different colleges—the Taylor Buildings [i.e. the University Galleries]—the Ashmolean &c &c., which ought to be gathered together into one University Museum of "Art and Archaeology"—the work of man as distinguished from the Natural History Museum . . . properly arranged in classes, in a fire-proof building, well-guarded', such a collection would attract benefactors. Certainly it might expect some gifts from him but, he added, 'to entrust my beloved children (my only family) to a baby-farm where they might die for want of proper nursing, clothing, or care, would be the act of an extremely careless or unnatural parent'.

Fortnum's next step was a public one: he contributed to the *Academy* for 10 December of that year an article on Oxford's need for a museum of art and archaeology. When Parker died on 31 January 1884 it was clear that the Ashmolean Museum would be reorganized. On 17 June a most persuasive and energetic advocate of reform was appointed Keeper—Arthur

Evans, son of the distinguished geologist, numismatist, and archaeologist Sir John Evans, who had long been known to Fortnum. Fortnum immediately corresponded with Arthur Evans on the refurbishment of the upper room of the Ashmolean Museum. Fortnum clearly admired the young archaeologist's 'pluck and energy' in dealing with the University authorities and especially the faction represented by Benjamin Jowett, whom he seems to have despised.

The understanding was that if the University committed itself to improving the Museum's facilities Fortnum would eventually give his collection and an endowment. In November 1884 Evans held a 'conversazione' shortly after his inaugural lecture. An album of photographs of Fortnum's collection was on a table in his room. When Evans had secured a grant for a hot water apparatus and cases from Messrs Sage, Fortnum began to send his collection on loan. At first he sent the archaeological pieces which by then he esteemed least among his collection. Ninety bronze arrowheads, spearheads, fibulae, vase handles, and the like were sent on 22 December 1885. Early in the following year he sent the first major work of art, the remarkable terracotta head already described. Then on 12 December 1886 he dispatched a further 87 ancient bronzes—this time Etruscan, Roman, and Greek statuettes, including the celebrated Herz *Venus*, and, on 21 December, 59 items of ancient pottery and glass.

Fortnum was uneasy in his dealings with Arthur Evans because 'you & others at Oxford are too fond of classic to care for renaissance objects which form by far the most important & valuable portion of my collection' (letter to Evans of 27 August 1886); the 'renaissance things' are those which 'in my heart of hearts I love more dearly'.

Nevertheless, among the next batch of 112 items which he sent on loan on 8 June 1887 there were pieces of Italian majolica, some Renaissance pewter platters, and Spanish jet carvings. On 19 August he sent a couple of Renaissance bronzes as well as more majolica (16 items in all), and then on 26 August 40 important ceramic pieces, mostly maiolica and Hispano-Moresque ware, which had been on exhibition at the Burlington Fine Arts Club. A further 36 ceramic pieces followed on 5 October.

Having begun to part with his maiolica Fortnum next began to send his Renaissance sculpture. Forty-six bronzes together with some of his Della Robbia ware were sent on 7 January 1888 and 28 bronzes together with 10 other pieces—some terracottas and some carvings (the *pietra serena* relief, No. 27, and the boxwood *St Sebastian*, No. 348, among them)—were sent on 20 March from the Royal Academy where they had been on exhibition. Then on 14 September he sent 120 small works in low relief (medals and plaquettes) with one bronze Etruscan candelabrum—eight additional items of terracotta and bronze followed ten days later. This concluded the first phase of Fortnum's benefaction and on 24 November he wrote to the Vice-Chancellor offering everything on loan (there were 690 objects in all) as a gift to the University. Thanks were decreed by Convocation on 4 December. The 'SKM people were sadly disappointed', Fortnum noted, not perhaps without gratification, in a letter to Evans dated the previous day. He was made a Visitor of the Museum in December and in the

following year, on 26 June 1889, an Honorary Doctorate was conferred.

Neither Evans nor Fortnum saw this as a conclusion. They still wanted to see Oxford's archaeological and art collections sensibly combined in a situation adapted to their use for teaching purposes. The obvious solution was to add a building to the back of the University Galleries and move Fortnum's gift and the other archaeological collections in the Ashmolean Museum there—to combine the Ashmolean with the University Galleries (and then take over the University Galleries). Fortnum was prepared to establish a trust fund with £10,000, out of the interest of which £300 would be paid to him annually for the rest of his life; the remainder of the interest would be divided between maintaining and increasing the collection and augmenting the salary of the Keeper. On his death this trust fund would belong to the Museum. Fortnum had never been an easy man to deal with and, now he was getting old and his health and that of his wife were failing, he became impatient and cantankerous. The death of his wife on 19 December 1890 made matters worse: his marriage on 27 October 1891 to another cousin, Mary Fortnum (only child and heiress of Charles Fortnum who died in 1845), did not do much to improve his patience or temper. There was an element of bargaining entailed in all his acts of generosity. This one was conditional on the University being prepared to spend no less than £10,000 on the extension to the University Galleries. There were numerous minor complications with the conditions he made and much obstruction on the part of the University Galleries. But eventually the matter was agreed.

In August of 1894 the upper room of the old Ashmolean was dismantled, the cases were remodelled, and the collections were transferred. In addition to the 698 works which he gave in 1888, 50 medals and badges had been sent in June 1889, 214 antique and Renaissance bronzes on 15 November 1889, and 23 buckles and spearheads on 8 July 1891. Now that the new rooms were nearly ready another 144 works were sent in October 1894 including 45 Renaissance bronzes—they were sent as a loan but turned into a gift. In January the following year, 1895, two rooms in the northern extension, one named after Fortnum, were opened. In 1896 C. F. Bell was appointed as an Assistant Keeper with special responsibility for Fortnum's collection and busied himself arranging the great collection of fictile ivories assembled by Professor Westwood which Fortnum had purchased for the University. Half a dozen extra ceramic items including the exquisite Medici porcelain ewer arrived on 10 September and in July of the following year, to celebrate the opening of a gallery devoted to jewellery, gems, and cameos lit by electricity, there was a grand opening at which the Italian mandolinist Signor Marchisio performed, and Fortnum's collection of rings was exhibited. This was an extraordinary period for the Ashmolean Museum. The acquisitions poured in. Moreover the Museum was established as a centre for scholarship. Professor Percy Gardner's catalogue of the Greek vases was published in 1893 with an appendix by Evans on the series from Gela. To match this Fortnum published in 1897 a *Descriptive Catalogue* of the maiolica and kindred wares which he had given to Oxford. From his correspondence it is clear that he also prepared one for the

bronzes. And a typescript for this has recently been discovered.

There was not now much left at the Hill House, Stanmore, and, besides, Fortnum, who had long wintered in the south of France and now owned a villa at Mentone, spent less time in England. It is interesting to note, however, that he did retain, in addition to those paintings and ornamental items which furnished the house, a few of the most remarkable of his bronzes, the *St John the Baptist*, the Pan inkstand, and one of the inkstands by Peter Vischer which Bode so coveted. The *Baptist* and the *Pan* were only to go to Oxford shortly before his death in October 1898. Earlier that year he made his will and on 6 March of the following year he died. His wife survived him by less than a month. In addition to the £10,000, Oxford University received his house and lands at Stanmore, a share in a villa at Mentone, and an extra £500 for cases and fittings for the Museum.

Fortnum's copious correspondence with Arthur Evans survives (together with a few other papers of Fortnum's) in the archive of the Ashmolean Museum library. No one who has read through it can fail to be amazed by the patience and tact that Evans displayed over the course of fifteen years. He not only excited paternal sentiments in Fortnum but a rarer fraternal respect. Some idea of the difficulties he encountered may be gathered from the following extracts from Fortnum's letters selected to reveal his distrust of the University and the violence of his opinions. It was 'foolish to think that my pearls might be appreciated by your Vice-Chancellor' (7 August 1884). 'If I let my children leave the parental roof it will be by groups at a time on loan, which would be permanent unless they were snubbed by the great ones of the University' (5 December 1884). 'But then I am not quite dead yet! & certainly shall not give in during my life. In fact the state of affairs generally [he had earlier ascribed a boil on his neck to the "advance of Democracy" and the activities of Gladstone] is so unsatisfactory & there is so much doubt as to the future of all endowments that one hardly knows what to do—the University may be disendowed … and the things I would give, or the money I would leave, may be realized and converted into & for some totally different purpose. It makes one more and more disposed to caution and checks all desire to establish what one feels may be useful institutions, professorships & &c.' (8 October 1884). 'How differently the matter would be treated in Germany!' (9 November 1890). 'I am getting old & want to see something done' (20 April 1891). 'The British Museum & Cambridge shall have the rest of the coll between them & the rest be sold, the books also: the 10,000 to hospitals' (13 November 1891). 'I have small confidence in the conscience of public bodies even when composed of Dons or Clericals' (17 November 1891). 'They are a tricky and not too honest a body & have broken faith with me, by which treatment they have alienated my affections & have brought about a change in my intentions which will be no small loss in money to the University & so you may tell any of them you please' (24 April 1893). 'My old friend Hope was disgusted—Ruskin was disgusted—and I seem to be on the road, & you with me, to the same state of disappointment and dissatisfaction with the powers of the University' (21 October 1894).

3. *The Manuscript Catalogues and Other Sources for the Study of Fortnum's Collection*

In addition to the letters and papers in the Ashmolean library's archive the principal source for the study of Fortnum's collection is the catalogues kept in the archive of the Department of Western Art. The earliest of these is a small notebook entitled 'Catalogue of Works of Art &c Stanmore 1857 et seq.' which is referred to in my catalogue entries as the 'preliminary catalogue'. Despite the 'et seq.' it is evident that this catalogue was compiled in one campaign in 1857 and that, although space was left in it for adding entries as the collection expanded, this was never done. Tucked into this notebook (previously in an envelope of miscellaneous notes in Fortnum's hand) is a single folded sheet of paper entitled 'Memoranda of prices paid' which provides supplementary information on the date and cost of acquisitions made between the late 1840s and 1859.

The next catalogue is in a set of three box-files ('Stone's Patent boxes for the Safe and Orderly keeping of all letters, papers and documents'), each of which contains a series of notebooks with soft covers of a marbled pattern. The box-files are entitled 'Sculpture and Various', 'Ceramics' (which includes glass and terracotta), and 'Bronzes'. In the last mentioned box-file there are ten notebooks for the 'Modern'—that is for the most part Italian Renaissance—bronzes, three for the 'antique' items, and two for the oriental ones (these mostly being pieces 'given and bequeathed [in 1878] to me by my dear old friend the late John Henderson'. These boxed volumes are referred to in my entries as the 'notebook catalogue'. Unlike the preliminary catalogue these were manifestly compiled over a number of years. I suspect that Fortnum commenced them in the early 1860s both from internal evidence (which it would be tedious to detail here) and from the fact that he abandoned his 'memoranda of prices paid' in 1859 which suggests that he had an alternative place to put this information.

In July of 1889 these box-files were sent to Oxford to accompany the large part of his collection which was by then, as we have seen, in the hands of the University. By then Fortnum had completed transcribing the information in them into a series of five large red leather-bound volumes, omitting some facts, changing others, adding a good deal, and also rationalizing the arrangement whilst retaining the system of numeration. Two of these volumes are devoted to bronzes, the first to antique and oriental pieces and to modern pieces in 'rilievo' (that includes the medals and plaquettes) and the second volume to 'Statuettes, Busts and Utensils'. The third volume is devoted to ceramics, the fourth to 'Varia', which includes sculpture in stone, marble, and wood, paintings, and furniture, and the fifth to rings.

These volumes are referred to as the 'large catalogue' in my catalogue entries. They include photographs of many items in the collection, have elegant title-pages, and are also too bulky for convenient reference. They are surely intended to commemorate what was by then a public collection and were to serve as the basis of his published catalogues of which only the ceramic volume appeared. Most of the work in these catalogues was complete in 1889—the date which appears on the spines—but Fortnum added notes to the entries in the last decade of his life although he added very little to his collection. After his death in 1899 the volumes came to Oxford with the residue of his collection. Thereafter C. F. Bell annotated them in a hand as neat as Fortnum's, but respectfully and in pencil. Subsequently others have also done so, but much less neatly and judiciously—indeed at times ignorantly (the practice of annotation was discontinued during my Keepership). The typescript catalogue of bronzes which was recently discovered was made from the large catalogue and includes few significant changes.

Three additional sources of information must be mentioned. Fortnum's library, which includes not only many rare volumes for the student of sculpture but valuable annotations within these, is incorporated into the Western Art section of the Ashmolean library. In the archives of the Department of Western Art there is a small black-covered notebook entitled 'Objects sent to the Ashmolean Museum' which meticulously lists each consignment of objects sent as loans or gifts to Oxford in Fortnum's lifetime. There is also a heavy photograph album entitled 'The Hill House / Great Stanmore / Photographs / 1873'—this must be the album borrowed by Evans for his conversazione in 1884 (Plates A, F, G, and H).

Unlike the large catalogues which came to the Museum on Fortnum's death, the album must have been inherited by his niece, for it was presented to the Department in 1943 by her descendant General Spencer E. Holland. The historian should not accept this as a reliable record of the interiors of Fortnum's home and the arrangement of his collection in 1873, for on careful examination it turns out that some of the rooms appear more than once, differently decorated, and some of the views show works of art which were acquired after 1873—in particular, furniture which was, we know, bought in Florence in 1875. It seems that there are two sets of photographs, one set doubtless of 1873 and another perhaps taken in 1875 after extensive alteration and redecoration of the house (with which the acquisition of furniture may be connected). We know from Fortnum's letters that further extensive alterations to the house took place in the winter of 1886 and 1887. It should be noted too that even within a set of photographs which appear to have been made at the same date the same work of art can be seen in different places. Clearly things were specially arranged for the photographer, and Fortnum was also, like many other collectors, forever making small modifications to the display of his pieces. The photographs do, however, reveal how Fortnum liked to exhibit and store his sculpture, both as furnishing and as specimens, and the dense arrangements of his rooms, in which all available surfaces were bristling with art objects.

4. *The Display of the Fortnum Collection in the Combined Ashmolean Museum and University Galleries*

The northern extension of the University Galleries, which Fortnum had made possible, was the work of H. Wilkinson Moore. It consisted, on the first floor, of three principal galleries, slightly lower in level than those in Cockerell's building and very much less palatial in style—as utilitarian, indeed, as

F. A room in the Hill House, Stanmore. To the left is the glazed bookcase (No. 170) serving as a display case for maiolica and other ceramics and also some small bronze sculptures such as the *Pietà* after Michelangelo (No. 60) and the small prisoners (Nos. 385, 386). Larger bronzes are arranged on the shelf of the bookcase, including the *Capitoline Flora* by Zoffoli (No. 115). The Mermaid inkstand (No. 233) and the little *St Catherine* (No. 146) are in the adjacent case. On the central table are the boxwood *St Sebastian* (No. 348), a casket (No. 211), and a small ink vessel (No. 226). On a shelf behind are the *Cleopatra* after Bandinelli (No. 9) and the 'Herz Venus' (Plate C). On the walls are frames of plaquettes, also the *Triumph of Ariadne* (No. 55), the electrodeposit after a follower of Donatello (No. 28), the *pietra serena* relief in the style of Desiderio (No. 27), and the terracotta relief after Pierino (No. 73). Above the door there is a small bronze bust of Cicero by Boschi (No. 15).

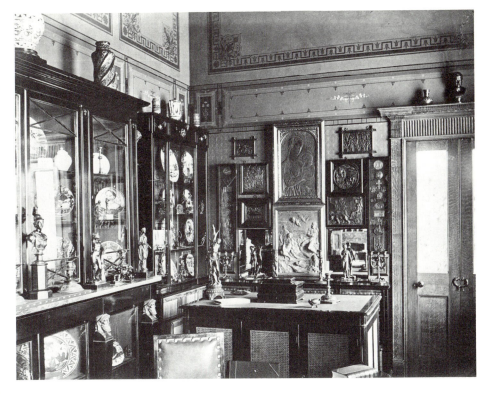

G. The study in the Hill House, Stanmore. The glazed bookcase (No. 170) featured to the left of Plate F reappears in this view but now with crowned monograms in the frieze (perhaps undergoing restoration when the other photograph was taken). The bookcase supports four bronze busts (Nos. 15, 16, 80, 81), one of which (No. 15) appears above the door in Plate F. The bronze *St John the Baptist* by Severo da Ravenna (not included in this catalogue) surmounts the ivory and rosewood casket (No. 213). Other bronzes, including the gilt centrepiece with hippocamps (No. 246), are in glass boxes. The display case above the bookshelf to the left contains oriental bronzes and Italian maiolica.

H. The parlour in the Hill House, Stanmore. To either side of the looking-glass are the Leeds ware vases (Nos. 530, 531) and on the chimneypiece is the *Centaur ridden by Cupid* (No. 164) between the candelabra in the manner of Clodion (Nos. 264, 265). The bronze *Jupiter* (No. 377) is on the corner cabinet and the set of wax profile heads (No. 133) hangs on the wall, near the small painting of *St Jerome* (perhaps by Giovanni Bellini) in its quaint gothic revival frame.

the average science laboratories of the period, a fact which seems to have distressed Fortnum, who made a special grant for some stencilled decorations on the walls. The three galleries were named in the *Handbooks* of the combined Ashmolean and University Galleries as the Antiquarium I and II (the present rooms to the west) and the Fortnum Room (now the Leeds Room). Many of Fortnum's antiquities were absorbed in the first two rooms. The third was dominated by his maiolica and kindred wares, his Venetian glass, his brass and pewter platters, displayed in wall cases, his Della Robbia ware and other Renaissance sculpture hanging on the walls between them, his plaquettes and rings in desk cases, and his bronzes in eight free-standing glass cases. The arrangement was much as Fortnum himself had planned—or at least approved.

A number of important items had been added to the collection from elsewhere in the University with Fortnum's approval, perhaps at his suggestion: most notably the superlative wax relief by Pierino da Vinci (No. 72), the importance of which Fortnum had recognized (he had a terracotta of the same composition in his collection—No. 73), had been transferred from the Bodleian library in November 1897, and the bronze head of Michelangelo by Daniele da Volterra (No. 109), which he had himself published, had been transferred in December 1896 from display in the University Galleries where it had been exhibited with the Michelangelo drawings. Ivories were also put on exhibition here, including some from the old Ashmolean's original collection.

In addition, and possibly in some cases encouraged by Fortnum himself, other collectors put their works on loan in the Fortnum Room. The cigar merchant Henry J. Pfungst FSA had assembled a collection of over fifty Italian Renaissance bronzes in his house in Cleveland Square. These statuettes,

candlesticks, inkstands, and bells were very similar in character, and comparable in quality, with those of Fortnum, near which they were placed on loan in 1897, but in the winter of 1900 he sold the collection for £2,000 to George Durlacher and Asher Wertheimer (two leading dealers of the period) who sold it to J. Pierpont Morgan in the following summer. Between then and his death in 1917 Pfungst gave the Museum a few works of art in compensation, including a curious Milanese carving, a modern door-knocker, an old wooden casket, two ancient taps, and an odd marble relief (Nos. 201, 203, 210, 234, 319, 418). A marginal note by C. F. Bell in the copy of the catalogue of Morgan's collection in the Ashmolean library points out that the holes in the bronze *St Sebastian* now, like many of Morgan's bronzes, in the Frick Collection were 'filled up by Mr Pfungst's order in the workshop of the Ashmolean Museum'. If this is correct (the fillings are not visible) it is the sort of favour made in anticipation of a benefaction.

A still more important loan was made in 1899—that of 750 bronze plaquettes from the collection of T. Whitcombe Greene. This loan was extended over the following decade to well over a thousand items. Bell, whose own scholarly interests were chiefly in this field, knew that this was the greatest collection of such works in the world, with the exception of that formed by Gustave Dreyfus in Paris and by Bode for the Kaiser Friedrich Museum in Berlin, and was mortified when in 1915 the entire collection was withdrawn only to be given to the British Museum. Another collection of plaquettes formed by Max Rosenheim was placed on loan in 1905 and 1908. It too was withdrawn. Instead Mr Rosenheim presented the Museum with an old tap (No. 202). In 1901 Henry Willett placed his collection of Renaissance rock crystals and agate cameos on

loan—a collection which complemented the plaquettes very interestingly. This too was withdrawn. As a token Mr Willett gave the Museum some curious old glass holders (Nos. 392–5). Many other collectors since have seen fit to use the Museum as a safe deposit and shopwindow whilst congratulating themselves on their philanthropy.

Far less satisfactory than the Fortnum Room was an area known as the Fortnum Corridor in a part of the space now occupied by the Heberden Coin Room. This was created to accommodate miscellaneous extra items from Fortnum's benefaction—the oriental bronzes formerly in the Henderson collection; the French ormolu and the marble copies of antique heads; Persian, Syrian, and Anatolian ceramics.

In 1921 the Department of Antiquities, which was very much the senior and most powerful Department in the combined Ashmolean Museum and University Galleries, took over the Fortnum Room. Fortnum would not have been surprised. 'I know that between Gardner [Professor Percy Gardner] & you nothing but classic abominations will be cared for . . . there are lots of your dirty pots *sub terra* but of the *bel cinque cento* all are known', he wrote satirically to Evans on 11 June 1892. Bell, who was by now Keeper of the Department of Fine Art, was furious. 'The Eldon room [the present Founder's Room] with its harmonious arrangement of eighteenth-century Venetian pictures beside the Gobelin's tapestry and the busts of the barocco period, had been pulled to pieces, and the Della Robbia ware and other relief-sculpture and busts of the sixteenth century have had to be intruded in the place of pictures which are . . . now crowded into the Raffaello [the present Fortnum] Gallery.' This outburst was published in the *Annual Report* for 1921. His Department's copy includes the following reflection which he suppressed in proof (with the marginal note 'Toute vérité n'est pas bonne à dire'): 'It is disquieting to find that within a quarter of a century of the donor's decease the Fortnum Collection can be subjected, even if merely temporarily, to treatment varying however widely yet still only in degree from that meted out to the benefactions of Mr Finch and Lady Chantrey'. Bell does not appear, however, from the archival evidence, ever to have been especially concerned with the Chantrey benefaction (the grim fate of which is related in the second preliminary essay of the third volume of this catalogue).

Bell was still complaining vigorously in 1926 about the disorder and congestion consequent to the forced surrender of the Fortnum Gallery: 'It is hard to believe that any other Department in the University can stand more grievously in need of increased space, or can have more valid claims for funds to provide it', he wrote in the *Annual Report* for that year. Soon afterwards the architect E. Stanley Hall created an extra floor with a sequence of three new galleries out of the immense height of Cockerell's great gallery—something Bell had planned two decades before and which the University had approved in 1922. The rooms were opened with a reception described in the *Times* for 3 June 1929. The first room, the Chambers Hall Room (as it is still known), was hung with green damask and gave on to the large central room, the new Fortnum Room (later to be the Madan Room and changed in my Keepership to the new Combe Room), which was hung with 'warm

crimson moiré like that in the Tribuna, Florence'. The author of the *Times* report noted that the old galleries of the Ashmolean 'were the first in England to be decorated in grey, in imitation of the gallery at Parma, as remodelled by Corrado Ricci 40 years ago', which had set an unfortunate fashion for 'dingy shades of putty-coloured *acqua sporca*'. These rooms would represent a short-lived reaction against this. Upon three of these rich walls in the Fortnum Room the Renaissance paintings, largely from the Fox-Strangways Collection, were crowded. Upon the fourth were examples of Fortnum's Della Robbia ware and other relief sculpture with plaquettes, medals, and the like in 'slopes' below them. Bronzes and Venetian glass and maiolica and other ceramics were exhibited in free-standing cases. This was a real gain over the previous arrangement in that it enabled the sculpture, ceramics, and other arts of the same period to be seen together with the paintings. This was Bell's last great achievement as Keeper.

Under Kenneth Clark, who succeeded Bell as Keeper in August 1931, Bell's Fortnum Gallery began to be changed. Some of the bronzes and the early Italian paintings were moved to the Raffaello Room, then renamed the Fortnum Gallery. The medals and plaquettes were moved to the Eldon (now Founder's) Room and the maiolica was moved first to cases on the landing outside the upper galleries and then in 1934 into a wall case in the Eldon Room paid for by Sir Arthur Evans who was doubtless disturbed at the marginalization of what had been intended always as something central in the plans which he and Fortnum had had for the Ashmolean.

To trace the changing locations of all the parts of the Fortnum Collection during the last sixty years would be impossible here but it is worth pointing out that for several decades only the bronzes were displayed with some of the Renaissance paintings. During my Keepership all the Renaissance paintings were concentrated together with more of the bronzes, some sculpture in wax and marble, and with the Renaissance plaquettes and medals in the present Fortnum Room (the old Raffaello Gallery), with an effect probably not unlike Bell's in 1929. It was less crowded than Bell's gallery, although too much so for many visitors whose taste has been formed by the style of display which has long been fashionable in more spacious museums, or in museums with less of an obligation to keep as much as possible on public exhibition.

That Fortnum's collection is a didactic one should never be forgotten. 'My wish and hope was', he wrote to Evans on 19 July 1895, 'to see the old Ashmolean developed into an institution of the first importance for teaching and illustrating by authentic examples, the development of art as applied to both small and larger objects'. This has not happened. Bell kept his galleries in immaculate order. It is not fair to claim that he discouraged visitors, for he provided them with an admirably complete, clear, and exact guide to his Department. It is surely hyperbole that 'he would have particularly deplored the presence of an undergraduate'—as Kenneth Clark claimed in his autobiography. Nevertheless the Department Bell created, the type of genteel good taste exemplified in its arrangement, the sense that it was his personal collection, was not conducive to the idea of the Museum as an institution for teaching. Moreover, Fortnum's hope that his collection would be seen

as part of a continuous display extending from 'the first flint implements' to the art of the present day has not been realized owing to the division between the Department of Antiquities and the Department of Fine Art, so that even the finger rings are displayed in separate parts of the museum, the Etruscan in one room, the archaic Greek in another, the medieval and modern in a third. Fortnum would regret that those visitors to the Museum who enjoy his grotesque Renaissance inkstands are unlikely to notice his miniature Hellenistic bronze of a deformed squatting slave (B67) and that his goddesses by Giambologna are so far from the Herz *Venus*. The two Departments have also had different priorities. It would be hard to say whether Fortnum's accorded more closely with one or the other, but he was certainly more of an archaeologist or natural scientist in his outlook than any of the custodians of his Renaissance collection from Bell to myself.

SCULPTURES OF THE ITALIAN SCHOOL

Associated with a Named Sculptor, Craftsman or Supplier

Unknown founder

After Alessandro ALGARDI (1598–1654)

1 and 2. Flagellators of Christ

23.2 cms. (height of No. 1, figure with both arms raised);
23.5 cms. (height of No. 2, figure with right arm only raised);
5.5 cms. (height of plinths)

Bronze with a warm brown natural patina retaining extensive patches of translucent red varnish, now partially blackened, especially in the hollows. Hollow, lost-wax, casts. There is a perforation in the bronze below the loin cloth worn by No. 1, also a plug beside the ankle of the right foot of this figure. Both figures are very finely tooled with the hair (including hair in armpits and pubes) sharply but boldly cut. The loin cloth is minutely punched. The figures must originally have held separately fashioned whips.

Both figures are mounted on plinths of oak veneered with brass, fire-gilt, and with tortoiseshell, fitted with bronze scroll-feet and lion masks, also fire-gilt. (Some pieces of veneer are loose, broken, or missing especially below the lion heads on the back and side faces of both plinths.) There are circular paper labels below the plinths with black borders and 'J. FRANCIS. &. MARGARET. MALLETT' printed, and with '27E' inscribed in ink, in the centre. Both plinths marked 'M $\frac{176}{1}$' and 'M $\frac{176}{2}$' in black paint on the corner of the upper ormolu moulding of the plinth where chamfered.

Bequeathed by J. F. Mallett, who died 7 January 1947. Received in the Museum during the last week in May 1947. No. 176 (1 and 2) in the inventory of his collection where valued at £100. No provenance supplied.

Described by Mallett as 'Finely modelled and highly finished. Beautiful brown patina. N. Italian. Attributed to Pietro Tacca.' The pair of figures are in fact cast from models almost certainly made by Algardi. Together with a figure of Christ bound to the column, they formed one of the most popular small sculptural groups (of silver as well as of bronze) in European art. The same model for Christ is employed with flagellators of a different design which may plausibly be attributed to Duquesnoy, who is indeed credited by Bellori with the invention of a group of this subject (including Christ). Jennifer Montagu has proposed, convincingly, that the more vigorous of the pairs of flagellators—that represented by the Ashmolean's bronzes—originated in models by Algardi. She dates these models to the second half of the 1630s. Of this particular pair of bronzes she writes: 'The casts appear to be reasonably old, although the Boulle-type bases are no doubt of more recent date' (J. Montagu, *Alessandro Algardi* (London and New Haven, Conn., 1985), i. 197, ii. 315–22, no. 9; and for the Ashmolean bronzes 319, no. 9 C. 19). The bases resemble in both style and materials French work of the late seventeenth century of the kind revived in the second half of the eighteenth century, but they may be of modern manufacture; certainly all screw fittings appear to be modern. The figures, which are of as high quality as any other bronze versions I have seen, seem to be either Italian or French. **See also No. 434.**

Luigi AMICI (1813–97)

3. Thalia

53.5 cms. (height excluding socle); 13 cms. (height of socle)

Carrara marble. The turned and waisted socle (made of a different piece of marble) has been broken at the base, repaired, and then rebroken. Some chips are missing.

Bequeathed by C. D. E. Fortnum in 1899. S. 37 in his catalogues. Said in the large catalogue and the notebook catalogue to have been acquired from Amici in Rome in 1853; but in the preliminary catalogue of 1857 the date is given as 1851.

This bust of the Muse of Comedy was evidently acquired with that of *Melpomene*, the Muse of Tragedy (No. 20), as a companion, this couple in turn forming a pair for the two copies of antique heads by Gott (Nos. 514, 515). Fortnum noted that it was 'Thalia. Copy from the antique statue in the Vatican'. The statue in question is a seated Muse in the Sala delle Muse in the Museo Pio-Clementino which was discovered, together with the *Melpomene* and other Muses, at the supposed Villa di Cassio at Tivoli in excavations commenced before 1773 by Domenico de' Angelis, and was obtained for the papal museum by the intervention of Giovanni-Battista Visconti in 1774 (W. Amelung and G. Lippold, *Die Skulpturen des Vaticanischen Museums*, III, i (Berlin, 1935–56), no. 503—erroneously 508 in plates; C. Pietrangeli, *Scavi e scoperte di antichità sotto il pontificato di Pio VI* (Rome, 1958), 139–40). The copy is in some respects an improvement on the original, in which the leaves in the hair are not completely undercut but retain their bridges. Amici had worked in Canova's studio and was one of the leading sculptors in Rome in the decades following Canova's death. He completed the tomb of Pope Gregory XVI in St Peter's in 1854 and would have been busy with this huge work when Fortnum visited his studio. Such a bust is likely to have been produced under Amici's supervision rather than executed by him in person and was probably a stock item designed for sale to studio visitors rather than specially commissioned. An identical bust is in the Royal Palace in Madrid (numbered 427 in hollow behind chest), also paired with a *Melpomene*. Another was lot 246 in the sale of Durwards Hall, Kelvedon, Essex, Christie's, 10–11 July 1989.

Style of Bartolommeo AMMANATI (1511–92)

4. Inkstand in the form of a faun astride a tortoise

22.5 cms. (height); 19.75 cms. (length)

Bronze with a dark brown natural patina with traces of black or blackened varnish in the hollows. Thick-walled hollow cast. Cast in two pieces; the faun and shell together with the shell of the tortoise forming one piece. There is a plug in the faun's right shoulder and a firing crack in the back of the faun's neck and in the top of his left arm. There seems to have been an extra pouring of metal in the head. Chaplet pins evident in the interior of the bronze (at faun's right shoulder). 'B/—88/ᴵF' is painted in white on the interior of the tortoise shell together with a recent label numbered '112'. The same is painted on the inside of the body of the tortoise with another label numbered '112' below.

Lent by C. D. E. Fortnum on 20 March 1888 and given later in the same year. B. 1088 in his catalogues. Presumably acquired after 1857 when the preliminary catalogue, in which it is not included, was compiled.

An ink pot would presumably have been placed in the shell held in the faun's right hand. Divisions for pen and sand are found in the body of the tortoise. Classed by Fortnum as 'Florentine?' and dated to 1580 in his notebook catalogue. Having discovered that it was in the manner of Bartolommeo Ammanati (1511–92), he corrected the date to 1560, and toyed with the idea that it might be by Ammanati, but, surely rightly, confined himself to observing that there is an obvious debt to the latter's eight split-legged fauns, some with similar grins and brushed-back hair, placed in 1575 around the rim of the Fountain of Neptune in the Piazza della Signoria in Florence—works designed probably in 1560 when Ammanati was competing for the commission. Bode, oddly, seems to

have ignored this connection and published the inkstand as a Venetian work of around 1575 (*Italian Bronze Statuettes of the Renaissance* (London, 1907–12), i. 74, fig. 90). Pope-Hennessy on the other hand regarded it as 'likely that the inkstand is an autograph small bronze by Ammanati' (*Italian Bronze Statuettes* (Victoria and Albert Museum, London, 1961), no. 113). J. Draper in his 1980 revised edition of Bode has suggested 'North Italian late Sixteenth Century'.

The surface of the bronze is very dull and the linear pattern of the tortoise shell and skin in particular is blunt and vague. This is also true of the version in the Metropolitan Museum, New York (10.173—in reserve), but less true of that in the Rijksmuseum (J. Leeuwenberg, *Beeldhouwkunst in het Rijksmuseum* (Amsterdam, 1973), 379, no. 638). (Neither of these versions retains the body of the tortoise as a base.) It is surely very unlikely that any of these three bronzes are autograph works by Ammanati. The casting technique (which may not be lost-wax) does not resemble that of any sixteenth-century bronze inkstand I have inspected. It is possible that they were made in the last century when at least one sculptor was an accomplished mimic of Ammanati's style—this was Francesco Pozzi (1779–1844), who, in 1831, executed the right-hand satyr of the south-east face of the fountain—the 'satyr to left of the marine goddess who looks towards the Marzocco' (A. Lensi, *Il Palazzo Vecchio* (Milan, 1929), 315, citing F. Moisè, *Illustrazione storico-artistica del Palazzo de' Priori, oggi Palazzo Vecchio* (Florence, 1843), 169 n.)—as a replacement for one of Ammanati's. This large bronze is, however, a superior cast, the equal of its neighbours and far sharper than the inkstands. For a reduction of a part of Ammanati's fountain on a scale comparable with the inkstands see Christie's, New York, 1 November 1989, lot 53.

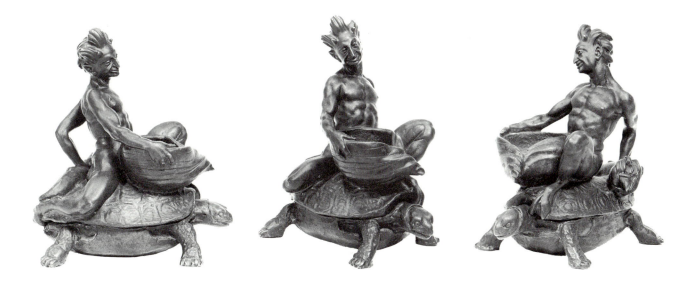

Foundry of de ANGELIS fils (early twentieth century)

5. Victory

39.3 cms. (height from foot to head); 12.2 cms. (length of shaft); 9 cms. (diameter of marble ball)

Bronze with a dull green patina and simulated corroded surface. Hollow cast, filled with core. A red paste gem is inserted in the bracelet on the figure's left upper arm. Cast without right arm of index finger of the figure's left hand and with empty eye sockets (replicating damaged original). The shaft stamped with miniature letters: 'DEANGELISFILS'. Mounted on a ball of *Porto venere* marble (black marble with gold veins) and a columnar shaft of ebonized wood (the latter not original).

Bequeathed by the Rev. J. W. R. Brocklebank in 1926. No. 30 on Andrew Shirley's receipt of January 1927 ('A verde statuette, Victory, standing on marble sphere & plinth').

This is unusual among the bronzes in Brocklebank's collection in that it is a replica of an antique, but it is nevertheless not unrelated in taste to his other pieces, and in particular his versions of Gilbert's treatment of the same theme (Nos. 502, 503, 512). The firm of De Angelis was founded in 1840 and prospered in the last years of the last century and in the early years of this, specializing in reproductions of the most popular items in the Naples Museum. Larger works produced by them in the first decade of this century are signed 'S. de Angelis & Fils' (see the life-size *Athlete* at Cartwright Hall, Bradford, dated 1905 and the reduction of the *Adorante* sold at Sotheby's, London, 11 June 1987, lot 239/2, dated 1907). By 1915 the firm had merged with that of Chiurazzi (which had been established in 1870 by J. Chiurazzi) to form the

'Fonderie Artistiche Riunite'. By 1929 the firm was under the management of Frederico and Salvatore Chiurazzi and known as 'Chiurazzi', or, officially, the 'Società Anonima: Fonderie, Ceramica, Marmoria'. Their catalogue of that year noted that the firm was formerly that of 'Chiurazzi and De Angelis'. In this catalogue the 'Vittoria' appears as no. 93, and was available in four sizes of which one was the size of the original (40 cms.—as here, approximately; two of the others were larger) and in three patinas (Pompeian, Herculanean, and Renaissance, the first, which is used here, being closest to the original and also the cheapest, at 1,000 lire for this size, as against 1,250 for the black Herculanean and 1,500 for the brown Renaissance). The Roman bronze reproduced has the inventory number 4997 in the Naples Museum, and the modern number 576. It is regarded as a copy of a Hellenistic original and is not now included in the popular anthologies, although Chiurazzi's 1929 catalogue describes it as 'questa mirabile statua . . . rimarchevole per la leggerezza del drappo svolazzante al vento e che delinea le svelte forme del corpo'. As Chiurazzi acknowledged, the marble ball is a modern idea (found in the display of the bronze in the Naples Museum). The figure would originally have been suspended from the ring in its back. The bronze in the Naples Museum is also furnished with a wand in the figure's left hand but the figure would originally have held a palm or trophy. The other arm would, it is supposed, have held a trumpet to broadcast victory. A version of the *Victory* in the Glasgow Art gallery and Museum (93-28d) was purchased from Sabatino de Angelis et fils on 30 March 1893 for £8. An inferior cast was lot 148, Sotheby's, London 4 July 1991.

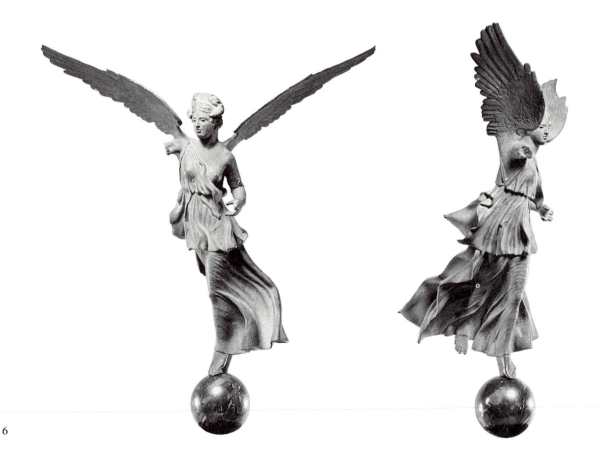

Probably foundry of de ANGELIS/CHIURAZZI (early twentieth century)

6. Heroic head (so-called *Dionysosplaton*)

47.3 cms. (height of bronze); 22 cms. (height of socle); 26 cms. (diameter of socle)

Bronze of a dull black to dark green patina simulating corrosion. Hollow, lost-wax, cast. The upper portion of the back dented. The iron cramp attaching the bronze to the socle loose.

Provenance unknown.

The simulated *diaspro di Sicilia* marble employed for the socle is of a type often employed by the firm of De Angelis/Chiurazzi (for which see No. 5). The bronze is an accurate replica of a fragment of a statue found in the eighteenth century in the Villa dei Pisoni, Herculaneum (Museo Nazionale, Naples, inv. no. 5618, modern number 605). It was long supposed, following a theory of Sogliani, to represent an ideal mingling of the type of Dionysus with the likeness of Plato and was known as the *Dionysosplaton*. Friederichs considered it an original by Scopas or Praxiteles, but it is now regarded as a hellenistic modification (or sometimes as a Roman copy of a Hellenistic modification) of an earlier model. (A. and B. Maiuri, *Das Nationalmuseum in Neapel* (Munich, 1958), 66.) In Chiurazzi's 1929 catalogue this is no. 1 and priced at 2,400 lire for the original size (given as 50 cms. but the same as this version) in the 'Herculanean' patina (black). It cost 3,000 lire with a 'Renaissance' patina (brown), and was not available with a 'Pompeian' patina (green). It could also be purchased 28 and 15 cms high. The turned and waisted socle, unhappy in size and shape, reproduces that upon which the bronze in the Naples Museum is mounted. Other versions of this bronze are furnished with an alabaster base (one was with the dealer Edric Van Vredenburgh, Davies Street, London, in the winter of 1989). One in the Art Gallery and Museum, Glasgow (93-28b) was purchased from Sabatino de Angelis et fils on 30 March 1893 for £12.

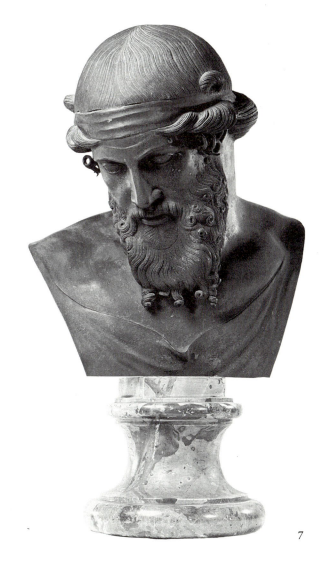

Perhaps foundry of de ANGELIS/CHIURAZZI (early twentieth century)

7. Adorante

130.5 cms. (height, including integral plinth, to top of head); 6.5 cms. (height of integral plinth); 31.8 cms (length and width of plinth)

Metal with a black patina, scratched and worn in small areas of the chest and thigh. Neither the rusty colour of the metal where it is apparent beneath the patina nor the sound of it when struck suggest that it is of bronze as usually defined. Hollow cast. The plinth has been cast separately, but the feet are very tightly attached. There is a small hole for fixing a leaf above the penis.

Provenance unrecorded. It had been for many years in the basement store of the Department of Western Art when it was, in November 1985, erected in the principal niche of the main staircase of the Museum. The sculpture is unlikely ever to have been acquired by the Department of Western Art and had probably strayed into its store from the Department of Antiquities.

Bronze casts of this famous antique statue were offered for sale in the early decades of this century by the firm of De Angelis and Chiurazzi (for which see No. 5). In the catalogue of 1929 produced by the firm (by then trading as the Società Anonima: Fonderie, Ceramica, Marmoria) it is the 'Fanciullo Orante', no. 734 and offered in four sizes: 127 cms. (the size of the original, as here), 71 cms., 36 cms., and 27 cms. In the original size and with a black or 'Herculanean' patina, as here, it cost 5,000 lire, and with a chocolate brown or 'Renaissance' patina, 6,000 lire. A smaller version of the *Adorante* marked as made by 'S. de Angelis et fils' and dated 1907 was lot 239(2), Sotheby's, London, 11 June 1987. The Ashmolean's cast is certainly similar in character to bronzes of this size produced by the Neapolitan foundries, but it is unmarked and it is impossible to be sure that it was not produced at an earlier date elsewhere. The 'génie adorant' was cast in bronze by Barbedienne's Paris foundry, for example (one is mentioned by A. de Champeaux, *Dictionnaire des fondeurs, ciseleurs, modeleurs en bronze* (Paris, 1886), 67), and there is a fine cast datable to 1826 and chiselled on its plinth as 'Gegossen von Krebs, Ciseliert v. Coué' in Berlin–Dahlem (*Ex aere solido: Bronzen von der Antike bis zur Gegenwart. Eine Ausstellung der Stiftung preußischer Kulturbesitz Berlin aus den Beständen ihrer Staatlichen Museen* (Berlin 1983), 201–3, entry by Peter Bloch).

The fame of the *Adorante* was such that it should perhaps have been included in the anthology of the most celebrated antique statues compiled by F. Haskell and N. Penny (*Taste and the Antique* (London and New Haven, Conn., 1981)). The statue seems first to be mentioned by Lorenzo da Pavia writing to Isabella d'Este on 28 September 1503. A Greek bronze statue of a boy had arrived in Venice with arms and one foot broken off. It belonged to a Knight of Rhodes, Andrea di Martini, by whom it seems to have been bequeathed to Benedetto di Martini. A private view was arranged for Isabella. Enea Vico tells a story of how Pietro Bembo donated a spare antique bronze foot from his collection to the owner

in order to complete the figure. There is a very curious letter from Aretino to Benedetto of January 1549 in which the statue is described as a *Ganymede* and ascribed to Phidias and the lower parts preferred to the upper and the back preferred to the front. Aretino also alludes to a story later reported by Francesco Sansovino in more detail (*Delle cose notabili che sono in Venetia . . .* (Venice, 1561), 19ʳ) that Cardinal Nicolo Ridolfi (1501–50) offered a benefice worth 300 *scudi* per annum for the statue. A copy of the statue (now in the Museo Archeologico in Venice) was donated to the Venetian state in 1576. This was perhaps the date at which it left Venice. By 1589 it was certainly in the Bevilacqua Collection in Verona. Thence it passed to the Gonzaga in Mantua, and so on to King Charles I of England, to Fouquet at Vaux-le-Visconte in 1661, to Prince Eugène of Savoy in 1717, to Prince Wenzel of Lichtenstein, and to Frederick the Great in 1747. In 1787 it was placed in the Stadtschloss in Berlin whence it was removed by Napoleon to the Louvre (where it was to be seen 1808–12). It was still often referred to as a *Ganymede* in this period. From Paris it was returned to Berlin and the Staatliche Museen. (M. Perry, 'A Greek Bronze in Renaissance Venice', *Burlington Magazine* (Apr. 1975), 204–11; B. F. Tamaro, 'La replica dell'Adorante al Museo Archeologico di Venezia', in *Studi in onore di Aristide Calderini e Roberto Paribeni* (Milan, 1956), iii. 155–69; L. Franzoni, *La Galleria Bevilacqua* (Milan, 1970), 111–23; P. Bloch, 'Der betende Knabe von Sanssouci', *Berliner Museen*, 3 (1978), 6 ff.)

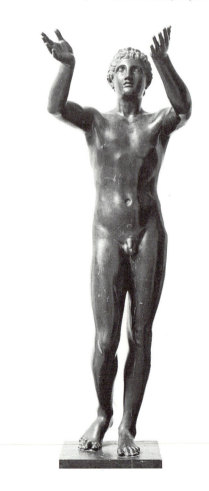

Baccio BANDINELLI (1493–1560)

8. Head of St Paul

39.7 cms. (height); 13.7 cms. (height of socle at front); 18.3 cms. (diameter of socle)

Pink-grey terracotta with traces of white plaster especially in cracks and hollows. Hollow but with very thick walls. Apertures are concealed behind the beard to proper left. There are hair-line cracks in many places. A chip is missing on the collar to proper right. A portion of the moustache and proper right eyebrow is made up with wax slightly darker than the terracotta. Finger prints are evident in some areas (e.g. in the beard and ear-lobe to proper left). Mounted, by means of lead reinforced with, and largely concealed by, plaster of Paris, to a turned and waisted socle of *verde di Prato* (Tuscan serpentine). 'S. 24.Ⓕ' is painted in black on the back of the collar.

Lent by C. D. E. Fortnum on 20 March 1888, given later in the same year. S. 24 in his catalogues. Bought by Fortnum from the sculptor and dealer Professor Emilio Santarelli of Florence in 1870 together with a bust of Lorenzo de' Medici. The socle is shown in Fortnum's photographs and must have been fixed in Florence. A letter from Santarelli to Fortnum of 19 June 1870 discusses shipping from Livorno (undertaken through the agency of Luigi Stombert). The head had safely arrived on 26 July, followed by Santarelli's certificate, dated 16 August, in which he declared that he had acquired it 'circa venti anni fa'—i.e. in about 1850—from Professore Bibliotecario Ajazzi who had, he understood, long owned it. It was 'formerly in the Laurentian Library whence it had been abstracted many years ago'. In his notebook catalogue Fortnum recorded that Santarelli would not for a long while agree to part with this head and the bust of Lorenzo. He paid £40 for the latter: this is likely to have cost the same amount.

Emilio Santarelli, who sold this terracotta to Fortnum, had acquired it from Ajazzi as a portrait of Cellini. Santarelli also believed it to be by Cellini. Santarelli was one of the leading sculptors in Florence and also a noted connoisseur (for other dealings betwen him and Fortnum see the Preliminary Essay). His most famous work was the full-length portrait of Michelangelo completed in 1856 for the Arcade of the Uffizi and he was much concerned with the iconography of famous Florentines of the Renaissance and incurably optimistic about the portraits of them. Fortnum was at least convinced that it was by Cellini, although the possibility of it being by Bandinelli had occurred to him. It is 'beyond Baccio Bandinelli, & the rest, and by M. angelo it certainly is not', he wrote in the notebook catalogue. The attribution is defended at greater length in his large catalogue: 'the vigorous expression, the quiver of the lip, and the admirable treatment of the beard are remarkable. I do not know any other sculptor of the period of its unquestionable production with whose manner it so much agrees. It seems to me too good for B. Bandinelli.' The handling he compared with that in Cellini's bust portrait of Bindo Altoviti (Isabella Stewart Gardner Museum, Boston) and the statue of *Perseus* in the Loggia dei Lanzi—both of them bronzes, and indeed no comparable work in clay by Cellini—or by Bandinelli—seems to have survived. Fortnum noted that Cellini was said to have modelled a bust of Annibale Caro 'to the medals of whom this bears some resemblance'. C. F. Bell, however, annotating the large catalogue, noted

that this possibility was ruled out by comparison with Dosio's memorial bust of Caro in S. Lorenzo in Damaso in Rome. Bell also 'inclined' to think that it was by Bandinelli, to whom it seems first to have been attributed by E. Plon (*Benvenuto Cellini, orfèvre, médailleur, sculpteur* (Paris, 1883), 341). The modern literature on Cellini, most recently the monograph by Pope-Hennessy of 1986, does not discuss the terracotta. Maria Grazia Ciardi Dupré in 1963 published the head as by Rustici ('Giovan Francesco Rustici', *Paragone*, 14 (1963), 45–6), but without giving compelling reasons. Charles Avery in a letter to Ian Lowe of 9 March 1967 speculated that there might be a connection with a marble bust of Andrea Doria recently acquired by the Victoria and Albert Museum and attributed to Montorsoli.

One can see why Fortnum preferred to give this head to Cellini rather than to Bandinelli: he was right to liken it to the bust of Bindo Altoviti (the vigorous treatment of the beard is especially close) and it has the fire of Cellini's bronze portrait of Cosimo and none of the blandness of Bandinelli's marble portrait of the same sitter. On the other hand, the head certainly resembles those in the engraved portraits of Bandinelli and in his own self-portraits (most notably as Nicodemus in the *Pietà* which marks his own tomb in SS Annunziata in Florence, in the profile relief in the Museo dell'Opera del Duomo, Florence, and in the painting in the Isabella Stewart Gardner Museum, Boston). There is a still closer relationship with some drawings by Bandinelli of amply bearded, frowning men, usually regarded as somewhat idealized self-portraits, and perhaps intended as such, of which one notable example is in the British Museum (1895-9-15-555), and another was recently with La Sirène, of 14 rue de L'Eschaudé, Paris (no. 41 in their catalogue of *Estampes et dessins anciens* (1987) I). But both of these have rounded and softer modelling, typical of Bandinelli's drawings in chalk (and his marble reliefs), which is particularly evident in the hair, which flows forward in ornamental curls, whereas in the terracotta it is roughly clawed back and stabbed.

This need not discourage us from an attribution to Bandinelli, however, for whom working in clay may well have been analogous to drawing with a quill or reed, in which medium his work has a similar jagged energy. Furthermore, there is one marble sculpture by Bandinelli which is so similar to this terracotta that the two works must be closely related: the head of the saint in the niche to the left of Pope Leo X in the latter's tomb of 1536–41 in S. Maria sopra Minerva, Rome—a saint intended for St Paul but consistently misidentified (see R. Ward, *Baccio Bandinelli* (Fitzwilliam Museum, Cambridge, May–July 1988), 58–9). If the terracotta is what it seems—a large preparatory sketch for the marble (or even the fragment of a clay sketch for the marble salvaged and baked) then it is a very rare survival, without parallel in the sculpture of its period. The heads are difficult to compare (the marble can only be studied from below) but the differences are slight. In the marble the hair on the crown is more pronounced, the beard neater, the lips more pouted.

A sample was taken from the terracotta by Mrs Doreen

Stoneham of the Oxford Research Laboratory for Archaeology and the History of Art in March 1987 and thermo-luminescence tests suggested a firing date between 1487 and 1637 (381-z-88).

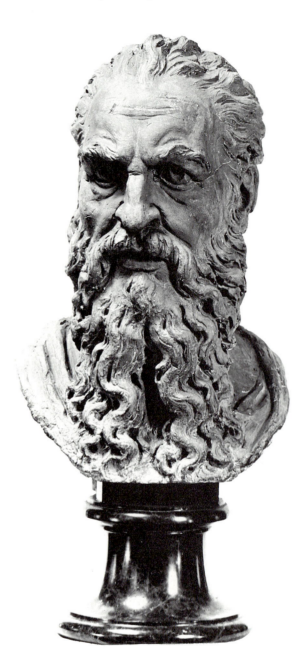

Foundry of Severo da Ravenna
After Baccio BANDINELLI (1493–1560)

9. Cleopatra

29.6 cms. (height of figure, excluding integrally cast tang);
3.4 cms. (height of base)

Bronze with a greeny-brown natural patina and traces of a red-brown varnish, blackened in parts. Hollow, lost-wax, cast. There is a crack at the back of the figure's right heel. Large holes (0.3 cms. diameter) in the proper left buttock and on the back of the proper right thigh and right shoulder, more or less imperfectly filled, evidently derive from chaplet pins which have shaken loose. Mounted on a triangular base with three feet with a large threaded hole into which the tang fits (for the base see below).

Lent by C. D. E. Fortnum on 20 March 1888 and given later in the same year. B. 412 in his catalogues. 'bt. Florence 1865.'

Fortnum regarded this as 'somewhat coarsely executed but with a distinctive character': the inept chiselling between the legs, the uncleaned junction of forearm and head, the hideous nipples, the botched modelling of the eyes (one smudged and the other crudely stabbed to suggest a pupil) deserve less qualified censure. He considered it as 'probably intended for Eve, the serpent fondling rather than wounding'. Cleopatra seems more likely, for although it is odd for that heroine to be represented completely undressed, the reptile is more the size of an asp than of the large serpent of the Garden of Eden. It also seems more inclined to bite than to whisper. The design of the triangular base with its feet in the form of abortive fat-headed dolphins and its weak frieze of floral arabesque and its execution—the dolphins and the field of the frieze given a punched texture—are typical of the workshop of Severo da Ravenna and no doubt suggested to Fortnum the idea that it was north Italian of the late fifteenth or early sixteenth century. Bode, however, recognized that the bronze was a copy of a statuette by Bandinelli (*Italian Bronze Statuettes of the Renaissance* (London, 1907–12), ii. 18), and perhaps for this reason the base began to look wrong. Bell's pencil annotation to Fortnum's large catalogue reads, 'This misleading addition was removed and replaced by a marble plinth 1929' (old photographs show it mounted on a block of *porto venere*, gold-veined black marble). By the 1970s, however, it had become possible to identify the products of Severo da Ravenna's workshop and to see that the workshop continued in business under the management of Severo's son into the second half of the sixteenth century using, for the most part, models dating from about 1500. It was quite able to take over a model from Bandinelli. Consequently Anthony Radcliffe pointed out in a letter of 6 September 1976 to Christopher Lloyd that the triangular base was probably original. The base was found by November 1976 and was restored in March 1977. Examination of the bronze and 'X-rays' made from it for Radcliffe and Richard Stone of the Metropolitan museum, New York, confirmed that the technique of the bronze was entirely consistent with Severo's foundry style.

Other versions of the bronze are recorded. One from the

Museo Nazionale di Capodimonte, Naples, was exhibited in 1961 (*Italian Bronze Statuettes* (Arts Council, Victoria and Albert Museum, London, 1961), no. 106). Another is in the Abbott Guggenheim Collection and was exhibited at the Fine Arts Museums of San Francisco (L. Camins, *Renaissance and Baroque Bronzes from the Abbott Guggenheim Collection* (San Francisco, 1988), 20, no. 3). Three casts of the figure, even more coarsely finished and clumsily modelled, with serpents in different positions and the women given idiotic smiles, combine to form the second lowest set of supporters of a seven-stage, three-sided, candelabrum ($5\frac{1}{2}$ feet high) in the Fine Arts Museum of San Francisco (61.35), the other elements of which are all found in other standard productions of Severo da Ravenna's workshop (it looks indeed like a compilation designed to cope with a surplus of stock).

The bronze in the Museo Nazionale of the Bargello, Florence (no. 354), from which these versions derive is of superior finish and larger—32.2 cms. high (including, however, an integral bronze base about 1 cm. high). The subject has always been identified as *Cleopatra* and is one of a set of six bronzes identified as by Bandinelli since the sixteenth century, two of which (a *Venus with a dove* and a *Jason*) also bear his name. Of these bronzes, three are larger than the *Cleopatra* (*Jason* 39.8 cms., *Venus with a dove* 37.8 cms., and *Hercules* 36.1 cms.), but two very close in size to it (a *Venus* 33.3 cms. and a *Leda* 31.5 cms.). Three engraved portraits of Bandinelli show him in the company of similar bronze statuettes, and one of these, showing him surrounded by students drawing them by candlelight, is inscribed by the engraver, Agostino Veneziano, as depicting Bandinelli's 'academia' in the 'luogo detto Belvedere' in 1531. According to Vasari's life (*Opere*, ed. G. Milanesi (Florence, 1906), vi. 153), it was when he was working in the Vatican Belvedere that Bandinelli first made bronze statuettes. This was after 1529 when he had accompanied Pope Clement VII from Bologna to Rome and was making plans for the adornment of Castel Sant'Angelo. 'To pass the time and to experiment with casting technology he made numerous statuettes *alte due terzi e tonde* ["height two-thirds of a *braccio* and in the round"—a *braccio* being for him about 50 cms.] of Herculeses, Venuses, Apollinos, Ledas, and other figures of his invention [*altre sue fantasie*] and, having then cast in bronze by Maestro Jacopo della Barba of Florence, they came out superbly.' Vasari notes that he presented these 'to His Holiness and to *molti signori* and some of them are now in Duke Cosimo's *scrittoio*, among over a hundred antique pieces, all rarities, and other modern ones'. The Bargello's bronzes have a Medici provenance. They may derive from models made in about 1530, but Heikamp has shown that the *Cleopatra* was made in 1544, that the *Hercules* was first recorded in 1549, and that the group of six was recorded for the first time in detail in an inventory of 1553. Chiarini notes that a document of 1550 reveals that three bronze figures by Bandinelli belonging to Cosimo I were then in the shop of the goldsmiths Domenico and Paolo Poggini who may therefore have been responsible for casting them. (*Committenza e collezionismo medicei* (Palazzo Vecchio, Florence, 1980), 319–20, nos. 649–54, entries by M. C.

[Marco Chiarini]; D. Heikamp, 'note' in the edition of Vasari's *Vite* published Milan, 1964, vi. 39.)

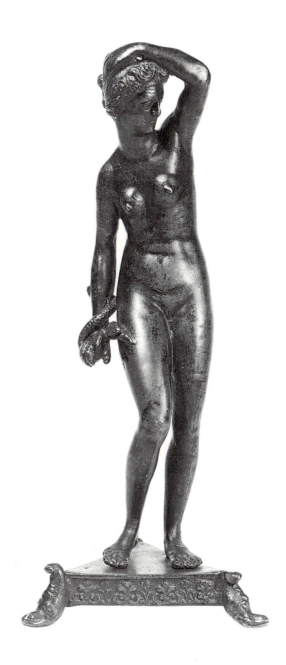

Workshop of Michelangelo BARBERI (1787–1867), 148 Via
Rasella, Rome

10. Circular inlaid slab of 'marble' specimens serving as a table top

127.7 cms. (diameter of slab); 3.7 cms. (depth of slab); 77 cms.
(height of table)

Coloured stones are inlaid into a slab of white Carrara marble in a
geometric pattern of scales radiating in increasing sizes from a
central micro-mosaic circle. Each scale-shaped piece of stone is
outlined in black Belgian marble. The border design is framed in
white Carrara marble. The coloured stones include imperial
porphyry, granites, serpentines, alabasters, and semi-precious stones
as well as marbles. Many are reworked from fragments of ancient
Roman architecture (for example, the very distinctive *bianco e nero
antico*, with its jagged pattern of black and white, the Pyrenean
quarries of which were only rediscovered in the late nineteenth
century), easily available in Rome. Others (most notably the brilliant
green malachite from Siberia used for the smallest scales) were
imported. The slab is supported by a tripod table veneered in
coromandel with dull gilt metal mounts (perhaps not bronze,
certainly not fire-gilt).

Bequeathed by C. D. E. Fortnum in 1899. F. 27 in his catalogues.
The table top was probably bought in Rome in 1852 (see below).

Table tops composed of numerous types of polished stone—
and especially reusing the stones the ancient Romans had so
esteemed—were perhaps first produced in Italy in the late
fifteenth century. A splendid one was made for Isabella d'Este
in 1499 out of a great variety of stones including serpentine
and porphyry, and others the names of which were unknown
(C. M. Brown, ' "Lo insaciabile desiderio nostro de cose
antique": New Documents for Isabella d'Este's Collection
of Antiquities', in C. H. Clough (ed.), *Cultural Aspects of the
Renaissance: Essays in Honour of Paul Oskar Kristeller*
(Manchester, 1976), 349 n. 53). However, I know of no
surviving table tops in which a wide variety of stones are
displayed in a geometric pattern designed as much for
geological instruction as for ornament, which were made
before the second half of the eighteenth century. They seem
to have been a speciality of Roman craftsmen. One such
litoteca with a curvaceous shape and short ormolu paw feet
which folds open like a games board was presented in 1763
by Cardinal Riminaldi to his native Ferrara (*Il Museo Civico
in Ferrara: Donazioni e restauri*, ii: *Chiesa di San Romano*
(Ferrara, 1985), 139–40). A painting by Laurent Pécheux of
1777 shows the Marchesa Boccapaduli in her museum
unveiling a monstrance full of butterflies which is supported
on an altar, as it were, of marble specimens (reproduced as
colour plate XVII in A. González-Palacios, *Il tempio del gusto*
(*Roma e il regno delle Due Sicilie*), 2 vols. (Milan, 1984) I).
The tops were at first rectangular and intended for pier tables
in grand apartments. Lalande in the first edition of his *Voyage
en Italie* (Yverdon, 1764, v. 224) mentions such rectangular
table tops as a novelty. Francesco (III) of Lorrain, husband
of Maria Teresa of Austria, is depicted with such a table in a
portrait by Franz Messmer and Ludwig Kohl dated 1773

(eight years after the emperor's death) which is in the
Naturhistorisches Museum, Vienna, and a very similar table
is in the Pitti Palace, Florence (A. González-Palacios, *Il tempio
del gusto* (*La Toscana e l'Italia settentionale*), 2 vols. (Milan,
1986), i. 144, ii. 299–300). By 1787 when Lalande's second
edition appeared (v. 71) they were clearly a well-established
fashion. A parallel fashion may be observed in gold boxes
including specimens of hardstones which were a speciality of
Dresden workshops in the last quarter of the eighteenth
century.

An early British reference to table tops of this sort comes
in the sale of the stock-in-trade of Thomas Carter in 1777
when a pair of 'inlaid studios of marble' were sold for 20
guineas (Department of Prints and Drawings, British
Museum, A-5-9, pp. 54–60). In the same year Henry Blundell
bought a specimen table from a marble dealer in the 'Campo
Vacino' (*sic*) and was also presented with one by Pope Pius
VI ([H. Blundell], *Account of the Statues, Busts, Bass-Relieves,
Cinerary Urns, and Other Ancient Marbles, and Paintings,
at Ince, collected by H.B.* (Liverpool, 1803)). The majority
acquired in the late eighteenth century are likely to have been
purchased by gentlemen on the Grand Tour who had
throughout the century imported slabs of ancient marble from
Rome (as well as *pietra dura* inlay from Florence) for table
tops.

Circular specimen marble table tops appear to have been
the nineteenth-century fashion in Britain. Christopher Gilbert
(in 'A Specimen Marble Table', *Connoisseur* (Oct. 1973), 78–
81) notes that circular tables with marble, scagliola, mosaic,
or marble inlay tops were known as Dejune tables, and were
described in George Smith's *Designs for Household Furniture*
of 1808 and in the second edition of his *Cabinet-Maker's and
Upholsterer's Guide* of 1826 as suitable for 'ladies Boudoirs or
Morning Breakfast Rooms' and for 'the boudoir or drawing
rooms'. The circular form when large, however, may always
have been intended for libraries or galleries. Large or small,
they are characteristic of the tendency, increasing steadily in
the early nineteenth century, for furniture to be designed for
the centre of a room. It was the circular shape which
stimulated more complex patterns in place of the
chequerboard.

Two other table tops of the same size and pattern as that
in the Ashmolean Museum have come to my attention. One
with a massive rosewood support of about 1850 (combining
heavy baroque scrolls with Gothic trefoils and Gothic foliage)
was lot 146 at Christie's, London, 7 May 1987. Another,
supported by three gilt sphinxes in the Empire style which,
if original, would date from the first two decades of the
nineteenth century and would probably have been made in
France, was illustrated in the *Connoisseur* for July 1965
(p. 153). In all cases the central feature is a 'micro-mosaic'
reproduction of the famous ancient mosaic found in Hadrian's
Villa, and preserved in the Capitoline Museum since 1765,
representing three doves drinking from a brazen vessel in
which they are partially reflected. In all cases the first and

smallest scales are of malachite. There are variations in the colours—for example the largest scales are all outlined in black against porphyry in the Ashmolean table top but against *giallo antico* in the one at Christie's in 1987. The support of the Ashmolean table top with its lion's paw feet and its lion masks at the braced centres of its three tense scroll supports is an example of early nineteenth-century British furniture at its most bold. It could have been made as early as 1815 or as late as 1855.

One Roman workshop known to have made such work is that of Giacomo Raffaelli (1753–1836). The smaller inlaid table top published in 1973 by Christopher Gilbert (op. cit.)—3 feet in diameter—is of similar character. The inlaid marble is arranged in a radial pattern forming a star with twenty-four outer points, each 'scale', however, being sharper, and the black borders being legible as continuous lines. It is similar also in its use of malachite. A plan and description of this table survives which commences with the information that it was purchased on 8 March 1831 'from the very illustrious Signor Erskine in the establishment of Councillor Giacomo Raffaelli Via del Babuino No. 92—near the Albert Theatre in Rome'. Raffaelli was councillor to the Imperial Russian Court for which he did much work (which explains the use of malachite).

Fortnum also owned two smaller tables of this type. One, which he bequeathed to E. Maude Thompson (F. 28 in his catalogue), had a top of 'Florentine mosaic' with a spray of flowers in *pietra dura*. He bought it in 1852 in Florence and noted that it was the work of 'Cav. Bianchini' of that city. He had it mounted in London on an elaborate tripod support involving terms of Hercules. Another (F. 29), mounted in a similar manner and regarded as a companion, was of 'Roman mosaic'. It featured a central medallion of 'Cupid in the act of discharging an arrow from his bow' and was made by 'Cav. Barberi' of Rome. This latter table, also acquired in 1852, he bequeathed to Lord Halsbury. In his large catalogue

Fortnum did not name the maker of the large table top in the Ashmolean, but in his notebook catalogue he cites this also as the work of Barberi. We may conjecture that it too was acquired in 1852 or possibly a little earlier or later, suggesting or suggested by his acquisition of the smaller example.

Michelangelo Barberi was the leading practitioner of the Roman art of micro-mosaic pictures in the mid-nineteenth century. Like Raffaelli he had many contacts with Russia. Indeed he was a protégé of the Princess Volkonski and helped establish the mosaic school of St Petersburg. Some of his most celebrated works—the *Trionfo d'Amore* of 1826, the *Twenty-Four Hours of Rome* of 1839—are in the Hermitage. One might suppose that he only made the central circle of the table top, but there is evidence that mosaicists also supplied the larger marble inlay; indeed Giacomo Raffaelli was also chiefly known for his micro-mosaic although one could (as we have seen) buy table tops from him without any mosaic element. Fortnum could have known of Barberi's work without travelling to Rome for it was awarded a medal at the Great Exhibition in 1851. In 1856, when appointed Commendatore del Pontificio Ordine di S. Silvestro, Barberi published engravings of 'Alcuni Musaici usciti dallo Studio del Cav. Michel 'Angelo Barberi'. (M. Alfieri, M. G. Branchetti, D. Petochi, *I mosaici minuti romani* (Rome, 1981), 46, 125–30). Two important round micromosaic tabletops, with views of major Italian cities in one case and of the flora and classical ruins of southern Italy in the other, are in the collection of Mr and Mrs Arthur Gilbert and on loan to the Los Angeles County Museum of Art (M.77.1.81 and L.88.22.3). The supports are of gilt bronze but otherwise similar to that of the Ashmolean table.

Of all the designs reproduced in Roman Micro-mosaic between 1770 and 1870 none exceeded in popularity Pliny's Doves (see Alfieri, Branchetti, and Petochi, op. cit., figs. 13 and 29 and the ten plates on 226–7).

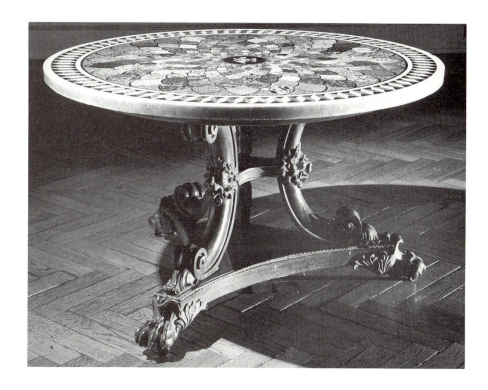

Perhaps studio of Lorenzo BARTOLINI (1777–1850)

11. Mask of Dante Alighieri

22 cms. (approximate height of mask); 57.5 cms. (height of shadow box; 44.8 cms. (width of shadow box)

Plaster of Paris. Cast from a piece-mould, with all the seams preserved—hollow behind. The mask is mounted on a board covered with burgundy-coloured velvet framed as an irregular oval within a rectangular oak frame. The oval aperture is surrounded with a carved frieze of laurel leaves with a line of water gilding to either side; the laurel berries are also gilded. The oak frame is set within an oak shadow box.

Transferred at an unrecorded date from the Bodleian Library where it was recorded in the Gallery by Mrs R. Lane Poole in an appendix to her *Catalogue of Portraits in the Possession of the University, Colleges, City and County of Oxford*, iii (Oxford, 1925), 308, as follows: 'Cast of Bertolini's [*sic*] mask believed to have been taken from the mask originally placed on the Poet's Tomb at Ravenna. Presented to the Oxford Dante Society by Baron Kirkup in 1879. Deposited on loan by the Oxford Dante Society in 1916.'

Dante's admirers were not idle in Oxford in the 1910s. Dr Paget Toynbee presented the Bodleian Gallery with a collection of 'all the portraits' of the poet in 1917, and in 1919 the Hon. William Vernon added a plaster cast of Munro's bust of the poet (the marble, which belonged to Henry Acland, had been exhibited at the Royal Academy in 1856 as no. 1304). The quality of the Ashmolean's cast is lamentable and it may have been made by an amateur, the taking of 'squeezes' during the mid-nineteenth century often

being undertaken by gentlemen travellers. The source would seem to have been the terracotta bust in Palazzo del Nero in Florence which was much venerated in the last century because it was believed to have been made from a cast taken after the poet's death in Ravenna in 1321. There is a similar plaster mask, including, however, less of the cap and with less evident seams, in Palazzo Vecchio, Florence, the gift of the literary critic Senatore Alessandro d'Ancona. This had previously belonged to Seymour Kirkup (1788–1880), who is recorded as having given the Ashmolean's cast to the Oxford Dante Society shortly before his death. Kirkup was a British painter resident in Florence whose chief claim to fame was his discovery of a presumed portrait of Dante on a wall of the Bargello in the early 1840s. There is no record in M. Tinti's monograph *Lorenzo Bartolini* (2 vols. (Rome, 1936)) of the sculptor making a portrait of Dante but it is unlikely that the reference to him is without significance and it is possible that his studio supplied casts of this and other famous Florentine works of art and memorabilia. Bartolini was certainly a strong adherent of the view that the Florentine masks *were* death-masks (which is exceedingly improbable)—see C. Ricci, *L'ultimo rifugio di Dante* (Florence, 1891), 279–80. An alternative explanation would be that the cast was in fact furnished by Bartolini's rival Stefano Ricci (1765–1837), who was responsible for the poet's cenotaph in S. Croce, Florence (commissioned in 1829), in which the effigy was based closely on the Palazzo del Nero mask.

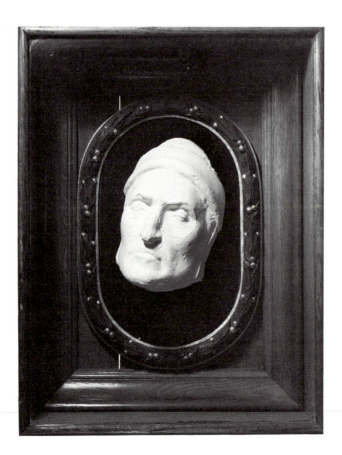

Unknown foundry, unknown modeller

After Gianlorenzo BERNINI (1598–1680)

12. Constantine the Great beholding the sign of the Cross, before the Battle of the Milvian Bridge

81 cms. (height); 98 cms. (length); 80.2 cms. (height of pedestal); 92 cms. (length of pedestal)

Bronze with a dark brown to black patina worn to a chestnut brown in some salient areas (e.g. horse's forelegs, ridges of drapery). Hollow, lost-wax, cast in numerous pieces. Both the back legs and the tail of the horse were separately cast and fixed with difficulties: rivets are apparent and there are cracks in the tail near the join. The front legs were separately cast, but fixed with no visible joins. Constantine's body is cast in two parts—the upper part including both of his arms. The join is apparent on close inspection of the cloak. The fit of the lower part of his body on the horse is ingenious, especially where his cloak fits tightly over the saddle cloth below. Three of the four tassels on the saddle cloth on each side of the horse were separately cast and one is missing from both sides (the tassels nearest the horse's neck are integral with the cloth). The strap across the horse's chest is also attached. The horse's head is cast separately and the join in the upper part of the horse's neck is most evident on the emperor's left side but there is a crack along a part of the join on the other side of the neck. The wall of bronze is very thin in the highest portions of the horse as also in the tail with minute perforations in these parts. A small patch of the mane appears to have been separately inserted. The group is mounted on a pedestal of pale mahogany (modelled on that designed by Michelangelo for the *Marcus Aurelius* on the Capitol) by means of solid extensions of the back legs.

Purchased 1952 through the agency of Mary Bellis of Charnham Close, Hungerford, from the collection of the American newspaper tycoon William Randolph Hearst. Purchased for Hearst at the sale of Leopold Hirsch deceased of 10 Kensington Palace Gardens, London, Christie's, London, 8 May 1934 (lot 151). The present pedestal seems to have been made for Hirsch. Previously in the collection of T. M. Whitehead and in his sale, Christie's, London, 10 May 1898 (lot 104), at which date it had an ebonized pedestal the top of which was the same shape as the present one. Said in this sale to have been brought from Rome in 1855 by T. W. Faulkner, Esq., of Lime Bank, Cheetham Hill, near Manchester. Mary Bellis was a dealer in antique furniture who had for a brief while a special arrangement to sell works of art from Hearst's home in Wales, St Donat's Castle. See also Nos. 130 and 416.

Bernini's colossal marble statue, upon which this bronze is modelled, is placed, as if in high relief, against the wall of the principal landing of the Scala Regia in the Vatican Palace. It had first been conceived of in the autumn of 1654 in response to an idea of Pope Innocent X to fill a niche in the Basilica of St Peter's and had been blocked out by 1655 when Alexander VII became pope and plans were changed. The present location was decided upon in 1662 and the statue was finished

in the summer of 1668, transported by January 1669, and unveiled, against a background of agitated stucco drapery, on 1 November 1670. (R. Wittkower, *Bernini* (Oxford, 1981), 251–4.)

The Ashmolean's bronze is a work of high quality suggestive of a diplomatic gift. It is also the only recorded version in bronze of this masterpiece by Bernini. It is not a copy. The horse rears rather less high than in Bernini's marble and the emperor's right arm is lower (so that his gesture is closer to that devised by Raphael for the mural of the same subject in the Sala di Costantino of the Vatican). Some of the differences—the trappings on the horse and the antique armour here worn by Constantine—may be explained as appropriate for a less monumental setting, a more ornamental purpose, and perhaps a scholarly patron. Other differences may be explained by the different medium: the tail in the marble version is attached to the rump and legs, whereas in the bronze it flows free; likewise the cloak in the bronze, where blown back over the flank of the horse, does not adhere as closely to it as in the marble version. None of the differences observed so far precludes the possibility that this is a work made from a *modello* by Bernini himself. In one or two respects (above all the cuirass) the bronze does correspond with a damaged terracotta *bozzetto* by Bernini in the Hermitage (G. Matzulevitsch, 'Tre bozzetti di G. L. Bernini', *Bolletino d'arte* (1963), 71–2, fig. 3).

It is, however, far more likely that the bronze is the work of a later sculptor. Wittkower (op. cit. 254) suggested the Florentine Giovanni Battista Foggini, who studied in Rome, between 1673 and 1676, under Ercole Ferrata—'the sculptor may have used a Bernini *bozzetto* as a starting point for his version'. The suggestion is attractive both because Foggini was much involved in equestrian groups in bronze (indeed his *Kaiser Joseph I* in the Bayerisches Nationalmuseum, Munich, and his *Carlos II* in the Prado, Madrid, both have rearing mounts) and because the complex piecing of the bronze is typical of Florentine foundries of the late seventeenth and early eighteenth centuries. They were, however, more ingenious in concealing joins. Other sculptors working in Rome (including pensioners of the French Academy) could have been responsible.

The bronze may be considered as a correction of, as well as homage to, the marble, for it avoids the controversial mannerisms of Bernini's late style. The cloak is less abstract in its agitation, more like cloth in its weight, and the horse's mane is less extravagant. The alteration of the emperor's attitude may reflect apprehension concerning the decorum of Bernini's interpretation which is expressed in a polemical pamphlet on the sculptor which deplored the way in which Constantine resembled St Francis receiving the Stigmata (G. Previtali, 'Il Costantino messo alla Berlina o Bernina . . .', *Paragone*, 13 (1962), 55–8, no. 145).

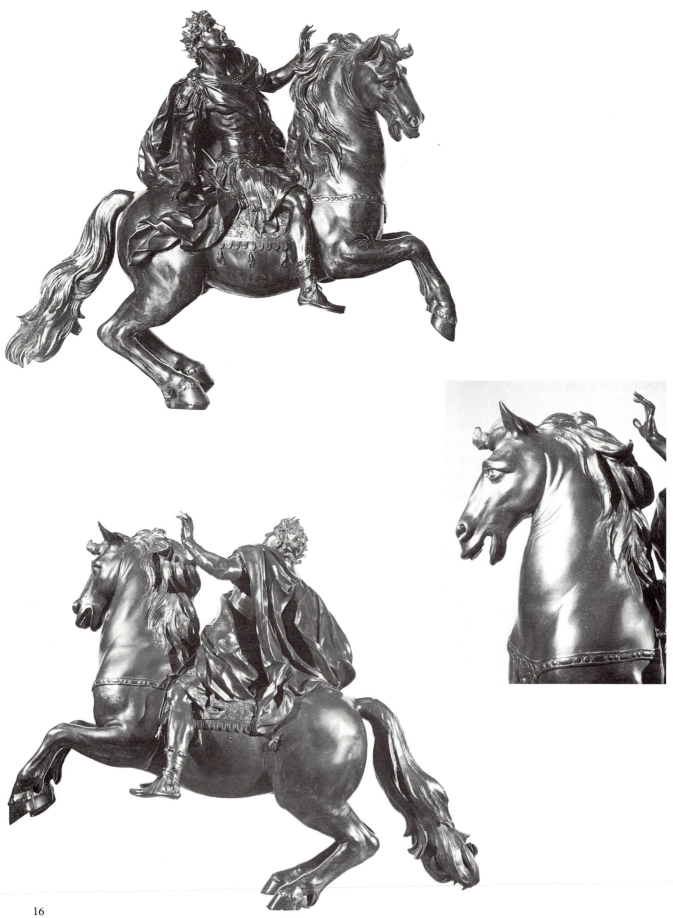

Workshop of BONGIOVANNI–VACCARO

13. Young country woman with an infant in conversation with an older country man

23 cms. (height); 21.8 cms. (length); 12.9 cms. (width)

Terracotta, partially hollow. Minor firing cracks; many subsequent breaks. The whole of the man's left arm, the index finger of the woman's left hand, and the end of her thumb, also the child's left foot are missing. His bundle is broken at one end (a relatively recent loss). The base is cracked across the front and repaired in the interior with cement, small patches of which are smeared on the front. Inscribed '1978.334' in red letters in the interior.

Given by G. R. Reitlinger in 1972. The gift, exceptionally, remained in Reitlinger's possession. Much was lost in the fire of 6 February 1978 at his home. What was salvaged was removed to the Museum. The donor died on 8 March 1978. The number corresponds to a card index of some 225 Western ceramic items transferred from the Department of Eastern Art. These were never registered. The card for this piece includes Reitlinger's number E. 336 and a note that it was bought at Phillips and Harris on 3 February 1970.

Reitlinger identified this group as modelled by 'Bongiovanni Vaccaro' about 1840–60. Salvatore and Giacomo Bongiovanni (born 1769 and 1772 respectively) had established a workshop for the making of small terracotta figurines for cribs and the like at Caltagirone in Sicily by the end of the eighteenth century. Their sister's son, Giuseppe Vaccaro, continued with, and further improved upon, their work, and other members of the family were also employed.

Their most ambitious cribs included numerous rural types in local dress, as had long been traditional in southern Italy. Many of these were occupied in a manner quite unrelated to the sacred narrative and these groups—the shepherds making ricotta, the women washing linen in a stream, the old women winding wool, and so on—could presumably also be purchased independently by tourists. The finest compendium of their models is to be found in the crib in the Real Collegiata di S. Maria de Betlem in Modica (Sicily) unveiled on Christmas Eve 1882 (C. Naselli, 'Presepi di Sicilia', *Emporium*, 74 (1931), 332–7). Scholars who have seen this and the independent figures in Sicilian museums have confirmed the attribution of this piece to the Bongiovanni–Vaccaro workshop, whose productions seem however to have usually been coloured. The style, and extremely skilful management of petals of clay for the ragged clothes, are very closely matched in a piece representing a pedlar or beggar which is stamped 'BONGIOVANNI VACCARO' with raised letters on its base (reproduced *Emporium*, 34 (1911), 310), and may also be compared with a group of cobblers and a figure of a 'contadino di Bronte' in the collection of crib figures in the Bayerischers Nationalmuseum, Munich (vitrine no. 120). Work of this kind was still being made in Caltagirone in this century, by when, however, the standards of modelling had declined. The subjects still continue to be popular, and not only in Sicily—the 'Eleganza Collection of Seattle', which sells reproductions of Renaissance and classical masterpieces in oxolyte, also supplies the Italian-American market with the *Contadino con cesti de frutta*, the *Giustapiatti*, Pizzamakers, and other street vendors in this tradition.

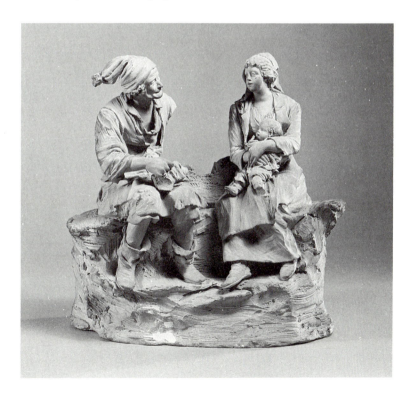

Workshop of BONGIOVANNI–VACCARO

14. Pedlar or vagrant in traditional Sicilian dress

18.6 cms. (height); 6 cms. (widest diameter of irregular oval base); 1.6 cms; (height of same)

Terracotta, partially hollow. Minute chips and firing cracks.

Given by R. E. Alton of St Edmund Hall. Registered 23 March 1962.

The piece is unmarked but has long been stored with No. 13, to which it is very closely related in style and technique. On registration it was described as Neapolitan but later attributed to the French sculptor Leopold Harzé of Liège (1851–93).

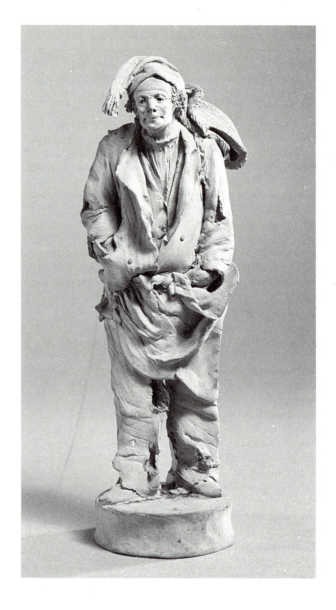

Giuseppe BOSCHI (active 1790s)

15. Portrait bust of Cicero

22.2 cms. (height of bust); 10 cms. (width across truncation of chest); 6.9 cms. (height of socle); 9.8 cms. (diameter of socle)

Bronze with a dark green-brown patina, worn to chestnut on a few salient points (e.g. tip of nose and lips). Hollow, lost-wax, cast. Mounted on a turned and waisted socle of bronze, fire-gilt, with a label chiselled 'M. T. CICERO'. An integrally cast bronze tang projecting from the inside of the chest serves as an attachment. The bust is incised, apparently in the model, along the edge behind the neck: 'G. BOSCHI · F. ROMAE. 1793'. Painted in the hollow interior of the bust to proper left in white 'B / 407. / ₣.' The socle has been filled with plaster of Paris to give it weight.

Bequeathed by C. D. E. Fortnum in 1899. B. 407 in his catalogues. Bought in Rome for £2 in 1870.

Boschi is described by Charles Heathcote Tatham in a letter of 10 July 1795 to his patron the architect Henry Holland as an 'obscure' artist but one who was recommended by 'Madame Angelica [Kauffmann], Zucchi her husband, Canova, Visconti and Bonomi' (Tatham papers, Victoria and Albert Museum). Tatham, who was supplying Holland with ideas and items for furnishing his interiors, noted that Boschi was much cheaper for work in bronze and ormolu than were the better-known Righetti (see Nos. 79–81) and Valadier whose workshops were evidently extensive. But this, Tatham continued, was explained by the fact that Boschi was 'himself the artist, and not a principal' (i.e. an entrepreneur). We know of few other works signed by Boschi and little has been attributed to him. A small bronze version of Canova's *Hebe* signed by him was lot 193 at Christie's, London, 11 December 1979, one of the lion on Canova's tomb of Pope Clement XIII was lot 131 at Sotheby's, London 12 April 1990, and one of the *Marcus Aurelius* was lot 146 at Sotheby's, London, 4 July 1984. A pair of busts of Achilles and Ajax, both after the antique were lot 89 at Christie's, London, 10 December 1991 (the bold signatures, 'G. BOSCHI F.', not noted in the catalogue). Gordon Balderston has drawn to my attention a small bronze group of a centurion in a two-horsed chariot signed by him (in a private collection). D. Udy, in his catalogue of his stand at the Grosvenor House Antique Dealers Fair, 1966, and Christie's (with Young and Gilling), *Hawling Manor, Gloucestershire*, 10 October 1988, lot 7, draw attention to small ormolu versions of the Farnese candelabra now in Naples perhaps commissioned by Tatham. A pair of portrait busts of the older and younger Brutus with a finish and technique like the Cicero, of the same size and mounted upon the same type of socle, are displayed as 'French?' and of about 1800 in the Städtische Galerie Liebieghaus, Frankfurt on Main.

There were three ancient busts believed (possibly correctly, it is conceded today) to be portraits of Cicero which Boschi might have taken as his model. The most famous of these was the one later acquired by the duke of Wellington from Cardinal Fesch which had been in the Mattei Collection since the sixteenth century (A. Michaelis, *Ancient Marbles in Great Britain* (Cambridge, 1882), 429–30). This shows the philosopher with a bare chest and a marble tablet beneath the chest bearing the name Cicero in lettering which although ancient is thought to be less so than the bust. There are, however, small differences: in the parting of the lips, the curls of hair beside the ear, and, more importantly, the corrugations of the brow. There is a closer resemblance to the head in the Capitoline Museum (Sala dei Filosofi, no. 75) which had been in the Barberini Collection—a portrait believed by Visconti to be of Maecenas (*Iconografia romana*, i (Milan edition of his *Works*, 1818–37), 171, pl. 12), and a still closer resemblance to the head in the Uffizi probably acquired from the Ludovisi Collection by Grand Duke Ferdinand II de' Medici in 1669 (G. Mansuelli, *Galleria degli Uffizi: Le sculture*, 2 vols. (Rome, 1958–61), ii. 44–5, no. 33), which is set in lavish onyx drapery. It seems likely that Boschi had access to a cast of the latter.

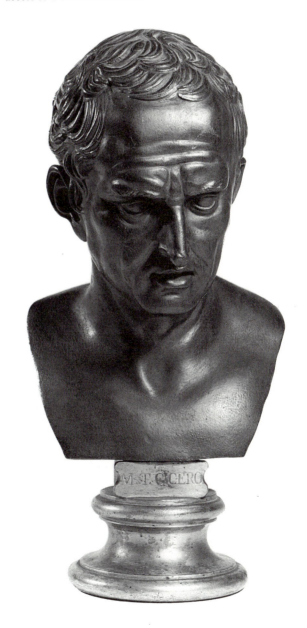

Perhaps by Giuseppe BOSCHI (active 1790s)

16. Bust of Juno

24 cms. (height); 16.8 cms. (length, across shoulders)

Bronze with a mixed olive green to chestnut patina. Hollow, lost-wax, cast. 'B. / 406. / Ⅎ.' Painted in white in the hollow interior to proper right.

Bequeathed by C. D. E. Fortnum in 1899. B. 406 in his catalogues. No indication of provenance but presumably acquired after 1857 when the preliminary catalogue, in which this is not included, was compiled. Mounted, when in Fortnum's possession, on a 'giallo base' (no doubt a socle of *giallo antico*).

The attribution of this bronze to Righetti was made by Fortnum presumably because of its similarity in technique, character, and colour to those busts of *Bacchus* and *Ariadne* in his collection which are chiselled with Righetti's name (Nos. 80 and 81). In the large catalogue he claims that the bust is after an antique marble in the Vatican but I cannot find a similar statue there. The prototype may be in this country, for in Righetti's printed list of bronzes dated 1794

under 'Bustes avec leur base dorée, en tout, hauts d'un palme, cinq onces' we find 'La fameuse Junon colossale en Angleterre' companion with 'Le Jupiter du Museum Vatican'. The measurement of this bronze *Juno,* which would only have been approximate, was the same as that for the *Bacchus* and *Ariadne,* although at 15 'Sequins Romains' (nearly £7 10s.) it was more expensive. The size of the Ashmolean *Juno* is close to that of the *Bacchus* and *Ariadne.* It is however impossible to feel sure that the bust is not the product of one of the rival foundries of the period. It is different in the cutting of the chest and the modelling has less vitality especially when compared with the *Ariadne.* An attribution to Boschi is advanced on the grounds that two other versions of the bust are found as companions to versions of the *Cicero,* which is (in the Ashmolean's example, No. 15) signed by Boschi. In both cases, one in a private collection in London and one with a French dealer from whom they were stolen in late July 1989 (see the *Gazette de l'Hôtel Drouot* (Sept. 1989), 56), the socles were of gilt bronze of the same type as the Ashmolean's *Cicero.*

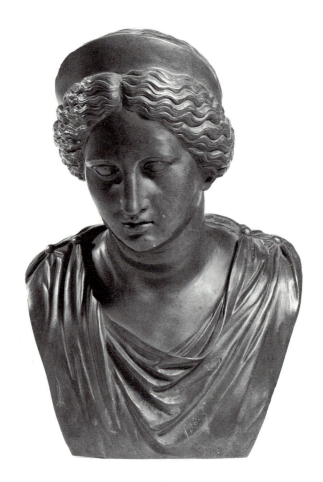

Perhaps by Cesare BRAZZINI (active 1870s)

17. Bust of a boy of the Medici family

46.2 cms. (height)

Terracotta of a pinky grey colour, dirty. There is a network of cracks and breaks over the chest, with some plaster infill tinted to match the clay. Much plaster has been poured into the hollow interior of the bust to reinforce it. There is a small hole in the top of the head. Slip-cast and retaining many minute seams from the piece-mould: e.g. across his right eyebrow, across front of fringe.

Given by Thomas Harris of Garden Lodge, Logan Place, London W8. Registered 25 October 1947.

The Register records that the donor believed that the bust was cast from an eighteenth-century mould of an earlier original. Another version of the bust is in the Victoria and Albert Museum (no. 231-1876). There is no surviving documentation for the latter save that it was acquired in 1876 as a bust of 'Il Moro' from a Cesare Brazzini in Florence. If this is the name of a sculptor he is not otherwise recorded, and it may rather be the name of a dealer. The Medici family *palle* on the breastplate and the coronet above would suggest that a Medici duke was intended, and, given the youth of the sitter and his scowl, there can be little doubt that he is meant for the first Medici duke of Florence, Alessandro de' Medici, natural son of Lorenzo, duke of Urbino. Alessandro was made

ruler of Florence in 1530 by the imperial army at the age of 20 and died, murdered by his kinsman, after seven years' rule, the horror of which thrilled the city's late Victorian historians: 'The exaltation of this foul and evil youth to a position of power absolutely uncontrolled showed mankind an example of what human nature is capable of under such conditions', wrote Colonel Young (*The Medici* (New York, 1910), 365), and he proceeded to quote Adolphus Trollope on the 'low forehead and mean expression' of this boy whose life was one 'continual orgy'. The bust mixes elements suggestive of fifteenth-century sources—the pudding-basin hair style, the ornamental breastplate, and the proud look derive chiefly perhaps from Pollaiuolo's terracotta bust of an unknown youth, no. 166 in the Museo Nazionale of the Bargello, Florence—with others contemporary with the sitter—the mask ornament on the front face of the base is inspired by that on the armour of Michelangelo's Giuliano de' Medici— see no. 62. At the same time the boy seems unmistakably to be a contemporary of the fisherboys and urchins of Vincenzo Gemito.

The Victoria and Albert Museum version is exhibited among their fakes but it is not certain that the portrait was intended as such rather than as an imaginary portrait. It is covered, like the Ashmolean version, with piece-mould seams but seems to have been fired in two parts, the back of the head, neck, and shoulders forming a 'lid' cemented on to the rest.

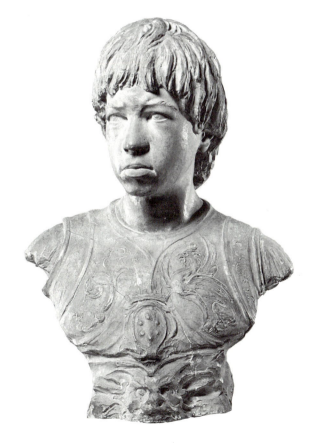

Probably by Elias de Witte, called Elia CANDIDO (active 1570s in Florence)

18 and 19. Pair of putti in twisted attitudes

19.5 cms. (length of figure (18) with arm behind his head);
22.1 cms. (length of figure (19))

Bronze with a black varnish (leaving a dark green deposit when handled), worn, on salient points such as curls, nose, knees, toes, and buttocks, to expose a natural warm coppery brown patina. The surface has been punched and the varnish is better preserved in the small dents, giving a spotty appearance, particularly evident in the figure with one hand behind his head (No. 18). Extremely heavy, apparently solid, casts. The thickness of the bronze is evident from the depth of the large screw holes (perhaps for suspension) of which there is one in the back and one between the legs of No. 18 and one in the back and one in the back of the proper right thigh of No. 19. These holes are over 1 cm. in depth and do not enter into a hollow core. The proper left hand of No. 19 has been cast separately and the join at the wrist is easily perceived and is slightly loose. There is a small firing crack on the proper right foot and above the proper left knee of No. 19.

Given by E. Barry Bowyer of Mulberry House, Peppard, Henley on Thames, through R. M. Courtier of 70 Peppard Road, Caversham, Reading, Berkshire, in March 1984 (deposited early in March, formerly offered and accepted on 15 March). Mr Bowyer died in April, soon after making this gift. Mr Courtier, in a letter to the Keeper of 6 November 1986, explained that Mr Bowyer was a 'bachelor, retired some years as senior partner of the firm Buckland and Sons, Auctioneers and Surveyors of Slough, Windsor and Reading', who had 'spent a long life time collecting pictures & objects d'art, some from his sales but many from second-hand "junk shops". If all were not in perfect condition everything had an intrinsic beauty, or antique value; only in his later years did he spend real money! The putti referred to were bought in a very shabby second hand shop in Oxford Rd., Reading in about 1970.' This last date, however, is inaccurate since Mr Bowyer had been in correspondence with the Department of Architecture and Sculpture at the Victoria and Albert Museum concerning the putti in February and March 1956. The department had expressed a tentative interest in purchasing them but only for a 'modest sum' and Mr Bowyer decided not to sell to them.

It is hard to imagine the larger work of art from which these putti must have been removed. Although of identical style and technique they do not certainly form a pair, No. 18 being smaller, most obviously in the head, than No. 19. They may be from a larger group in which such differences mattered less or were intended. Paired putti of about this size, leaning backwards and with one knee raised, sometimes adorn the scrolled feet of sixteenth- and seventeenth-century Venetian andirons (see for instance those in the Nelson–Atkins Museum, Kansas City, 62-19/1.2). The positions of the arms and the fragments in the hands, however, make such an origin unlikely. No. 18 has a piece of drapery in the hands behind his head and a stem in the other. No. 19 holds thin, striated pieces of foliage or possibly hair in both of his hands. This perhaps suggests that the figures originally held up swags or held back drapery upon the cornice or upper portion of a

tabernacle. They bear some resemblance in character to the larger bronze putti supporting the epitaph below the half-length portrait of Lucrezia Tomacelli (duchess of Palliana, wife of Filippo Colonna) on her tomb in the Colonna Chapel in S. Giovanni in Laterano, Rome, a work dated 1625 and made by Teodoro della Porta (legitimate son and heir of Guglielmo della Porta) in collaboration with the founder Giacomo Laurenziani (illustrated and discussed by U. Middeldorf, *Raccolta di scritti* (Florence, 1981), iii. 97–8, fig. 93).

The putti were registered as German and of the seventeenth or eighteenth century, following the opinion of them expressed in a letter to the donor from the Victoria and Albert Museum in 1956, but the closest parallel is certainly with bronzes which were made in Italy, and in particular with a pair of dancing putti upon small domed bases, of similar size. One of these, with his left foot raised before him, is in the Victoria and Albert Museum (A. 109-1910) and the other, with his left foot behind him, is in the Museo Nazionale of the Bargello, Florence (inv. 64). They have similarly active and twisted poses, identical wild pointed curls, their extremities also appear to have been clipped off to form sharp points, and the flesh has been given the same distinctive finish with a broad punch. They even have similar fragments in the hands—probably bits of stem and leaf. (The Victoria and Albert Museum has a variant of the Bargello Bronze (A. 78-1951) and other versions are known, for which see the catalogue of the exhibition *Giambologna: Ein Wendepunkt der europäischen Plastik* (Vienna, 1978), nos. 255–6, which, however, does not mention the version of the Bargello's putti in the Thiers Collection (no. 131) in the Louvre.) These dancing figures have been attributed to Elia Candido, Elias de Witte of Bruges, because of their resemblance to the larger bronze *Aeolus* in the Studiolo of the Palazzo Vecchio in Florence which is inscribed with this mysterious sculptor's name and dated 1573. Anthony Radcliffe (in the Vienna catalogue cited above) did not find the similarities sufficiently strong to justify the attribution. But the precarious and spiralling pose is extreme in both and the treatment of the hair is very idiosyncratic and exactly comparable. Moreover there is another bronze which shares much with both the dancing putti and the adolescent wind god. This is the graceful *Meleager* (Staatliche Museen, Berlin-Dahlem, inv. 2594), similar in size to the former (but even smaller) and similar in subject to the latter, who is as delicately balanced (with one foot on a boar's head) and has exactly the same pointed hair and dimpled flesh as the putti (see the persuasive entry by Volker Krahn in *Maecenas und Berlin* (Ausstellung des Kaiser-Friedrich-Museums-Vereins, 1988), 16–17, attributing this to Candido).

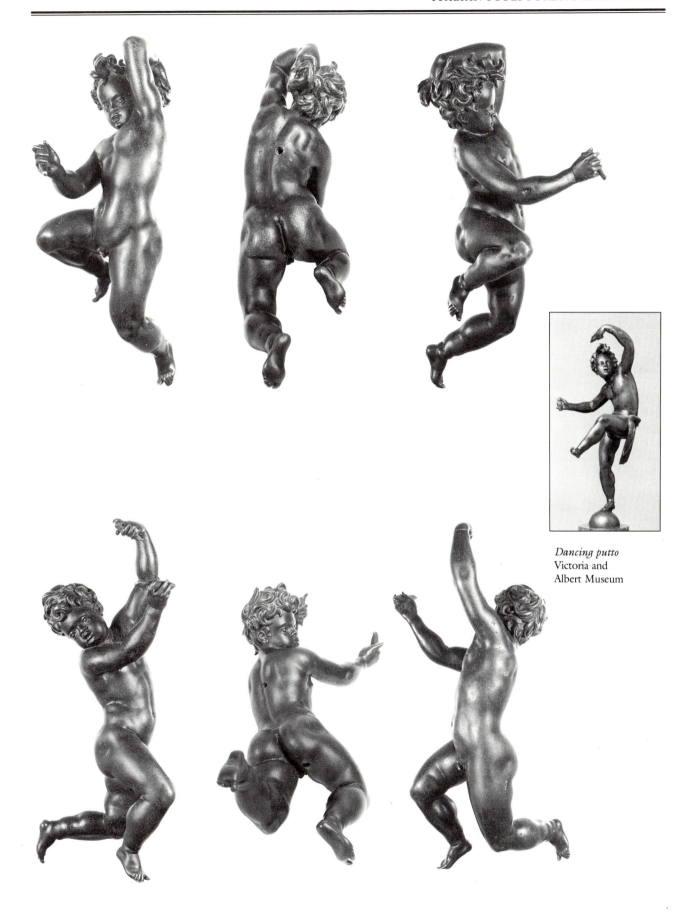

Dancing putto
Victoria and
Albert Museum

Pupil of Antonio CANOVA (mid-nineteenth century)

20. Melpomene

41.2 cms. (height excluding socle); 13 cms. (height of socle)

Carrara marble. The turned and waisted socle is of a different piece of marble with the chiselled word 'MELPOMENE' on the front of the tablet above the upper moulding. Inscribed on the back of this tablet in black ink 'S 36 ₤'. A few minor chips are missing from the vine leaves in the hair.

Bequeathed by C. D. E. Fortnum in 1899. S. 36 in his catalogues. Acquired with *Thalia* (No. 3).

The *Melpomene* is companion to *Thalia* (No. 3), this couple forming a pair for the two copies of antique heads by Gott (Nos. 514, 515). Fortnum noted that it was a 'copy from the head of the antique statue in the Vatican . . . the work of a student pupil in Canova's studio' but in his preliminary catalogue of 1857 (p. 7) he phrased this rather differently: 'Said to be by one of Canova's pupils and from his studio.' One might suppose that this was supplied by Amici together with the *Thalia* (No. 3), but if so it is surprising that the socles are of slightly different dimensions and character (and that *Thalia* does not have her name on the tablet). It may also be that this particular bust was cut down from a failed copy of the entire statue because it is crudely chiselled and hardly at all hollowed out behind and is even rough under the cut of the chest. Like the *Thalia* the *Melpomene* is, in execution, an improvement upon the antique prototype, the vine leaves and grape clusters of the Bacchic crown being more sharply defined and deeply undercut and far more completely carved from behind. This prototype is a standing figure with her left leg raised on a block holding a mask in her right hand in the Sala delle Muse in the Museo Pio-Clementino. It was discovered together wth the *Thalia* and other Muses at the supposed Villa di Cassio at Tivoli in excavations commenced before 1773 by Domenico de Angelis and was obtained for the papal museum by the intervention of Giovanni-Battista Visconti in 1774 (W. Amelung and G. Lippold, *Die Skulpturen des Vaticanischen Museums*, III, (Berlin, 1935–6), no. 499; C. Pietrangeli, *Scavi e scoperte di antichità sotto il pontificato di Pio VI* (Rome, 1958), 139–40).

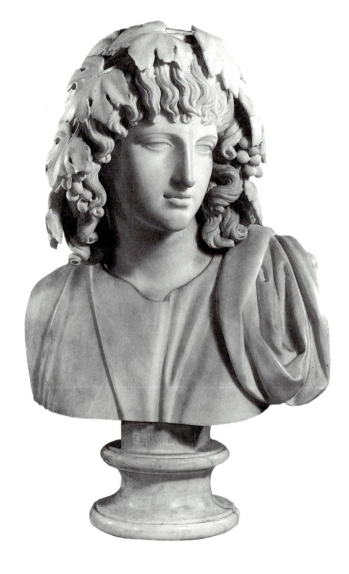

Perhaps by Benvenuto CELLINI (1500–71)

21. Reclining female nude

8.55 cms. (height); 10.8 cms. (length); 3.7 cms. (height of porphyry slab); 12.3 cms. (length of porphyry slab); 5.4 cms. (width of porphyry slab); 1.5 cms. (height of wooden plinth); 13.5 cms. (length of wooden plinth); 8.7 cms. (width of wooden plinth)

Bronze with a green and dark brown varnish, flaked and rubbed to expose, in many areas, a yellow metal. The nipples are both of silver, and so is the figure's left eye. The silver has fallen out of her right eye. The figure's right arm, where it is broken, is solid. Her right leg appears solid but has been filled with wax to give this impression. The thin wall of the bronze above the break has been twisted and bent. There is a firing crack in the upper part of the figure's left arm. The bronze has been tooled and the cloth which is part of the coiffure has been minutely punched. The figure is mounted by means of a coarse bolt to a slab of imperial porphyry which rests in a plinth of ebonized wood. The slab may originally have served as a plinth for another bronze in the Chamber Hall gift (see No. 223).

Given by Chambers Hall in 1855 (for this gift see the Preliminary Essay to volume iii). Probably placed on display in 1856: blocks for mounting the bronzes were paid for in January of that year.

This fragment of an exquisite bronze figure, known only in this cast, was formerly labelled as possibly by Guglielmo della Porta, because the reclining pose was thought to be similar to those of the personifications on the tomb of Pope Paul III by that sculptor in St Peter's. This attribution was probably proposed, and certainly approved, by C. F. Bell. It was, however, Bode's opinion that the figure, which he erroneously captioned as in the Pierpont Morgan Collection, might be by Benvenuto Cellini (*Italian Bronze Statuettes of the Renaissance* (London, 1907–12), ii, pl. CXLVI). Planiscig agreed, although correspondence with Bell makes it clear that he knew the bronze only from photographs (*Piccoli bronzi italiani del Rinascimento* (Milan, 1930), 45). Pope-Hennessy also considered it as possibly by Cellini (*The Life of Benvenuto Cellini Written by Himself* (London, 1949), 484) and has recently reaffirmed this position:

One small bronze of a reclining female nude, which exists only in a single version at Oxford may also have been produced by Cellini at this time [1546]. It has no provenance (no provenance of consequence, that is), but the exquisite modelling of the figure is so closely related to the Earth on the Vienna saltcellar as to permit a tentative attribution to Cellini. (*Cellini* (London, 1985), 226)

The somewhat elongated proportions; the pose, intermediary between reclining and sitting, which is certainly reminiscent of the see-saw attitudes of Ops and Neptune on the salt-cellar; the elaborately dressed hair which nevertheless retains freedom, body, and softness; also the exquisite silver additions characteristic of goldsmith's work; all tend to support the connection with Cellini. Two factors, however, weigh against the attribution. Firstly, Cellini's surviving bronzes, large and small, are all of a highly coppery metal with a warm brown natural patina, whereas this is the colour of brass. Secondly, the woman's face with its pointed dimpled chin and its arched brows rising from a fine nose is dissimilar to the female type which is found in Cellini's work which is particularly distinguished by square brows. It may be significant that before the compilation of this catalogue no photographs of the bronze gave a frontal view of the face. Draper, in his 1980 edition of Bode's *Italian Bronze Statuettes of the Renaissance*, suggested that the bronze was Roman and of about 1570–80.

It is not only the identity of the creator of this bronze which is mysterious. Its original purpose and setting are also hard to imagine. It perhaps served as an ornament on an elaborate inkstand. It is impossible to believe that a sculpture would have been so highly finished in a fragmentary form so the damage must have occurred subsequently. It is possible to imagine a firing crack in the arm, especially if it were solid, causing it to break in half when dropped, and it is easy to imagine that the leg, being so thin, could be broken. It is odd, however, to find a cast with such an extreme variation in thickness.

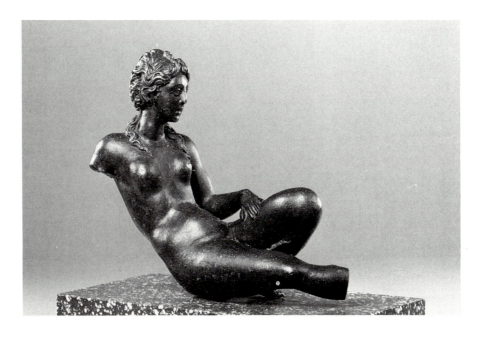

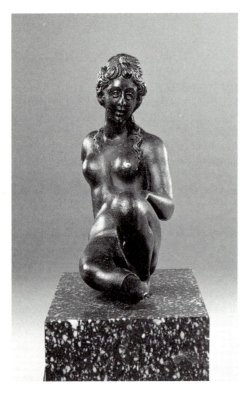

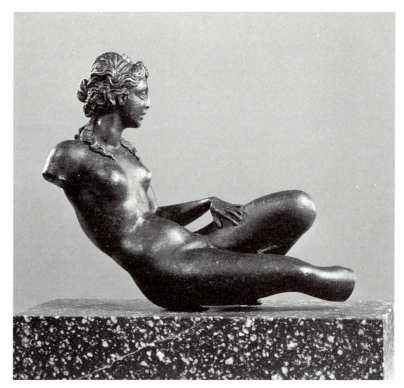

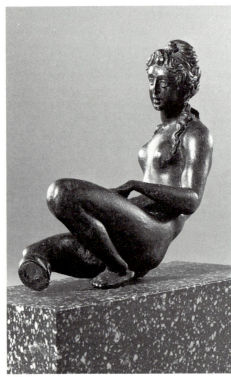

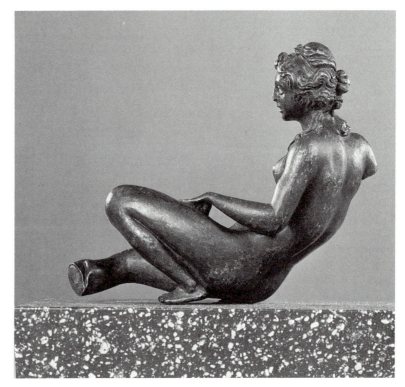

Giuseppe (Joseph) CLAUS (active between 1754 and 1783)

22, 23, 24, and 25. Popes Innocent XIII, Benedict XIII, Clement XII, and Benedict XIV

74.5 cms., 72.8 cms., 73.2 cms., 72 cms. (heights of busts, excluding socles); 19.5 cms. (height of each socle)

White Carrara marble mounted on mottled dove grey marble socles. The knotted cords attaching the stole have, in each bust, save that of Innocent XIII (22), been broken and the parts are missing. There are small chips missing from the lowest portions of the stoles in the busts of Popes Benedict XIII and Clement XII (23 and 24) and on the fur fringe of the *mozzetta* (short, hooded, buttoned cape) of Pope Benedict XIV (25) to proper left. The busts are all chiselled with cursive letters of the 'rims' of marble above the hollowed backs as follows: 'joseph Claus fecit anno 1754' (on that of Benedict XIV); 'Claus jnven. et fecit anno 1755' (on that of Innocent XIII); 'joseph Claus jnven. et fecit anno 1755' (on those of Clement XII and Clement XIII). The socles are adorned with the names of the popes and of the artist in gold letters (applied since acquisition by the Museum). It cannot be certain that the socles are original. For the pedestals upon which they are placed see Nos: 219–22.

Bought at Christie's, London, 22 June 1950, lot 67, 'the property of Frances, Lady Ashburton'. Acquired by Alexander Hugh Baring, 4th Baron Ashburton, between 1860 and 1889 (probably nearer the latter date).

Tantalizingly little is known of Claus. In addition to these busts, there is a reduced marble copy of the *Apollino* of the Tribuna signed 'Josephus Claus fecit 1766' at Brocklesby Park, Lincolnshire, a bust signed by him at Maddesfield Court (note in the Department's files), a bust of a man at the Rhode Island School of Design, Providence, and a bust of Clement Augustus, archbishop elector of Cologne (1700–61), signed 'Joseph Claus invt. et fect. 1754', in the Lady Lever Art Gallery, Port Sunlight (E. Morris and M. Evans, *Lady Lever Art Gallery, Port Sunlight: Catalogue of Foreign Paintings, Drawings, Miniatures, Tapestries, Post-Classical Sculpture and Prints* (Liverpool, 1983), 109, no. LL202, X4202). Gerald Taylor has observed ('Uno scultore ignoto Joseph Claus', *Bollettino d'arte*, 3 (July–Sept. 1952), 231–3) that Claus is not mentioned in the records of the Academy of St Luke. This might suggest that he stayed for only a relatively short period in Rome–at least a brief visit is suggested by the portrait busts of the popes, and by the style of his work. His name suggests that he came from Germany and the portrait of the archbishop elector, a lover of Italian art, might suggest a patron by whom he was sent to Rome. However, as Hugh Honour pointed out in a letter to Hugh Macandrew of 27 July 1969, it was from a Giuseppe Claus that Canova took over a largish studio in Vicolo delle Colonette di S. Giacomo degli Incurabili in 1783 in order to carve the monument to Pope Clement XIV. If this is the same Claus one wonders how he was employed in Rome between 1766 and 1783.

The popes depicted are Innocent XIII (Conti) who died 1724, Benedict XIII (Orsini) who died 1730, Clement XII (Corsini) who died 1740, and Benedict XIV (Lambertini) who died 1758. The last named pope was therefore alive when the bust of him was carved whereas the others were posthumous, and this might explain (as Taylor pointed out, op. cit.) the different styles of signature, 'invenit' being absent from the portrait of the living pope because invention was less important when a work was executed from the life. On the other hand the sculptor might have wished to underline the imaginative contribution he made in those cases when he was inevitably dependent upon the models of earlier artists. He certainly was dependent upon the bronze bust of Clement XII by Pietro Bracci in the Museo Capitolino of 1736 for his portrait of that pontiff (as Taylor noted). However physiognomical truth seems to have been modified in the interest of decorative symmetry. Claus's Benedict XIV resembles Innocent XIII and Benedict XIII resembles Clement XII. All four have a very similar undulating termination to the *mozzetta* which in every case is imperfectly buttoned and each pope has a similarly curling collar in every case supported by marble bridges, but on closer examination they are paired in attire as well as facial type: Benedict XIV and Innocent XIII have polished marble (for satin?) *mozzettas* and caps whereas the busts of Benedict XIII and Clement XII have *mozzettas* and caps with rougher punched textures (for velvet?); the former pair have stoles with a punched ground whereas the latter pair wear stoles with a striated ground.

Strikingly similar to these busts, not only in formal, costume, and size but in execution, is that of Clement XIV now in the Vestibolo Quadrato (formerly Stanza della Cleopatra) in the Vatican Museums, which was acquired earlier in this century from the Galleria Sangiorgi (with an attribution to Canova which now seems absurd).

In addition, the bust of Benedict XIV in the Castello Sforzesco in Milan (no. 1314) is a truncated version of that in the Ashmolean and so perhaps a product of Claus's studio.

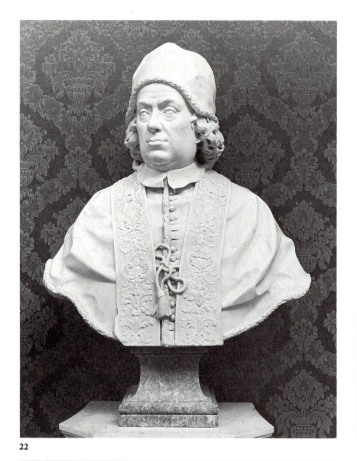

22

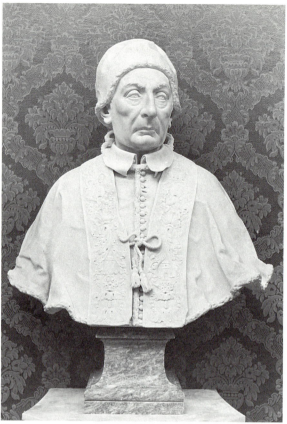

23

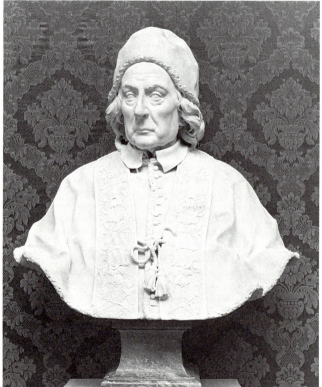

24

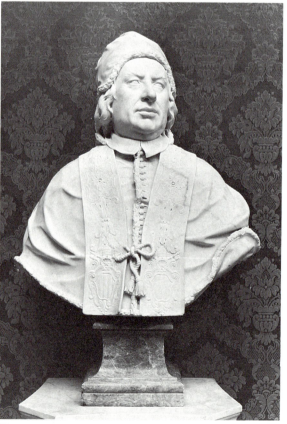

25

Imitator of DESIDERIO DA SETTIGNANO (b. *c*.1430, d. 1464)

26. Virgin and Child

63.5 cms. (height); 39.5 cms. (width)

White marble, presumably from Carrara, with some ingrained dirt in the finer hollows. Framed in a wood frame partially black and partially gilded.

Given by C. D. E. Fortnum on 20 March 1888. S. 7 in his catalogues. Bought in 1864 from the executors of 'the late Sig. Lombardi' [Francesco Lombardi] for £20 (according to the notebook catalogue). As mentioned in the introduction Fortnum also bought Italian paintings from Lombardi's collection.

Fortnum considered that 'the delicate and tender expression and fine execution of this marble are much in the manner of Desiderio'. In the notebook catalogue it is clear that the 'much' replaced a 'quite' and that the prudent qualification that it 'may be by some equally able pupil of Donatello's school' was an afterthought. He was aware of another version of the relief in the Galleria Reale, Turin, which he described, rashly, as a copy or 'replica'. The Turin *Madonna* is now generally (and surely correctly) regarded as a masterpiece by Desiderio: N. Gabrielli's opinion in her catalogue of that collection (*Galleria Sabauda: Maestri italiani* (Turin, 1971), 261, no. 167) that it is an imitation by Bastianini has not met with support. It was bought in Florence by Baron Garriod in 1850 and casts may well have been taken from it in this period. In any case numerous stucco reproductions of it exist, most of them purporting to be, and many of them certainly looking like, fifteenth-century works (see L. Cardellini, *Desiderio da Settignano* (Milan, 1962), figs. 369–74). From one of these Fortnum's version could easily have been carved.

Bell, in his annotations to Fortnum's large catalogue, recorded Bode's opinion that the Ashmolean's relief was a 'modern copy', and noted the great superiority of the relief in Turin, but he kept the piece on display in the Fortnum Gallery and in his *Summary Guide* of 1931 described it as 'school of Desiderio da Settignano' (p. 23). Kenneth Garlick informed Anthony Radcliffe in a letter of 19 October 1973 that he had just put it up in the redecorated Fortnum Gallery—'for better or for worse'. Radcliffe was then helping John Pope-Hennessy's research into the forging of Florentine quattrocento sculpture, research which resulted in Pope-Hennessy's paper, first published in *Apollo* in 1974, entitled 'The Forging of Italian Renaissance Sculpture', in which Bode's opinion that the relief was a fake was repeated. 'The relief differs', Pope-Hennessy correctly observes, from that in Turin, 'in the overall flattening of the forms, e.g. of the drapery beneath the Virgin's right forearm and of the Child's right hand, and in the misunderstanding of certain passages, e.g. in the decoration of the Virgin's dress on the right shoulder and the buttoning of her sleeve, represented with a third button and a seam that are not present in the original.' (J. Pope-Hennessy, *The Study and Criticism of Italian Sculpture* (Princeton, NJ, 1980), 267 n. 30.) The argument that the variations were stimulated by deficiencies in a cast of

the original in Turin is persuasive. The relief certainly looks like a copy and probably (but not certainly) of the mid-nineteenth century, rather than of the fifteenth. Whether, if it is of the mid-nineteenth century, it was made to deceive, it is impossible to ascertain. For Lombardi see No. 27.

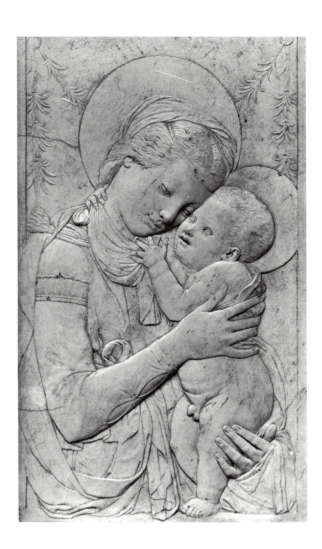

Imitator of DESIDERIO DA SETTIGNANO (b. *c*.1430, d. 1464)

27. Virgin and Child

66.5 cms. (height); 41 cms. (width)

Pietra serena (fine-grained grey-green Fiesole sandstone). Unfinished. All the edges of the block of stone are chipped and irregular. The lower corner to proper right has broken off but has been reattached. 'S. / 5. / ℰℱ' is painted in black on this corner. The relief is set in a gilded wood frame of the 'Salvator Rosa' type but with an arched top and foliate ornament in the spandrels.

Given by C. D. E. Fortnum on 20 March 1888. S. 5 in his catalogues. Bought 'from Lombardi [Francesco Lombardi] in Florence in 1859', for 17 gold Napoleons according to a receipt and certificate dated 16 February and signed by Lombardi which is stuck in the notebook catalogue. (It cost £14 10s. according to the separate 'Memoranda of prices paid'.) Said by Lombardi to have come from the Palazzo Brunaccini-Compagna, Florence (see below).

Fortnum considered this unfinished *schiacciato* relief to be one of the masterpieces in his collection. He found the 'admirable folds of the drapery' and 'noble expression of the heads' comparable even with the celebrated relief, also in *pietra serena*, of an ideal female profile bust then regarded as of St Cecilia. This latter relief, now in the Toledo Museum of Art, had also been sold by Francesco Lombardi, the distinguished Florentine jeweller, goldsmith, and art dealer to 'an Englishman'. It was said to have come from the same source, Palazzo Brunaccini-Compagna, and was attributed by Lombardi to the same artist, Donatello. The Englishman who had bought the *St Cecilia* was either Samuel Woodburn or someone acting for him. At Woodburn's sale on 15 May 1854 it was bought by Mr Rickman 'of Duke St.' for Lord Elcho (not, as recently asserted, by a Mr Hickman acting independently). Fortnum also related his relief to another one in *pietra serena* of the *Virgin and Child* acquired for the South Kensington (now the Victoria and Albert) Museum in 1861 with the Gigli-Campana Collection (7582-1861). This was, with the *St Cecilia*, for the half-century between 1880 and 1930, one of the most admired, reproduced, and imitated of all Renaissance sculptures.

Lombardi sold the relief to Fortnum with a certificate quoting the opinions of the eminent Florentine sculptors and academicians Emilio Santarelli and Vincenzo Consavi that it was by Donatello and came from the same source as the *St Cecilia*. Fortnum at first accepted this but he altered the entry in his notebook catalogue—he was now 'inclined to attribute these works to Desiderio rather than Donatello' and with this view most subsequent scholars agreed after the exhibition at the Royal Academy in 1888. Not long after Fortnum's death, however, Bode, the world's leading authority on Italian sculpture, visited Oxford and expressd doubts about the relief. C. F. Bell noted in the margin of Fortnum's large catalogue Bode's opinion that it was a forgery, perhaps by the same hand as No. 26. (He also noted the opinion of the Donatello scholar P. Schubring that the material was not *pietra serena* but *verde di Prato*.) Bell kept the relief

on display in the Fortnum Gallery and in his *Summary Guide* of 1931 described it as 'school of Desiderio da Settignano' (p. 23). Doubts had also been expressed concerning the *St Cecilia* before 1910 but not by Bode who, however, did also believe that the Victoria and Albert Museum's relief was fake.

In a paper first published in *Apollo* in 1974 entitled 'The Forging of Italian Renaissance Sculpture', J. Pope-Hennessy grouped the three reliefs which Fortnum had first associated and cited three others in the same material as also being by the same hand: a portrait of a lady in the Detroit Institute of Art, a *Virgin and Child* sold in Zurich in 1909 (Hommel Sale, 10–18 August, lot 1149) and a portrait of a lady in Berlin, concluding that 'there can be no reasonable doubt that all of these six *pietra serena* reliefs belong together, were planned by a single mind, and date from the middle of the nineteenth century'. (*The Study and Criticism of Italian Sculpture* (Princeton, NJ, 1980), 235). He proposed that they were made by a Florentine sculptor, Odoardo Fantacchiotti (1809–77), for the dealer, jeweller, and goldsmith Francesco Lombardi (1787–1864).

This hypothesis has met with widespread acceptance. But it is not proven. Lombardi is described as 'one of the principal instigators and one of the main vendors of forged sculptures' in Florence (ibid. 233), but no evidence is produced to support this claim. His tomb, erected by his heirs in S. Croce, incorporates what is now thought of as a very accomplished pastiche of a relief by Donatello, which Lombardi had given to the church in his lifetime. But, if it is a pastiche, might not Lombardi have been deceived by it? Surely genuine pride and piety, a desire to associate himself with a great work of Florentine devotional art and to gain credit for giving it to the public (for S. Croce is a museum of sorts), is more probable than Pope-Hennessy's proposal that he enjoyed the idea of continuing to fool connoisseurs after his death. As for Fantacchiotti, there is no very close relationship between the style of the *pietra serena* reliefs and the accomplished blend of neo-classicism with a quattrocento relief style found in his tondo of the *Virgin and Child* in the tomb of Raphael Morghen in S. Croce and in that on the Giuntini monument in S. Giuseppe, both completed in 1854, (illustrated by Pope-Hennessy, *The Study and Criticism of Italian Sculpture*, 230–1, pls. 15 and 16). There is little sign in these reliefs of the distinctive mannerisms of those in Oxford and the Victoria and Albert Museum which derive from a study of Desiderio: the flattening of volumes (so that eyelids, fingers, limbs, and haloes seem to have been cut out of card or very thin dough), the rhyming of drapery folds and edges (so that, for example, the edge of the Virgin's sleeve in Oxford or one end of the openings in the cuff are aligned with folds in the drapery behind), the tremulous undulations of the Virgin's hair. Fantocchiotti had a genuine feeling for quattrocento art and was doubtless capable of mimicking it, but there were other sculptors of whom this was no less true—Ulisse Cambi, for instance, whose tomb in SS Annunziata for Marchese Luigi

Tempi-Malzimedici, dated 1849, includes angels imitated from Luca della Robbia and a floral border imitated from Ghiberti, or the Venetian Vincenzo Favenza, who between 1849 and 1853 carved the boxwood dining room doors for Kingston Lacy in Dorset, imitating works by Donatello, Luca della Robbia, and Jacopo Sansovino, as well as the antique, as prescribed by his patron the connoisseur William Bankes (1786–1855).

Little is known of Fantacchiotti's career and few works are attributed to the last years of his life, but this is true of many artists. There is nothing strange in reference books only listing early works by which artists first established a reputation. In fact Fantacchiotti was at work on the ambitious and acclaimed *Susanna* (signed 1872, Museo d'Arte Moderna, Palazzo Pitti, Florence) in his later years and not merely engaged on minor monuments. And even if diminished productivity in the second half of his career were established there are numerous explanations for this other than the clandestine activity as a forger implied by Pope-Hennessy's observation that 'There is no telling what he was up to during the crucial years when foreign collectors and museums were engaged in the block buying of Italian sculptures', (ibid. 230–1). Elsewhere in his paper Pope-Hennessy discusses the case of Giovanni Bastianini, who was exposed as a forger in 1867, and remarks that as well as being trained at the Florentine Academy under Pio Fedi he 'may also have worked under Fantacchiotti; in any case the two sculptors must have known each other well' (ibid. 237). He 'may' have worked under Fantacchiotti, but there is no reason to suppose that he did: he would probably have 'known' Fantacchiotti, but there is no reason to suppose that they were friends or associates.

The possibility that all three *pietra serena* reliefs grouped by Fortnum, the Toledo *St Cecilia*, the Victoria and Albert Museum's *Virgin and Child* and the Ashmolean Museum's unfinished *Virgin and Child*, are Renaissance works should be reconsidered. When compared with the works of Desiderio da Settignano, such as the reliefs in the Bargello and in the Galleria Reale in Turin or the exquisite fragment of a *pietra serena* relief of the *Virgin and Child* in the Musée at Lyons (I. Cardellini, *Desiderio da Settignano* (Milan, 1962), 121–2, 136–8, Fig. 323), which inspired them, it is impossible to believe that the Victoria and Albert and the Ashmolean reliefs are by Desiderio (I have not studied the *St Cecilia*). But Desiderio was imitated in the fifteenth century as well as in the nineteenth.

It is true that to most expert eyes today both the *Virgin and Child* reliefs have a modern 'look' but this is due to the great influence which the Victoria and Albert Museum relief enjoyed in the early decades of this century—a striking example of which is the marble head of the Virgin of 1922–3 by the young Henry Moore. No one could claim that the styles of the 1850s betray themselves in these works.

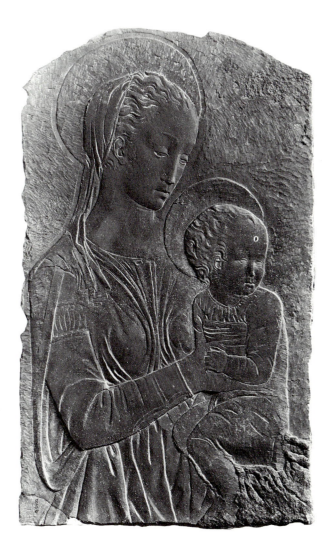

Workshop of Giovanni Franchi and Sons (active 1860s)

After a follower of DONATELLO

28. Entombment of Christ

23.9 cms. (height); 45.3 cms. (length)

Copper (electrotype) with some gilding. The relief is loosely mounted in a flat ebonized wooden frame with a gilded chamfer at the sight edge. 'B / 703 / ℰℱ' is painted in white on the back of the copper. The frame has an old paper label marked 'B 675 ℰℱ'.

Lent by C. D. E. Fortnum in October 1894 and bequeathed in 1899. B. 675 in his large catalogue, B. 703 in his notebook catalogue.

Fortnum described this as an

Electro-deposit by Franchi from the work by Donatello in the Museum, Lambras, at Vienna [the Schloss Ambras Collection then on display in the Lower Belvedere]. Some portions of the original work are picked out with gold as the shield and fibula of the soldier, the sarcophagus &c. this has been reproduced in the deposit. Many years ago, I noticed this fine and highly elaborated work in a dark corner of the Ambras Museum and was most courteously permitted to have a cast taken from it, which was subsequently photographed at Venice [perhaps an error for Vienna], and from which the deposit was taken by Mr Franchi for the S.K.M. [South Kensington Museum]. It is engraved in Perkins Italian Sculptures. Supp^t. p. 274.

This relief which has, since 1891, been in the Kunsthistorisches Museum, Vienna (inv. 6059), is no longer regarded as a 'noble work in Donato's most forcible manner', as Fortnum proposed, but as the work of a follower, perhaps indebted to Mantegna as well as to Donatello. It is surely by the same artist as the no less mysterious bronze, gold, and silver mirror, the so-called Martelli Mirror, in the Victoria and Albert Museum (8717-1863) where one finds the same minute attention to folds and creases of drapery and skin and the same frozen expressions—a point not made in the admirable entry on the relief by M. Leithe-Jasper in *Renaissance Master Bronzes from the Kunsthistorisches Museum, Vienna* (National

Gallery of Art, Washington (and elsewhere), 1986), 61–4, no. 4.

According to Leithe-Jasper the attribution to Donatello goes back to E. von Sacken's *Kunstwerke und Geräthe des Mittelalters und der Renaissance in der Kais. Kön. Ambreser Sammlung in Originalphotographien* (undated but Vienna, 1865). Fortnum, however, was not inclined to exaggerate his own discoveries; had the work been published when it was 'noticed' by him he would certainly have been told as much (since he must have had dealings with the curatorial staff in order to have a cast taken from it) and he was invariably scrupulous in recording such references. It is likely therefore that von Sacken took the attribution from Fortnum. His cast was made in the winter of 1865 and 1866 when Franchi was in Florence and Pisa making casts for the South Kensington Museum and Fortnum had a plaster of it made for presentation to that institution—the business is described in Fortnum's letter to Henry Cole of 10 January 1866 in the Victoria and Albert Museum. That Franchi was active in the making of electrotypes is clear from Fortnum's comment in his *Bronzes* of 1877, that 'electro deposit as carried out by Messrs Elkington and the late Signor Franchi' had been a 'singular success'. An idea of Franchi's talents as an original craftsman may be obtained from the casket he cast and chased to contain the memorandum of the Great Exhibition in 1871 (Victoria and Albert Museum 319-1872). His family firm were to become the principle rivals of Brucciani (see Nos. 450, 580, 581) as suppliers of academic plaster casts.

In 1867 Fortnum acquired in Florence a fine plaquette of the *Deposition* (B. 615 in his catalogue) which he believed to be 'by Riccio or the master himself' (i.e. Donatello), which is now regarded as by Riccio but inspired by Donatello's relief (in stone, but thought by Fortnum to be in terracotta) made 1446–50 for the altar of the Santo in Padua which must also be the starting-point of the relief in Vienna.

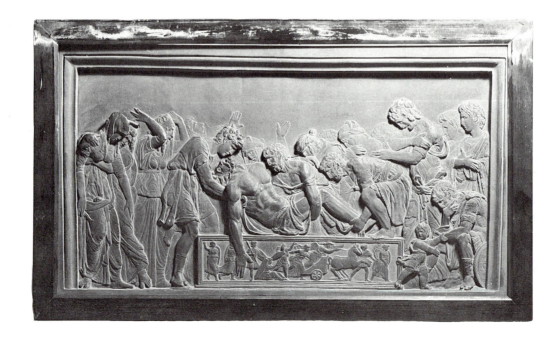

After Francesco (François) DUQUESNOY ('Il Fiammingo')
(1597–1643)

29. Sleeping child

13.7 cms. (length); 7 cms. (height)

Bronze with a brown patina with traces of black varnish and some verdigris. Hollow-cast. Open below.

Lent by C. D. E. Fortnum in October 1894 and bequeathed in 1899. Bought in Bologna in 1883 for 3 guineas. B. 450 in his large catalogue.

The figure is derived, as Fortnum supposed, from the models of sleeping putti attributed to Duquesnoy which already existed in large numbers in bronze and ivory by the end of the seventeenth century, not only in Italy but in France and the Low Countries. Neither in the modelling nor in the finishing is this example a work of a quality that would normally have attracted Fortnum.

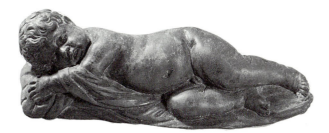

After Francesco (François) DUQUESNOY ('Il Fiammingo')
(1597–1643)

30 and 31. Pair of plaquettes decorated with revelling children

9.15 cms. (diameter of both plaquettes)

Copper, fire-gilt. The gilding has worn off in a few salient parts. The metal is very thin and has been modelled in repoussé. Most of the detail has been chased (as distinct from chiselled). There are some small traces of verdigris in the front of one, and in the back of both, plaquettes. There are small perforations around the head of the goat, by the chin of the boy being dragged by the goat, and by the cheek of the boy dragging it in one case (30), and between the legs of the child pretending to be a ghost and by the recumbent child's right shoulder and right armpit in the other (31). The plaquette with the goat (30) is endorsed in white paint 'B. / 684 / Œ', the one with the 'ghost' (31) with 'B. / 685 / Œ'.

Lent to the Museum by C. D. E. Fortnum on 14 September 1888 and given latter in the same year. B. 684 and B. 685 in his catalogues. No provenance is given in either catalogue, but they were presumably acquired after 1857 when the preliminary catalogue, in which they are not included, was compiled.

The relief of the revelling children with a goat derives from a composition invented by Duquesnoy. Bellori relates how this sculptor made a relief of divine love fighting profane love, and another relief, the same size, of a bacchanal of putti dragging by the horns and beating a goat and including one boy frightening some others with a mask. The wax model was copied in porphyry by Tomaso Fedele of Rome, 'Tomaso del porfido', who was celebrated for fashioning this notably hard material with precision and softness. Bellori notes that the *mezzo-rilievo* by Tomaso after Duquesnoy was given by Cardinal Francesco Barberini to King Philip IV of Spain. In fact the relief by Tomaso is after the first of these compositions, the *Sacred and Profane Love*, payments for which were made in 1631. A marble relief of the bacchanal in the Doria Pamphili Collection has been dated to about 1626 (C. Noehles, 'F. Duquesnoy: Un busto ignoto e la cronologia delle sue opere', *Arte antica e moderna* (1964), 90, 93–4, n. 25; for Bellori see G. P. Bellori, *Le vite de' pittori, scultori e architetti moderni*, ed. E. Borea (Turin, 1976), 289–90). A notable seventeenth-century version of the goat composition is the one in black marble in the Villa Borghese (no. 508, reproduced in M. Fransolet, 'François du Quesnoy', *Mémoires de l'Académie Royale de Belgique*, 2nd series 9 (1942)). But if the composition originated in this complex scene of twelve actors it was soon reduced to eight, as in the ivory in the Victoria and Albert Museum (no. 1061, companion with no. 1064, a group of the putti around a goat which is milked by a satyr), to six, as here, or to four, as in the fictive frieze below the portrait of a man with a view of St Peter's by Hendrik Frans Van Lint (*Copper, Slate and Marble* (Hazlitt Gooden and Fox, Oct. 1967), no. 30). The composition of the children playing at ghosts (or blind man's buff, as Fortnum supposed) was much repeated in the eighteenth century but is of uncertain origin: it might be

considered as a development of the theme initiated by
Duquesnoy with his putto holding a mask (itself a
development of an idea found on antique cameos).

Gilt bronze or copper plaquettes of this type are sometimes
found applied to luxury furniture in the eighteenth century.
Such might well have been the purpose for which these
examples were made. There is a pair of plaquettes of dancing
and fighting putti of similar size in the Hermitage (M. Lopato,
Western European Plaquettes ... the Hermitage Collection
(Leningrad, 1976), 63, no. 165, inv. 17551). The pretty
landscape setting in the Ashmolean's reliefs also suggests an
eighteenth-century date, but does not exclude a late
seventeenth-century one. Fortnum described the plaquettes
as 'carefully executed from designs by Clodion' in his
notebook catalogue but changed this to 'the style of Clodion'
in his large catalogue.

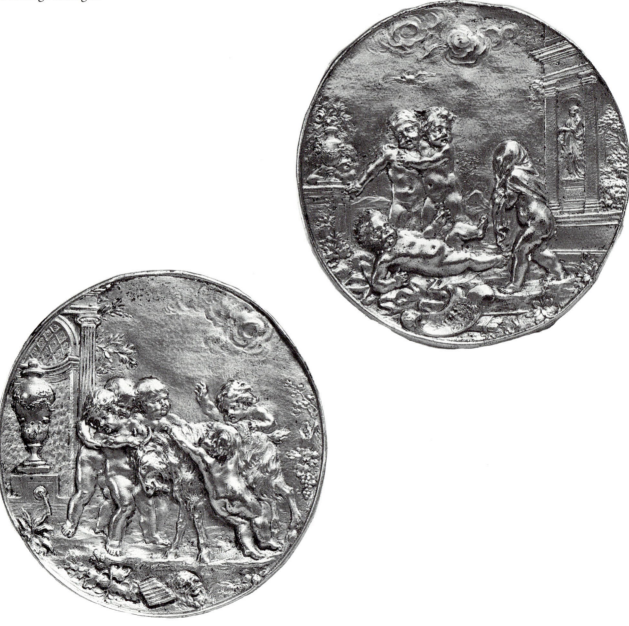

Pio FEDI (1816–92)

32. Pia de' Tolomei and Nello della Pietra (also known as *Il sospetto*)

90.2 cms. (height including integral plinth); 4 cms. (height of plinth); 35.2 cms. (diameter of plinth)

Carrara marble. 'PIO FEDI SCULTORE FIORENTINO' is chiselled behind the figures on the upper surface of the octagonal plinth with 'FECE NEL 1872' in smaller capitals on a separate line. On the front of the same plinth and also on the upper surface is chiselled in decorated letters 'RICORDITI · DI · ME' to left of his left shoe, 'CHE · SON · LA · PIA' to right, the capital 'R' and 'P' being larger and more decorated, and also on another line 'DANTE', to left of the shoe and 'PUR. c. V' to right. There are numerous chips and losses to the lower moulding and the hollow of the octagonal base especially beside the left foot of Nello. Projecting drapery at the back of the group has also been broken. The pommel of his sword hilt and the end of the scabbard are missing. There are holes, regular in shape and penetrating carved areas in a manner which makes it seem unlikely that they are flaws in the marble, possibly caused by a pointing machine—large ones are on the back on his tunic and on the back of her right arm, smaller ones on her right breast and shoulder and in the back of her dress.

When acquired, the marble was covered in a dirty yellow film with some black encrustation in the less conspicuous parts of the drapery and a few (test?) patches of clean and polished white marble. The sculpture had been filthy (but not apparently from exposure outside, since there was no evidence of frost damage) and cleaning had been attempted with an acidic solution, the surface thereby losing its original textures. Cleaning was continued in the conservation laboratories of the Ashmolean Museum's Department of Antiquities, by Kathleen Kimber under the direction of Mark Norman, with distilled water steam and some acetone. The holes, already mentioned, were filled and the surface was then slightly waxed.

Purchased for £2,676 (hammer price £2,400) at Sotheby's, London, 10 June 1988, lot 140, from the France Fund, with a contribution of £1,320 from the Museums and Galleries Commission's Regional Fund administered by the Victoria and Albert Museum. The group arrived in the Museum on 28 June, but was in the conservation studio throughout 1988 and 1989. Put on display in the Combe Room in December 1989.

The group illustrates the final lines (130–6) of the fifth Canto of Dante's *Purgatorio* (one of which is chiselled on the plinth):

'Deh, quando tu sarai tornato al mondo,
e riposato della lunga via,'
sequitò il terzo spirito al secondo,

'ricorditi di me, che son la Pia;
Siena mi fe', disfecemi Maremma:
salsi colui che innanellata, pria

disposando, m'avea con la sua gemma.'

Which may be translated:

The third spirit upon the second followed:
'Pray, when the living world you have regained,
And taken rest from this long road,

Remember me who was La Pia named.
Born in Siena: undone in the marshy land
Of Maremma. How is known to him who claimed

Me with a ring; who held me in his hand.'

Nineteenth-century commentators on Dante believed La Pia to be a lady of the Sienese family of Tolomei who married Nello d'Ighiramo, captain of the Tuscan Guelphs, and was put to death by him in 1295 at Castello della Pietra, in the Sienese Maremma, out of jealousy (unfounded, according to some). The manner of her death was said to have been confinement in a place where marsh air was fatal. Banchi in his commentary of 1886 proved that this identification was impossible. The subject was also treated by Domenico Trentanove in an imaginary bust portrait dated 1886 (Museo d'Arte Moderna, Palazzo Pitti, Florence) and by Dante Gabriel Rossetti in a finished drawing in a private collection and in a painting in the Spencer Art Gallery of the University of Kansas at Lawrence (1868). Whereas Rossetti showed the lady languishing in the Maremma, Pio Fedi represents her with her husband. The moment may be that at which suspicion steals into the husband's mind to the dismay of his innocent wife, or that at which intimations of his plans dawn upon her. Theodosia Trollope had no doubts:

The group represents the ill-fated lady, at the moment when her husband prepared to leave her all alone in the dreary old tower of the Maremma, which is yet pointed out as the scene of her piteous ending. Laying one arm around his shoulder, she bends forward and looks into his averted face with anxious foreboding, as though enquiring how soon he will return. He meanwhile gazes gloomily at the ground, wrapping himself in the blackness of his evil thought, and shrinking from the pleading eyes of his victim. He seems rather to be waiting for the sound of his horse's hoofs on the stones without, and chafing at its delay, than listening to her timid words of inquiry. ('Notes on the Most Recent Productions of Florentine Sculptors', Part III, *Art Journal* (1 July 1861), 210–11)

This group may come as a surprise to those whose acquaintance with Pio Fedi's sculpture has been confined to the more conspicuous public monuments by him in Florence—the once famous *Rape of Polyxena* (executed 1860–5 from an earlier plaster) which was erected by public subscription in the Loggia dei Lanzi, the statues of the sculptor Nicola Pisano and of the botanist and anatomist Andrea Cesalpino in the series of great Florentines filling the niches of the Uffizi (both commissioned in 1846), the monument to General Manfredo Fanti of 1872 in Piazza San Marco, or the *Liberty* on the monument to Niccolini of 1883 in Santa Croce. In its shallow relief and its costume accessories it reminds us of Fedi's training as a goldsmith and engraver. An interest in quattrocento sculpture found in the exquisite low relief of this group can also be seen in the figures on the base of the Fanti monument and he in fact created a number of sculptures of historical subjects involving virtuoso marble carving—for instance his *Beatrice Cenci at her Trial* or his infant Christopher Columbus seated half-nude on the shore among the sea shells earnestly launching a model boat (a group dated 1886)—and he was also interested in sweetly

ornamental gallery sculpture which represented mental disturbance, intriguing because inaccessible to us—as in his *Secret*, a group of a mother earnestly listening to a confidence whispered by her son, or his *Chrysalis* in which a young nude girl contemplates with perplexity a cocoon from which a butterfly is emerging, an emblem of her own puberty. Versions of these sculptures were numbers 89, 91, 224, and 225 in Fedi's atelier sale in Florence on 28, 30 April and 1 May 1894 (catalogue in French, sale 'sous la direction de Mr G. Sangiorgi'), where a version of this group 108 cms. high signed 'Pio Fedi scolpì' featured as no. 223 (illustrated) together with a twisted column pedestal of *verde di Prato* 103 cms. high. In addition there were two plaster casts (lots 97 and 194) and the first maquettes, also in plaster (lots 35 and 43), of the group.

The group of *La Pia and Nello* was originally made as a model in 1846 and commissioned as a full-size marble, to match Dupré's *Dante and Beatrice*, by the Grand Duke Leopold II in the same year (the contract was dated 17 November). Final payment was made on 31 May 1848 and at the end of that year or early in 1849 a repetition was commissioned. One of these two versions was placed in the grand ducal gardens at Poggio Imperiale. Neither has been traced. (*Cultura neoclassica e romantica nella Toscana granducale* (Palazzo Pitti, Florence, 1972), 75–6, no. 12, entry by Sandra Pinto.) Leopold II took special interest in the Maremma as a subject (the marshes were then being drained) and he also commissioned from Enrico Pallastrini (1817–76) a painting of Nello at the tomb of La Pia. He also took a special interest in Pio Fedi, paying for him to study in Rome earlier in the 1840s. The group remained immensely popular and Fedi made a number of replicas on a reduced scale. The earliest of these would seem to be that dated 1861, and exhibited in that year at the Esposizione Italiana di Firenze, which is now in the Galleria d'Arte Moderna, Palazzo Pitti (*Cultura neoclassica . . .*, op. cit.). All the later versions seem to have been bought by British visitors to Florence for whom the exquisite textures, miniature detail, medieval dress, and psychological drama were already familiar from the paintings of the Pre-Raphaelites. It is in fact tempting to propose that the lost original version of Fedi's group was an influence on Holman Hunt's *Claudio and Isabella* (completed 1850) and Munro's *Paolo and Francesca* (completed in plaster by 1851). Mrs Trollope when she visited Fedi's studio in Via Chiara (near that of Hiram Powers) noted that the group was 'being twice repeated on commission for London, the one for Mr Overend, the other for Mr N. Clayton' (op. cit.). She noted that there are not wanting distinguished art judges who rank this 'poetical little group' on a level with 'Signor Fedi's colossal Pyrrhus and Polyxena'.

The versions she mentions are likely to be identical with two sold in London in recent years—at Sotheby's, 6–7 November 1986, lot 307 bearing the inscription 'Pio Fedi Statuario di Firenze Sculpi 1862', and at Sotheby's, 18–21 March 1988, Lot 120 signed 'Sculptor. P. Fedi. Fior°', without a date. This latter version (purchased by Anthony Roth, then of Maddox Street), which is in exceptionally good condition, has a narrower original plinth than the others

(diameter 27 cms.) and also a separate octagonal base. It is also considerably smaller (67.6 cms. high including the 2 cms. high plinth). In these versions and the Ashmolean's the detailing is different: for instance, the rope by which her purse is suspended and the tassels hanging from it, the ornament on his sword belt, the patterns of the brocade. Careful variations such as this are impossible in routine studio reproductions, and the date of 1872 on the Ashmolean's version, not being the date of the first reduced version, is surely a further indication of its status as a special replica by Fedi himself the creation of which he felt to be worth documenting. It is noteworthy that in the Ashmolean version some symbolism is probably intended in the patterns of the brocade: there are dragons on his sleeves and putti play with birds in the panels of her dress. Similar versions and variants are recorded of Fedi's *La Fiorentina*, dated 1874, in the Walker Art Gallery, Liverpool, which seems to be the only other recorded statue by him in a public collection in Britain (see *Walker Art Gallery: Foreign Catalogue* (Liverpool, 1977), no. 4226, pp. 298–9).

Mrs Trollope noted that Fedi had tried to repeat the success of this group with another of Ippolito Buondelmonte with Dianora de' Bardi which was in course of execution in 1861.

Unknown Italian factory

After Giovanni Battista FOGGINI (1652–1725)

33. Bacchus and Ariadne

30.5 cms. (height); 23.3 cms. (length, from panther head beside thigh of Bacchus to the vase beside Ariadne); 22.7 cms. (length of integral base); 14.9 cms. (width of integral base)

Earthenware of a pinky cream colour (warmer in tone than its companion No. 34). The glaze is very slightly green where gathered, very slightly crazed in places, and worn and chipped in a few small areas. The left foot of Bacchus is broken off and the toes lost, two fingers of the left hand of Ariadne are broken off and lost, the left arm of Bacchus is broken at the shoulder and repaired with ugly discoloured adhesive apparent in the join and chipped edges to it, and a large chip is missing from the base, front proper right (this is the only recent damage). The group was cast in four parts: the base (which is hollow below); the two figures (hollow only in the thickest parts); and the urn (apparently hollow), all of which would have been assembled before firing. The leaves and grapes were also evidently separately modelled and dropped into place at this stage—many of these are chipped or have fallen off, which might be early damage.

Purchased from David Pickup Ltd. of 15 High Street, Burford, together with No. 34 for £1,250 on 5 March 1989 with a contribution of £625 from the Regional Fund administered by the Victoria and Albert Museum, the remainder coming from the Reginald Jones Bequest Fund. The groups were seen by Gerald Taylor in Late January 1989 and taken to the Museum on 30 January. Purchased by Mr Pickup at the sale of Hill Court, Herefordshire, in 1986.

This group, representing Bacchus introducing Ariadne to viticulture, seems to have been designed by Foggini as a bronze. Several casts are known in this medium: one is in the National Gallery of Art, Washington (exhibited *The Twilight of the Medici* (*Gli ultimi Medici*) (Detroit and Florence, 1974), no. 297); another is in the J. Paul Getty Museum, Malibu (83.SB.333); another is in the Musée Nissim de Camondo, Paris (no. 110); another in the Musée Jacquemart-André, Paris (n. 251—formerly Bardini Collection); and others are in private collections (see catalogue entry by J. Montagu in the catalogue of the exhibition just cited, in the unpaginated *addenda*). Most of these bronze groups are paired (or are known to have once been paired) with a group of *Venus and Cupid* also by Foggini.

The group was evidently also made in terracotta, and subsequently in porcelain by the Doccia factory, for a late eighteenth-century inventory of models includes a 'Gruppo di Arianna e Bacco. La detta Arianna in alto di premere l'uva in un vaso, di terra cotta con forma. Del Foggini.' The piece-mould survives in the factory's museum (K. Lankheit, *Die Modellsammlung der Porzellanmanufaktur Doccia* (Munich, 1982), 127, pl. 123). The porcelain version (as reconstructed from the surviving moulds) differed in no essential respects from the bronze except that the grapes are held less high by Bacchus and connect with the grapes in his hair which thus supplies an additional support. The Ashmolean's earthenware must be derived from a porcelain version. Much detail has been lost. There is no longer any pattern on the girdle passing between Ariadne's breasts and she no longer wears a bracelet. The vase beside her has no handle and she is given no grapes to squeeze into it. There is no vine branch on the ground between her and Bacchus. Her face is also turned slightly up. The modelling is also generally much cruder. For the factories where it could have been made see No. 34.

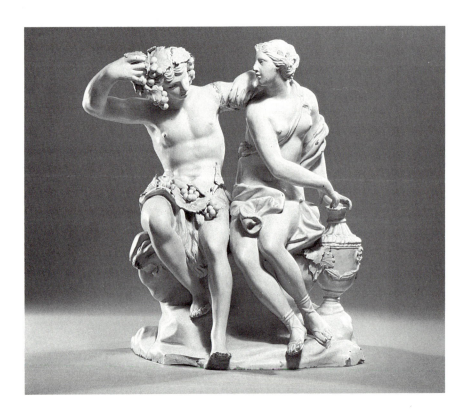

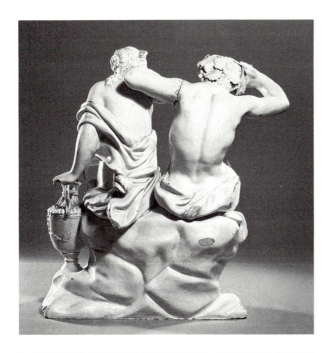

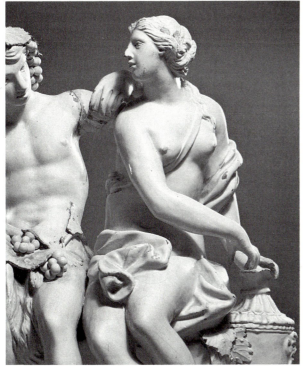

Unknown Italian foundry

After Giovanni Battista FOGGINI (1652–1725)

34. Hercules and Iole

31.15 cms. (height); 26.7 cms. (length, from Iole's right arm's stump to the right hand of Hercules); 22.7 cms. (length of integral base); 15.1 cms. (width of integral base)

Earthenware of a pinky cream colour. The glaze is slightly green where gathered, crazed in a few areas (e.g. on the left knee of Hercules), and either worn or chipped off in numerous areas (e.g. on the right thigh of Hercules). The left foot of Hercules has been broken and repaired, three of the fingers of his left hand have been broken and are lost, his nose and upper lip have been broken off and are lost, the thumb of Iole's left hand has been broken off and is lost, her right arm has been broken at the wrist, and the hand is lost. There is a large chip missing from the base, back proper left (this is the only recent damage). There is a hole in the base beside the right foot of Hercules to secure his club held by Iole (now missing). The group was cast in four parts; the base (which is hollow below); the two figures (hollow only in the thickest parts); and the club (presumably solid), all of which would have been assembled before firing.

See No. 33 for provenance.

This group representing Hercules infatuated with Iole, having surrendered his club and lion skin to her and taking up her distaff (as described by Boccaccio and Tasso, adapting the ancient tale of Hercules and Omphale), seems to have been designed by Foggini as a bronze and several casts are known in this medium: some were exhibited by his sons; one was catalogued as his work in Düsseldorf in 1751; examples are known in several private collections; and one is in the Victoria and Albert Museum (A. 9-1956)—for these see the entry for the latter version by J. Montagu in the catalogue of the exhibition *The Twilight of the Medici* (*Gli ultimi Medici*) (Detroit and Florence, 1974), 60–1, no. 24. There is also a terracotta version in the Birmingham City Museum and Art Gallery, in which the right leg of Iole is not crossed behind that of Hercules, which might be a variant on the composition by Foggini, but is more probably by a follower.

A wax model was recorded in a late eighteenth-century inventory of the Doccia factory 'Gruppo d'Ercole e Jole. Del Foggini in cera con forma'—and the piece-mould survives in the factory's museum (K. Lankheit, *Die Modellsammlung der Porzellanmanufaktur Doccia* (Munich, 1982), 122). It was no doubt a version in porcelain which served as the model for this and other versions in earthenware. These differ from the bronze in that here the arm of Hercules is placed on his hip rather than being raised. The lion skin in the earthenware version also falls over Iole's shoulder, the drapery folds between the legs of Hercules are less deeply undercut, and there is no plant on the rock-work base.

A version of this group is illustrated by Giuseppe Morazzoni in his *La terraglia italiana* (Milan, n.d. [?1956], pl. 119), paired, as this is, with one of *Bacchus and Ariadne*, both in the collection of Cav. Eugenio Imbert in Milan (perhaps the pair today displayed in the Castello Sforzesco, Milan). Another

version of the *Bacchus and Ariadne* in the same collection and also illustrated (pl. 116) seems to have been a companion with a *Pan and Syrinx* after the famous antique group (see F. Haskell and N. Penny, *Taste and the Antique* (London and New Haven, Conn., 1981), 286–8). Both the *Hercules and Iole* and two *Bacchus and Ariadne* groups illustrated in Morazzoni are certainly from the same factory as the Ashmolean's groups. This is identified by Morazzoni as the Manifattura Aldrovrandi in Bologna and the models are even attributed to Giacomo Rossi who is known to have managed the factory. No reasons are given, but tradition (which is presumably the basis for the attribution) must be treated with respect.

Count Filippo Aldrovandi-Marescotti opened the factory in 1794 in his palace in Contrada Galliera, Bologna: it was in full operation by 1798. The aim was to compete with English creamware which was being so successfully exported to Italy and the body consisted of 'terra di Vicenza bianchissima' together with pure white marble dust from Carrara and the glaze was made with 'litargirio d'Inghilterra', Italian flint, and sea salt (Morazzoni, op. cit. 109–15). The earthenware body of these groups is pale but is less fine than creamware.

There are many other factories in Italy at which these figures might have been produced—the Este factory from 1779 under the ownership of Girolamo Franchini (1728–1808) has been regarded as a likely place of origin—so too has the Ferniani factory at Faenza. A version of the group of *Hercules and Iole* was certainly made at Faenza but in a more careful model with numerous variations (the right leg of Hercules is drawn in, his left arm raised—as in the bronzes—Iole's head is differently inclined, a lion's paw is tied across her breasts) and as a companion group with an entirely different interpretation of *Bacchus and Ariadne*. (The examples of these groups in the Villa Case Grandi in Faenza come from the factory's own collection—see the catalogue of the exhibition *L'età neoclassica a Faenza* (Palazzo Milzetti, Faenza, 1979), 242, nos. 533–4, pl. 398.) On the other hand examples of the Ashmolean groups also survive in Faenza's Museo Internazionale delle Ceramiche (inv. nos. 9859 and 9860—ibid. 243, nos. 538–9, unillustrated). Several large groups, one of a couple at an altar, another of Pan making unwelcome advances to a girl, and a third of *Cupid and Psyche* included in the Cini gift displayed (without labels) in Palazzo dei Conservatori in Rome are very similar in modelling and colour and character of glaze to the Ashmolean groups and must be from the same factory.

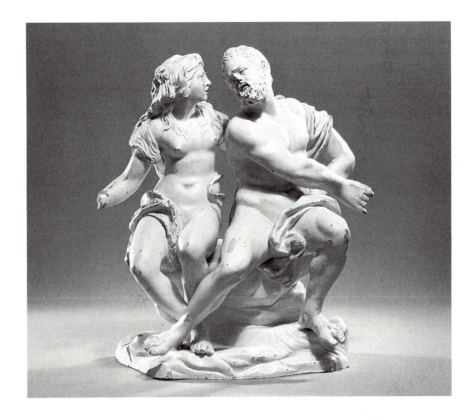

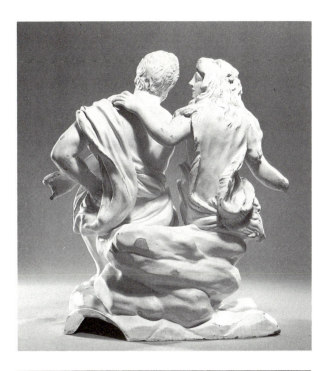

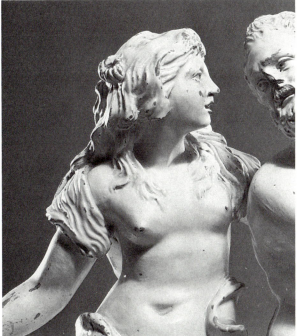

Unknown founder

Perhaps after Giovanni Battista FOGGINI (1652–1725)

35. Group of furniture mounts: four scroll feet, four tendril volutes, and five plants

> 8.3 cms. (height of each foot); 16 cms. (length of each foot); 35.5 cms. (length of each tendril); 4.4 cms. (height of the largest, central plant); 19.8 cms. (length of the largest, central plant)

Bronze, fire-gilt. Each ornament is solid cast. All are partially textured with a punch. Two of the plants retain hand-wrought irregular-headed gilded nails.

The mounts are attached to the 'Fitzwilliam Coin Cabinet'. Purchased for the Heberden Coin Room from 'The Highly Important Collection of Roman Brass Coins and Medallions originally formed in the mid-eighteenth century' and sold by order of 'The Earl Fitzwilliam's Wentworth Estates Company' by Christie's at Spencer House 30 and 31 May 1949 in which it was the final lot, 501. According to tradition in the Coin Room the cabinet was purchased by the Keeper without previous plans, but copies of the catalogue mark it down to 'Spink' for £50. Whether the Keeper asked Spink's to bid shortly before the lot was auctioned, or bought it immediately afterwards from Spink's, is not clear. The cabinet of ebony with *pietra dura* pictures, friezes, and columns is presumed to have been acquired by the 2nd marquis of Rockingham (1730–82) when he was still Lord Malton, perhaps when in Florence on the Grand Tour between his arrival there in early January 1748/9 and his departure for Siena in May 1749, or upon his return there around 1 September 1749, but cabinets of this type, a speciality of the grand ducal workshops in Florence, had been popular with British visitors to Italy for over a century.

The cabinet was not originally designed for coins and the substructure in ebonized wood decorated with ivory medallions (see Nos. 159–61) must have been added in the third quarter of the eighteenth century when it was converted for this purpose. The ormolu *Venus* on top (see No. 40) is also an addition but of what date is less certain. The cabinet if purchased by Rockingham may not have been acquired with conversion in mind. Although his passion for collecting coins was well established by 26 April 1750 when he wrote to his father from Rome that he had not been able to resist the 'temptation' of purchasing 'medalls', he is unlikely to have been bothered by storage problems at that moment. He continued to collect avidly long after he returned, boasting in 1774 that his 'collection of Great Brass is indeed acknowledged to be the finest in Europe in regard to the great number of rare heads and reverses, and also in regard to the high preservation they are in. I keep constantly upon the watch to pick up what I can in England, and having now been a collector for near 28 years and having always found great pleasure in the pursuit, I shall constantly continue it' (R. J. Hopper, 'The Second Marquis of Rockingham, Coin Collector', *Antiquaries Journal*, 62/2 (1982), 322).

This was not the only example of Florentine *pietra dura* work, nor the only elaborate cabinet, in Rockingham's possession. A 'curious cabinet' of tortoiseshell, ivory, and

ebony is the work of art which receives most attention in the 'Description of Wentworth House' published in the *Universal Magazine* for October 1770 (169–70). In the inventory of 'Household Goods, Plate, Pictures' etc. made after Rockingham's death we find two entries which might correspond with the Ashmolean's cabinet: a 'Cabinet Curiously inlaid with different kinds of Stones and Ornamented with Glass Columns & containing 10 Drawers, upon a black frame' in the Green Drawing Room at Wentworth Woodhouse (p. 13ʳ, this part of the inventory dated 16 September 1782) and a 'Black Ebony Cabinet Beautifully inlaid with Marbles etc.' in a ground floor room of the family's house in Grosvenor Square, London (p. 51ᵛ, this part dated 28 August 1782). An 'Italian casket with domed lifting top exterior decorated in pietra dure [*sic*] mosaic with sprays of fruit held by ribands on black marble and ebonised ground with ormolu corner mounts and borders chased with masks and foliage' was lot 27 in the sale at Christie's, London, on 15 July 1948 of 'Etruscan and Greek Vases and Fine English Furniture' from Wentworth Woodhouse. An 'Important Early 18th Century Italian Ebony Cabinet and stand . . . elaborately inlaid in lapis lazuli scaglia [*sic*] and coloured marbles with exotic birds and sprays of flowers and fruit' was lot 293 in the sale of a 'large portion of the contents of Wentworth Woodhouse' conducted at the house, 4–9 July 1949, by H. Spencer and Sons of Retford, Worksop, and Sheffield.

Some of the ormolu mounts on the coin cabinet—the four scroll and shell feet, the four tendril volutes, and the five loosely arranged plants on the cornice—are likely to be original, although it is hard to be sure since they have all been refixed. There are also some very inferior ornaments in mastic and wood such as the leaves above the keyhole escutcheon, and the drop below it. The keyhole escutcheon itself, which is the most remarkable of the ormolu mounts, is catalogued separately (No. 63). It may always have been fitted to this cabinet but it looks as if it might originally have been designed for another, earlier piece. The scrolled feet are very close in character to those on an ebony and *pietra dura* casket in a private collection which have been attributed to Foggini and, if enlarged, would be similar to those on the celebrated ebony and *pietra dura* prie-dieu in Palazzo Pitti which was made by A. Suster, G. A. Torricelli, and P. Molti to Foggini's designs in 1706 (A. González-Palacios, *Il tempio del gusto* (*La Toscana e l'Italia settentrionale*), 2 vols. (Milan, 1986), i. 43–4, 51, ii, pls. 88 and 135). The bronze tendrils are very similar to those projected in about 1705 for the urn of S. Maria Maddalena de' Pazzi in a drawing made by Foggini now in the Metropolitan Museum, New York, and they may also be related to some of the ornaments on a sumptuous *pietra dura* table presented to the king of Denmark in 1709, now in Rosenberg Castle, Copenhagen (ibid. i, pl. xii, ii, pl. 124). Whereas it could be argued that the feet are merely in the style of the late seventeenth century in Italy, tendrils of this sort seem to be an original invention of Foggini's.

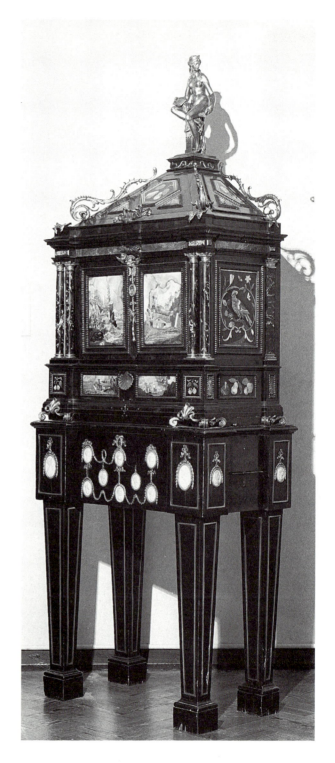

Antonio GAI (1686–1769)

36. Angel supporting a horn-shaped candle-holder

52.8 cms. (height including base); 2.1 cms. (height of base);
13.5 cms. (diameter of base)

Bronze with oil gilding, extensively worn to reveal a slightly olive tan coloured natural patina. There is evidence of extensive chiselling. The figure is hollow, and presumably a lost-wax cast. The wings are solid cast and riveted to the back—solder now reinforces a join which must originally have been neater. The chiselling of the feathers passes over the join. The upper portion of the horn has been cast separately and soldered. There is a hole between the wings in the figure's back. 'A⁰ GAI 1749' is chiselled with angular strokes on the side of the integral base behind the figure at proper left: the cross bar of the 'A' is in the form of a 'v' and the top of the '9' is squared. This is preceded by a diagrammatic chalice, also chiselled.

Purchased in late January 1960 from Herbert N. Bier of 2 Strathearn Place, Hyde Park Square, London W2, for £900, from the France Fund with the assistance of a grant from the National Art-Collections Fund. Registered 15 December 1960. 'In recent times' it had belonged to 'an American Collector'.

The angel must have been companion to another in a complementary pose, as Parker noted when publishing the bronze in the *Annual Report* for 1960 (p. 65); indeed it probably belonged originally to a set of four, not least because it is very similar in character to the four standing angels (over 4 ft high) also with horn-shaped candle-holders which Tiziano Aspetti was commissioned to make in the autumn of 1593 by the Congregazione dell'Arca for the altar of St Anthony, in S. Antonio, Padua (see A. Sartori, *Documenti per la storia dell'arte a Padova* (Vicenza, 1976), 11–12). Gai may well have been asked to take these famous angels as his models: if so he was not averse to imitating details as well as the general appearance of Aspetti's work: the belts and drapery borders of Aspetti's angels, and of the four Virtues he created for the altar rail of the same church, reappear in Gai's work.

What must be either *the* companion or, more probably, one of three companions for the Ashmolean's angel was exhibited at the Heim Gallery, September 1984 (as no. 31), and belongs to the London art dealer Daniel Katz. It has a black varnish much worn to expose a brassy metal like that of the Ashmolean's bronze, with traces of gilding, and the name, date, and device chiselled in the same style on the side of the base. Since the right foot of Mr Katz's angel is advanced and his head turned to his left he must have been placed on the other side of the altar to the Ashmolean's angel, but since his hands are joined in prayer it seems likely that he was matched by another in an equivalent attitude. Beside Mr Katz's angel there was perhaps one with his left hand to the breast in adoration, more or less a mirror image of the Ashmolean's.

The workmanship and material of these angels by Gai is characteristic of other Venetian eighteenth-century bronzes; the same brassy colour and extensive chiselling is found, for example, in similarly sized figures by Francesco Bertos (active 1693–1734) of *SS Francis Xavier* and *Ignatius of Loyola*—

lot 118 at Christie's, London, 3 July 1985. Gai, who was (according to Tomaso Temanza, *Zibaldon*, ed. N. Ivanoff [Civiltà veneziana: Fonti e testi, 6, 1st series 3] (n.d., [1963]), 29) apprenticed to a wood carver, is recorded as executing numerous works in wood, stone, and marble all over the Veneto (see the list compiled by Camillo Semenzato in *La scultura veneta del seicento e del settecento* (Venice, 1966), 131–2), but only one commission for a bronze is documented. This was for the gates of the Loggetta of the Campanile of Piazza San Marco in Venice upon which we read 'ANT. GAI ET FILII. VEN. INV. FUS. & CAELAR. MDCCXXXIV.', which is an unusually explicit statement of total responsibility for modelling, casting, and tooling. There can be little doubt that Gai (or his sons Francesco and Giovanni) had considerable experience in this medium; he could not otherwise have been awarded such an important commission. And yet the two altar angels described above are the only other two works in bronze that can be associated with him.

These angels may (as suggested above) have been commissioned as small variants on Aspetti's, and the gates of the Loggetta obviously had to be in a style congruous with the sculpture and architecture of Sansovino, but Gai was in any case inclined to revive a sixteenth-century style in reaction to the followers of Bernini. He consistently avoided bustling drapery, deep shadows, broken outlines, and dynamic torsion in his figures. In this conservatism Gai was doubtless encouraged by the most important arbiter of taste then resident in Venice, Consul Smith, whose patronage he enjoyed and who was responsible for sending some of his works to Britain—'Atalanta', 'Meleagro', and 'Senatori antichi' are cited in a contemporary source (Temanza, op. cit. 31).

A *Meleager* in marble, 143 cms. high, and dated 1735, was sold at Sotheby's, London, 22 April 1986, lot 48 (the vendor was anonymous, but the sculpture was included in a photograph of private rooms at Castle Howard published in the *World of Interiors* magazine). This figure is very close to the Ashmolean's angel especially in the flattened and straight-lined folds of drapery but also in the manner in which the figure's left hand is caught in the drapery and the foot projects beyond the circular base. The Swedish diplomat and collector Nicholas Tessin noted that no sculptor in Italy was more highly esteemed than 'le grand Gai', this 'demi Michel-Ange', 'si fort gâté par les Anglais qu'il demande et obtient 80 seguins pour la moindre petite Statue' (O. Sirén, *Dessins et tableaux de la Renaissance italienne dans les collections de Suède* (Stockholm, 1902), 109). A much damaged statue by Gai, rescued from an English country house park, survives in a private garden in Oxford.

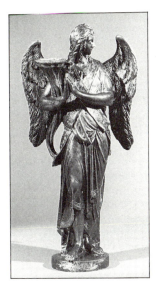

Antonio Gai
*Angel supporting
a horn-shaped
candle-holder*
Daniel Katz, London

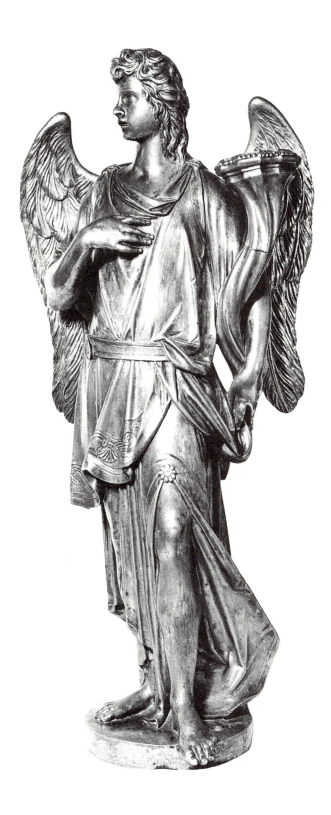

Possibly by Gaetano GANDOLFI (1734–1802)

37. Fortitude

43.4 cms. (height); 27.5 cms. (length)

Terracotta of a pale beige colour. There are traces of some dark colour on the ground and many traces of gilding, for instance on the figure's right breast, on the lion's right ear, and in the follicles above his upper lip. There are also traces of gesso, most obvious under the figure's right forearm, which was presumably a preparation for the gilding. Several of the straps over the biceps of the figure's left arm are missing and there has been a small loss to the lion's right ear. The group was modelled in two parts and joined before firing, doubtless in order to facilitate the hollowing of the clay. The base, lion, and draped legs were modelled together with the figure's left hand and a portion of drapery. The join across the figure's right wrist and the drapery in her left hand is apparent and there is a small aperture where the belly meets the front fold of drapery.

The group is first mentioned in a letter of 7 March 1960 from the dealer David Carritt to Sir Karl Parker: 'I have just bought something which would amuse you very much: a terracotta group representing Bologna as a lady sitting on a lion, the work of Gaetano Gandolfi. I shall send you some photographs.' A letter enclosing these and giving the price of £275 was dated two days later. The sculpture was bought with the assistance of the Regional Fund administered by the Victoria and Albert Museum and registered on 4 June 1960.

The terracotta is likely to be a *modello* for a larger sculpture in stucco or marble which has not been identified (it may never have been executed or may have been destroyed). It is designed to be seen from several points of view and is compelling but somewhat simplified from behind which suggests a position on the canted podium at the corner of a free-standing, or a boldly projecting, monument.

The sculpture was attributed to Ubaldo Gandolfi by K. T. Parker in the *Annual Report* (1960: 66) 'both on stylistic and circumstantial evidence'. The 'circumstantial evidence' would appear from a note in the Register to have been the dealer's claim that it was acquired from a descendant of Gandolfi in Bologna—presumably there was a tradition that it had been made by a member of the family. No details of this transaction, of the family's history, or of their heirlooms generally are given in the correspondence with David Carritt, whose nose for concealed treasures and deftness at extracting them, was, however, proverbial and who is unlikely to have invented the story. Both Ubaldo (1728–81) and Gaetano (1734–1802) Gandolfi, leading painters and engravers in Bologna in the second half of the eighteenth century, are known to have made clay models as part of the preparation of their paintings. Gaetano is documented as the author of the competition reliefs in terracotta which survive in the Accademia Clementina in Bologna. There is no proof that he was given sculptural commissions later in his career but various terracottas have been attributed to him, including the remarkable polychrome *Lamentation* group in the sanctuary of the Madonna di S. Luca in Bologna of the 1780s. Ubaldo is documented as having designed the large statue of *Diana* in the garden of Casa Savioli in 1773 (also partially executed by him but with much assistance from Giovanni Lipparini)

and as having modelled in 1780 the imposing stucco figures of *Isaiah* and *Jeremiah* for the new church of S. Giuliano in Bologna. (R. Roli, 'Aggiunte e precisazioni sui Gandolfi plasticatori', *Il Carobbio* (1976); E. Riccòmini, *Vaghezza e furore: La scultura del settecento in Emilia e Romagna* (Bologna, 1977), 123–4). Ubaldo's declamatory stucco prophets (Riccòmini, op. cit., 201–2) differ greatly in style from the Ashmolean terracotta. Gaetano's documented reliefs are closer, although they present no obvious similarities, and, if we accept the 'circumstantial' evidence pointing to authorship by one of them, then Gaetano (Carritt's candidate) must be preferred to Ubaldo. If all that was known of the Ashmolean terracotta was that it came from Emilia-Romagna one would perhaps be inclined to attribute it to Antonio Trentanove (b. *c*.1740, d. 1812) in whose work one can find the same broad heavy drapery treated with an easy fluency. The lion which he modelled for his *St Mark* in S. Lucia, Forlì, also has the same comic face as the one here (Riccòmini, op. cit., pl. 119).

A sample was taken by Mrs Doreen Stoneham of the Oxford Research Laboratory for Archaeology and the History of Art in March 1987 and thermo-luminiscence tests suggested that it had been fired between 1727 and 1827 (ref. 381-z-94).

Vincenzo GEMITO (1852–1929)

38. Emperor Charles V

22 cms. (height including socle); 5.5 cms. (height of socle); 5.8 cms. (length and width of plinth of socle)

Bronze with a dark chestnut brown patina worn to a paler brown in some salient or smooth areas. Hollow, lost-wax, cast. Traces of plaster core (and animal hair bonding) in interior, and a line of flashing inside the neck. The turned portion of the socle with its plinth are separately cast and soldered to the projection below the chest. '500' is chiselled in the interior of the socle. 'OPRIETÀ ARTISTICA' (for 'Proprietà artistica') is incised in the model across the side of the plinth of the socle at the back and 'GEMITO' is incised in the model on the back of the projection below the chest. A minute foundry stamp in the metal to the edge of the chest to proper left: 'FONDERIA / GEMITO / NAPOLI' has slipped to read 'FOND / GEMERIA / NAPITO / . . .l'

Purchased on 6 October 1987 from Anthony Roth Fine Arts Ltd, 49 Maddox Street, London, for £6,000, with the fund established by Dame Helen Gardner.

A life-size full-length statue of the Emperor Charles V was commissioned from Gemito by King Umberto I in 1886 for the façade of the Palazzo Reale in Naples as one of a series of eight statues of the city's illustrious rulers (or at least eminent viceroys). The commission, together with another for a silver centrepiece, precipitated a mental collapse in the artist who was admitted in 1887 to an asylum from which he immediately fled. The statue had to be completed by another sculptor using Gemito's design. Gemito's original wax model for the statue is in the Galleria d'Arte Moderna, Milan (L. Caramel and C. Pirovano, *Galleria d'Arte Moderna: Opera dell'ottocento F.-M.* (Milan, 1975), no. 1032, pl. 1030). This bronze may be an abbreviation of such a preliminary sketch. In any case it is possibly identical with the 'esquisse de Charles V', a bronze exhibited by Gemito at the Exposition Universelle of 1900 in Paris where his lost-wax casts, of which this is a superlative example, had been enormously admired since the success of his *Neopolitan Fisherboy* at the Salon of 1878 and his portrait of Meissonier completed in 1879. Gemito had established his own foundry by 1883—'geloso di Cellini', as he informed Meissonier (S. di Giacomo, *La vita e l'opera di Vincenzo Gemito* (Naples, 1905), 121)—but how active this was, and indeed how active Gemito was, during the period of about twenty years after he fled from the asylum and became a recluse is not clear, nor are the exact degree and duration of his mental illness (see the admirable review of the conflicting evidence by P. Fusco in 'Medusa as a Muse for Vincenzo Gemito (1852–1929)', *J. Paul Getty Museum Journal*, 16 (1988), 127–8 n. 6). We have no record of other casts of this bust, but it is unlikely to be unique. A bronze statuette of the whole length figure is in the Museo di Capodimonte, Naples (IC 4110).

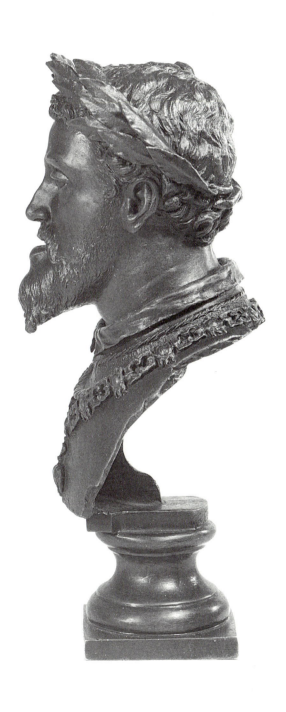

Unknown foundry

After Giovanni Bologna (GIAMBOLOGNA) (1529–1608)

39. Woman at the bath

33.2 cms. (height including integral base)

Bronze with a natural patina of olive green and pale tan with vestiges of blackened varnish. A few traces of plaster in the hollows. The interior blocked with wax. No obvious evidence of tooling. 'B.420 ⊕' is painted in white on upper surface of base behind the foot.

Lent by C. D. E. Fortnum in October 1894 and bequeathed by him in 1899. B. 420 in his catalogues. For the circumstances of its display when in his collection see Nos. 112–15. It was then placed upon a shaft of green fossil marble for which see the bust of Henri IV (No. 299). Purchased in Rome 'about 1853' according to both the large, and the notebook, catalogues, but 'bt. Rome 1851' according to the preliminary catalogue compiled in 1856 (38), and possibly identical with the 'Venus XVc' purchased by him before 1851, together with a *Spinario* and the miniature version of Michelangelo's *Pietà* (No. 60), according to his manuscript 'memoranda of prices paid'.

Fortnum described this a few years after he had purchased it as 'Venus stepping from a Bath after the marble in the Villa Ludovisi known as the Venus of M. angelo' (preliminary notebook catalogue, 38), but he considered that it was 'in the style of Giovanni da Bologna'. A bronze statuette (24.8 cms. high) of this same figure with the artist's name, 'IOANNES BOLOGNA · BELGA', chiselled on its base, in the Kunsthistorisches Museum, Vienna (no. 5874), has been plausibly, but not certainly, identified as the *Venus* by Giambologna presented to the Emperor Maximilian II by the Grand Duke Cosimo I de' Medici in 1565. If so, however, he returned to the theme when he carved the nearly life-size marble now in the American Embassy in Rome (the *Ludovisi Venus* to which Fortnum alludes) for Giovanni Giorgio Cesarini in 1583 (C. Avery, *Giambologna* (Oxford, 1987), 107, pl. 101). There are numerous bronze versions of this figure, all of them larger in size than the signed one in Vienna, but differing only in minor details—the treatment of the fringe of the drapery by the feet and of the coiled hair, for instance. Many of these are very close to the version in the Ashmolean Museum, not only in size and details, but in finish (there being little evidence of tooling in the metal, as Fortnum observed). Some were being made in Florence by the early seventeenth century and one was among the group of statuettes presented in 1611 by the Grand Duke Cosimo II de' Medici to Henry, prince of Wales (K. Watson and C. Avery, 'Medici and Stuart: A Grand Ducal Gift of "Giovanni Bologna" Bronzes for Henry Prince of Wales (1612)', *Burlington Magazine*, 115 (1973), 493–512). It was described in the inventories of King Charles I as 'a stoopeing standing woeman upon one leg . . . her left hand on her left nipple' (ibid. 506).

A list of bronzes of this type is given by William Wixom in his *Renaissance Bronzes from Ohio Collections* (Cleveland Museum of Art, Cleveland, Ohio, 1975), under no. 148. This list, however, includes variants in which the drapery consists

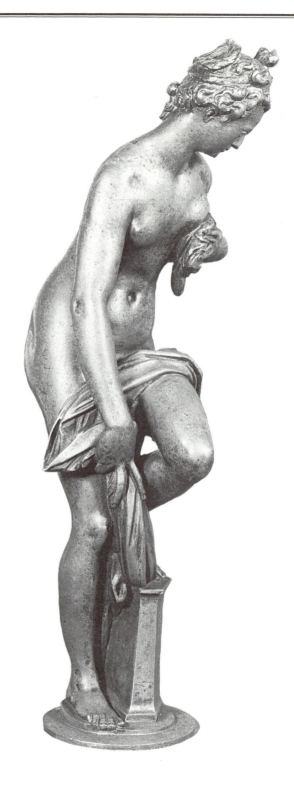

of one continuous piece of cloth. There are fine versions of this variant, among them that on loan to Cleveland Museum from the Bishop family (ibid., no. 148), as well as very poor nineteenth-century sand-casts (see for example the example in the reserve collection of the Fogg Museum, Cambridge, Mass., 1937-13). It cannot be proved that this variant was invented by Giambologna. It relates to another figure of a nude woman at the bath attributed to him, which is known in statuettes of a smaller size, among them another in Ohio (ibid., no. 149) and the gilt bronze in the Herzog Anton Ulrich-Museum, Brunswick, which was one of the most exquisite objects in the Giambologna exhibition of 1978 (C. Avery and A. Radcliffe (eds.), *Giambologna, 1529–1608: Sculptor to the Medici* (Victoria and Albert Museum, London, 1978), 64, no. 5). In this latter variant the goddess's left foot is also on a step and a length of drapery is raised to her left breast in her left hand, but her right arm is drawn across her body and her head is turned to her right shoulder. This pose would seem to derive from the sculptor's group of *Florence Victorious over Pisa* (of 1565–70) but with the female nude reversed and deprived of an abject enemy. Its complex, continuously winding rhythm has an irresistible appeal, but as narrative the other versions are more enticing—providing a glimpse of beauty, intimately occupied, unconscious of our admiration. Narrative is reintroduced into the sinuous variant, however, by the addition of an infant whose squalling supplies the pretext for her turned head (as in the bronze in the Bayerisches Nationalmuseum, Munich—Avery and Radcliffe, op. cit. 66, no. 9).

It is clear that elegant variations on these bronze statuettes were being devised by other sculptors within Giambologna's own lifetime, among them the 'L.P.' whose initials appear, with the date 1579, on the exquisite boxwood statuette in the Museum für Kunsthandwerk, Frankfurt on Main (St. 12, Oskar und Ilse Mulert-Stiftung). A reduced variant with continuous drapery was modified to form a companion for an equally free variant on the antique *Callipygian Venus* (see *Die Bronzen der fürstlichen Sammlung Liechtenstein* (Liebieghaus, Frankfurt on Main, 1987), 166–7, nos. 10 and 11).

Among versions close to the bronze in the Ashmolean Museum are the following: Wallace Collection, London (S. 110), Nelson-Atkins Museum, Kansas City, Missouri (31-54—not listed by Wixom), Poldi Pezzoli Museum, Milan (Piccolo Museo Mario e Fosca Crespi, FC. 24/68), Fairhaven Collection, The National Trust, Anglesey Abbey, Cambridgeshire (Avery and Radcliffe, op. cit. 63, no. 2, not listed by Wixom), Menil Foundation, Houston, Texas (ibid. 63, no. 3, listed by Wixom as with Michael Hall Fine Art Inc.), Berlin-Dahlem, Staatliche Museum, inv. 1966 (W. Bode, *Bildwerke des Kaiser-Friedrick Museums*, ii: *Bronzestatuetten, Busten und Gebrauchsgegenstände* (Berlin and Leipzig, 1930), no. 156, pl. 50). But there are minute variations in the treatment both of the hair and of the base.

Unknown foundry, unknown modeller

After Giovanni Bologna (GIAMBOLOGNA) (1529–1608)

40. Venus at the bath

35.1 cms. (height from plate attached to plinth); 0.1 cms. (height of plate attached to plinth); 0.8 cms. (height of plinth); 6.2 cms. (length of projecting attachment)

Bronze, fire-gilt. The gilding is worn in parts to reveal a natural dark brown patina. Minute traces of a ruddy varnish remain in the figure's right armpit, on her left calf, and on parts of the drapery. There is some verdigris in hollows of drapery. Hollow cast, in parts. There are joins on the upper part of the figure's right arm, on her right thigh, and below the knee of her left leg. There are patches above and below the join on the arm, on the figure's shoulder. The back is extensively patched. There is a firing crack in her left foot. The original plinth of the figure is extended to proper right by means of a separate piece of bronze—both are attached to a plate of bronze below. Screws in the back of the pedestal fix it to a block of metal, the projection of which, beneath the hollow base, is cased in wood.

The bronze is attached to the Fitzwilliam Coin Cabinet (purchased 1949) for which see No. 35.

The *Venus* is derived from one of Giambologna's most popular inventions, his *Architecture*, also known as *Geometry*. The life-size marble version of *Architecture* formerly in the Boboli Gardens is in the Bargello in Florence (C. Avery, *Giambologna* (Oxford, 1987), 100–4, pls. 95–6b). Of the bronze statuettes the finest is the signed version in the Museum of Fine Arts, Boston (40.23; see C. Avery and A. Radcliffe (eds.), *Giambologna, 1529–1608: Sculptor to the Medici* (Victoria and Albert Museum, London, 1978), 72, no. 17) and one in the Louvre which may well be the one described in the seventeenth century (when in Girardon's collection) as 'fait par Messer Jean Boulogne et reparé de Soucine'—'Soucine' being Antonio Susini (ibid.). Most casts of the figure appear to have been made from a slightly defective model, with a part of the set square, for instance, missing. Lists of versions are given by E. Dhanens, *Jean Boulogne* (Brussels, 1956), 165 n. 2, and W. Wixom, *Renaissance Bronzes from Ohio Collections* (Cleveland Museum of Art, Cleveland, Ohio, 1975), no. 150. The Ashmolean's *Venus*, however, which has not been previously discussed in the literature on the sculptor, departs deliberately from its prototype. A large comb replaces the set square, protractor, and dividers in the right hand, and, instead of the drawing board supported behind the figure with her left arm, this figure has been given a shell. To accord with the theme of bath and toilet the hair, instead of being tied up in elaborate knots above the diadem, is gathered in a looser bun behind and falls freely over the shoulder. The necklaces are omitted and there are variations in the drapery, no longer intended for a smock, which falls over the figure's seat.

The bronze was perhaps acquired, together with the *pietra dura* cabinet it crowns, in Florence, by Lord Malton (later 2nd marquis of Rockingham) in the late 1740s, but it would seem, from the improvised character of its base fixture, to

have been adapted to serve this purpose. It may well have been gilded or at least regilded at the same time. There seems no good reason for a bathing Venus to preside over a collection of coins, but it is unlikely that Rockingham originally intended his cabinet to serve this purpose. If the bronze was acquired separately by Rockingham it might be the bronze *Venus* costing 8 guineas which was sent to him by Richard Hayward, the sculptor and dealer, on 22 April 1773 (and paid for 28 June)—no. 40 among the 'Vouchers for Works of Art', Wentworth Woodhouse Muniments, Sheffield City Library.

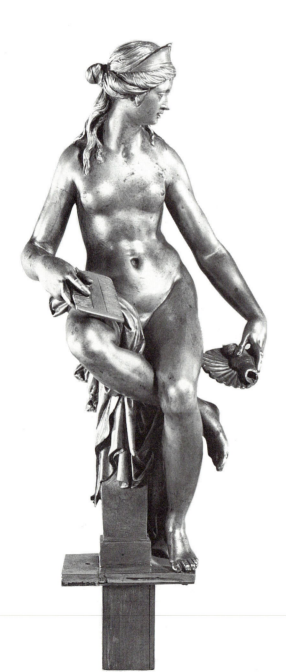

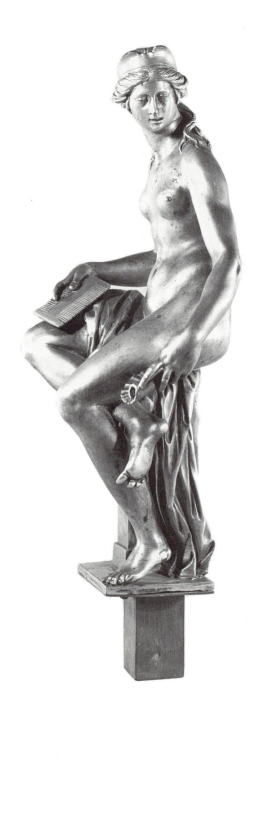

Unknown foundry (perhaps French early nineteenth century)

After Giovanni Bologna (GIAMBOLOGNA) (1529–1608)

41. Hercules and the Erymanthian Boar

45 cms. (height to boar's back left trotter); 43.7 cms. (height to boar's front right trotter); 10.2 cms. (height of plinth); 24.2 cms. (length of plinth); 20.2 cms. (width of plinth)

Bronze with a deep russet-gold varnish largely blackened, partially worn and scratched to reveal a natural pale tan patina. Hollow, probably lost-wax, cast. There is much tooling: in particular, the club is covered with punched marks in an undulating pattern. The figure is bolted to a mahogany plinth, toned and varnished to match the bronze. Rough platforms below the feet are just visible where they are attached to the plinth.

Presented in memory of Otto Gutekunst by his widow in 1953. Registered on 15 July. The bronze had been bought in at Christie's, London, 25 June 1953, where it was lot 11 (already with its present plinth).

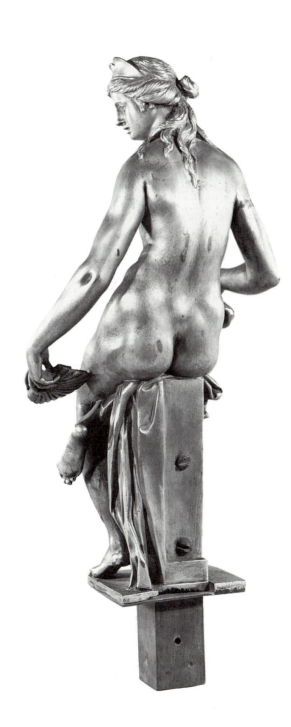

The group, representing the fourth labour of Hercules, was cast in silver from a model by Giambologna, as one of a series of six groups commissioned by the Grand Duke Francesco I de' Medici for the Tribuna in the Uffizi. The casting of this group by Michele Mazzafirri took place in 1589, but the model might have been made some years previously, for work began on the commission in 1576. The earliest bronze version to be documented is the example in the Kunsthistorisches Museum, Vienna (5846), which is recorded in the inventory of the *Kunstkammer* of the Emperor Rudolf II compiled between 1607 and 1611 (see C. Avery and A. Radcliffe (eds.), *Giambologna, 1529–1608: Sculptor to the Medici* (Victoria and Albert Museum, London, 1978), 122–3, for the series generally, and 126, no. 79 for this model; see also C. Avery, *Giambologna* (Oxford, 1987), 141–5, for the series). The version in Vienna is the only one in which the hair of the hero is bound with a fillet; it is also of higher quality than any other.

Far more bronze versions of this group exist than of any of the other groups originally in the Tribuna: it is hard to believe that this reflects especial esteem for the model, which possesses rather less of either grace or drama than many of the others. The *Annual Report* for 1953 mentions that six other versions are recorded. This is an underestimate. W. Bode illustrated one in his *Italian Bronze Statuettes of the Renaissance* (London, 1907–12), iii, pl. CXCVII (private collection, Milan); another was illustrated by Planiscig in his *Piccoli bronzi italiani del Rinascimento* (Milan, 1930), pl. XI, no. 17; one was sold with the Castiglioni Collection in Vienna on 25 November 1925. There are versions in the Museo Nazionale di Capodimonte, Naples (10785; Avery and Radcliffe, op. cit. 125, no. 78); the Metropolitan Museum, New York (1982-60-100, published by J. D. Draper in *The Jack and Belle Linsky Collection in the Metropolitan Museum of Art* (New York, 1984), 154, no. 69); the National Gallery of Art, Washington (1942-9-121); the Museo del Castello

Sforzesco, Milan; the Museo Nazionale of the Bargello, Florence; the Walters Art Gallery, Baltimore (54.679); the Wallace Collection, London (S. 125).

With the exception of the version in Naples which is a reproduction made in the late nineteenth century and that at Baltimore which has exceptionally precise tooling and is attached to an irregular-shaped bronze base, all these museum versions resemble each other very closely. Details of modelling (for example, the treatment of veins on the hero's left hand) and finishing (for example, the punching on the bark of the club) are identical and the only obvious differences are the curls of the boar's tail, which is easily bent out of place, and in the colour of the bronze, which, however, always shows evidence of an original warm varnish. These versions are generally catalogued as Florentine and seventeenth century, but in no case is there a provenance to prove that they were made before the last century. They do resemble very closely a version, one of a set of four of these Labours, from Wentworth Woodhouse, sold at Christie's, London, 15 July 1986, lot 47, and catalogued as likely to have been one of the bronzes by Giambologna acquired by Lord Malton (later 2nd marquis of Rockingham) in Florence in the late 1740s (see his letter to his father of 1 September 1749, Wentworth Woodhouse Muniments, M2). However, the very careful and full inventories of Rockingham's collection do not list the group. A version of the bronze which also closely resembled the casts under discussion was sold at Sotheby's, London, 11 December 1986, lot 72. It was possible to examine this closely, and it turned out to be a sand-cast assembled out of four elements (the boar together with the hero's left arm; the club; the hero's right arm; the hero's torso and legs) in a manner typical of Parisian foundries in the last century. The nature of the varnish would make the joins hard to detect in many of the examples cited above.

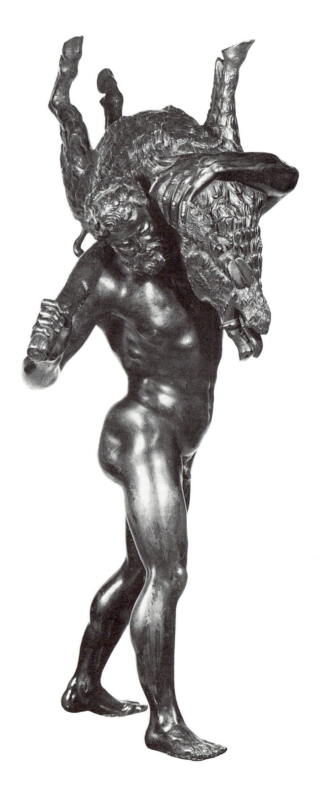

Unknown foundry (perhaps English early nineteenth century)
After Giovanni Bologna (GIAMBOLOGNA) (1529–1608)

42. Candlestand in the form of Mercury flying

24.8 cms. (height); 1.3 cms. (height of marble base)

The body of Mercury is of bronze with a green varnish worn to expose a natural brown patina where handled on the legs. Hollow, presumably lost-wax, cast. Helmet, the two wings attached to it, the wings attached to the ankles, and the head of the wind god, all of bronze fire-gilt, and each separately cast and attached. The band across the chest and loop of flying drapery of pliable metal (probably copper) fire-gilt. Mounted on a base in the form of a disc of white Carrara marble.

Purchased from the dealer David Carritt in 1960 for £75. The transaction took place around 7 March when Carritt wrote to assure Parker of his confidence that the gilt accessories were original. Registered 5 May 1960.

Giambologna was commissioned by the Grand Duke Cosimo I de' Medici in the second half of 1564 to execute a flying Mercury the size of a 'fanciullo di 15 anni' as one of several diplomatic presents for the Emperor Maximillian II. Large and small versions were made over the next twenty years, the status and dating of which are much debated (a variety of opinions may be extracted from C. Avery and A. Radcliffe (eds.), *Giambologna, 1529–1608: Sculptor to the Medici* (Victoria and Albert Museum, London, 1978), 83–8, nos. 33–5). The figure was much copied throughout subsequent centuries. By the late eighteenth century it was adapted to carry candles. Among the sketches and reports from Rome sent by Charles Heathcote Tatham to the architect Henry Holland in 1795 are two designs for candelabra by Giuseppe Boschi (see No. 15), one of which is a 'Mercury of Florence'—in fact Giambologna's famous figure—balanced on a ball of 'oriental alabaster' placed upon a circular pedestal of 'red porphyry' with 'bronze mouldings gilt in french gold'. There is a short branch in his raised right hand and a larger one in his left. As a pair Boschi proposed 'the celebrated Antique fame in the Collection of the Empress of Russia' with the candles arising from the basket she holds aloft. Each was 2 feet 10 inches high including pedestals and the pair was priced at '250 Roman scudis equal to abᵗ. £58 English'. A pair of *Mercurys* but slightly larger, with different pedestals and supporting several branches of Empire design, is to be found in the Royal Palace, Madrid. The Ashmolean's bronze is inferior in execution and design. The folds of the drapery are simply pressed ridges. The little wings look stuck on to the helmet and ankles with no idea of growing from them, the features of the face are inarticulate, the extremities are inexpressive, and there is no life in the modelling of the torso, even below the crude varnish. It may well be English and of about 1800 as Parker suggested (*Annual Report* (1960), 66) and if so perhaps a poor imitation of a bronze by Boschi.

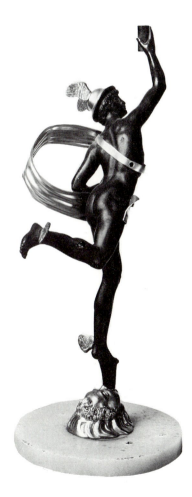

After Giovanni Bologna (GIAMBOLOGNA) (1529–1608)

43. Rape of the Sabines

29.9 cms. (height); 26.5 cms. (width)

Verde di Prato (Tuscan serpentine). Broken into eight principal, and two smaller, pieces. Some pieces missing.

Found in fragments in the basement in 1979. Provenance unknown.

This is a very poor copy, probably made in this century, of Giambologna's relief of the *Rape of the Sabines* incorporated on the base of the marble group of that subject which he was carving in October of 1581 and which was unveiled in the Loggia dei Lanzi on 14 January 1583. A smaller version (9 × 12 cms.) of similar quality and also in this material is in the reserve collection of the Museum of Fine Arts, Boston (52. 1942).

Unknown foundry and unknown modeller (perhaps Francesco Fanelli)

Probably after Giovanni Bologna (GIAMBOLOGNA) (1529–1608)

44. Seated peasant boy with bagpipes

9.1 cms. (height)

Bronze with a pale tan natural patina rubbed to a brassy yellow on salient points. Hollow, lost-wax, cast. Mounted on a block of serpentine. Inscribed in black ink '1460.1888'.

Lent by C. D. E. Fortnum on 19 August 1887, given in 1888. B. 416 in his catalogues. 'Bought at Geneva' according to his notebook catalogue, presumably after 1857 when the preliminary catalogue, in which it is not included, was compiled. Fortnum noted that the bronze was gilt. C. F. Bell added a note that this was paint (perhaps gilding on a gesso coating) which he had cleaned off in 1902.

Among the group of bronzes sent from the Grand Duke Cosimo II de' Medici as a diplomatic present to Henry prince of Wales in 1611 was 'uno Pastore che suona la piva' (K. Watson and C. Avery, 'Medici and Stuart: A Grand Ducal Gift of "Giovanni Bologna" Bronzes for Henry Prince of Wales (1612)', *Burlington Magazine*, 115 (1973), 505). Statuettes of the type in the Ashmolean have been plausibly associated with this 'pastore'. They must be related to another only slightly less common statuette of a rural figure, a peasant or shepherd leaning cross-legged on a staff. Next on the list of bronzes sent to England in 1611 was 'uno Pastore che s'appoggia a uno bastone'. These two figures are also found together as a pair in the Museo di Palazzo Venezia, Rome (*Collezione Auriti, Museo di Palazzo Venezia* (Rome, 1964), pls. 37 and 38; at present displayed in the fifth case to the right of the second room of bronzes), and look very much as if they were designed together—the standing figure listening to the seated performer. A '*Villano*' described as leaning on a staff and a '*pastore*' appear together on a list (discovered in the Florentine archives by James Holderbaum) of silver statuettes, evidently recently made, which were loaned in 1601 from the Galleria of the grand duke to Antonio Susini, Giambologna's most talented Florentine pupil, presumably so that further versions of them could be cast. The models of these silver figures are likely to have been by Giambologna: in any case we know from the inventory of Benedetto Gondi's collection in Florence in 1609 that Giambologna made at least one *Pastorino* (C. Avery and A. Radcliffe (eds.), *Giambologna, 1529–1608: Sculptor to the Medici* (Victoria and Albert Museum, London, 1978), 164–5, nos. 135–7).

Statuettes of the seated bagpiper fall into two categories. There are rough casts, such as the Ashmolean's, all with minor variations and often with losses (thus, the example in the Wernher Collection at Luton Hoo, Bedfordshire (no. 476), has no mouthpiece, and the horn is lost below the figure's left hand, the head is fitted further back, and the hat is of slightly different shape). The most familiar and least crude

of these rough casts was the one published by Bode (*Italian Bronze Statuettes of the Renaissance* (London, 1907–12), ii, CCV), today in the Staatliche Museen, Berlin-Dahlem (2242, in reserve, see *Ex aere solido: Bronzen von der Antike bis zur Gegenwart. Eine Ausstellung der Stiftung preußischer Kulturbesitz Berlin* (Berlin, 1983), 148, no. 79, entry by M.-T. Suermann). It has a certain amount of texturing on bag, trunk, and drapery. Of far finer finish, and plausibly associated with the workshop of Antonio Susini, are the statuettes, of approximately identical size, in Palazzo Venezia (already mentioned), in the Bargello (no. 464, formerly in the Uffizi, gilt), in the Victoria and Albert Museum (A. 59-1956), in the Fitzwilliam Museum (M. 2-1961), and in the Liechtenstein Collection (formerly Bardini Collection; *Die Bronzen der fürstlichen Sammlung Liechtenstein* (Liebieghaus, Frankfurt, 1987, no. 22) and lot 83, Sotheby's, London, 10 April 1975. Of these the Fitzwilliam version has most detailing (stops in the pipe, texture on the sack, fringes to the clothes) and it, together with the Sotheby's 1975 version, includes a feather in the hat which is reproduced in some of the rougher versions.

The rougher versions are not merely inferior derivatives but have considerable character. Their authorship was not discussed in the Giambologna exhibition catalogue (Avery and Radcliffe, op. cit. above). They resemble the bronzes by Fanelli (see Nos. 491, 492), who might have had access either to the version in the English Royal Collection or to one in his native Florence. His work on this scale has the same roughness, his casts are of very similar weight, and his metal is often close in colour.

Fortnum in his notebook catalogue observed simply that the bronze was 'Italian XVIth Century'. In his large catalogue he wrote, 'This doubtless represents one of the "pifferari" (of the period) who still make their music at Roman and other shrines at "natale" and may probably be of Roman workmanship'. C. F. Bell, annotating this, noted the superior quality of the Liechtenstein version and also that Bode had proposed a connection with Giambologna, speculating, because of their 'Netherlandish character' that they were early works by him (*Renaissance Bronzes in the Pierpont Morgan Collection* (London, 1908), p. xxii). There may well have been a tradition of small statuettes of low-life subjects north of the Alps before there was one in Italy. A boxwood figure of a player standing with crossed legs attributed to the Nuremberg school and dated *c.*1600 in the Cleveland Museum of Art may be representative of such a tradition. This figure is derived from a print by Dürer and Charles Avery has suggested that Dürer's prints were an inspiration for Giambologna as well (*Giambologna* (Oxford, 1987), 47, pls. 35 and 36).

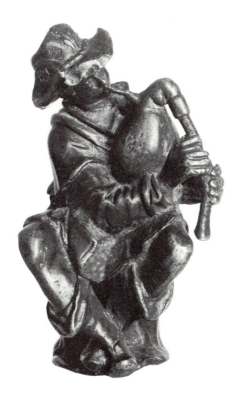

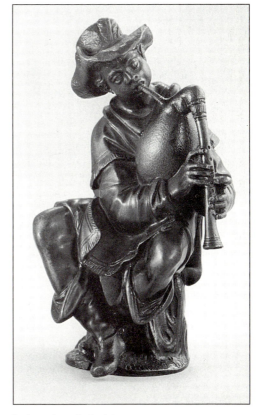

Perhaps Antonio Susini
Seated peasant boy with bagpipes
Fitzwilliam Museum, Cambridge

Perhaps Antonio Susini (active by 1580; d. 1624)

Probably after Giovanni Bologna (GIAMBOLOGNA)
(1529–1608)

45. Pacing stallion, wearing a saddle-cloth

23.2 cms. (height); 24.7 cms. (length); 13.8 cms. (height of wooden plinth); 28 cms. (length of plinth); 13.8 cms. (width of plinth)

Bronze with a uniform dark brown-green patina. Hollow, lost-wax, cast. Tiny firing crack on the front standing leg. Tooled with great precision and highly polished. Fixed to a base of ebonized wood.

Lent by C. D. E. Fortnum in October 1894 and bequeathed 1899. No. 445 in his catalogues. No date of acquisition recorded but presumably after 1857 when the preliminary catalogue, in which it is not recorded, was compiled.

A very similar horse, with the same action, saddle-cloth, and cropped mane and tail dressing, but somewhat larger (42 cms. in length), is included in the bronze relief of the Grand Duke Cosimo I's triumphant entry into Siena on the base of the statue of him by Giambologna erected in 1599 in the Piazza della Signoria, Florence. The horse in the colossal group which this base supports (cast 1592–3) is of a similar, but less neat, character, as Fortnum noted (although he missed the much closer connection with the horse in the relief). It has been conjectured that the model for the small bronze may have originated as an idea for the colossal horse which, when rejected, was retained in the relief and then cast separately as a statuette. The invention is, in any case, clearly associated with Giambologna or at least with his workshop.

A cast such as this is a good example of the extraordinary quality of the work produced by members of that workshop, and in particular by Antonio Susini, in the decade or so following Giambologna's death. Other versions exist in the Bargello, Florence (golden red varnish, with an original oval bronze base), the Kunsthistorisches Museum, Vienna (dark red-gold varnish), and the Sterling and Francine Clark Art Institute, Williamstown (dark patina similar to the Ashmolean's bronze, with a coat of arms engraved on the saddle-cloth). These three casts were exhibited together in the exhibition *Giambologna, 1529–1608: Sculptor to the Medici* at the Victoria and Albert Museum in 1978 (nos. 155, 156, 157). The compilers of that catalogue cite other versions in the Nationalmuseum, Stockholm; the Museo Arqueológico Nacional, Madrid; the Art Institute, Chicago, but not this example nor those in the Museum and Art Gallery, Kelvingrove, Glasgow (SMT 107) and in the Faringdon Collection at Buscot Park, Oxfordshire. Inferior later casts with minor variations (for instance in the tail and top knot) are also known (one was lot 114, Christie's, London, 5 December 1989).

Fortnum observed of this 'highly finished & well modelled figure' that it was 'perhaps French, & by P. Dupetit circa 1768'. This was due to a similarity with a bronze at Windsor: however Fortnum's own notes on this subject reveal an uncharacteristic carelessness. Among his books preserved by the library of the Department of Western Art is a photographic album of the bronzes in the Royal Collection at Windsor. Accompanying this is a memorandum dated 21 May 1875, from which we see that Fortnum noted of one of the bronze horses in a corridor 'Horse same model, differing in details from mine'. This is in fact a statuette of the horse ridden by Cosimo on the monument itself. After it Fortnum wrote, 'signed on base Pʳ· DUPETIT. 1768'. But, as someone, perhaps Fortnum himself, subsequently observed, this name was in fact chiselled on the base of a similiar neighbouring equestrian statuette—as can indeed clearly be seen in the photographic album—and the memorandum is corrected by an arrow. The error reveals Fortnum's open mind about dating and also draws attention to the similar taste for a satin finish and precision detailing which prevailed in Paris in 1760 and Florence in 1610. It is not in fact at all unlikely that some of the bronze equestrian statuettes after Giambologna were cast in France in the eighteenth century. Having made this connection Fortnum seems to have retreated from it and he added 'if not from the atelier of Giovanni Bologna' in the large catalogue. The bronze is not likely to have had this uniform dark patina originally.

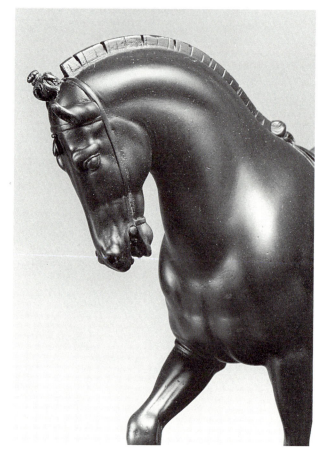

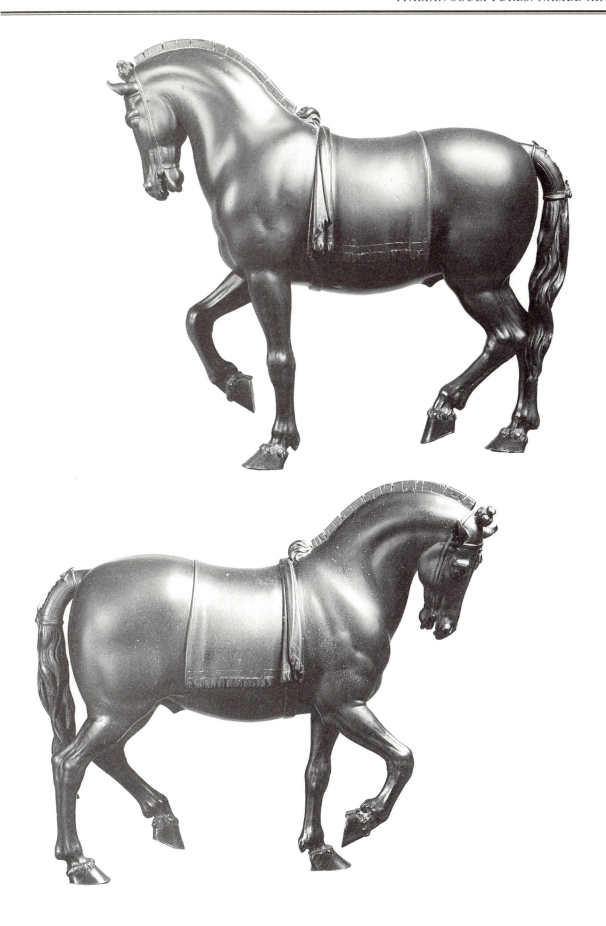

Probably follower of Giovanni Bologna (GIAMBOLOGNA)
(1529–1608)

46. Venus removing a thorn from her foot; Cupid by her side

12.5 cms. (height including integral plinth); 4.45 cms. (length of integral plinth); 3.3 cms. (width of integral plinth); 6 cms. (height of porphyry base); 7.8 cms. (length of porphyry base); 6.5 cms. (width of porphyry base)

Bronze with a pale, slightly olive, tan natural patina and considerable remains of a ruddy gold varnish (well preserved on Venus' proper right thigh and on the neck of Cupid). Hollow, lost-wax, cast. There are many casting flaws: the plinth is of uneven thickness and of an irregular shape with an untidy aperture below the tripod stool; the end of part of the drapery beside Cupid has been broken off; there is a crack at the contact of Venus' thigh with the drapery. There is much evidence of filing. A rectangular patch in Venus' left buttock may be discerned in a good light. 'B. / 426. / ℮' is painted in white on the scroll foot of the stool behind the figures. The group is mounted on a block of porphyry with a moulded plinth of ebonized wood.

Lent by C. D. E. Fortnum on 20 March 1888 and given later in the same year. B. 426 in his catalogues. 'Bought 1867', according to the large catalogue—in Florence for £4 from the dealer 'Dr Foresi' (for whom see the introduction), according to his notebook catalogue. Fortnum had the bronze mounted on a yellow marble base. C. F. Bell exchanged this for the porphyry base as he noted in pencil in Fortnum's large catalogue.

Fortnum described this bronze in his notebook catalogue as 'an elongated figure with a mannered grace after the manner of Gian Bologna', and in his large catalogue as 'an elongated figure with a mannered grace characteristic of the later period of John of Bologna's followers or fabrique'. According to an annotation in Fortnum's larger catalogue, Bode regarded it as by Giambologna himself, but most scholars today would prefer Fortnum's more cautious formulation. The pose of Venus certainly seems to depend upon some of Giambologna's inventions involving women with raised knees (most notably the marble *Florence Triumphant over Pisa* of about 1570 in the Bargello, Florence) and the pose of the Cupid is strongly reminiscent of the continuous spiral that Giambologna devised for the *Apollo* in the Studiolo, although it also recalls inventions of Michelangelo and Raphael. The group may be associated with several other small bronzes of nude women in elegant attitudes ostensibly prompted by the activities of the toilet: above all, the Venus standing on one foot unfastening her sandal (Ca d'Oro, Venice, D. br. 60) who has a very similar hair dressing and is the same size; also the nymph cutting her nails (No. 326).

The finest surviving example of this group of Venus and Cupid is certainly that in the Metropolitan Museum, New York (32.100.183; C. Avery and A. Radcliffe (eds.), *Giambologna, 1529–1608: Sculptor to the Medici* (Victoria and Albert Museum, London, 1978), 67, no. 10), which is more detailed and more cleanly finished than the Ashmolean group, with a similar, but better preserved, ruddy gold varnish.

Among Giambologna's followers Antonio Susini seems likely to be responsible for this group. Anthony Radcliffe has pointed out the similarity between the Cupid in the New York version and the Child in the larger group of the *Virgin and Child* in the Museum of Fine Arts, Houston, Texas, which seems to correspond to a group documented as an original work by this sculptor (ibid.). It is noteworthy that the type of stool that Venus rests her foot upon is much the same as that upon which David sits in the group signed by another member of the Susini family, Giovanni Francesco (*Die Bronzen der fürstlichen Sammlung Liechtenstein* (Liebieghaus, Frankfurt, 1987), 196–7, no. 30).

The Ashmolean's bronze must be supposed to be a later cast, having much the same relation to the New York version as the Ashmolean's little bagpiper (No. 44) has to the neater casts of that figure. It should, however, be distinguished from other much rougher casts of the some group in which there is a small mound under the feet of the stool, the scrolled feet of the stool are different, and the aperture between Cupid's bent left and straight right leg is smaller or non-existent. These tend to be a little larger in size (usually 13.7 cms. high): examples are in the Victoria and Albert Museum (A. 150-1910), the Museo Schifanoia, Ferrara (R. Varese, *Placchette e bronzi nelle Civiche Collezioni* (Ferrara, 1975), 144, no. 132), and the collection of Sir Brinsley Ford (where there is also a version in red wax); one such was also recently for sale in London (lot 75, Sotheby's, London, 20 April 1989).

In addition there are versions of the *Venus* without the Cupid in the Musée des Beaux-Arts, Dijon (see Avery and Radcliffe, op. cit., no. 8), the Staatliche Museen, Berlin-Dahlem (1967), and the Liebieghaus, Frankfurt (St. P. 378). Of these the Dijon version is of a quality comparable with the New York group.

The composition seems to have been familiar all over Europe by the early seventeenth century and was employed by the Dutch goldsmith Thomas Bogaert as the supporter of one of a pair of silver gilt salts made in Utrecht in 1624 (Sotheby's, Geneva, 14 November 1988, lot 18). An ivory version of the group considered to be Italian and of the second half of the seventeenth century is in the Bayerisches Nationalmuseum (R. 4732).

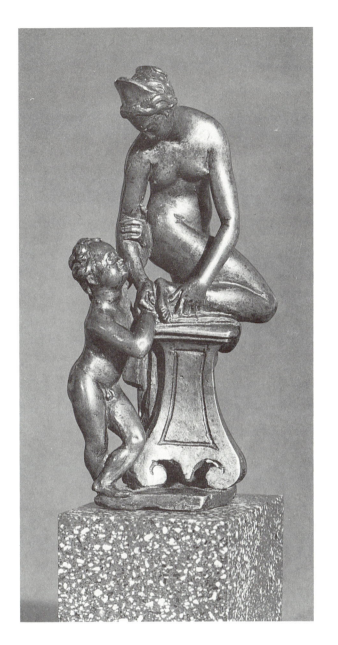

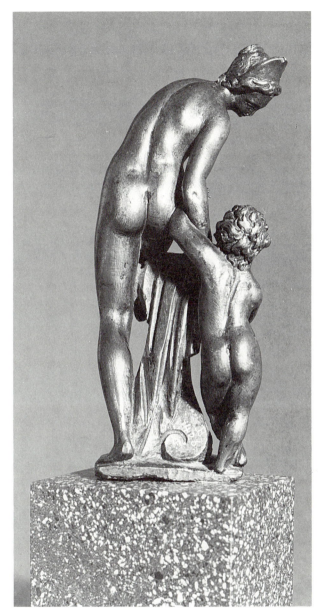

Perhaps by Giovanni Bologna (GIAMBOLOGNA) (1529–1608)

47. Self-portrait wearing the Cross of the Knights of Christ

13.5 cms. (height)

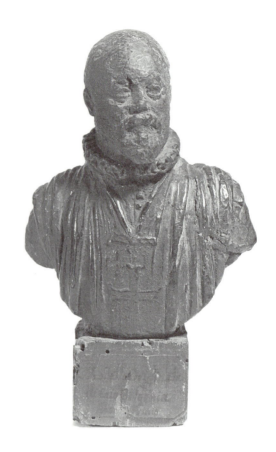

Wax covered with discoloured paint, flaking to reveal a battered surface. Chips at the lips reveal the original red of the wax. There are cracks in the bust across the proper left side. The bust is crudely reinforced with plaster of Paris in the hollow behind. On the pine base is an old paper label inscribed 'B FAC / A. G. B. Russell'—from an exhibition at the Burlington Fine Arts Club. Another larger and older one inscribed in ink in an Italian hand, perhaps of the eighteenth or early nineteenth century, 'modello originale di Gio Bologna Cos Primo' is pasted on the front face.

Bequeathed by A. G. B. RUSSELL KCVO, JP, Clarenceux King of Arms, who died in 1956. No. 19 on the receipt of works in the bequest collected from Mrs Stedall on 8 October 1958. Acquired by Russell before 1913 when exhibited at the Burlington Fine Arts Club.

The old label on the bust would seem to suggest that the Grand Duke Cosimo I was believed to be the subject. This might be a mistake from an earlier label describing Giambologna as Cosimo's court sculptor. E. Dhanens (*Jean Boulogne* (Brussels, 1956), 108–9) accepted that Cosimo was the sitter and supposed that the cross hanging on his chest was that of the Order of S. Stefano, founded by Cosimo in 1561 with himself as Grand Master. H. Keutner, reviewing Dhanens (*Kunstchronik*, II (1958), 326), pointed out that the Cross is not the Maltese Cross of that order, but the Cross worn by the Knights of Christ, an order to which Giambologna was admitted in 1599, and remarked justly that the person depicted resembled Giambologna in the drawing by Goltzius of 1591 (Teylers Museum, Haarlem). He speculated that the portrait might be by Pietro Tacca. There is also a close relationship with the small bronze busts convincingly proposed by Charles Avery as portraits of Giambologna of which there are examples in the Rijksmuseum and the Musée des Beaux-Arts, Dijon, and in the collection of Sir John Pope-Hennessy (C. Avery and A. Radcliffe (eds.), *Giambologna, 1529–1608: Sculptor to the Medici* (Victoria and Albert Museum, London, 1978), 168, nos. 143–5).

In 1964 the Ashmolean's bust was displayed with a label attributing it to Leone Leoni and suggesting that the sitter was Philip II of Spain. Pope-Hennessy, then Keeper of Sculpture at the Victoria and Albert Museum, urged that this should be changed. An association with Giambologna obviously exists but 'the poor state of preservation does not permit a positive identification of its author' (C. Avery, *Giambologna* (Oxford, 1987), 277, no. 203).

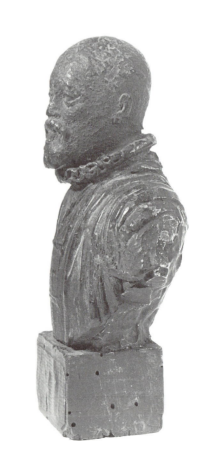

Giuseppe Domenico GRANDI (1843–94)

48. Alessandro Volta

66 cms. (height including integral plinth)

Bronze with a dark green and brown patina and a slightly granular surface. Hollow, lost-wax, cast. In the sloping moulding at the front of the plinth 'A VOLTA' (with the 'A' and 'V' interlaced) is incised in the model (with conspicuous burr) and to proper left side of the same moulding in smaller letters 'GRANDI' is chiselled in the metal.

Sotheby's, London, 21–2 March 1985, lot 296 bought (hammer price £900) by Anthony Roth. Bought for £1,800 from Mr Roth in January 1986 with funds from the Madan Bequest.

Conte Alessandro Volta (1745–1827) was one of the greatest scientists of his age. The volt is named after him. The bronze, which perhaps records a sketch for a projected public statue, probably dates from the 1870s. Carlo Bozzi (in 'Artisti contemporanei: Giuseppe Grandi', *Emporium*, 16 (1902), 91–108) refers to 'Il Volta pure così pieno di carattere e di vita, che vale un monumento e chi si vuole sia stato improvvisato nel marmo' and reproduces a statuette presumably in clay or plaster corresponding to this bronze but with more obvious tooling in the folds of the coat (ibid. 99). R. Boccardi ('Giuseppe Grandi', *Rassegna d'arte*, 21 (1921), 201) refers to a 'statuina in marmo' and reproduces the same work. No version in any material other than bronze, and no other version in bronze, has been traced, but the figure was reproduced as no. 681, pl. c in the catalogue of the 'Manifattura di Signa. Terre cotte aristiche e decorative' which had show-rooms *c.*1910 in Rome, Turin, and Paris.

Grandi was perhaps influenced by the brief popular biography by Luigi Alfonso Girardi (*I contemporanei italiani: Galleria Nazionale del Secolo XIX* (Turin, 1861)) in which the solitary walks which Volta took on the city walls of Pavia in the last decade of his life and the gravity of his deportment, the artless neglect of his dress, and his broad, albeit corrugated, brow are memorably sketched. He must also have consulted the marble bust by G. B. Comolli dated 1828 (Museo d'Arte Moderna, Milan). If there was a plan for a statue to him (and it was a period in which statues of almost every eminent Italian, ancient and modern, were projected) then it would have been likely to have been for Pavia, where Volta became professor in 1775, rather than for his native Como where there was already a statue of him by Pompeo Marchesi.

Grandi first attracted public notice by winning the competition for the monument to Cesare Beccaria (Palazzo di Giustizia, Milan) signed in 1870 and unveiled on 19 March 1871 in Palazzo di Giustizia, Milan (the marble figure is now in the Galleria d'Arte Moderna, Milan, no. 1111, and has been replaced by a bronze replica). The *bozzetto* for the figure was cast in bronze (examples are in the Museo Nazionale d'Arte Moderna in Rome and the Galleria d'Arte Moderna, Milan) and so too was his sketch, dated 1880, for a statue of Marshal Ney. These are both smaller than the bronze of Volta, but of similar patina and finish and with a similar plinth. The Ney would seem to have been cast in a large edition—

versions are in the Galleria d'Arte Moderna, Milan, in the David Daniels Collection (exhibited Minneapolis, 1979–80, no. 63, previously Shepherd Gallery, New York, 1974), and two have appeared in recent years with London dealers. All three statuettes, but especially that of Volta, possess a dynamic plasticity and an exaggerated, almost grotesque, characterization suggestive of developments in France of which Grandi knew nothing: Daumier's earlier *Ratapoil* (No. 274) and Rodin's later *Balzac* (No. 309) both come to mind.

In 1881 Grandi won the competition for the huge bronze monument in Milan commemorating the *Cinque giornate*— the popular uprising of 19–23 March 1848 against Austrian rule—for which he completed the half-size model in 1886 and which was only just completed in bronze when he died. To this work, perhaps the most powerful and original public monument of the second half of the nineteenth century in Europe, he devoted most of the last fourteen years of his life. For the influence of his ornamental designs and novel ideas for bust sculpture which he had pioneered in the 1870s see No. 83. The Ashmolean's statuette of Volta is the only work by Grandi on public view in this country with the exception of the extraordinary *Kaled, al mattino del conflitto di Lara* (*Il paggio di Lara*) of 1872 which stands in a high niche on the street front of no. 193 Fleet Street in London—'una meraviglia di vita e insieme un magnifico, secentistico, esempio di modellatura spigliata e di insieme decorativo, ma che, esposto a Brera [in 1873], ancora peggio che incompleto, procurò al Grandi tali amarezze' (Bozzi, op. cit. 98).

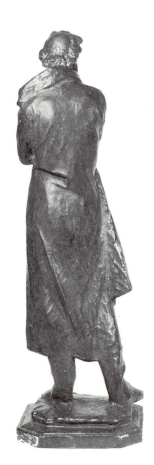

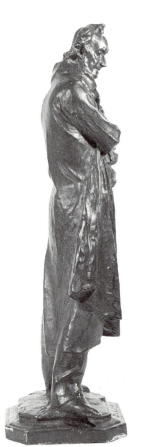

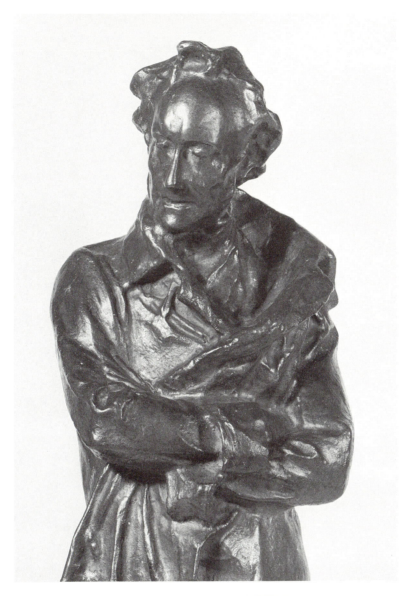

Antonio GUSELA (dates unknown)

49. Saturn devouring an infant boy

21.5 cms. (height including integral pedestal); 4 cms. (height of integral pedestal); 6.9 cms. (length of pedestal); 4.1 cms. (width of pedestal); 2.8 cms. (height of modern plinth)

Probably lime, highly varnished—the varnish has given the wood a redder appearance than normal and has darkened in the hollows. The group is carved from two pieces. The vertical join may be discerned down the cheek of Saturn and the sides of his body: his right leg and left arm are fashioned for the most part from one block and left leg and right arm from the other. There is a slight split in the lower left leg. 'Antonio Gusela / Sculto.re de Belluno' is written in black ink in an old hand in a hollowed-out area behind the pedestal. The long 's' is easily read as a 'g' or 'z' and the next letter could be a 'z', 'a', or 'e'. 'M 232' is written in pen with black ink on the back of the hour-glass and on the base of the pedestal to proper right. The group has been mounted on an unmoulded mahogany plinth.

Bequeathed by J. Francis Mallett who died 7 January 1947. Received in the Museum during the last week of May 1947. No. 232 in the inventory of his bequest (as a work by 'Gugela'). Valued by Mallett at £10. Acquired by him from 'Christie 1937'.

The group looks as if it might be derived from a bronze statuette, but it is obviously not designed to be seen from behind. The shape of the pedestal suggests that it must date from the first half of the seventeenth century or later (compare the socle of Dieussart's bust of Prince Rupert, No. 471), but it could certainly be an eighteenth-century work. The little brackets incorporated into the front of the pedestal to accommodate the projections of the feet are an unusual feature. Belluno, in the Venetian Alps, was noted for its native wood-carving. It was the birthplace of Andrea Brustolon (1662–1732), much of whose work may be seen there. Among Brustolon's pupils listed in a document of 1722 is Giovanni Battista Alchini known as Gusela. This Gusela was noted as a carver of frames. Among works by him are the *Madonna del Carmine* in the church of Loreto in Belluno and a crucifix in the collection of the Avvocato A. da Borso also in that city (G. Biasuz and M. G. Buttignon, *Andrea Brustolon* (Padua, 1969), 14, 307 n.). Antonio Gusela is likely to have belonged to the same family.

Dr John Brazier who identified the wood as probably lime noted that it might be a fruit wood. It has previously been described as box.

Probably Parisian foundry of second half of the nineteenth century

After François LADATTE (Francesco Ladetti or Ladetto) (1706–87)

50. Judith with the head of Holofernes

39.7 cms. (height); 17.6 cms. (length of integral plinth); 15.6 cms. (width of plinth excluding projection of sandal)

Bronze with a ruddy brown artificial patina simulating the natural patina of a coppery bronze, worn to reveal a yellow metal in some salient areas, notably the chin, nose, and hair. Hollow, sand, cast in three pieces, the sword with the drapery caught up by it forming one subsidiary unit and the heroine's right arm another. To proper right of the plinth on the side '2480' is stamped in the metal.

Bought in Paris in 1965, apparently on 14 September, from the Heim Gallery.

Ladatte exhibited a terracotta of *Judith* at the Paris salon in 1738 (no. 159) and another in the following year. The latter was the model for his marble version of 1741 (Musée du Louvre) which was his *morceau de réception* at the French Academy where he was nominated professor in 1743, the year before he returned to his native Turin. The terracotta, 84 cms. high, acquired 1981 by the Musées d'Art et d'Histoire de Chambéry may be the statuette of 1739. A gilded terracotta in the Museo Civico, Turin (pl. 13 of L. Mallè, 'Traccia per Francesco Ladatte, scultore torinese', in D. Fraser, H. Hibbard, and M. Levine (eds.), *Essays in the History of Art Presented to Rudolf Wittkower* (London, 1967), 242–54), which differs in many minor details—the treatment of the belt, the drapery over the sword hilt, the heroine's hand in the hair of her victim's head—may reflect another model, and may even be by Ladatte himself if the loss of sharpness is explained by the ground covering the terracotta preparatory to the gilding. The bronze in the Ashmolean is a reduced copy of the marble differing in that the sword hilt is not curved downwards in the bronze (someone may have supposed that the curve was due to a clay model sagging and have corrected it) and in many small details, the texturing of the sash (far more subtle in the marble) and the treatment of the eyes (deeply drilled in the marble), for instance. Ian Robertson bought it as a work by Ladatte himself, who was indeed noted for his bronzes, but the type of cast and its assembly are typical of Parisian foundries in the last century and the work is mechanical, without any of the vitality of either modelling or tooling that is found in works by Ladatte himself, such as the clock surrounded by allegories of Time and military glory, or the harpy furniture mounts and the candelabra in the Palazzo Reale, Turin (reproduced in A. N. Cellini, *La scultura del settecento* (Turin, 1982), 206, 217, 220). Ladatte is a sculptor little represented in British collections but the ormolu mounts on the fantastic mother-of-pearl stand in the Victoria and Albert Museum (W. 34-1946) attributed to Pietro Piffetti can be attributed to him on account of the helmet revealing its quilted lining which is

part of the trophy nestling in the cross stretchers—an identical helmet lining is found in the *Judith* and in the terracotta group of the *Triumph of Virtue* of 1744 (Musée des Arts Décoratifs, Paris, inv. 6313).

Perhaps by François LADATTE (Francesco Ladetti or Ladetto) (1706–87)

51 and 52. Pair of sphinxes

26.5 cms. (height of 'Summer', 51); 25.5 cms. (height of 'Winter', 52)

Bronze with a blackened ruddy varnish worn in a few parts to expose the yellow metal. Heavy, lost-wax, casts. There are holes drilled through the back left leg and the front left leg. There are firing cracks on the rump under the tail of the sphinx with its left fore paw raised (51) and in the tail of the other. Mounted, before late 1987, with modern bolts on discoloured white marble bases, cut from a single piece of marble, obviously not original. This was replaced by dark mahogany moulded plinths made by Ray Ansty of the Museum workshop. Placed on display in the Chambers Hall Room in 1987, previously in reserve.

Given by G. Reitlinger, 1972, but only received by the Museum after the fire in his home in 1978 (see No. 13).

According to the donor, these were originally fire-dogs (which may well be correct) and solid (which is incorrect) and the heads are portraits 'representing, according to Sir Francis Watson, Madame Parabère, Mistress of the Regent Philippe Duke of Orleans, after the models made by Jacques Caffieri c.1715–20 for Chateau de Champs'. The idea that the royal French mistresses—or English actresses—of the eighteenth century were depicted in sphinxes in bronze, and porcelain was a very popular one in the early part of this century, probably strengthened by the pastiche sphinxes made in the late nineteenth century in terracotta and plaster incorporating heads of Madame du Barry and so on (striking examples were sold Christie's, London, 3 April 1985, lot 79). There seems no good reason at all to believe that there was any portrait element in these bronzes. On the other hand, the idea (also credited to Sir Francis Watson) that the two sphinxes may be connected with two of the Seasons, and may possibly belong to a series of four, is surely correct: in any case one sphinx (51) wears a rose-trimmed dress (for Summer) and the other (52) a fur-edged pelisse (for Winter).

Although there is something French about the ornamental character of these sphinxes neither the type of heavy cast nor the colour has convinced experts that they are French. They are reminiscent of the ornamental work of Francesco Ladatte at the court of Turin. In the gilt bronze harpies which he supplied for the furniture made by Pifetti for the queen's Gabinetto di Toletta in the Palazzo Reale soon before his second stay in Paris which lasted from 1734 until 1744 (see M. Bernardi, *Barocco piemontese* (Turin, 1964), 130) and in the allegories surrounding the great clock in the Palazzo Reale signed in 1775 (ibid. 49) we find the same taste for elegant female heads, fringed draperies, strung pearls, brocade with relief patterns and a textured ground, and the same sinuous outline broken by the projection of floral crowns and ribbons.

Jennifer Montagu, to whom I owe the suggestion that the sphinxes might be from Turin, pointed out that they probably supported shields with their raised paws. For other sphinx fire-dogs with shields see the pair in the Bayerisches Nationalmuseum, Munich (24-106; H. Ottomeyer and P. Pröschel, *Vergoldete Bronzen* (Munich, 1986), i. 71, no. 1.10.10) and the pair signed by Eugène Piat sold 11 June 1989 at the Hôtel des Ventes, Troyes (*Gazette de l'Hôtel Drouot*, 2 June 1989).

Perhaps by Pierre LEGROS II (1666–1719)

53. Bust portrait of a cardinal

43.5 cms. (height, excluding socle); 17.4 cms. (length of base of socle); 15.8 cms. (width of base of socle); 11.5 cms. (height of socle)

Carrara marble. The foremost curl on the proper right-hand side has been broken off (the point where it touches the collar remains). There are some rusty stains natural to the marble (most obvious in the cap), also some grey stains.

Purchased for £550 by the National Art-Collections Fund, 1959, and presented to the Ashmolean Museum. Said to come from the Lazzaroni Collection, Nice. Sir Karl Parker first appealed to the Fund on 30 June 1959 when the sculpture was on offer from Hans Calmann for £800. Lord Crawford, the Chairman of the Fund, replied from his castle in Fife on 22 July that the Committee had 'felt a little uncertain about the Bust—or, rather, I should say whether we should pay up' because a bust of the same period 'more certainly by Foggini' had been purchased by the Victoria and Albert Museum for a mere £80, not many years before. In view of this Ian Robertson, writing on behalf of the Keeper, reported on 1 August that Mr Calmann had lowered his price to £550. The grant for this amount had been made by October.

On acquisition this bust was attributed to Giovanni-Battista Foggini (1652–1725), but Parker wrote in the Museum's *Annual Report* (pp. 45–6) that 'an alternative and perhaps in some ways more probable' attribution to Giuseppe Mazzuoli (1644–1725) 'is worth considering in conjunction with the problem of the sitter's identity'. He added that

No traditional or otherwise proven identification has been recorded; and though it is safe to reject the recent suggestion that the bust is of Leopoldo de' Medici, a glance at the series of engraved portraits of cardinals of the period in question, published by Giovanni Giacomo dei Rossi, is enough to show the almost baffling difficulty of recognizing a subject with certainty when conventional standards of expression, attire, hair-style, &c. were so universally adopted.

With this it is impossible to disagree; but Parker continued to claim that

Such features, however, as the unusually prominent nose, the wide-set eyes, the projecting lower lip, and the reflective, as it were withdrawn, expression of the face, point to Paluzzo Paluzzi degli Albertoni (1623–1698), who was raised to the purple in 1664 by Alexander VII, but came into power chiefly after the election to the Papacy of the octogenarian Clement X in 1670, and was by him permitted to adopt the name of the Altieri, a family long associated with the sculptor Mazzuoli.

The comparisons upon which this identification depend are not strong and the idea began, one must suspect, with a desire to clinch the attribution to Mazzuoli. Oddly the identification was accepted and because of it Klaus Lankheit proposed an attribution (made also by Hugh Honour) to Lorenzo Merlini (in a letter of 28 March 1960 to Mr Taylor and then in his *Florentinische Barockplastik* (Munich, 1962), 185), noting that, according to an anonymous memoir and autobiography, Merlini made a 'statua al naturale of Cardinal Paluzzo Paluzzi degli Albertoni' for Cardinal Lorenzo Altieri

for the anticamera of his palace (Palazzo Altieri al Gesù) in Rome. Unfortunately for this argument Merlini's portrait—almost a half-figure rather than a bust (hence perhaps the term 'statua')—survives in Palazzo Altieri, and a terracotta for it (labelled as by Lorenzo Ottoni) is in Palazzo Braschi (see A. N. Cellini, *La scultura del seicento* (Turin, 1982), 106–7, pl. 4) and it does not resemble the bust in the Ashmolean. Moreover, even Merlini's best work (such as the effigy in the monument in S. Giovanni dei Fiorentini, Rome, illustrated in R. Enggass, *Early Eighteenth-Century Sculpture in Rome* (Pennsylvania, 1976), figs. 90–2) does not approach the Ashmolean portrait in vitality and his modelling was always superior to his carving. It must be said also that none of the portraiture by Foggini or Mazzuoli has quite this sharpness of carving or mobility of features or is so utterly lacking in dull surfaces or gross handling. Lorenzo Ottoni's comparable portraiture in marble (for example, his bust of Pope Alexander VIII in the Städtische Galerie Liebieghaus, Frankfurt on Main) is not dissimilar but is cruder in its pursuit of effect, especially in the use made of the drill.

The sculptor working in the last decade of the seventeenth century, and the first of the eighteenth, who was most capable of work of this quality and character was Pierre Legros II. There are no comparable bust portraits by him but his recumbent effigy of Cardinal Girolamo Casanata, now partially concealed by the German-language confessional in S. Giovanni in Laterano (1701–3), and his statue of the same man in the Biblioteca Casanatense (1706–8), also in Rome, exhibit the same exaggerated features, grotesque in any other artist's work, combined with great vitality of expression, variety of profile, and exquisite treatment of detail. (The carving of the aged flesh of the neck at contact with the collar is remarkably close in the statue and the Ashmolean's bust.)

As was pointed out in the *Annual Report of the National Art-Collections Fund*, 56 (1959), 30, the shape of the bust strongly suggests that it was designed to be set in a circular frame. The socle upon which it is now mounted cannot be original.

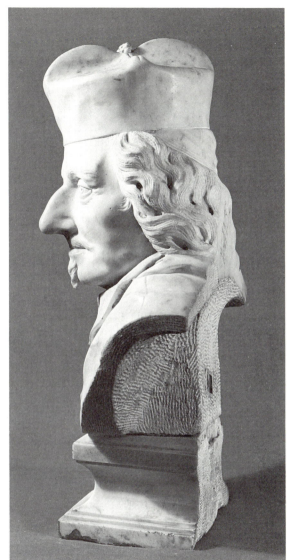

After Antonio LOMBARDO (b. *c.*1458; d. 1516)

54. Portion of a frieze involving vine tendrils and a cherub

33.5 cms. (height); 89 cms. (length)

Plaster of Paris, somewhat grey and abraded (perhaps from damp), with some minor cracks and very irregular edges. Solid cast with no apparent seams. Set in a thick pine frame, serving also as a tray.

Provenance unknown. Possibly a residue of the Ruskin School's teaching aids.

The plaster cast is made from moulds taken of the frieze on the base of the north face of the pedestals of the two pilasters which form a triumphal arch distinguishing sanctuary from choir within the raised Capella Maggiore of S. Maria dei Miracoli in Venice. This church was erected between 1481 and 1489 under the direction of Pietro Lombardo and his sons Tullio and Antonio, the latter being credited with this particular frieze, which develops, to either side of the portion represented here, into female sea monsters upon whose tails the putti are riding. The carving, which is among the most skilled and charming of its period in northern Italy, was much admired by the close of the nineteenth century. Comparison with the original reveals that the cherub's nose has been damaged since this cast was made. The cast might have been supplied by a firm such a Brucciani (see Nos. 450, 580, 581), in whose list, published before 1906, one finds a pilaster from this church, but it is unlike their work in its solidity and absence of seams and is no less likely to have been acquired in Italy.

Ruskin, in the *Venetian Index* appended to the third volume of *The Stones of Venice*, considered the church of the Miracoli to be the 'most interesting and finished example in Venice of the Byzantine Renaissance, and one of the most important in Italy of the cinquecento style. All its sculptures should be examined with great care, as the best possible examples of a bad style.... Its grotesques are admirable examples of the base Raphaelesque design', he continued, and urged his readers to

Note especially the children's heads tied up by the hair, in the lateral sculptures at the top of the altar steps. A rude workman, who could hardly have carved the head at all, might have been allowed this or any other mode of expressing discontent with his own doings; but the man who could carve a child's head so perfectly must have been wanting in all human feeling, to cut if off, and tie it by the hair to a vine leaf. Observe, in the Ducal Palace, though far ruder in skill, the heads always *emerge* from the leaves, they are never tied to them. (E. T. Cook and A. Wedderburn, *The Works of John Ruskin*, xi (London, 1904), 393.)

Given the specificity of this reference, and the fact that one of his finest drawings given to the Ruskin School Collection (Educational Series 94) is of a portion of the same frieze, one must wonder whether this cast was not made at his instigation. As with his architectural daguerrotypes, the commissioning of casts is a relatively little-documented aspect of his work as a historian and critic, but he presented casts to the Architectural Museum as early as 1854 (ibid. xii, p. lxxi) and also gave some, later in life, to the St George's Museum in Sheffield (ibid. xxx (1910), 189). We know that he obtained casts in Venice through his friend the Commendatore Giacomo Boni: those Boni made of the Colleone monument apparently disintegrated (ibid.). The church was extensively restored by the Besarel brothers for Count Roberto Boldù in 1887 and that is a likely date for the making of casts on a commercial basis. However, an identical plastercast, in store in the Victoria and Albert Museum (1851–432), was acquired in 1851.

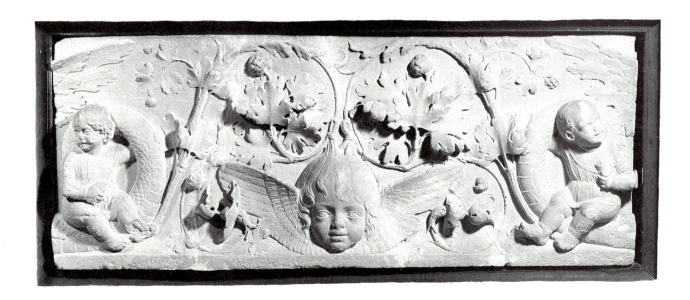

By or after Girolamo, Aurelio, or Lodovico LOMBARDO
(active 1550–80)

55. Triumph of Ariadne

28.1 cms. (height); 38 cms. (length)

Bronze with a chocolate brown patina. Lost-wax cast. A firing crack
at upper right-hand side with two plugs inserted in the bronze, of
which one is now missing. The surface much scratched, especially
at top left, perhaps in cleaning. 'B. / 687 / Œ' painted in white in
the lower right-hand corner.

Lent in October 1874 by C. D. E. Fortnum and bequeathed by him
in 1899. B. 687 in his catalogues. 'Found in London among refuse
old metal, rescued by the older Hatfield, the bronzist, who cleaned
it and yielded it to me about 1856' (large catalogue). 'I found this
fine bronze in London. It had been rescued from the melting pot
by Hatfield the bronzist, by whom it was cleaned from the
accumulation of filth with which it was covered, and purchased by
me' (notebook catalogue). It was not included in the preliminary
catalogue compiled by Fortnum in 1857 and so was probably not
acquired before 1858. It is likely to be the 'Ariadne' in an MS
'Memorandum of Prices Paid' which cost him £4 in 1858. It was
exhibited at the Archaeological Institute in February 1861. In
Fortnum's photograph it is displayed on a plain flat wooden
moulding with a gold fillet at the sight edge. The present heavy
walnut frame with gilt egg and dart and waterleaf mouldings was
probably made by the Museum workshop in the 1950s to match
the old Renaissance moulding found for the panel painted by Filippo
Lippi.

Fortnum esteemed this relief very highly and expanded
unusually upon its merits: a 'work of great beauty and interest;
the admirable treatment of the Satyrs, the calm grace of pose
and expression in Ariadne; the spirit of the antique well
sustained, but the best manner of the Renaissance equally
apparent'. He recognized that it was a version of one of the
two reliefs that adorn the Renaissance base made for the
antique bronze statue of a nude boy known as the *Idolino*
which was in his day in the Uffizi but is today in the Museo
Archeologico in Florence, but he did not appreciate that this
statue, believed originally to be a Bacchus, had been discovered
in 1530 at Pesaro (for its history and reputation see F. Haskell
and N. Penny, *Taste and the Antique* (London and New
Haven, Conn., 1981), 240–1). The *Idolino*'s base had been
attributed, as Fortnum noted, to Vittorio, son of Lorenzo
Ghiberti, by J. W. Gaye, (*Carteggio inedito d'artisti*, i
(Florence, 1839), 108 n.), but Fortnum seems to have
preferred the attribution to Desiderio da Settignano, being
much struck by the exquisite low relief. Neither sculptor
could, however, have been responsible for the base since this
cannot have been made before the statue was discovered.
Furthermore, it was not likely to have been made in Florence.
The base is in fact known to have been made for Duke
Giudobaldo II of Urbino, that is after 1538, and probably
several decades later, but before 1574 (when he died). Ulrich
Middeldorf ('Notes on Italian Bronzes', *Burlington
Magazine* (Dec. 1938), 251–7) convincingly attributed it to
the three sons of Antonio Lombardo (see No. 54). These
Lombardi established a foundry at Recanati. The bronze

tabernacles in the Cathedral of Milan of 1559–60 and at
Fermo of 1570 and the bronze doors and font for the basilica
at Loreto which are documented as by them are very close
in style to the base of the *Idolino* both in the naturalistic
ornament and in the unmannered classicism of the narratives.

It has not been possible to place the Ashmolean's relief
next to the bronze in Florence but in both reliefs most of
the detail (which appears in both to be reproduced from the
wax model) is the same—for example, the pattern of fur at
the top of the second satyr's leg as it meets the edge of the
vine leaf, the rippling neckline of Ariadne's dress, the faintly
indicated lion head on the hub of the chariot wheel. The relief
in Florence appears to be more varied in depth and more
vigorous in facial character; it also curves forward below feet
and wheel; but, when parts of the two reliefs are measured,
they correspond exactly: in both cases the chariot wheel is
6.7 cms. in diameter, the wand 9 cms. in length (from top of
Ariadne's thumb to tip), and the second satyr measures
4.85 cms. in a straight line from under his right armpit to his
left shoulder. This exactness would be remarkable if achieved
by a copyist who would have to calculate the degree to which
the bronze shrinks when cooling.

One must therefore respect Fortnum's idea that his relief
was made in the same period and from the same model as
the base (the reliefs, that is, were cast in bronze from two
wax models which were cast from the same mould and tooled
with reference to a common master version). What would
seem unlikely is that it was a 'rejected first casting' as Fortnum
proposed, because, although there is a firing crack in
Fortnum's relief, there are more serious flaws in the relief on
the base—in particular a crack across the right arm and
shoulder of the first satyr and a damaged area between the
second satyr and Ariadne—as Fortnum himself observed in
separate notes interleaved in his notebook catalogue.

It is, of course, just possible that the Lombardi's moulds
and master version survived and were employed in a later
period. That there would have been an interest in doing so
in the second half of the eighteenth century seems probable
since the Lombardi's style of relief uncannily anticipates the
imitation of the antique which then became fashionable. A
wax mould and a wax cast after the relief are recorded in an
eighteenth-century catalogue of models at the Doccia
porcelain factory and orders were placed with Vincenzo
Foggini for versions of the two reliefs on the *Idolino*'s base
on 12 June 1748—a wax cast survives in the Museum's
collection (K. Lankheit, *Die Modellsammlung der
Porzellanmanufaktur Doccia* (Munich, 1982), 136, and
pl. 202). The Adam brothers had a plaster cast of the base in
their collection and Robert Adam employed one in the
furnishings supplied to Audley End in Essex where he worked
from 1763 onwards. A study of the base is to be found in a
sketchbook by Joseph Nollekens in the Ashmolean Museum
(fo. 81). Terracotta casts of the relief, identified merely as
'Bassorilievo greco', were illustrated as available for sale in
the catalogue of the 'Manifattura di Signa. Terre Cotte

artistiche e decorative' which had sale-rooms in Florence, Rome, Turin, and Paris in the early years of the century (no. 381, pl. xxxviii in the copy belonging to the Sculpture Department, Sotheby's).

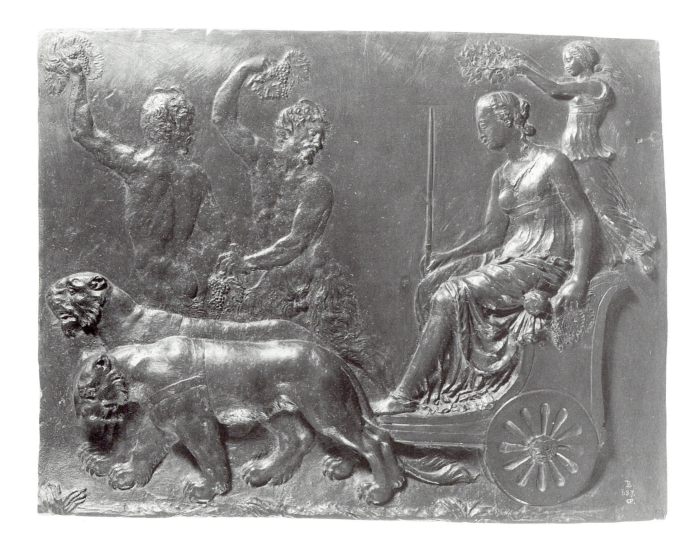

Stefano MADERNO (1576–1636)

56. Farnese Hercules

50.7 cms. (height including integral plinth); 22.3 cms. (length of plinth); 17.9 cms. (width of plinth); 4 cms. (height of plinth at back); 2 cms. (height of plinth at front)

Terracotta of pale pinky grey colour, fired, or perhaps refired, at a very high temperature, the body as hard as stoneware. There are slight vertical firing cracks, e.g. down front of the chest. The proper right corner of the back of the base has been broken off and refixed. Proper left corner also, including a portion of the hillock support, has been broken and refixed. There are also large cracks in this latter area. The figure is hollow and the interiors of hillock, club, and drapery are visible from below. A large plug of clay in the centre of the underside of the plinth (not beneath the feet). Incised on the front face of the rock below the club:
"ΓΛΥΚϢΝ / ΑΘΗΝΑΙΟΟ / ΕΠΟΙΕΓ"—with a line below, and beneath this 'St. M. Ex/1617'.
Given by Edmund Oldfield FSA, July 1899.

The colossal antique statue of which this is one of the earliest known reproductions seems to have been discovered in 1546. It had been placed by 1556 in Palazzo Farnese in Rome (see F. Haskell and N. Penny, *Taste and the Antique* (London and New Haven, Conn., 1981), 229–32, no. 46). For later copies of it in terracotta and bronze see Nos. 152, 414 and 416. There are a series of four terracotta figures and groups of similar size signed by Maderno in the Ca d'Oro, Venice (D. sc. 79, 80, 81, 82). They represent *Hercules and the Lion*, *Hercules and Cacus* (both dated 1621), *Hercules and Antaeus* (dated 1622), and the group of a bearded hero holding a youth over his shoulder now thought to represent *Neoptolemus with Astyanax* (undated). The last mentioned is signed 'St. M. ex' like the Ashmolean's terracotta, whereas the others are signed 'St. M. f', the 'f' for fecit perhaps being reserved for works which he had invented. It it tempting to speculate that Maderno devised the three groups of Hercules in action as companions for his copy of Hercules resting after his labours, although he is unbearded when struggling with the lion which is surprising if a series is intended. The Neoptolemus group has been interpreted in numerous ways. In Perrier's prints of antique sculpture published in 1638 it is identified as Commodus. Maderno may well have thought that it too represented Hercules. It is likely, in any case, to have been thought of as a companion for the terracotta *Farnese Hercules* since the marble originals were displayed together in Palazzo Farnese (the group is now in the Naples Museum (no. 150, inv. 5999)).

Maderno may have made more than one version of these peices: another *Hercules and Antaeus*, dated 1620, is in the Royal Scottish Museum, Edinburgh (1981.1, from the Clerk of Penicuik Collection, said to have been bought in Italy in the 1720s), and this group was also reproduced in bronze (Walters Art Gallery, Baltimore, 54.665), as was the *Hercules with the Nemean Lion* (L. Camins, *Renaissance and Baroque Bronzes from the Abbott Guggenheim Collection* (Fine Art Museums of San Francisco, 1988), 84–5, no. 28). Some of

the Ca d'Oro terracottas have clean lines across the upper limbs of the figures. These cannot be caused by separate firing since that could not result in such neat joins. The terracottas must have been cut carefully into pieces, presumably to facilitate the taking of moulds, and then reassembled.

Maderno's *Farnese Hercules* is not a meticulously exact copy. The curls of hair and beard are, relatively, smaller in the marble. Here they are treated more like the lion's mane and with the same crisp tooling that is found in the groups in the Ca d'Oro, and the face has the same mean or pained grimace that seems to have been Maderno's only idea of expression. This is less true of a terracotta copy of the *Farnese Hercules*, unsigned and larger (82.08 cms. high), also in the Ca d'Oro which as been attributed to Maderno (B. Candida, *Bronzetti, terrecotte, placchette rinascimentali di ispirazione classica alla Ca d'Oro e al Museo Correr di Venezia* (Rome, 1981), 57–9, no. 14).

Edmund Oldfield, former librarian and fellow of Worcester College, Oxford, presented the Ashmolean Museum with a choice collection of small classical antiquities—gold ear pendants, iridescent glass perfume flasks, mortuary diadems, Greek vases—on the occasion of moving house from Thurloe Square in London to Torquay (see his letter to Arthur Evans of 27 May 1899 in the Archives of the Department of Antiquities); he died at Torquay in 1902 and bequeathed some few additional items. The *Hercules* is identified in the manuscript list of objects presented in July 1899, section IV 'objects separate from cabinet', p. 7. There seems to have been no other 'modern' work, or at least no other avowedly 'modern' work, in his collection (see, however, No. 165). Most of his collection is likely to have been assembled when he was travelling in Italy and the Mediterranean.

A sample was taken from the base of the figure by Mrs Doreen Stoneham of the Oxford Research Laboratory for Archaeology and the History of Art in 1973 and again in Mach 1987 and thermo-luminescence tests suggested a date between 1573 and 1743 or 1537 and 1697 (refs. 81-m-61 and 381-z-93).

Whilst this catalogue was in proof Sergey O. Androssov's important article 'Works by Stefano Maderno, Bernini and Rusconi from the Farsetti Collection in the Ca d'Oro and the Hermitage' appeared in the *Burlington Magaine* (May 1991, pp. 292–7). Androssov shows that the terracotta *Farnese Hercules* in the Ca d'Oro is likely to be by Camillo Rusconi to whom he also attributes a terracotta *Apollo Belvedere* in the same collection. To the Maderno terracotta groups in Venice he adds four others *Nicodemus with the body of Christ*, dated 1605, now in the Hermitage, a *Herculese and Telephus*, dated 1620, a *Herculese and the Centaur*, dated 1626 (surviving only as a plaster cast) and a *Laocoon*, dated 1630. He demonstrates that it is likely that the works by both Maderno, Rusconi and Bernini in the Hermitage and the Ca d'Oro all came from the collection of the Abate Filippo Farsetti (1703–1774).

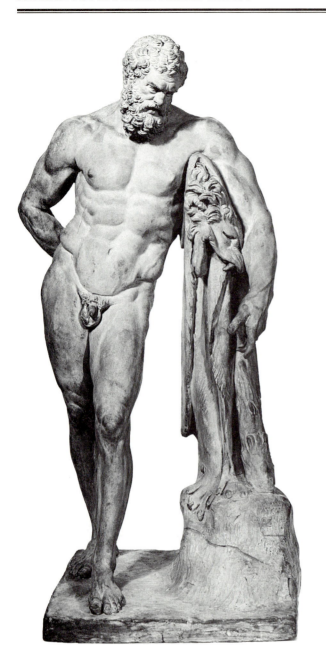

Giuseppe MAZZUOLI (1644–1725)

57. St Matthew

35.7 cms. (height); 11 cms. (length of base); 10 cms. (width of base, excluding the projecting cloud under the saint's right foot)

Terracotta of a pale pinky orange. Many breaks, mostly repaired with skill: the head of the saint, the child angel's right foot and both wings; part of the cloud base and both feet of the saint were once detached. There are a few minor chips in the drapery. A little filling is evident around breaks (e.g. the child angel's right foot).

Purchased together with No. 58 from Messrs. P. & D. Colnaghi, Bond Street, where exhibited February and March 1964 (*Seventeenth and Eighteenth Century Italian Sculpture*, no. 19), with a grant of £1,000 made by the National Art-Collections Fund on 19 April 1965.

See No. 58. A sample was taken from this figure by Mrs Doreen Stoneham of the Oxford Research Laboratory for Archaeology and the History of Art in March 1987 and thermo-luminescence tests suggested that it was fired between 1657 and 1777 (ref. 381-z-86).

Giuseppe MAZZUOLI (1644–1725)

58. St Philip

38.5 cms. (height); 14 cms. (length of base); 10 cms. (width of base)

Terracotta of a pale pinky orange with traces of red paint. Minor chips to edges of drapery (e.g. on saint's left arm). A slight firing crack behind the figure.

Purchased together with No. 57 from Messrs. P. & D. Colnaghi, Bond Street, where exhibited February and March 1964 (*Seventeenth and Eighteenth Century Italian Sculpture*, no. 20), with a grant of £1,000 made by the National Art-Collections Fund on 19 April 1965.

This terracotta *bozzetto* and its companion (No. 57) are related to two of the statues of the Apostles commissioned by 1679 for Siena Cathedral, executed in marble, apparently during the summer months of the years 1680 and 1695, and set up against the pillars of the nave in the latter year, replacing the trecento set which were placed in the skyline of the façade. The *St Philip* was being executed in marble in 1687 and the *St Matthew* in 1689. This was the most important commission given to Giuseppe Mazzuoli who was born in Volterra, brought up in Siena, and a protégé of Cardinal Flavio Chigi, 'Cardinale-nipote'—the Chigi being a Sienese family. Mazzuoli had studied in Rome under Ercole Ferrata and Melchiorre Cafà and had executed the figure of *Charity* on Bernini's tomb of the Chigi pope, Alexander VII (see L. Pascoli, *Vite de' pittori, scultori ed architetti moderni* (Rome, 1736), ii. 479–82; V. Suboff, 'Giuseppe Mazzuoli', *Jahrbuch der preußischen kunstsammlungen* (1928), 37; F. Pansecchi, 'Contribuiti a Giuseppe Mazzuoli', *Commentari*, 10 (1959), 35; E. Carli, 'Le statue degli Apostoli per il Duomo di Siena', *Antichità viva*, 7 (1968), 3–20). The Apostles were removed from the Cathedral in 1890 after almost forty years of fierce debate (D. I. Romano, 'Le statue degli Apostoli del Duomo di Siena ovvero una brutta pagina di storia senese', *Paragone*, 26 (Nov. 1975), 85–100). They were purchased for the London Oratory in the Brompton Road in June 1895 on the strength of photographs of them in a warehouse in Genoa (A. Laing, 'Baroque Sculpture in a Neo-Baroque Setting', in M. Napier and A. Laing (eds.), *The London Oratory: Centenary 1884–1984* (London, n.d. [1984]), 65–74). Other *bozzetti* connected with this commission survive. That for St Simeon Zelotes is in the City Art Gallery, Birmingham (see Heim Gallery, London, *Faces and Figures of the Baroque* (autumn 1971), no. 64); that for *St Paul* is in the Museo dell'opera del Duomo, Orvieto; that for *St John the Evangelist* was in 1965 in the possession of an American professor (purchased in Florence, coloured, somewhat larger—48 cms. in height—and with a square base); and gilded *bozzetti* for *Christ holding the Cross* and the *Virgin Mary*, two statues added to the series in Siena Cathedral but not purchased for the Oratory and now untraced, are in the Royal Scottish Museum, Edinburgh (also larger—46 cms. in height—see Heim Gallery, London, *Seven Centuries of European Sculpture* (summer 1982), nos. 21–2). Versions of several of

these *bozzetti* (*Paul, Philip,* and *Matthew*) are also to be found in the Fondazione Accademia Musicale Chigiana in Siena, as is the only recorded version of the *St Bartholomew*. The *bozzetti* for *Philip* and *Matthew* in Siena are larger (42.4 and 42.2 cms.) than those in Oxford, and more scratchily modelled in the head. That of *St Philip* is initialled 'D.B.' (M. Butzek, 'Die Modellsammlung der Mazzuoli in Siena', *Pantheon,* 46 (1988), 75–102, pls. 33–6). The inventory of the vast collection of models and casts belonging to the Mazzuoli family which was compiled in 1767 specifically mentions two *St Matthews* as original clay models by Giuseppe (ibid. 88, no. 102, and 91, no. 107) and there are other duplications of this sort. The attributions in the inventory are unlikely to be entirely reliable, and it certainly seems as odd that Mazzuoli should have repeated himself as it seems natural for one of his pupils or family to have copied him. Laing (op. cit.) notes the significance in this connection of the fact that a nephew of Mazzuoli made full-scale replicas of the statues for the Collegiata of Sinalunga. Hugh Macandrew (notes in the Department's files) points out that there is a relationship between the Ashmolean's *bozzetto* (probably representing St Philip) and a *St James the Less,* one of a series of wooden sculptures, about 2½ feet high, in the Museo dell'Opera del Duomo in Siena—another statue in the series, the *St Jude,* is also related to one of Mazzuoli's Apostles, but there is no reason to attribute these figures to Mazzuoli nor to call them *bozzetti* (as Enzo Carli does in *Il Museo dell'Opera e la Libreria Piccolomini di Siena* (Siena, 1946), 27).

The relationship between the Ashmolean's two *bozzetti* and the marble statues now in the Oratory has been admirably defined by Macandrew.

The St. Matthew is close to the full scale figure, except that in the latter the head is inclined more to the right and the Apostle looks directly at his gospel. In the larger format there is greater emphasis on the front plane. The *putto* is turned more to the spectator while the Apostle's left foot and drapery are brought more to the front. . . . The other statuette is obviously connected with the Oratory's St. Philip, the essential differences being that in the latter the Saint is shown with his usual attribute, a Cross, which he supports under his left arm. Apart from this however and also the fact that in the larger format the head is turned up to the left, correspondence is very close indeed. Facial features are exactly similar as indeed are his stance, the folds of the drapery and the position of the right arm holding the book . . . it is possible that the modification was the result of the instability which is plainly evident in the *bozzetto*.

Documents do in fact reveal that Mazzuoli modified his *St Philip* when he was carving it (Butzek, op. cit. 89 and n. 104).

After MICHELANGELO Buonarroti (1475–1564)

59. Aurora

10.8 cms. (height from support below figure's right elbow to top of head); 18.7 cms. (length); 23.5 cms. (length of figure from top of head to broken end of figure's right leg); 22 cms. (length of base); 9 cms. (height of base); 8.9 cms. (width of base)

Red wax. The figure's left arm and right foot are missing. A large patch has been repaired on the upper part of the figure's left thigh. Repairs are also evident on the upper and lower parts of the left leg. There is an incongruous addition to the lower part of the right leg. Old adhesive is apparent where the figure is broken and on the drapery below. The surface of the figure is pitted, scratched, and cracked. The wax is mounted on an old worm-eaten arched block of pine which retains on the square face behind the figure's back some original painted decoration consisting of a radial pattern of arabesques in gold against a dark ground with a gold border.

Gift of Chambers Hall, April 1855 (*Donations Book*, 28). Bought by him from one of the Woodburn brothers who bought it at a sale of Sir Thomas Lawrence's collection in 1830 (see below). Probably placed on display in 1856 (cf. No. 21). The wax is recorded in the *Handbook Guides* of 1859 and 1865 as on display with the paintings given by Chambers Hall in what is now the Founder's Gallery.

Michelangelo's marble statue of *Aurora* (Dawn) was executed between 1524 and 1531 for one side of the sarcophagus below the effigy of Lorenzo de' Medici duke of Urbino in the Medici Mausoleum in S. Lorenzo, Florence. It was never completed in the feet and drapery. An accurate small copy such as this wax might have been made as an exercise by another artist in the sixteenth, seventeenth, or eighteenth centuries. It could then have been adopted as a collector's piece, but is also finished enough to have been intended as

such. Such wax copies were certainly sought after. Pierino da Vinci made one of Michelangelo's *Moses* for his patron in the mid-sixteenth century, and early seventeenth-century Flemish paintings of collector's cabinets show small figures in red wax among the small bronzes of varied patina—for instance, the allegory of *Sight* signed by Jan Brueghel in 1617 (Prado, no. 1394) which includes a red wax statuette of the *Antinous* about 10 cms. high and what may be pink wax statuettes, rather larger in size, of *Aurora* companion with one of *Night* (from the tomb of Giuliano de' Medici).

The work is entered in the Museum's *Donations Book*, presumably in accordance with the donor's description, as 'Wax Model, original by Michael Angelo, being the figure of Night in the Medici Chapel, formerly in the possession of Sir Thomas Lawrence'. The appropriateness of adding it to a collection which included the drawings by Michelangelo which had also belonged to Lawrence is obvious. In the sale of Lawrence's collection at Christie's, London, on 19 June 1830, lot 346 was 'A Wax Model, by Michelangiolo, of one of the recumbent female figures executed by him in marble in the Sacristy of the Church of St. Lorenzo at Florence', marked down to 'Woodburn' for £14 3s. 6d. Presumably it was sold by Woodburn to Chambers Hall. Lawrence also owned a number of small groups and reliefs in wax attributed to Giambologna (ibid., lots 348, 349, 350, 357), of which two, bought at his sale by Richard Ford, survive in the collection of Sir Brinsley Ford (for one of these see No. 46). It is likely to be the reclining statuette mounted on a buhl plinth in the foreground of an anonymous engraving of Lawrence's sitting room in 65 Russell Square (K. Garlick, *Sir Thomas Lawrence* (Oxford, 1989), 27, fig. 4).

Probably an Italian goldsmith, perhaps of the seventeenth century.

After MICHELANGELO Buonarroti (1475–1564)

60. Pietà

14.6 cms. (height of group); 6.7 cms. (height of plinth);
12.25 cms. (length of plinth); 7.6 cms. (width of plinth)

Bronze with a pale chocolate patina, evidently an alloy very rich in copper. Thin-walled, lost-wax, cast, open behind. All projecting elements seem to be hollow except perhaps for the right arm of Christ. The Virgin's thumb is broken off and there are dents in both of Christ's knees (damage already recorded in Fortnum's catalogues and photographs). A brown-red wax has been used to plug a small hole within the deepest fold of drapery on the proper right side of the group; other pin-sized holes remain in this area. Set in a plinth, rectangular in plan but with the front corners chamfered, made of a solid block of *rosso antico* with *nero antico* mouldings above and below. This is unlikely to be original, not least because the irregular form of the integral rock-work bronze base does not fit perfectly into the aperture for it and is surrounded by disfiguring cement. It looks like an Italian eighteenth-century plinth. The bronze is painted 'B. / 434. / Œ.' in white on its hollow rear.

Lent by C. D. E. Fortnum in March 1888, given later in the same year. B. 434 in his catalogues. No. 8, p. 38, in his preliminary catalogue of 1857, where it is stated to have been bought in Rome in 1851. On a sheet entitled 'Memoranda of Prices paid' it is listed as an item acquired in or before that year, for 12 *scudi*, together with the small bronze *Spinario* and the *Venus*, i.e. the bathing woman after Giambologna, No. 39 (for 18 and 20 scudi), the total of 50 scudi translating as £10 12s. 6d. (The entries for these latter items in the preliminary catalogue both conclude 'Rome 51', which confirms this date.)

Fortnum in his preliminary catalogue described this bronze as of 'very light font' and of the 'highest quality and finish'. He thought it Florentine and 'worthy of Cellini'. In the notebook catalogue he considered it late sixteenth century, 'probably' Florentine, and 'possibly' by Annibale Fontana to whom a *Crucifixion* in the South Kensington Museum (Victoria and Albert Museum 7440-1860) was then attributed. Finally, in his large catalogue, he suggested that it was perhaps an example of Florentine goldsmith's work of the early seventeenth century. This last proposal seems highly probable; but it might be later in date. It is a work of very meticulous and miniature workmanship, equalled in this among the Ashmolean Museum's bronzes only by Nos. 385 and 386—also early acquisitions of Fortnum's. The rippling edge of the robe, the blood from Christ's wounds, and the nails of fingers and toes are especially remarkable.

Michelangelo's marble *Pietà*, today in St Peter's, Rome, was commissioned for the church of S. Petronilla, by Cardinal Jean Villiers de la Groslaye, probably in 1497 and is supposed to have been completed by 1500. If the model for this bronze was made directly from the marble then it must have been executed before 1736 when four broken fingers of the Virgin's left hand were incorrectly restored by Giuseppe Lironi—the hand here corresponds to that in the sixteenth-century engravings. Small bronzes were being made after

Michelangelo's marble sculpture during the sixteenth century when Pietro da Barga made one of the *Risen Christ* of S. Maria sopra Minerva. The *Pietà* was copied in marble by Nanni di Baccio Bigio for the Florentine church of S. Spirito where it was installed in March 1549, so a model for the bronze statuette could easily have been made in Florence after that date.

While faithful in all essentials, the more minute particulars in the Ashmolean bronze do not correspond with those in the original. For instance, in the marble, the folds in the cloth over the Virgin's head are more broken; the Virgin's thumb as well as her fingers appears beneath Christ's right arm, and the fingers are opened; the rock-work base is more extended to the left of the base and is not so apparent in front of the group. The Ashmolean bronze is indeed less close to the original—and far more artistic in its modifications—than the other bronze copies of the group, all of which are between two and three times larger (Frick Collection, New York— formerly Pierpont Morgan and Pfungst Collections, for which see J. Pope-Hennessy and A. F. Radcliffe, *The Frick Collection ... Italian Sculpture* (New York, 1970), 196–8; another with Jacques Seligmann & Co., New York, in February 1937 when loaned to *Master Bronzes*, an exhibition at the Albright Art Gallery, Buffalo—reproduced in the catalogue as no. 136; another sold Sotheby's, London, 10 April 1975, lot 85; and a fourth, with different drapery on the Virgin's chest, lot 111 at Christie's, London, 3 July 1985).

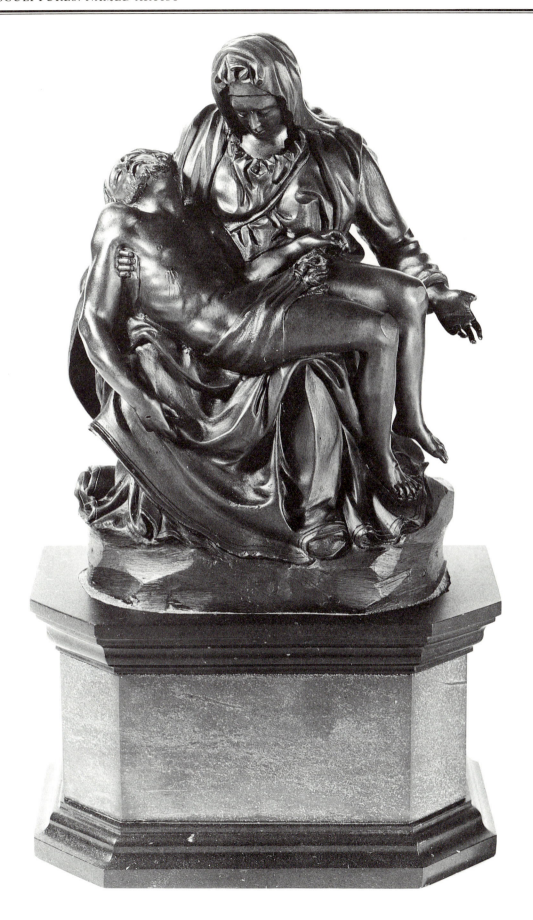

Probably a French modeller and foundry of the late
seventeenth century

After MICHELANGELO Buonarroti (1475–1564)

61. Moses

39.8 cms. (height); 18.4 cms. (length from front of sandal to back
of block); 8.1 cms. (width of block at base excluding the left foot
of Moses)

Bronze with warm slightly green brown natural patina with much
varnish, in places now black, especially in the hollows. Hollow, lost-
wax, cast. The walls are of irregular thickness, with small perforations
in the folds of drapery where the bronze is thinnest. The figure is
open below and some core remains in the prophet's left foot. In
some parts the cast is imperfectly cleaned (see the folds of drapery
around the neck); in others, such as the head, it is boldly but precisely
chiselled. Remains of a small paper label with the word 'Coll.' printed
in red are on the block in front of the prophet's left foot.

Lent by C. D. E. Fortnum in October 1894 and bequeathed in
1899. B. 441 in his catalogues. 'Bought at Christie's £30.'
Presumably after 1857 when the preliminary catalogue, in which it
is not mentioned, was compiled. Placed in the Students' Room of
the Heberden Coin Room in 1956.

Michelangelo's celebrated marble *Moses* was carved for the
tomb of Pope Julius II. The tomb was first conceived in 1505
but the statue probably dates from 1513. It was abandoned
in 1516 and set up in its present position in S. Pietro in
Vincoli, Rome, in 1542. Small copies began to be made soon
afterwards: according to Vasari one in wax was made by
Pierino da Vinci. Fortnum supposed this 'finely executed
reduction after the statue by Michel Angelo . . . of rich
coppery metal & fine dark patina', to be Italian of the
seventeenth century or of the earlier years of the eighteenth
century. Fortnum's dating may well be correct, but the bronze
might be French rather than Italian. In any case it is in France
that bronze statuettes of the *Moses* are found. Most notably
in the Paris Salon in 1699 (*Livret*, 13) a group was exhibited
consisting of a *Christ*, *Moses*, and *John the Baptist* on a pedestal
'de marqueterie' (possibly buhl) and symbolizing the 'union
de l'Ancien et du Nouveau Testament par le venue de Jesus
Christ'. The *Christ* was by 'François Flamand' (that is 'Il
Fiammingo', Duquesnoy), the *Moses* by 'Michel Ange', and
the *John* by M. Girardon. The 'by' is misleading and it is
surely possible that all three works were modelled by Girardon,
although only the last was his invention. The group also
features in the engravings, and in the posthumous inventory,
of Girardon's collection—'le tout de Bronze mais sur un pied
d'Estail de Marquetrie enrichi d'ornament dorez dor moulu'.
The engravings reveal that Girardon rejoiced in making
groups out of works of art independently conceived, but these
seldom have a symbolic significance such as was suggested
here. (F. Souchal, 'La Collection du sculpteur Girardon,
d'après son inventaire après décès', *Gazette des beaux-arts*,
82 (1973), 38–9, no. 16, fig. 17).

Bronze statuettes of *Moses* of both a larger and smaller size
than the Ashmolean's are known: one 68.4 cms. high, thin-
walled, with a ruddy varnish, was no. 35 in J. Fischer, *The*

French Bronze 1500–1800, catalogue of an exhibition at
Knoedler and Co. (New York, 1968), no. 35; another 34 cms.
high, thin-walled, with a blackened red varnish, is in the
reserve collection of the Victoria and Albert Museum (A.84-
1910); a third, of high quality and very close in size to the
Ashmolean's bronze, was lot 139 at Sotheby's, New York, 22
June 1989. Souchal (op. cit.) notes that a bronze *Moses*, '11
pouces, 9 lignes de haut', was included in the Royal French
inventory of 1707 (unpublished MS, fo. 899) and that one
'15 pouces de haut' was in that of Cardinal Richelieu
(L. Boislisle, 'Les Collections des sculptures du Cardinal de
Richelieu', *Mémoires de la Société Nationale des Antiquaires
de France*, 42 (1881), 87). The latter converts to a
measurement only half a centimetre higher than the
Ashmolean's bronze so that the two are likely to be cast by
the same foundry or at least from the same model.

It is noteworthy that reproductions of Michelangelo's *Moses*
were not among the bronze statuettes offered for sale in
Rome in the late eighteenth century by Righetti and Zoffoli.
On the other hand the Barbedienne foundry did make sand-
cast bronzes of inferior finish and after mechanically
reduced models in the mid-nineteenth century.

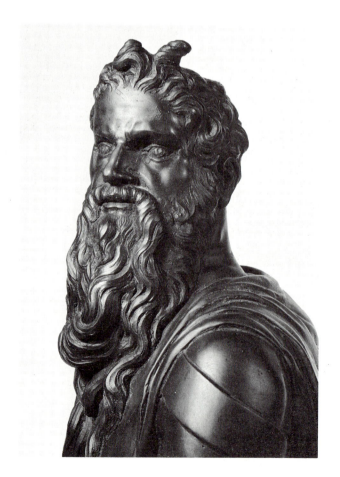

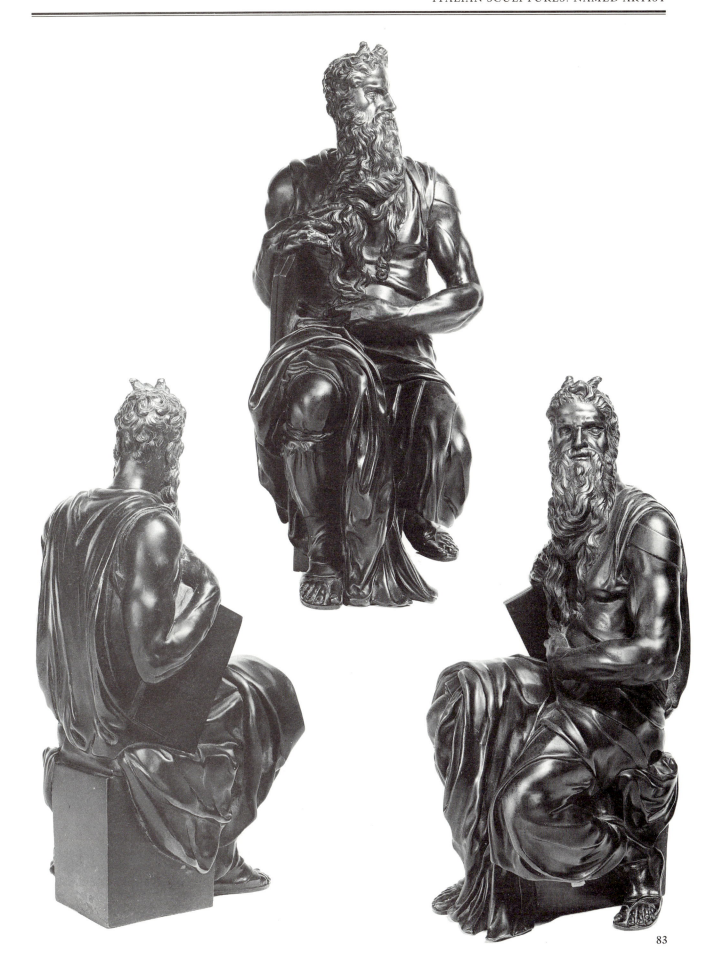

Nineteenth-century foundry, probably French or Belgian

After MICHELANGELO Buonarroti (1475–1564)

62. Giuliano de' Medici

93.6 cms. (height); 33.3 cms. (length of plinth); 36 cms. (width of plinth)

Bronze with a natural pale greeny-brown patina. Hollow, sand-cast, in five pieces: the head; the figure's right arm from the shoulder to the hand, including the top portion of the baton; the figure's left arm from near the shoulder to the wrist; the figure's right leg, including a portion of the plinth; the rest of the figure including most of the plinth. Some of the joins are fine (that on the top of the neck especially so, although the rivet is very apparent) while others are crude. Piece-mould seams are visible in some places (e.g. his left shoulder). Much patching of casting flaws has been carried out in a different coloured alloy: the patch below the figure's left forearm is apparently of lead. The metal is imperfectly cleaned and only in a few areas of flesh, most obviously the head, is it fully polished. See also below.

Given by R. P. B. Davies 'late of 28, Wellington Square' [Oxford]. Registered on 23 March 1960.

The seated effigy of Giuliano de' Medici, duke of Nemours, brother of Pope Leo X, may have been first conceived by Michelangelo when he took on the planning of a new Medici Mausoleum in S. Lorenzo in 1520, and is probably the effigy which documents suggest to have been well advanced by June 1526. It was placed in its niche before the autumn of 1534. This effigy was the most finished of the figures in the chapel (only the projecting right foot requiring further work). All the allegories and effigies of the Medici Mausoleum were much reproduced in France in the nineteenth century from models reduced by the machine invented by Collas which were cast by the Barbedienne foundry. The figures of *Day* and *Night* had been appropriately adapted as clock ornaments in both the early and late eighteenth century (see H. Ottomeyer and P. Pröschel, *Vergoldete Bronzen*, 2 vols. (Munich, 1986), i. 45 and 296; ii. 481). In the middle of the nineteenth century Collas and Barbedienne devised a massive chimney-piece clock involving not only the allegories of the times of day but the effigy of Lorenzo as 'Le Silence', approximately 30 inches high. The Barbedienne catalogue of 1862 includes all six statues from the Medici tombs (see M.-T. Baudry, Ministère de la Culture, *La Sculpture* (Paris, 1978), 326). Other foundries also reproduced these figures, among them the firm of Sauvage, which also incorporated Lorenzo's effigy into a mantel clock (see lot 98, Christie's, London, 28 September 1989), and the 'Compagnie des Bronzes Bruxelles', one of whose casts of Lorenzo, 71 cms. in height, was lot 62W, Sotheby's, London, 10 June 1988, and another, of the same size, lot 302W, Sotheby's, London, 5–6 November 1987. The Ashmolean Museum's bronze of Giuliano is unmarked but this is unsurprising since it is also unfinished. Given the patching, a darker artificial patina was obviously meant to be applied, but there would also have been much tooling to sharpen the detail and to make the joins less apparent. However improved, it is hard to believe that this would ever have been mistaken for anything other

than a mechanical reduction—and one made from a plaster cast. Undercutting is avoided, for instance in the baton, and the drapery escaping from the armour on the figure's left has not been understood.

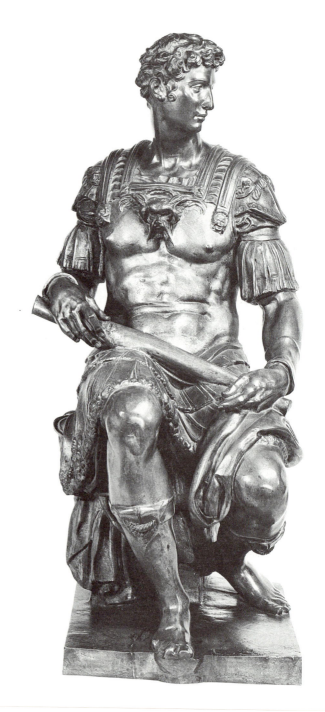

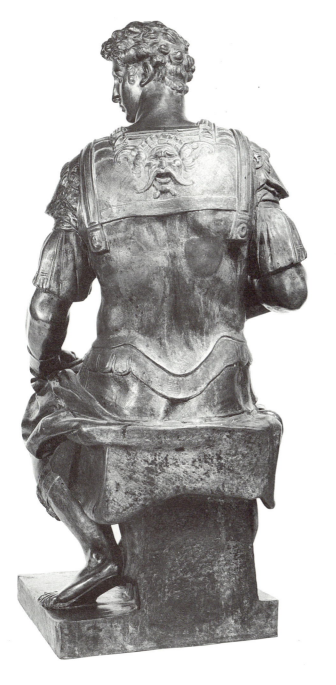

Style of MICHELANGELO Buonarroti (1475–1564)

63. Keyhole escutcheon in the form of a grotesque winged mask

8.9 cms. (height); 11.8 cms. (width, wing-tip to wing-tip)

Bronze, fire-gilt.
Attached to the 'Fitzwilliam Coin Cabinet', for which see No. 35.

As discussed elsewhere in this Catalogue (under No. 35), some of the ormolu mounts on the *pietra dura* cabinet are likely to be original. The scroll feet, tendril volutes, and leaves may well be cast after models by Giovanni Battista Foggini but this escutcheon perhaps came from another, earlier, piece of Florentine furniture. It is a typical variation on a theme in Michelangelo's art, best represented by the front and back of the breastplate of the effigy of Giuliano de' Medici in the Medici Chapel in S. Lorenzo, Florence (for which see No. 62). Whereas such grotesque masks are most characteristic of the second half of the sixteenth century they continued to be popular in Florence in the seventeenth century and a distinct echo of them is found in some designs of the eighteenth century such as the handles of vases by Clodion (see Nos. 262, 263) or the keyhole escutcheon of the silver microscope of about 1763 made for King George IV when prince of Wales by George Adams (Science Museum, London).

Egidio MORETTI (active between 1611 and 1638, d. after 1651)

64 and 65. Pair of Romans in consular dress

213 cms. (height of No. 64, including integral plinth); 8 cms. (height of 64's integral plinth); 56 cms. (length of 64's integral plinth); 216.5 cms. (height of No. 65, including integral plinth); 10 cms. (height of 65's integral plinth); 77 cms. (length of 65's integral plinth)

White marble of uncertain origin. The surface is severely weathered and discoloured with ingrained dirt (especially in the case of No. 65). There is a horizontal crack in No. 64 at hip level. The head of No. 64 looks original but was 'pieced' (carved from a different block of marble) and inserted with the neckline of the drapery concealing the join. It is now loose and the join is very evident. A rusty iron cramp is exposed behind the neck. The scroll held in the figure's left hand and two fingers and the thumb of the hand itself have been broken off and replaced, with considerable additions in plaster. The irregular shape of the plinth is unlikely to be original. The head of No. 65 appears to have been carved out of the same block as the body and the plinth but has been broken off and replaced: a large chip below the break is missing. The nose has been restored: the replacement is loose and of a darker colour. A large part of both forearms has been broken off and is missing. The figure's right stump has been cut and drilled to receive a new forearm and an iron cramp, but neither are now in place.

Given to Oxford University by the dowager countess of Pomfret (see Nos. 516, 517) in 1755. For the provenance see Nos. 66 and 67. The statues may be discerned in William Westall's drawing of the sculpture gallery in the Old Schools signed in 1813. After transfer to the University Galleries they were certainly among the statues described in the Crypt or Sub-Gallery but whereas one is surely described there as 'a statue of a Roman Consul', the identity of the other is uncertain—it may be 'a statue of Demosthenes'

(*Handbook Guide* (1859), 23). No. 64 was taken out of storage in the mid-1970s and placed on display in a niche in the Randolph Gallery on the initiative of Michael Vickers.

For Moretti and Arundel see Nos. 66 and 67. Although apparently not intended by Arundel as portraits, one at least of these statues had, like both companion Roman warriors, assumed a specific identity by the eighteenth century. Vertue described one of them as 'A statue very noble, and bigger than the life of Quintus Fabius Maximus, in his senatorial robes (a true antique as are both the Scipios), the l. hand is wanting, the r. held up in a speaking posture'. The other was merely 'a fine statue of a Senator in his robes' (quoted in J. Hess, 'Lord Arundel in Rom und sein Auftrag an den Bildhauer Egidio Moretti', *English Miscellany*, 1 (1950), 209). It is surprising that Vertue considered the statues to be antique. That the figures were modern does, however, seem to have been acknowledged in Oxford for Chandler did not include them in his *Marmora Oxoniensia* of 1763. It had been forgotten again by the time of the *Handbook Guide* of 1859 in which they are recorded as antique. Michaelis regarded No. 65 as 'very effective, but the whole statue seems to be new' and No. 64 to be of 'similar style' but 'coarser execution' and 'likewise the work of a very clever modern imitator'. Michaelis noted that No. 64 was wearing the pallium, the common outer garment of a Greek citizen, and 65 the Roman toga, although in an unusual arrangement (*Ancient Marbles in Great Britain* (Cambridge, 1882), 553–4, nos. 46 and 47), but it is clear from Arundel's contract with Moretti that both figures were intended to represent Romans in consular dress.

Egidio MORETTI (active between 1611 and 1638; d. after 1651)

66 and 67. Pair of Roman warriors

224 cms. (height of No. 66 including integral plinth); 11 cms. (height of 66's integral plinth); 76.5 cms. (length of 66's integral plinth); 226.5 cms. (height of No. 67, including integral plinth); 8.5 cms. (height of 67's integral plinth); 79 cms. (length of 67's integral plinth)

White marble of uncertain origin. The surface is severely weathered and discoloured with ingrained dirt (especially in the case of No. 67). There is a crack across the plinth of No. 66. A large chip is missing from the front of the helmet, and also from the drapery at the figure's right elbow. The pommel and the blade of the sword have been broken off and do not survive. The figure's left arm has also been lost; its stump retains an old hole for securing an addition and the marble may have originally been pieced here. In the case of No. 67 a large portion of the cloak crossing the chest has been broken off and lost, as has the figure's left arm and the sword in his right hand, together with part of the hand itself. The nose and lower lip are missing, the surface of both places has been cut to a convenient flat surface, scored, and fitted with an iron cramp from which restorations have since become detached. A small iron cramp is also evident in the figure's right hand. 'AEGIDUS. MORETTUS. / ROMMANUS.FACIEBAT' is chiselled on the side of each plinth to proper left.

Given to Oxford University by the dowager countess of Pomfret (see Nos. 516, 517) in 1755. The sculptures are the 'homini armati' which Moretti contracted to make for Thomas Howard, 2nd earl of Arundel, on 10 June 1614 in Rome together with a pair 'in abito alla consolari' (Nos. 64 and 65) and which were all completed by 25 January 1617 (J. Hess, 'Lord Arundel in Rom und sein Auftrag an den Bildhauer Egidio Moretti', *English Miscellany*, 1 (1950), 199–200; also, for a transcription of the contract, D. Howarth, *Lord Arundel and his Circle* (New Haven, Conn., and London, 1985), 229–30 n. 40). The statues were acquired with a large portion of the Arundel marbles by Lady Pomfret's father-in-law Sir William Fermor (later Lord Lempster) from the 6th duke of Norfolk in 1691 and were for some years kept in the gardens of the family seat of Easton Neston, Northamptonshire, although by 1632 they had 'latterly almost all' been taken within doors ('The Vertue Notebooks', iv, *Walpole Society*, 24 (1935–6), 40). In Oxford the statues were displayed in the Old Schools and then transferred to the University Galleries where they are recorded in the *Handbook Guide* of 1859 in the Crypt or Sub-Gallery but visible to the public (pp. 23–4 as 'statues of Roman Emperors', nos. 113 and 119). They remained on display until the 1870s when they seem to have been put in store. In the late 1940s they were declared to be 'lost' (one enquirer observed that the Museum's basement must have been remarkably compendious for colossal statues to disappear in them). They were traced by the mid-1970s when one statue of this pair, No. 66, was placed on display in a niche in the Randolph Gallery on the initiative of Michael Vickers.

Egidio Moretti was a minor sculptor working in Rome in the early seventeenth century. He is documented as supplying sculpture for the Borghese Chapel in S. Maria sopra Minerva in 1611 and statues for the skyline of the façade of St Peter's in 1613, also as restoring antiquities for the Quirinal Palace in 1623 and making a tomb for S. Bartolomeo in 1638

(Hess, op. cit. 213–14; see also S. Pressouyre, *Nicolas Cordier*, 2 vols. (Rome, 1984), i. 219 n., 303 n., and ii. 393). The contract between him and 'Signor Tommaso' was for the four statues (these two warriors and the two men in consular dress, Nos. 64 and 65) to be ten *palmi* high and made within a year—'160 di moneta di paolo 10 per ciascuna statua finita nel modo sopradetto: in questo modo cioe scudi 60 ogni tre mesi anticipata da comminciare dal giorno che comminciera il lavoro et cosi sequitare fino al intiero pagamento facendo pero il lavoro che merita et denaro che se gli dara'. It is surprising that Arundel employed such a minor sculptor, but Moretti may have seemed to be a promising young man and when Arundel arrived in Rome in 1613, the better-established sculptors, such as Stefano Maderno, Pietro Bernini, and Nicolas Cordier, were fully employed. He may also have employed Moretti as restorer of the antique statues which he had acquired or which he hoped to acquire in Rome (certainly those exported in his name in 1626 were restored, as is clear from the document cited in No. 139). The four statues were evidently designed to be displayed in niches or against a wall for although the backs are finished they are of no interest. Contracts are not always an infallible guide to the precise identity of works of art but, if portraits of particular Romans were intended, then it seems likely that this would have been mentioned. By the eighteenth century, however, Vertue described them as 'Two fine statues of the Two Scipio's in their general's habit, very perfect and exceeding fine' (quoted in Hess, op. cit. 209). He believed them to be 'true' antiques, but when in Oxford they must have been recognized as modern works—Moretti's name is on the plinths and Lord Arundel's heraldic animals are carved on the fringes of the cuirasses—and they were not included in Chandler's *Marmora Oxoniensia* of 1763. In character they may be compared with the statues of Romans, and of modern rulers in the guise of Romans, found, for example, in Palladio's Teatro Olimpico in Vicenza, in the Sala del Duecento of Palazzo Vecchio in Florence, and, above all, in the Palazzo dei Conservatori in Rome—some, if not all, of which Arundel must have seen. The style of armour, the belt over the cuirass, and the treatment of the cloak recall Cordier's great bronze statue of *King Henry IV of France* erected in the Lateran in 1609 and the helmets on the plinths recall those in his unfinished statue of *St Sebastian* of 1604–5 in the Aldobrandini Chapel in S. Maria sopra Minerva (Pressouyre, op. cit., pls. 64 and 136).

Francesco Maria NOCCHIERI (active mid- to late seventeenth century)

68. Apollo, seated holding his lyre, attentive to the Muses

46 cms. (height); 25.75 cms. (length of base); 17.2 cms. (width of base)

Red terracotta with a pale pinky grey slip thickest where gathered in the hollows so that the salient ridges of the hair and clawed texture of the ground are pronounced. The projecting drapery is broken off behind the figure's right arm, as is the foremost loop of the drapery behind his left arm; the figure's right hand has been broken off very neatly.

Purchased apparently in 1950, but never registered and 'mislaid' 1965—6 (see below).

Queen Christina of Sweden commissioned a marble statue of Apollo from Nocchieri to complete a group of eight antique Muses which she had acquired. She projected a Chamber of the Muses for the sculptures in her palace (formerly Palazzo Riario, subsequently Palazzo Corsini) in the Via della Lungara in Rome after she was installed there in July 1659. The Muses were placed between sixteen Corinthian columns of *giallo antico* with gilded stucco captials against frescoes of landscapes—the *Apollo* was on a broader base in the centre of the short wall opposite the chief entrance (*Christina Queen of Sweden—a Personality of European Civilization* (Nationalmuseum, Stockholm, 29 June–16 Oct. 1966), 321, no. 741, pl. 62). Little is known of Nocchieri. He was a protégé of Cardinal Azzolini coming, like Azzolini, from the *Marche*, and is said to have died young. He executed the monument commemorating Queen Christina's visit to the Capitol in 1656 (Sala dei Magistrati, Palazzo dei Conservatori)—a work of very poor design featuring a very unhappily modelled and poorly executed bust of the Queen. The terracotta is a work of a different order. The still life at the god's feet alone suggests exceptional talent.

The queen's collection was bequeathed in 1689 to Cardinal Azzolini, who died a few weeks afterwards, and was then sold (for the most part) in 1692 by his heir, Marchese Pompeo Azzolini, to Don Livio Odescalchi, nephew of Pope Innocent XI. In 1713 Odescalchi's collection was inherited by his cousin Baldassare d'Erba who sold the *Apollo* and Muses to Philip V of Spain in 1724. The Muses are now in the Prado in Madrid while the *Apollo* has, for over half a century, formed part of a fountain in the gardens of the Palace of Aranjuez. His rock-work seat crowns a miniature mountain of similar rocks cut into steps in front down which water can run into a basic fringed with simulated stalactitic rock. Behind the god is a curved screen of six Corinthian columns connecting two piers crowned by putti supporting bases.

The Ashmolean Museum's terracotta was acquired with an attribution to Michelangelo Slodtz. It was recognized as a *bozzetto* for Nocchieri's *Apollo* by Ian Lowe, Assistant Keeper in the Department, in February 1966 after he had seen a slide of an engraving of the latter in one of Carl Nordenfalk's Slade Lectures. Thanking Mr Lowe for communicating this

discovery on 5 March Professor Nordenfalk asked that the terracotta be added to the list of items in the Ashmolean Museum which the Council of Europe were requesting for the exhibition on Queen Christina at the Nationalmuseum in Stockholm. On 9 March Mr Lowe replied that, after an extensive search, the terracotta could no longer be found. On 17 June, Luke Herrmann, another Assistant Keeper, reported to Nordenfalk that the terracotta had been retrieved, having been advertised by a 'London dealer' in the *English Art Journal*. It had been stolen from the Museum. Because the matter was 'in the hands of the police' the statuette could not be loaned.

Comparison with photographs of the marble statue kindly sent to the Museum in November 1986 by the Patrimonio Nacional show that there are only minor differences—in the marble version the lyre has an acanthus leaf ornament on its arms, the rock-work is of a different pattern so that the god's right foot is placed higher, the quiver beside his right foot is reversed so that, now that it is on a slope, the arrows do not slip out (most of the bow is missing but seems to have been of the same type), the posture and character of the head with its pronounced corymbos approximate more closely to those of the *Apollo Belvedere*, and the left hand is placed differently on top of the lyre. This last-mentioned difference may

however be due to erroneous restoration, for the hand of the marble *Apollo* is missing (as are some of the fingers of his right hand) in the photograph kindly sent to the Museum by Jennifer Montagu on 9 October 1967 ('a small present from Spain, just in case you mislay the terracotta again'). The god's left hand as represented in the (admittedly not entirely reliable) print by Francesco Aquila, plate CXI in the *Raccolta di statue antiche e moderne*, published by Domenico de' Rossi in Rome in 1704, is closer to the terracotta than to the marble as it is today. The print also shows a plectrum in the god's right hand which has been restored in the marble version with the open gesture of the *Apollo Belvedere*. This plectrum would be an unlikely addition for Aquila to make and it is also mentioned by P. A. Maffei in his commentary on the plate. Maffei (p. 104) describes Nocchieri as a 'discepolo del Cavalier Bernini'. He also makes the amazing claim that the *Apollo* is a portrait of the queen of Sweden—'e gli fece nel volto i lineamenti della medesima Reina, che veramente dir si potea la madre delle muse'.

A sample was taken from the figure by Mrs Doreen Stoneham of the Oxford Research Laboratory for Archaeology and the History of Art in March 1987 and thermo-luminescence tests suggested a firing date between 1677 and 1787 (ref. 381-z-95).

Nocchieri, *Apollo*
Aranjuez, Spain

Possibly NOVE factory near Bassano (flourished from 1760s)

69. Hercules resting

22.2 cms. (height); 18.6 cms. (length of base excluding the projecting foot); 15.7 cms. (width of base)

Hard-paste porcelain. The hollow figure has been filled with cement to consolidate it. The glaze has been worn in the hair. The figure's right foot is discoloured yellow. There is a firing crack beside the club on the base, another in the figure's left heel, beside the lion skin over the base to the proper left, and another more serious, across the back of the base. 'NON PLUS / ULTRA' is incised in the model on the side of the base beside the figure's right leg. There are two holes in the rock-work platform behind the figure. That to proper left is approximately one centimetre in diameter—that to proper right was intended to be the same size but coincides with a firing crack. '1971.328' is painted in red on the underside of the figure.

Bequeathed by W. R .B. Young in October 1971 together with a considerable collection of porcelain, mostly Meissen and Chelsea. This item was said to have come from the collection of the earl of Shrewsbury, Ingestre Hall. Mr Young was a retired solicitor who was, for some while before his death, a resident of St Cross Hospital, Winchester, a Church of England home for the destitute, from which he had concealed his wealth and the value of his collection—'really only a poor jackdaw's collection', 'made since the Hitler War out of a very small income' (letters to the Department of 27 February 1962 and 3 February 1969).

In Mr Young's own list of his collection made on 14 September 1968 in blue biro on blue paper this figure was described as 'Buen Retiro' (? Capo di Monte)'. The 'Buen Retiro' was struck out by Mr Lowe, in whose hand also the provenance recorded above was added ('Lord Shrewsbury'). Young had been a friend of George Savage, the well-known ceramic expert, and the attribution may have come from him. There is another version of the figure in the collection of Sir Brinsley Ford which comes from the collection of his ancestor Richard Ford (1796–1858) and has an old label inscribed 'The Famous Torso / of the Belvedere / in the Vatican / by Apolonius'. A third version is in the Metropolitan Museum, New York (Charles E. Sampson Memorial Fund, 1981.412; published *Notable Acquisitions* (1981–2), 29–30). Of this last version it has been observed that 'the clear white hard paste and lustrous glaze are not those of Doccia or Cozzi; the presence of numerous fire-cracks suggests a factory not yet in control of work of this kind ... It may have been made at Le Nove, northwest of Venice, in the little known early period of that factory' (entry by C. le Corbeiller in *Notable Acquisitions* cited above). This attribution is strengthened by the Ashmolean and Ford examples which are of different, darker body and have a less lustrous glaze. The treatment of the rock-work base and the robust classicism of the figure is similar to that of some of the ambitious earthenware groups produced by the Nove factory – such as the allegorical ensemble of three virtues in the Museo Civico, Bassano del Grappa (reproduced in J. Fleming and H. Honour, *The Penguin Dictionary of Decorative Arts* (London, 1977), 566). No explanation for the space and the holes behind Hercules

seems to have been advanced but it might have been devised to enable the figure to be attached to an ensemble of precisely this kind. Despite the connection, made already in the early nineteenth-century label on the example in the Ford Collection, with the *Belvedere Torso* (for which see No. 135) , the similarity is not remarkable.

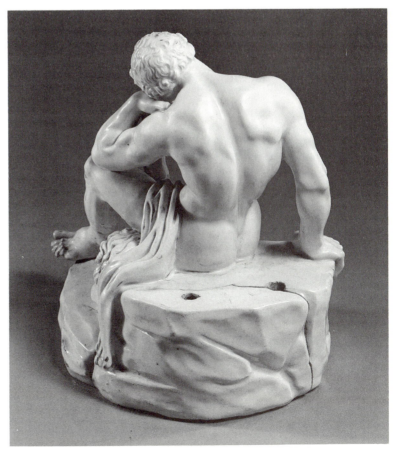

Probably by Giuseppe PIAMONTINI (1664–1742)

70 and 71. Jupiter riding upon his eagle and Juno reposing upon the clouds holding her sceptre and peacock

44.4 cms. (height of No. 70); 46.5 cms. (height of No. 71); 17.4 cms. (length of base of 70); 16.9 cms. (width of base of 70); 20.2 cms. (length of base of 71); 18.5 cms. (width of base of 71)

Bronze with a chestnut brown patina, with very dark brown varnish, golden brown in parts and perhaps originally golden all over. Hollow, cast in pieces. In the case of No. 71, the clouds and, in the case of No. 70, the clouds and eagle are separately cast, although the joins are almost invisible (but the right foot of Juno clearly was not cast with the clouds below). In the case of Juno her sceptre is cast separately (see below), also her right forearm and her left arm at contact with drapery in the former case, just below it in the other. Jupiter's right arm is separately cast and joined just below his shoulder (the line is almost invisible, but is more apparent in the Philadelpha version). The head and torso of the Jupiter is cast separately from the drapery and legs. The upper portion of the body of Juno is cast separately from the lower part which is probably cast with the peacock—the join is concealed by the tail of drapery blown across the upper thighs. Much evidence of tooling; the hair, plumage, and clouds chiselled and punched.

Given by Mrs J. C. Conway in 1959. Registered on 18 December 1959. The sceptre of Juno ('which turned up at Spring cleaning time') given in July 1960. Stated by the Keeper, Ian Robertson, in the *Annual Report* for 1960 to have 'come from the Borghese Palace Collection in Rome'. The Borghese provenance must be considered unproven. It is given for both bronzes (nos. 87 and 91) and for two others (nos. 88 and 90, a *Venus and Cupid* and a *Bacchus and Ariadne*) in the Bardini catalogue (*Catalogue des objets d'art provenant de la collection Bardini dont la vente aura lieu à Londra chez Mr Christie* (Florence, 1899) and separate plate volume, pl. IV). They were sold together as lot 434, Christie's, London, 5–7 June 1899. The provenance was then repeated when the figures reappeared as 'Jupiter and Juno . . . a pair of Louis XIV groups' lot 174 of the sale at Christie's, London, of 'the Collection of Fine French Furniture Objects of Art and Porcelain formed by L. Neumann Esq and removed from 11 Grosvenor Sq.' when they were purchased by 'Clements' (code for Wertheimer) for £714. They were offered again at Christie's on 16–17 June 1920—the sale sale of 'the remaining stock of French Furniture, Porcelain and Objects of Art of Mr Asher Wertheimer Deceased late of 158 New Bond Street'. Bought in by Mrs Conway's husband (who had changed his name from Wertheimer). The bronzes seem always to have been on display: at first on pedestals in the Fortnum Gallery: more recently in the Weldon Gallery.

The two groups were registered and recorded in the *Annual Report* as 'probably the work of Michel Anguier (1612–86) . . . related to a considerably larger pair of fire-dogs in the Wallace Collection, which are by Anguier after Alessandro Algardi'. An almost identical pair of the figures in the Philadelphia Museum of Art (Wilstach Collection, W. 68-1-1 and W. 68-1-2) were attributed to Giovanni Battista

Foggini. The attribution to Piamontini was proposed by Jennifer Montagu in 'Some Small Sculptures by Giuseppe Piamontini', *Antichità viva* (1974), unpaginated. Piamontini studied under Giovanni Battista Foggini and, from 1681 until 1686, attended the Academy founded in Rome by the Grand Duke Cosimo III, working under Ercole Ferrata on tomb sculpture, narrative reliefs, large statues of saints, and portrait busts. According to his own account, groups and statues of marble and bronze by him were sent (presumably from Florence) 'in Roma, Bolognia, Prussia, Londra, al Reno, e Scozzia, e Inghilterra' (Autobiographical note printed in K. Lankheit, *Florentinische Barockplastik* (Munich, 1962), doc. 46, p. 232).

Montagu noted that among the models in the inventory made for the Doccia ceramic factory established in 1743 by Senator Carlo Ginori were three attributed to Piamontini: a 'Giove con Aquila, sulla base', corresponding, she proposed, with the polychromed porcelain figure in the Museo Civico, Turin (her fig. 4), and an 'altro Giove piu piccolo sedente sull'Aquila' together with a 'Giunone', which, she proposed, correspond with the bronzes in the Ashmolean. A Jupiter group is also mentioned among Piamontini's models by Baldinucci. A version of the bronze group on a wall bracket is to be seen in Thomas Patch's painting of a party of dilettanti at the home of Sir Horace Mann (Chatsworth, Derbyshire). Ceramic versions would presumably have served a similar purpose, but the bronzes probably originated as ornaments for fire-dogs (Jupiter with his thunderbolt representing the flames, and Juno the air which a good fire requires), and were certainly inspired by groups modelled by Algardi for this purpose. The suggestion that the bronzes might be made in France is also understandable since Parisian founders were to become masters at joining bronzes cast in numerous pieces (see No. 341), a task which is accomplished so skilfully here. This method of construction is also characteristic of Florentine foundries, for example, in the bronze versions of Massimiliano Soldani's groups and reliefs which are likely to be of the same date as Piamontini's. Soldani's bronzes are also similarly sharply chiselled and punched. Whether Piamontini would have directed the casting and participated in the finishing of his bronze is uncertain, but not unlikely given the practice of other Florentine sculptors of this period.

The only differences between the groups in Oxford and Philadelphia, apart from the loss of the sceptre in the Philadelphia Juno group, and the defective crest on the peacock in the Oxford Juno group, are minute ones in the pattern of the tooling—joins and solder smear are also more easily seen in the Philadelphia groups partly because metal and varnish are less dark.

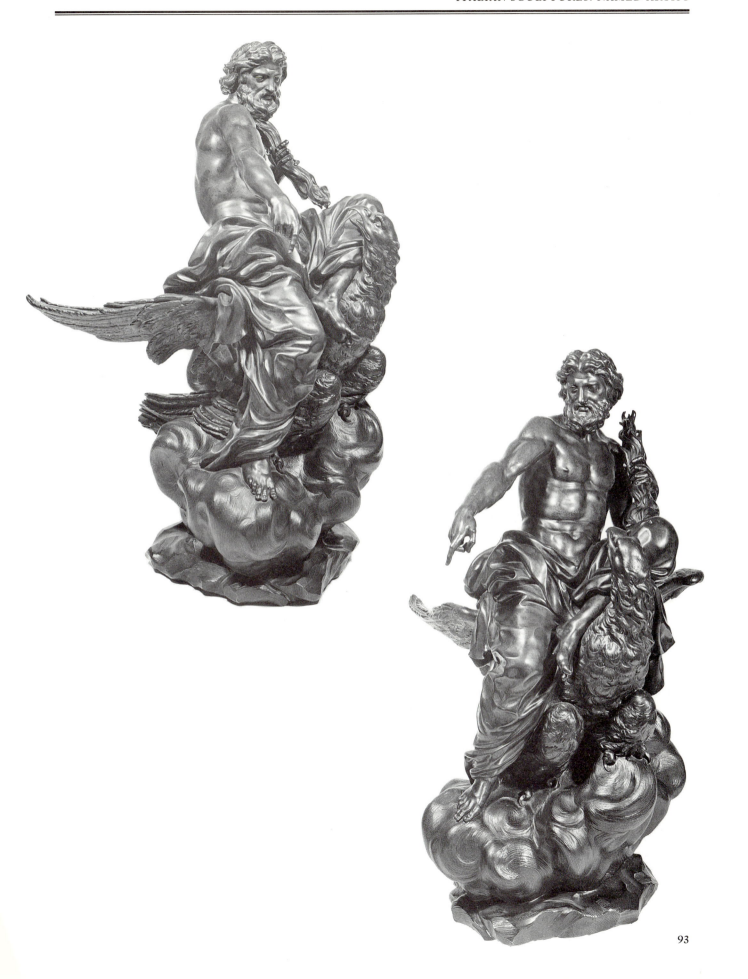

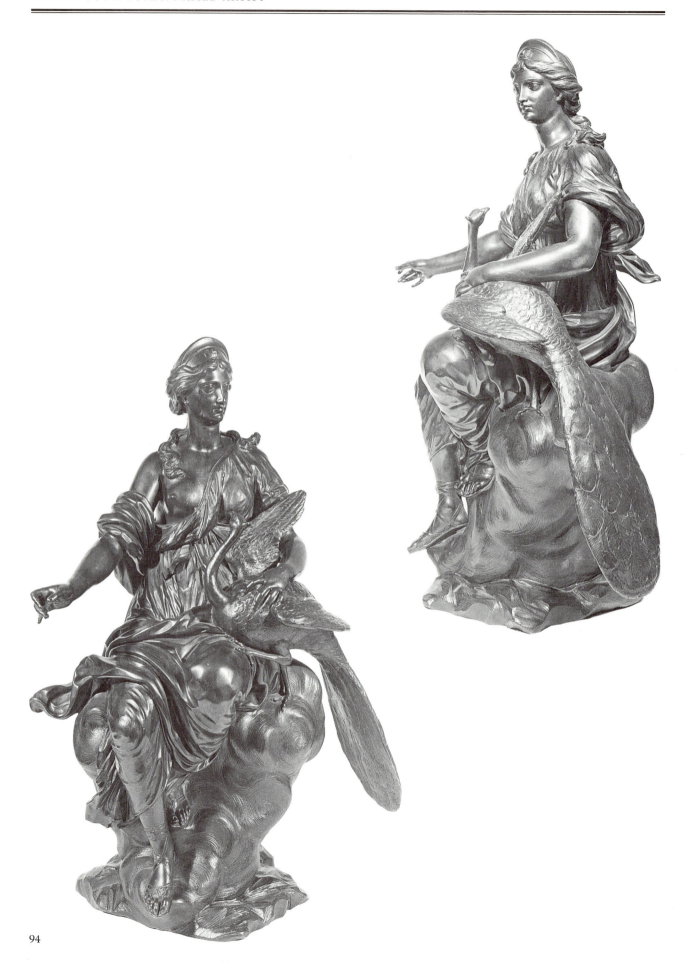

PIERINO DA VINCI (1530–53)

72. Ugolino, imprisoned by the Arno, with his sons and grandsons, visited by Famine

62 cms. (height); 45 cms. (width); see also below

White wax discoloured to a yellow cream colour. The reverse is partly hollowed: the hollows corresponding to the highest relief on the side viewed. This reveals that the wax was cast; but it was also extensively modelled, for many details, most notably the fingers of Arno's left hand on his urn or those of the right hand of the seated youth whose knees touch the left-hand border of the composition, are completely undercut, and the entire surface has been sharply tooled, as is clear on close inspection in a good light and still more so under magnification. There is a network of cracks on the left-hand side of the relief: from the left elbow of the personification of Famine to the right shoulder of the seated youth already referred to, across the left knee of the other seated youth behind him, and (very fine) along the left thigh of the reclining youth; across the rocky river bank and river in the lower left corner; across the left foot of Ugolino. The fingers, excepting the index finger, of Arno's left hand have been broken off and refixed. Incised on the rocky river bank: 'DANTE XXXIII INFERNO'. Some spoonings of wax have been removed from the reverse of the relief perhaps to serve, reworked, as cement for repairs—a more recent (cleaner coloured) wax is apparent along the major cracks. The irregularly rectangular relief is fixed into an old wooden frame with cement and old hand-made nails. The front of the wax is cut back within its rough edges to a sharp edge forming an approximate rectangle of the dimensions given above. The relief is mounted in a heavy glazed walnut frame with partially gilt egg and dart mouldings probably made by the Museum in the 1940s (see No. 55). A letter from Arthur Evans to Fortnum of 5 November 1897 mentions that 'its dirt was dreadful but I suggested a gentle application of soda & water which has had most successful results'.

Deposited in the Ashmolean Museum by the Radcliffe Trustees in 1897; presented to the University of Oxford in 1841 by Philip B. Duncan, Keeper of the Ashmolean, to whom it had been presented by his friend Prince Hoare (1755–1834), the artist, who had inherited it from William Hoare (1706–92), who may have acquired it from Henry Trench. 'Mr Trent a painter' is said in John Breval's *Remarks on Several Parts of Europe* of 1738 to have bought this 'noble Bas-relief' over to England 'some years ago'—this was, apparently, shortly before 1719 when Jonathan Richardson the Elder published his *Discourse on the Dignity, Certainty, Pleasure and Advantage of the Science of Connoisseurship* in which (pp. 32–3) he mentions the relief as in the hands of 'Mr Trench, a Modest, Ingenious Painter, lately arriv'd from his long Studies in Italy'. (The only problem with this provenance, apart from any firm evidence of where Hoare acquired it, is that neither Breval nor Richardson specify that Trench's relief is of wax.)

Vasari described how Pierino, the nephew of Leonardo da Vinci, studied with Bandinelli and then with Tribolo, by whom he was recognized as a prodigy, and how Luca Martini, a scholarly nobleman and one of Duke Cosimo's leading courtiers, made him his protégé. Martini commissioned a marble relief of *Christ at the Column* when Pierino was less than 17 ($1\frac{1}{4} \times \frac{2}{3}$ *braccia*, possibly to be identified with the

rather smaller but obviously cut-down oval *Flagellation* relief at the Nelson Atkins Museum, Kansas City, 51–3, generally regarded as by Vincenzo Danti). Martini also introduced Pierino to Francesco Bandini who took him to Rome where he enjoyed great success (and made, among much else, a wax copy of Michelangelo's *Moses* as a present for Martini). Then he summoned him to Pisa, of which city Cosimo had made him *provveditore* in 1547, and gave him several commissions there. Of the latter commissions the most private one, an idea of Pierino's own but reflecting Martini's scholarly commentary on Dante, and his interest in Pisa, was a relief illustrating the fate, in a Pisan prison, of the Florentine Count Ugolino della Gherardesca recounted by Dante in the thirty-third Canto of the *Inferno*. Vasari describes this work at length, mentioning also that Pierino began work on it at the same time that he carved the river god now in the Louvre presented by Martini to the Duchess Eleonora (who presented it to her brother). The relief must date from after 15 October 1548 when, as Jonathan Nelson has pointed out to me, Martini borrowed an ancient manuscript version of Dante and commenced his annotations.

Vasari specifies that the model was in wax and was subsequently cast in bronze to the delight of his patron. Whether the casting was managed by Pierino himself may be doubted (Vasari records that the children Pierino had modelled for the rim of the Hercules fountain by Tribolo at the Medici Villa at Castello had been cast by Zanobi Lastricati). The emphasis placed on the wax model by Vasari suggests that it was valued in its own right and also that such a model survived the casting process. If the original wax model was the one employed in the casting then it would of course have been lost in the process, but it seems most unlikely that the sculptor would not have retained a replica of this original wax model, not least as a precaution against a foundry accident. Such a replica would perhaps have been worked up from an approximate cast made after the first model; and that is exactly what this wax would seem to be. This hypothesis would be supported by the survival of other wax models preparatory to bronze reliefs of this period, and one does not have to look far to find examples: the models in red wax (Victoria and Albert Museum, 328, 329, 330-1879) for the reliefs in the Grimaldi Chapel of S. Francesco di Castelletto in Genoa commissioned from Giambologna in the late 1570s are as highly finished as this relief (although in less good condition), but cannot be reproductions of the bronzes since they differ from them in minor respects. On the other hand wax reliefs were also cast for collectors as alternatives to casts in terracotta, reproducing popular works also available in bronze or precious metal. The export of such casts in red, black, and white wax is mentioned as an important part of the sculptor's business in the litigation concerning Cobbert's models in Rome in 1609 (A. Bertolotti, *Artisti lombardi a Roma* (Milan, 1881), ii. 123–61). If this wax does not come into this category then the only other explanation for its existence is that it was prepared for casting in bronze. This would incidentally explain the hollowed reverse, designed to

avoid uneven thickness and consequent strain in cooling. This is what Fortnum believed it to be (letter to Arthur Evans of 12 December 1897).

Even if this wax is made after the bronze, however, it has been finished with quite extraordinary care. When examined closely, and especially under magnification, every detail has been tooled and the undercutting is formidable. It has sometimes been described as a later cast, or even as an aftercast, by careless scholars, or by dealers. Many of the latter and some of the former have made large claims for the other surviving versions of the relief in terracotta, gesso, and marble, which, however, all omit or slur details included with crisp clarity in the wax—none of them, for example, includes the long, very low relief, fingernail of the pointing hand of Famine; they all either exclude or confuse the lion's head peeping out beside Arno's urn; and, perhaps most significantly, none of them includes any of the undercutting. Furthermore, when details are measured it will be found that all these other reliefs are considerably smaller, as would be expected if they were cast from moulds made after the original bronze, or, in the case of the marble versions, copied from models made in this way, for bronze and terracotta both contract when cooling.

Of the other versions in terracotta one is in the Ashmolean Museum (No. 73) and the other has long been in the collection of the Gherardesca family (that is Ugolino's family) in Florence. The latter was exhibited at the *Mostre dei tesori segreti delle case fiorentine* in Florence, June–July 1960 (no. 172, pp. 71 and 118 in the catalogue). The relief was engraved as early as 1782 (see F. Yates, 'Transformations of Dante's Ugolino', *Journal of the Warburg and Courtauld Institutes* (1951), pl. 17b). This print is interesting in that it extends the composition to clarify the fact that the figures are on an island in the Arno. The Gheradesca relief is illustrated, together with what appears to be its sixteenth-century frame, in *Pantheon* (1960), 18, p. cxix. Although superior claims have been made for the Gherardesca version, which has sometimes even been described as the original bronze, it is little different from the Ashmolean's terracotta (which also has a Florentine provenance), and is no more sharp in its details. It seems also to be the same size. In the wax version the foot of the Arno is 6.85 cms. in length but in the Ashmolean's terracotta it is 6.5 cms. In the wax the distance between the left shoulder of the youth with his back to us and the uppermost part of Ugolino's left arm is 42.35 cms., whereas it is 41.3 cms. in the Ashmolean's terracotta.

The plaster or gesso versions appear to have been cast after these terracottas. One such was lot 36 in the sale at Christie's on 3 July 1823 of the studio of Nollekens. One, which is very coarse, is in the Bargello ('mentioned by some German authorities to be an original marble', C. F. Bell notes in the margin of Fortnum's large manuscript catalogue). Another, rather better in quality, belonged to Michael Hall Fine Arts, 6 East 79th Street, New York, in March 1969 (when advertised in the *Burlington Magazine*, p. cxvii). Most bronze casts also look like aftercasts—one was in a private collection in Cheltenham in September 1976 when it was taken to the Museum—in this version Arno and the reclining youth's

genitalia were concealed by bullrushes or drapery; another of this character was sold at Christie's, 9 July 1979, lot 90, as 'A north Italian bronze plaque of an allegorical scene after Pietro da Barga'. The one exception, which will be considered separately below, is the cast in the collection of the duke of Devonshire which Charles Avery was the first to propose as possibly the original.

A marble version, acquired by a New York dealer at auction in New York in 1987, is a work of some quality. It includes the teeth of Famine, although not those in the mouth of the desperate youth nearest to Ugolino, but does not attempt the undercutting of the fingers, and does not possess, in the treatment of the waves of the Arno or the curls of hair, a plasticity that matches that in the wax version. There are also minor differences tending to simplify the details—the reeds by the river side are not clearly reeds for instance and are excluded from the hair of Arno.

The relief was sometimes attributed, in the eighteenth and even nineteenth century, to Michelangelo and Prince Hoare retained this attribution. The Richardsons evidently entertained doubts about this when they published the French edition of their *Works (Traité de la peinture* (Amsterdam, 1728), ii. 138–40). Bottari was also to do so in his edition of Vasari of 1759–60 (iii. 354) as was Charles Rogers in his translation of the *Inferno* of 1782 (pp. 128–9).

The disagreeable drawing purporting to be a preparatory idea for the relief which was purchased by the Ashmolean in 1963 (Sotheby's, London, 12 March 1963, lot 18) is hardly of a quality one would expect from Pierino. However, it, and another drawing of similar character, are curious in that they come closer to Vasari's description of the relief than the relief itself does (an observation I owe to Charles Avery).

It remains to consider the bronze version at Chatsworth. This is set with lead into pedestal no. 99a. This pedestal, which is of oval plan, now supports the colossal bust of the Emperor Napoleon by Canova, but in the inventory of 1905 it is described as supporting the *Greyhound and Puppies* by Joseph Gott and it was clearly designed to do so. Gott's sculpture was one of the marbles which arrived at Chatsworth from Rome in 1825 and the pedestal is likely to have been made soon afterwards. It is of local stone in common with several others into which the 6th duke, characteristically, had miscellaneous pieces of coloured marble, and even in one case some antique coins, embedded. The duke does not mention the bronze relief in his own description of his collection which suggests that he set little store by it, and perhaps he did not buy it himself. If he did inherit it, then it is quite likely to have come, along with much else at Chatsworth, from the collection of Lord Burlington. It is interesting in this connection that Trench, who is credited with importing the relief of *Ugolino* into Britain—in accounts which do not describe it as a wax— was a protégé of Burlington. Vertue records that he came from Rome, where he had studied with Chiari, to London but enjoyed no success as a history painter and so went again to Italy for several years, returning to London in October 1725 ('The Vertue Notebooks', iii, *Walpole Society*, 20 (1933–4), 25.) The account suggests that

he was likely to sell what he had collected, and if so Burlington would have been likely to buy it.

This bronze is 65 cms. high (but the topmost edge is embedded in the stone slot in which it is set) and 46.5 cms. wide. It extends further to all sides than any other version, especially along the top where there are two holes presumably for attaching it which have been plugged. There is a bad casting flaw in the waves on the lower border of the relief to proper right which must once have been filled with wax. Although it has been impossible to inspect the rear of the bronze the character of this flaw suggests that this is a lost-wax cast. Every detail found in the Ashmolean's wax is also found here—including the lettering on the rocky bank, the

lion's head in the lower right corner, the sharp-edged reeds flowing over the biceps of Arno, the fingernails of Famine. Arno's left hand is not undercut but it is in the same attitude. It is hard to consider this as anything other than Pierino's original. The measurement of Arno's foot is the same as in the wax; other measurements are a little larger in some cases and smaller in others. This does not clarify its relationship with the wax, but clearly both it and the wax are to be distinguished in size as well as quality from all other known versions. Charles Avery has proposed to me that the wax was perhaps cast in the eighteenth century from the Chatsworth bronze but that does not explain why some details (most notably Arno's left hand) are finer in the wax.

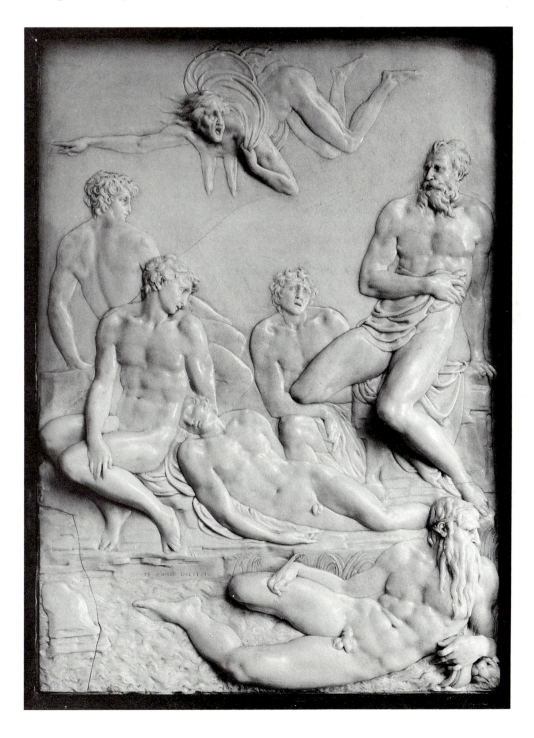

After PIERINO DA VINCI (1530–53)

73. Ugolino, imprisoned by the Arno, with his sons and grandsons, visited by Famine

61 cms. (height); 45 cms. (width)

Terracotta of a grey red colour. Cast, but with some lines tooled before the clay was fired—e.g. in the contour of the reclining youth. There is a chip on Ugolino's left knee. The relief has been broken into three parts: a rough line, passing under Ugolino's right arm and over the head of the youth beside him which then divides to pass up to the pointing hand of Famine and down to the upper chest of the prominent seated youth and to the back of the youth behind him, indicates the repair; there is a certain amount of filling and applied colour at points on this line. 'S.28.Ⅎⅎ' is written in black ink on the rocks in the lower left corner. There is a seal with arms and coronet on the reverse.

Lent by C. D. E. Fortnum on 20 March 1888, given by him later in the same year. S. 28 in his catalogues. Purchased by him in Florence in the winter of 1864–5 for £12. 'For many years in the house of a Del Agata in Via Ghibellina' in Florence.

See No. 72.

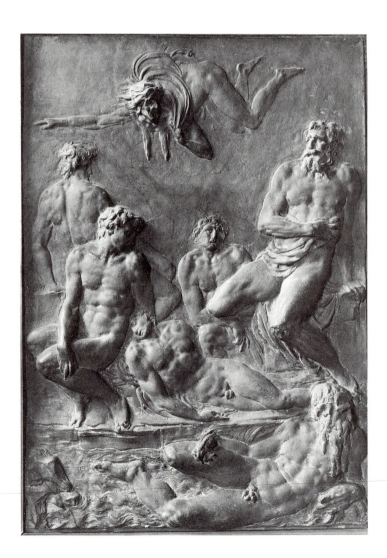

Unknown founder

Probably after PIERINO DA VINCI (1530–53)

74. Male nude probably intended for Adam tempted

17 cms. (height); 9.5 cms. (height of pedestal); 8.4 cms. (width and length of pedestal)

Bronze with a pale green to grey brown natural patina darkened in the hollows, covered with a warm golden translucent lacquer preserved in many areas. Hollow, lost-wax, cast. The surface covered with very fine wire-brushed lines following the contours except on the figure's right forearm where a fine joint may just be perceived: this part was evidently separately cast and given the lack of continuity of finish was doubtless a later replacement. There is a small firing crack in the bicep of the figure's left arm. Plugs (presumably replacing holes made by chaplets) can be detected above the figure's right arm, also above his left knee where there is a very slight crack. The figure is mounted on a moulded pedestal, square in plan, of mahogany veneer of three tones, the recessed panels and mouldings darkest. The lighter, golden wood matches the lacquer of the bronze. 'ꓞ 421' is painted in black.

Lent by C. D. E. Fortnum on 20 March 1888. Given later in the same year. B. 421 in his catalogues 'Bought in London' (according to his large manuscript catalogue), but more precisely 'Bought at Christie' (according to his earlier notebook catalogue), presumably after 1857 when the preliminary catalogue, in which it is not included, was compiled.

Fortnum speculated that this 'nude man walking and in anxious attitude' might be intended as Adam. Certainly the figure seems to be responding to another as in numerous instances of paired nudes, representing Adam and Eve at the moment of their temptation or, more commonly, of his temptation, in prints and statuettes of bronze and boxwood, produced in the first half of the sixteenth century north of the Alps—the pair of bronze figures attributed to Leonhard Magt, lot 32 at Sotheby's, London, 10 December 1987; the pair of boxwood figures attributed to Conrad Meit in the Kunsthistoriches Museum, Vienna (295; 9888/9); the pair of boxwood figures attributed to Christoph Weidith in the same museum (317; 3965 and 3967); or those attributed to Daniel Mauch in the Cleveland Museum of Art (46.429 and 46.491), are good examples of the statuettes. Such groups were also found in Italy at least in the second half of the century in bronze (see W. Bode, *Italian Bronze Statuettes of the Renaissance* (London, 1907–12), ii. 23–4, pl. CLX; ii. 20, pl. CXLVIII; iii. 23, pl. CCLVII), and there was also the marble group of Adam and Eve made by Bandinelli in 1551 for the Duomo in Florence (Museo Nazionale, Florence).

The sculptor is more difficult to guess than the subject. Fortnum catalogues the figure as 'the work probably of a goldsmith sculptor of the later XVI century, a follower of the schools of Gio: di Bologna or of Ben⁰ Cellini'. Bell however recorded in the margin of the large catalogue that Bode suggested that it was French. Ian Robertson later wrote there that the figure was 'probably by Hubert Gerhard'. A northern European artist has generally been suggested since then,

perhaps because of the beard which compares very closely, for example, with that given to Adam by Zacharias Hegewald in his marble group of 1630–1 (destroyed 1945 but reproduced J. Rasmussen, *Barockplastik in Norddeutschland* (Museum für Kunst und Gewerbe, Hamburg, 1977), 46), and also because its extreme precision and beauty of surface are characteristic of documented German court goldsmiths. Hans Weihrauch suggested that it is by a Netherlandish goldsmith and of *c.*1600 (*Europäische Bronzestatuetten* (Brunswick, 1967), 363, pl. 439).

There seems, however, no reason why the statuette should not be, as Fortnum proposed, Italian. Although ideal nude figures were less likely to be influenced in Italy by modern fashions in facial hair, the beard here is not unlike that which Bandinelli gave to his *Adam*. There is also plenty of evidence that exquisite and miniature work was made by Italian goldsmiths even if names and works can seldom be matched. The golden varnish employed on this figure is also known to have been popular in Florence in the late sixteenth century. If we search for other sixteenth-century statuettes which are of comparable size and finish, two, with an Italian provenance, present themselves: the *Bacchus* and the *Pomona* (or *Venus*) in the Ca d'Oro in Venice (nos. 58 and 59). Not only is the size the same—exactly the same in the case of the *Venus* or *Pomona*—but this size is a most unusual one, so a coincidence is improbable. Furthermore the type of varnish and the distinctive wire-brush finish is identical. The style is very close: the treatment of facial features, details such as fingernails and hair on the *Adam* and the *Venus* or *Pomona* are the same. Furthermore the quality is the same: the *Adam* and the *Venus* or *Pomona* are among the most beautiful small bronzes to have survived from the sixteenth century.

It has recently been demonstrated by Peter Meller ('Un gruppo di bronzetti di Pierino da Vinci del 1547', *Mitteilungen des Kunsthistorischen Instituts in Florenz*, 18 (1974), 251–72) that the two bronzes in the Ca d'Oro were originally fixed to a handsome bronze base (no. 60) in the same collection decorated with the Stemma of the Martini family (to which Pierino's chief patron belonged) upon which is chiselled the date 'M·D·XL·VII' (1547) and 'OPERA · DI · PIERO · DA · VINCI.' It may seem hard to understand how a figure supposed to represent *Adam* can have any relation with these pagan figures, but the *Pomona* looks very much like an Eve, as Meller, with no knowledge of a possible partner in Oxford, astutely observed—and he even speculated that Pierino might originally have thought of creating an Adam and Eve group (ibid. 259–62 and n. 19). When the *Adam* is seen, or rather imagined, beside the Ca d'Oro female nude the relationship has indeed far more interest, formally and as narrative, than that which exists in the pagan grouping. The *Bacchus* exists in only one other version (formerly in Berlin—see Meller, op. cit. 263) but the female bronze statuette exists in two other versions, one in the Louvre (Donation Thiers no. 87) and one formerly in the Benda Collection in Vienna (Bode, op. cit., ii, pl. CL, p. 20), and

one of these could have originally been the *Eve* for the Ashmolean's *Adam*. The Louvre bronze retains exactly the same finely scratched surface and colour both of varnish and of natural patina as the Ashmolean's figure. That a sculptor in this period could have sanctioned the change of a work originally conceived as Eve into a Venus or Pomona (or vice versa) need not surprise us: Alessandro Vittoria in a will dated 7 November 1570 made special mention of 'La mia statua di bronzo' which could serve as a Sebastian or a Marsyas according to taste (G. Gerola, 'Nuovi documenti veneziani su Alessandro Vittoria', *Atti del Real Istituto Veneto di Scienze, Lettere ed Arti*, 84 (1924–5), 348).

There is one other bronze statuette which might be related to this group by Pierino; it is a female nude in the reserve collection of the Art Institute of Chicago (1964-1159)—a figure of mysterious identity, described as a *Lucretia* and holding open a wound in her breast. This is very similar in character to the Ca d'Oro female although less well preserved in its surface. It is 7.4 cms. high, but this includes an integral base and if that is excluded the size is 17.1 cms.—nearly identical. It is also possible to imagine her serving as a companion for the Ashmolean Museum *Adam*. It should also be pointed out that the remarkable pair of polychrome wooden statuettes representing *Epimetes* and *Pandora* by El Greco (Prado, Madrid) must have been derived from the Ashmolean male nude and the Ca d'Oro female one, and were indeed once supposed to be of Adam and Eve (Conde de las Infantas, 'Dos esculturas del Greco', *Archivio español de arte*, 18 (1945), 193–200).

The inscription on the bronze base in the Ca d'Oro should not be taken as proof that Pierino was responsible for the casting or even finishing of the bronze figures once attached to it. There are certainly cases of such names placed boldly on bronzes which are known to have been cast by independent

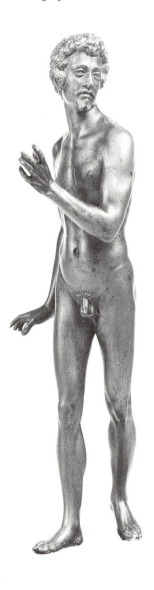

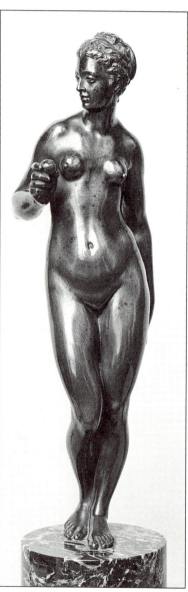

Eve or *Pomona*
Musée du Louvre, Paris

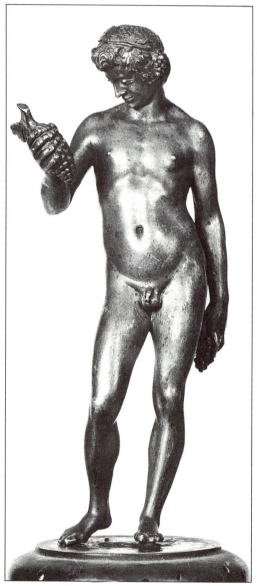

Bacchus
Ca d'Oro, Venice

craftsmen (Bandinelli, one of Pierino's masters, is a case in point). Vasari mentions that the children which Pierino modelled for the rim of the Hercules fountain by Tribolo at the Medici Villa at Castello had been cast by Zanobi Lastricati, and it would seem likely that he was dependent upon specialist founders and goldsmiths for the execution of subsequent work in this medium. The only other surviving bronze which has been convincingly attributed to him is the candlestick in the form of a miniature tripod in the British Museum (U. Middeldorf, 'Notes on Italian Bronzes', *Burlington Magazine* (Dec. 1938), 204–9) the finish of which is not very close to that of the Ca d'Oro figures.

Finally, it must be asked how the *Adam* fits into Pierino's *œuvre*. The answer has to be that one would never have guessed that it was by him, any more than one would have guessed that the female nude or the *Bacchus* in the Ca d'Oro were by him. Comparisons, for example between the hair of

the *Adam* and that of the youths in the *Ugolino* relief (No. 72) or of the *River God* in the Louvre, can be made which reduce one's surprise, but one aspect of the figure remains unexpected—the alert, nervous tension and arrested movement which depends upon the figure's unbent right leg. Pierino in his other works consistently avoided giving figures an erect posture and had indeed an unusual preference for sagging poses.

Peter Meller, who accepts that the *Adam* must have been made as a companion with the *Eve/Pomona*, has proposed to me that it might be the work of the same, surely Netherlandish, artist who created the exquisite statuette of *St John* (presumably from a *Crucifixion* group) in the Bargello, Florence (Inv. 741). Also striking is the relationship with the battered and highly restored *Adam* by Stoldo Lorenzi in the Castello Sforzesco, Milan (038).

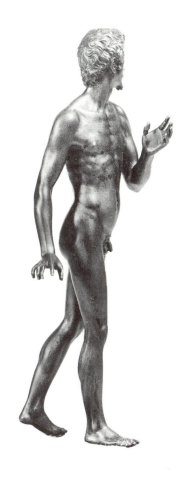

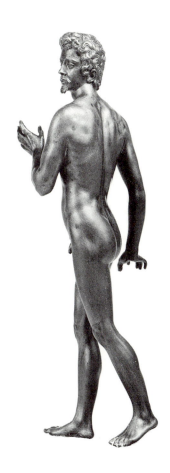

Bartolomeo PINELLI (1781–1835)

75. Man baiting a bull with mastiffs

35 cms. (height, approximate because the base is sunk in the wooden plinth); 41 cms. (length of rough integral oval base); 45.8 cms. (length of wooden plinth); 38.1 cms. (width of wooden plinth)

Terracotta of a pale cream to grey-pink colour. Numerous minor firing cracks but few chips missing. The end of the bull's right horn is missing. There is an old repair where the man's hand grips the forehead of the bull. The back legs of the bull have been broken and recently repaired. 'Pinelli fece 1827' is incised boldly and cursively on the rim of the rough integral oval base; the '2' is easily mistaken for an '0'. The group is mounted on a plinth of pale beech.

Given by Mrs Harvey in 1910 from the collection of her husband the late H. A. Harvey of Christ Church. The recent repairs were carried out by Mr Saleh in the 1970s.

Pinelli seems always to have modelled on a small scale in clay, picking up the art from his father, an impoverished maker of cheap devotional images; but his terracottas only attracted attention from the public, and perhaps only received serious attention from him, after his drawings and prints came into great demand in the years following the successful publication 1809 of his etchings of the picturesque costumes of the Campagna. His earliest dated terracotta is of 1812, and most

of his surviving works are dated between 1828 and 1835. In 1834 he published etchings of some of them under the title 'Gruppi pittoreschi modellati in terra-cotta da Bartolomeo PINELLI ed incisi all'acquaforte da lui medesimo', consisting of a frontispiece and twenty plates. An additional eight plates were added to the series in 1835. The subjects tend to be carnival *Piferrari*, the *Saltarello*, *Brigands*, or simply *Contadine* with their children (see G. Incisa della Rocchetta, *Bartolomeo Pinelli* (Palazzo Braschi, Rome, 1956)—a catalogue of twenty-two signed sculptures all from Roman collections which also includes an edition of the biography of Pinelli by Oreste Raggi). The Ashmolean's group is typical of a heroic tendency in Pinelli's treatment of traditional popular activity which recalls some of the studies Géricault had made ten years previously in Rome. It makes Pinelli's relatively rare treatments of classical subject-matter easier to understand. (For this latter aspect of his art see the gilded terracottas of *Jupiter* and *Juno* dated 1815, published by A. González-Palacios (*Il tempio del gusto* (Roma e il regno delle Due Sicilie) (Milan, 1984), i. 179), and for Pinelli's neo-classicism generally see id., 'La grammatica neoclassica', in *Antichità viva* (Sept. 1973), and M. Fagiolo and M. Marini, *Bartolomeo Pinelli 1781–1835 e il suo tempo* (Rome, 1983), 102–6, for the watercolours and line drawings of 'Episodi della storia Greca' dated 1820–1, and 141 for his treatment of the Niobids.)

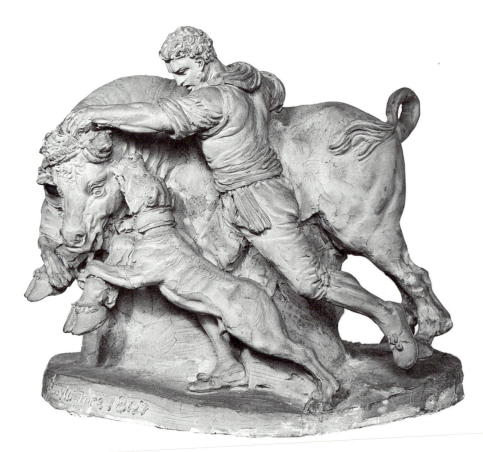

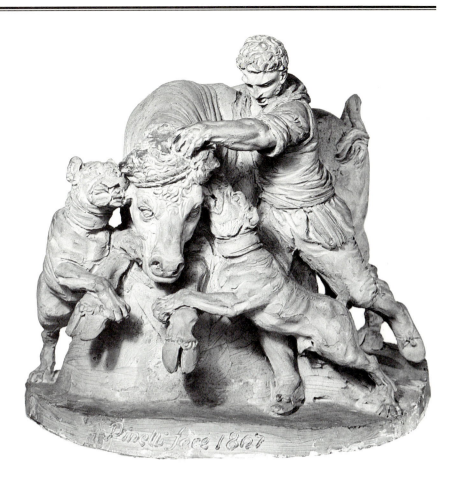

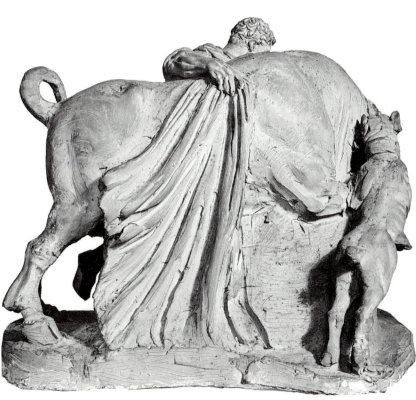

Imitator of Angelo Gabriello PIÒ (1690–1770)

76. Virgin and Child

25.9 cms. (height); 20.8 cms. (width); 1.4 cms. (thickness of relief); 20.5 cms. (height of pedestal); 24.3 cms. (length of pedestal); 13.8 cms. (width of pedestal)

Terracotta of a pale pink colour. Old colouring seems to have been removed upon acquisition, but traces of blue and white pigment remain in the hollows of the drapery. There are also traces of gilding around the edges of the ground, possibly from a frame. There is a crack passing through the entire relief to proper left of centre, most evident across the back of the Virgin's hand. There is another crack in the ground to proper right, also small losses from the edges of the drapery and numerous tiny cracks and scratches. There is an irregular edge cut back all around the relief for the rebate of a frame. This looks as if it has been cut out of the relief after firing. The relief was apparently mounted on a velvet-covered plinth and surround shortly before acquisition but this was probably replaced because the dark green velvet is one much used by the Museum. The pedestal of gilded wood with rather coarse foliate C-scrolls against a field of blue-grey colour is likely to have been supplied by the dealer.

Bought with the aid of the Blakiston Fund from Messrs. P. & D. Colnaghi, Old Bond Street, London, in 1964. The purchase was discussed by the Keeper, Ian Robertson, in a letter to Roddy Thesiger of Colnaghi's on 27 February 1964. Robertson agreed to make the first half payment in April. He was keen that the relief should be included in the gallery's spring exhibition *Paintings by Old Masters* where it was no. 8 (illustrated as pl. VI in the catalogue). The relief was registered on 10 June.

The relief was acquired with an attribution to Giuseppe Mazza and Robertson published it in the *Annual Report* as 'of about 1700, and perhaps executed during the artist's visit to Venice'. He added that 'it offers features of handling comparable with the initialled oval relief of the same subject formerly in the Kaiser Friedrich Museum, Berlin' (reproduced in A. E. Brinckmann, *Barock-Bozzetti* (Berlin, 1923), i. 150, pl. 66). There are similarities with the terracotta reliefs signed 'G.M.' which are attributed to Mazza, but there is no very close connection with the relief Robertson singled out, and his precision of dating was over-confident. There were other sculptors from Bologna working in terracotta in this style and on this scale among whom the sculptor who succeeded Mazza as the leading artist in terracotta and stucco there, Angelo Gabriello Piò (1690–1770), seems worthy of consideration in connection with this relief. (For Mazza see E. Riccòmini, *Ordine e vaghezza: Scultura in Emilia nell'età barocca* (Bologna, 1972), 90–115 and elsewhere, and for Piò, id., *Vaghezza e furore: La scultura del settecento in Emila* (Bologna, 1977), 50–69.) The curvaceous eyelids of the Virgin, her slightly pointed nose, the flat ends of her tapering fingers, and the very small mouth of the Christ Child are all idiosyncrasies to be observed in Piò, although in less marked form. The work does not, however, seem quite good enough to be by him.

The highly attractive handling of the drapery, its softness of texture combining with the infantile and feminine flesh with which its continuous flutter contrasts, conceals only briefly the uncertain management of the planes—the flatness of the Virgin's right arm and the uncomfortably abrupt foreshortening of her left arm. Also unsatisfactory is the uncertain direction of the Virgin's gaze and the tight and truncated character of the composition, especially where her left arm is cut off and the drapery stops below the arms. However, if, as there is reason to suspect, the relief was cut down, then we would originally have understood whether she was sitting or standing, a St John or a donor would have made sense of her gaze, and the composition would appear less cramped. Most intimate devotional reliefs of this type made in Bologna were oval.

Samples were taken by Mrs Doreen Stoneham of the Oxford Research Laboratory for Archaeology and the History of Art in April 1974 and a thermo-luminescence test indicated that the relief was fired between 1583 and 1788 (ref. 81-m-63). Another sample taken in October 1986 indicated that it was fired between 1606 and 1736 (ref. 381-y-37).

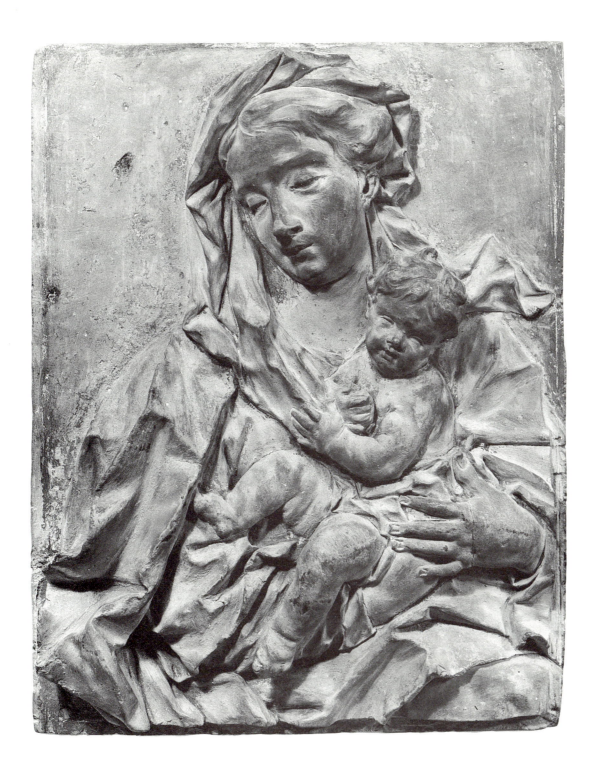

Probably by Francesco Antonio Franzoni (1734–1818) and
Lorenzo Cardelli (active 1770–1810)

After designs by Giovanni Battista PIRANESI (1720–78)

77 and 78. Pair of candelabra, one involving three cranes and a kneeling faun (77) and the other three elephant heads and an altar decorated with reliefs of deities (78), both supported by three lion's legs

244.1 cms. (height of No. 77, excluding marble pedestal); 243.9 cms. (height of No. 78, excluding marble pedestal); 41 cms. (height of each marble pedestal); 44.5 cms. (diameter of the acanthus cup crowning each candelabrum); 68.5 cms. (height of the cranes in 77).

White marble, of a variety of types, with much of the surface abraded. Each candelabrum is composed of numerous parts and iron has been used extensively in assembling them. In some areas the rusting cramps are evident on the surface, e.g. in the tail of the crane standing below the faun's tail in No. 77, in one corner of the altar stage in No. 78, and on the plinth between paws of the lions and the central support in No. 78. The question of which parts of the candelabra are ancient is discussed below. Piranesi was capable of breaking and rejoining the modern work to make it look ancient which complicates this discussion, but there has also been accidental damage (and perhaps vandalism) since the candelabra arrived in Oxford. The breaks in the legs of the cranes, for instance, are relatively recent, to judge by the modern adhesive all too evident on them. It is interesting that there were originally two struts between each pair of crane legs—struts left by the restorer to improve the sculpture's chances of surviving unbroken in transport. These should have been carefully cut away by a mason when the candelabra were erected in the Radcliffe Camera. One remains; the others have been knocked off, leaving little branches on the legs. The stage of No. 77 which consists of a relief of masks framed by eagles has been pitted all over perhaps as an attempt at 'distressing'. The upper surface of the plinth of No. 77 has been very coarsely tooled and what looks like a letter 'a' and certainly a letter 'b' have been crudely chiselled on it. The points of the beaks of all the cranes and the ends of the trunks of two of the three elephants have been broken off and lost. Both unmoulded marble pedestals are chiselled with the following text, blacked for emphasis: 'ACADEMIAE. OXONIENSI / HUC / ROMANAE · ELEGANTIAE · EXEMPLA EX · RUDERIBUS · VILLAE / IMPERATORIS.HADRIANAE.TIBURTINAE / NUPER. EFFOSSUM / ROGERUS.NEWDIGATE.BARONETTUS / GRATÒ.ANIMO / D.D.D. / A.D.MCCLXXVI'

The candelbra were bought in Rome on 6 May 1775 by Sir Roger Newdigate from Piranesi for 1,000 Roman *scudi*, shipped to London through the agency of Thomas Jenkins, who also acted as Newdigate's banker, in the same year, and presented to the University in the following year, as declared by the Latin inscriptions. A bill for minor restoration, for transport, for the pedestals (in plain marble, unmoulded, following the line of the plinths), and for the inscription on the latter was submitted on 21 December 1776 by the London sculptor Richard Hayward. The candelabra were certainly installed in the Radcliffe library by February 1777. (See

M. McCarthy, 'Sir Roger Newdigate and Piranesi', *Burlington Magazine* (July 1972), 466–72). The position of the candelabra within the Radcliffe Camera against the piers of the great reading room may be seen in R. Ackermann's *History of Oxford*, ii, (London, 1814), 238. In F. Mackenzie's drawing (engraved in 1836 for the *Oxford Almanack*) they are shown surrounded by casts of the *Apollo Belvedere*, the *Diane chasseresse*, the *Stooping Discobolus*, the *Laocoön*, and the *Wrestlers*. According to all recent published accounts the candelabra were transferred to the University Galleries in 1846, but Michaelis recorded them as still 'said to be' in the Radcliffe library where he did not have time to examine them (*Ancient Marbles in Great Britain* (Cambridge, 1882), 593–4) and they were in fact transferred in 1894 and were probably immediately set up in the Randolph Gallery where they were certainly to be seen in 1909 (*Summary Guide*, 17) and where they have remained since, although in different positions. Their position at the eastern end of the gallery was taken up in 1983. They were moved to the entrance of the Ruskin lecture hall in 1991.

Having established himself by the early 1750s as the leading topographical printmaker in Rome, Piranesi moved into the field of archaeological illustration with this *Trofei di Ottaviano Augusto* of 1755 and the four volumes of the *Antichità romane* of 1756. Such work entailed a close study of the loose fragments of architectural ornament as well as the half-buried bones of buildings. His interest in such fragments must have increased during the mid-1760s when he was invited to employ and invent such ornaments himself, serving his fellow Venetian Pope Clement XIII (Rezzonico) as architect and designer of furniture and décor. And in the same years he became more interested in architectural theory, publishing in his *Parere su l'architettura* of 1765 a boldly polemical defence of the licence of Roman architectural practice, which was based on a thorough study of the originality and fantasy of ancient Roman ornamental sculpture. By 1767 Piranesi was certainly busy with the design (and in supervising the manufacture) of chimney-pieces in which fragments of ancient relief carving and even portions of ancient architraves were sometimes incorporated, so he must have begun to collect antiquities by then and had probably already begun to form 'a museum specially devoted to fragments of architecture and a collection of ornaments unique in its kind', as it was described by his biographer J. G. Legrand ('Notice historique sur la vie et les ouvrages de J. B. Piranesi' (1801), first reprinted in *Nouvelles de l'estampe*, 5 (1969), and subsequently fully edited by G. Erouart and M. Mosser in *Piranèse et les Français* (Rome, 1978), 213–52, see 241). By 1768 his activities in this field were exciting the satire of his rival and associate the dealer and banker Thomas Jenkins. Writing to the collector Charles Townley on 9 November Jenkins described the latest interest of Piranesi the 'cav of the candelabri'. (For this letter see G. Vaughan's Ph.D thesis 'The Collecting of Classical Antiquities in the Eighteenth Century: A Study of Charles Townley (1737–1805) and his Circle' (Oxford, 1988), 42–3.)

Jenkins mentions a couple of candelabra which it seems

Piranesi had hoped that Townley might buy, and also notes that Piranesi has composed a monument for himself. His 'third Candelabra'—perhaps meaning this monument—'is compleatd, the which As he sais, was found *tele quale* as well as the other two in Adrians Villa'. Jenkins concludes by reporting that 'he declares he does not wish to sell any part of his collection' which, it is implied, would not fool Townley. Piranesi's chimney-pieces were for sale and according to this letter he had hoped to sell a pair of candelabra to Townley: over the following decade, the last of Piranesi's life, he sold a great deal from his museum. The etchings which he had made during those years and which were assembled in the two volumes of his *Vasi, candelabri, cippi, sarcophaghi, tripodi, lucerne, ed ornamenti antichi* in 1778, the year of his death, were designed to promote business as well as to assist learning, since they recorded sales and advertised work for sale. Nevertheless, it does seem to have been the case that Piranesi wished to keep much of his collection together and he enjoined his heirs to preserve it as a museum. His son Francesco in fact continued to sell choice items, to British and other foreign collectors and to the papal museum, before selling the bulk of the collection in 1792 to King Gustavus III of Sweden (O. Neverov, 'Giovanni Battista Piranesi, der Antikensammler', *Xenia*, 3 (1982), 71–90; C. Gasparri, 'La Galleria Piranesi da Giovan Battista a Francesco', *Xenia*, 3 (1982), 91–107.

It is not hard to explain why Piranesi became so interested in candelabra. There were no antiquities in Rome more talked about in the latter 1760s than the exceptionally grand Hadrianic marble candelabra with their extraordinary undercut acanthus leaves acquired by Jenkins from the Barberini family in 1766 and sold by him to William Lock of Norbury in the following year but blocked for export by Winckelman in his capacity as Prefect of Antiquities. They were then acquired by the new Pope Clement XIV and were one of the pretexts for the creation at the end of the decade of his new museum in the Vatican. In 1770 also a great antique candelabrum was presented to the pope by Cardinal Zelanda (and an erudite paper published on it in the *Giornale pisano* by Gaetano Marini). In the following years Pope Clement secured the antique candelabra preserved in S. Costanza and S. Agnese for his museum.

The earliest evidence of Piranesi designing his own candelabra is to be found in his *Diverse maniere d'adornare i camini*, published in 1769 but prepared over the previous years, in which there are high relief candelabra adorning the uprights of one chimney-piece, free-standing candelabra to either side of another one, and smaller, presumably ormolu, candelabra both on a chimney-piece and by themselves intended as candlesticks (see pls. 20, 29, 34, and 51). Perhaps even more significant, and probably earlier, are the candelabra which Piranesi envisaged flanking the high altar of S. Giovanni in Laterano in one of the drawings (now in the Cooper Hewett Museum, New York) for redecorating the chancel of that basilica which he made for the Rezzonico family between 1763 and 1765, a point first made by John Wilton Ely (*The Mind and Art of Giovanni Battista Piranesi* (London, 1978), 113). So many of Piranesi's ideas may be traced back to sources

in his native city that it is worth mentioning the bronze candlestands which were such an impressive feature of churches in Venice and the Veneto, especially since they were far more complex in design than any such to be seen in Rome and served, as it were, as anthologies of fantastic imagery.

Piranesi was so keen on the candelabrum as a type of sculptural architecture that he designed his own monument in this form—something which no one had ever thought of before. It was erected for a while over his tomb in the church of the Certosa (S. Andrea delle Fratte) but in 1779 when his remains were moved to S. Maria del Priorato (the church of the Knights of Malta on the Aventine which Piranesi had rebuilt) the candelabrum was replaced by the portrait statue by Angelini and so re-entered the family collection. It was then sold to Cardinal Braschi from whom it was appropriated by the French and placed in the Louvre (Gasparri, op. cit. 106 n. 48). It may be to this memorial candelabrum that Jenkins refers in his letter to Townley, although it was not in fact composed out of fragments excavated at Hadrian's Villa but, according to Piranesi's own text on his print of it (in Vasi, candelabri, cippi . . .), out of pieces 'dimessi' in Palazzo Salviati at Longara.

The candelabra in the Ashmolean Museum are, after that in the Louvre, the most splendid and imposing of those that Piranesi assembled. In the first of the two prints which he made of No. 77, he states explicitly that it was reconstructed from pieces discovered in the Pantanello Lake at Hadrian's Villa in 1769 when it was drained by Gavin Hamilton. The earliest of the two prints made of No. 78 states that it had the same origin, although the date is not given. Legrand's biography implies that these discoveries in the Pantanello were the initial stimulus to the creation of Piranesi's museum. However, as Dr Vaughan observes (in his thesis cited above, 96–8), Jenkins letter reveals that Piranesi not only had a considerable collection before 1769 but had also access to excavations at the Villa before then, which is significant in view of Hamilton's own observation that Piranesi had played a part in identifying the best location for his immensely fruitful excavation there (Vaughan, op. cit. 96–8). The etchings of Hadrian's Villa, surely the greatest of all Piranesi's prints, belong, significantly to the late 1760s, and he must have spent much time there.

The size of Piranesi's 'museum' in Palazzo Tomati, Strada Felice, was commented upon by many. A letter to Townley from the architect Vincenzo Brenna of 10 February 1769 describes the numerous *botteghe* in the Strada Felice taken over by the sculptor and the thirty people employed by him to work the marble (Vaughan, op. cit. 98). This may be an exaggeration, for the first of the three carvers whom Legrand mentions as employed by Piranesi, Lorenzo Cardelli, is unlikely ever to have been a member of Piranesi's household factory. Cardelli had his own workshop—'entrando nella Strada Condotti', as it is listed on a memorandum of notable suppliers of antiquities compiled in 1769 or 1770 in connection with the foundation of the new Vatican museum by Clement XIV (S. Howard, 'An Antiquarian Handlist and the Beginnings of the Pio-Clementino', *Eighteenth-Century Studies* (autumn

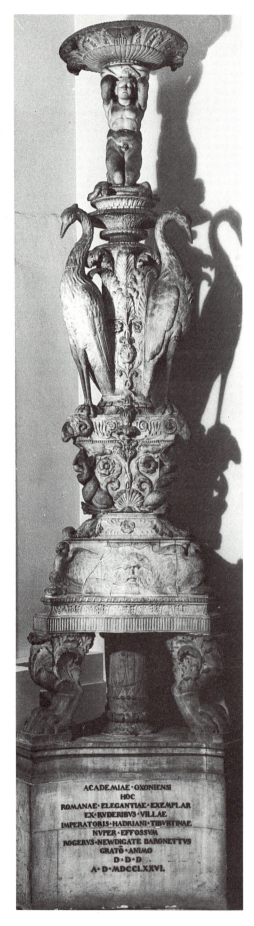

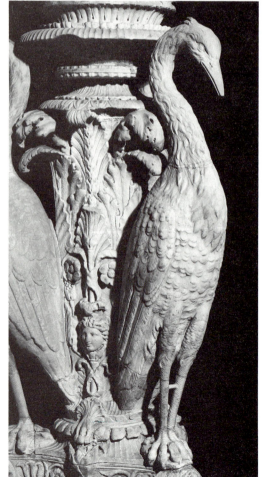

ACADEMIAE·OXONIENSI
HOC
ROMANAE·ELEGANTIAE·EXEMPLAR
EX·RVDERIBVS·VILLAE
IMPERATORIS·HADRIANI·TIBVRTINAE
NVPER·EFFOSSVM
ROGERVS·NEWDIGATE·BARONETTVS
GRATO·ANIMO
D·D·D
A·D·MDCCLXXVI·

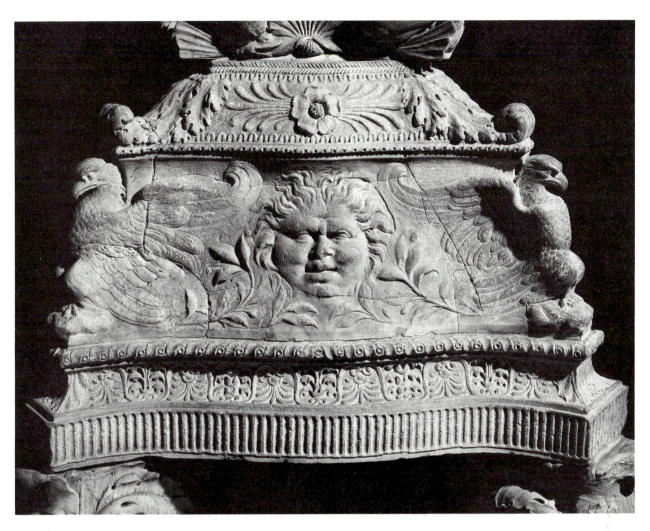

1973), 40–61). Moreover, Cordelli either had other artists working for him or at least retailed their work, for the mosaic on the chimney-piece which he sold to Thomas Mansel Talbot in 1771, and which is today at Penrice Castle, is signed by 'Aquatti' (J. Cornforth, 'Penrice Castle, Glamorgan', ii, *Country Life* (25 Sept. 1975), 757 and fig. 4). Of the two other sculptors mentioned by Legrand, 'Pronzoni' and 'Jacquietti', the first must be Franzoni, who certainly also worked independently, although it is possible that he began his career employed exclusively by Piranesi, and the second has not been identified for certain (I do not accept the ingenious suggestion of Erouart and Mosser that it is 'sans douter graphie fautive pour Francesco Righetti').

It has never seriously been suggested that Piranesi ever carved anything himself, but according to Legrand he made models for the broken parts whose restoration was tricky ('delicate'). There are a dozen or so drawings by him for candelabra and similar compositions, but they are very bold compositional studies (see especially the drawing in the British Museum for a candelabrum, no. 44 in A. Bettagno (ed.), *Disegni di Giambattista Piranesi* (Vicenza, 1978); and some of the drawings recently discovered in Bologna, pls. 116–24 in A. Cavicchi and S. Zamboni, 'Due "taccuini" inediti', in A. Bettagno (ed.), *Piranesi tra Venezia e l'Europa* (Florence, 1983)). Presumably more detailed drawings or models must have been made for the Ashmolean candelabra, although an element of inspired improvisation may well have played a part in their construction.

In the texts on the plates which Piranesi made of the Ashmolean candelabra there is no indication of how extensive the modern additions are, nor any hint that the reconstruction of the parts was, to say the least, highly speculative. Of No. 77 Piranesi wrote in his first etching, dedicated to James Byres, that 'si rende pregievole per l'elegante Varietà, e l'idea dell'intagli con finezza di gusto scolpiti, e sue sculture con leggiadria distribuzione e grottesco disposte; di maniera che non ingombrano essi l'idea generale', which one would like to think was written tongue-in-cheek. The junction of the kneeling faun in No. 77 with the cup above in fact looks hastily designed. The contraction of the candelabrum below the cranes is painful, as is the way in which the noses of the dolphins collide with the next stage. The continuation of the acanthus shoot from the dolphin stage to the post behind the cranes works better on paper than in reality. In No. 78 the altar base of triangular plan which is so often incorporated in antique candelabra is placed higher up than any antique precedent or modern convention could have suggested and seems awkward. The arrangement of fluted and reeded elements below the crowning cup in No. 78 is also congested in a manner for which there are no ancient sources. The candelabra, even if consisting entirely of genuine antique fragments, could only have been composed by Piranesi and there can be little doubt that the congestion, awkwardness, and painful transitions were enjoyed by him. Some of his earliest imaginary reconstructions of the 'wild enormities of ancient magnanimity' published in his *Opere varie* of 1750 already include fantastic hybrid inventions, for instance in the 'Parte di ampio magnifico porto' a conical storiated column

emerges from a tapering rostral column which emerges from an obelisk decorated with the S-fluting found on sarcophagi, as if parts of each antique had been reassembled by a witty barbarian.

In the first etching that he made of No. 78 which was dedicated to 'Cav. Carlo Morris' Piranesi expanded, not on the beauty of the composition, but on the meaning on the imagery: the figures in low relief on the three sides of the altar stage represent Hercules, Minerva, and Silvanus to whom the candelabrum was sacred, the base was decorated with 'teschi, e simboli allusivi alla Religione', and the sphinxes and elephant heads placed at the angles were guardians. The base with its sacrificial instruments and garlanded bucrania is surely modern work, although derived from a common form of Roman frieze. The reliefs of deities are all fragments inserted into a framework which must also be modern. Piranesi cannot have been sure that they originated in such a setting. It is hard to understand how the very worn figure called by him Silvanus can be identified with any confidence, and hard to accept that the other two reliefs came unaltered from the Pantanello. The 'Hercules' has a feminine build, a light step, a fluttering lion pelt, and carries his club so daintily that he looks like an invention by Perugino, and indeed this might well be a fragment of a Renaissance relief. The Minerva is more orthodox, but the way that the further side of her shield simply disappears suggests an interest in aerial and evanescent effects more typical of the fifteenth-century low relief than of Hadrianic sculpture.

The parts of the candelabra which are probably ancient, even if patched up and sometimes worked over, are, on No. 77, the kneeling faun, the stage decorated with screwed dolphins with a scallop between them, the foliate lion's feet, and, most interestingly, the part of the base with expressive masks in low relief flanked by eagles. On No. 78 the three lion's legs with their pelts and heads on their knees and the stage decorated with squat sphinxes with vegetal tails come into this category. Particularly problematic are the cranes in No. 77 and the elephants in No. 78. A portion of the tail and feet of each crane is integral with the central foliate post and does look genuinely abraded. The heads and necks of each crane are certainly all new and their legs have all been restored, but the body of one bird (that below the tail of the kneeling faun) looks like ancient work only slightly recut. The most vividly carved of all the birds (that below the faun's right leg) is surely modern, although it is patched. One might suspect the antiquity of the elephant heads because they are such a peculiarity. Such heads had been employed, in 1756, surely without knowledge of the antique, by modellers at the Sèvres factory, for vase candlestands (of which there are fine examples in the Wallace Collection) and had been employed by Piranesi himself in his chimney-piece for Burghley House (above the *rosso antico* herms) and in a design for a clock (both published in *Diverse maniere*, pls. 1 and 61) before the alleged discovery of the antique fragments out of which his candelabra were composed. Nevertheless, the elephants in No. 78 look genuine and had they been invented by Piranesi he would surely have made the leaf ornament between them more interesting.

Having retrieved what is likely to be ancient, we can identify what is certainly modern. The identical cups crowning each candelabrum with their curling acanthus leaves and crisp waterleaves between them are neither worn nor reworked and cannot have spent centuries in the Pantanello. This is also true of the altar section of No. 78 with its ram's heads and down-curling leaves above (but excepting the inserted reliefs). It is also true of the entire base of No. 78 above the lion's legs and below the sphinxes (all of one piece of marble with a diagonal grey streak) and true of the plinth of No. 77 below the eagles. Reviewing these modern portions we note that they have a consistency of handling which derives from a very ostentatious use of the drill—a small drill is used to create points of shadow in palmettes and honeysuckle and the serrated edges of acanthus, a larger one is used in the ram's heads and leaves and berries above the altar section in No. 78 to such an extent that when looked at closely the forms dissolve, as when photographic reproductions reveal themselves as mechanical dots. This use of the drill is a feature of many of Piranesi's restored antiquities and is also found in his chimney-pieces, for instance those at Burghley and Gorhambury, and it can be seen in some of the ornamental carving in the Museo Pio-Clementino—for instance, the frames of the reliefs set into the wall of the Sala degli Animali and the decorative borders of the *verde antico* tables with winged ram supporters now in the same room (originally in the Sala dei Busti). It is a type of carving inspired by what has often been regarded as a decadent tendency in ancient Roman sculpture. Such drilling is never found on ancient Greek ornamental work. Piranesi, as a defender of the originality of the ancient Romans, must have known this and perhaps encouraged this manner of handling for this reason.

It remains to identify the sculptors who made the modern portions of the candelabra. As we have already pointed out, Legrand, whose biography was written with information provided by Piranesi's family, mentioned Cardelli. This sculptor was the restorer of the candelabrum now in the National Gallery, Stockholm, which came from Piranesi's museum. We know this from the catalogue made in 1792 by Giuseppe Angelini when it was bought by Gustavus II (P. Kjellberg, 'Piranesis antiksamlung i Nationalmuseum', *Nationalmusei arsbok*, 2 (1920), 156–69). That Cardelli was particularly associated with the restoration of candelabra might also be concluded from the fact that he is documented as working on the candelabra removed from S. Agnese and taken to the Vatican in 1772 (see the note by C. Pietrangeli appended to W. Amelung and G. Lippold, *Die Skulpturen des Vaticanischen Museums*, III, ii (Berlin, 1956), 544). The Swedish candelabrum has many passages of drillwork similar to those in the Ashmolean candelabra. One wonders whether it was this aspect of his work which Father Thorpe had in mind when on 6 February 1774 he wrote to his patron Lord Arundel from Rome about chimney-pieces that could be bought there, citing Cardelli in particular as someone who 'cuts ornaments in marble as fine as the ancients did' (quoted by W. Rieder in 'Piranesi at Gorhambury', *Burlington Magazine* (Sept. 1975), 590–1).

The second sculptor mentioned by Legrand was Franzoni.

His special talent was for the carving of animals and he is documented as the restorer of most of the small sculpture asssembled in the Sala degli Animali created by the papal architect Michelangelo Simonetti in the Museo Pio-Clementino, between the mid-1770s and the mid-1780s. Outstanding among these are the birds, similar in size and often in type to the cranes in No. 77, and indeed including a crane with spread wings (W. Amelung, *Die Skulpturen des Vaticanischen Museums*, (Berlin, 1908), II, ii, no. 122, pl. 32, as 'Reiher?') which was noted by E. Q. Visconti as coming from Piranesi's collection (*Il Museo Pio-Clementino*, vii (Rome, 1807), 50–1, commentary on pl. XXVIII). Visconti considered that the carving of the plumage is hard to match in ancient or modern sculpture, but in fact it was matched by Franzoni. If, as seems likely, the Vatican crane had already been restored by Franzoni when it was acquired from Piranesi's collection (which was certainly also the case, incidentally, with the 'Capra con gru e serpe' which was also bought for the museum from Piranesi's collection—see Gasparri, op. cit. 94) then it might have been because of his work for Piranesi on Hadrianic animal fragments that Franzoni came to be employed for this same purpose by the pope. Franzoni was (I am informed by Professor Pietrangeli) responsible for the magnificent winged ram supports of the *verde antico* tables mentioned above which suggests that, like Cardelli, he too employed this style of decorative drillwork.

Finally a note is required concerning Sir Roger Newdigate, the noted connoisseur and collector, also a talented amateur artist, who presented these remarkable objects to the University for which he was Member of Parliament between 1751 and 1780. He bought the Candelabra from Piranesi during his second Grand Tour which he made between July 1774 and December 1775, after the death of his first wife. Before buying them he had associated with Piranesi as a fellow antiquarian, showing him drawings of the Roman arch at Aosta which Piranesi promptly etched, and borrowing from him a plan of the Baths of Caracalla (McCarthy, op. cit.) It has generally been supposed that Newdigte bought the candelabra with Oxford in mind: possibly, however, he realized on returning home to his country seat of Arbury Hall in Warwickshire that he would find it hard to accommodate them and then thought of the University. Certainly Piranesi seems not to have realized that they were destined for the University and he did not mention this in the text on the second etching that he made of candelabrum No. 77 where he mentions that 'Sig. Cavaliere Rugiero Newdigate, gentiluomo di gusto' has transported it to his 'Patria'. 'Extant in Bibliotheca Radcliviana' was, however, later added in small letters. Newdigate had earlier played a part in negotiating the donation of the Arundel marbles to the University: indeed it was his letter which conveyed to the Meeting of Convocation on 20 February 1755 the offer of the dowager countess of Pomfret to present her 'Inestimable collection of Statues, Busts and other Antiquities' (R. F. Ovenell, *The Ashmolean Museum, 1683–1894* (Oxford, 1986), 144). Fifty years after the gift, Newdigate, shocked at the inadequate accommodation of the marbles in the Logic School, offered to pay for their cleaning, restoration, and

transfer to the Radcliffe library where his candelabra already stood—he envisaged the statues placed against the piers and between the arches of the reading room while reliefs and inscriptions would be in the open space below which would be glazed and secured by iron bars (as it is today). His offer was accepted (after some attempts to deflect it) by the Radcliffe Trustees and then, on 24 March 1806, by Convocation, but the Radcliffe librarian Professor Hornsby refused to allow the marbles in and the decree of acceptance was rescinded in the following year (ibid. 184–5).

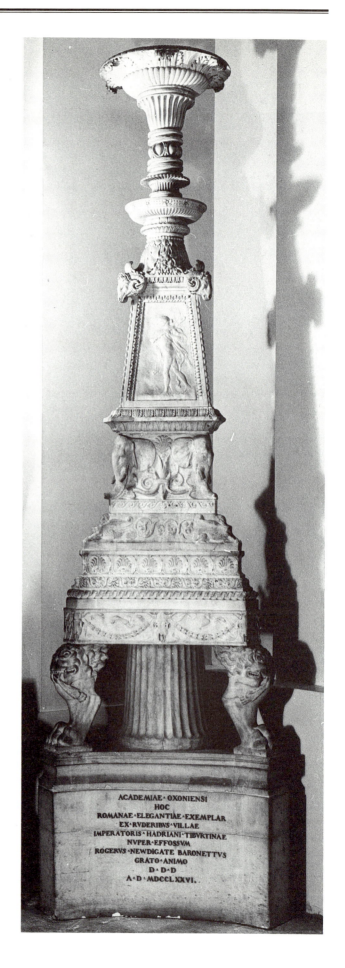

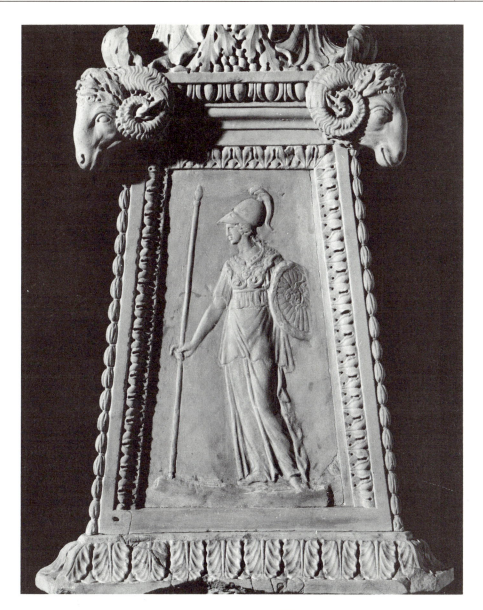

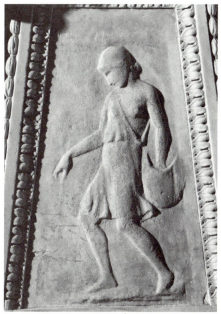

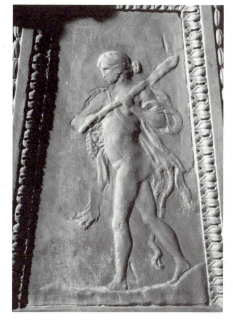

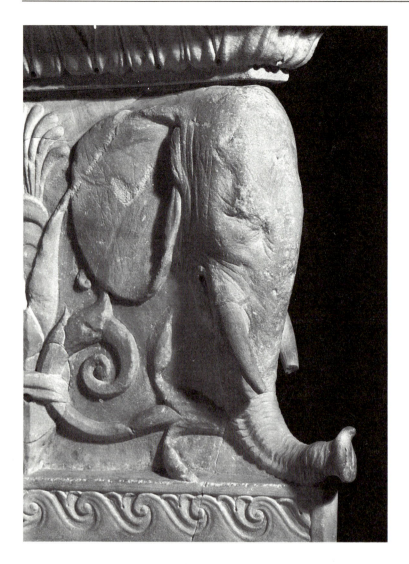

Supplied by Francesco RIGHETTI (1738–1819)

79. Callipygian Venus

34.6 cms. (height)

Bronze with a dark brown patina, ruddy where worn, with a slight green tinge in some areas. Hollow, lost-wax, cast. The figure's right leg has been cast separately and attached with a clear line at mid-thigh (possibly a replacement for a leg damaged in the casting, such additions being unusual in Righetti's bronzes). The circular unmoulded base is integral. 'F RIGHETTI · F · ROMAE· 1788' is chiselled behind the figure's left foot.

Purchased on 15 November 1960 for £65 from Alfred Spero, 'Art Expert', 4 Park Mansions Arcade, Knightsbridge, London SW1. Registered on 4 November.

Righetti, who studied under the Roman silversmith and bronze founder Luigi Valadier, established himself as one of the leading suppliers of bronze sculpture in the city in the last two decades of the eighteenth century. The four-page printed catalogue of his products dated 1794, and in French, survives in the Tatham papers in the Victoria and Albert Museum (reproduced F. Haskell and N. Penny, *Taste and the Antique* (London and New Haven, Conn., 1981), 343). Like his rival Zoffoli (see Nos. 110–15) he specialized in bronze reproductions of the most famous antique sculptures, 'fidélément [sic] copiés ... reduits à une juste proportion', but unlike Zoffoli it seems he also produced full-size casts. He also supplied ornaments for clocks, vases, and obelisks in bronze 'dorés à differentes coleurs [sic], imitant parfaitement [sic] les belles dorures de France.' That his business was still active in 1810 is proven by his bronze reduction of Canova's nude standing portrait of Napoleon in the Louvre (LP. 2715) which is chiselled 'Francesco Righetti et fils 1810'. Models for his copies after the antique were supplied by Roman sculptors such as Pacetti (it is notable that the copies of statues not in Rome such as the *Medici Venus* dated 1787, with Agnews, Bond Street, winter of 1985, are less accurate). We know from C. H. Tatham that Righetti was not himself personally involved in either modelling or casting but was an entrepreneur (see No. 15). Given the large bronzes that he sold, however, it is unlikely that he did not have a foundry, although it is not impossible that he put work out. In the list of 1794 the statuette of the 'Venus Callipige de la Farnesine' was priced at 18 zecchini (nearly £9). Full size it could be supplied for 550 zecchini (£225). For the history and reputation of the *Callipygian Venus* see Haskell and Penny (op. cit. 316–18).

K. T. Parker, then Keeper of the Department, whose decision to acquire this bronze must have been stimulated by his purchase of the version of the same antique prototype attributed by him to Hans Mont (No. 351), described it in the *Annual Report* for 1961 as follows: 'Closely based on the marble in its present condition, and obviously executed after the restoration by Albacini in the Eighteenth Century ... It is by Francesco Righetti ... dated 1788, thus clearly proving the minor but not uninteresting point that Albacini's restoration must have been fully carried out prior to that

year.' But the bronze does not in fact correspond to the marble statue in its present condition in the Museum in Naples (to which it was taken not long before 1792—see Haskell and Penny, op. cit. 316–18). Superficially it may seem to reproduce Albacini's restorations, as Parker proposed, but only because Albacini's restorations were not very different from those they replaced. Two changes that Albacini did make may be mentioned: he altered the figure's hair dressing so that the locks tumbled down the neck to meet the top of the smock at the figure's left shoulder and he altered the end of the drapery which extends from the raised hand making it longer and more vertical. The Ashmolean Museum's bronze follows neither of these alterations, but follows the restorations which preceded them and which can be seen in the early engravings of the sculpture. In some small details the bronze departs from the prototype entirely: for instance it omits the central knot in the girdle below the breasts which is found in the statue today and is included in prints of the statue before Albacini restored it. This detail is included in the small bronze by Zoffoli (lot 92, Sotheby's, New York, 20 May 1988), which also has a bracelet on the figure's right wrist and a smaller base.

Supplied by Francesco RIGHETTI (1738–1819)

80 and 81. Busts of Bacchus and Ariadne

29 cms. (height including socles)

Bronze with a dark green and brown patina. Hollow, lost-wax, casts. Little evidence of any tooling. Both busts are attached by integral metal fixtures to turned socles of *rosso antico*. The bust of *Bacchus* (No. 80) has a slightly chipped socle and a dent on his chin. 'F. RIGHETTI. F. ROMÆ. 1789' is chiselled in the metal across the narrow edge of back below the neck, in both cases, with triangular shaped stops, in the case of *Bacchus* with a long tail to the last numeral. 'B. / 404. / Ⅎ.' and 'B. / 405. / Ⅎ.' are painted in white in the hollow interiors.

Given by C. D. E. Fortnum in 1889. B. 404 and B. 405 in his catalogues. Bought in Rome in 1848 for £5 according to the notebook catalogue, but in 1849 according to the earlier preliminary catalogue (p. 40). The bronzes have served as ornaments for coin cabinets in the Heberden Coin Room since 1959.

Fortnum was aware that these were reproductions of antique sculptures and in his large manuscript catalogue he suggested that both were after prototypes in the Capitoline Museum in Rome. The *Ariadne* (81) is indeed a reduced copy of a sculpture in that museum, a work much favoured by Winckelmann who published it in his *Monumenti inediti* of 1767 (no. 55), and which is now considered to be an effeminate *Dionysus* (see H. Stuart Jones, *The Sculptures of the Museo Capitolino* (Oxford, 1912), 344–5). It is an exact copy save that the edge of the bust comes closer to the curls and the leaves in the hair are worn in the antique marble. This bust was much reproduced in marble, sometimes with a copy of the *Capitoline Antinous* as a companion (see for instance

the pair sold at Sotheby's, London, 7 July 1988, lots 285 and 286).

The *Bacchus* was described when exhibited in Fortnum's lifetime as 'apparently a reduced model of the Braschi Antinous', but this is incorrect. It is in fact based on a marble in the Townley Collection in the British Museum (no. 1899, as an *Antinous-Dionysus*). Townley acquired this from the Villa Pamphili and casts, upon which Righetti's model would no doubt have been based, were made before it was exported (C. W. Clairmont, *Die Bildnisse des Antinous* (Rome, 1966), 51, no. 37, pl. 27). There is a difference in the inclination of the head and in the pattern of leaves and grapes.

For Righetti see No. 79. These two bronzes are likely to correspond with the busts of *Ariadne* and *Bacchus* in Righetti's 1794 catalogue—a bust of 'Lisimaque' comes between them so they were not perhaps always sold as a pair—if so then they cost 12 zecchini each at that date. That was approximately £5—the sum for which Fortnum bought these examples half a century later. Small pairs of these two busts are also found—in bronze with ormolu socles (with Vinci Antiques, 124 New Bond Street, London, in 1986) and in ivory on ebonized socles (Christie's, London. 28 January 1988, lot 65). The bust of *Ariadne* is also found oddly incorporated in the tripod support for a *pietra dura guéridon* table probably of the Second Empire (lot 387, Sotheby's, London, 17 March 1989, while that of *Bacchus* serves as the gilt bronze support for a *tazza* signed 'Beaujault 1871' (lot 176, Sotheby's, London, 28 September 1989). Clearly Righetti's models entered the stock of the Parisian bronzists. Inferior sand-cast copies of the pair on miniature marble pedestals each stamped 'GS [M]EDAILLE D'OR 1867' were lot 53, Christie's, 23 March 1989.

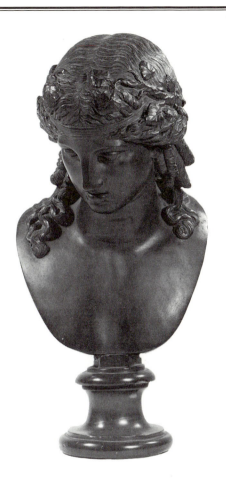

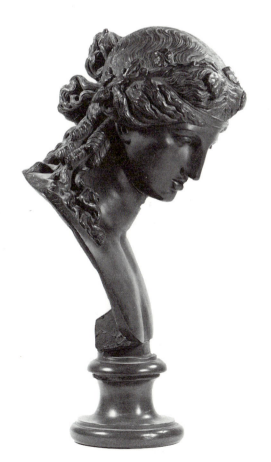

Perhaps by Niccolò (Nicolino) ROCCATAGLIATA (active 1593–1636)

82. Infant angel, or amorino weeping

27.7 cms. (height including bronze base); 0.5 cms. (maximum height of base); 10.5 cms. (height of marble pedestal)

Bronze covered with a dark brown to black varnish, red where thinnest, worn to expose a dull greyish green-brown natural patina chiefly on the belly and thighs. Flaw on top of boy's left thigh. Dent also in thigh. Little evidence of tooling—the detail of the feathers, for instance, is all in the wax model. The small round bronze base is integral. The bronze is mounted (loosely) on a dark green breccia marble pedestal lettered in gold with the name of the donor and her brother.

Given by Miss Elinor Rokeby Price in May 1948 (registered 21 May 1948), in memory of her brother Brigadier General Bartholomew G. Price, CB, CMG, DSO. Said to be from the collection of Jacob Goldschmidt.

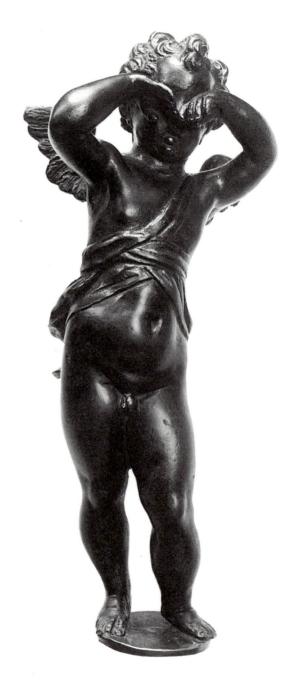

Another version of this bronze is in the Staatliche Museen, Berlin–Dahlem (no. 1814, see W. Bode, *The Italian Bronze Statuettes of the Renaissance* (London, 1912), iii, pl. CCLXV, and *Ex aere solido: Bronzen von der Antike bis zur Gegenwart* (Berlin, 1983), no. 74 (entry by Ursula Schlegel)). It differs a little in the mouth (the teeth may be detected only in that version), the drapery, the pattern of curls, and the degree to which the boy's toes overlap the base which in that case is also supported by a sub-base of egg and dart moulding (which is, however, separately cast). The size of the figures and the character of the bases suggests that they originally served as andiron ornaments. Such a weeping putto might have had a laughing putto as a companion—the merry child, 33.5 cms. high, from the Soulages Collection in the reserve collection of the Victoria and Albert Museum (8432-1863) perhaps reflects such a figure. A weeping putto of very similar character but smaller (19 cms. in height) and with thicker legs, and the hands in a different position (the back of his left hand flat against his left eye) which is in the collection of Sir Brinsley Ford (and was in the collection of Sir Thomas Lawrence) has as its pair a cheerful putto turning with his arms raised to his right. Fine examples of andirons with winged putti of similar character on top of them (but considerably larger in size) are in the Nelson Atkins Museum, Kansas City (62-19/1 and 2).

Putti of this type, with elongated, undulating contours and loosely articulated forms—plump thighs, full bellies, the upper chest distinguished from the torso below by a high belt of drapery—and with ovoid heads crowned with thick top curls, the open lips rendered as smooth projections, unjoined, not dissimilar to the chin, and the eyes, also summary in treatment, given segmental brows, have been particularly associated with Roccatagliata. They are in fact characteristic of Venetian sculpture generally in the second half of the sixteenth and in the early seventeenth century, and will be found in works documented as by other sculptors (the *Annunciation*, commissioned from Alessandro Vittoria by Hans Fugger in 1580, today in the Art Institute of Chicago—

1942.249—is a striking example) and in numerous bronzes which are of inferior quality (see Nos. 124, 125, 175, 176). But it is true that Roccatagliata seems to have been particularly fond of the type. Examples are the Christ Child held by the standing Virgin inscribed with the name 'NICOLLIN', in the Musée National de la Renaissance, Écouen (CL. 13272); the large putti half-kneeling on the lower scrolls of the candelabra of S. Giorgio Maggiore, Venice (documented as made by him in collaboration with Cesare Groppo in the 1590s); the 'ventidue puttini di bronzo che si convertono in scartozzi con campanello attaccato a una mano e candelabro sopra la testa' commissioned for the same church, which may be identified as the light-fittings in the form of angel terms surviving beside all the side altars, one of which retains its bell attachments, in that church; and, above all, the altar front crowded with child angels and cherubim which since 1779 has served as the retable of the sacristy of S. Moisè, Venice—a work signed by him in 1633 and made with his son Sebastiano. It is noteworthy also that Roccatagliata's adults are also influenced by this infantile idea: this is true of the faces of his finest surviving works—the statues of *Sts George* and *Stephen* commissioned early in 1593 for the 'Scabelli delle prime sedie' of the new choir stalls and today on the altar rails of S. Giorgio Maggiore, Venice.

It is also characteristic of Roccatagliata's work that the detail is not tooled but reproduced from the wax model. This is true, for example, of the scribbled pattern in the fringe of the Virgin's veil at Écouen, and of the decorations of St Stephen's chasuble. It is true too of the wings in this weeping putto. An idiosyncratic feature of the putto is the treatment of the second toes which are flattened, square ended, and with the nail very deeply set. This will also be found in the feet of the Virgin at Écouen, in the visible foot of the *St George* and in those of the exquisite terracotta *Madonna and Child with Angels* in Berlin (Staatliche Museen, Berlin-Dahlem, no. 2616).

In all the literature on Roccatagliata it is assumed that he was responsible for the casting of his bronzes, but most of his recorded commissions were collaborative and he may have only provided the models— it is odd, if he was an experienced bronze founder, that the S. Moisè relief should have been cast by Jean Chenet and Martin Feron. His excellence as a modeller is suggested by the tradition that he was employed in this capacity by Tintoretto (recorded by R. Soprani in his *Vite de' pittori, scultori, ed architetti genovesi*, ed. C. G. Ratti (Genoa, 1768–9), i. 353–5).

Volker Krahn informs me that the version of this bronze in Berlin was reproduced by Berlin foundries in the first decade of this century.

Raffaello ROMANELLI (1856–1928)

83. Bessie Rosalie France

70.5 cms. (height of bust, from lowest portion of shawl to top of head); 63.2 cms. (height of bust, from back of bust where supported); 59.4 cms. (width of bust); 125.9 cms. (height of pedestal)

Carrara marble. The plinth is of three separate units: plinth; shaft with base; capital, abacus, and block. There is gold in the recesses of the relief of a vase, ivy leaves, and berries on the block, in the hollows of the capital, in the channels on the shaft, and in the lettering: 'Boss & Mac' is chiselled in untidy cursive lettering on the front and back faces of the base of the shaft. 'BESSIE / ROSALIE / FRANCE' is chiselled in the tablet in the capital on its front side. 'Prof. R. Romanelli of Florence' is chiselled lightly in cursive letters obliquely to proper right in the fringe of the shawl. The bust was cleaned by Rachel Kenward in August 1988, and the pedestal cleaned by Mark Norman in April 1989.

The provenance is unrecorded but is presumably connected with the France bequest. Remembered by Mr Taylor as being in the Museum when he commenced work here in 1948. Kept in the Museum's basement until March 1989 when placed in the Combe Room.

Raffaello Romanelli was the son of Pasquale Romanelli (1812–87) a pupil and chief assistant of Lorenzo Bartolini. Pasquale, like Bartolini, was noted for his attempts to produce marble, three-dimensional versions of famous paintings. His versions of Raphael's *Madonna del Cardellino* and of Allori's *Sleeping Christ* were famous. A good idea of his reputation with British and American visitors to Florence may be obtained from Mrs Trollope's 'Notes on the Most Recent Productions of the Florentine Sculptors', Part IV, *Art Journal* (1 Sept. 1865), 263–4, which describes a visit to his studio (formerly Bartolini's) near Porta S. Frediano. He produced candelabra and an elaborate chimney-piece for Lord Portarlington which were especially admired. Raffaello was no less successful. Among his most notable works in Florence are the splendid bronze statue of Ubaldino Peruzzi in Piazza Independenza, the bust of Cellini on the Ponte Vecchio, some of the sculptures on the façade of the Duomo, and the tomb of Donatello in S. Lorenzo. Also by him are the tomb of Pope Alexander II in St Peter's, Rome, and the statues of Garibaldi in Siena and of Charles Albert of Savoy on the Quirinal in Rome. But like his father he depended for much of his business on foreign visitors to Florence. His son, Romano, was also a successful sculptor.

The variety of texture in this bust is characteristic of Raffaello Romanelli's work in marble. The rose petals and leaves in Mrs France's bosom are represented in thin and transparent marble, but impression is as much the sculptor's concern as imitation and it is not clear where the rose ends. The shawl appears to have first been carefully rendered in a low relief imitation of a textile pattern and then covered with rough blows of a chisel to give a vibrant effect. The hair is rendered by tremulously undulating chiselled channels. No less remarkable is the evanescent half-smile and the half-distant expression in the eyes. A still more exceptional example

of Romanelli's virtuosity in carving and imaginative portraiture is his ideal bust portrait *Iris Fiorentina* in the Museo Nazionale d'Arte Moderna, Rome. This is also terminated in an unorthodox manner: the shawl overhangs the pedestal over which flowers and ribbons also drip.

The bizarre character of the pedestal of the bust of Mrs France is unlike anything found in British or French sculpture in the late nineteenth century but is typical of Italian work in this period, reflecting the innovations of Giuseppe Grandi, in particular in his marble portrait of Avvocato Billia commissioned in 1873 for the Municipal Cemetery in Milan (replaced by a bronze, the marble is now in the Galleria d'Arte Moderna, Milan, no. 1118—pl. 1114 in L. Caramel and C. Pirovano's catalogue *Opere dell'ottocento* (Milan 1975)). Grandi also did much to popularize the revival of early medieval, Lombardic, geometric decoration such as is employed here. It was very popular in Italian sculpture around 1880 often in combination with modern, art-nouveau, ornament—an extreme example of its use is the bronze statue *Rinascita* by Ettore Ximenes of 1897 in the Museo Nazionale d'Arte Moderna, Rome.

Bessie Rosalie France was the wife of George Flood France, for whom see No. 84. It may be assumed that 'Boss' and 'Mac', the dachshunds represented 'adorsed' in relief on either side of the plinth of the pedestal, were her pets.

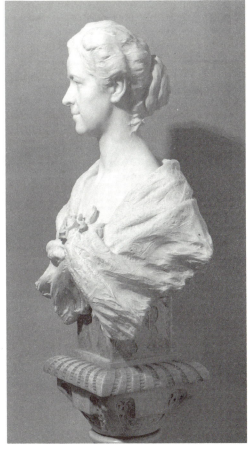

Foundry of G. Vignali

After Raffaello ROMANELLI (1856–1928)

84. George Flood France

63.8 cms. (height including integral bronze base); 1.3 cms. (height of integral bronze base); 4.2 cms. (height of marble plinth); 19.6 cms. (length of marble plinth); 16.4 cms. (width of marble plinth)

Bronze of uniform dark brown patina. Hollow cast. Stamped into the model on back side of the integral bronze base 'FONDERIE. G. VIGNALI. E Co' with 'PARIS' continuing on the proper right side of the same base, the capitals irregular. Incised in the model across the proper left corner of the upper surface of the base 'Prc [: Prof. ?] Romanelli Rᵒ./Florence. 1903.' in cursive letters. Chiselled in the metal on the front side of the base below the sculptor's name 'George F. France', a simulated signature with a tail to the 'e' and flourishes to the 'Gs' and 'Fs'. Mounted on ruddy brown Tuscan marble (*marmo rossastro*).

Provenance unrecorded, but presumably connected with the France bequest. Remembered by Mr Taylor as being in the Museum when he commenced work here in 1948.

G. F. France (MA Exeter College) who died on 14 February 1933 bequeathed seven-tenths of his estate to the University of Oxford subject to the payment of a life annuity of £2,000. Three-tenths of his bequest was to be devoted to the Ashmolean Museum. This bequest was accepted by decree of 7 November 1933. The recipient of the annuity died on 19 January 1947 and this bronze statuette together with the marble portrait bust of Mrs France (No. 83) may be supposed to have come to the Museum in that year—one in which the proper recording of accessions was, understandably, disrupted. Statuettes of this size and medium and informal character were not unknown in England—J. E. Boehm had indeed created something of a vogue for portraits of this sort, his *Thackeray* with pince-nez and both hands in pockets and his *Millais* with one hand in pocket and the other with a cigarette (both plasters of which are in the National Portrait Gallery) belong to the early 1860s—but by the end of the century this had ceased to be a popular type of portraiture in Britain. In Italy on the other hand such statuettes were much in demand. A number of examples from this period are preserved in the Museo d'Arte Moderna in the Palazzo Pitti in Florence, among them two striking examples by Raffaello Romanelli, one of the Avvocato Alfredo Ambrosiano of 1892 which represents him cross-legged holding a bowler hat and a cigar (Giorn. 741), and another of an unknown man with his hands in his pockets (CG. 647; Dep. Com. 240). The later was cast by the Vignali foundry, whose name appears on many Florentine bronzes of this period—the bronze statuette of George France is the only one I have seen in which the foundry is located in Paris rather than Florence and it must be concluded that it moved there, perhaps only briefly. Once cast, the bronze was perhaps sent back to Florence because the marble of the plinth is of a local type much favoured in Tuscany. Romanelli exhibited statuettes in the Royal Academy Summer Exhibition in 1909, one of which, of an

English sitter, Mr Bushnell (no. 1681), was specified as of bronze. An Englishman, A. Bartlett, also wrote a book about Romanelli—*Raffaello Romanelli and his works* (Rome, 1915), which is unobtainable, however, in England and not easy to locate in Italy. For Romanelli see also No. 83. As mentioned there one of his most notable public statues was that of Ubaldino Peruzzi in Piazza Independenza in Florence dated 1897—the high reliefs of its pedestal include many figures very similar in size and character to this statuette.

Little is known of France. He was the first son of the Revd George France and was born at Brockdish, Norfolk, in 1847. He was educated at Eton and matriculated at Exeter College, Oxford (also his father's college), in May 1864, taking his BA in 1867 and his MA in 1871. He was called to the Bar on 26 January of the latter year and by 1902 he had ceased practising. He was a JP for Middlesex and also FSA. (Information from Mr Maddicott of Exeter College and Mr Breem of the Inner Temple Library).

Unknown foundry

After Jacopo SANSOVINO (Jacopo Tatti) (1486–1570)

85. Virgin and Child

48.5 cms. (height, including base); 13.7 cms. (length of bronze plinth); 9.8 cms. (width of bronze plinth)

Bronze with a dark brown, in parts slightly green, patina. Hollow, lost-wax, cast, with varied, but mostly thick, walls, with some perforations in the folds behind the Virgin's right arm. There is much evidence of work with files and chisels. There is a firing crack at the back of the veil. An irregular large plug is visible in the drapery on the shoulder to proper right. Circular plugs are visible in undraped corners of the plinth proper front right and back left. There is a small knob on the head of Christ with a screw hole behind it and a plugged hole behind that; also a small hole in the top of the Virgin's head and nearby much evidence of filing, over a patch perhaps of a different metal. The integral bronze base is screwed to a spreading hollowed ebonized plinth and a sub-plinth, also of wood and painted to simulate *verde antico* marble.

Bequeathed by Mrs Leverton Harris, 1939.

A version of this statuette, with Sansovino's name (JACOBUS SANSOV.) chiselled across the front of the plinth, was published in 1922 (E. de Liphart, 'Deux maquettes en bronze de la Renaissance italienne', *Gazette des beaux-arts*, 64/2 (1922), 339–47) when it was, or at least had recently been, in the possession of a private collector in Leningrad. This found its way in the 1930s into the collection of Baron Heinrich Thyssen-Bornemissza and then, through Adolph Loewi in 1951, to the Cleveland Museum of Art (51.316). A certificate signed by Planiscig in January 1935 asserted that the lettering corresponds 'fully' to that on the plinths of the bronze statuettes of Sansovino's Evangelists in St Mark's in Venice. The similarity is hardly surprising and proves little, and in any case is not exact, since the Christian name commences here with a 'J' rather than an 'I' (not apparent at first since the tail is not firmly attached to the body of the letter), which is the case with no other version of the sculptor's name chiselled on either bronze or marble. Furthermore, it is curious, if the lettering is contemporary with the casting, that there is a disfiguring patch in the plinth between the first and second names. One would suppose that this was originally a neat enough repair for the letters to continue over it. However, the lettering certainly looks old and must at least reflect a tradition concerning the origin of the model. The elongated proportions and continuous curve from the Virgin's right foot to the fold of drapery above her head recall the sweep of Jacopo Sansovino's *St James* in the Duomo in Florence, while the conception of the Madonna as a mantelled Roman matron recalls both the seated *Virgin and Child* he made for S. Agostino in Rome and the works of his master Andrea Sansovino.

More decisively, as Liphart observed when first publishing the bronze (ibid.), the bronze is only a little varied from the marble *Virgin and Child* above the tomb of Gelasio Nichesola in the Duomo of Verona which it is now known that Sansovino executed between 1530 and 1532. Since it is smaller in size (the marble version is 80 cms. high) the bronze was supposed by Liphart to be based on a maquette; this may be correct but the more upright pose which is the chief difference might also be explained as a modification to enable it to make more sense as an independent group (on the tomb the figures are designed to comfort the bishop who reclines in effigy below them)—a point made by Bruce Boucher in his forthcoming monograph on Sansovino's sculpture. Like Liphart, Boucher discerns a debt to Donatello, and, noting that in the Cleveland statuette the irises of the Virgin's eyes have been perforated, he wonders whether the face was originally silvered, as with Donatello's *Virgin and Child* in the Santo in Padua. The finish of the Cleveland bronze resembles those known to have been cast after his models in Venice, and in particular the Evangelists of St Mark's which are of comparable size, and, where the darkened varnish has worn off, the metal is of the same chocolate colour, typical of a very coppery alloy, as is seen in the Evangelists. On the whole it seems likely that the bronze in Cleveland was made by, or for, Sansovino himself, and if so it may well be his first experiment with this medium (as Boucher also observes) made soon after his first contact with the thriving foundries and advanced casting technology of the Veneto.

When Hans Weihrauch published his *Studien zum bildernischen Werke des Jacopo Sansovino* (Strasburg, 1935), 34 he was able to point out the existence of other bronze versions, unsigned, in the Goldschmidt Collection in Berlin and in the Gualino Collection (Galleria Sabauda, Turin). Another is in the Museo Poldi-Pezzoli, Milan (Piccolo Museo Mario e Fosca Crespi FC. 15/68), one is in the private collection of Professor Keutner in Florence, and one was sold at Sotheby's, London, 2 July 1973, lot 70, perhaps identical to one sold there 13 December 1990, lot 128. These versions, together with the Ashmolean's have been classed as replicas of a later period by W. D. Wixom (*Renaissance Bronzes from Ohio Collections* (Cleveland Museum of Art, Cleveland, Ohio, 1975), no. 112) and, by implication, by Boucher (op. cit.). When compared with the Cleveland bronze the Ashmolean version is slightly larger (the base is 13.7 cms. long as against 13.5, 9.8 cms. wide as against 9.5, the distance from disc fastening to disc fastening is 7.6 cms. as against 7.4) so it is not a modified aftercast. In the Ashmolean versions the Virgin's fingers are more pointed and delicate, the suspended hand of Christ is less curled, the knot of drapery under the Virgin's wrist is less rounded, the hair curling down beside the disc fastenings is slightly thicker, the divisions of the virgin's hair are less parallel, the surfaces generally are smoother. The Cleveland version is at every point closer to the Verona marble and more typical of Sansovino, but the modifications do not suggest a mechanical copyist. Furthermore it is wrong to group all the later versions together. That in Milan has a round base, a rough finish, less definition in the Virgin's hair, and far tighter curls on Christ's head. That in Turin, to judge from photographs, is imprecise in all its details and may be an aftercast. That in the collection

of Professor Keutner resembles the Ashmolean version in details such as the delicate hand of the Virgin, but is rougher in finish, with numerous flaws, pitted surfaces, and evidence of chiselling. It also has textured surfaces, the Virgin's mantle being heavily punched and chiselled with trefoil flowers. That sold at Sotheby's in 1990 seemed very close to the Ashmolean version.

The holes in the backs of the heads in the Ashmolean group suggest that haloes were once fitted to them: these may have been replacements for earlier haloes to judge from the integral bronze projection on the top of Christ's head and the filing marks on top of the Virgin's.

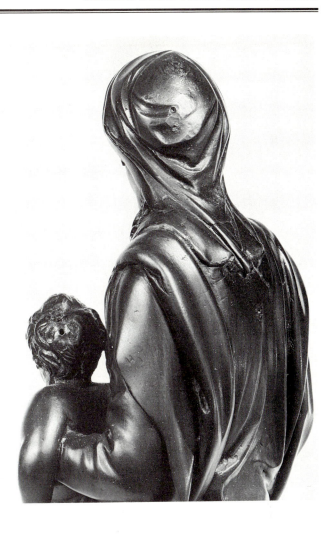

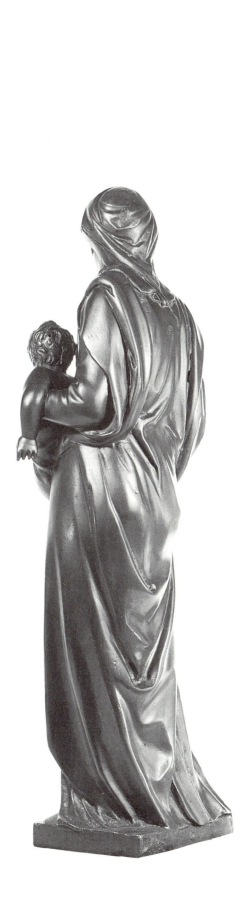

School of Jacopo SANSOVINO (1486–1570)

86. St Jerome in penitence

26.8 cms. (height including integral plinth); 2.1 cms. (height of integral plinth); 35.7 cms. (length of integral plinth); 14.7 cms. (width of integral plinth)

Stone of an exceptionally fine grain with a pale, beige colour, polished in some smooth salient features such as the knee and forehead. Said to be Istrian stone but perhaps a limestone from the northern Veneto or from Brescia. There are chips missing from the edges of the plinth especially along the front lower edge, and at both back corners. The saint's left wrist is broken and has been refixed with some plaster infill. This was rebroken as a result of careless handling in 1987 and was refixed by David Armitage of the Department of Antiquities, old distorting plaster infill being removed at the same time. There are scratches to the surface in some areas which suggest cleaning and vestiges of paint may be discerned in some folds of drapery. Portions of an inscription painted in black letters on the back face of the plinth may be made out: the word 'Eglise' seems to be part of it, and, earlier in the line, a word including the letters 'racc.'.

Bought in 1962 from the Arcade Gallery (Paul Wengraf) of The Royal Arcade, 28 Old Bond Street, London W1, with the France Fund, and with a grant from the Regional Fund administered by the Victoria and Albert Museum. Registered on 8 March. The sculpture seems always to have been displayed in the Fortnum Gallery on top of a *cassone*.

Ian Robertson, publishing this unusual small stone carving (the size and colour of a terracotta modello) in the *Annual Report* (1962: 63–4), felt that an 'attribution to Jacopo Sansovino may be put forward with some confidence. The piece plainly shows the high-mannerist character of Sansovino's latest work, and valid comparison may be made with the figures recumbent in the framework of the bronze door of the Sacristy of St Mark's (the model for which seems to have been completed in 1546). The latter comparison is valuable. The torsion of the head and the treatment of the long beard blown against the upper chest also bring to mind Sansovino's bronze statuette of *S Matthew* on the altar rail of the Basilica of St Mark's (installed 1553) and his colossal marble *Neptune* (1554–67) on the Scala dei Giganti in the courtyard of the Doge's Palace. Such comparisons, howevr, only enable us to associate the figure with Sansovino's large school. The elongation of the saint's body and the treatment of the anatomy as a sequence of rounded lumps, loosely if dynamically related, suggest some of the tendencies in the work of his followers which may also be observed in figures invented by Tintoretto—particularly pertinent in this connection are the river gods in the spandrels of the library of San Marco delegated by Sansovino in the mid-1550s to Vittoria, Cattaneo, Ammanati, and Tommaso Lombardo.

The existence of independent statuettes of St Jerome can be connected with the taste for small paintings of him, a taste which seems to have been particularly strong in the Veneto by the last quarter of the fifteenth cetury. The Ashmolean also possesses a terrracotta figure 38.5 cms. high, of the kneeling saint with his lion which was purchased from the Arcade Gallery (registered 12 November 1960), which looks as if it dates from the early sixteenth century.

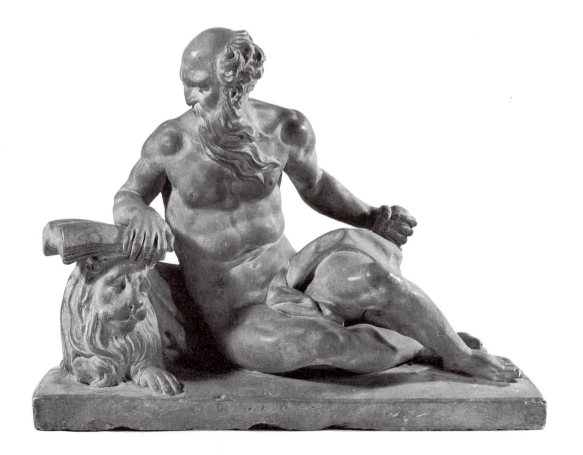

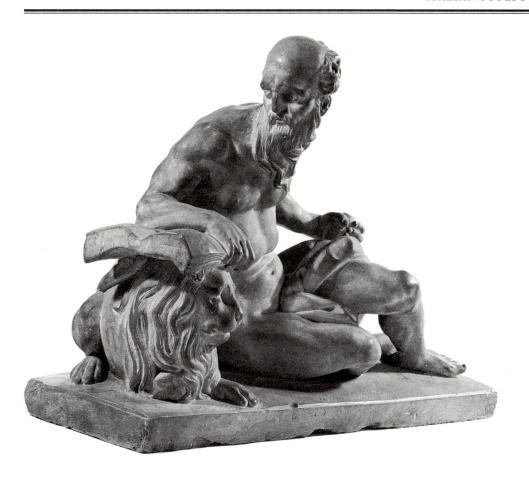

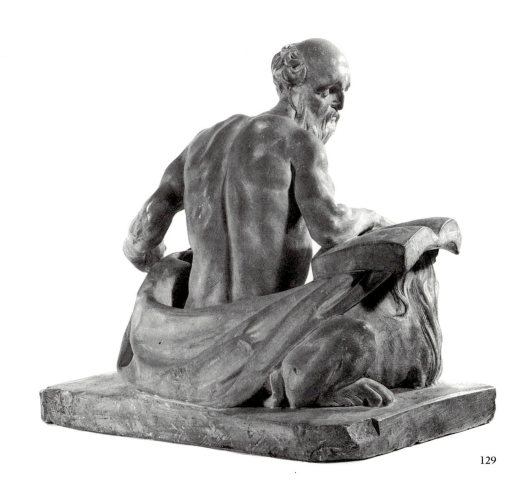

SBORDONI (mid-nineteenth century)

87. Lion

33 cms. (height); 37.2 cms. (length from front to back paws); 40.6 cms. (length of marble slab); 18 cms. (width of marble slab); 47 cms. (length of wooden plinth); 23.8 cms. (width of wooden plinth)

Bronze with a pale green to yellow tan patina. Hollow, probably lost-wax, cast. Precisely tooled and highly polished. There are a few small perforations in the area of the mane. Fixed to a slab of Siena (yellow, flecked with grey) marble, on a rectangular, moulded plinth of ebonized wood.

Bequeathed by C. D. E. Fortnum in 1899. B. 444 in his catalogues. Fortnum records that the bronze was commissioned by him in 1853. Long displayed on top of a cabinet on the staircase outside the Print Room. Placed in the Fortnum Gallery in 1987.

Fortnum had this lion made (as a companion for the bronze *Bull* (No. 162). A lion must seem an odd companion given the relative natural size of these animals. The explanation lies in the Sala degli Animali of the Museo Pio-Clementino where, as Fortnum knew, the antique marble prototype of his *Bull* had as its companion (on the other side of a stag carved out of flowered alabaster) a standing lion after which this lion was cast. The Vatican *Lion* is fashioned out of a yellow oriental breccia, of a colour close to that of a lion's coat, fitted with a tongue of *rosso antico* and with teeth and claws of white marble, and is mounted on a plinth of green porphyry. This 'lioncino', ancient, but extensively restored by Franzoni (see Nos. 77 and 78), was regarded as one of the most remarkable of the items in this now unfashionable corner of the Vatican Museums. (For an idea of the esteem with which it was regarded see E. Q. Visconti, *Opere* (Milan 1818–37), vii. 52, pl. XXIX).

The *Lion* was first described on 30 June of 1780 ('un piccolo leone di pietra colombina, che tende al vermiglio lungo palmi due . . .'), and was included in a list of works recently acquired from the Mendicant Fathers (who owned the Basilica of Maxentius where it was excavated), compiled on 14 September 1780, as item 8: 'leone scolpito di certa breccia gialla simile al color naturale' valued at the high sum of 300 *scudi* (see C. Pietrangeli, *Scavi e scoperte di antichità sotto il pontificato di Pio VI* (Rome, 1958), 32, 41). Fortnum recorded that the foundry which cast his lion was that of Sbordoni in Rome. The Sbordoni family are still engaged in metalwork there (the showrooms of Gino Sbordoni and Edoardo Litardi are at 133 Circumvallazione Clodio).

Unfortunately Fortnum is not explicit as to whether moulds were made of the antique on his initiative or that of the founder. One suspects it was Fortnum's idea (no other bronze version of the *Bull* is accompanied by a bronze version of the *Lion*), but once the founder had the moulds he seems to have made at least one other cast.

Another version of the bronze *Lion* is illustrated in Bode's *Italian Renaissance Bronzes* (1908), iii, pl. CCXLVII, as in Dr Simon's collection in Berlin. Bode considered this as Italian of the first half of the sixteenth century and it was sold on 10–11 October 1929, lot 47 of the Berlin sale of Simon's collection, as a Florentine bronze of this period. J. Draper in his edition of Bode, suggesting that it might in fact be an Italian seventeenth-century cast, noted that the bronze is now unlocated. It is in fact in the National Gallery, Washington (Samuel H. Kress Collection 1957.14.7), at present displayed as of the late eighteenth century (presumably because it has been recognized that the prototype was not available previous to that date), although J. Pope-Hennessy in his catalogue of *Renaissance Bronzes from the Samuel H. Kress Collection* (London, 1965), no. 499, pp. 136–7, fig. 563, assigns it confidently to the second quarter of the sixteenth century.

The Washington *Lion* differs from the Ashmolean's only in its tail, which falls down to the ground on the near rather than the far side of the lion, and in its rougher surface. But the tail in the case of the Washington *Lion* is joined and so might be a replacement or wrongly reattached, and the rougher surface turns out on careful examination to be created by a dark brown varnish which, where it has worn off, in the lion's mane, exposes chiselling as sharp and careful as in the Ashmolean's version. It is unlikely that a craftsman who had taken such trouble to tool his bronze would have obscured his workmanship in this way, and it seems probable that the varnish was applied by an unscrupulous dealer later in the nineteenth century to fool connoisseurs into thinking that it was a Renaissance piece. This ploy, which was so successful, depended upon a low estimate of nineteenth-century craftsmanship and a lack of interest in the Museo Pio-Clementino among such connoisseurs—and of course upon the fact that the Ashmolean's bronze was neither publicly displayed nor published.

A pair of small bronze statuettes after groups of mastiffs attacking stags in the Sala degli Animali which were lot 126 at Sotheby's, London, on 12 April 1990 seemed to be of similar colour metal, to be finished with similar precision, and to have identical Siena marble slabs.

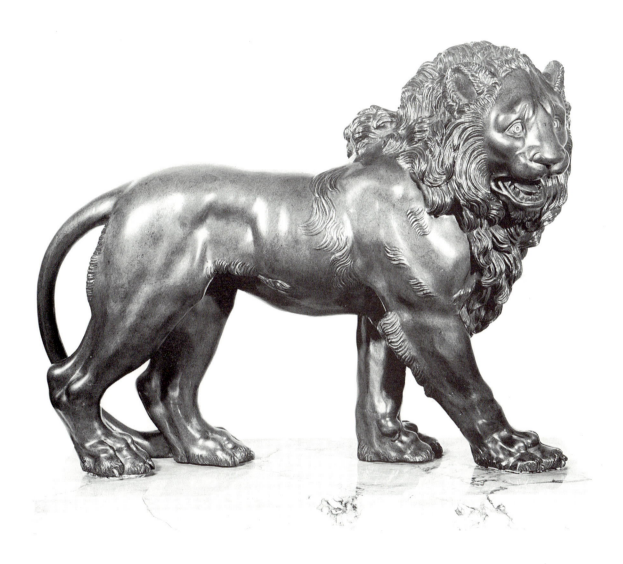

Workshop of Massimiliano SOLDANI (1658–1750)

88. Autumn (Pomona)

30.7 cms. (height excluding the plinth); 2.5 cms. (height of plinth); 11 cms. (length of plinth); 8.9 cms. (width of plinth)

Bronze with a blackened varnish scratched and worn especially on the back to reveal a cool pale green and tan natural patina. Some traces of golden colour remain, especially on the neck. Hollow, lost-wax, cast. Thick walls. The plinth separately cast and the figure attached by threaded tangs projecting from the hollowed interiors of the feet (but the plinth has been filled with wax, cement, and wood). The machined gilt metal strap around the lower part of the plinth has been added to conceal the projection of a wooden block set into it. Plugs are easily perceived in the back of the figures, each 0.5 cms. in diameter.

Purchased 1963 as 'Flora' from Alfred Spero, 4 Park Mansions Arcade, Knightsbridge. Registered on 25 November.

Soldani's corespondence with his patron Johann Adam, prince of Liechtenstein (1666–1712), reveals that in July of 1701 the Florentine sculptor had had, for some time, in his possession a set of clay statuettes which reproduced the most notable statues, mostly antique, in the city of Florence. They had been made by one of his pupils under his supervision. From piece-moulds of these he could supply wax statuettes. From these stone enlargements could be cut by local craftsmen for the prince's palace garden in Vienna, as the prince had suggested. From them bronzes could also be made for the prince's cabinet. The prince did not like the dozen waxes sent to him early in 1702, but by December 1706 Soldani had made the bronzes anyway and offered them to the prince who was still not interested. This probably indicates the period at which the bronzes became available, but the Medici might reasonably be supposed to have been given a set already and they are likely to have served as diplomatic gifts. A group was in the collection of Johann Wilhelm, elector palatine, a son-in-law of Grand Duke Cosimo III de'Medici, as is shown by the inventory of the Düsseldorf Gallery on its transfer to Mannheim in 1730. However, the Liechtenstein correspondence makes it clear that the original initiative was not a courtly commission but a speculative venture, and the number of surviving casts, as well as the provenance of some of them, reveals that these reproductions were available to, and were perhaps designed for, the wealthy travellers whose importance for Italian sculptors was steadily increasing. This is the market which, later in the century, Roman founders such as Boschi, Righetti, and Zoffoli (see Nos. 15–16, 79–81, 110–15) were to supply with similar small bronze souvenirs of the antique. The whole episode has been explored, and Soldani's series reconstructed, with exemplary scholarship, by Klaus Lankheit in 'Eine Serie barocker Antiken: Nachbildungen aus der Werkstatt des Massimiliano Soldani', *Mitteilungen des Deutschen Archeologischen Instituts, Roemische Abteilung*, 66 (1958), 186–98. To this Charles Avery's article 'Soldani's Small Bronze Statuettes after "Old Master" Sculptures in Florence',

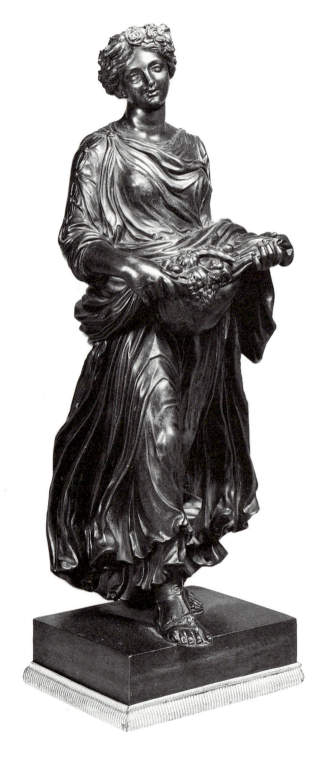

Studies in European Sculpture (London, 1981), 122–32, forms an indispensable supplement.

The Ashmolean's *Autumn*, which is recorded by neither Lankheit nor Avery, exists in at least three other versions: one is in the Gewerbemuseum, Nuremberg (Lankheit, op. cit., pl. 60, no. 3), another is in a private collection, Toronto, companion with a *Vestal Virgin* (*Paintings and Sculptures*, Heim Gallery, London (June–Aug. 1967), 11, nos. 24–5; Avery, op. cit. 126, pl. 4), and a third is in the reserve collection of the Bayerisches Nationalmuseum, Munich (69/29). Unlike the other bronzes in Soldani's series it corresponds with a type of bronze statuette well known in antiquity, of which there are fine examples in the British Museum (no. 1513) and in the Ashmolean Museum, Department of Antiquities (1971.1159). This, however, is a coincidence and Soldani's model was certainly a large marble statue in the Uffizi which had been admired in Florence for over a hundred years (G. Mansuelli, *Galleria degli Uffizi: Le sculture*, i (Rome, 1958), 154, no. 124, pl. 120). The correspondence in the body is exact except that the drapery in the bronze is freed from the extra supports in the marble (supports needed because the marble was itself derived from a bronze prototype). The heads however are quite different. That on the marble in the Uffizi today is not antique but is an old restoration recorded in the engraving of the statue (as a *Pomona*) which served as plate LXIII of Gori's *Museum Florentinum*, vol. iii, published in 1734. Soldani's bronze must record an earlier restoration, for there is no other instance in the series of bronzes of such a departure from the original prototype. It therefore possesses considerable interest as documenting a restoration which came to be regarded as inappropriate and was replaced. The restoration in question may well have been one for which Giovanni Battista Foggini or even Soldani himself had been responsible—certainly its lyrical radiance is very much in their manner.

Probably by Massimiliano SOLDANI (1658–1750)

89. Soldier saint pleading

17.2 cms. (height including integral bronze plinth); 1.25 cms. (height of integral bronze plinth); 6.2 cms. (length of plinth); 5.8 cms. (width of plinth)

Bronze with black to brown varnish worn to reveal a chocolate brown patina. Hollow, lost-wax, cast. A crack across the figure's right heel. Near it is a plug; there is another in the figure's left leg above the knee—both are 0.2 cms. in diameter. There is a crack in the figure's left thigh under the chain mail. A band of bronze 0.1 cms. wide in the figure's right leg just above the knee presumably indicates a repair or join. 'B. 422.᚛' is painted in white on the side of the integral bronze plinth behind the figure. The hollow plinth appears to have been given extra weight by a second pouring of bronze which conceals the point of contact with one foot, but in the indentation, which connects with the other foot, there are traces of solder and also of an iron pin.

Lent by C. D. E. Fortnum on 20 March 1888 and given by him later in the same year. B. 422 in his catalogues. In his notebook catalogue he records that it was 'bought of Hatfield' (for whom see Nos. 55, 264, 265), presumably after 1857 when the preliminary catalogue, in which it was not included, was compiled.

Fortnum considered that his figure perhaps represented Ulysses in the act of pleading. He attributed both it and a statuette of a warrior drawing a sword to Adriaen de Vries (No. 95), noting that it was 'elaborated with the greatest care, agreeing precisely in manner and workmanship with the figures in relief on the cuirass of the portrait of Rudolf II in the South Kensington Museum'. However, he also observed that it was 'exaggerated, almost Berninesque in manner' which would of course imply a later, seventeenth-century date, such as now seems certainly correct for it.

Fortnum noted that he had seen one or two later and inferior casts of the figure. None are known to me, but there is a wax version, about half-size (7.92 cms. high), in the Doccia porcelain factory, less precisely detailed, with the head differently positioned, and the figure's right hand intended to hold something (K. Lankheit, *Die Modellsammlung der Porzellanmanufaktur Doccia* (Munich, 1982), no. 913, pl. 227). The wax models in the factory were obtained by its founder, Marchese Ginori, from the heirs of the leading families of Florentine sculptors, the Foggini and Soldani. This particular figure is considered by Lankheit to be perhaps by Vincenzo Foggini. Jennifer Montagu, who first pointed out the connection with the wax model (letter to Gerald Taylor of 16 December 1970), suggested that it might correspond with a 'Giorgio Martire', one of a list of ten saints in an inventory of models at Doccia made in about 1780 (Lankheit, op. cit. 154). She also wondered whether it might be associated with a set of four statuettes recorded in a catalogue of the collection of 'modelli e figure di terracotta, di Bossolo, d'avorio e d'ebano' in the 'Museo' of Antonmaria Biscioni, granducal librarian in the mid-eighteenth century. (K. Lankheit, *Florentinische Barockplastik* (Munich, 1962), 284, doc. 354.) These statuettes were said to be 'della mano di Massimiliano Soldani, e sono tutte di buon lavoro e in

buona stato'. They represented *St Andrew* 'appoggiata alla Croce', 'un S. Pontefice' (a papal saint), *St Augustine*, and a 'S. Miniato Guerriere'. These were said to be 'circa un quarto di Braccio' in height, that is about 14.6 cms., which fits this figure if the fraction was approximate. There is in a private collection in London, as Dr Montagu has pointed out, a bronze *St Augustine*, clutching folios and extending a flaming heart, which has the same proportions, long, amply bearded face, large hands, swaying pose, look of pious desperation, and shape of plinth. It is also of similar size (19.5 cms.; the extra height being caused by his mitre). There is also, in another private collection, a statuette of a papal saint of very similar size and style. The only problem with this hypothesis is that, although the Ashmolean's bronze is of a warrior saint, he is unlikely to be St Miniato, who is represented as a younger man and usually crowned. He looks more like a St George or a St William of Aquitaine or even a St Longinus. On the other hand the compiler was no expert— he could not identify the papal saint—and might have hastily

assumed that Miniato, as the best-known Florentine warrior saint, was intended. The group seems somewhat miscellaneous and the saints may once have formed a different, larger group. In any case they must have come from a setting which was dismantled before they entered a 'Museo'. Both the Ashmolean warrior saint and the *St Augustine* require a pretext for their demonstrative poses which a miniature domestic altar of architectural character might supply. The poses recall the rhetoric characteristic of saints on the skyline of baroque churches. Among Soldani's smaller works in bronze the best comparison for the expressive face and outflung gesture is with the oval narrative reliefs of Ambrogio Sansedoni of 1692– 1700 in Palazzo Sansedoni, Siena (Lankheit, *Florentinische Barockplastik*, 40 and 41 especially). Equally close are the little figures made in silver gilt by Pietro Motti in 1691, after Soldani's designs, for the reliquaries of S. Alessio, S. Raimondo di Penafort, and S. Pasquale Baylon (in Cappella dei Principi, S. Lorenzo, Florence, 41, 109, and 110/1945).

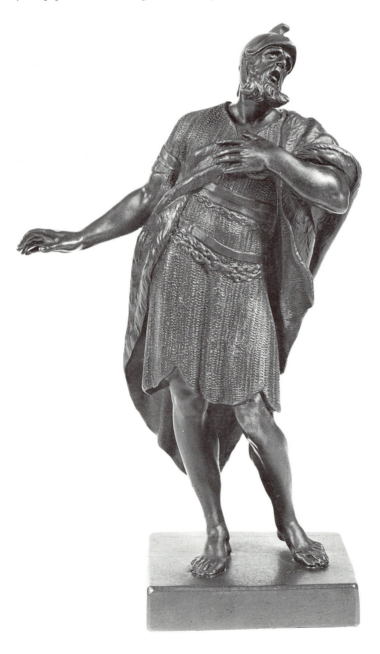

Probably by Massimiliano SOLDANI (1658–1750)

90 and 91. Pair of door-handles in the form of busts of lovers in conversation

10.9 cms. (height of male); 11.1 cms. (height of female)

Bronze with a warm tan natural patina. Hollow, lost-wax, casts, open behind. Brass Bars fitted across the openings.

Bequeathed by C. D. E. Fortnum in 1899. B. 1068 and B. 1069 in his catalogues. 'Bought in Florence', before 1857 when included in his preliminary catalogue as nos. 14 and 15 (p. 47).

Fortnum, who described these busts as of 'Venus or Bacchante' and 'Adonis or Bacchus', regarded them justly as 'very elegant' models and dated them to the late sixteenth or early seventeenth century. The elegance—the melting flow of drapery and hair—and languid lyricism are more suggestive of the late seventeenth and early eighteenth century and in particular of Massimiliano Soldani's sculpture in Florence (where the handles were acquired). The colour, the subtle punching in the hair, the satin finish of the flesh, are typical of Soldani's bronzes. The slightly turned-up nose, the parted lips, and the hair of the female head compares closely with the head of Psyche in the bronze group of *Cupid and Psyche* (Staatliche Museen, Berlin-Dahlem, 8/64; U. Schlegel, *Die italienischen Bildwerke des 17. und 18. Jahrhunderts* (Staatliche Museen, Berlin-Dahlem, 1978), no. 46, pl. 60), or that of the nymph to the extreme right of his relief of *Autumn* (or the *Triumph of Bacchus*), and that of the nymph in the extreme left holding a sieve in his relief of *Summer* (or the *Triumph of Ceres*) both first cast in 1708 (Bayerisches Nationalmuseum, Munich—later casts are in the Royal Collection and the Spencer Art Museum of the University of Kansas, Lawrence; terracottas are in Palazzo Pitti, Florence). The fact that these handles were not given to the Museum by Fortnum with most of the others in his collection in 1889 may indicate his special esteem for them. Busts of a slightly similar character, perhaps of the same date, serve as handles on the doors leading from the Sala del Settecento in the Uffizi Galleries. See also No. 92.

Probably by Massimiliano SOLDANI (1656–1750)

92. Door-handle in the form of a bust of a half-clad woman

10.7 cms. (height)

Bronze with a chestnut patina and a few traces of a black, or blackened, varnish. Hollow, lost-wax, cast, open behind. The threaded tang is apparently integral.

Given by C. D. E. Fortnum on 15 November 1889. B. 1070 in his catalogues. Acquired before 1857 when included in his preliminary catalogue as no. 13 'Venus or Ariadne very graceful' (p. 47).

As Fortnum noted, this is a duplicate of his B. 1069 (No. 91). There are only minor variations, the drapery of this version being more deeply modelled. Placing it in his preliminary catalogue before his B. 1069 (there no. 14) may suggest that he acquired it first.

Style of Massimiliano SOLDANI (1658–1740)

93. Pietà

45.3 cms. (height); 53.7 cms. (length at lowest part); 62.8 cms. (length of wooden base); 34.7 cms. (width of wooden base)

Terracotta of a pale cream and pink beige colour. Poorly fired. Crudely hollowed out from below. There are losses from the fourth toe of Christ's right foot, the end of the child angel's right wing, the index finger of the Virgin's right hand, the large toe of her right foot. Breaks to the right leg of Christ below the knee, the large toe of his right foot, the child angel's left wing-tip (in 1987), upper right arm, and right wrist, the right hand of Christ near the wrist, Christ's right arm at the bicep, Christ's left arm at the bicep, across his neck and upper chest, and across his abdomen have been repaired. Filled cracks—some of them probably breaks—in the Virgin's drapery near the left arm of Christ and across her left knee. The right hand of the child angel and the thumb of the Virgin are evidently modern. An old paper label inscribed 'No. 149' in ink is stuck to the underside of the group. Mounted on a plinth, irregularly oval in plan, of pine, carved and gilded.

Purchased in May 1962 from Paul Wengraf of the Arcade Gallery, London. Registered in July. One of the first purchases made by Ian Robertson after his appointment as Keeper of the Department.

On acquisition the group was restored, although to what extent is not clear, but presumably old repairs were revised. The restorer was against stripping the terracotta; Robertson was against the idea of restoring the Virgin's foot; a missing wing of the angel 'turned up' when the restoration was under way. The work was not attributed by the dealer, but Robertson published it as by Soldani in the *Annual Report* for 1962, claiming that it shows 'close affinity with a number of the artist's later compositions in bronze or porcelain media'. Groups of the *Pietà* or *Lamentation* of this size were popular with Soldani, both free standing and in high relief. The puffy-faced child angel tearfully contemplating (and perhaps preparing to kiss) the wound in Christ's right hand may be matched by a type of child popular in the sculpture of Soldani and so may the elongated and languid face of Christ. But Soldani, especially in his late work, gave drapery, hair, and rockery an agitated horizontal emphasis which is absent here.

A sample was taken from the unrestored portion of the plinth by Mrs Doreen Stoneham of the Oxford Research Laboratory for Archaeology and the History of Art in March 1987 but it was too poorly fired to obtain a firing date from thermo-luminescence tests (ref. 381-z-96).

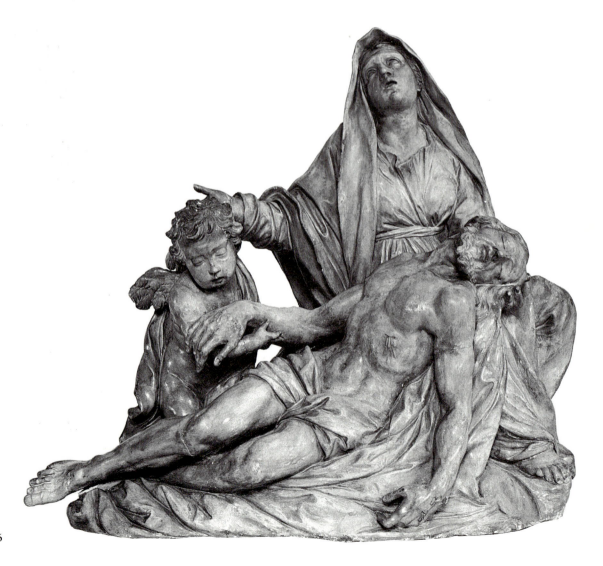

Giovanni Francesco SUSINI (active 1592; d. 1646)

94. Seated Mars

35.4 cms. (height); 26.5 cms. (length from proper right foot to back of mound); 12.9 cms. (height of wooden plinth); 28 cms. (length of wooden plinth); 17.2 cms. (width of wooden plinth)

Bronze with a darkened ruddy brown translucent varnish now largely worn off to reveal a golden brown patina. Hollow, lost-wax, cast, all apparently in one piece except for the shield and the handle of the sword (now missing). The proper right cheek guard of the helmet has been broken off. Plugs of 0.5 cms. diameter visible (most obvious on the figure's right wrist). 'IO. FR. SVSINI / FLOR. FAC.' is chiselled in the mound upon which the god sits, beneath his right thigh. The stops are of triangular form, the letters very neat. The bronze is mounted on a moulded mahogany plinth.

Given by Mrs Otto Gutekunst in memory of her husband in 1953. Registered on 15 July. The bronze had been bought in at Christie's, London, 25 June 1953, where it was lot 10 (with its present plinth).

The bronze is one of a few signed examples of exquisitely finished and careful copies of celebrated antique statues which were, as we know from Baldinucci's life, a speciality of Gianfrancesco Susini, as they had been of his uncle Antonio. The antique marble, now in the Museo delle Terme, Rome, had been acquired by the Ludovisi in Rome by the first half of 1622 and was recorded as having been restored by 20 June of that year. It was generally regarded as representing Mars. (See F. Haskell and N. Penny, *Taste and the Antique* (London and New Haven, Conn., 1981), 260–2, for a full account of its fame.) This is probably the earliest reproduction of it. The bronze lacks the sword handle which is one of the restorations with which Bernini supplied the antique statue—but this is because it has been detached. Also absent is the Cupid playing beneath the god's extended right foot, the most notable embellishment by Bernini. This has been explained both as precocious antiquarian purism on the part of Susini or his patron and as evidence that Susini had access to the antique before it was restored. The former possibility is hinted at by Haskell and Penny, op. cit. 260, who point out that the Cupid is also excluded in the prints of the statue in de Rossi's anthology (P. A. Maffei, *Raccolta di statue antiche e moderne* (Rome, 1704), pl. LXVI, LXVII) and in late eighteenth-century biscuit porcelain versions. The latter possibility is stated as a fact by Pope-Hennessy (*Italian Bronze Statuettes* (Victoria and Albert Museum, London, 1961), no. 133). However, if the sculptor, and the subsequent draftsmen and modellers, were using casts after the antique original, these may have excluded the Cupid because of the complication in the moulds which it would have occasioned. It is, however, more probable, that Susini *did* include the Cupid, and it is no longer in place: it would have been separately cast (touching the Mars at no point) and so could easily have been detached. In this connection it is significant that the plinth here cannot be the original one and is unlikely to be more than a hundred years old.

The bronze may have been one of a series of copies after notable marbles in the Ludovisi Collection: Susini also signed bronze versions of the *Dying Gladiator* (Museo Nazionale, Bargello, Florence) and one of the *Hermaphrodite* (Metropolitan Museum, New York)—the latter dated 1639—and Baldinucci records that he also made a copy of the *Paetus and Arria*. (Of these, the first and third were well-known Ludovisi pieces. On the other hand the *Hermaphrodite* has been supposed to be a copy of the version in the Borghese Collection, but it is surely after the version restored for the Ludovisi between 1621 and 1623, for which see Haskell and Penny, op. cit. 235).

Among the bronzes in the collection of André Le Nôtre was 'Le dieu Mars, assis, d'après l'antique' valued at the high sum of 150 livres (J. Guiffrey, 'Testament et inventaire après décès de André Le Nôtre et autres documents le concernant', *Bulletin de la Société de l'Histoire de l'Art Français* (1911), 257, no. 365). This might have been the Ashmolean Susini or another version of it, although no other version has been traced. No other small bronze copy of the *Mars* that I have seen seems likely to have been made before 1700.

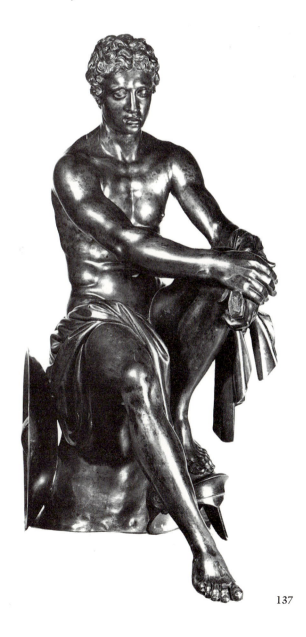

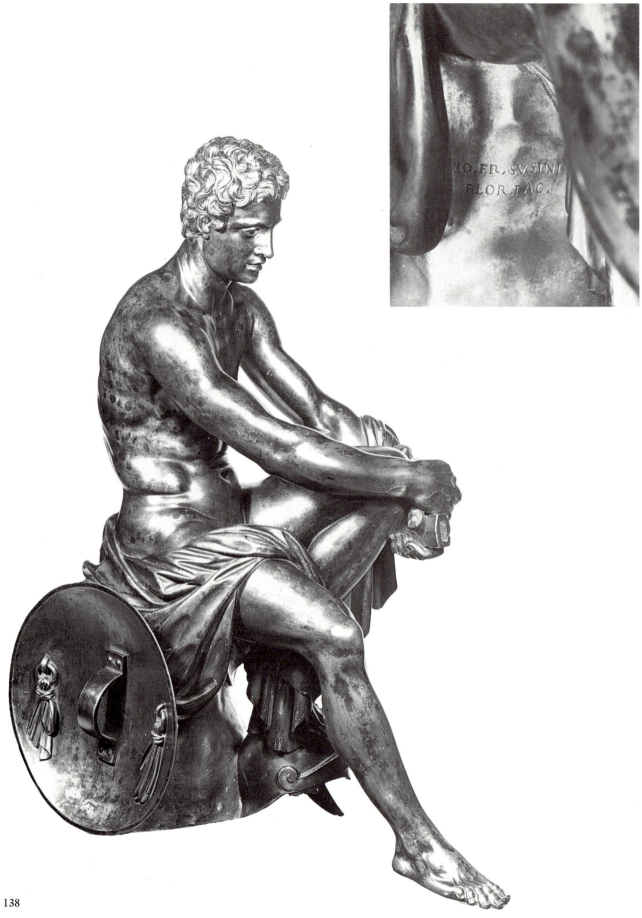

Probably by Ferdinando TACCA (active from 1640; d. 1686)

95. Warrior drawing a sword

14.1 cms. (height)

Bronze with a natural chocolate-brown patina. Hollow, lost-wax, cast. There is an integral base in the form of a thin rectangular plate of bronze, cracked from the central hole whereby it is bolted to a plinth of ebonized wood. 'Ⅎ 423' painted in white on the upper surface of the base behind the feet.

Lent by C. D. E. Fortnum on 20 March 1888. Given later in the same year. B. 423 in his catalogues. Presumably acquired after 1857 when Fortnum compiled his preliminary catalogue in which this is not included.

This little bronze was considered by Fortnum as 'assuredly' by the same hand as his no. 422 (No. 89 here)—it was the hand, he proposed, of Adriaen de Vries. C. F. Bell in his annotations to Fortnum's large catalogue noted that he did not 'feel sure' of this and recorded Bode's opinion that this bronze was perhaps Flemish of the period of Louis XIV. Jennifer Montagu in a letter to Gerald Taylor of 16 December 1970 mentioned as perhaps of significance the fact that Massimiliano Soldani is documented as having made a model of a 'Gladiatore in atto di tirare stoccata' (K. Lankheit, *Die Modellsammlung der Porzellanmanufaktur Doccia* (Munich, 1982), 334, doc. 671), but she considered the bronze as earlier in date. The type of balletic torsion, the arrested action, and the elongated proportions are found in several of the high relief foreground figures (almost three-dimensional statuettes) in the bronze relief of the *Martyrdom of St Stephen* by Ferdinando Tacca, given to S. Stefano al Ponte in Florence by Giovanni Bartolomei in 1656. And we find there the same alert face, with small chin, large eyes, and sharply tapering nose, also the same style of moustache and of armour. On the basis of comparisons with the bronze relief in S. Stefano a series of lively two-figure narrative groups with subjects from Ariosto and Ovid have been convincingly attributed to Tacca, and this bronze, which is less than half of the size of these, looks like half a group of similar character. 'It was Ferdinando Tacca', Anthony Radcliffe proposed, when publishing these groups, 'who led the way in Florence towards a new function for the small bronze group, who transformed it from an object to be handled or walked around into a sort of miniature theatre to be precisely placed upon a piece of furniture and to be seen from one view only' ('Ferdinando Tacca, the Missing Link in Florentine Baroque Bronzes', in H. Keutner (ed.), *Kunst des Barock in der Toskana* (Munich, 1976), 14–23—quotation taken from p. 22). In style the figure is also close to those in reliefs attributed to Fanelli but it seems likely that Fanelli derived much of his style and even took some of his models from Tacca and other Florentines (see also No. 97).

A version of this figure was lot 151 at Christie's, London, 5 December 1989, with an attribution to Fanelli. It differed in that the metal was very brassy (it has been polished), all details were less distinct, and there was a double plinth (which strongly suggests an aftercast). That this version was from a

series perhaps intended for a cabinet is suggested by the roman numeral 'VI' chiselled underneath the plinth. The nature of the plinth on the Ashmolean version strongly suggests that it too was designed to be fixed to a cabinet. A cast of the statuette was attached to a good cabinet on stand, lot 115 at Christie's, London, 5 July 1990. This was exhibited by Jonathan Harris at the 1991 Grosvenor House Antiques Fair with the information that it was recorded in an inventory of 1724 at Drayton House, Northants. The cabinet was decorated with plaques of pale beige marble with dendritic markings framed in ripple mouldings. It has been described as Flemish but may be Italian. The companion bronzes were of similar finish, but far less interesting design.

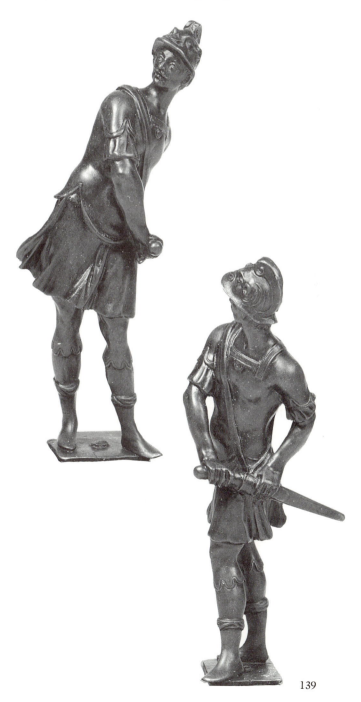

Perhaps by Ferdinando TACCA (active from 1640; d. 1686)

96. Inkstand in the form of Orlando pulling the Orc from the deep

15.4 cms. (height); 12.1 cms. (length of bronze plinth); 10.1 cms. (width of bronze plinth); 14.5 cms. (length of wooden base); 11.5 cms. (width of wooden base); 4.5 cms. (height of wooden base)

Bronze with a natural warm chocolate patina. There are a few traces of darkened varnish, e.g. around the strap fixing the arms to the jaw. Hollow, lost-wax, cast in one piece including the plinth. The interior is now filled with plaster of Paris in which a screw is set fixing the bronze to a walnut base. 'B.-84.⨍' painted white behind the Orc.

Lent by C. D. E. Fortnum in October 1894 and bequeathed by him in 1899. No. 1084 in his catalogues. 'For many years in the Passerini family . . . At Professor Passerini's death (the entomologist) it was sent to England by Freppa the dealer and bought by me in . . .' The date is omitted in the large catalogue. In the earlier notebook catalogue there is a fragment of a letter by Freppa in French from Florence. The acquisition was presumably made after 1857 because it is not recorded in the preliminary catalogue compiled in that year. For Freppa see below. It is almost certainly 'the Cellini inkstand' recorded in an MS 'memoranda of prices paid' under 1860 with the very high price of £35.

Fortnum catalogued this 'quaint and charming bronze' as Florentine of the first half of the sixteenth century. The subject, as seems first to have been pointed out to him by the dealer Freppa, comes from the most popular verse romance, not only of sixteenth- and seventeenth-century Italy but of the whole of modern European literature, the *Orlando furioso* by Ariosto. The Orc is a sea monster placated by the inhabitants of the island of Ebuda who feed him damsels. He is first mentioned in Canto 8 when Angelica is kidnapped and chained naked to a rock to await this fate. In Canto 10 Ruggiero, flying by on his hippogriff, espies her. The Orc is approaching—a huge coiling mass unlike any animal except for its head which has the protruding eyes and teeth of a boar (stanza 101). Ruggiero fights it from his flying steed with sword and lance:

> Like battle with the snapping mastiff wages
> The audacious fly on dusty August days (stanza 105)

but he cannot penetrate the Orc's skin. Eventually he succeeds in stunning him with a reflected beam from his magic shield. He then carries off Angelica to a nearby wood and at the close of the canto he is furiously stripping off his armour, overcome with desire for her. In canto 11, Angelica saves herself just in time—making herself invisible by placing a magic ring in her mouth—and the frustrated Ruggiero is involved in another adventure. Another hero, Orlando, arrives to find the revived Orc about to devour another fair victim, Olympia. He strips off his armour, and gets in a little boat equipped with a small sword and a huge anchor. When the Orc advances upon him he jams the anchor in his open jaws:

> So prudent miners prop the tunnel as they crawl
> Lest as they hack the rock in front the roof behind them fall.
>
> (stanza 43)

Entering the Orc's throat Orlando slashes at it with his sword. When the Orc dives he swims out and then tugs the monster, which is belching blood and thrashing foam, to shore (stanza 43). For obvious reasons Tacca has altered the relative scale of the Orc implicit in the poet's similes and he has also put the hero on the Orc's back, rather than on a nearby rock, as he hauls at the anchor cable. A part of the anchor may originally have been visible in the monster's mouth.

This certainly does not prove that the bronze is Italian, but there are parallels with other pieces which would seem to be Italian (compare, for example, the ornament on the integral bronze base and the convolutions of the monster's tail with ornament and tail in the inkstand with a mermaid, No. 233), and there is the Florentine provenance, which also support such an assumption and make us doubt the suggestion that the bronze might be German. (In addition, there is the armorial evidence set out below.)

Fortnum and Bode seem both to have known the piece when it was still with Professor Passerini, and so did Alessandro Castellani the scholarly Roman dealer. The fact that it passed through the hands of Freppa, who was exposed, in 1868, as the employer of the forger Bastianini, might otherwise have given cause for alarm. Fortnum noted that it had long been regarded by the Passerini as 'the work of Benvenuto Cellini' and he considered that it 'has very great affinity' with Cellini and was especially reminiscent of the 'treatment' of the reliefs on the base of the *Perseus* in Florence and the 'action on the Vienna salt cellar'. Castellani thought it 'might be by Bambaia an opinion not shared by Dr. Bode or by me, we agreeing rather in its Cellini manner'. Bode later classed it as Venetian of about 1575 (*Italian Bronze Statuettes of the Renaissance* (London, 1907–12), iii, fig. 22).

The fragmentary letter from Freppa, also referred to, reveals that he also suggested to Fortnum that the arms on the escutcheon hung by a strap over the monster's upper jaw were those of the Rondinelli family of Florence. The bearings are a chevron between three stars of six points; in chief a label of four between which are three fleurs-de-lis. The crest is a salamander. C. F. Bell seems to have further investigated the arms and noted that the lilies and label in chief—part of the bearings of Anjou—suggest that it belonged to a family which had, or once had, Guelf affiliations. Michael Maclagan examined the arms in May 1977 at the suggestion of Christopher Lloyd and reported that they looked authentic, also distinctly Italian rather than German (the suggestion that the bronze was German had recently been made), especially because of the Guelf factor (already mentioned by Bell). He considered that it could refer to one of two Italian houses: the Lapi of Bologna or the Scarlatti-Rondinelli of Florence, more probably the latter, although their stars should normally have eight points (a detail to which a modeller might not have felt inclined to attend).

Another version, sold on 7 April 1970 at Sotheby's, London

(lot 95), resold at Phillips, London, 30 November 1976 (lot 175), was bought by D. Katz (then of 22 Grosvenor Square, London). It is approximately the same size but looks from photographs as if it was neither modelled nor chased with comparable care and might even be a modified aftercast. The chief difference is that it lacks the escutcheon, the hero has no ornamental boots, and the sword blade has been broken off; but in addition many details are simplified in form and less sharply finished. The base mouldings have no corner leaves and consist of incised lines without raised rectangular elements superimposed, the rope is less defined (and is not tightly drawn), the fins and tail are less undercut and the fringe along the back less minutely defined. Mr Katz in his

letters to the Department in 1979 observed the relationship not only with the Mermaid inkstand (No. 233) but also with the small bronze statuette of a warrior drawing a sword (No. 95) which is indeed of very similar metal, finish, and character, and it is surprising that Fortnum himself, who owned both items, did not note this connection. The figure looks very similar in the face and the armour to those by Ferdinando Tacca and it is surely relevant that among the larger groups convincingly attributed to Tacca are several from Ariosto, including one of Angelica eluding her excited saviour by placing the ring in her mouth as he tears his clothes off (Louvre 0A. 7811).

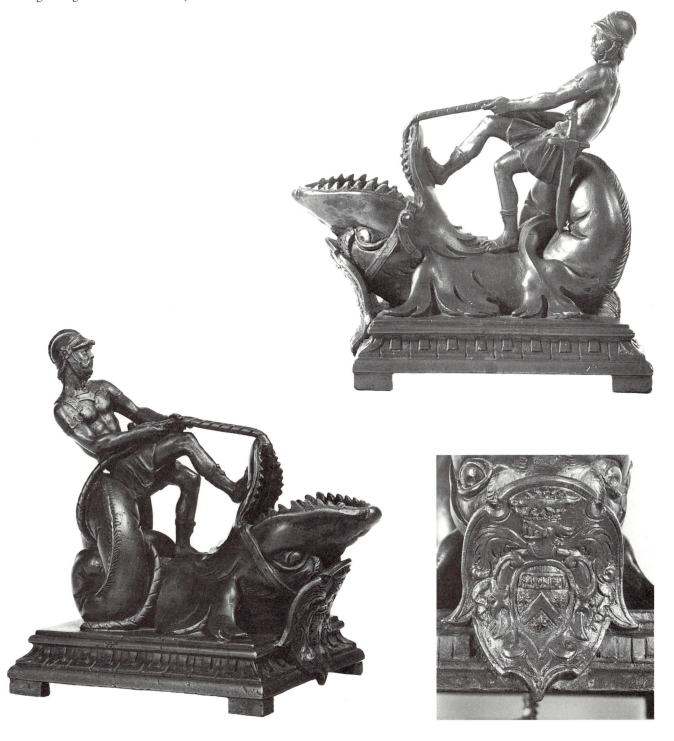

After a model perhaps by Ferdinando TACCA (active from 1640; d. 1686)

97. Marcus Curtius leaping into the gulf

29.2 cms. (height); 44 cms. (width)

Lead with a ruddy gold brown 'bronze finish'. The lead is partially diseased (possibly from storage in an oak cupboard), disfigured with white efflorescence, as well as scratched and bent (especially in the lower corner to proper right). An arm of the warrior by the bank to proper left has been broken off, as has part of the hero's right hand. The right forearm of the warrior nearest the rear legs of the horse is broken but not detached. The elements in highest relief—the hero and some of his mount, the head and one leg of the dog barking at him, and much of the warrior leaning forward—are separately cast and let into the relief. Scratched on the rear are the words 'PROVENANCE UNCERTAIN / THIS PLAQUE WAS FOUND IN A / RUSKIN SCHOOL CABINET (REFERENCE SERIES) / 1976'.

Provenance uncertain. See scratched inscription above.

A bronze version of this relief measuring 27 × 41 cms. in the Staatliche Museen, East Berlin (inv. 5042), was published in E. F. Bange, *Staaliche Museen zu Berlin: Bildwerke der christlichen Epochen*, III, ii (Berlin, 1922), no. 53, and pl. 20, as an anonymous late seventeenth-century work. There are a number of minor variations: the Berlin version does not include a stump beneath the horse's belly but does have trees on a hill slope rising above the horse's tail; it does not include a spire on top of the distant tower, its foliage is defined more by punched marks than short lines, the warrior leaning forward holds his torch or baton in an upright position, and the dog appears to bite the horse's leg. Neither version is of high quality (although the bronze is superior to the lead) but they seem likely to reflect some superior prototype. Anthony Radcliffe proposed in a footnote that this might have been by Ferdinando Tacca ('Ferdinando Tacca, the Missing Link in Florentine Baroque Bronzes', in H. Keutner (ed.), *Kunst des Barock in der Toskana* (Munich, 1976), 23 n.) and there are numerous points of comparison with Tacca's bronze relief of the *Martyrdom of St Stephen* (given to S. Stefano al Ponte in Florence by Giovanni Bartolomei in 1656): in both there is a mixture of a few figures in very high, almost detached, relief with pictorial low relief and landscape; the same open poses of the high relief figures, the same densely composed choral groups, the same interpretation of antique dress, the same long-bearded sages. Francesco Fanelli has also been suggested as the author of the Berlin relief and it is similar to the reliefs of the *Carrying of the Cross* and the *Holy Family in the Robber's House* which he is known to have cast but it is not certain that these compositions were invented by him and in any case Fanelli may well have been indebted to Ferdinando Tacca or other Florentine sculptors of that date.

Another version of this relief, in bronze, less high and with only minimal landscape background was lot 154 at Sotheby's, London, 13 December 1990.

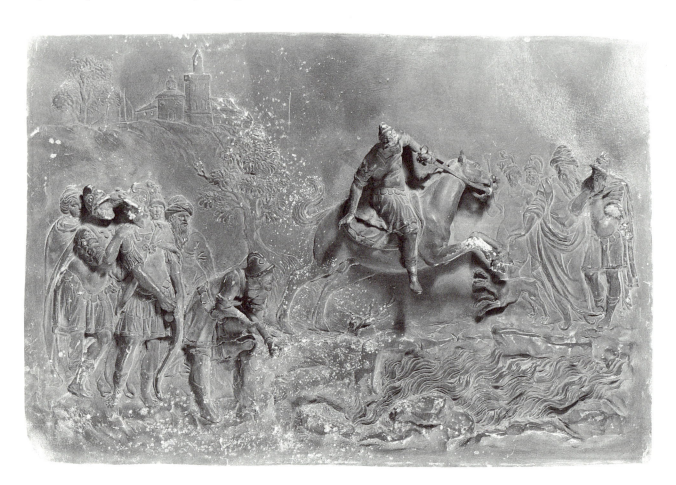

Marcus Curtius leaping into the gulf
Staatliche Museen, Berlin

Royal porcelain factory, Naples

After a model by Filippo Tommaso TAGLIOLINI (1745–1809)

98. River god

21.55 cms. (height, including plinth); 22 cms. (length excluding projecting foot); 10.5 cms. (width)

Biscuit porcelain, somewhat scratched and much discoloured from engrained dirt. Hollow cast, open below the plinth. There is a firing crack in the reverse of the figure. The upperside of the large toe of the god's right foot and the end of the index finger of his right hand have been broken off and are missing.

No provenance recorded.

Having been awarded the first prize for sculpture in the Consorso Clementino at the Accademia di San Luca in Rome in 1766, Tagliolini travelled to Venice in 1767 where he worked for at least six years in a porcelain factory, moving probably soon afterwards to the porcelain factory in Vienna, whence in 1780, apparently at the request of the king of Naples and the Two Sicilies, and in company with a furnace technician, Magnus Fessler, he travelled to Naples to work for the royal porcelain factory there. By 1781 he was appointed 'capomodellatore'. He worked under the inspiring direction of the artistic adviser to the court, the learned and cultivated Marchese Domenico Venuti (1745–1817) and was responsible for modelling a succession of graceful and delicate biscuit statuettes, many of them after, or inspired by, antique statues (and especially those locally available from the Farnese Collection and the excavations at Herculaneum and Pompeii), some of them incorporated into highly ambitious groups and extravagant presentation desserts composed of numerous figures. He was chief modeller until the sale of the factory under the French in 1807 and was employed in the final years of his life in restoring antique sculpture. Tagliolini's biscuit statuettes are unmarked and have often been confused with the contemporary productions of the Volpato factory (see

No. 106). The full extent of his activity and the quality of his work have only become clear with the publication of *Lo scultore Filippo Tagliolini e la porcellana di Napoli* by Alvar González-Palacios (Turin, 1988).

A list, compiled in 1805, of models made at the factory since 1776, with their prices, includes, under the section headed 'serie di figure', 'fiumi sedenti' for seven ducats (presumably each) and in the inventory of the factory, made when it was sold two years later in 1807, a number of river gods are also recorded, including a group representing the four parts of the world valued at forty-eight ducats (ibid. 171, 196). González-Palacios lists surviving versions of such river gods in Naples (one at the Museo di Capodimonte (inv. 5268) is coloured and gilded, one in biscuit is in the Museo di San Martino (inv. 273), and another is in the Museo Artistico Industriale, Naples (inv. 96) and in Turin (Museo Civico 1543). None of these is now part of a group. The first two cited are adapted from the less familiar of the two statues of the *Nile* in the Vatican Museum (ibid., no. 59). The Ashmolean's statuette, which is very close to this *Nile* statuette in size, general character, pose, and the modelling of beard and drapery, may correspond with the example in the Museo Artistico Industriale (h. 21 cms.) of which, however, no illustration is available. The plinth of the Ashmolean statuette is of a pattern, more or less regular in shape but slightly suggestive of rock-work, favoured in many antique marble sculptures whereas those of the *Nile* statuettes have smooth sides, but such variation is not unexpected and both forms of plinth were favoured by the factory (for other rock-work plinths see ibid., nos 3, 29, 30, 33). Further confirmation that the Ashmolean river god was modelled by Tagliolini is found in the figure of Time on a porcelain and ormolu clock in the Museo di Capodimonte which is adapted from it (González-Palacios, op. cit., no. 71).

Porcelain and ormolu clock
Museo di Capodimonte, Naples

Unknown foundry, probably Roman

After Bertel THORVALDSEN (1770–1844)

99. Venus

14 cms. (height; 4.35 cms. (diameter of base)

Bronze with a dark grey patina, with hints of green. Very heavy, probably solid, cast. A tang project from the integral base (photographed with an improvised plasticine support)

Given or bequeathed by C. D. E. Fortnum (the large catalogue is not annotated so it was probably only received after his death in 1899). B. 429 in his catalogues. According to the notebook catalogue 'bought at Naples', apparently after 1857 when the preliminary catalogue, in which it was not included, was compiled.

Fortnum supposed that this was probably executed in Italy in about 1815 (large catalogue) or '1815–20' (notebook catalogue)—i.e. at the period of Thorvaldsen's full-size statue of which it is a miniature reproduction. Thorvaldsen created his **Venus** between 1813 and 1816. It was bought by the banker Henry Labouchère and taken to London, but a cast remained in the artist's studio. The cast is now in the Thorvaldsen Museum Copenhagen (A. 12), as is the marble (A. 853). A similar small bronze of the *Venus* is in the Museo Nazionale di Palazzo Venezia, Rome, mounted on an alabaster base.

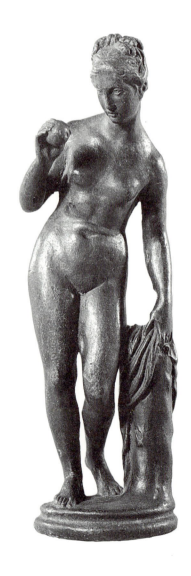

Unknown manufacturer

After Bertel THORVALDSEN (1770–1844)

100, 101, and 102. Three strips of a relief representing the triumphal entry of Alexander into Babylon

30.6 cms. (length of No. 100); 32 cms. (length of No. 101);
40.9 cms. (length of No 102); 5 cms. (height of each strip)

Bronze with a yellowed varnish. No. 100 has a rusty deposit on top of the bronze presumably from storage near iron. There are pin holes in the corners of all three strips. The lower corners of No. 101 have been torn off around these holes.

Provenance unrecorded.

Thorvaldsen made his plaster frieze of the *Triumph of Alexander* (as it was commonly abbreviated) for the Salone d'Onore in the Quirinal Palace in 1812. It was planned in collaboration with the architect Raffaele Stern with a programme devised by Vivant Denon and Martial Daru for the anticipated official visit of the modern Alexander, the Emperor Napoleon. The work was repeated during the 1820s in plaster for patrons in Munich and Frankfurt and in marble for the Palace of Christiansborg at Copenhagen (subsequently destroyed by fire) and for Giovanni-Battista Sommariva's Villa Carlotta (B. Jørnaes, 'Il patriarca del bassorilievo', in *Bertel Thorvaldsen* (Galleria Nazionale d'Arte Moderna, Rome, 1989–90), 45–6). The portion showing the emperor on his chariot was later repeated, with revisions, as one of a series of reliefs for the courtyard of Palazzo Torlonia in Rome in 1837. The frieze enjoyed enormous fame and was also reproduced extensively outside the artist's studio—in plaster for staircase halls and in marble for chimney-pieces in British houses, for example. Fine plaster miniatures were sold to tourists in Rome and these metal strips, which are imprecisely modelled, may derive from aftercasts of such plasters. Mass production seems already to have been envisaged by 1825 (E. di Majo and S. Susinno, 'Thorvaldsen e Roma', ibid. 24 n. 66).

Scenes of quiet rural life in ancient Babylon (No. 100) give way to preparations for the conqueror's reception (No. 101) and the actual homage to him and his entourage with a personification of Peace greeting his chariot (No. 102).

Style of Andrea VERROCCHIO (b. *c*.1435; d. 1488)

103. Head of a youth

25.2 cms. (height); 11.8 cms. (height of socle)

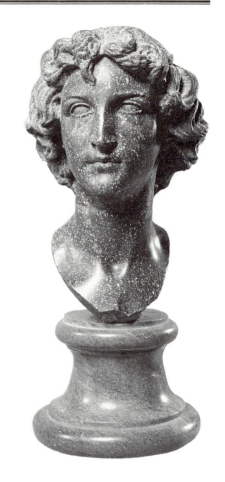

Imperial porphyry. There is a break through the front of the neck and the lowest part of the hair behind. Some of the cement, tinted to match the porphyry, is now apparent in the join. One prominent curl at the centre of the front of the hair has been broken off and the stump recarved to conceal the loss. Chips are missing at the front of the chest. The crown of the head and the underside of the bust at the back are only roughly finished. (See below for a discussion of this.) The head is mounted on a turned dovegrey (*bardiglio*) marble socle. '1975.86' is painted in white on the back of the prong attaching the head to the socle. A visiting card engraved 'Miss Joan Evans' is sellotaped to the underside of the Socle. On it is written 'Bought at Conway Sale 1951 for £68 / Bought by Frank Conway in Venice 1912 for 1500 lire (£50).'

Given by Dr Joan Evans in 1975. Registered on 15 July. See above for provenance on card. Placed on display in the Fortnum Gallery in October 1989.

The head seems never to have been displayed in the Museum and has attracted little scholarly attention. It was registered, and described in the *Annual Report* (1975: 30), as 'Roman' but 'refashioned probably in the nineteenth century'—a note in the Register indicates that Conway, the previous owner, had suggested that the reworking had taken place in Florence. The character of the head is very distinctive and recalls the youthful male ideal of Andrea Verrocchio most familiar from his bronze *David*, but found also in paintings of his school such as no. 296 in the National Gallery, London. It is likely to be a modern work in the Renaissance style, dating from after 1850 when the appreciation of Verrocchio and the taste for his particular contribution to Florentine art began to become popular; but it is possible, as Alastair Laing has pointed out to me, that this is in fact a Florentine sculpture of the early sixteenth century by Pier Maria Serbaldi da Pescia, called 'Il Tagliacarne' (1455–*c*.1520) who was the very first sculptor to revive the carving of the figure in the notoriously hard material of porphyry. The difficulty that the sculptor has had in carving the stone (especially evident in the hair) does suggest an early date, and is reminiscent of the bust of *Polyhymnia* in the Kunshistorisches Museum, Vienna (no. 3529) and the small group of *Venus with Cupid* signed in Greek (Museo degli Argenti, Palazzo Pitti, Florence, no. 1067—A. Giusti (ed.), *Splendori di pietre dure* (Palazzo Pitti, 1988–9), 74–5, no. 1. The portion of rough-hewn stone under the neck suggests that the head was designed to be inserted in a bust made of marble or stone of a contrasting colour. The treatment of the crown of the head, roughly worked but without any attempt to indicate the hair, suggests that it was designed to be covered by a crown or cap perhaps of gilded metal.

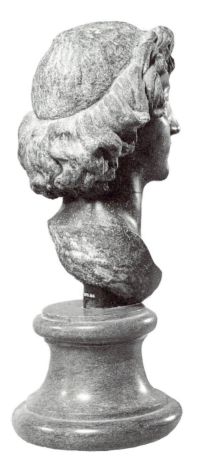

Perhaps by Alessandro VITTORIA (1525–1608)

104. Bust portrait of a bearded man

60 cms. (height); 45.3 cms. (width across shoulders); 12 cms. (height of block base); 25 cms. (length of block base); 23.2 cms. (width of block base)

White Carrara marble with numerous pale grey and rusty patches most pronounced on the drapery and in the moustache and nostril on the proper right side of the face. The bust has had additional blocks of marble added under each shoulder. The surface is abraded in parts. The bust has been mounted on a block of serpentine, with cement ensuring that it rests level on the block—the marble is cut back so that it would naturally tilt upwards.

Bought from Rodney Thesiger of Messrs. Colnaghi, Bond Street, 1956. Registered on 5 March. Sold to Mr Thesiger by John Gere who bought it at the sale of Thomas Harris, Christie's, London, 22 November 1951, lot 84. Photographs taken in the 1960s show the bust on a free-standing pedestal in the Farrer Gallery. It has been in reserve for at least a decade.

In the Harris sale the bust was catalogued as a self-portrait by Alessandro Vittoria, but there is no good reason for this. That it is close to many portrait busts by Vittoria is however unquestionable: an interesting comparison may be made with the bust of Alessandro Contarini (d. 1553) set in a tondo of the black marble pyramid tomb in the Santo, Padua, or with the bust of Marcantonio Grimani (d. 1565) set within a shell niche above an epitaph in the first north chapel of S. Sebastiano in Venice, both of them signed works. This bust too must have had a high mural, probably sepulchral, setting, within a church or chapel and the adjustment of the back of

the bust strongly suggests the sort of modifications required for display on a pedestal in a gallery once it was removed from a tondo or niche recess. Some parts of the bust are very finely carved, most notably the flesh around the eyes and in the cheeks, and the beard beside the ears and below the lower lip. On the other hand the deeper channels cut into the beard with a running drill are crude and seem unhappily related to the chiselling. Perhaps when set in place the shadows in the beard did not tell and needed correction. A coarse use of the drill is found in some busts which are signed by Vittoria (one which it is possible to study closely is in the Louvre—Chauchard bequest 1910, M. 213) and similarly isolated channels are evident in the beard of the bust of Ottavio Grimani (Staatliche Museen, Berlin-Dahlem, no. 303). The beard is not undercut, little thought has been given to its meeting with the neck, or to its relationship with the folds of drapery—no undercutting has been attempted in these folds and their pattern is routine. But these deficiencies are not uncommon in Vittoria's signed work, much of which must have been carved by assistants of varying quality. Bruce Boucher, cataloguing the sculpture in the Arts Council exhibition *Andrea Palladio 1508–1580* (1975), 133, no. 238, comments that

the bust is similar to a number of portraits by Vittoria during the 1570s and 1580s and is probably the work of a contemporary sculptor, well versed in Vittoria's style. The treatment of the high forehead, the hair, and the well defined cheekbones invites comparison with the terracotta and bronze portraits of Tommaso Rangone (in the Museo Correr and the Ateneo Veneto respectively), which were probably commissioned from Vittoria in the 1570s.

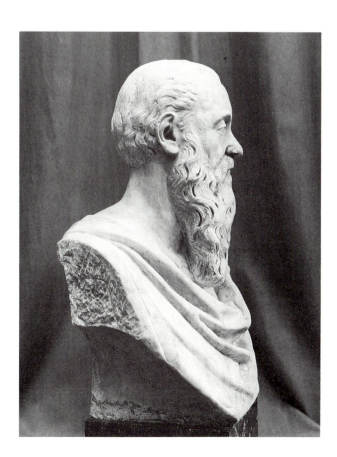

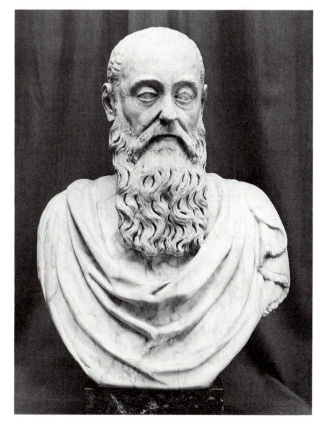

Theodore de VOGHEL (active 1590s)

105. Stipo in the form of a miniature temple decorated with scenes from the New Testament and the Trojan War

32 cms. (height); 26 cms. (length); 24.6 cms. (breadth)

Rosewood, ivory, and ebony. There are eight small drawers. In addition the entire base of the temple façade serves as a drawer and the entablature as two drawers. Two secret slides reveal four long drawers in the back. Some small pieces of ebony veneer have fallen off to proper right near the feet and are preserved in the drawers. The rosewood has been quarter cut to give a particularly rich figure. The piece of ivory inserted in the centre of the underside of the temple is engraved as follows: 'THEODORUS / DE· VOGHEL· FLA / NDER· SUAE· CATHO· / LICAE· MAIESTATIS· / BELLICORUM· TORME· / NTORUM· MAGISTER· / NEAPOLI· FECIT / 1593'.

Bequeathed by C. D. E. Fortnum, 1899. Bought by him for £30 at the sale in 1884 of the Castellani Collection (in Rome? It is not in the catalogue of the 'Objets antiques du moyen-âge et de la renaissance dépendant de la succession Alessandro Castellani', sold Hôtel Drouot, Paris, 12–16 May 1884). F. 21 in Fortnum's catalogues. Fortnum purchased another, larger, stipo of ivory and ebony from the Castellani Collection (F. 22) which he bequeathed to Mrs A. C. King of Oxford.

De Voghel was a master gunsmith for the king of Spain: firearms in this period were often ornamented with rosewood and engraved ivories. Between 1588 and 1600 he was working on the intarsia of the sacristry of the Certosa di San Martino, Naples. Had these ivories all been designed for a single stipo they surely would not have been such an odd mixture of sacred and profane subjects. The scenes on the little drawers represent the *Annunciation*, the *Visitation*, the *Nativity*, the *Adoration of the Shepherds*, the *Massacre of the Innocents*, the *Flight*, the *Lamentation*, and *Christ disputing with the Doctors*, with the *Adoration of the Kings* in the lower frieze and *God the Father* presiding above. There are larger plaques engraved with the *Judgement of Paris*, the *Rape of Helen*, the *Flight of Aeneas*, and the *Gods in Dispute* on the sides and top of the stipo. Moreover, had the series of New Testament scenes been intended as drawer fronts then the artist would have taken into account the need for handles. As it is the turned ivory handles interrupt the compositions crudely, on one occasion obliterating much of the Christ Child. A similar stipo was lot 234 at Sotheby's, New York, 22 June 1989.

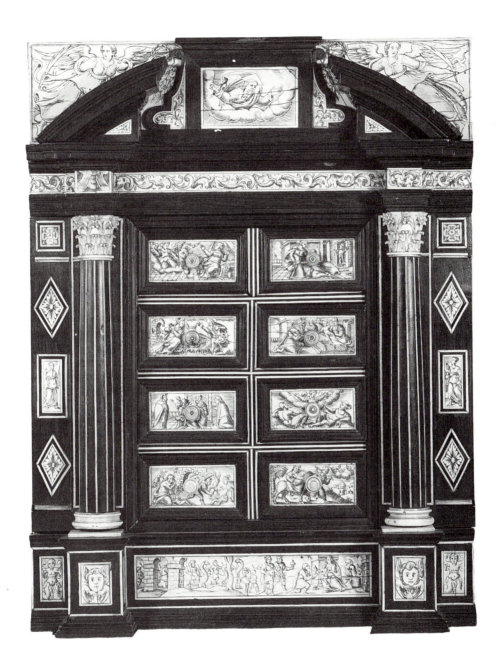

Factory founded in Via Pudenziana, Rome, by Giovanni VOLPATO (1733–1803)

106. Melpomene

28 cms. (height): 1 cm. (height of integral plinth): 10.5 cms. (length of integral plinth); 6.95 cms. (width of integral plinth)

Biscuit porcelain badly discoloured from dirt. There is a repaired break across the lower part of the mask, the adhesive now discoloured brown. Part of her right hand is missing. Her left hand is missing and the stump is discoloured with old adhesive. There is a slight firing crack across the back of the figure. The front face of the plinth is impressed 'MELPOMENE'. The proper right face is impressed 'G. VOLPATO ROMA', the 'V' and 'R' in larger capitals. A relatively clean rectangle to proper left of the impressed name on the front face of the plinth indicates the former position of a paper label. 'C. / 471. / Œ' is painted in black on the drapery behind the figure, above the plinth.

Given by C. D. E. Fortnum in 1888. C. 471 in his catalogues. presumably acquired after 1857 at which date the preliminary catalogue, in which it is not included, was compiled.

The statuette is a miniature copy of one of the Muses in the Vatican Museum. Fortnum also owned a full-size copy in white marble of the bust of the same antique Muse—see No. 20. Giovanni Volpato was practising as an engraver in Venice before he established himself in 1771 in Rome where he engaged in the highly acclaimed production of huge and faithfully coloured engravings of Raphael's Loggie decorations, produced reproductive prints after Raphael and the Caracci, and was involved in speculative excavations of sculpture. He opened a factory in 1785 in Via Pudenziana in Rome making biscuit porcelain reproductions of antique sculpture such as this. The factory moved in 1793 to Strada Urbana Monti, Vicolo della Caprareccia 142. A printed 'Catalogue des Statues antiques, groupes, et Dessert de Porcellaine en biscuit, de la Fabrique Jean Volpato à Rome' is included among the letters of C. H. Tatham to the architect Henry Holland for whom he was acting as an agent in Rome, providing items and ideas for interior decoration. 'Apollon Cythéré avec les neuf Muses du Museum Vaticanum' was priced at 40 zecchini (then, approximately, a little under £20), but each of the ten figures was also available for 4 zecchini. Tatham, writing to Holland in 1795, marked the Muses as a 'very beautiful collection'. He noted that 'Madame Angelica', that is Angelica Kauffmann, recommended Volpato's ceramic figures and that they were of the 'whitest porcelain similar to the French—but very superior as to design, workmanship and art'. In fact the porcelain was not always so white. The version of the *Melpomene* in the Cini Bequest (347) in the Capitoline Museum is a slightly pinky yellow colour as are the *Euterpe* and *Thalia* (but not the *Terpsichore* and *Clio*) exhibited in the Volpato exhibition in the Gabinetto dei Disegni e Stampe in the Farnesina, Rome, January–April 1988.

The Via Pudenziana factory is said to have produced cream coloured earthenware as well as biscuit porcelain. The factory at Cività Castellana, which was opened in 1801, produced coarser and cheaper figures in 'terraglia all'Inglese' with a glossy yellowish glaze, many of them after the antique. The factory was managed by Giuseppe Volpato, who is also said to have managed the earlier factories. Giuseppe outlived his father only by a couple of years, and the business was then managed by his widow Maddalena Righi and her second husband, the factory's chief modeller Francesco Tinucci, until 1818 when it was taken over by Giuseppe's son Angelo who managed it until 1831. In addition to the *Melpomene* and the *St Joseph* (No. 107), Fortnum owned a pair of cream glazed vases (C. 467 and C. 468—Nos. 530, 531) and a cream glazed oval plaque with a scratchy low relief of the *Virgin and Child with St John* in a landscape setting (C. 469), but these are not products of the Volpato factory as he supposed.

Factory founded by Giovanni VOLPATO (1733–1803),
Città Castellana, near Rome

107. St Joseph with the infant Christ

27.2 cms. (height), 1.7 cms. (height of integral plinth); 12.7 cms.
(length of integral plinth); 8.8 cms. (width of integral plinth)

Earthenware with a cream coloured lead glaze, yellowy green where
thickest (in some folds of drapery), with minor imperfections. Chips
are missing from the edges of the drapery and the ridges of its
folds—a large chip from the lower edge above the advanced right
foot. Losses: the fingers from Christ's left hand, the whole of his
right arm below the bicep, and the lowest portion of both legs.
'VOLPATO ROMA' is impressed on the face of the plinth to proper
left. 'C. / 470. / Ⅎ' is painted in black on the drapery above the
plinth behind the figure.

Given by C. D. E. Fortnum in 1888. C. 470 in his catalogues. A
separate memorandum among his papers dated 1875 indicates that
he paid £2 10s. for it but where is not stated.

Fortnum described this as 'beautifully modelled in the fine
earthenware' and noted also that the mark 'but rarely occurs'
on such pieces—evidently it appealed to him for both its
artistic and documentary value. There is another version of
the figure among the Bequest of Conte F. Cini (displayed
without a number) in the Capitoline Museum Rome, which
has the same glaze, also slightly green where thickest, and
similar minor imperfections. The only significant difference
is that the plinth of the Capitoline version is far less regular,
and it is unmarked. The factory produced other devotional
subjects in this earthenware (for example, the *Christ at the
Column* in the Capitoline Museum, impressed like the
Ashmolean's *St Joseph*) as well as some classical ones (for
example, the *Cupid and Psyche* in the Capitoline Museum).
For Volpato and his factories see No. 106. St Joseph may
have had a special significance for the Volpato family:
Giovanni's son Giuseppe (Joseph), who died in 1805, seems
to have managed the factory at Città Castellana where these
figures were made, and after 1831 Giuseppe II Volpato revived
the family business, increasing, according to G. Morazzoni
(*La terraglia italiana* Milan, n.d. [1956]), 57, the
manufacture of saints.

Probably factory founded in Via Pudenziana, Rome, by
Giovanni VOLPATO (1733–1803)

108. Pope Pius VI on horseback

35.3 cms. (height, including integral oval plinth); 1.7 cms. (height
of integral oval plinth); 22 cms. (length of integral oval plinth);
13.7 cms. (width of integral oval plinth)

Earthenware with a greenish cream coloured lead glaze. The glaze
is peppered where the granules in the earthenware body project.
Three breaks in the raised front left of the horse have been mended,
A crack behind the other front leg has been filled. Some losses to
the pope's left foot and the stirrup have been made up, and the
thumb and two raised fingers of his raised hand are also repairs (this
was perhaps done soon after the original firing). The reins to proper
right have broken off except where they fall from the pope's hand;
parts of the reins to proper left are also lost.

Purchased from the dealer Alfred Spero of 4 Park Mansions Arcade,
Knightsbridge, 1965. Registered on 22 September.

Pope Pius VI (elected 1775, d. 1799) is here represented as
he appeared in the processional *possesso* after his election,
wearing a *mantelletta* over his rochet with a *mozzetta* and
embroidered stole and hat, riding a (white) palfrey with
elaborate caparison, blessing his people. The Braschi arms
decorate the pier supporting the belly of his mount, although
the bending flower is less distinct than the three stars and the
wind blowing at the flower is impossible to discern. There is
another version of the group in the City Museum and Art
Gallery, Kelvingrove, Glasgow (SMT 101) with a creamier
colour, less granular texture, and crisper details. The Glasgow
version is better preserved although the pope's right foot and

all the tassels of the saddle-cloth are missing. Another version
is mentioned as having been exhibited in 1889 in the Museo
Artistico Industriale di Roma (G. Morazzoni, *La terraglia
italiana* (Milan, n.d. [1956], 57). The group has sometimes
been associated with the earthenware products of the Città
Castellana factory which Volpato opened in 1801 but it differs
in its granular body and the colour of its glaze from
earthenware figures stamped 'VOLPATO' (such as No. 107)
which one might also suppose to have been made at Città
Castellana, and by 1801 Pius VI had died. If the group is
correctly associated with Volpato, as seems very probable, it
is far more likely to have been made at the Via Pudenziana
factory which Volpato opened in 1785—especially since this
enterprise enjoyed the official protection of Pius VI. The
factory was chiefly noted for its biscuit figures (see No. 106)
but did also make other wares.

The same model, but with the face and arms of Pius VI's
successor Pius VII (elected 1800), was employed for a painted
terracotta in the Victoria and Albert Museum. J. Pope-
Hennessy (in his *Catalogue of Italian Sculpture in the
Victoria and Albert Museum* (London, 1964), ii. 677, no.
722), unfamiliar with the earlier ceramic statuettes, claimed
that this terracotta recalls the 'sketch models' of Pinelli, but
these are far more lively in handling and are never heraldic in
composition (see No. 75). This terracotta may well have been
produced by the Città Castellana factory, either shortly after
its foundation or when the pope returned to the Vatican in
May 1814.

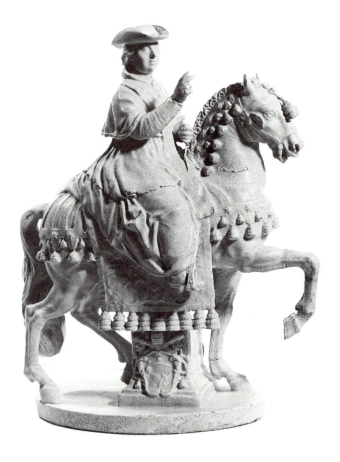

Daniele Ricciarelli da VOLTERRA (*c*.1509–66)

109. Michelangelo Buonarroti

28 cms. (height from lowest portion of the neck to the top of the head); 16 cms. (height of socle to lowest portion of bronze); 20 cms. (diameter of socle)

Bronze with a dark brown patina. Hollow, lost-wax, cast. Walls of uneven thickness. There are some minute perforations and a firing crack to proper left of the nose. There is no evidence of tooling of any kind. The lowest part of the neck has been broken and refixed with solder. A skin of the original core remains in much of the interior but has been partially concealed by a pouring of modern plaster of Paris into the uppermost part of the head. The head is mounted on a turned, waisted, and moulded walnut socle made for exhibition in the Department of Prints and Drawings in the British Museum in 1975. (An earlier socle of similar form, but of serpentine—and 23.3 cms. high— is in storage.) In the last century the head was mounted on a bust of plaster, presumably bronzed— see J. C. Robinson, *The Drawings by Michel Angelo and Raffaello in the University Galleries* (Oxford, 1870), 101, no. 90, who described this as added 'at a recent period'. It can, however, be seen in an undated engraving of Lawrence's sitting room at 65 Russell Square (reproduced as Fig 4 on p. 27 of K. Garlick, *Sir Thomas Lawrence* (Oxford, 1989).

Given by William Woodburn, 1845. Presumably lot 392 in the sale of the collection of Sir Thomas Lawrence, Christie's, 19 June 1830, 'A fine original Bust of Michelangelo Buonarroti in bronze—size of life', bought by 'Woodburn' (which member of the family is unspecified) for the high price of 40 guineas. Conceivably purchased by Samuel Woodburn and bequeathed by him to his brother William. In any case given to the University Galleries to accompany the drawings by Michelangelo, also from Lawrence's collection, which had been bought from Samuel Woodburn. The *Handbook Guides* of 1859 and 1865 record it as in the Raffaelle Gallery, the present Fortnum Gallery, where the Michelangelo drawings were displayed. It seems possible that Lawrence acquired the bust from the collection of Richard Cosway in whose inventory of 1820 and earlier self-portrait drawing such a bust features (information from Stephen Lloyd).

Although Daniele da Volterra is now remembered chiefly for his work as a painter, he was, as is clear from Vasari, an active and important sculptor. He seems to have made decorations in stucco as well as fresco for Cardinal Trivulzi's villa at Salone, in a room of Palazzo Massimi in Rome he was responsible for 'molti partimenti di stucco ed altri ornamenti', for the chapel of Elena Orsina in S. Trinità, Rome, in 1541 he created a 'most beautiful and varied' stucco surround for his celebrated altarpiece of the *Deposition* including two figures supporting the altar frontal. And that this work consisted in more than making designs for craftsmen is suggested by the fact that he was a skilled maker of casts: Vasari specifically mentions that he made moulds of Michelangelo's sculpture in the Medici Chapel in S. Lorenzo, Florence. His direct experience of bronze casting is also clear: Vasari describes his bronze equestrian statue of Henry II of France, in which Michelangelo assisted him, but which was not complete at the end of 1559 when Pius IV became pope. It is presumably because there exists relatively little by him which is not in

stucco, and because works in stucco are so little esteemed by art historians, that he obtains no mention at all in the standard survey of Italian sculpture of the sixteenth century (that by Pope-Hennessy).

The inventory of Daniele's house (formerly Michelangelo's) made on 5 April 1566 was published by Benvenuto Gasparoni in his rare and eccentric periodical miscellany *Il Buonarroti* (vol. iii—but in reality vol. i— (Rome, 1866), 178–9). Among 'infinite teste et pezzi di figure di gesso', wax models and casts, some specifically connected with the equestrian statue, there are listed 'una testa con petto di bronzi di Michelagnolo bonarroti' and, in another 'stanza da basso', 'due teste di bronzo con petti di Michelangnolo' and, in yet another 'stanza da basso', 'Dua teste di Michelagnolo con teste di bronzo', and, in the 'stanza di san Pietro', 'una testa di bronzo di Michelagnolo con busto'. It is clear from this that before his death Daniele had made at least six casts of Michelangelo's head, of which three were heads alone, three included at least a portion of the chest, and one was with a proper bust (that is assuming that 'con petto' and 'con busto' are meaningful distinctions). This document has perhaps not received the attention it deserves: no other sculptural portrait head of the Renaissance before this date is recorded as existing in so many versions. It would seem that the sculptor was capitalizing on the demand for a likeness of his recently deceased friend. Other evidence suggests that he would not have regarded these bronze casts as completed. But he might already have disposed of some that were.

It would seem that two of the casts were intended for Michelangelo's nephew, Lionardo Buonarroti, to whom Daniele Leoni wrote on 6 October 1565 that he had reminded 'Daniello' about them. His own cast was 'a buon termine' which would make Lionardo want to have his own cleaned— 'di fare rinettare'—that is filed, chiselled, and polished, as soon as possible. From this it would seem likely that Daniele would have wanted the bronzes to be finished. He was, however, ill and he died early in the following year. Lionardo was informed by Jacopo del Duca on 18 April about the 'teste di metallo' which had been cast by 'Messer Daniello' but needed work 'con ciselli et lime', and he was not sure that Lionardo would appreciate them as they stood. For his part he wanted Lionardo to have 'il ritratto della bona memoria di missere, non d'un altro'. Lionardo must do what he deems best. The implication is that he, Jacopo, would try to oblige if Lionardo so desired. 'Daniello', had he lived, would have known how to finish them, but as for his men— 'questi soi genti', a reference to Daniele's heirs, Michele degli Alberti and Feliciano da S. Vita—it was not clear what they were capable of. The first of these 'genti', Alberti, wrote to Lionardo at the same date with word that the bronzes had been cast and could be cleaned within a month.

By 26 August 1570 a portrait head was in the hands of Michelangelo's servant Antonio del Franzese, who offered it in a letter of that date to the duke of Urbino. He described it as 'il vero ritratto di Michelangnolo Bonarroti già mio padrone, et è di bronzo designato da lui proprio' (A. Gotti,

Vita di Michelangelo Buonarroti (Florence, 1875), i. 373—the letters to Lionardo cited above are on pp. 372–3). Of the surviving versions of the bronze portrait it is most likely that the one in the Museo Nazionale at the Bargello, Florence, which is set in a dignified, classically draped, bust on a very elegant socle, must be the one offered by Antonio to the duke—the treasures of the duchy of Urbino being transferred to the Medici in the seventeenth century and then, in the nineteenth being absorbed into the state museum. Alone among these bronzes it is highly finished. (It has sometimes been attributed to Giambologna, whose participation would be less unlikely had it been in Florence in his lifetime. Giambologna is also credited with the version in the Casa Buonarroti.)

The following is a list of the whereabouts of the other versions, excluding that in the Ashmolean: Bayonne, Musée Bonnat (No. 345); Florence, Accademia; Florence, Casa Buonarroti; Milan, Brera; Milan, Castello Sforzesco (297); Rome, Capitoline Museums (Palazzo dei Conservatori); Rome, Museo di Palazzo Venezia (Auriti Collection, no. 10806); Paris, Musée Jacquemart-André (no. 141); Paris, Musée du Louvre (R.F. 2385); Rimini, Museo Civico. Of these the versions in Casa Buonarroti, the Brera, and the Capitoline are fitted with busts, the first two of bronze and the third of *bigio Morato* (antique dark grey cloudy marble). The Louvre, Casa Buonarroti, Bayonne, and Palazzo Venezia versions are cast with portions of the collar (and that in the Capitoline Museums also has such in addition to a bust, although it is broken); the Jacquemart-André and Rimini versions include more of the chest, separately cast; the Ashmolean and Castello Sforzesco versions are heads only. The heads in Rimini and the Bargello have longer and more curled beards. The degree of chiselling is varied: none is apparent in the Louvre, Jacquemart-André, Castello Sforzesco, or Ashmolean versions; there is some in the Capitoline version which has a dull smooth finish (most notable in the Beard), much in the Casa Buonarroti version and in the Bargello version (as has already been observed). That some of the busts are aftercasts seems likely. The thorough researches of Fortnum for his paper 'On the Bronze Portrait Busts of Michel Angelo Attributed to Daniele da Volterra and Other Artists', published in *Archaeological Journal*, 33 (1876), 168–82, includes measurements of the Capitoline, Casa Buonarroti, Bargello, Accademia, Louvre (then Piot), Jacquemart-André (then Cottier) heads which suggest that none of these fall into this category. The version in Rimini looks suspicious (it is reproduced in E. Steinmann, *Die Portraitstellungen des Michelangelo* (Leipzig, 1913), pl. 59). That in the Castello Sforzesco, Milan, looks as if it must have been made from a very battered wax model, perhaps after Daniele's death (ibid. 61). Its surface is very rough and imprecise: the moustache is very smudged and neither pupils nor irises are marked.

The fact that Fortnum took such an interest in these bronzes may seem curious. It reflects, of course, his own interest in the collections in Oxford and, still more perhaps, the fact that the bronze now in the Louvre, but then belonging to Monsieur Piot, had been purchased 'from a private possessor at Bologna, several years since, in whose hands I had previously seen it, and regret, too late, having neglected to secure it for my own collection' (Fortnum, op. cit. 176). Fortnum also owned the wax model made by Leone Leoni for his medallion portrait of Michelangelo (now British Museum, MLA 1893, 10-11, 1; one of a few important items which he gave to the British Museum rather than to Oxford and the subject of another paper in the *Archaeological Journal*, 32 (1875), 1–15, which is preliminary to the paper on the bronze busts).

Robinson observed of Daniele's portrait that it 'represents Michel Angelo in his extreme old age, and it seems to have been modelled from nature' (op. cit. 101). Fortnum agreed with this but the 'heavy look of the eyelids and the closed mouth' suggested to him that it 'may have been made from a mask taken after death'. Both 'Mr. Warrington Wood, the eminent sculptor of Rome' and 'Professor Emilio Santarelli, a sculptor well known to fame, and whose knowledge, arising from long and loving study of the works of the great *renaissance* artists, is perhaps unrivalled in Florence' (see Nos. 8 and 27 for his dealings with Fortnum) both independently expressed the same opinion to Fortnum. It is an opinion which receives some support from the evidence that most, and probably all, of the portraits were cast posthumously and it has been repeated ever since. However, the flesh is neither drawn nor sagged, the features are not sunk, the eyes seem open (rather than opened), and, above all, the portrait is surely not of someone in their 'extreme' old age. The head resembles one in a drawing by Daniele in the Teyler Museum, Haarlem (A. 21), which was made, or was at least used, for the portrait of Michelangelo inserted into a fresco of the *Assumption of the Virgin* in the Della Rovere Chapel of S. Trinità dei Monti, and probably completed by 1555. (For this drawing see the entry by P. Ward-Jackson in *Drawings from the Teyler Museum, Haarlem* (Victoria and Albert Museum, London, 1970), no. 75.)

It is likely, however, that Daniele's portraits were revered rather as death-masks were—as reliable likenesses not works of art—and this may explain why so few of them were in the end finished. It is tempting of course to suppose that despite the evidence of the contemporary letters which we have quoted—letters which were, after all, written by people with an interest in finishing the bronzes—the lack of finish, the untooled lost-wax cast, was then appreciated by some connoisseurs. Certainly the ostentatiously untooled character of Giambologna's *Monkey* (Musée du Louvre, OA. 10895) and *Turkey* (Bargello, Florence) and of Vincenzo Danti's *Descent from the Cross* (National Gallery, Washington) suggests that such connoisseurs did exist. We may, however, be sure that Michelangelo was not himself among them, for Ascanio Condivi in his authorized life remarks apropos of Donatello's work in bronze that Michelangelo praised Donatello for everything except that he lacked patience in the cleaning (*ripulir*) of his works so that, though seeming marvellous from afar, from nearby they lost their reputation' (Vita di Michelangelo (Rome, 1553), para. 20).

Some of the casts Daniele made included the 'petto' and in one case perhaps more. It is likely that the portion of

buttoned-up tunic which is part of the Jacquemart-André cast (F. de la Moureyre-Gavoty, *Sculpture italienne: Musée Jaquemart-André* (Paris, 1975), no. 141) would be described as a 'petto' rather than a 'busto'. (It is separately cast but surely original: although now joined with solder there are old metal strap attachments.) In any case such a termination, which would at a later date have been unconventionally modest, corresponds with the unheroic, even domestic, character of the head. In this case, as also in the very different setting of the bust in the Capitoline Museum, the head is tilted forward which gives an appropriate melancholy to the lack of explicit expression and suggests a setting high on a wall, even above a door, such as was frequently favoured in fifteenth- and early sixteenth-century interiors. By contrast the manner in which the Ashmolean head has been mounted is unfortunate. A turned socle for a head without a neck is inevitably perceived as a sort of parody neck.

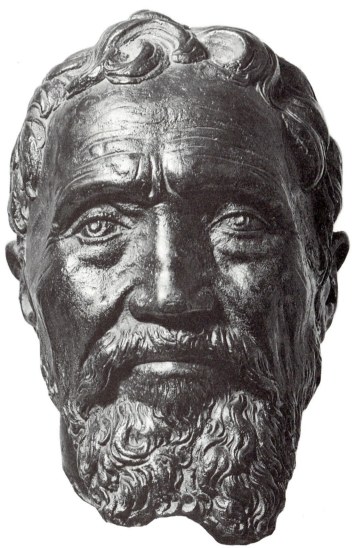

Supplied by Giacomo (*c*.1731–85) and Giovanni (*c*.1745–1805) ZOFFOLI

110 and 111. Pair of vases

34 cms. (height of vases including plinths); 11.6 cms. (height of pedestals); 9.4 cms. (length of plinths of vases); 9.31 cms. (width of plinths of vases); 12.6 cms. (length of plinths of pedestals); 12.5 cms. (width of plinths of pedestals)

Bronze with a patina varied from very dark brown to chestnut with some dark green. The plinths and upper mouldings of the pedestals are fire-gilt. Hollow, lost-wax, casts. Each vase is composed of at least three separately cast pieces—cap; body with foot and plinth; pedestal. There may also be a division between the bodies and the feet. There are slight casting flaws under the top moulding of the stem of one foot. 'G.Z.F.' is chiselled in the sides of the plinths of the vases, in one case below a handle, in the other centred.

Bequeathed by C. D. E. Fortnum in 1899. B. 1124 and B. 1125 in his catalogues. According to the notebook catalogue, given to Fortnum by Ellen Rigby in memory of her father (cf. Nos. 179 and 181).

Giacomo Zoffoli was a goldsmith, established in Rome by 1758. Giovanni (his brother, cousin, or nephew) and he came to be one of the four principal suppliers in Rome of bronze reproductions of antique statues: Righetti and Boschi were two of their rivals (see Nos. 15–16, 79–81). The Zoffolis seem chiefly to have supplied sets of bronzes of a size suited to display as chimney-piece ornaments. The earliest work associated with them is the copy of the *Marcus Aurelius* signed by Giacomo and dated 1763 (in the Green vaults, Dresden) and the set of five bronzes brought back to England by Francis Russell, marquess of Tavistock, from his Grand Tour in the same year (C. Avery, 'Bronze Statuettes in Woburn Abbey', *Apollo* (Feb. 1984), 97–8). British travellers on the Grand Tour were certainly among the principle customers (see *The Treasure Houses of Great Britain* (National Gallery of Art, Washington, DC, 1985), 358, entry A. Radcliffe). There is no need to suppose that either of the Zoffolis was directly involved either in the making of models, or in the business of casting or finishing the bronzes, although a background as goldsmiths suggests that they might have been expert at the latter. It is safer to regard them as publishers. We know that they commissioned clay models from established Roman sculptors: Vincenzo Pacetti recorded in his diaries in 1773 and 1774 making a *Farnese Flora* and a *Borghese Hermaphrodite.* They may then have put the task of making casts out to small Roman foundries.

There is a printed list of 'Serie di figure fatte, e da farsi in bronzo dell'altezza di un palmo e mezzo bono romano' offered for sale by 'Giovanni Zoffoli Romano' (whose home and 'studio'—i.e. showroom—was given as *above* the 'Vermicellaro alli Avinionesi', the pasta makers in Via degli Avignonesi off Strada Felice in Rome, an impossible location, incidentally, for a foundry, as Anthony Radcliffe has pointed out to me. A copy of this was supplied by C. H. Tatham to Henry Holland in 1795, and survives among his papers in the Victoria and Albert Museum. Tatham was acting as Holland's

agent in Rome, supplying him with ideas and items for interior decoration. Zoffoli's list included seven vases—the Medici Vase, the Borghese Vase, the Albani Vase, the Giustiniani Vase, the Gaeta Vase, and two which would seem to have been modern designs, a 'vaso a urna' and a 'vaso a Pila'. This pair being closed with lids, are likely to be the former, which were priced at 20 zecchini (then a little less than £10) each. The shape is close to that of the Medici Vase but with handles like those of the Borghese Vase. The designer is not known.

For Zoffoli generally see *The Treasure Houses of Great Britain*, op. cit. 358 (entry by A. Radcliffe) and H. Honour, 'Bronze Statuettes by Giacomo and Giovanni Zoffoli', *Connoisseur* (Nov. 1961), 198–205.

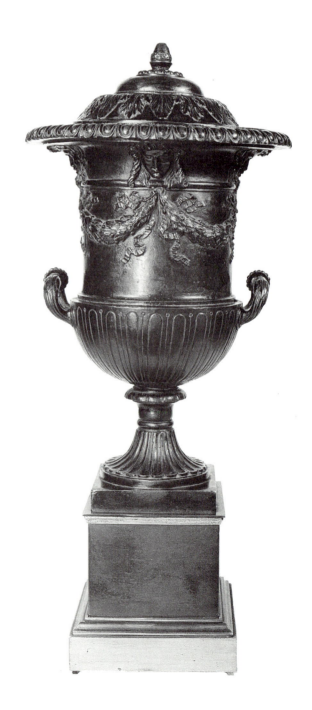

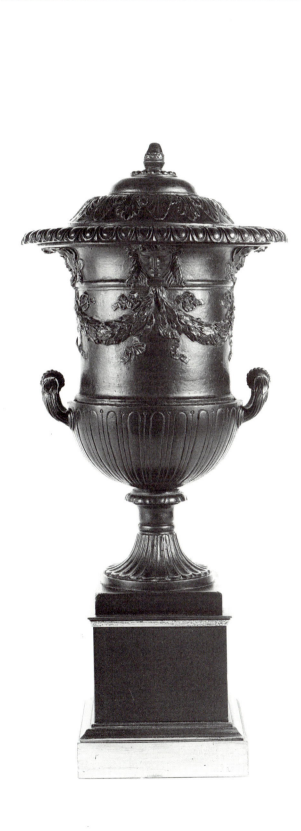

Supplied by Giacomo (*c*.1731–85) and Giovanni (*c*.1745–1805) ZOFFOLI

112. Farnese Flora

34.2 cms. (height including integral bronze plinth); 1.2 cms. (height of integral bronze plinth—approximate because sunk in marble plinth); 10 cms. (length of integral bronze plinth); 9.3 cms. (width of integral bronze plinth); 4.6 cms. (height of marble plinth); 10.8 cms. (length and width of marble plinth)

Bronze with a mixed dark and pale green varnish, chipped and worn. Hollow, lost-wax, cast. There is a perforation from a casting flaw in the heel of the figure's left foot exposing some vestigial core. There is also a plugged hole in the ankle of the figure's right foot. 'G. ZOFFOLI' chiselled on the proper right side of the integral bronze plinth in irregularly sized and inexactly aligned capitals. 'B. 446. F' is painted in white on the side of the integral bronze plinth behind the figure. The bronze is mounted on a black marble plinth.

Lent by C. D. E. Fortnum in 1894; bequeathed by him in 1899. B. 446 in his catalogues. No provenance given in his large or his notebook catalogue, but in his preliminary catalogue (pp. 30–40) noted as acquired in Paris together with No. 113, the copy of the *Apollino*, in 1853. According to a separate 'Memoranda of prices paid', apparently under the year 1852, '2 Zoffolis. Flora and Apollino' are entered with '6' (pounds, presumably) opposite.

For the famous antique statue in the Museo Nazionale, Naples, of which this is a copy see F. Haskell and N. Penny, *Taste and the Antique* (New Haven, Conn., and London, 1981), 217–18. The bronze reproduces the statue before the revision (by Tagliolini, see No. 98) of the floral attribute from chaplet to nosegay. It is probably derived from a clay model made for the Zoffolis by Vincenzo Pacetti in 1773, and in any case certainly from a model made before 28 February 1800 when the statue left Rome for Naples. For the Zoffolis generally see Nos. 110 and 111. The 'Flora di Farnese' was the twelfth item on Giovanni Zoffoli's printed list and was priced at 18 zecchini, the same price as the equivalent on the list of his rival Righetti. The model was surely made before 1793 when another bronze was probably acquired by Lord Boringdon as part of a set still in place on a chimney-piece at Saltram Park, Devon, where it is companion with a *Capitoline Flora*. Another bronze *Farnese Flora* is at Schloss Wörlitz. The green varnish on the Ashmolean's version would seem to be original and is found on other bronzes by Zoffoli such as the *Capitoline Antinous* in the Victoria and Albert Museum (Reserve Collection, A. 15-1974), which appears to have been very little interferred with and even retains what may be an original paper label, and the pair of *Furietti Centaurs*, unusually signed 'GIACOMO ZOFFOLI F', which were lot 112 at Christie's, London, 28 April 1988. C. H. Tatham in a letter to Henry Holland sent from Rome on 10 July 1795 discussing bronzes of this type mentions that the 'best colour' in Rome was 'esteemed to be that which approaches the colour of green basalt' (Victoria and Albert Museum, D. 1479. 14–19), i.e. the rare Egyptian graywacke, basanite, commonly misdescribed as basalt.

Supplied by Giacomo (*c*.1731–85) and Giovanni (*c*.1745–1805) ZOFFOLI

113. Apollino

34.1 cms. (height including integral bronze plinth); 2 cms. (height of integral bronze plinth—approximate because it is let into the wooden plinth); 13.2 cms. (length of integral bronze plinth); 8.5 cms. (width of integral bronze plinth); 15.4 cms. (length of wooden plinth); 10.2 cms. (width of wooden plinth)

Bronze with a dark green khaki varnish, worn to a paler colour in parts, slightly chipped. Hollow, lost-wax, cast. The vine leaf is separately cast and soldered. There is a casting flaw in the proper right foot and a crack under the proper left arm. 'G. ZOFFOLI' is chiselled, on the side of the integral bronze plinth beside the proper right foot, in irregularly sized and inexactly aligned capitals with the point in triangular form. 'B.447 / Ɛ' is painted in white on the side of the integral bronze plinth behind the figure. The bronze is mounted on an ebonized wooden plinth.

Lent by C. D. E. Fortnum in 1894; bequeathed by him in 1899. B. 447 in his catalogues. 'Bought in London' according to his notebook catalogue, but in his preliminary catalogue (pp. 39–40) noted as acquired in Paris together with No. 112, the copy of the *Farnese Flora*, in 1853. According to a separate 'Memoranda of prices paid', apparently under the year 1852, '2 Zoffolis. Flora and Apollino' are entered with '6' (pounds, presumably) opposite.

For the famous antique statue in the Tribuna of the Uffizi, Florence, of which this is a copy, see F. Haskell and N. Penny, *Taste and the Antique* (New Haven, Conn., and London, 1981), 146–8. The bronze is made from a very accurate model and even reproduces the integral irregular rounded-off rectangular plinth on the original marble, although this did nothing to help the figure match the companion pieces with which it would usually be sold to form a *garniture de cheminée*. For the Zoffolis generally see Nos. 110 and 111. The *Apollino* was the second item on Giovanni Zoffoli's printed list and was priced at 15 zecchini, three zecchini less than the equivalent on the list of his rival Righetti, and less than other items of the same size on his own list. The lower price may suggest that it had been in production for some time and the title 'Apollino di Villa Medici' may suggest that the model was made before the statue was removed to Florence from the Villa Medici in 1769–70 (although the old name no doubt survived on the plaster casts remaining in Rome).

Supplied by Giacomo (*c.* 1731–85) and Giovanni (*c.* 1745–1805) ZOFFOLI

114. Capitoline Antinous

33.3 cms. (height including integral bronze plinth); 2 cms. (height of integral bronze plinth in front); 9.05 cms. (length of integral bronze plinth); 8.2 cms. (width of integral bronze plinth); 3 cms. (height of wooden plinth); 11.3 cms. (length of wooden plinth); 10.45 cms. (width of wooden plinth)

Bronze with a dark brown varnish, chipped slightly, and worn in salient parts to a golden brown patina. Hollow, lost-wax, cast. There are casting cracks across the figure's right wrist and perforations at the junction of figure's right leg with the tree stump. 'G. ZOFFOLI. F' is chiselled in irregularly sized and inexactly aligned capitals below the stump on proper right side of the integral bronze plinth. The bronze is mounted on an ebonized wooden plinth.

Lent by C. D. E. Fortnum in 1894; bequeathed by him in 1899. B. 448 in his catalogues. 'Bought in London' according to his notebook catalogue. In his preliminary catalogue (pp. 39–40) noted as acquired in London together with the *Capitoline Flora* (No. 115) in 1852. According to a separate 'Memoranda of prices paid' under the year 1851 he noted 'Antinoo 4–4' (4 guineas).

For the famous antique statue in the Capitoline Museum, Rome, of which this is a copy, see F. Haskell and N. Penny, *Taste and the Antique* (New Haven, Conn., and London, 1981), 143–4. The bronze is made from a less accurate model than was usual with Zoffoli: the third, fourth, and fifth fingers of the youth's left hand are bent upwards in the marble; the bark of the stump is given a far more ostentatiously lively, clawed texture in the bronze. On the other hand, as seems to have been a policy with Zoffoli, the integral unmoulded block plinth of the original marble is reproduced, although this did nothing to help the figure match the companion pieces with which it would usually be sold to form a *garniture de cheminée*. For the Zoffolis generally see Nos. 110 and 111. The 'Antinoo di Campidoglio' was the third item on Giovanni Zoffoli's printed list and was priced at 15 zecchini, three zecchini less than the equivalent on the list of his rival Righetti. The model must have been made by 1769 when one was included on the chimney-piece in the drawing room where Sir Laurence Dundas sits with his grandson in the portrait by Johann Zoffany, its companion (at some distance) being the *Borghese Gladiator*. Another version of this bronze is in the Victoria and Albert Museum (A. 15-1974).

The 'F.' terminating the name on this bronze and the initials on the vases (Nos. 110–11) may have been misinterpreted by Fortnum who, in his manuscript catalogues and his introduction to the *Catalogue of Bronzes in the South Kensington Museum*, supposed that Zoffoli was Florentine.

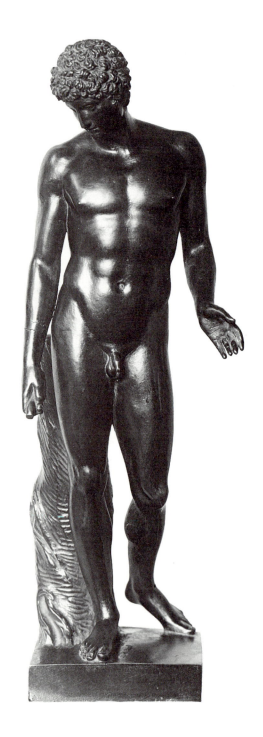

Supplied by Giacomo (*c.* 1731–85) and Giovanni (*c.* 1745–1805) Zoffoli

115. Capitoline Flora

33.8 cms. (height including integral bronze plinth); 9.9 cms. (length of integral bronze plinth); 7.2 cms. (width of integral bronze plinth); 4.6 cms. (height of marble plinth); 10.8 cms. (length and width of marble plinth)

Bronze with a dark brown varnish worn in salient parts (especially the figure's right knee) to a dull tan natural patina. Hollow, lost-wax, cast. 'G.Z.' chiselled beneath the figure's right foot in the hollow of the integral bronze base. 'B. 449. Ⴑ' is painted in white in the same hollow, behind the figure. Mounted on a plinth of black marble with a few white fossils.

Lent by C. D. E. Fortnum in 1894; bequeathed by him in 1899. B. 449 in his catalogues. 'Bought in London' according to his notebook catalogue. In his preliminary catalogue of 1857 (pp. 39–40) noted as acquired in London together with the *Capitoline Antinous* No. 114) in 1852. According to a separate 'Memoranda of prices paid' under the year 1851 he noted 'Flora 6–6' (6 guineas).

For the famous antique statue in the Capitoline Museum, Rome, of which this is a copy, see F. Haskell and N. Penny, *Taste and the Antique* (New Haven, Conn., and London, 1981), 215–17. The bronze is made from a very accurate model and even reproduces the integral oval hollowed base of the original marble, although this did nothing to help the figure match the companion pieces with which it would usually be sold to form a *garniture de cheminée*. For the Zoffolis generally see Nos. 110 and 111. The 'Flora di Campidoglio' was the thirteenth item on Giovanni Zoffoli's printed list and was priced at 16 zecchini, two zecchini less than the equivalent on the list of his rival Righetti. It is interesting that the amount paid by Fortnum was not much beneath its original price (which would have been equivalent to slightly less than £7). The model for this figure was surely made before 1793 when another bronze was probably acquired by Lord Boringdon as part of a set still in place on a chimney-piece at Saltram Park, Devon, companion with a *Farnese Flora*. It is interesting that the two *Floras* in Fortnum's collection (this and No. 112) have the same type of marble plinth. If these were fitted by Fortnum one would expect to find them on his other bronzes by Zoffoli.

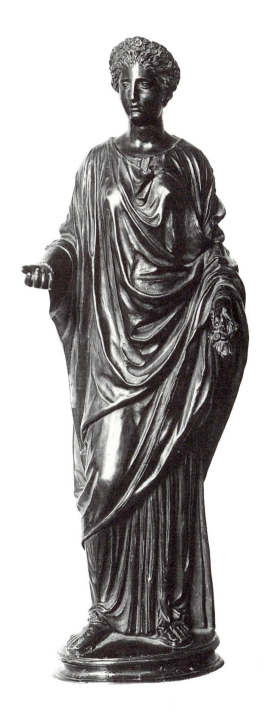

INDEPENDENT SCULPTURES OF THE ITALIAN SCHOOL

Unassociated with a Named Sculptor, Craftsman, or Supplier

116. Bust of St Geneviève

38.6 cms. (height); 31 cms. (width)

Carrara marble discoloured brown from ingrained dust. There is a small flaw in the marble above the saint's left eye with some discoloured plaster filling in it and there is a grey fleck in the figure's chest. The medallion of Christ around the figure's neck has been gilded: some of the gilding has been rubbed off. The edges of the relief are neat enough from in front, but have been coarsely hewn when studied from behind. There is a corner of the relief missing behind the head to the proper left before the arched top, and there are traces of plaster cement on the edges. The relief is set with crude supports in a framework of pine coated with gesso with a punched pattern which has been gilded and then covered with a thin ebonized veneer much of which has been broken off.

Lent by C. D. E. Fortnum, 20 March 1888, and given later in the same year. S. 54 in his catalogues. Bought at the sale of the collection of Alexander Nesbitt on 19 May 1887 for 38 guineas (notebook catalogue).

The relief has generally been described in the Department's files as representing the youthful St John but sometimes as a young woman. If St John is intended it is curious that the drapery over his left shoulder is not of goatskin and the cap is also unusual for him or any other young male saint. Much the most likely subject is St Geneviève the shepherd girl (born in Nanterre in 421) who at the age of about 7 was given a small copper coin marked with the sign of the cross by St Germain, bishop of Auxerre. It is unusual for her medallion to have the head of Christ rather than a cross on it and it is also a surprising subject for an Italian artist, but Fortnum is known to have owned a bust of this saint, and although he described it as of St Geneviève of Brabant this was a common mistake for St Genevière of Nanterre. He acquired the sculpture from the collection of Alexander Nesbitt who believed that it has 'formed part of the old facade of the Duomo at Florence' and attributed it to one of the pupils of Orcagna (*Proceedings of the Society of Antiquaries*, 2nd series 8 (23 June 1881), 547) and thus dated it to the late fourteenth or early fifteenth century.

The odd shape of the relief, with curved lower edge and sraight tapering sides stepped back to the arched top, either suggests, or is designed to suggest, that it is a fragment. At the same time the cutting of the chest and upper arms recalls the type of termination common in fifteenth-century Florentine busts of women and children, and in particular busts of the infant Christ and Saint John. The miniature drill holes in the hair—and the single drill hole in the corner of the figure's right eye—may also be inspired by genuine fifteenth-century Florentine reliefs (such as the relief of the young *Baptist* in the Los Angeles County Museum of Art which 'looks as though it had been through a sewing machine'—J. Pope-Hennessy, *The Study and Criticism of Italian Sculpture* (Princeton, NJ, 1980), 224–5, fig. 5). Certainly the insipid religiosity and parted lips are inspired by the tender sentiment and evanescent expression found in the domestic devotional works by sculptors such as Mino da Fiesole and Desiderio da Settignano. Whether the sculpture

is a pastiche or a fake is impossible to say, but it is likely to have been made in Florence in the 1860s or 1870s. The drilling and the religiosity are reminiscent of Bastianini's bust of Lucrezia Donati (Victoria and Albert Museum 38-1869) trumpeted as a masterpiece of Mino until exposed as a fake by the dealer Alessandro Foresi in 1868. Fortnum must have been acutely aware of this controversy but he certainly did not doubt the authenticity of this piece. Bell in his annotations to the large catalogue recorded Schubring's opinion that it was by Nanni di Banco and Bode's that it was modern. It was on display in the Fortnum Room together with other reliefs (e.g. Nos. 26 and 27) in 1909 but was not included in the newly arranged Fortnum Room in 1931 (*Summary Guide*, 23).

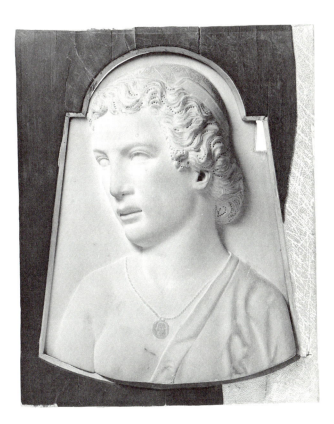

117. Death-mask purporting to be of Lorenzo de'Medici 'il Magnifico'

23 cms. (approximate length of mask); 56.5 cms. (height of shadow box at front); 17.7 cms. (depth of shadow box)

Plaster cast mounted on a board covered with crimson velvet and set behind glass inside a deep oval shadow box with an oak frame and a deep, concave, slip also of oak but water gilded. There are splits in the frame and slip.

Given by J. M. Dent—presumably Joseph Malaby Dent (1849–1926), the successful publisher—in 1903. Deceptively described as a 'print of the death mask' in the *Annual Report* for that year (p. 10).

It is likely that this cast of the death-mask of Lorenzo de'Medici (1449–92), as it was generally believed to be, was felt to be an appropriate possession for the Ashmolean Museum because of the terracotta portrait of Lorenzo which Fortnum had presented to the Museum in 1888 having bought it from Emilio Santarelli, the Florentine sculptor, expert, collector, and dealer in 1870. (Fortnum indeed believed that the head was based on such a mask.) The mask was on receipt 'framed and placed close to the terracotta bust in the Fortnum Collection for purposes of comparison' (*Annual Report* (1903), 10) but by 1909 according to the *Handbook Guide* (p. 101) the bust was displayed with a photograph of the mask in the possession of the Società Columbaria in Florence and the cast was presumably in the basement store whence it seems never to have been removed.

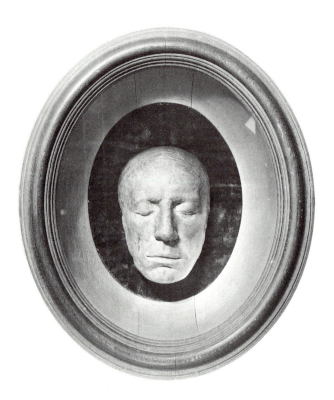

118. Pacing horse (Horse of St Mark's)

28 cms. (height of horse); 28.2 cms. (length of horse, nose to heel); 6 cms. (height of plinth); 26.5 cms. (length of plinth); 11 cms. (width of plinth)

Bronze with a dark brown to black varnish extensively worn to reveal a slightly olive green brown natural patina. The centres of the rosettes and the studs between them on the collar are of silver, which has tarnished. The eyes are hollowed perhaps for silver inserts which have fallen out. Hollow, lost-wax, cast with thin walls. The nostrils and mouth open into the interior of the cast. The rear portion of the tail where it curves has been added with extreme care. The line of the join is hard to see but the small heads of the four iron pins are betrayed by slight rust. There are small perforations in the horse's back which have been stopped with wax and one lozenge-shaped hole 0.4 cms. across. There is a larger lozenge-shaped hole, 0.8 cms. across, presumably from a chaplet, in the belly which is not plugged. All the details seem to be reproduced from the wax model. The bronze is attached to its plinth with two bolts extending from the horse's front right and back left hoofs. The small pile of earth supporting the horse's back right foot is made of mahogany toned to match the bronze. The plinth is of mahogany with the key pattern inlaid in satinwood. A small portion of the inlay at the edge of the front face has been lost. 'M. 177' is written in black ink in the interior of the plinth.

Bequeathed by J. Francis Mallet who died 7 January 1947. Received in the Museum during the last week of May 1947. No. 177 in the inventory of his bequest. Valued by Mallet at £30. 'Christie' given as the only provenance in Mallet's own list. The British eighteenth-century base suggests that it had been for more than 150 years in this country.

Mallet described this as 'A bronze horse walking with left forefoot raised. Style of John de Bologna. Circa 1650. On wooden pedestal with key pattern inlay, 18th century, English.' In view of his reference to Giambologna Mallet perhaps meant to write 1550 rather than 1650. It seems perfectly possible that it was made as early as 1550, and might have been made as early as 1500, and the silver inlay would be less surprising at either of these dates than in 1650 or 1750. In any case it is likely to have been made in the Veneto for it is in fact, as Mallet surprisingly did not note, a reproduction of one of the four famous antique bronze horses of St Mark's in Venice (for a general account of the history and fame of which see F. Haskell and N. Penny, *Taste and the Antique* (London and New Haven, Conn., 1981), 236–40). The antique horse reproduced is the one on the beholder's right and the imitation of the pattern of the collar, the veins on the nostrils, the creases on the neck, the breaks in the clipped mane, and the skimpy arched tail is all remarkably precise. The cast is of superb quality: all the detail, which is remarkably crisp, seems to have been made in the model. What looks like another cast with a dull patina but all the same details in the modelling and even with an identical hole in the belly is on loan to the Royal Ontario Museum, Toronto (at present in reserve). One in the collection at Schloss Pommersfelden may be a third, although there are minor differences (this example is reproduced by H. R.

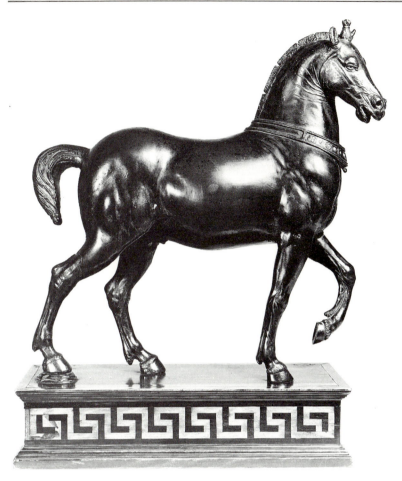

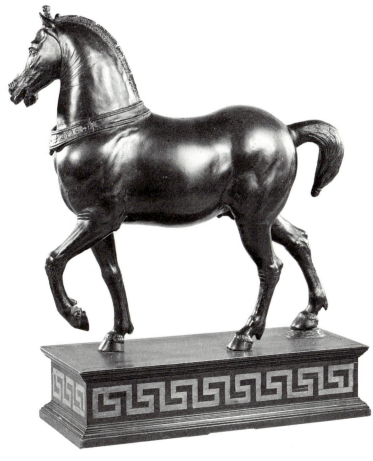

Weihrauch in his *Europäische Bronzestatuetten* (Brunswick, 1967), 50, pl. 48, captioned as Venetian of the seventeenth century). There exist other bronze versions of other horses in the quartet which are less precise as copies, less detailed in modelling, less accomplished as casts, and often smaller in size. One such in the Ashmolean Museum, coming from the collection of Chambers Hall, is modelled on the first horse of the four on the beholder's left, another, also modelled on this same horse, is in the Walters Art Gallery, Baltimore

(Weihrauch, op. cit. 50, pl. 47, and E. P. Bowron, *Renaissance Bronzes in the Walters Art Gallery, Baltimore* (Baltimore, Md., 1978), 30–1), but these have usually been regarded as probably Venetian or Paduan works of the first half of the sixteenth century.

The distinctive manner in which the repair is made to the tail of the Ashmolean's horse with the extra piece of bronze attached with four minute iron pins (see above) may help to identify where and when it was made.

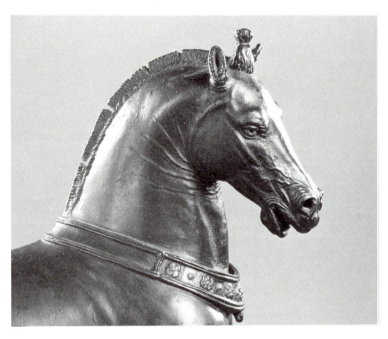

119 and 120. Pair of reclining female personifications

7.6 cms. (height of 119, figure leaning on a book, from socle to top of head); 14 cms. (length of same figure, from extended foot to the large book); 8.2 cms. (height of 120, figure with anchor, from socle to raised hand); 16.5 cms. (length of figure with anchor); 2.5 cms. (height of socles); 16.75 cms. (length of socles); 7.2 cms. (width of socles)

Bronze, heavily fire-gilt, with the gilding worn in the knee and index finger of the right hand of the figure with a book (119) to expose a natural patina, warm chocolate in colour, suggesting a high copper content. Hollow, lost-wax, casts. The casts are heavy and the limbs and heads appear to be solid. Both the figures have been minutely tooled on both sides, although the rear view is obviously subordinate. The hair, drapery folds, and fingers are precisely chiselled and a punch has been employed to texture the outside of the drapery. In both figures there are small areas of tarnishing and also some dirt in the deeper hollows. In the case of No. 119 there is a flaw in her right foot which has probably been caused by the bolt penetrating it. The loss has been filled with red wax. The folio volume is dented on the visible cover and flawed on the concealed one. It is cast together with the figure but the quarto volume upon which the folio rests is cast separately and screwed to it. The quarto volume has not been gilded and must be a later addition or a replacement. In the case of No. 120 there is a large empty bolt hole in the drapery spread behind the figure's left foot. The figure's raised hand has been separately cast. The joint is slightly loose and the hand is now turned with the palm facing to the front whereas it was intended to face away from her head. Both figures are bolted to spreading rectangular white marble plinths. These are not original and the figures do not (when seen from the rear) fit neatly onto them. The edges of the plinths have been slightly chipped. Three of the corners in one case and two in the other have been made up with plaster. 'FRANCE / BEQUEST / PURCHASE / 1935' is written in ink on fringed circular labels stuck to the underside of each plinth.

Bought from the dealers 'Cecil Leitch and Kerin' together with the boys riding lions attributed to Roccatagliata (Nos. 124 and 125) with fund from the bequest of George Flood France. Recorded in the Donations Book on 30 April 1935.

On acquisition these figures were tentatively attributed to Guglielmo della Porta on account of the reclining female personifications of somewhat similar character on the sarcophagus in that sculptor's tomb for Pope Paul III in St Peter's. A more likely location for figures in these positions would be the sides of a pediment—for there are miniature pediments, for example on luxury cabinets in ebony with marble inlay and marble columns taking the form of temples and on aedicular picture frames, whereas minature sarcophagi are harder to imagine. If these little bronzes were attached to a pediment and the pediment was broken and filled with an achievement of arms then that would explain the outstretched arm of the figure with an anchor, especially if the original position of the hand is borne in mind (see above).

Larger and less precisely finished versions of these figures, slightly adapted in pose (the version of the second figure with neither an anchor nor a raised arm), both about 14 cms. in length, were attached to the broken pediment of a spectacular night clock with a copper face painted with the Fates by Filippo Lauri and the body inlaid with semi-precious stones and bristling with ormolu fittings, which was made in about 1660 for Prince Colonna. This clock was, early in 1987, in the possession of the dealer Raffaello Amati (of Antiquus, 90–2 Pimlico Road, London SW1). The figures are likely to have been invented long before 1660 and one would be inclined to date the Ashmolean's bronzes to the last decades of the sixteenth century. The unknown sculptor was an artist of great ability. The figures, especially when seen from the side, their feet nearest us, are most elegantly composed.

The use of reclining figures on pediments is not common in antiquity (although they were of course frequently employed in the spandrels of arches) and is not usual in the first half of the sixteenth century or before (although Donatello introduced the idea in his tabernacle of the Sacrament in St Peter's in the 1430s). It was a motif which was favoured by Palladio from 1550 onwards and it became popular first in the Veneto and then all over Europe.

No. 120, the figure with an anchor (one prong of which, incidentally, emerges behind the figure's left foot), presumably represents Hope. Her companion with a folio is less easily identified. She probably held another attribute in her right hand. If this was a Cross then she would represent Faith.

There is an inferior version, perhaps an aftercast of the *Hope* (but without the anchor), in the collection of bronzes in the Museo Bardini in Florence (unlabelled).

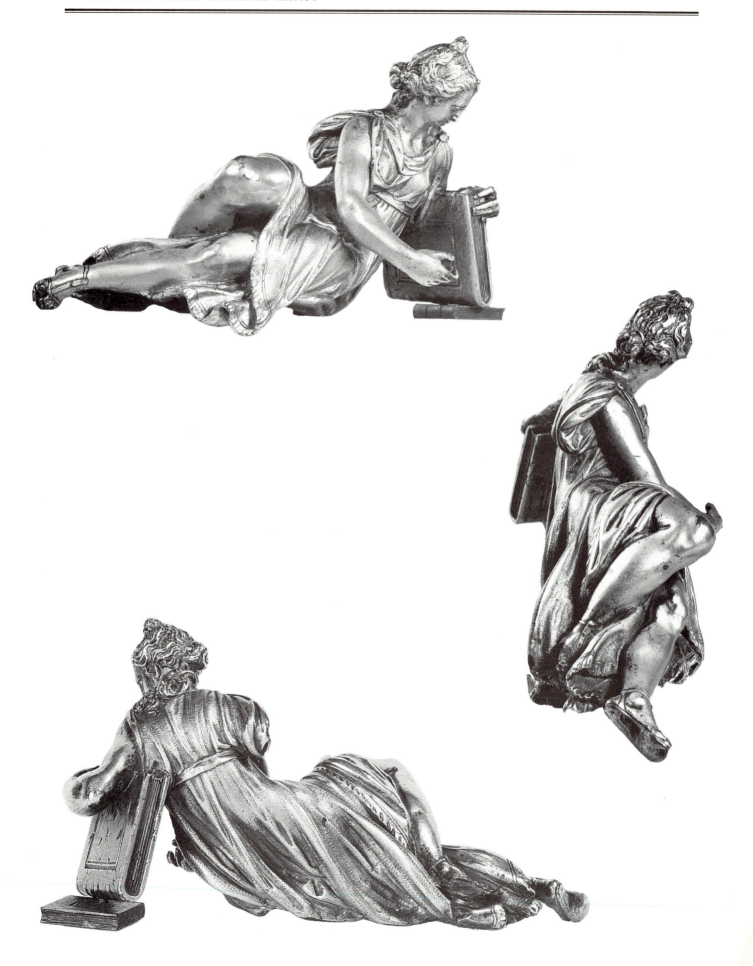

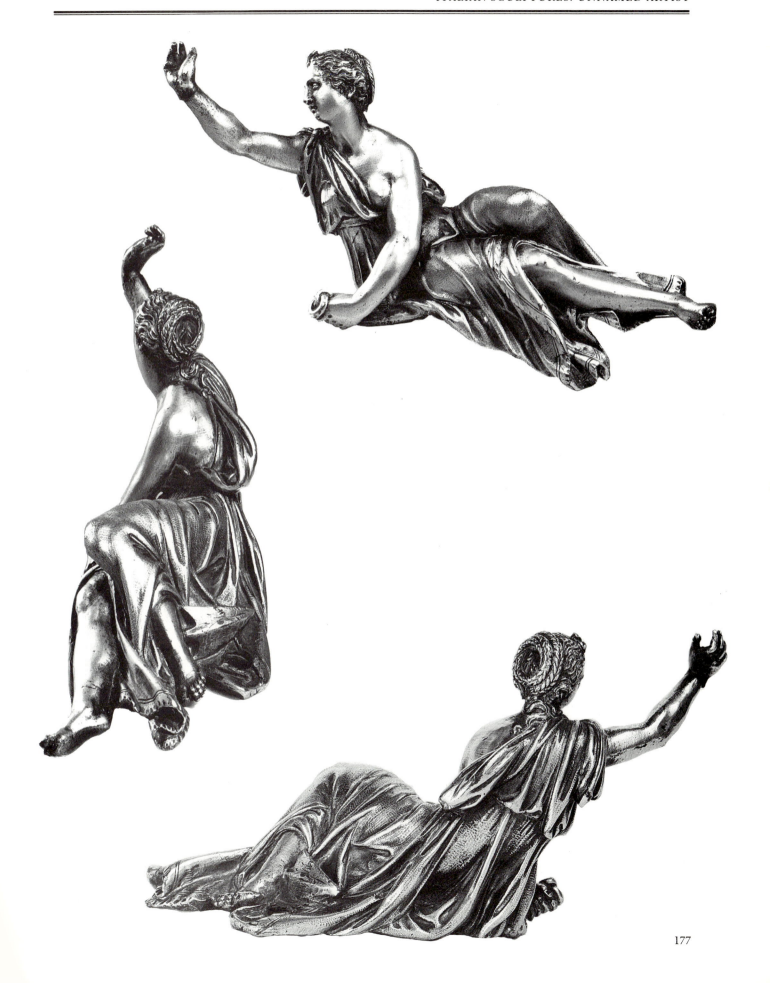

121. Winged female personification

25 cms. (height including integral base); 13 cms. (width, across wings); 3.5 cms. (height of base); 7.55 cms. (length of base); 6.45 cms. (width of base)

Bronze with a dull slightly olive, pale brown patina and traces of a gilt varnish (not fire-gilding) especially in the folds of the drapery behind the legs and on the figure's right knee. Hollow, presumably lost-wax, cast. The details are apparently reproduced from the model and tooling is evident only at the tips of the wings. There are small round perforations at two points in the drapery beside the proper left leg, probably from chaplet pins. The interior of the base has been filled with plaster of Paris. Both hands have been separately cast. The proper left hand is slightly loose and the join at this wrist may be easily discerned, whereas the join at the other wrist is not at all obvious. The attribute in the proper left hand has a screw fitting within. It is clear that this object has been broken off under the hand and traces of solder remain from an attempted refixing. 'B.433. ⊕.' is painted in white vertically in one of the hollows of the drapery behind the figure. A paper label with 'B / 433' written in brown ink within a printed blue border is stuck to the underside of the base.

Lent by C. D. E. Fortnum on 7 January 1888 and given later in the same year. B. 433 in his catalogues. 'Bought in Florence' according to the notebook catalogue, presumably after 1857 when his preliminary catalogue, in which it is not included, was compiled. The bronze was accidentally damaged in 1965 and repaired 1965–6 by the conservation studio of the Department of Antiquities.

Fortnum catalogued this figure as an 'angel or Ceres' but with question marks. Given the separate casting, and hence possible replacement, of both hands, the attributes may not determine the figure's original identity. 'The ears of corn and the cup (now incomplete) may be original but injured and restored', Fortnum continued carefully. 'They may have been emblems of Ceres or of bread and wine.' Whereas corn is certainly held in the figure's right hand it is not certain that the item in the other is, or rather was, a cup.

If the attributes are removed and the figure's right shoulder is twisted forwards this figure is seen to relate very closely to a bronze statuette which is known in many versions all of more or less the same size. These *Victories* have long been recognized as probably derived from an antique prototype (see for instance W. Bode, *Italian Renaissance Statuettes* (London, 1908), ii, pl. CII). No such prototype has, however, been identified. Figures of a similar character stand at the corners of a Roman sarcophagus of AD 180 in the Walters Art Gallery, Baltimore (23.29), but since this was excavated in 1885 it cannot be the source, which one would, in any case, expect to be a free-standing figure. It may be that the Ashmolean's bronze is independently derived from the unidentified antique source. It looks likely to be more faithful to it than are the other versions all of which are more twisted. The hexagonal base with stepped mouldings is very unusual in a Renaissance bronze: it is a type of base favoured in British sculpture around 1890 (see for instance No. 504).

Fortnum regarded his bronze as Italian of the fifteenth century. No one would now favour such an early date. Charles Avery published a version of the statuette in an American private collection (*Giambologna, 1529–1608: Sculptor to the*

Medici (Victoria and Albert Museum, London, 1978), no. 195), for which he ingeniously proposed an attribution to Pietro Francavilla (Pierre Francheville) because of its similarities with a statuette held by that sculptor in his portrait of 1598 by Paggi (published by M. Fransolet, 'Une œuvre d'art retrouvée: Le Portrait de Pierre de Francheville par Giambatista Paggi, 1589', *Bulletin de l'Institut Historique Belge de Rome*, 18 (1937), 199–207). But Francavilla's statuette, described by Baldinucci (who at one time owned it) as 'a model, apparently in wax, representing Fame', is blowing a trumpet, has drapery blown back to reveal both lower legs, seems to have both breasts bare, and does not have wings.

The very tight torsion found in the *Victory* statuettes other than the Ashmolean's was popular generally in Italy around 1600: one finds it in the caryatid figures of *Painting* and *Architecture* which flank the bust of Alessandro Vittoria on his tomb in S. Zaccaria, Venice, and in the four caryatids by Ippolito Buzio and Pompeo Ferrucci supporting the attic of the tomb of Pope Paul V in the Cappella Paolina in S. Maria Maggiore, Rome.

Nevertheless the *Victory*, if not the Ashmolean's bronze, is likely to be a Florentine invention. A diminutive version of the figure serves as a finial on a bronze standard lamp in the Museum für Kunsthandwerk, Frankfurt on Main (inv. no. V218) which is inscribed 'FERDINANDUS MEDICES MAGNUS ETRURIAE DUX' (a connection noted independently by Volker Krahn). A statuette of the same size and pose as the *Victory* statuettes, but gilded and holding a platter of fruit or vegetables in her left hand and some vegetation aloft in her right, and without wings, is cradled in one hand by a man in a portrait attributed to Pontormo, and certainly Florentine, in the Christ Church Picture Gallery (J. Byam Shaw, *Paintings by Old Masters at Christ Church Oxford* (Oxford, 1967), 61, no. 63, pl. 60). The man's other hand rests on a companion statuette which is based on Andrea del Sarto's fresco of *Hope* in the Chiostro dello Scalzo, or just possibly on a sculptural source used by Sarto who was much indebted to models made by his friend Jacopo Sansovino. The connection beween the statuette cradled in this painting and the *Victory* was noted independently by Peter Meller who has convincingly identified the sitter as Vincenzo Borghini and suggested that the statuette may be by Tribolo and derived from the *Victories* which Michelangelo proposed for the first project for the tomb of Julius II.

Various distinctions may be made among the bronze *Victories*. Of those that I have studied the version in the Ca d'Oro in Venice (D. br. 57) is by far the finest cast. In this version her left hand is empty but her right hand holds aloft a laurel crown. The undergarment buttoned over the thigh and falling down behind the legs, also emerging in a small fold under the exposed breast, is given a minutely punched texture. The hem of the upper garment lifts and ripples. The version in the Louvre (OA. 6415) is also of high quality with particularly lively modelling in the front of the wings (but much less interest in the drapery). There is no diadem in this case but it may have been attached for there is a small hole in the hair. The same applies to the bronze in an American

private collection published by Charles Avery in the
Giambologna catalogue (cited earlier) which would seem to
be the version sold at auction at Weinmüller, Munich, 28–
9 October 1970, lot 622. This is very close to the French
version. Another good example, without wings and without
a diadem, is in a private collection in Berlin (formerly in the
collection of the architect Adolf Wollenberg, and sold at
auction by Rudolph Lepke, 17 March 1982, no. 90, p. 19).
Of less high quality are the examples in the collection of Sir
Brinsley Ford, that formerly in the collection of Guido von
Rhò (E. W. Braun, *Die Bronzen der Sammlung Guide von
Rhò in Wien* (Vienna, 1908), 18, pl. XXb), in the
Kunsthistorishes Museum, Vienna (5653), and the one in
the Victoria and Albert Museum (71.1866)—which may be
an aftercast.

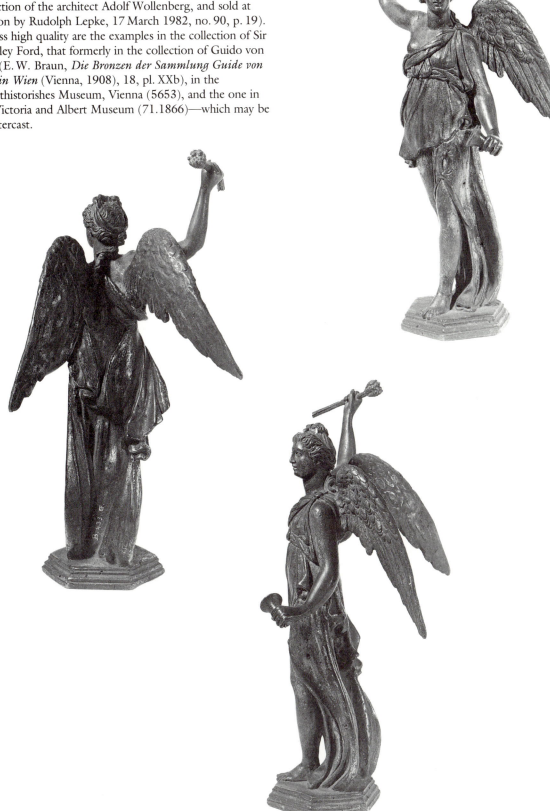

122. Roman warrior riding a camel

7 cms. (height excluding the tangs); 1.6 cms. (length of tangs)

Silver gilt, the gilding worn to expose a tarnished silver. Hollow, lost-wax, cast. Finely and minutely tooled. There is a circular aperture between the camel's front legs. Threaded tangs extend from each foot of the camel. The slab of lapis lazuli to which the camel was attached has not been traced. The end of the camel's tail has been broken off and is lost.

Given by C. D. E. Fortnum in October 1894. Not in his large and notebook catalogues, but listed among 'objects sent to new rooms of Ashmolean Museum October 1894' in a separate notebook without a number. Acquired before 1857 when recorded in his preliminary catalogue (p. 65). On the separate MS sheet of 'Memoranda of Prices paid' Fortnum noted 'Silver camel C. cento 1 scudi', converting the '1 scudi' (*sic*) as 4 shillings.

Fortnum described this as Italian cinquecento work. It is not dissimilar in character to No. 123 and was perhaps also made as a cabinet ornament. A date in the seventeenth century is as likely as one in the sixteenth.

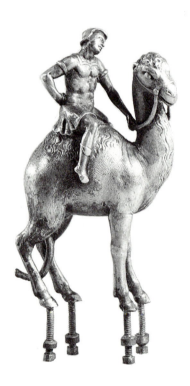

123. Warrior in Roman armour with a wolf beside him

6.5 cms. (height, excluding tang); 1.1 cms. (length of tang)

Bronze of a very high copper content, fire-gilt in the front, worn to expose a natural chocolate coloured patina in parts of the wolf, the proper right arm, and proper left hand; the ungilded bronze behind with the same patina. Partially hollow, lost-wax, cast. There are traces of solder behind the seat. There is a large hole behind the figure's waist, smaller ones below it and in the proper left shoulder. The integral irregular plate base was probably intended to continue below the proper right foot. A threaded tang extends from below the figure's left foot by which it was attached to a slab of *cipollino rosso* marble (which replaced one of red breccia) which has not been traced. These are traces of black painted letters along the back of the figure.

Lent by C. D. E. Fortnum on 7 January 1888 and given by him later in the same year. B. 417 in his catalogues. No provenance or date of acquisition are given in his catalogues, but it was presumably acquired after 1857 when the preliminary catalogue, in which it was not included, was compiled.

Fortnum catalogued this bronze as Italian of the sixteenth century and as a 'cleverly model'd ornament' for a 'Cabinet or some other piece of furniture' with which it is hard to disagree—although it might perhaps be seventeenth century in date. Fortnum wondered whether the wolf might indicate that the figure represented Romulus or might be an attribute of Rome. It is not, however, certain that it represents a wolf. The figure must originally have held or been designed to hold something in his right hand.

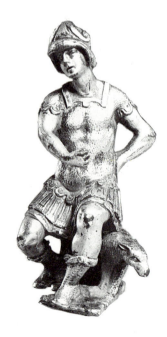

124 and 125. Pair of andiron ornaments in the form of nude putti riding rampant lions and holding shields

18.3 cms. (height of group with the shield held in the putto's right hand, from the lion's left foot); 17.7 cms. (height of group with the shield held in the putto's left hand, from the lion's left foot); 12.7 cms. (diameter of wooden socles)

Bronze with a black varnish. Hollow, probably lost-wax, cast. The surfaces have all been roughly chiselled. There are flaws in the group with the shield held in the putto's right hand and chaplet holes in both groups. The groups are fixed to turned wooden socles coloured to resemble bronze. On the undersides of the socles are fringed circular paper labels inscribed 'J. J. de Zoete' in ink.

Bought with the George Flood France Bequest Fund in 1935 from the dealers Cecil Leitch and Kerin. Entered in the Donations Book on 30 April together with Nos. 119 and 120.

As was noted in the *Annual Report* for 1935 (p. 25) the groups must have come from a pair of andirons—the heraldic character of the design and the arms held by the putti support this. The bases to which they are now attached must be replacements. There is another pair of very similar character

but with clubs held in place of shields in the Kunsthistorisches Museum in Vienna (reproduced L. Planiscig, *Venezianische Bildhauer der Renaissance* (Berlin, Vienna, 1921), 607). These groups were attributed to Nicolò Roccatagliata but this would have been on account of the anatomy and, still more, the faces of the putti which, however, are found generally in Venetian sculpture of the second half of the sixteenth century as is discussed in the entry for No. 82. The quality of the sculpture that can be documented as by Roccatagliata is superior in design and execution to these. It is unlikely that any of the three principal components in each group was originally designed for each other. The putti hold the shields as if they were supported below, which they are not. The two lions are essentially the same and the wax models were probably taken from the same mould and the heads then twisted into different directions. The two putti on the other hand are reversed in pose, but in neither case do they sit agreeably on their mount—the right leg of the putto with the shield in his left hand is in particularly unhappy relationship with the raised back right leg of the lion. The putti appear to grip the lions by their names but a piece of inconsequential drapery emerges above their hands. The groups are perhaps more likely to be the work of a third-rate Venetian founder improvising with spare moulds than pastiches devised by a forger.

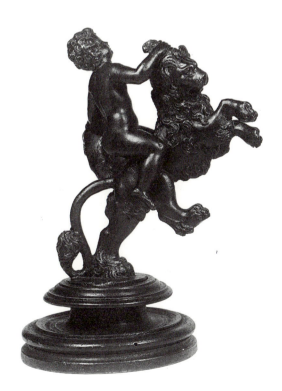

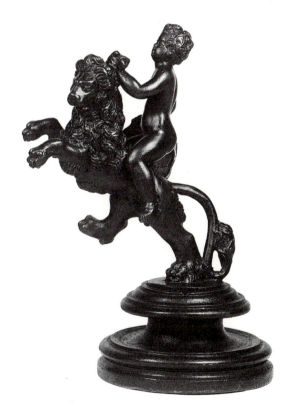

126. Dead Christ

25.7 cms. (height); 50.8 cms. (length of figure); 55 cms. (length of plinth); 19.5 cms. (width of plinth); 6.5 cms. (height of plinth)

Painted terracotta. The paint has darkened but the drapery is still red and some red may be discerned in the wounds. The flesh is now a dark olive brown but may be distinguished from the darker brown of the ground. The rear of the model is unpainted and is a pale beige colour. The paint has flaked in numerous small areas. The figure has been broken along the lower edge and part of the drapery and all the fingers of Christ's right hand are missing. The terracotta has been bolted to a plinth of rosewood with four separately carved feet. The bolts have not been unfastened but if the clay has been hollowed it must, to judge by the weight, be very thick walled.

Bequeathed by F. Hindley-Smith in 1939 (*Annual Report* (1940), 16). The sculpture seems always to have been displayed on a *cassone* in the Fortnum Gallery.

The sculpture, which was highly untypical of the collection from which it came (a collection consisting largely of Impressionist and Post-Impressionist works, for which see Preliminary Essay in Vol. II), was described on acquisition as 'School of Jacopo Sansovino'. It is indebted, in the build of the body, the facial type, and, above all, the half open hand, to the Christ in Michelangelo's *Pietà* (for which see No. 60). It may well be by a Florentine sculptor such as Sansovino who had studied Michelangelo deeply, but it is hard to date. The plinth with its simple spreading hollow sides and lack of mouldings must be early twentieth century and looks like French work. It is unusually well chosen for colour, polish, and proportions.

A sample was drilled from the rear of the terracotta in April 1987 by Mrs Doreen Stoneham of the Research Laboratory for Art and Archaeology but it proved to have been taken from a restoration and no dating by thermo-luminescence was possible (ref. 381-z-89).

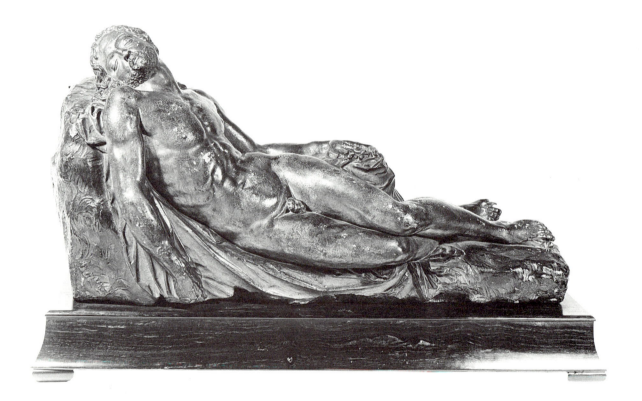

127 and 128. Pair of nude boy supporters from a cabinet

19.5 cms. (height of boy with right arm raised); 19.6 cms. (height of boy with left arm raised); 4.8 cms. (length of block supported by boy with right arm raised); 4.6 cms. (width of block supported by boy with right arm raised); 4.7 cms. (length and width of block upon which boy with right arm raised is standing); 4.6 cms. (length and width of block supported by boy with left arm raised); 4.8 cms. (length and width of block upon which boy with left arm raised in standing)

Ebony. Each figure including plinth, and block supported, is carved out of a single piece. In the case of the boy with right arm raised there is a small loss in the corner at the back of the plinth to proper right. In the other case a large piece of wood is missing at the same point. In both cases there are two holes in the upper surface of the supported block and three on the underside of the plinth including one which perforates the entire plinth between the feet of the boy.

'Stanmore' is written in pencil on the underside of the plinth supporting the boy with right arm raised. The hand resembles that of C. F. Bell.

Presumably in the bequest of C. D. E. Fortnum in 1899. The items are not included in his large or notebook catalogues and bear no mark but one has the name of Fortnum's house written on it and they correspond with an entry in his preliminary catalogue of 1857: 'Two boys in Ebony: part of a Cabinet? The hand raised to support the frieze or moulding above the head. Venetian work. Cinque cento. 8½″ with the provenance "Venice 1851"' (p. 70, nos. 1 and 2 of the section 'Carvings in Wood etc.').

It is curious that Fortnum, whose cataloguing was so scrupulous, should have omitted these items. The explanation may lie in his uncertainty whether to class them as miscellaneous sculpture or with furniture. They may well be Venetian of the sixteenth century as he supposed, or perhaps a little later in date: the character of the curled heads is certainly reminiscent of Venetian bronzes of that period (such as Nos. 124 and 125).

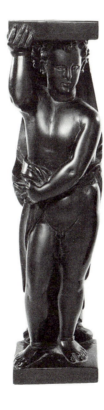
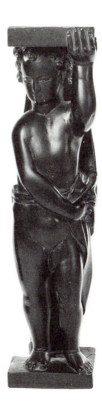

129. Pietà

39.5 cms. (height including integral plinth); 16.7 cms. (length of plinth); 14.4 cms. (width of plinth)

Terracotta of a pale pinky beige colour. Solid, but what might have been an aperture in the underside of the base is filled with plaster. The Virgin's left forearm has been broken off and lost, as have both legs of Christ just above the ankles, parts of Christ's left hand, part of His nose, and a portion of the Virgin's drapery behind Christ's left shoulder. Christ's right arm has been broken a little above the elbow and repaired. The Virgin's left arm has been broken and repaired, crudely with glue, at the elbow. There are breaks across the Virgin's back, through a large portion of the Virgin's drapery near the plinth, and through the plinth which have been cemented very obviously. There are numerous minor chips. The modelling has been blunted by the addition of a thick slip. In some areas the granular and bubbly character of this mixture can be clearly perceived. In others it appears to have been partially scraped off. The abraded face of Christ is given a certain coherence by this slip; but it makes the fingers of the Virgin's right hand almost indistinguishable from the cloth beneath.

Bought in 1961 from the Arcade Gallery (Paul Wengraf) of The Royal Arcade, 28 Old Bond Street, Lonon W1, for £315 (the price being reduced from £350 by 10 per cent). The invoice, dated 19 September, was passed for payment on the following day. The sculpture was registered on 15 October. Photographs taken in 1974 show it in a glass case in the Fox-Strangways Room. It has been in basement storage for at least a decade.

The sculpture was recorded by Ian Robertson in the *Annual Report* for 1961 (p. 64) as of the 'Venetian school . . . from the middle of the 16th century, emanating certainly from the circle of Jacopo Sansovino (1486–1570) with a strong imprint of the influence of Michelangelo. Instinct with an intensity of emotion, it displays a simple dignity and pathos unexpected in a work of so small a scale. Doubtless conceived to be carried out in life-size figures, it has not yet been possible to connect it with any known group of the subject.' It is certainly indebted to Michelangelo's *Pietà*. It does look like a sketch model, and an Italian work of the sixteenth or seventeenth century. It might be Venetian.

Notes in the Department's files and on an old label indicate that Robertson did later connect it with a large group: that in the lunette of the huge wall monument to Doge Francesco Venier (d. 1556) in S. Salvatore in Venice, completed in 1561, to designs by Sansovino. This particular part of the tomb was delegated by Sansovino to Alessandro Vittoria in 1557–8. The similarities are very slight and superficial. Vittoria's group has a bolder outline: the Virgin's left arm stretches out with a clear gesture and her knees form a solid base for the body of her Son, whereas the support in the terracotta is notably weak. The terracotta is also surely not a model for a relief.

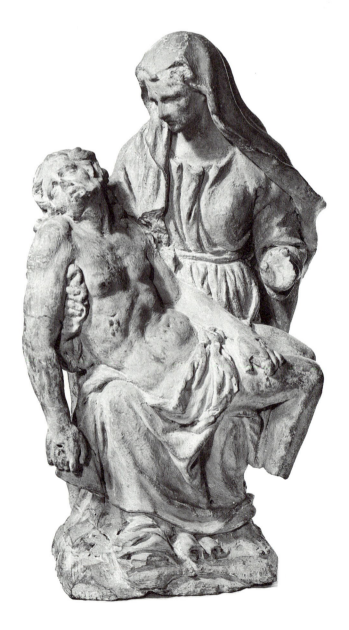

130. Lamentation

33.9 cms. (height including integral base); 27 cms. (length of integral base); 1 cm. (height of integral base in front)

Wood (lime ?) covered with gesso and paint. The paint has discoloured and flaked, as has the gesso in some parts. Some of the paint would seem not to be original, for instance the red on parts of the robe of Mary Magdalene is evidently applied on top of a blue. There are traces of gilding on the rim of the base, the hat of Joseph of Arimathea, and the implements he holds. The group appears to have been carved from a single piece of wood (although joins could easily be disguised by the gesso). There is severe damage from woodworm. The Virgin's raised left hand has been broken off and lost: the stump is riddled with worm channels. The top of the ladder has also been broken off and lost. One of the uprights was also clearly weakened in this manner. The group is carefully coloured behind but the composition is flattened as if to be set against a background. A slot in the back of the base at the centre may have been for a cross against which the group is likely to have been set.

Bought from Mary Bellis, Charnham Close, Hungerford, in 1964. Registered on 20 January 1964. Mary Bellis was chiefly a dealer in old oak furniture, but see Nos. 12 and 416.

Ian Robertson described this acquisition in the *Annual Report* for 1964 (p. 50) as 'North Italian in origin and somewhat provincial in character, it is nevertheless a dramatic and moving group, the form of which owes much to Michelangelo's rendering of the subject, in particular in the central figure of the Virgin supporting the body of Christ in her lap'. He dated it to the middle of the sixteenth century. It may well be later for third-rate devotional carvings are notoriously conservative in character.

131. Bust portrait in profile of a bearded ecclesiastic

32.6 cms. (height); 26 cms. (width)

Carrara marble, discoloured grey. The relief ground has been cut out so that there is no ground behind the crown of the head. Plaster adheres to parts of the back of the relief and a wedge of concrete has been attached to the lower portions of it so that it can stand up. There was originally an aperture in the underside of the bust presumably for fixing it.

Provenance unrecorded. Transferred from the basements of the Department of Antiquities in 1986.

The studied curls of the hair and beard and the smoothly rounded, clean outlined, inflated body suggest Baccio Bandinelli's relief style at its least animated taken to the point of parody. It is hard to imagine the setting from which this has been extracted, and it is not easy to imagine the setting for which it has been adapted.

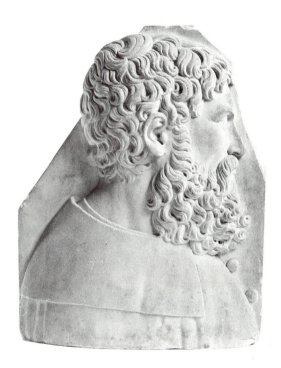

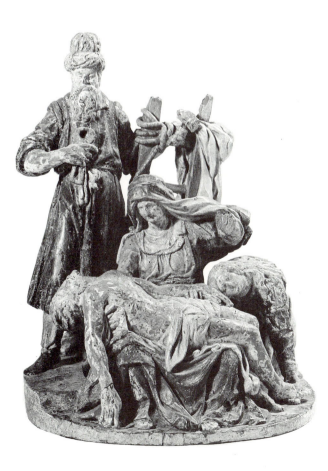

132. Youth attired as a Roman warrior

29.8 cms. (height, including integral plinth); 1.3 cms. (height of integral plinth at rear); 1.2 cms. (height of integral plinth at front); 6.9 cms. (length of plinth); 5.9 cms. (width of plinth)

Ivory. There is a yellow patch on the proper right knee, much yellow on the rear of the figure, and a grey patch, perhaps a stain, on the figure's chest. These are numerous thin vertical splits of various length (most densely on the face and the cloak as it passes over the upper chest), numerous cracks (in the figure's left hand and arm, and above his left knee especially), numerous breaks mended with more or less conspicuous adhesive (in the figure's right arm at the elbow and wrist, in the figure's right hand across fingers and baton, and across both shins), some insertions of ivory (in the neck to proper right and in the figure's left thigh and also of mastic filler in this thigh), numerous losses (the finger of the figure's left hand, a portion of the edge of the cloak above his right elbow, and much of the edge of the cloak behind), and numerous chips and scratches. Splits, cracks, joins, and scratches are accentuated by dirt. Most of the figure's right arm and the whole of his left arm have been separately carved and attached. The join in the latter case coincides with the edge of the breastplate. In the former the join is concealed by the cloak and reinforced with a peg visible in the cloak. The plinth is also carved from a different piece of ivory and pegs attaching the feet to it are visible on its underside. 'M.215' is painted in black to the left of the back face of the plinth. Vestiges of old labels, both printed and manuscript, remain on the underside of the plinth.

Bequeathed by J. Francis Mallett who died 7 January 1947. Received in the Museum during the last week of May 1947. No. 215 in the inventory of Mallett's bequest. Catalogued by Mallett as 'ex Magniac and Kennedy Collections. Christie 1933 Girdwood Collection'. Valued by Mallett at £58. Bought at Christie's, London, in 1933, according to Mallett. The vendor was a certain Girdwood. It was lot 387 in the sale at Christie's 18–22 March 1918 of the collection of S. E. Kennedy where it was bought by 'Webster' from £65 2s. The catalogue claimed that it came from the 'Magniac Collection', i.e. the great collection of *Objets d'art* sold in 1892 and in large part collected by 1861 when the best pieces were published in J. C. Robinson's *Notice of the Principal Works of Art in the Collection of Hollingworth Magniac*. But I have not traced it in the sale catalogues.

Mallett regarded this ivory as 'sixteenth or early seventeenth century' and noted that it was 'reputed to be Cosimo 1st Grand Duke of Tuscany'. A thin and crumpled piece of paper in the Department's files with a typewritten account of the sculpture may have come from Mallett's papers and been acquired by him together with the ivory itelf. Having quoted the Kennedy sale catalogue in which the statuette was catalogued as 'Italian sixteenth century', representing 'in all probability Cosimo I de Medici in Roman armour; about his lorica is the collar of the Golden Fleece', it continues to assert that 'the opinion of several well-known judges adds confirmation to the above probability. This is still further strength [*sic*] by reference to "Les Medailleurs de la Renaissance—Florence—deuxième partie" by Alois Heiss, in which there are two reproductions of portraits of Cosimo I. Each shows the curly hair and the determined mouth while the features bear a striking resemblance to those of the statuette.' It does not seem impossible that this is an idealized

portrait of Cosimo (1519–74, created duke in 1537 and grand duke in 1567) at about the age of 25 (in 1546) when he was made a Knight of the Golden Fleece by the Emperor Charles V. However, comparison with the portrait busts by Cellini and Bandinelli of 1545 and with the painting by Bronzino does not support this hypothesis since in both portraits he sports a slight beard. Some connection with the Medici is on the other hand suggested by comparison with the late sixteenth-century marble statues in the Sala del Cinquecento in Palazzo Vecchio, Florence—Vincenzo de' Rossi's *Alessandro de' Medici* for instance has very similar stylized curls and Caccini's *Grand Duke Francesco I* wears very similar armour.

An ivory figure of a crowned warrior with a thick beard, holding a sword in his right hand and pointing downwards with his left, wearing a more ornate cuirass but very similar buskins (lot 1,874 at the sale of Mentmore, Buckinghamshire, by Sotheby's, 23 May 1977), was also said to represent Cosimo (for no good reason). It looks, from photographs, as if it might be a work by the same artist. The similar size (30 cms.) and antique dress might even suggest that both belonged to a series, were it not for different bases (the Mentmore warrior treads on slugs and snails and snakes).

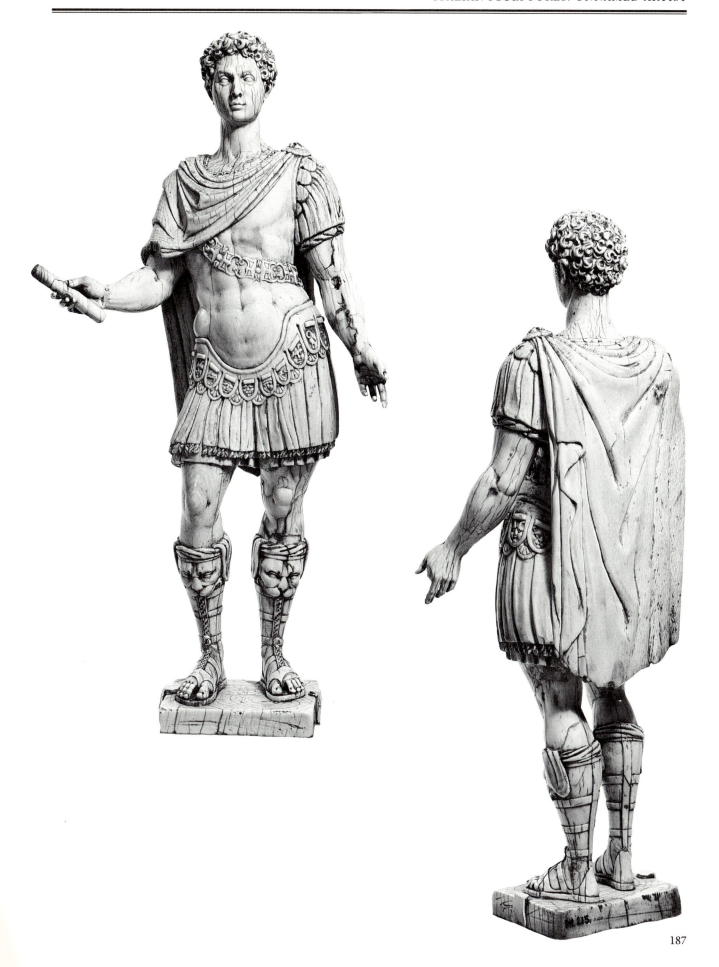

133. Five profile portrait busts in a carved frame

6.3 cms. (height of the male bust portrait placed top left—(*a*); 5.7 cms. (height of the female bust portrait placed top right—(*b*); 5.8 cms. (height of the male bust portrait placed lower left—(*c*); 5.6 cms. (height of the male bust portrait placed lower right—(*d*); 6.2 cms. (height of the central male bust portrait—(*e*); 28 cms. (outside height of frame); 29.5 cms. (outside width of frame)

Wax of various colours mounted on slate within a boxwood frame. Minute pearls, paste jewels, and a silver chain are applied to the wax. The representation of clothing has been aided by impressing fine fabric on to the wax to obtain convincing textures. There is some damage to the edges of the profile of the face of (*c*). There is a crack across the lower part of the face of (*d*). There is a crack across the neck of (*b*) where a discoloured adhesive is also apparent.

Lent by C. D. E. Fortnum in October 1894 and bequeathed by him in 1899. S. 30 in his catalogues. Stated in both catalogues to have been bought in Florence in 1864; the price of £5 is given only in the notebook catalogue.

Fortnum recorded that the waxes 'are stated to be portraits of members & connections of the Medici family'—presumably stated by the dealer from whom he bought them. The frame, which looks like mid-nineteenth-century work, has Medici lilies in the cartouches at the corners perhaps to reinforce this association. He regarded the portraits as Florentine of the late sixteenth or early seventeenth century. In his notebook catalogue he wrote 'They are probably the work of the Abbé Lumbo or Zumbo (a Sicilian) who worked for Cosimo III in the second half of the seventeenth century' but then corrected 'are probably the work of' to 'have been attributed to' adding the parenthetical observation 'these look earlier'. The dress does indeed suggest a date in the late sixteenth century. The man (*a*) wears the red cross of Malta. The younger man (*c*) wears the order of the Golden Fleece over black armour. The man (*e*) wears a cross 'fleury gules' on a collar set with rubies and emeralds. As Fortnum justly observes there is a 'certain family likeness' between all the portraits excepting (*e*). The latter is not only of a different size in the face but has paler flesh tones. Fortnum wondered whether (*a*) and (*b*) were brother and sister and (*d*) the father

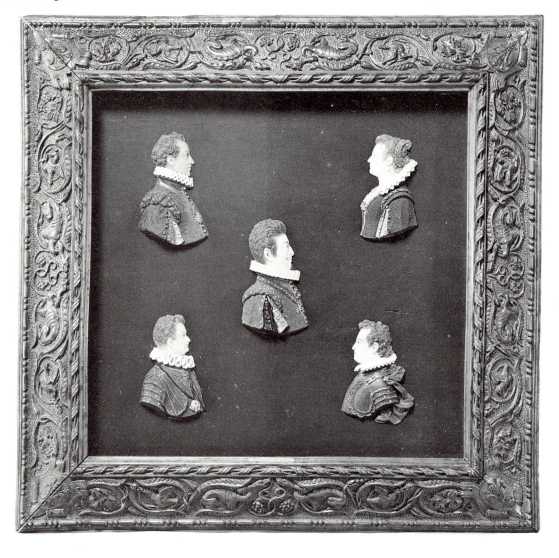

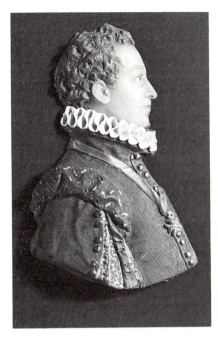

a

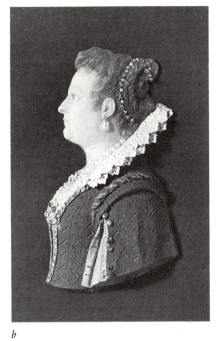

b

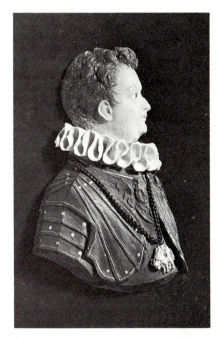

c

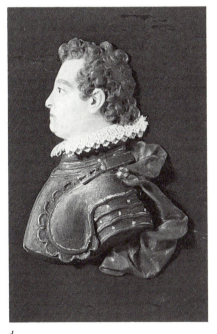

d

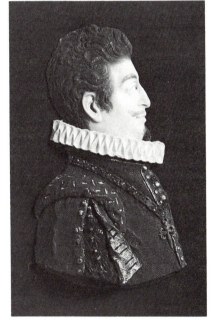

e

of (*c*). Alternatively (*a*) and (*b*) may be the parents of (*c*) and (*d*). Little is known of the artists responsible for work of this kind.

C. F. Bell in a pencil annotation of Fortnum's large catalogue observed of (*e*) that 'a replica' of it which 'was said to be in coloured stone (pietra commessa) and not wax and to represent a Spaniard—connected doubtless in some way with the Grand Ducal court—is in the Gabinetto delle Gemme in the Uffizi'.

The portraits are similar in minute workmanship to those of King Philip II of Spain and members of his family which survive in their original lockets in the Victoria and Albert Museum (A. 523, A. 524, A. 525, A. 526-1910) and have been attributed to Antonio Abondio (*c.*1538–91). The evidence for this attribution is set out in J. Pope-Hennessy, *Catalogue of Italian Sculpture in the Victoria and Albert Museum*, 3 vols. (London, 1964), ii. 556, nos. 594–8. It is admitted there that they differ in style from those wax portraits of the Emperor Maximilian II and his wife in the Münzkabinett at Munich (for which see Habich, 'Studien zu Antonio und Alessandro Abondio', *Monatsberichte über Kunstwissenschaft und Kunsthandel*, 1 (1900–1), 400–7, and Fiala, *Antonio Abondio, keroplastik a medajlér* (Prague, 1909), 46, nos. 82–3) but it is claimed that there is a close relationship with the wax profiles of an unknown lady and of Mary, wife of the Emperor Maximilian II, in the Ambrosiana, Milan, attributed to Abondio. But it is not at all clear that these two portraits in Milan are by the same hand, and the second of the two, which looks more likely to be by Abondio, has a fluttering diaphanous scarf which introduces a poetic element and linear interest unparalleled in the literal portraits in the Victoria and Albert Museum. (The two Milan waxes, together with one of the Emperor Maximilian II, are published by E. Kris, 'Di alcune opere inedite dell'Ambrosiana', *Dedalo*, 9 (1928–9), 390–6.) Comparison should also be made with the wax portraits of this period in the Staatliche Museen, Berlin-Dahlem, for instance 5466, of Joanna of Austria, attributed to Domenico Poggini, and 8275, considered to be Italian and *c.* 1600 (no. 52, pl. 49, in U. Schlegel, *Die italienischn Bildwerke des 17. und 18. Jahrhunderts* (Staatliche Museen, Berlin-Dahlem, 1978)).

134. Bust portrait of Christ

24 cms. (height including socle); 13.8 cms. (height of marble base); 12.8 cms. (diameter of base)

Bronze with a slightly leaden brown patina with slight traces of a darker varnish. Hollow, lost-wax, cast in two pieces: the bust separate from the socle. The surface has been minutely tooled (see below).

Bought out of the Blakiston Fund from Peel and Humphris Ltd. of 37 New Bond Street, London W1 for £195—the invoice is dated 1 December 1961, payment was authorized on 14 December, the bust was registered on 27 December.

On the invoice, made out by the dealer Cyril Humphris, this bust was attributed to Bastiano Torrigiani. Ian Robertson, describing the acquisition in the *Annual Report* for 1961 (pp. 62–3), wrote that

the clue to the probable authorship of this bust is supplied by the small portrait of Pope Clement XIII, recently exhibited at the Victoria and Albert Museum in London, the papal effigy being supported by an identical socle, in the form of the deferentially bowed head of a cherub, alike in design and execution to that supporting the present bust (Pope-Hennessy, Arts Council Exhibition of *Italian Bronze Statuettes*, 1961, Victoria and Albert Museum, No. 185).... The attribution of the papal bust to Torrigiani is due, on the evidence of two large papal busts by this artist in the Kaiser Friedrich Museum, in Berlin, to Bode (*Bildwerke des Kaiser Friedrich Museums, Die italienische Bildwerke der Renaissance und des Barock*, 1930, ii, p. 2, nos. 6 and 7, plates 5 and 6)

It is indeed true that the socle of the papal bust (in fact of Pope Gregory XIV and in the Rijksmuseum and not certainly by Torrigiani) is similar in design to that supporting the Ashmolean's bust of Christ, but that bust could hardly be more different in execution, being remarkably freely modelled in the wax and virtually unworked after casting, whereas every aspect of the Ashmolean's bronze is precisely tooled.

The socle may indeed be a clue as to the origin of the bust of Christ. A combination of scrolls, wings, and head are found also in some other sixteenth-century supports for busts, for instance that devised by Pompeo Leoni for his bust of King Philip II of Spain in the Prado. But the complex character of the scroll support behind the cherub in the Ashmolean's bust which is not found in the Leoni, nor in the Rijksmuseum bust, is unmistakably characteristic of Florence in the second half of the sixteenth or in the early decades of the seventeenth century—such an object might be found, little modified, in a female coiffure invented by Bronzino, or as a console designed by Buontalenti. The bronze holy water basins supported by cherubs and scrolls in the *cortile* of SS Annuziata in Florence which are dated 1615 are similar in conception. It may be questioned whether this socle was originally designed for the bust, or merely adapted to it, but in any case the impassive expression and high finish of the bust do correspond with the ideals of Florentine devotional art in the second half of the sixteenth century as they are familiar in painting. Of the busts of Christ in Berlin (neither of which is large as Robertson claimed) one is from the same model as

the Ashmolean's but has a cartouche, also of very Florentine character in place of the cherub.

Apart from Torrigiani, the only other sculptor that seems to have been seriously considered as the author of this bust is Antonio Abondio (1538–91), on the grounds of a similarity with his medallions of Christ (see U. Schlegel, 'Einige italienische Kleinbronzen der Renaissance', *Pantheon* (1966), 2: 391–6 and, for these and other medals of Christ, G. F. Hill, *The Medallic Portraits of Christ* (Oxford, 1920)). But Rudolf-Alexander Schülle is right to reject this connection as in any way conclusive (see his entry for the version of this bust in Berlin) in the catalogue of the exhibition *Prag um 1600* held in Prague in 1988 (593, no. 491).

Three other versions of the Ashmolean's bust are recorded: that in Berlin, already mentioned (Staatliche Museen, Berlin-Dahlem, 10/62); one formerly in the collection of Oscar Bondy in Vienna which was lot 76, Sotheby's, New York, 25 November 1986, and one in the Metropolitan Museum, New York (40.14.2a, in store). In all four versions there are minor differences in finish: the base mouldings of the socles are varied as is the chiselling of the beard and texturing of the garments. The finish on the Ashmolean's bust is most unusual: the tunic and cloak (punched in most of the other versions) are completely covered in finely cross-hatched engraved lines. These are also used for Christ's flesh, only on a more minute scale. In character these lines exactly resemble those used in highly finished copperplate prints from around 1600. I have never seen this finish on any other bronze of the sixteenth or seventeenth century although it is a distinctive characteristic of the bronzes produced by the firm of Elkington in Birmingham in the mid-nineteenth century (for instance the statuettes of Burke and Goldsmith after Foley) and is found, also on the bronze chiselled by A. Mertens after Christian Daniel Rauch's group of Emerentia Lorenz von Taugermunde in the Schinkel-Pavillion, Schloss Charlottenburg, Berlin. Elkington probably transferred the technique from silver and this may also have been the case with the bust of Christ centuries earlier.

There is another type of bust of Christ with which the versions under discussion have often been associated. These are similar in size but have more expression; they do not have the cherub support; Christ is turned to his right; the folds of his tunic are quite different; his beard is not parted; his hair is longer and less regular, some of the locks falling over his right shoulder being pierced; and there is a knob to attach a halo. One example of this type was lot 65 at Sotheby's, London, 20 April 1989, previously exhibited in *Sculpture from the David Daniels Collection* (Minneapolis Institute of Arts, 1979–80), 56–7, no. 18; others are in the Victoria and Albert Museum (A. 81-1951, gilt); the Staatliche Museen, Berlin-Dahlem (inv. no. 5033); and the collection of Sir Brinsley Ford, London (bought Christie's, London, 2 June 1964, lot 49). Of these the Daniels and Victoria and Albert versions seem to be aftercasts (as pointed out in the Daniels catalogue). That in Berlin is quite distinctive in modelling, being far less tooled: it also has a more slender socle of an unorthodox shape. There need be no connection between these busts and those of the type represented at Oxford

beyond the fact that some of them reflect a similar taste for
very precise and minute goldsmiths' finish. Schlegel (op. cit.)
associates both of them with a popular pair of miniature busts
of *Christ* and the *Virgin Mary* as well as with the medals of
Christ by Abondio.

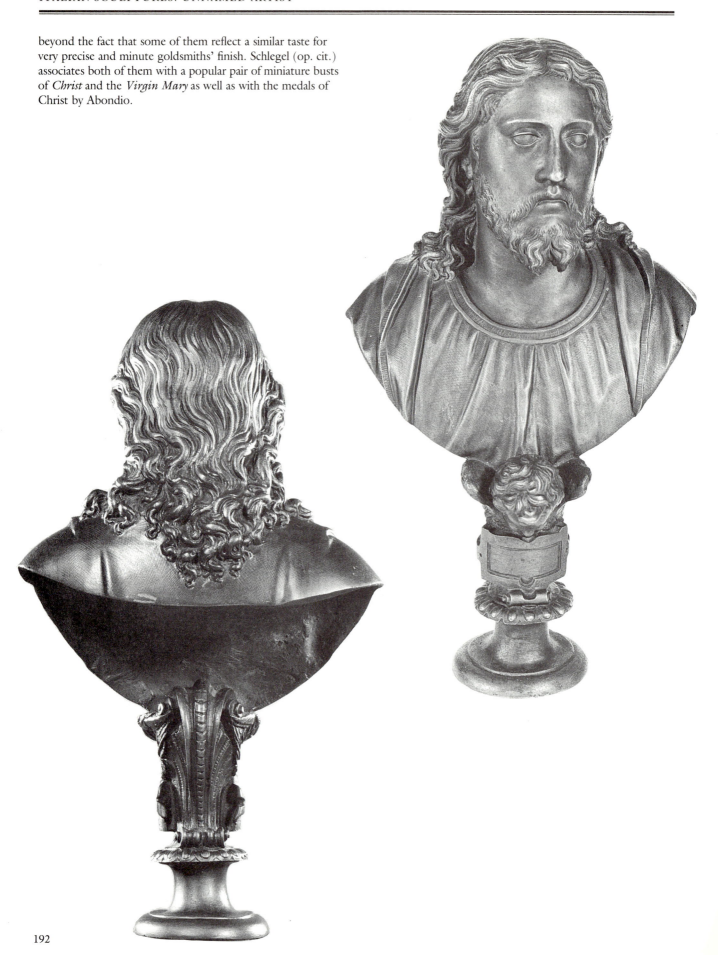

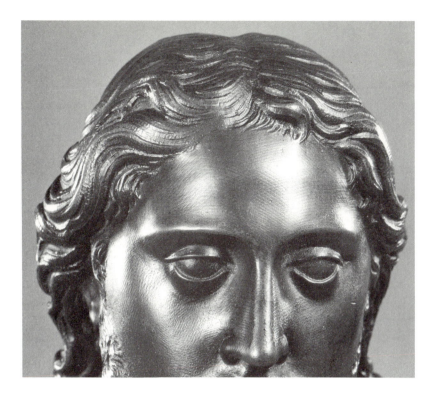

135. Belvedere Torso

22 cms. (height)

Terracotta of a pale orange beige colour. The model has been broken and reassembled. There are vertical joins to proper right of the abdomen and to proper left of the chest and there is a horizontal join to proper right of the upper abdomen. On the back the horizontal join continues to the proper left side where it meets a vertical break which passes through the whole figure. There are other lines which are cracks rather than breaks. Some of the chips missing along the lines of the breaks have been filled with orange wax. A chip has been lost from the shoulder to proper left. The torso has been broken away from what was perhaps a separately modelled base. A cavity between the legs has been filled with wax and mastic to fasten a large nail into place. The projecting point of this is used to secure the terracotta to a stepped plinth made of wood covered in green velvet.

Bought from the Arcade Gallery (Paul Wengraf), The Royal Arcade, 28 Old Bond Street, London W1, in January 1961 for £500. Registered on 31 January. Photographs in the Department's files of the sculpture which must have been supplied by the dealer were made by a Roman photographer (Boccardi of Via delle Carrozze), which indicates an Italian provenance.

The marble fragment of a heroic seated male figure, signed by Athenian sculptor, Apollonius, known in Rome (where it was probably excavated) in the fifteenth century, became one of the most famous sculptures in the world with its installation in the Belvedere Courtyard of the Vatican after which it was named. It has remained ever since one of the chief attractions of the Papal Museums. A full account of its history and reputation is given in F. Haskell and N. Penny, *Taste and the Antique* (London and New Haven, Conn., 1981), 311–14. This reduced copy in terracotta omits the disfiguring cavities and chips in the proper right thigh and chest and also the portion of a block, draped with the lion skin of Hercules and chiselled with the name of Apollonius, upon which the hero sits, although it is likely that this was originally included. At the neck, upper chest, shoulders, thighs, and penis the modeller has freely combed the clay instead of attempting to reproduce the rough surface of the fractured marble. The copy is of a quality which suggests that it must have been made from the original or from a cast, rather than from prints or drawings. That copies of this size existed by the 1530s is clear from the fact that one is included in a family portrait by Bernardino Licinio (Villa Borghese, Rome). Nevertheless such copies continued to be valued and must have multiplied in subsequent centuries and we cannot agree with Parker that 'it is probable' that this copy 'was executed soon after the setting up of the marble in the Belvedere Gardens, that is to say in the second quarter of the 16th century, by an artist of the Roman School of Michelangelo (1475–1564)'.

Samples of the *Torso* have been taken by Mrs Doreen Stoneham of the Oxford Research Laboratory for Archaeology and the History of Art on two occasions, in 1973 and in March 1987. Thermo-luminiscence tests suggested a firing date between 1428 and 1698 on the first occasion (ref. 81-m-64) and between 1467 and 1647 on the second (ref. 381-z-87).

136. Aesculapius

13 cms. (height including integral plinth); 3 cms. (height of base);
5.1 cms. (length of base); 3.9 cms. (width of base)

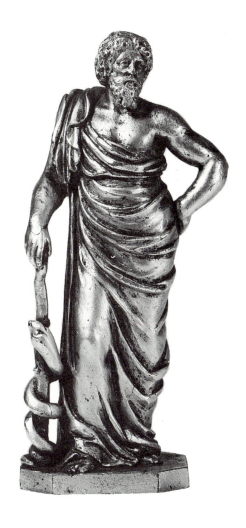

Bronze, fire-gilt, with some patches tarnished black, also worn in a
few areas to reveal a natural coppery chocolate patina. Hollow, lost-
wax, cast. There are firing cracks in the god's right arm and in one
of the coils of the snake. 'B. 425. **Œ**' is painted in black on the
black face of the plinth. Mounted on a block of antique serpentine.

Lent by C. D. E. Fortnum on 19 August 1887 and given by him in
1888. B. 425 in his notebook catalogue. Bought in Florence in
1867 for '20 francs' according to that catalogue. The bronze altar
pedestal upon which it was placed when in Fortnum's collection—
B. 425A in his notebook catalogue, B. 712 in his large catalogue—
was removed before it was lent in 1887.

Fortnum regarded this bronze as Italian of the sixteenth
century and 'an imitation of the antique', 'derived if not
copied from an antique statue'. It is surely possible that it is
later in date and in any case the rather poor (perhaps aftercast)
Paduan pedestal in the form of an altar and probably dating
from the early sixteenth century (similar to that supporting a
little *Apollo*, B. 414 in Fortnum's collection) now looks quite
inappropriate. This pedestal was cleaned of its green paint by
Bell in 1902 and probably had its *rosso antico* slabs on top
and below removed later in this century when a small bronze
Silenus, perhaps from the Bodleian Library, was fixed to it
instead. I have found no exact ancient prototype for the
figure.

137. Pair of winged putti bridling a lion

23.1 cms. (height) 30 cms. (length)

Carrara marble, discoloured grey. There are a couple of fresh scratches on the cheeks of the prominent putto. There are a few old chips missing from the uppermost edge of the relief slab. The shape of the slab is unlikely to be original: the angles at which the corners are cut off are not equal. A less discoloured rectangular patch in front of the chest of the lion indicates the position of a relatively recent paper label.

Provenance unrecorded. Transferred from the basements of the Department of Antiquities in 1986.

The sculpture looks like one of a series of playful variations on a family emblem such as might adorn the frieze of an Italian villa or palace, possibly of the sixteenth, but more probably of the seventeenth, century.

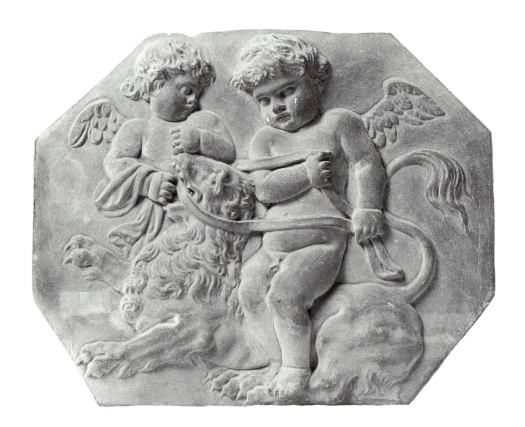

138. Head of the Pseudo-Seneca

40.5 cms. (height); 3 cms. (height of base at the front)

Grey, slightly peppery, marble. The surface is severely weathered and battered. Large chips are missing from the hair on the front of the crown, the end of the nose, and the back of the neck. The top of the chest is cut in a manner which suggests that insertion into a separate marble bust of drapery was intended. Drill holes are apparent in the corners of the eyes and in the hair beside the ears. The head has been mounted on a small shaped beech base.

Provenance unrecorded. Perhaps given to Oxford University by the dowager countess of Pomfret (see No. 517) in 1755. If so, then the head is probably from the collection assembled by Thomas Howard, earl of Arundel, in the early seventeenth century which was bought by the countess's father-in-law Sir William Fermor (later Lord Lempster) from the 6th duke of Norfolk in 1691 and kept at Easton Neston, Northamptonshire. In Oxford the Pomfret Collection was displayed in the sculpture gallery of the Old Schools until its transfer to the University Galleries, but there is no certain reference to this head in any of the nineteenth-century *Handbook Guides*, although it could be one of several items simply identified

as 'a head' which were to be seen in the Crypt or Sub-Gallery. It was not noticed by Michaelis on his, admittedly hurried, visit in the late 1870s to compile his *Ancient Marbles in Great Britain* (Cambridge, 1882). It was discovered in store and placed on display in the Randolph Gallery by Michael Vickers in the mid-1970s.

The head is a copy of a famous antique portrait type which, it was proposed by Fulvio Orsini in a publication of 1598, represented the stoic philosopher Seneca. (For an account of the type see F. Haskell and N. Penny, *Taste and the Antique* (London and New Haven, Conn., 1981), 52.) It has been remarked by Michael Vickers that the version of the portrait of Seneca which presides over Rubens's famous group portrait (now in the Uffizi, Florence) of four philosophers is more similar to this than to any other surviving replica (although there are differences; most obviously the upper chest is cut off more squarely in the Ashmolean version). He has pointed out that Rubens's own version of this portrait may well have been acquired by the duke of Buckingham together with much of his collection and if so might have been acquired from Buckingham by Arundel (as is known to have happened in other cases).

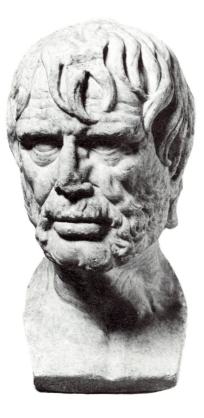
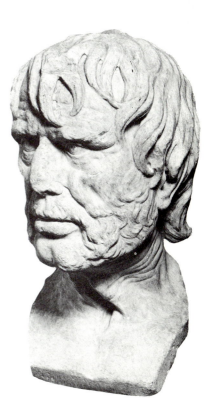

139 and 140. Pair of supports involving heraldic animal heads

59 cms. (height of Nos. 139 and 140); 103 cms. (length of 139); 25 cms. (width of 139); 102.8 cms. (length of 140); 26.5 cms. (width of 140).

White marble with a coarse crystalline structure (probably Greek, perhaps excavated in Rome), severely weathered and with black stains below the mouths of the talbots and lions. Both pieces are rough hewn on the reverse. The undercut branch in the mouth of the horse has cracked to proper left and has broken off to proper right in 139 but survives in 140. There is a large chip from the lower corner to proper right of 140 and cracks across the brow of the talbot and the horse.

Given to Oxford University by the dowager countess of Pomfret (see No. 517) in 1755. They must have been made for Thomas Howard, 2nd earl of Arundel, since they are decorated with the heraldic animals proper to him—the horse, lion, and talbot (a breed of hound). They were acquired with a large portion of the Arundel marbles by the countess's father-in-law Sir William Fermor (later Lord Lempster) from the 6th duke of Norfolk in 1691 and were for a long time in the gardens at his seat of Easton Neston, Northamptonshire. By 1732 the marbles there had 'lately almost all' been taken within doors—but these items might well have been among the exceptions ('The Vertue Notebooks', *Walpole Society*, 24 (1935–6), 40). In Oxford the supports were kept in the Schools until their transfer to the University Galleries where they are recorded in the *Handbook Guide* of 1859 in the Crypt or Sub-Gallery, but visible to the public (19, nos. 68 and 69). For much of this century they were in store, but they were placed in the Randolph Gallery in the 1970s.

A list of works of art exported from Rome for Lord Arundel in 1626 includes (in addition to many paintings; 'una testa di metallo di Socrate di naturale moderna'; four cases of 'gessi moderni' of legs, torsoes, heads, busts; a draped portrait statue of Lord Arundel 9 *palmi* high; and many antique figures extensively restored) the following items: '2 piedi intagliati di commesso con l'arme del Sig Conte della Rondella con la sua tavola di 10 palmi lunga et 5 larga di commesso di varie sorte di alabastri et di mischio moderni'—that is two carved supports ('piedi') inlaid with the arms of the earl of Arundel with their table top, 10 *palmi* long and 5 wide, inlaid with varied alabasters and modern figured marbles of a smoky pattern (F. Gori, *Archivio storico artistico archeologico letterario romano* (1880), fasc. 11, pp. 74–91). The identification of Rondella as Arundel, and the significance of this reference, were first pointed out by Jacob Hess ('Lord Arundel in Rom und sein Auftrag an den Bildhauer Egidio Moretti', *English Miscellany*, 1 (1950), 213). These supports are carved with Arundel heraldry and would carry a slab of the size mentioned although one would certainly expect to find a plinth beneath them. Nevertheless the document does specify that the supports included marble inlay which these do not. A recent book on Arundel interprets 'Sua tavola', which must in context mean 'their table top', as 'his picture' and 'commesso' as 'mosaic', and supposes that Arundel had commissioned a mosaic portrait of himself 9 feet high

(D. Howarth, *Lord Arundel and his Circle* (New Haven, and London, 1985), 56–7).

The nature of the marble used for these supports suggests that they were made in Rome, carved out of 'marmo di scavo'. The carving is coarse with a very obvious use of a large drill. The back of each support is so rough that one wonders whether they were intended to be incorporated in a wall. The *Handbook Guide* to the University Galleries described them as the fronts of capitals for pilasters and as ancient work. Michaelis, surprisingly, did not question this (*Ancient Marbles in Great Britain* (Cambridge, 1882), 571, nos. 123 and 124).

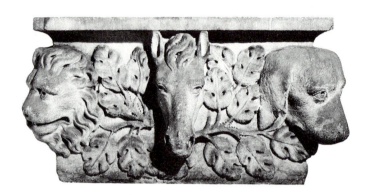

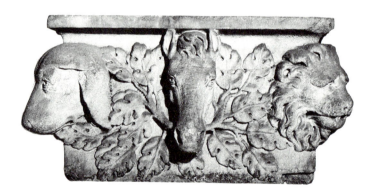

141. Head of a Niobid

40.5 cms. (height); 16 cms. (height of plinth)

White marble, probably Carrara. The surface is slightly worn. There is a vertical crack in the chest to proper left. A chip is also missing from the boy's left ear and from the nose. The head is mounted on a plain stone plinth with no mouldings but a bold chamfer. This has been painted black. The marble was cleaned by Kathleen Kimber using the steam process in 1989.

Given to Oxford University by the dowager countess of Pomfret (see No. 517) in 1755. The head is probably from the collection assembled by Thomas Howard, 2nd earl of Arundel, in the early seventeenth century which was bought by the countess's father-in-law Sir William Fermor (later Lord Lempster) from the 6th duke of Norfolk in 1691 and kept at Easton Neston, Northamptonshire. In Oxford the Pomfret collection was displayed in the sculpture gallery of the Old Schools until its transfer to the University Galleries where this head was recorded in the *Handbook Guide* of 1889 in the Crypt or Sub-Gallery but visible to the public (19, no. 54). Early in this century (perhaps late in the last) it was consigned to store. It was placed again on display, this time in the Randolph Gallery, by Michael Vickers in 1980 (*Annual Report* (1979–80), 12).

The head was engraved in Richard Chandler's *Marmora Oxoniensia* in 1763 (no. 55) with no indication that it was not a genuine antique, but Michaelis (*Ancient Marbles in Great Britain* (Cambridge, 1882), 557, no. 63) observed that 'to me the head appears modern' and the view that it is a copy has prevailed ever since. The figure from whose head it is copied is the son of Niobe with his left knee raised in the group of Niobe and her children, now in the Uffizi but in Arundel's day (and indeed still in Lord Pomfret's) in the Villa Medici in Rome. The group was discovered early in 1583, restored by 1588, and erected in the garden of the Villa (F. Haskell and N. Penny, *Taste and the Antique* (London and New Haven, Conn., 1981), 274–8). How Arundel came to acquire such a work (if indeed he did do so) is unknown: modern marble copies were not, it seems, characteristic of his collection. The fact that he owned a version of the head of Niobe herself (considered by some to be the finest version extant, but thought by Michaelis to be perhaps modern— op. cit. 557, no. 62) may well be pertinent. He may not of course have acquired the head as a modern copy (there is, after all, no evidence of anyone suspecting its status before Michaelis). If he did acquire it as a copy then it may well be relevant that he was involved in making diplomatic exchanges of works of art in 1620 with the grand duke of Tuscany, as Michael Vickers has pointed out, for the grand duke's permission would probably have been required for such a copy to be made.

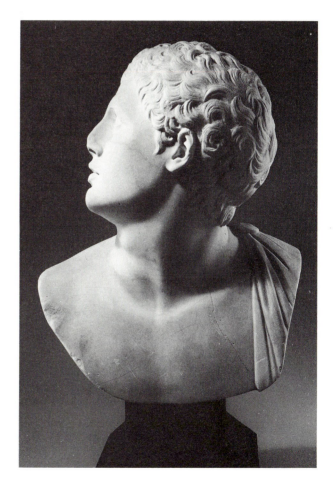

142. Pope enthroned, extending his hand in benediction

24.1 cms. (height)

Terracotta with a grey and brown colour partially achieved by soot or a similar substance worked into the surface of the clay before firing. The interior of the model reveals a clay of a beige colour. (When a sample was drilled in 1986 the clay was found to be unusually soft and pale.) The model has been hollowed out from below to about 6 cms. The pope's right hand has been broken at the wrist and reattached. The first two fingers of the same hand have been broken off and are missing. The handling is very rough and exhibits fingerprints in many places.

Bought from Dr Alfred Scharf in 1952. Registered on 19 March. Said to come from the collection of Mrs C. K. Norman. A photograph dated 1966 shows it in a pedestal case in the Fox-Strangways Gallery. It has been in reserve for at least a decade.

Although entered in the Register as a sculpture by a 'follower of G. L. Bernini' this was followed by the name of Algardi with a question mark and by the time Parker compiled the *Annual Report* for 1952 (p. 51) he had decided that the sculpture was a *bozzetto* by Algardi for his great bronze statue of Pope Innocent X commissioned in 1645 and completed in 1649 for the Palazzo dei Conservatori in Rome (for this sculpture see J. Montagu, *Alessandro Algardi*, 2 vols. (New Haven, Conn., and London, 1985), ii. 428, no. 152). He associated it with the terracotta (40 cms. high) in the Kunsthistorisches Museum, Vienna (ibid. ii. 429, no. 152.B.1), and found in it 'great dramatic force and masterly execution'.

The terracotta in Vienna is of very different character. The Ashmolean's sketch should be connected with a sketch purporting to be a *bozzetto* for Bernini's statue of Pope Urban VIII advertised in *Apollo* for October 1967 by David Peel and Co. Ltd. of 2 Carlos Place, Mount Street, London W1, and there are other small sketchy versions of famous baroque sculptures, often with variations intended to suggest abandoned preliminary ideas, which are exciting to art historians. In the Ashmolean sketch, Jennifer Montagu justly observed, in a letter to Gerald Taylor of 27 January 1982, 'the modelling is dry and rather sketchy, whereas his [Algardi's] terracottas all have a marvellous fluidity'. She also pointed out that the sculptor of this work seems to have no real knowledge of Innocent's appearance, the bumps on his forehead and the unpointed beard, with which Algardi would have been very familiar. Samples were taken from the terracotta in August 1973 and October 1986 by Mrs Doreen Stoneham of the Oxford University Research Laboratory for Archaeology and the History of Art and thermo-luminescence dating indicated on both occasions that the piece was fired less than 150 years ago (ref. 81-m-66 and 381-y-30).

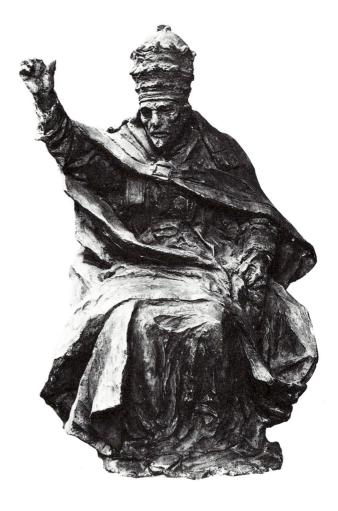

143. Hercules (or Samson) tearing open the jaws of a lion

19.2 cms. (height)

Bronze with a dark varnish, now black, worn on salient points—e.g. chest, nose, chin—to expose a coppery metal with a warm brown natural patina. Hollow, lost-wax, cast with very thin walls. Assembled from several separately cast pieces. There are firing cracks in the lion's back left leg. Much of the core remains and some chaplets are visible in the hero's left leg. A substance resembling core seems to have been poured into the body of the lion possibly to weight and consolidate the piece. The hero's right arm is separately cast and the join below the shoulder is clearly visible. The hero's left hand is cast together with the lion's jaw—the join at the wrist is clearly visible. The hero's left leg is separately cast—the drapery is intended to conceal the join but does not quite succeed in doing so. Solder reinforcing this join has recently cracked and the leg is loose. The remainder of the hero's body is cast in one piece and attached to the back of the lion—a smeared line of solder is just visible beside the lower leg. The bronze is extensively tooled, most obviously on the lion's fell.

Given by Mrs Gutekunst in memory of her husband the art dealer Otto Gutekunst, 1953. Registered on 15 July. The bronze had been bought in at Christie's, London, 25 June 1953, where it was lot 15. An old photograph (by Henry Dixon and Son of Albany Street) showing the bronze when it was in Otto Gutekunst's collection reveals that it was placed on a block of dark marble with sparse white veins (perhaps russet Tuscan marble) with an approximate rectangular base of bronze or bronzed plaster given the texture of rough soil below the group. The group is now mounted on a walnut base adapted from that designed by Michelangelo for the *Marcus Aurelius*.

This bronze group is generally supposed to represent Hercules in combat with the Nemean Lion, but it possibly represents Samson in the lion's den. The group is known in many versions. It is generally catalogued as an inkstand but some versions include a tongue in the lion's mouth, and, even in those that do not (such as this example), it is hard to imagine the nature of the vessel which would fit securely or snugly between the animal's jaws. Moreover a secure platform was an obvious precondition for an inkstand and yet few of these groups seem to retain their original base.

The group was considered to date from the late fifteenth century and has been associated with the *Hercules and the Nemean Lion* painted by Antonio del Pollaiuolo in Palazzo Medici by Planiscig, Hackenbroch, Ettlinger, and others, but, as Anthony Radcliffe has pointed out ('Two Bronzes from the Circle of Bernini', *Apollo* (Dec. 1978), 420), Vasari's description of that celebrated lost work strongly suggests that the combat was conceived of by Pollaiuolo as face to face. It is, however, easy to see why the group has been associated with the strenuous and expressive tendencies in late fifteenth- and early sixteenth-century Italian art to which Pollaiuolo contributed so much. The desperate grimace of the hero may be compared with the face of Riccio's *Shouting Horseman* (Victoria and Albert Museum) or of his penitential *St Jerome* (Staatliche Museen, Berlin-Dahlem) or of the Paduan candlestand with a screaming Triton bitten by a serpent

(Musée du Louvre, OA. 6942; Staatliche Museen, Berlin-Dahlem, 39/107).

Radcliffe's claim that the group has a distinctively seventeenth-century character is not entirely convincing, although it certainly could have been invented at that date. From the similarities between the version of the group in the Cottonian Collection, Plymouth City Art Gallery, and the lion supporters of a base for a miniature bust of Paolo Giordano II Orsini, duke of Bracciano, in the same collection, which is inscribed as cast by Bernardino Danese of Rome in 1675, Radcliffe proposed that the former group might have been cast by Danese from his own model (ibid. 418–23). (Danese is known to have been active casting sculptural elements for Bernini's Capella del Sacramento in St Peter's between 1673 and 1675). The similarities with the base of the Orsini bust do not seem sufficiently strong to support the first part of this hypothesis and no evidence of Danese's ability as a modeller has been found. In style, technique, and finish the bronze statuette of *St Sebastian* (No. 144) also given to the Museum by Mrs Gutekunst provides a striking comparison but little help with dating.

The earliest probable reference to the bronze known to me is that in the posthumous inventory of the collection of André Le Nôtre, which includes a pair of bronzes of 'Herculles quy égorge le lion' valued at 60 livres and a smaller bronze of the same subject valued at 40 livres (J. Guiffrey, 'Testament et inventaire après décès de André Le Nostre et autres documents le concernant', *Bulletin de la Société de l'Histoire de l'Art Français* (1911), 258, nos. 367 and 368). The only version of the group which is known to have an old provenance is that in Plymouth (Radcliffe, op. cit., fig. 5), which was purchased at Christie's, London, on 28 January 1772 at the sale of the Machese Leonori of Pesaro, lot 31 (as by Algardi). No scholar has ever considered the group as originating outside Italy (although it should be pointed out that many of Le Nôtre's bronzes are thought to have been of French origin).

The Ashmolean's group may be associated with the versions in the collection of William Newall (sold Christie's, London, 27 June 1922, lot 73, illustrated), Plymouth (Radcliffe, op. cit., fig. 5), the Victoria and Albert Museum (5543-1859, ibid. fig. 7), the Museum of Fine Arts, Houston (44-591), the Wernher Collection, Luton Hoo (480), the Metropolitan Museum, New York (1982-60-107, published by J. D. Draper in *The Jack and Belle Linsky Collection* (New York, 1984), no. 74), the Untermyer Collection (briefly in the Metropolitan Museum, New York, published by Y. Hackenbroch, *Bronzes, Other Metalwork and Sculpture in the Irwin Untermyer Collection* (London, 1962), p. xxiv, fig. 47), the Lisbon Museum of Ancient Art (reproduced when in the Gulbenkian Collection in *Connoisseur* (May 1956), 230, fig. 1), and the City Art Gallery, Manchester (1982-136). These vary greatly in condition and finish. There are traces of gilding only in the Houston version. Most have traces of dark varnish. All seem to be composite casts but to have been assembled with varying skill and in slightly different ways—the right foot of the hero in the rather poor version in Manchester for example is half way down the side of the lion rather than resting on

its back. The Plymouth and Victoria and Albert Museum bronzes have textured fell and loin-cloth, whereas in the Ashmolean and Metropolitan Museum versions the fell alone is textured. The lions' tails are differently fitted and have sometimes been detached. The versions in the Metropolitan Museum, Manchester, Luton Hoo, and the Victoria and Albert Museum all have tongues. The eyeballs are marked with unusual distinctness in the Ashmolean bronze.

There are also versions of the group which appear to have been made from different models which are relatively unenergetic in both pose and expression. One such is in the Victoria and Albert Museum (A. 152-1910, reproduced in

W. Bode, *Italian Renaissance Bronze Statuettes of the Renaissance* (London, 1902), p. xxiv, no. 48) which is perhaps made from a modified aftercast. Another example was in the Untermyer Collection (Hackenbroch, op. cit., fig. 48, not to be confused with fig. 47 mentioned above but like it sold by the Metropolitan Museum), and looks more like an inept imitation, as does the group which was lot 123 at Christie's, London, December 1989.

In even the best casts, such as the Ashmolean's, the execution seems unworthy of the conception, and one must suspect that the original has been lost. Perhaps it was made of silver.

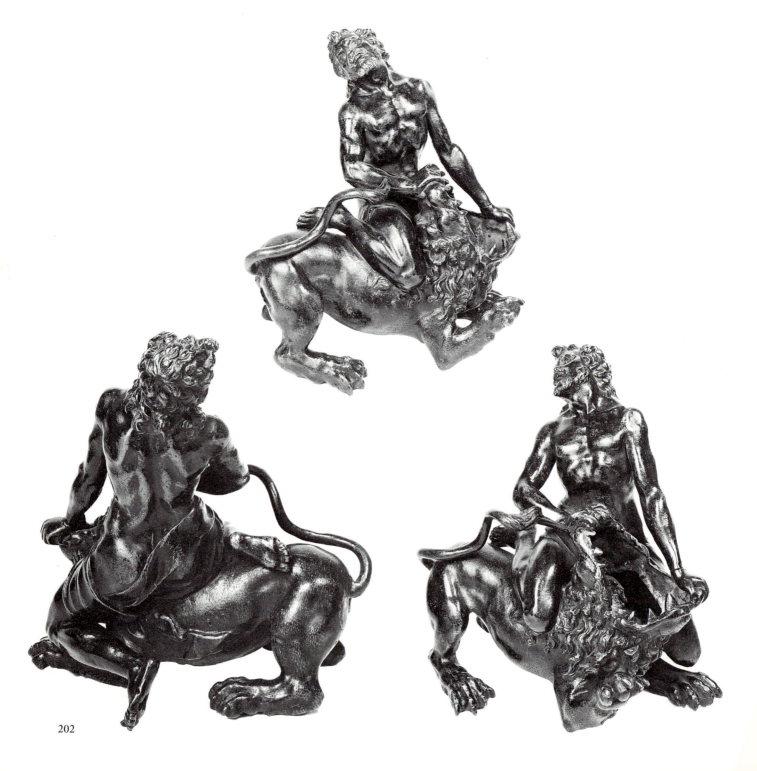

144. St Sebastian

26.5 cms. (height including integral base; 9.75 cms. (length of base; 10.3 cms. (width of base); 2.6 cms. (height of plinth); 11.5 cms. (length and width of plinth)

Bronze with a blackened varnish rubbed off in parts (especially the sides of the legs and the back of the saint's left arm) to expose the natural chestnut patina of a coppery alloy. Hollow, lost-wax, cast with thin walls. There are firing cracks at the base. The bronze is attached to a plinth of serpentine with a spinachy pattern.

Given by Mrs Gutekunst in 1953 in memory of her husband the dealer Otto Gutekunst. Registered on 15 July. The bronze had been bought in at Christie's, London, 25 June 1953, where it was lot 12 (together with its present base). The bronze was already in the Gutekunst Collection in 1912 when the bronze was published by W. Bode in *Italian Renaissance Bronze Statuettes* (1912), iii, pl. CCLVI.

Bode regarded this bronze as Italian, probably Venetian, of the early sixteenth century (op. cit. under provenance) as did Planiscig (*Piccoli bronzi italiani del Rinascimento* (Milan, 1930), pl. CXXXV, no. 236), and this opinion was echoed in the *Annual Report* (1953: 53), with the additional suggestion that it might possibly be a work of the Spanish school. Another example of the bronze was in the sale of the Henry Harris Collection, Sotheby's, London, 24 October 1950, lot 72. And one with a differently shaped base and retaining two arrows is in the Victoria and Albert Museum (Hildburgh Collection, A. 111-1956). James Draper in his annotated reprint of Bode observes of the Ashmolean bronze that it is of 'unknown facture, possibly 19th century'. In the character of the cast, its colour, and rough surface, combined with some tooling, and in the dynamic but ungainly torsion of the figure, with crudely modelled extremities, highly expressive uplifted head, roughly striated curls and beard, the bronze figure is very similar to the *Hercules* (or *Samson*) also from the Gutekunst Collection (No. 143). This contorted manner of depicting St Sebastian, reflecting the varied poses employed for the thieves crucifed beside Christ, seems to have become popular in the seventeenth century.

145. Ecce Homo

15.6 cms. (height including integral base); 3 cms. (height of plinth); 5.7 cms. (length and width of plinth)

Bronze, fire-gilt. The gilding is worn in some salient areas and scratched in others, exposing the natural chestnut patina of a coppery alloy. Hollow, lost-wax, cast. There is a large round hole in the drapery in the centre of the figure's back and smaller ones on the crown and in the back of the head (presumably for fixing a halo). There is also a smaller threaded hole beside the thumb and index finger of his right hand. The outside of the cloak and the loin-cloth have been textured with the same punch. There is a threaded tang soldered to the small integrally cast oval base. The tang is inserted into an ebonized wooden plinth. 'M. 171' is painted in black on the drapery behind the figure.

Bequeathed by John Francis Mallett who died 7 January 1947. Received in the Museum during the last week in May 1947. 171 in the inventory of his bequest.

The bronze was catalogued by Mallett as Italian of the sixteenth century, but it is more likely to date from the seventeenth century. It must have been part of a group presumably on a miniature altar.

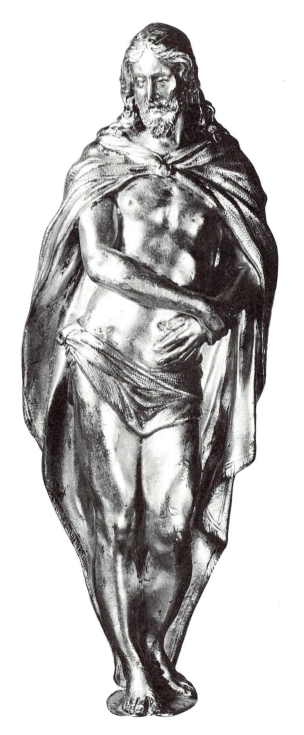

146. St Catherine of Alexandria

14.7 cms. (height)

Bronze with a natural tan patina. Hollow, very thin-walled, lost-wax, cast. No evidence of tooling. The surfaces are very rough and there is a firing crack through the wheel. Parts of the wheel may also be lost, although it was of course intended to be broken. An abrupt termination of the drapery above the figure's left hand may also be a loss caused by a firing crack. There are six square holes: by the saint's left knee, right breast, and right shin, in her back near her left shoulder, in the drapery behind her left shoulder, and behind her right knee. These must have been caused by chaplet pins and they may once have been filled, as a hole appears to have been filled on top of the figure's head, but plugs would easily be shaken out of a wall of bronze as thin as this. The integral plinth is filled with plaster of Paris as a weight. 'B. 428. Œ' is painted in white on the side of the plinth behind the figure.

Given by C. D. E. Fortnum on 20 March 1888. B. 428 in his catalogues. Bought in Florence in 1867, according to the large catalogue, from Gagliardi according to the earlier notebook catalogue, for £2.

Fortnum regarded this as a cast from a rough wax sketch by a seventeenth-century artist in Italy, perhaps 'Maderna or Fiamingo'. The roughness is not, in fact, much in excess of that often found in bronzes by Fanelli which, since they were repeated, are not likely to be attempts to preserve *bozzetti* (and indeed the whole idea of bronzes designed to perpetuate sketches in this manner is anachronistic—the practice was exceptional before the end of the last century). Anthony Radcliffe has suggested that this particular figure is by Fanelli and associates it with two other bronze saints he has seen, one belonging to an anonymous collector and the other in the collection of Sir Brinsley Ford. They might have formed part of a set on a cabinet or domestic altar. In any case Fortnum was surely right to suspect that this reflects some more monumental work by a major sculptor. The pose has a sweep combined with a daintiness and elegance which suggests a later date than the artists he had in mind.

The version in the Ford Collection is the same size (allowing for a slightly less high plinth). It differs from the Ashmolean's bronze in the tilting of the head and in the position of the right arm and absence of any attribute. The rough unchiselled character is the same and it even has holes (from the chaplet pins) in the same places. It was bought by Richard Ford at the sale of Sir Thomas Lawrence's collection.

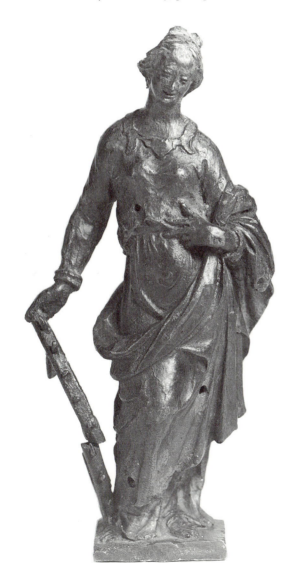

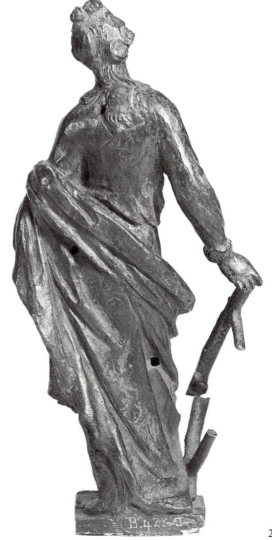

147. Nymph feeding a child from a horn

29.2 cms. (height); 24.3 cms. (width); 33.7 cms. (height of outside of frame); 28.4 cms. (width of outside of frame)

Terracotta of a pale beige colour. Much of the lower half of the moulding at the proper right edge has been broken off and replaced with plaster. An equivalent loss at the top edge has not been replaced. Some chips on the other edges have been patched with plaster but most have been left. The head of the serpent coiled around the tree trunk has been broken off and lost. A circular hole in the body of the serpent suggests that a repair was attempted. The right forearm of the infant satyr has been broken off and lost: only an iron wire remains from a plaster repair. His left forearm and his lower left leg (but not the foot) are old repairs in plaster. The heads of the standing goat, of the birds in the nest, and of the mother bird above them, also the drinking infant's left foot and a wing of the bird above the nymph's head, have been broken off and lost. The surface of the relief is mottled with mould and in a few parts the hard 'fire skin' of the terracotta has flaked off (this is most notable in the right forearm of the nymph). Framed in a dark oak moulding (probably original).

Presumably transferred during this century from the Department of Antiquities. The Benefactions Book of the Ashmolean Museum records that the relief was given by 'Harries' an 'Armiger' of Worcestershire in 1693: 'AD MDCXCIII. Ornatissimus Vir D. Harries de in agro wigorniensi armiger, donavit elegantissimam *Tabellam Plasticam*, in quà felici manu exhibetur JOVIS Historia in Cretâ insula enutriti Amalthaea scilicet nutrix sub elata quadam arbore, in eremo conspicitur; lacte repletum Cornu Copiae ad os infantuli admovens: huis Caprae abstantes cum Satyro, et canem in altà rupe eriscerans aquila. Quin et in summâ arbore, pulli aquilini in nido delitescunt, quibus serpens arborem ascendens, exitium denunciat.' The subject-matter and provenance had been forgotten and the medium mistaken by 1836 when it appears in *A Catalogue of the Ashmolean Museum Descriptive of the Zoological Specimens ...* as 'A Cast in plaister, representing a female figure holding a cornucopiae from which a child is drinking, &c.' (146, no. 493).

This relief is a copy after an antique Roman marble relief. That such terracotta copies were made in Rome in the seventeenth century is amply documented in the notebooks of Nicholas Stone the Younger (W. L. Spiers (ed.), 'Diary and Notebooks made in Italy', *Walpole Society*, (1918–19), 193–200), but no other examples certainly dating from that period are known to me in British collections. The copy is not entirely accurate. Above all, in the marble original (for which, see below) the rocks form an arch behind the infant satyr, presumably indicating the entrance of a cave. The composition has been somewhat compressed to fit into a neat rectangle. Other differences are due to ignorant restoration (e.g. the child satyr held a horn in his left hand).

The marble original was said to have been discovered in the digging of the foundations of Palazzo Giustiniani and was first published by Pietro Santi Bartoli in his *Admiranda Romanorum antiquitatum* in the 1670s with a note by Bellori identifying the subject and reflecting that the birds were an embellishment added by the sculptor. Bernard de Montfaucon in his *Antiquité expliquée* (I. i (Paris, 1963), 32–3, pl. VII) gave it priority as an ancient representation of the earliest years of the first of the gods. The eagle (eating a hare on the rocks above the satyr) was the bird of Jupiter and confirmed the subject, but he was puzzled by the other birds defending their young against the serpent and echoed Bellori in suggesting that they 'paroissent n'être là que pour l'ornement'. From the Giustiniani Collection the relief passed into that of Lucien Bonaparte before being acquired by Pope Pius VII for the Papal Collections. It was placed in the Appartamenti Borgia of the Vatican Palace before being moved to the Lateran Museum where it was catalogued in 1863 as the 'so-called Amalthea relief' in deference to the scepticism expressed by a relay of scholars over the previous half-century (O. Benndorf and R. Schöne, *Die antiken Bildwerke des Lateranensischen Museums* (Leipzig, 1867), 16–18, no. 24).

The identity of the donor, Harries, a gentleman who had presumably been on the Grand Tour, remains a mystery.

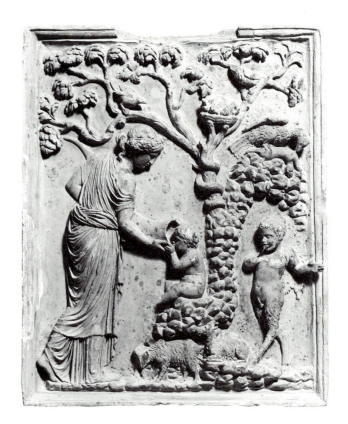

148. Ornamental crucifix

44.5 cms. (height); 24.5 cms. (width); 9 cms. (height of Corpus);
7.4 cms. (width of Corpus)

The Corpus is carved out of coral. The proper right leg and both
arms are made from separate pieces. The proper right foot is
restored. The back of the Cross consists of a plain sheet of brass.
Upon this is a brass sheet perforated and set with quatrefoil flower-
heads, radial petals, and smaller, tear-shaped pellets, all of coral. The
cresting along the edges of the Cross consists of short lengths of
brass each decorated with white enamel: the foliate scrolls at the
extremity of each arm of the Cross are also of brass with white
enamel ornament.

Bequeathed by Mary Irene Curzon, 2nd Baroness Ravensdale of
9 The Vale, Chelsea (1896–1966), in memory of her father, the
first Marquess Curzon, Chancellor of the University of Oxford
1907–25. Registered 2 June 1966. The bequest of Lady Ravensdale
consisted of 115 items, mostly pectoral crosses. This is unlike any
other item in her collection. In her autobiography (*In Many
Rhythms* (London, 1953), 122) she wrote of how a 'vile Russian
Customs Official' broke the 'coral feet of the Christ on the Crucifix
I had bought in Leningrad'.

The crucifix was originally displayed in the Museum as 'early
seventeenth-century Spanish'. Work in coral of this character
was made in Sicily, especially at Trapani, in the seventeenth
and eighteenth centuries. The Arte dei corallari, the guild of
coral workers, was established there in 1628. The skilled
workers were dispersed to other Mediterranean centres after
the repression of the insurrection in Trapani in 1672. Similar
devotional pieces with clumsy miniature sculptures and
densely but undynamically patterned with tiny pieces of coral
and enamel are not uncommon on the art market—see, for
instance, lot 195, 12 December 1985; lot 67, 3 July 1986;
lot 491, 8 December 1988; lot 256, 20 April 1989, at
Sotheby's, London. There are three pieces of this work
displayed in the Victoria and Albert Museum (M. 157,
M. 159 and M. 218-1956). A number of such pieces, secular
as well as devotional, were included in the exhibition *Civiltà
del seicento a Napoli* (Museo di Capodimonte and Museo
Pignatelli, Naples, 1984–5), including a *piatto* and *vassoio*
from the Museo di San Martino, Naples, which has similar
arrangements of tear-shaped coral pellets and similar flower-
heads of coral and white enamel and, in the latter case, similar
scrolled cresting (nos. 5.33 and 5.39). The catalogue includes
a general discussion of such work by Gina Carla Ascione (ibid.
ii. 336–41), as does her book *Gloria del Corallo a Napoli dal
XVI al XIX secolo* (Naples, 1991).

149. Bust portrait of Plato

28.2 cms. (height including tablet); 2.6 cms. (height of tablet); 3.6 cms. (width of tablet)

Bronze with a deteriorated dull grey and green patina, due to damp storage. There are traces of a ruddy golden varnish most evident on the neck. Hollow, lost-wax, cast. The bronze has been extensively tooled. Hair, beard, eyebrows, and the blank eyeballs have been textured with a punch. Part of the integral tablet below the chest has been cracked off and lost. Some remains of solder suggested a botched attempt at mending this. The punched ground of the tablet has been partly chiselled away. On the remaining ground the edge of a 'T' and an 'O' remain from the name Plato originally chiselled there.

Presumably transferred from the Department of Antiquities. Adolf Michaelis, when cataloguing Oxford's ancient sculpture (*Ancient Marbles in Great Britain* (Cambridge, 1882), 592, no. 233) observed that this was a sculpture which he 'could not find' or had 'over-looked'. The basement was dark, the sculptures covered in dust and ill-arranged, and Michaelis was in a hurry, but it is possible that the bust was, at the date of his visit, in the Bodleian Library or some other location. Bequeathed to the University by Dr Richard Rawlinson; for whom see No. 151. The engraving in Chandler's *Marmora Oxoniensia* (Oxford, 1763), i, pl. XLV, no. C11) shows the tablet complete and the letters chiselled on it as PL . . O. The third and fourth letters appear as if deleted. There is a turned socle below this, but it does not look likely to have been an original one. The bust may well have been one of the 'Fine Brass Heads' included in the 'Collection of the Right Honourable Edward Earl of Oxford, Deceas'd' auctioned by Mr Cock, London, 8 March and following days 1741/2, from which Rawlinson is known to have acquired much.

Michaelis (op. cit.) correctly observed of this bust, which he knew only from the plate in Chandler's *Marmora Oxoniensia*, that it was 'apparently a copy of the Florentine bust' of Plato. This Florentine bust is a small marble portrait (35 cms. high) long believed to represent Plato. It is now in Palazzo Medici-Riccardi, Florence, but was formerly in the Sala delle Iscrizioni of the Uffizi. For a long time it was considered to be the bust of Plato from Athens which Girolamo Rossi of Pistoia is recorded as presenting to Lorenzo il Magnifico, but that bust passed to the University of Pisa and there is no record of it returning to the Grand Ducal Collections in the Uffizi (G. Bencivenni, già Pelli, *Saggio istorico della Real Galleria di Firenze*, i (Florence, 1779), 26; G. Mansuelli, *Galleria degli Uffizi: Le sculture*, ii (Florence, 1961), 21, no. 2). The first certain record of the little Florentine bust of Plato is in fact an illustration (generally numbered 27) in Pietro Santi Bartoli's *Admiranda Romanorum antiquitatum*, first published in Rome in the mid-1670s with notes by Bellori.

This bronze copy which seems originally to have had a patina typical of Florentine bronzes was no doubt made in Florence in the late seventeenth or early eighteenth century. The marble bust has a tablet below the chest, but rather broader than the one in this bronze copy. It is chiselled with the name of Plato in Greek letters but the antiquity of the inscription was challenged in the mid-nineteenth century and doubts as to the identity followed. Richter observes that no other ancient portrait of Plato gives him a tuft of beard below

the lower lip, symmetrical swags of flesh in the lower neck, and so little hair on the centre of his head (G. M. A. Richter, *The Portraits of the Greeks*, 3 vols. (London, 1965), i. 168). Because the restorations to the upper lip and nose of the Florentine bust have been removed the illustrations in Mansuelli (op. cit., fig. 3) and Richter (op. cit., fig. 966) are less valuable for comparison with the bronze than that in J. J. Bernouilli, *Griechische Ikonographie* (Munich, 1901), ii, fig. 2 and E. Q. Visconti, *Iconografie grecque* (Paris, 1808), i, pl. XVIII.

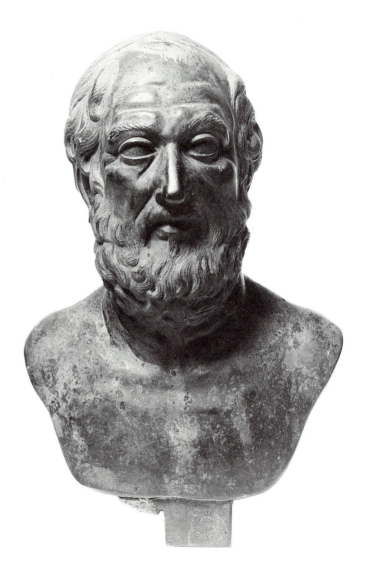

150. Profile bust portrait of Pope Innocent XIII

29.6 cms. (height); 18.3 cms. (width)

Carrara marble, discoloured by dirt. There are slight scratches on many parts of the surface and chips to the edges. 'Mavosi' is chiselled lightly below the chest (where it has been cut). Some of the letters, especially the third and fifth, are not clear.

No provenance is recorded.

The portrait has been described in the Department's records as of 'an ecclesiastic', but only a pope would be represented wearing the *mozzetta* (a short, hooded, buttoned cape) and cap. The porcine features, so exaggerated, or at least so unmodified, might suggest caricature were it not for the affable expression on the face. The dove hovering against a background of flames depicted in *rilievo schiacciato* on the stole does not, it seems, help to identify the sitter, but there can be little doubt that this is the amiable and fat Innocent XIII (Michelangelo de' Conti, b. 1655, elected 1721, d. 1724). Comparison may be made with the posthumous portrait of this pope by Claus in the Ashmolean (No. 23). No sculptor by the name of Mavosi has been recorded and the inscription may not be intended as a signature.

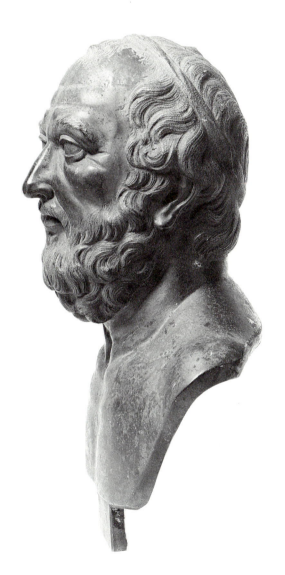

151. Profile head and shoulders of a laurel-crowned hero

28.7 cms. (height); 20.5 cms. (width)

White marble of uncertain type, now dark grey with dirt and scratched. The relief is partially abraded most noticeably in the areas of highest relief, possibly from exposure to the elements. The losses to top right and lower left are consistent with the injudicious prising of the relief from a wall into which it had been cemented. The edges may not however be original: that to proper right would not, if continued, contain the projecting portion of relief below it.

Transferred from the Department of Antiquities in 1986. The relief was moved to the basement of the University Galleries early in 1888 from the basement of the Old Ashmolean Museum. It had probably been kept during the eighteenth century in the Bodleian Library. In 1763 when published in Chandler's *Marmora Oxoniensia*, i, pl. XLIV, no. XCII, the relief was unbroken and framed with pilaster strips decorated with ribbon ornament and a substantial plinth and entablature. Bequeathed to the University by Dr Richard Rawlinson, Gentleman Commoner of St John's College (MA 1713, Hon. DCL 1719), a keen antiquary and avid collector in many fields, who died in 1755. Rawlinson had been a severe critic of the management of the Ashmolean Museum and established in his will a fund to pay for a proper keeper of it (who was to be neither a Scotsman nor in holy orders). He also bequeathed a few trifles to it (including a model gondola and a Muscovian fox). Rawlinson 'had formed his collection [of classical marbles], in which there was certainly a good deal of rubbish, principally at the Kemp sale and the Oxford sale' (A. Michaelis, *Ancient Marbles in Great Britain* (Cambridge, 1882), 539; Chandler, op. cit., pp. V–VI). The sale of John Kemp FRS was in March 1720/1 (the catalogue, by R. Ainsworth was entitled *Momumenta vetustatis Kempiana* (London, 1920)) and that of the earl of Oxford was in March 1741/2.

Michaelis in his late nineteenth-century catalogue of the antique marbles in Oxford (op. cit. 591, no. 222 observed merely that this relief is 'new', by which he meant not ancient, as had been assumed by Chandler in the eighteenth century (op. cit. i, pl. XLIV, no. XCII). It is likely to be Italian and possibly sixteenth or seventeenth century, but more probably early eighteenth century, in date. The style of hair and youthful, blandly idealized profile suggests the numerous portraits of Augustus. There are similar low relief crowned heads in profile in the second plane of the ancient Roman relief sculpture representing processions and triumphs: the head immediately in front of the emperor's chariot in one of the reliefs in the interior of the Arch of Titus (*c.* AD 90) and several heads in the relief of the *Vicomagistri* (AD 41–50) in the Museo Gregoriano Profano are convenient examples.

152. Farnese Hercules

56.4 cms. (height including plinth, but excluding the rough
projection beneath it); 3 cms. (height of plinth at back); 22.8 cms.
(length of plinth); 20.6 cms. (width of plinth); 4.8 cms. (height
of rough projection below the plinth)

Terracotta of a pale biscuit colour. Solid. The hero's head, arms, left
leg (at knee), and right leg (at lower thigh), also the drapery behind
the club and the base beside the feet, have been broken off and
replaced with a plaster cement which is very evident. Chips are
missing along the joins. The hands have been broken off. This right
arm now terminates in a stump and his left has a crudely modelled
substitute hand. '9427 / 1936 / C.Gg' is painted in black on the
underside of the plinth at the back.

Transferred from the Department of Antiquities, after the refixing
of some of the repairs, in August 1987. The terracotta was one of
numerous objects (chiefly flints, amulets, and gem impressions)
which were transferred from the Wellcome Institute for the History
of Medicine to the Department of Antiquities on 29 June 1982
(after an agreement reached in November 1981). Eric J. Freeman,
Librarian of the Wellcome Institute for the History of Medicine,
wrote on 3 December 1987, in reply to enquiries concerning the
provenance, that the terracotta must have come from the Gorga
Collection (hence 'C.Gg'). Wellcome purchased the collection of
medical and other antiquities formed by Signor Evan Gorga of 285
Via Cola di Rienzo, Rome, in 1924 (having first made overtures to
do so in February 1912). The figure is likely to be the 'Terra cotta
statuette (Hercules) W. 67' in the list of 'cases and contents' made
in Rome in 1924. There were, however, over 300 terracotta items
in the collection and at least one other terracotta *Hercules*.

The terracotta is a copy of the famous antique statue in the
Farnese Collection of Hercules resting after his labours. It
could have been made in the seventeenth, eighteenth, or
nineteenth century. There is another, slightly smaller,
terracotta copy of the *Hercules* signed by Maderno in the
Ashmolean (No. 56), also a large and small bronze copy
(Nos. 414, 416). This is less sharply modelled and less detailed
than the Maderno and in some respects is closer to the
original, although of little artistic merit.

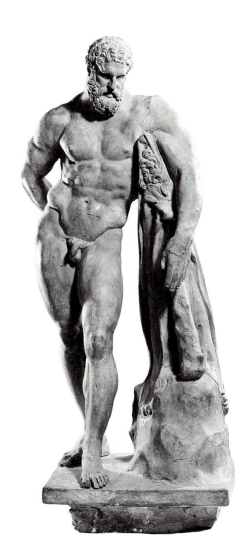

153 and 154. Hercules slaying the Erymanthian Boar and Hercules slaying Geryon

26 cms. (height of No. 153); 27 cms. (height of No. 154)

Terracotta. There are breaks across the base by the hero's left foot in No. 154, also in his raised right arm across biceps and wrist. These have been mended, but are conspicuous. There are traces of gilding on the lion skin and the boar in No. 153 and also on parts of No. 154. Both groups are unfinished from behind and appear to have been scraped down. No. 153 has on the underside of its base the following in blue pencil 'No 1818' and on a circular label in biro '8976'. No. 154 has in the same place some indecipherable marks in blue pencil and on a circular label in biro '8977'.

Bought from the Arcade Gallery (Paul Wengraf), The Royal Arcade, 28 Old Bond Street, London W1. Registered 12 December 1960.

The *bozzetti* were registered as possibly by Vincenzo de Rossi and described soon afterwards, in the *Annual Report* (1960: 63) as follows:

Their tense muscular action and vigorous *contrapposto* recall the style of Bandinelli's pupil, Vincenzo de' Rossi (1525–1587), who was commissioned by Cosimo de' Medici to execute the *Twelve Labours of Hercules* in marble and larger than life. Work on the series was in progress in the Opera del Duomo by 1563 and two of the finished groups were praised by Vasari in the 1568 edition of his *Lives*. Six

of the seven marbles completed, including versions of Geryon and the Boar, still stand, as they were arranged in 1592, along opposite walls of the Salone del Cinquecento in the Palazzo Vecchio.

For this series of sculptures see H. Utz, 'The *Labors of Hercules* and Other Works by Vincenzo de' Rossi', *Art Bulletin* (Sept. 1971), 344–6, where, however, these *bozzetti* are not mentioned, Professor Utz having expressed his opinion, on seeing photographs of the groups, that they had 'nothing in common' with sculpture by de' Rossi. He thought that they might be connected with a minor sculptor in the circle of Romulo del Tadda who was responsible for the groups carved in *pietra serena* which were placed around the *bolotto* of the Boboli Gardens (letter of 13 April 1971 in the Department's Archive). Professor Ulrich Middeldorf had also questioned the connection with de' Rossi as early as 23 June 1961, writing to Ian Robertson: 'The Labours of Hercules have nothing to do with Bandinelli or Vincenzo de' Rossi . . . They are as to period certainly closer to Maderno; but his groups have different proportions, movements and detail' (letter in the Department's Archive).

There is surely no reason why the groups should not date from the seveteenth or eighteenth century, nor is there any reason for them to be Florentine, for, although the Labours were especially popular subjects there in the fifteenth and sixteenth century, they were popular all over Italy as well: there are seventeenth- and eighteenth-century examples in or from the Veneto which are similar in character and conceived

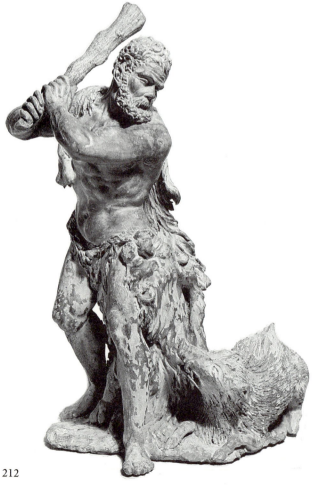

for niches (or at least to be placed against a wall or hedge)—a pair of crude Istrian stone groups of Hercules clubbing Cerberus and tearing the jaws of the Nemean Lion now flank the entrance of Palazzo Pisani in Venice; others may be seen in the grounds of villas in the Veneto; an impressive *Hercules and the Hydra* signed by Giovanni Marchiori and probably of about 1760 is in a private collection (F. Russell, 'A Statue of Hercules and the Hydra by Giovanni Marchiori', *Burlington Magazine* (June 1972), 393 and fig. 58).

A sample from both terracotta groups was examined by thermo-luminescence at the Oxford Research Laboratory for Art and Archaeology in October 1986 and estimated as fired between 240 and 370 years ago (ref. 381-y-36).

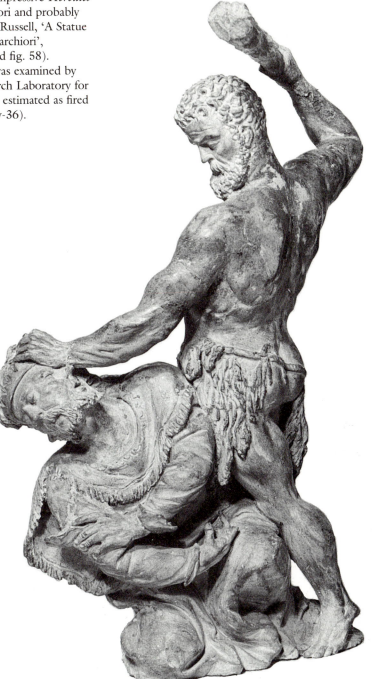

155. Bust of a black boy wearing a tasselled cap and frogged doublet

28.4 cms. (height); 20.6 cms. (length, across sleeves); 12.3 cms. (height of socle); 13.2 cms. (diameter of base of socle)

Bronze with a natural chestnut coloured patina exposed, especially in the face, beneath coloured varnishes. The flesh is varnished black; the cap a dark black-green; the kerchief, shirt, part of the eyes, and one tooth white; the kerchief ribbon and lips red. The varnishes have chipped off or worn through in parts and have darkened in colour. The doublet was covered with a gold varnish as were parts of the cap: this is best preserved at the back of the ball attached to the cap's tassell and in the ribbon attaching the feathers. Hollow, heavy-walled, lost-wax, cast. Some flaws in the lower part of the chest. The bust is open at the back of the chest and the head has been filled with plaster. An old iron file embedded in the latter extends to a waisted spreading socle of *verde di prato* (Tuscan serpentine).

Lent by C. D. E. Fortnum on 20 March 1888 and given later in the same year. B. 402 in his catalogues. According to the notebook catalogue it was bought in 1860 for £6 (the date but not the price is given in the large catalogue). The bronze has long been in reserve.

Fortnum described this remarkable bronze as 'n. Italian, probably Venetian'. Blacks of course played a large part in Venetian art. He dated it to the sixteenth century, although a later date seems more likely. Aileen Ribeiro considers it likely that it dates from the early eighteenth century and notes that a livery combining 'hussar' and 'Vandyck' elements was popular for servants then. The varnishes look old but may not be original. That on the cap conceals the very carefully punched foliate pattern and the textured contrast of the lining which is turned over at the back. The socle, recorded in Fortnum's catalogues, cannot be original.

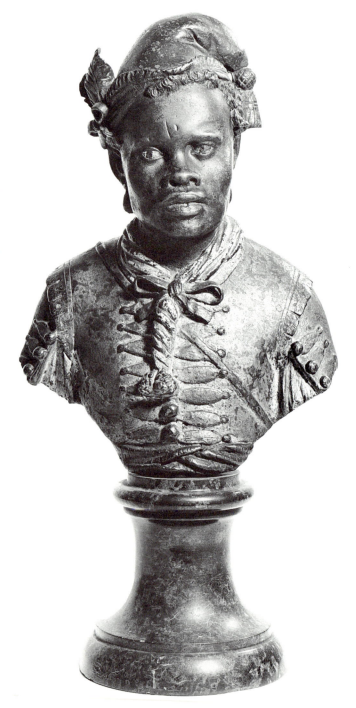

156. Virgin and Child with a crescent moon

56 cms. (height); 64 cms. (length; 30.9 cms. (height of oval relief within oval frame); 26 cms. (width of relief within oval frame); 18.2 cms. (height of Virgin from top of head to the sleeve below the wrist)

The relief of the Virgin and Child is certainly of terracotta. The framework has been described as of stone but seems also to be of terracotta. The rear of the relief is made up with lath and plaster and some bricks. The Virgin is clothed in red with a blue cloak. The ground against which the swags are set is a green blue and there are traces of green on the ground around the oval. But most colouring has darkened and flaked. Much seems also to have been distressed.

Bought from the Arcade Gallery (Paul Wengraf), The Royal Arcade, 28 Old Bond Street, London W1, in 1964. Registered immediately after the terracotta relief attributed to Mazza (No. 78) without a date but between 10 and 16 June. The relief is shown in photographs dated 1966 high on the wall of the Fox Strangways Gallery. It has long been in reserve.

The relief was associated by Ian Robertson with Giuseppe Mazza because of its supposed similarity to the terracotta relief of the *Virgin and Child* which he bought at about the same time (No. 78), although he conceded that it was 'less masterly in modelling' (*Annual Report* (1964), 51). The relief certainly looks Italian and of the seventeenth or eighteenth century. The architectural framework, colouring, and material would suggest that this originated as a popular street shrine. The removal of such, however, was not easily achieved even in the upheavals at the end of the Second World War. Work of this character and of such moderate quality is easily imitated.

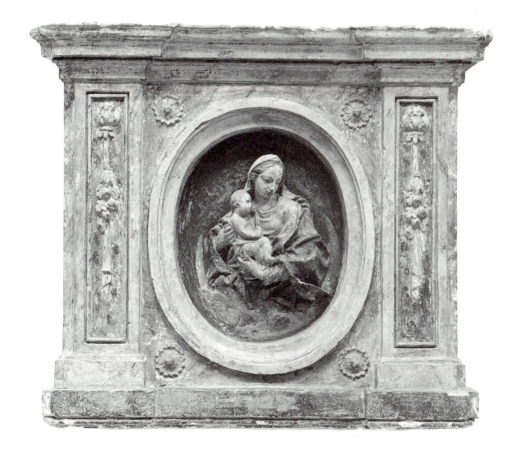

157. A young martyr stoned and beaten

31.5 cms. (height); 43.3 cms. (length); 41.5 cms. (outside height of frame); 53.5 cms. (outside width of frame)

Terracotta of a pale orange colour coated with a yellowish grey slip which has been rubbed to a warm brown on some salient parts (such as the buttocks of the flagellator and the foreheads of the most prominent elders). Mounted against a ruddy brown velvet framed with a gilt wood reverse moulding.

Bought at the Arcade Gallery (Paul Wengraf), The Royal Arcade, 28 Old Bond Street, London W1, for £850 in July 1962 (receipt dated 14 July, registered without a date but between 21 July and 6 August) with the aid of a grant from the Regional Fund administered by the Victoria and Albert Museum. Bought by Wengraf at Sotheby's, London, 10 May 1962, as lot 92. Framed by the Museum in 1962 (*Annual Report*, p. 27).

The subject was identified at auction, by the dealer selling it, and by the Keeper (Ian Robertson) buying it, as the *Flagellation of Christ*, but, as Alastair Laing has pointed out, two of the bearded elders appear to be preparing to stone the victim, only one figure is about to beat him, there is a crowned figure seated behind and presiding over the scene, accompanied by a large chorus of elders (also assembled to proper left) all of which is unorthodox in a *Flagellation*. Moreover, if Christ is represented by the figure tied to the column, he is unusually small in size. It may be that the episode represented is a relatively obscure one in the life of a martyr. Robertson, publishing the relief in the *Annual Report* (1962: 63), wrote that there was 'no evidence to uphold the tentative attribution made there either to Antonio Calcagni or to Tiberio Verzelli'. He was sure, however, that it was Venetian and mid-sixteenth century in date and added that it was 'Masterly both in composition and execution' and 'clearly a *modello* or trial piece for a panel in relief in a bronze door'. There seems no good reason to assign it to the sixteenth century and the concave-sided frame with cherubim in the chamfered corners is more typical of the seventeenth or early eighteenth century. It does not look certainly Venetian in style. And it could be a *modello* for a panel in marble or stucco on a plinth below a statue, or perhaps for a silver relief on an altar. It is not 'clearly' for a door. Nor is it 'masterly'. It looks like a pastiche and its antiquity has been put in doubt by the thermo-luminescence test carried out on a sample taken by Mrs Doreen Stoneham of the Research Laboratory for Archaeology and the History of Art in April 1974 which suggested that it was fired less than 115 years previously (ref. 81-m-65).

It has recently been observed by Peter Cannon-Brookes that this is clearly related to one of the marble reliefs of the life of St Trifone in the Cathedral of Boka Kotorska (*Bocche di Cattaro*) on the Dalmatian coast. A similar modello for another of these reliefs is in the Aartsbisschoppelijk Museum, Utrecht. The marble reliefs are by Francesco Ca' Bianca (1665–1737) and can be dated 1700–1704. They are very much more timid in style than the terracottas which might be by another hand. How this is reconciled with the suspicions voiced above is not clear.

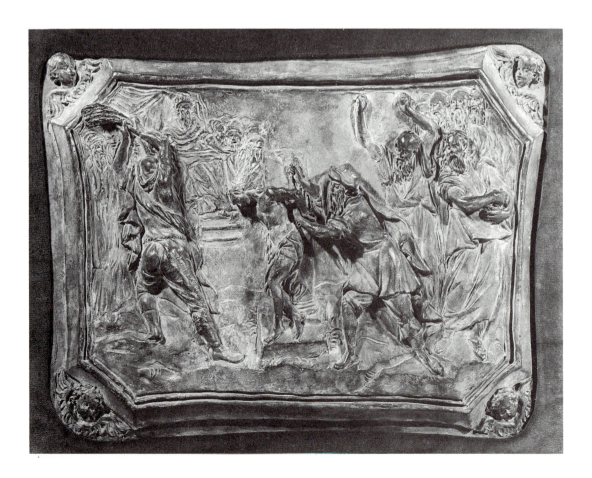

158. Charity in a landscape

32.7 cms. (height); 40.75 cms. (length); 7 cms. (maximum depth of relief)

Terracotta, painted naturalistically. The colours have deteriorated and the flesh is now a green grey and the foliage is brown. The clay has been slightly hollowed behind the woman. At the base it has been thickened and forms a flat surfce, the other edges are irregular. The paint has flaked off the woman's right shoulder and arm, the face of the infant to her right, and the body of the older child to her left. '4905' is written on the reverse of the relief in the upper corner to proper right.

Bought from the Arcade Gallery (Paul Wengraf), The Royal Arcade, 28 Old Bond Street, London W1, in September 1960 for £350 (the invoice is dated 20 September, the receipt 22 September, but the work was registered on 8 August).

Charity is traditionally represented as nursing three eager children and not uncommonly expressing milk, as seems to be the case here, into the mouth of the oldest and most active of them. The nest full of young birds, which is somewhat roughly indicated in the crook of the tree to proper right, is obviously an appropriate attribute. It is hard to imagine how a work like this could have been originally displayed (a frame would be impossible). It would seem likely that it was a sketch for a larger relief and that the colouring was not intended. Parker publishing it in the *Annual Report* observed that it was 'suggestive in style of the Genoese school of the early Eighteenth Century', adding that 'the name of Francesco Maria Schiaffino (1691–1765) has been tentatively put forward as the author, but, for the present, comparative material to support this attribution is not forthcoming'. It was, it seems, the dealer who first suggested Schiaffino. A note in the Register records a letter from Hugh Honour to the Keeper of 11 May 1961 proposing other Genoese sculptors of the early eighteenth century, Domenico Parodi or Anton Maria Maragliano. There seems no compelling reason to associate the relief with the Genoese School, nor can it be regarded as certainly Italian.

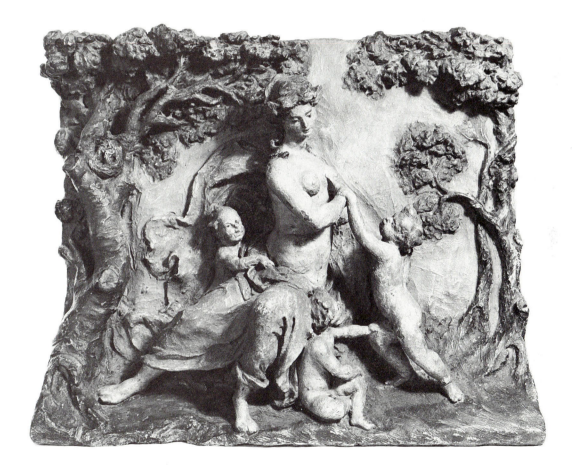

159. Set of profile medallion portrait heads of the Twelve Caesars

5.5 cms. (height of each ivory medallion); 4.3 cms. (width of each ivory medallion); 5 cms. (height of each medallion visible within its frame); 4 cms. (width of each medallion visible within its frame)

Ivory, mounted in frames of bronze, fire-gilt (ormolu), which are pinned to a stand of ebonized wood. The eight portraits on the front of the stand are linked by the swags of husks, also of bronze, fire-gilt. Many portions of the ormolu mounts have been removed, some of them in recent years. The bronze ribbons above Titus have a firing crack in the suspension loop and the end of the ribbon to proper right is missing. The entire swag of husks connecting the medallion of Augustus with that of Tiberius and the ring mid-way between them from which the medallion of Claudius is hung are missing. The ivory medallions are chiselled with the names of the emperors represented: 'DOMIT' (for Domitian); 'TITUS'; 'G IUL' (for Gaius Julius Caesar); 'NERO'; 'G CAES' (for Gaius Caligula); 'AUG' (for Augustus); 'GALBA'; 'TI CLAUD' (for Claudius); 'TI CAES' (for Tiberius); 'M OTHO' (for Otho); 'A VITELI' (for Vitellius); 'VESPAS' (for Vespasian).

The ivories are attached to the stand which forms part of the Fitzwilliam Coin Cabinet bought at auction in 1949 for the Heberden Coin Room (see Nos. 35 and 63).

The mounts consist of shot against a flat band (the band given a punched texture), husk swags (similarly textured), and suspension ribbons with fluttering ends (a punched texture on one side contrasted with a burnished reverse). The design is typical of the 1770s and could hardly be earlier than the mid-1760s. It is reminiscent of the patterns employed, especially for stucco interior decoration, by Sir William Chambers, James Stuart, and John Carr of York—the last two named architects, being employed by the marquess of Rockingham to make improvements at Wentworth Woodhouse, could indeed have designed the stand to which these mounts are applied. The stand, with its tapering square legs and avoidance of curves, is of sophisticated design, although not of superior workmanship or materials. It serves to support and supplement the *pietra dura* cabinet which was converted to serve as a coin cabinet as discussed under No. 35. The heads of the Caesars are an obvious enough ornament for a coin cabinet: a late eighteenth-century example with exceptionally large bronze plaquettes of the Caesars was with an antique dealer in Chipping Norton early in 1989. But it is surprising that a keen numismatist such as the marquess of Rockingham, for whom the cabinet was presumably made, should have tolerated such chronological disorder in the arrangement of these medallions on the outside of a piece of

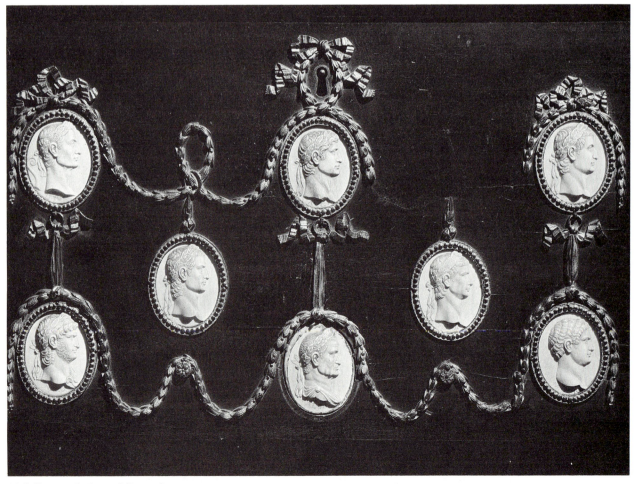

Medallions on the front of the stand

218

Medallions on the sides of the stand

furniture designed to keep medals and coins in proper sequence. The only evidence of thought in the arrangement is the priority given to Augustus in the centre of the top row below the keyhole. The explanation for this disorder may be in an unrecorded restoration of the cabinet, perhaps during the last century. Lord Rockingham seems to have owned some other furniture of a superior character, similarly decorated, for in the sale at Christie's, London, of 'Etruscan and Greek Vases and Fine English Furniture' from Wentworth Woodhouse on 15 July 1948, lot 135 was a 'Pair of Adam mahogany show cabinets the cornices with upsprung foliage and with festoons suspended from ivory medallions carved in relief from busts of Roman Emperors and others'.

It may be that the ivories on the coin cabinets were carved at the same date as the mounts, but it is much more likely that they were purchased at an earlier date and had not previously served as mounts. In any case they had to be supplemented by two ivories of a different character (Nos. 160 and 161) and the arrangement looks improvised. Rockingham had travelled all over Europe and bought from other collectors who had done so, so there is no reason to suppose that the ivories are of British origin.

Medallion portraits of the Caesars of the type which are imitated from Roman coinage (the source often being sixteenth-century engravings of such coin portraits by Marcantonio Raimondi, Hubert Goltzius, or Théodore de Bry) are common in a variety of size and media. Some metal plaquettes of the Caesars, many with identical portraits to those in the set catalogued here, seem to be Italian and of the mid-sixteenth century: a set of bronzes is in the Kunsthistorisches Museum, Vienna (IN. 7689–99, for which see *Natur und Antike in der Renaissance* (Liebieghaus, Frankfurt on Main, 1985–6), 345–9, nos. 36–46) and one of lead in the municipal collections of Ferrara (see R. Varese,

Placchette e bronzi neile Civiche Collezioni (Ferrara and Pomposa, 1974–5), 43–6). During the early seventeenth century such portraits were very popular in Limoges enamel (there are some examples in the Ashmolean Museum, but for the complete range see Musée de la Renaissance, Château d'Écouen, CL. 22625–8; CL. 10965–8; CL. 22629–34). Probably dating from the end of the seventeenth century are some ivory examples in which the head is cut out rather than part of an oval ivory medallion—'cut out' furniture mounts being popular in this period (see No. 256). The most splendid set of this type is that in the Bayerisches Nationalmuseum, Munich, in which the heads are placed against a tortoiseshell ground (they are arranged in two frames—R. 1050 and R. 1051—and labelled as German of c. 1700). Another set of good quality is in the Staatliche Museen, Berlin-Dahlem, and is catalogued as 'north German?' by C. Theuerkauff (*Die Bildwerke in Elfenbein des 16.–19. Jahrhunderts* (Berlin, 1986), 307–13 nos. 96–107). A very similar set, but of lower quality, mounted on a single tray, was with the Mount Street Galleries, 125 Mount Street, London, in June 1986. In this case there were ivory labels with the names of the emperors spelled in a way that suggests an Italian origin.

Ivory medallions of the type catalogued here are generally regarded as dating from the mid-eighteenth century or later. A set differing only in trifling details (such as the movement of the ribbon behind the neck of Vespasian), mounted in two ebonized frames, was lot 118 on 30 June 1987 at Phillips, London. Another set in a private collection, also very similar, is mounted as a book, in exactly the manner employed for gesso impressions of the same subjects, with an Italian text. A distinctive feature of all these medallions is that the emperors are now all represented with their profiles facing to the right whereas in the earlier cut-out ivories, as in the bronze and lead plaquettes, half the profiles face the other way.

160 and 161. Profile medallion portrait busts of Hadrian and 'Sabina'

7.7 cms. (height of each medallion visible within its frame); 5.9 cms. (width of each medallion visible within its frame); 9 cms. (height of each beaded frame); 14.7 cms. (height of each mount including suspension of ribbon); 6 cms. (width of each beaded frame)

Ivory, mounted in frames of ivory, fire-gilt (ormolu) pinned to an ebonized stand. There are slight vertical splits on the head and neck of Hadrian. The surface of those of Sabina is abraded and slightly discoloured. The mounts are cast from an identical mould. The end of the ribbon to proper left of the mount of the portrait of Sabina has been broken off and is missing.

The ivories are attached to the stand which forms part of the Fitzwilliam Coin Cabinet bought at auction in 1949 for the Heberden Coin Room (see Nos. 35, 63, 159).

The ivories are clearly by a different artist from the other ivory medallions of the Caesars on the same cabinet (No. 159). These are larger, more elegant, doubtless based on idealized bust sculpture rather than on the conventions of numismatic portraiture. That their prototypes are exactly adhered to is suggested by the disparity in the cutting of the chest. This might also suggest that they in fact came from different sets, but the style of carving is very similar. Their incorporation into the coin cabinet strongly suggests that the ornamentation of the cabinet was improvised out of a miscellany of existing ivories in Lord Rockingham's collection. Had he ordered a set of ivories for this purpose he would have included other emperors and other profiles facing left, would have had all the medallions of a standard size, and would not have included only one emperor from a later dynasty. Moreover the tightness of the frame around the chest of Hadrian and around the head and chest of Sabina suggests that the medallions have been adapted for these mounts. The portrait of Hadrian's consort, Sabina, does not correspond with any recorded in such standard sources of the period as the *Iconographie romaine* by A. Mongez, (Paris, 1826), and it may have been mistaken for Sabina or intended to pass for her. The other bust is certainly a portrait of Hadrian.

162. Standing bull

33.4 cms. (height); 40.6 cms. (length); 2.6 cms. (height of marble slab); 40.6 cms. (length of marble slab); 17.9 cms. (width of marble slab); 5 cms. (height of wooden plinth); 47 cms. (length of wooden plinth); 24 cms. (width of wooden plinth)

Bronze with a dark brown to golden brown patina. Hollow, presumably lost-wax, cast. The tail has been cast separately and riveted. The metal has been scratched to suggest hair. The bronze is mounted on a slab of Siena yellow marble with an ebonized wooden plinth.

Bequeathed by C. D. E. Fortnum in 1899. B. 443 in his catalogues. 'Bought of Maggi of Genoa with others 1848 £30' according to the preliminary and the notebook catalogues—the other bronzes which he obtained from this source in 1848 are the *Jupiter* (No. 337), the *Centaur with Cupid* (No. 164), and the famous *Listening Pan* formerly attributed to Riccio. Long in reserve, the bronze was placed on display in the Fortnum Gallery in 1985.

The bronze *Bull* is not dissimilar in character to a smaller one with its right foot raised which was cast in large numbers by the workshop of Giambologna, and this explains the relatively early date often given to it. The version in the Liebieghaus, Frankfurt (no. 1339), is described on an old label as 'Italian, sixteenth-century', which was the opinion published by H. Weihrauch, *Europäische Bronzestatuetten* (Brunswick, 1967), 379. The version in the Wallace Collection (in the Hertford House Collection by 1834) was catalogued by J. G. Mann as Italian and of the seventeenth or eighteenth century (*Wallace Collection Catalogues: Sculpture* (1931), with supplement of 1981, S143, p. 52). Fortnum seems at first to have regarded his version as by 'an able caster probably French and of the period of Louis XIV' but he amended his entry in his notebook catalogue inserting

'Italian' after the 'probably' and a 'perhaps' before the 'French' and changing the 'XIV' to 'XV or XVI'.

The prototype, as Fortnum knew, was the much restored antique *Bull* carved out of a fine-grained speckled grey marble in the Sala degli Animali of the Museo Pio-Clementino in the Vatican. This is now known to have been excavated between 1775 and 1780 at Ostia and so the bronze versions cannot date from before then (W. Amelung, *Die Skulpturen des Vaticanischen Museums* (Berlin, 1908), ii. 340, no. 131, pl. 33; C. Pietrangeli, *Scavi e scoperte di antichità sotto il pontificato di Pio VI* (Rome, 1958), 113). The earliest reference to it in literature seems to be Massi's *Indicazione antiquaria* of 1792 (41, no. 14) and it is unlikely to have been reproduced before then. The bronzes are more or less exactly the same size as the marble and differ only in that they dispense with the tree trunk support under the animal's belly. It is worth noting that the Vatican *Bull* may be the one listed by Zoffoli (see Nos. 110–11) in his printed *Serie di figure* available in bronze from his Roman showroom in the 1790s, as the *Toretto*, the little bull, next on the list to, and perhaps intended as a companion for, an *écorché* Tiger (*Notomia di tigre*). But he offered his bronzes of this subject for sale at 10 zecchini and they must at this price have been smaller than the Ashmolean's version. *Toretto* could also describe a bull of the Giambologna type. Too much significance should not be attached to the provenance of Fortnum's piece, but the fact that this is after a relatively obscure sculpture in the Vatican does make Rome the most probable place of origin. It was copied in Portuguese earthenware later in the nineteenth century at the Mafra factory at Caldas da Rainha (see J. Poole, *Plagiarism Personified* (Fitzwilliam Museum, Cambridge, 1986), 32, no. D12).

For the bronze *Lion* commissioned by Fortnum as a companion to this *Bull* see No. 87.

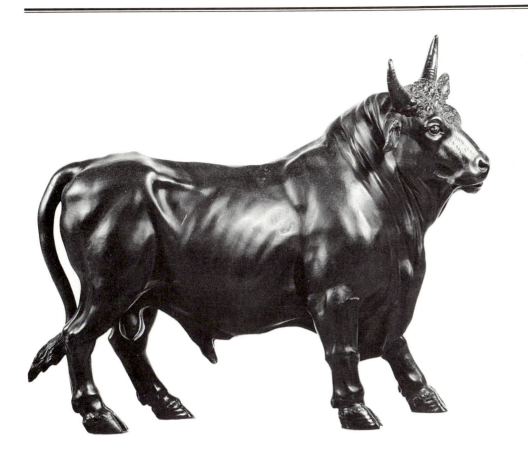

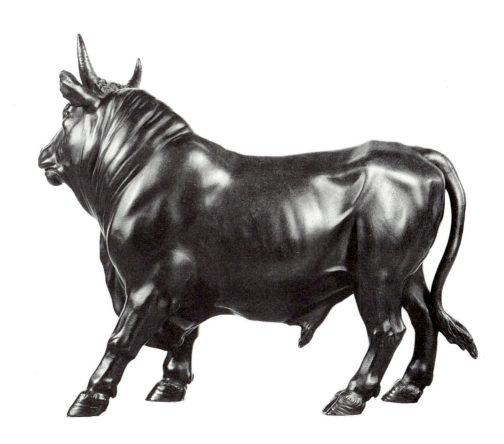

163. Medallion profile head of a hero or ruler

37.5 cms. (height including base); 33.4 cms. (diameter of marble relief)

Carrara marble, discoloured by dirt. Chipped at the rim at lower proper right. The relief is circular and has been set in a Portland stone base.

Transferred from the Department of Antiquities in 1986. Bequeathed by Dr Richard Rawlinson. For the provenance see No. 151. The stone support seems not to have been in place in 1763 when the relief was published in R. Chandler, *Marmora Oxoniensia* (Oxford, 1763), i, pl. XLV, no. CVIII.

Adolf Michaelis in his late nineteenth-century catalogue of the antique sculpture in Oxford (*Ancient Marbles in Great Britain* (Cambridge, 1882), 591, no. 223) observed merely that this relief is 'new', by which he meant not ancient as had been assumed by Chandler in the eighteenth century (op. cit.). It is likely to be Italian and probably dates from the early eighteenth century. It may be imitated from the head of a ruler on a Hellenistic coin.

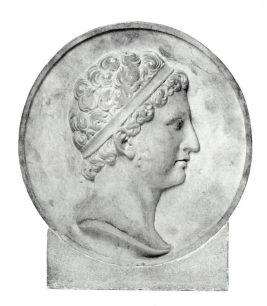

164. Centaur ridden by Cupid

40.5 cms. (height of centaur); 17.6 cms. (height of Cupid); 3.6 cms. (height of green marble plinth); 27.2 cms. (length of this plinth); 16 cms. (width of this plinth 9.4 cms. (height of marble sub-plinth); 30.8 cms. (length of this plinth); 19.9 cms. (width of same)

The centaur is of bronze with a dark brown to black varnish worn in parts to expose a chestnut patina. Hollow, presumably lost-wax, cast. The Cupid is of silver, also hollow cast, with separate, solid-cast, wings soldered to his body. The silver has tarnished to a dull pale brown and grey. The wrists of the centaur are attached to the Cupid with a miniature silver chain. The centaur seems to have been cast in two parts: an irregular join is visible just below the waist. The supporting rock below one foot has been separately cast. The centaur is mounted on a plinth of very dark green marble (said by Fortnum to be 'the richest quality verd-antique') to the short faces of which an ormolu swag of flowers is attached and to the long faces strips of ormolu, that at the front with raised letters against a textured field reading: 'COME'L CENTAURO, AMOR., DEH ANNODA IL TEMPO!' and that on the back engraved with cursive letters 'Gioanni da Bologna . Fece il Centauro. Gioanni Dughè fece l'amore'. This plinth rests on a sub-plinth consisting of a slab of streaky dove grey marble (probably from Carrara) supporting a slab of white Carrara marble each side of which is decorated in very low relief 'with a guilloche of leafy sprays which intertwine between inlaid coloured agates etc.' (Fortnum)—each of these stones is oval; among them are pieces of antique imperial porphyry, cornelians, and antique onyx. There are small chips and scratches, especially to the edges of the plinth.

Bequeathed by C. D. E. Fortnum in 1899. B. 440 in his catalogues. Bought by Fortnum from Maggi of Genoa in 1848 for £25 according to the notebook and the preliminary catalogues (no date, provenance, or price is given in the large manuscript catalogue). On display in the Coin Room lobby since 1956.

The group was catalogued by Fortnum as 'after one of the Centaurs of the Capitolone Museum found in Hadrian's Villa at Tivoli'. These black marble *Centaurs* (missing their riders) were excavated in 1736 and placed in the Museum by 1765 (see F. Haskell and N. Penny, *Taste and the Antique* (London and New Haven, Conn., 1981), 178–9). It is, however, possible that the antique prototype for the Ashmolean group was the white marble *Centaur* which was by the early seventeenth century in the Borghese Collection but has, since the early nineteenth century, been in the Louvre (ibid. 179), although the silver Cupid is different in attitude from the much-restored figure on the back of that version. In details this small centaur does not correspond exactly with either the Borghese or the Capitoline examples: the sexual organ has been omitted as have the veins on the belly. More generally there is much less sinew and muscle in the body and much less pathos in the face. Bronze reproductions of the Capitoline versions signed by Righetti in the late eighteenth century and the bronze reproduction of the Borghese version in the collection of Sir Brinsley Ford are not only more exact but far more lively than this.

The attribution of the centaur to Giambologna ('Gioanni Bologna') need not be taken seriously, although Fortnum presumably did date the work to the late sixteenth century

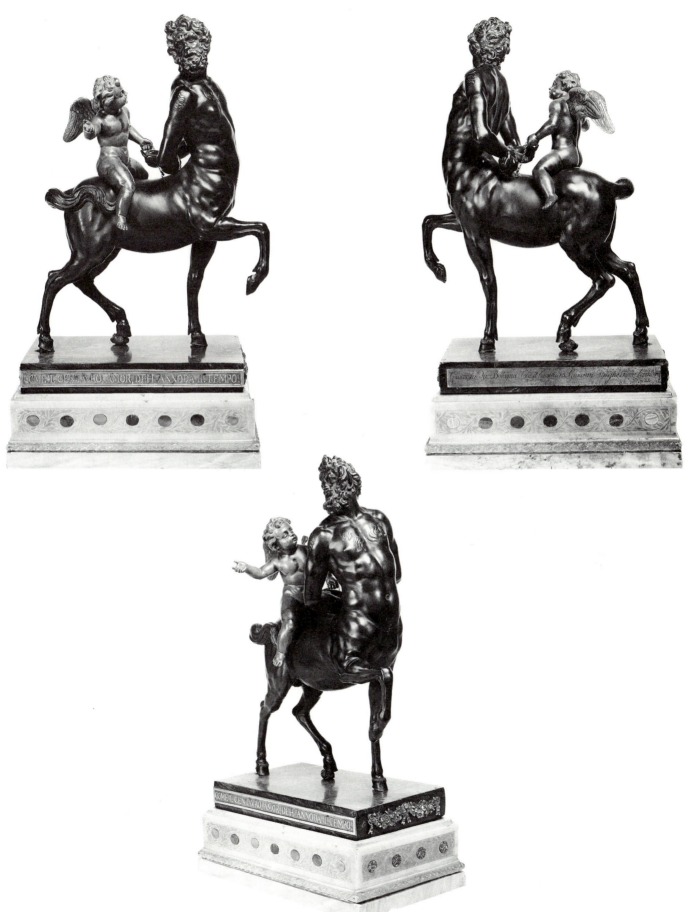

for this reason. The attribution of the Cupid to 'Gioanni Dughè', presumably Jean Dughet, Poussin's brother-in-law, is far more peculiar and merits explanation if not respect. It prompted Bell to give the group a seventeenth-century date. The insipid modelling and neat but prissy finish of the centaur would surely be less surprising in the eighteenth century than in the seventeenth—it would be still less unusual in the early nineteenth century. The Cupid is quite different in style as the double attribution acknowledges. It is typical of the blandly smiling and flabbily gracious version of the baroque style much beloved by Italian goldsmiths from the late seventeenth century onwards and still evident in ecclesiastical altar fittings of a traditional kind made today. The pose of the Cupid is not well suited to the mount and he relates uncomfortably to the centaur's tail.

The sub-plinth looks as if it cannot be much earlier in date than 1848 when Fortnum acquired the group and the green marble plinth, if older, may not be much earlier in date. The manner in which the centaur is bolted to the plinth at three points does not look as if it is original. A rock has been added to the centaur's back left hoof and the back right hoof has an extension enabling it to make proper contact with the plinth. There is a crack in the marble where the latter has been bolted. Bell in his marginal annotation to Fortnum's large catalogue observes that 'the Motto on the plinth may perhaps indicate that with its present setting the group was at one time intended to decorate a clock'.

165. Terminal head of a maenad

17.5 cms. (height including plinth); 2 cms. (height of plinth)

Giallo antico (yellow marble from Roman Numidian quarries). There is an old crack across the neck and the hair falling down beside it to proper right. There are losses along the front edge of the chest and on the nose which have been made up with plaster tinted to match the marble (but in the case of the nose now scratched in parts to reveal the white of the plaster). The leaves and berries below the ear to proper left have been broken and repaired. There are chips missing from many of the leaves. Mounted on a plinth consisting of a block of pale Siena marble with a paper label pasted to the front face with 'OLDFIELD COLL.' typed on it and '62' written in ink.

Transferred in August 1986 from the Department of Antiquities. Bequeathed by Edmund Oldfield FSA in 1902. No. 3 in the section 'Marble' of the list given in a letter from Oldfield's solicitors on 16 May—where described as 'a small mask of youthful faun'. No. 62 in the 'Catalogue of Works presented and bequeathed by Edmund Oldfield' which is compiled out of Oldfield's own manuscripts, where described as 'terminal bust of a Maenad'. Additional notes, apparently by Arthur Evans, record that Oldfield bought the head at the Purnell Sale at Sotheby's in April 1872. For Oldfield see also No. 56.

Miniature antique Roman heads of this sort do survive and there seems to have been no suspicion when this item was received in the Department of Antiquities that it was not ancient. However, the suspicions when they did arise were justified. There was a vogue for such works, often carved out of scraps of antique marble and copying famous heads in the great Roman museums, in the late eighteenth century. Charles Heathcote Tatham acting as agent in Rome for the architect Henry Holland included drawings of ten such among numerous miniature obelisks, urns, and baths in coloured marble on a sheet captioned 'Various modern ornaments for Chimney Pieces &c. (chiefly worked in antique marbles of the rarest kind, & others found in excavations made at Rome) collected there for Henry Holland Esq. Architect in the years 1795 & 1796' (Album of Sketches, private collection). One of these heads is very similar to this term except that it is cut at the neck and mounted on a columnar pedestal. For other heads of this sort see Nos. 166–8.

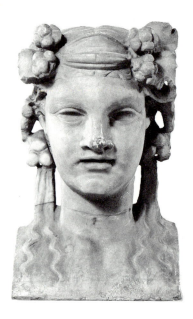

166. Terminal head of Jupiter

12.5 cms. (height)

Giallo antico (yellow marble from Roman Numidian quarries). The marble has a pink band and white vein. A small chip is missing from the front edges of the chest. '℉ / S.33' is painted in black on the rear of the term and below this '3182' is written in pencil.

Bequeathed by C. D. E. Fortnum in 1899. S. 33 in his catalogues. Employed by him as a chimney-piece ornament at the Hill House, Stanmore, together with three similar pieces (see Nos. 167, 168, and 169). 'Bought for £3-10s at the Sale of the Debruge Coll.' [that is the Debruge-Duménil Collection of *objets d'art* —for which see No. 292] in Paris, 23–31 January, 1–11 February and 12 March 1850, lot 134 (449, no. 134, in Jules Labarte's catalogue of 1847)—'marbre jaune antique tête de Jupiter d'après l'antique 13 centimetres'. In his preliminary catalogue (p. 7) Fortnum noted that this head had a pedestal of *rosso antico*.

For heads of this sort see No. 165. Fortnum catalogued this correctly as 'a reduced copy, probably from the antique. Italian 18th or early 19th century'. The work copied is the head of the *Verospi Jove* in the Museo Pio-Clementino of the Vatican.

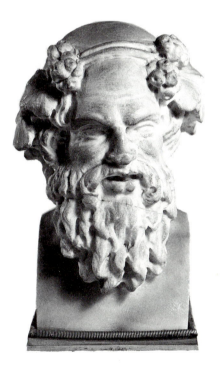

167. Terminal head of Silenus

12.55 cms. (height including brass base)

White, presumably Carrara, marble, now brown with ingrained dust. It has been broken across the beard and the lower part of the head: the adhesive employed to fix it has darkened and the line of the join although fine is therefore visible. The bust is mounted in a tray base of brass with a machined torus moulding. '℉ / S.3' is painted in black on the rear of the term. There are a small oval paper label and a small lozenge-shaped paper label with a blue border both marked '52' on the underside of the base.

Lent by C. D. E. Fortnum in January 1888 and given later in the same year. S. 3 in his catalogues. Employed by him as a chimney-piece ornament at the Hill House, Stanmore, together with three similar pieces (see Nos. 166, 168, and 169). Bought at the sale of the Debruge-Duménil Collection of *objets d'art* (for which see No. 292) in Paris, 23–31 January, 1–11 February, and 12 March 1850, lot 136 (no. 136 in Jules Labarte's catalogue of 1847)—'marbre blanc. Buste de Silène couronné de pampres 14 cents.' It cost Fortnum £3 10s. according to his notebook catalogue.

For heads of this sort see No. 165. This example is probably a companion piece for No. 168. The brass base has been lost from the latter and the use of the drill is more conspicuous in it. Fortnum believed it to be an ancient Roman piece broken from a sacrophagus relief and 'worked up' as a bust.

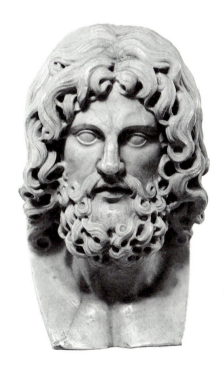

168. Terminal head of Jupiter Ammon

11.5 cms. (height)

White, presumably Carrara, marble, now brown with ingrained dust. It has been broken at the top of the neck and refixed. The proper left horn has been broken and most of it is lost. There are extensive traces of darkened adhesive on the stump of the horn. 'ᵮ / S.4' is painted in black on the rear of the term.

Lent by C. D. E. Fortnum in January 1888 and given later in the same year. S. 4 in his catalogues. Employed by him as a chimney-piece ornament at the Hill House, Stanmore, together with three similar pieces (see Nos. 166, 167, and 169). Bought from the sale of the Debruge-Duménil Collection of *objets d'art* (for which see No. 292) in Paris, 23–31 January, 1–11 February, and 12 March 1850, lot 135 (no. 135 in Jules Labarte's *catalogue raisonné* of 1847)—'marbre blanc. Buste de Satyr. 12 centimetres'. It cost Fortnum £3 10s. according to his notebook catalogue.

For heads of this sort see No. 165. This example is probably a companion piece for No. 167. Fortnum believed it to be of Pan and thought it was broken from the same relief.

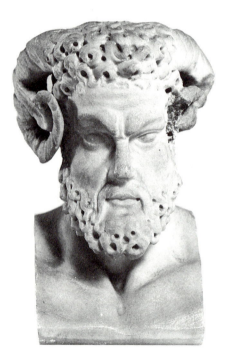

169. Mask of Pan or Silenus

17 cms. (height)

Giallo antico (yellow marble from Roman Numidian quarries), considerably abraded, also bleached, probably from exposure to the elements. The eye sockets are hollow as if designed for eyes of different coloured stone or paste. A portion has been broken off by the proper left ear and from the end of the central ringlet of the beard. The back of the mask is flat with holes filled with plaster of Paris in which large nails have been set. There is also a large patch of old glue on the flat back. 'S. / 2. / ᵮ.' is painted in black there.

Lent by C. D. E. Fortnum in January 1888 and given later in the same year. 'S. 2' in his catalogues. Employed by him as a chimney-piece ornament at the Hill House, Stanmore, together with three similar pieces (see Nos. 166, 167, and 168). 'from near Athens' according to both the large and the notebook catalogues. Acquired before 1857 when the preliminary catalogue, in which it is included (p. 1, no. 2), was compiled.

Although catalogued and displayed together with heads which he knew to be modern miniature chimney-piece copies Fortnum regarded this as belonging to a different category—'Greek. from near Athens. A boldly chiselled work full of artistic power. Probably the head of a terminal ornament.' In the notebook catalogue he speculated that the eye cavities would have been filled with coloured stone and after 'Greek' added 'or Greco-Roman'. Given the material it would have to date from after the Roman conquest of Greece, but it certainly does look ancient at first sight. It has, however, been confidently abandoned by the Department of Antiquities.

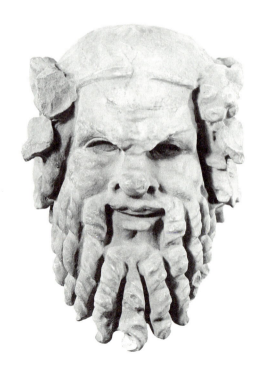

170. Four terminal busts of a bearded hero or deity attached to a bookcase

17.4 cms. (height of each); 9.2 cms. (length of each); 9 cms. (width of each)

Bronze with a dark brown varnish worn in several parts to a dark olive green natural patina. Hollow, lost-wax, cast, precisely chiselled. The busts are attached to, and were certainly made for, a bookcase illustrated in the photographs of C. D. E. Fortnum's house at Stanmore, probably dated from the later 1870s, but included in the album dated 1873. The bookcase was not included by him in any of his catalogues. It has long occupied the office of the Keeper of the Department of Antiquities, but whether it arrived in the Museum soon after Fortnum's death in 1899 or at a later date (for example through Arthur Evans) is not recorded. See below for more on the provenance.

The busts crown the pilasters which frame the three openings in the lower, plinth, stage of a severe but magnificent mahogany bookcase. Between each pilaster are glazed doors (double in the centre) and above these is a frieze containing drawers embellished, above each bust, with four gilt bronze or copper monograms of M and L interlaced below a royal crown. The frieze supports a shelf of somewhat grey *porto venere* (gold vein) marble from Genoa, above which rises the tall, narrower, rectangular upper stage of the case which is decorated, in the strips between the glazed doors, with an applied beading of darkly patinated bronze. This latter feature together with the pattern of the glazing bars, is typical of Tuscan neo-classicism. The numbers a, b, and c marked on ivory discs above the doors of the upper stage suggest that the case comes from a larger suite. Bookcases of a very similar character also with the same crowned monogram and similar bronze busts attached to the pilasters are to be found in the Palazzo Pitti: these are recorded as coming from Lucca at

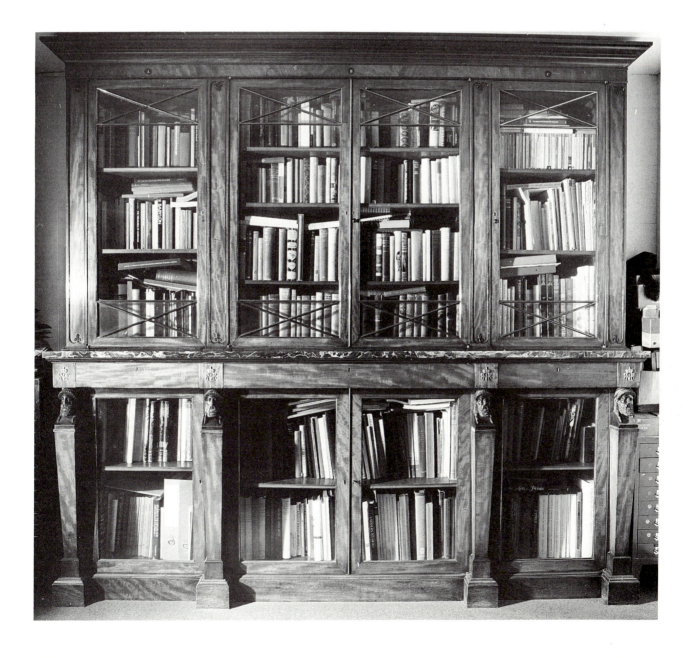

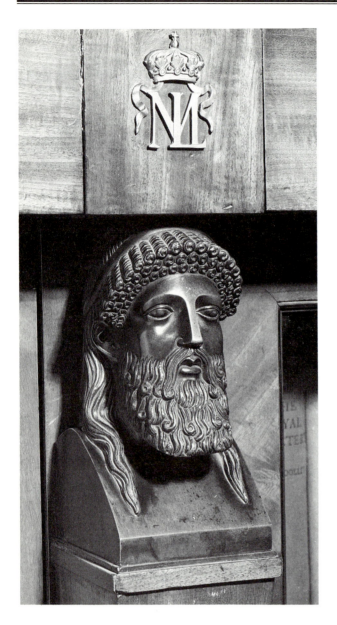

the very end of 1850, and Alvar González-Palacios has pointed out (cataloguing a comparable piece in *The Adjectives of History* (Colnaghi, June–July 1983), 34) that the monogram is that of Maria Luisa di Borbone (1782–1823), daughter of King Charles IV of Spain, who ruled the duchy of Lucca from 1817 until her death. The Ashmolean's bookcase must belong to this period: the crown is explained by Maria Luisa continuing to style herself queen (she had been very briefly queen of the newly created state of Etruria). González-Palacios notes that many talented cabinet makers, among them the Frenchman J. B. Youf, were active in Lucca in the early nineteenth century.

Queen Maria Luisa's furniture was retained in Lucca by her son Carlo Ludovico and his wife Maria Teresa of Savoy (daughter of Victor Emmanuel I) until 1847, when they became rulers of Parma (which had been Luisa's husband's duchy but had been granted at the Congress of Vienna to Marie Louise of Austria during her lifetime). After 1847 the furnishings of their palace in Lucca were dispersed, some remaining in Lucca, others being taken to Parma, and some (such as the bookcases already mentioned) being removed to Florence as the property of the grand duke of Tuscany to whom the duchy of Lucca now belonged. This was the very period at which Fortnum was starting to collect works of art in Italy and it is likely that he acquired the bookcase around 1850 and probably in Florence or Genoa. Alternatively he might have acquired it in Florence in 1875 when he seems to have bought many other items of furniture (e.g. Nos. 206, 209, 214, 215) for the refurbishment of Stanmore, but by that date he seems to have catalogued scrupulously his every acquisition, whereas in 1850 he probably did not regard even furniture of this kind as worth recording as part of his collection.

The bronze busts with their impassive expressions, the flattened front plane of the foreheads, the distinct curls of hair and beard, symmetrically disposed, must be modelled on a Roman marble copy of an archaic Greek bronze. The severity of style was more easily accepted in ornamental and architectural sculpture than in gallery statues in Napoleonic (and post-Napoleonic) Italy, as in Hadrianic Rome.

171. Fortitude

107.2 cms. (height from the upper surface of the integral base which is sunk in the top of the wooden pedestal); 102 cms. (height of pedestal); 48.5 cms. (diameter of base of pedestal)

Terracotta of a pale orange beige colour. Hollow and possibly cast. The upper part of the helmet is detachable and seems to have been fired separately. There is a break passing through the column and the figure's thighs. A large chip is missing from the lower part of the column shaft. Traces of gilding remain on the sandals, the column plinth, the girdle, and the cresting of the helmet. White paint, or at least a thin undercoat of gesso, remains in many of the hollows—its partial survival making the plaster repairs to the break already mentioned less conspicuous. The figure was mounted on a modern oak pedestal now employed for No. 78.

Ian Robertson wrote to Paul Wengraf of the Arcade Gallery (The Royal Arcade, 28 Old Bond Street, London W1) on 3 April 1963 that 'Although brought to the brink of bankruptcy by my so doing, I have decided to keep the terracotta figure, and accordingly enclose my cheque for £150.' The money had been found in the France Bequest Fund. The sculpture was evidently already in the Museum by April: it was registered on 21 June.

'The figure, originally polychromed and bearing traces of gilding, is emblematic of the city of Bologna', according to Ian Robertson publishing it in the *Annual Report* (1963), 52–3. There seems, however, no reason to suppose that it is anything more than a personification of Fortitude with the not unusual attributes of helmet, column, and club of Hercules. Robertson also wrote that it 'can be surely assigned to an artist of the Bolognese school, possibly a member of the Gandolfi family of sculptors.' For the sculptural activity of the Gandolfi see No. 37. This figure is not similar to any others that may reasonably be attributed to them. The pose is taken from a type of cross-legged antique Muse Polyhymnia known in a number of surviving marble versions which Canova so effectively imitated in his *Terpsichore* (completed in 1811). The gravity of demeanour, the lack of all flutter in the drapery, and the stationary and compact monumentality suggest a date in the first half of the nineteenth century. The figure no doubt comes from a series of Virtues, perhaps adorning the niches of a neo-classical palace, coloured white and gold to accord with the surrounding décor. It was not uncommon for terracotta to be used in this way and a number of figures supposed to be of stucco have turned out to be of terracotta coated with gesso. A large terracotta statue of *Ospitalità* in a private collection in Rome attributed by Federico Zeri to Camillo Pacetti (1758–1826), published in *Sculture del xv al xix secolo della collezione di Federico Zeri* (Milan, Museo Poldi Pezzoli, and Bergamo, Accademia Carrara, 1989) 66, is in very similar taste, as are smaller terracotta figures in Zeri's collection.

A sample was taken by Mrs Doreen Stoneham of the Oxford Research Laboratory for Archaeology and the History of Art in October 1986 and thermo-luminescence tests suggested that it had been fired between 1736 and 1836 (ref. 381-y-29).

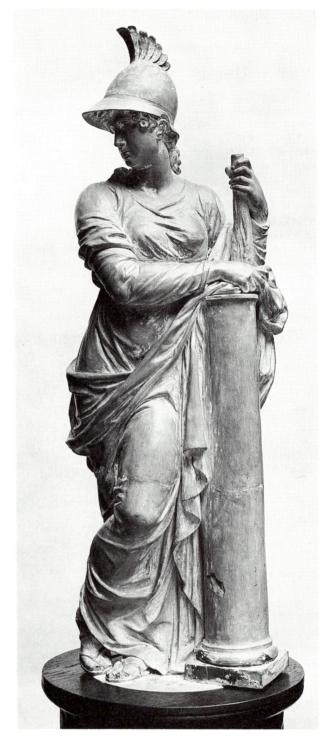

172. Profile head of a warrior

17.2 cms. (height from chin to forehead); 33.1 cms. (width)

Terracotta of a beige colour, partially covered with paint, now discoloured and flaking. The paint still covering much of the helmet is a dark grey. That on the face is a paler grey. There are traces of gilding on the crest of the helmet. The thickness of the relief varies between 3 and 5 cms. The relief is only a fragment but the edge behind the head and the corner behind the cresting of the helmet appear to be original.

No provenance is recorded.

The Greek profile and parted lips and rich flowing locks suggest the idealized portraits of Alexander the Great. The relief is probably Italian. It could date from the sixteenth, or the seventeenth, century but it more likely to have been made in the eighteenth or nineteenth, given the sympathy for, and knowledge of, Greek, as distinct from Roman, art which it reveals.

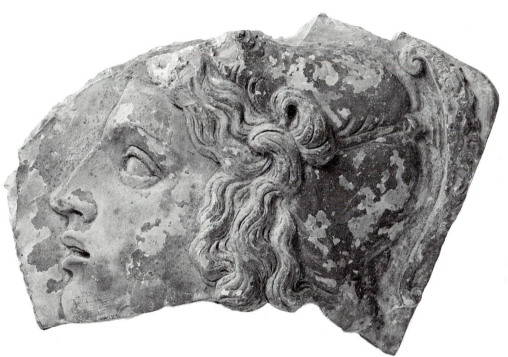

173. Ganymede with the Eagle

220.1 cms. (height, including integral marble base); 74.5 cms. (length, across the wings); 45.3 cms. (length of base); 29.2 cms. (width of base)

White Carrara marble. There are grey patches in the marble below the youth's right knee and at the back of the eagle's head and a rusty vein across the youth's chest. There are repairs to the dog's nose and its left ear (the latter is now loose). There are chips missing from the eagle's left wing at the tip and from behind the other wing. The sub-base is carved from a separate block of marble and so is the portion of the base to proper left together with the dog seated on it. The eagle's left wing is separately carved and added: the join is now loose. The drapery blown around in front of the youth's genitals is also separately carved, and presumably an addition which was not originally planned. Cleaned by Miss Western of the Department of Antiquities early in 1964. Mounted on a painted wooden pedestal. What must be the group's Victorian pedestal survives in the basement store: it is of Siena (flecked mustard yellow) marble of rectangular plan with canted sides and an arched front panel.

Given in 1937 by Mr Henry Donner (*Annual Report* (1937), 34). Placed on loan to the Cecil Jackson Room in the Sheldonian Theatre basement in March 1964. Retrieved and placed on the sill of the central window of the staircase to the Upper Galleries of the Department of Western Art in August 1989.

The only record of this sculpture seems to be the entry in the *Annual Report* for 1937 (p. 34) recording it as a work by Thorvaldsen given by Mr Henry Donner. It is not by Thorvaldsen, but by an Italian, or at least by a sculptor working in Italy, at the same period. The insipid sentiment, boneless grace, and considerable technical virtuosity are typical of sculptors such as Tadolini in Rome or of Giovanni-Maria Benzoni in Milan in the two decades following Canova's death. The cutting of the marble is in many passages very fine (for instance in the eagle's feathers, and the bark of the trunk), in the manner associated with skilled Italian craftsmen, but some of the drapery is routine and that which falls down beside the trunk is obviously designed to provide another vertical support. The bridge of marble between the index finger of the youth's left hand and his thigh was presumably intended to be removed after safe transport from the sculptor's studio. The support behind his left heel could however not be dispensed with prudently.

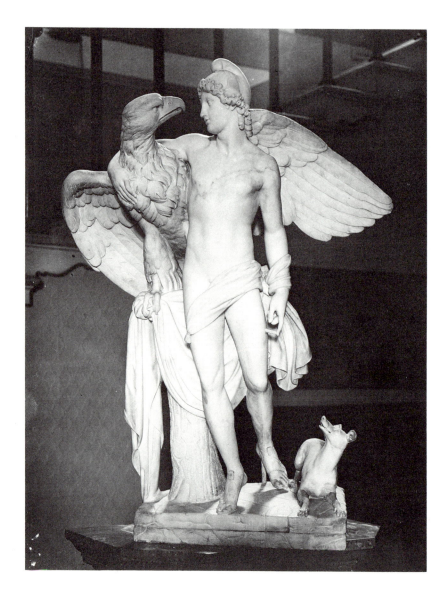

174. Head of a bishop saint

41.5 cms. (height); 50 cms. (length from top of mitre to chest)

Terracotta, pinky orange to beige in colour. The mitre is open at the top and the head has been clawed hollow from above. The cope has been modelled out of a separate piece of clay and this has been reinforced with clay from below to form a solid base. A hole has been pushed through this base to join the hollow in the head. There are firing cracks in the neck to proper right and, less conspicuously, across the beard. There are chips at the rim of the cope to proper right and there is a patch of plaster of Paris in the rim to proper left.

Bought for £1,200 from the Arcade Gallery (Paul Wengraf), The Royal Arcade, 28 Old Bond Street, London W1, in December 1966 out of the George Flood France Fund with a contribution from the Regional Fund administered by the Victoria and Albert Museum. The work was probably reserved in October. It was registered on 9 December.

Ian Robertson wrote to Hugh Wakefield of the Victoria and Albert Museum soliciting support for the purchase of this terracotta on 25 October 1966, praising the 'subtlety and distinction' of the modelling which he regarded as 'comparable with the quality of a painting by the elder Tiepolo'. Publishing it in the *Annual Report* for 1966 (p. 47) he considered it as the 'most noteworthy' of the five pieces of sculpture acquired in that year. In this case his enthusiasm was, it seems, supported by experts in the field. A letter from Charles Avery of the Department of Sculpture at the Victoria and Albert Museum to Ian Lowe on 8 December indicates that the idea that the terracotta was an eighteenth-century Venetian work came from the Keeper of his Department, John Pope-Hennessy. Avery proposed Giovanni Bonazza (1654–1736) as the artist and cited his figure of *St Zeno* completed in 1708 for the altar of St Antonio in the duomo at Montagnana (C. Semenzato, 'Giovanni Bonazza', *Saggi e memorie*, 2 (1959), 293, fig. 9), but also pointed to Giuseppe Bernardi ('Il Torretto') as a possibility. Robertson had already mentioned Bonazza in his letter to Wakefield in October and the terracotta had been registered as probably by him.

It is true that a similar type of bearded saint is found in works by Bonazza and Bernardi (see, for the latter, C. Semenzato, 'Giuseppe Bernardi detto il Torretto', *Arte veneta*, 12 (1958), 177, pl. 196), but the style of sketchy modelling with its deliberately smudged treatment of the features, the pupil of the bishop's right eye being almost indistinguishable, the beard expiring amid the lightly scribbled ornament of the cope, the opening of the lips left as a torn line, suggests a sculptor influenced by the *sfumato* of such late nineteenth- and early twentieth-century sculptors as Rodin, or, still more, Medardo Rosso. The introspective, even ghostly mood seems modern and so does the whole shape of the bust which is designed to give an apparitional, floating, character impossible to relate to a socle. (On arrival in the Museum the head was supported on an ebonized wooden stand from which it was emancipated on 4 January 1967 by Mohammed Saleh, during which operation a nut and a bolt, seven inches long, were removed from the back—as recorded in a note by Hugh Macandrew in the Register.)

Doubts concerning the antiquity of the terracotta are reinforced by the thermo-luminescence dating of samples taken from the head in April 1974 and October 1986 by Mrs Doreen Stoneham of the Oxford University Research Laboratory for Archaeology and the History of Art which indicated that the piece was fired less than 150 years ago (ref. 81-m-62 and 381-y-33). The probability of the work being modern does not make it a forgery. It might be a historical portrait in much the same spirit as Gemito's *Charles V* (No. 38), and, considered as such, it certainly possesses genuine merit.

FITTINGS FOR FURNITURE AND DOORS

Unassociated with a Named Sculptor or Craftsman
(Pediments, Frames, Knockers, Handles, Lockplates)

175. Ornamental pediment involving cupids and two putti supported by scrolls

14.2 cms. (height); 17.8 cms. (width of base moulding)

Bronze, with fire-gilding worn in parts to reveal a warm orange brown natural patina (most obvious on projecting knee of uppermost cupid). Lost-wax cast. The reverse is hollowed. There are distinct file marks in the lower part of the reverse. The circular interstices of the design—six in all, of two sizes—are drilled out of the metal. There is a crack in the scroll on the proper right side of the relief. 'B.1114 . Ƒ' is painted in white in the hollow reverse of the uppermost cupid.

Given by C. D. E. Fortnum on 15 November 1889. B. 1114 in his catalogues. 'Bought 10/-', according to his notebook catalogue, without provenance or date but after B. 1106 (No. 176) and probably in the later 1880s to judge from the number and the manner of its insertion.

See No. 176.

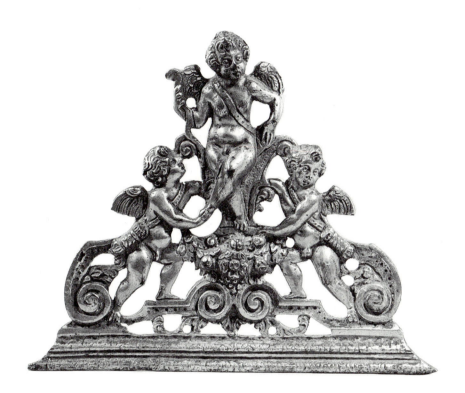

176. Ornamental pediment involving two winged putti, a mask, and a vase of flowers

13 cms. (height excluding ring); 15.8 cms. (length of base)

Bronze, with gilding (possibly fire-gilding, possibly a varnish) much worn to reveal a dull pale brown natural patina. Lost-wax, cast. The reverse is irregularly hollowed. The circular interstices of the design—six in all, of one size—are drilled out of the metal. 'B.— 106. ₣' is painted in white on the reverse of the vase.

Given by C. D. E. Fortnum on 15 November 1889. B. 1106 in his catalogues. No provenance or date of acquisition given, but presumably acquired after the compilation, in 1857, of his preliminary catalogue, in which it is not included.

The pediment is of very similar character to No. 175. The children's faces have the same round eyes and dimpled chins and curls—suggesting the type so popular in Venice in the late sixteenth century (see Nos. 82, 188–9, 225). They are also modelled in the same way, as those in No. 175, with elegance and naturalism sacrificed to the convenience of easily cut out or drilled out edges or apertures. The fact that the three putti in No. 175 are equipped with quivers and the

uppermost with a bow (confused with the scrollwork) indicates that they represent Cupid and two companions whereas in this case the winged putti could be angels. This pediment unlike No. 175 is also fitted with a suspension ring and the base moulding has projections with screw holes.

Pediments of this size and character served to adorn both secular and sacred objects: mirrors, bronze plaquettes, especially paxes, Limoges enamel portraits (there is one in the Nelson Atkins Museum, Kansas City), or even the three visible faces of a wall clock. A Venetian origin is suggested not only by the children's faces but by the similar character of the triangular pierced ornaments on the sides of the gilt bronze monstrance for the staurotheca of Henry of Flanders composed of fragments of the True Cross in the Treasury of St Mark's in Venice. This monstrance was probably made in 1618 when the reliquary was placed on the altar of the Holy Sacrament in the Basilica (see H. R. Hahnloser (ed.), *Il tesoro di San Marco*, ii (Florence, 1971), no. 140). These ornaments not only involve cherubim with heads like the putti and very similar scrolls but the casting is rough and the treatment of the apertures identical to that in the pediments. The backplate of a Hanukkah lamp in the Victoria and Albert Museum (M. 418-1956) which is datable on armorial evidence to the early seventeenth century is also in a very similar style and handling.

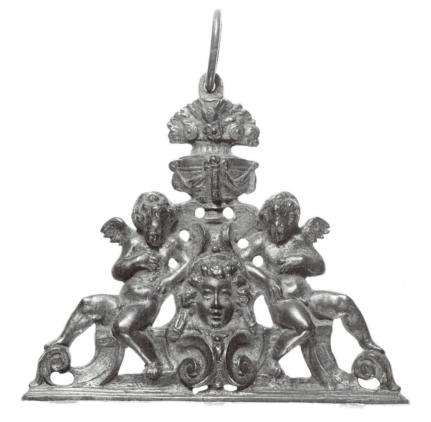

177. Oval frame of strapwork involving cherubim and angels

30.5 cms. (height); 23.0 cms. (width)

Bronze with a chocolate patina, fire-gilt on edges of the strapwork (but by some means which involved the application of gold leaf, for the distinctive overlaps of the leaves are evident on the edges of the strapwork top right and lower left). The metal is torn and cut at the junction of the wings of the lower cherub. Mounted against red velvet.

Lent by C. D. E. Fortnum on 20 March 1888, given later in the same year. B. 1050 in his catalogues. Purchased for £15 at the sale of the collection of Matthew Uzielli at Christie's, London, 17 April 1861, lot 670, using 'Whitehead' (presumably the dealer T. M. Whitehead) as his agent; previously in the Roussel Collection.

Fortnum, who was sparing with his superlatives, described this simply as 'very beautiful in design and execution'. He considered it as probably Florentine of about 1570, and also noted that a cup or shell for holy water had been detached

from below the lower cherub. He was repeating the views of J. C. Robinson given in his *Catalogue of the Various Works of Art Forming the collection of Matthew Uzielli, Esq. of Hanover Lodge, Regent's Park* (London, 1860), no. 605), except that Robinson thought that it might be either Venetian or Florentine. Fortnum supposed that a devotional painting would have filled the frame—a mirror, he noted, had 'recently' been fixed in place. The heraldic device (crest or badge) of an eagle with open wings, its breast bitten by the serpent it holds in its talons, which appears as a relief where the strapwork rises up into an ogee crown, and the motto 'SEMPER ARDENTIUS' chiselled into the metal, have not been identified—Michael Maclagan points out that the motto is not in Dielitz and he has not traced it elsewhere. It might, however, be an impresa. The 'smaller Talman volume' in the Ashmolean includes a number of frame designs of a comparable but not very similar character, notably one (p. 117) attributed to Naldini, with figures incorporated in strapwork (probably for a coat of arms), and one (p. 114) attributed to Federigo Zuccaro involving strapwork and a cherub's head (K. T. Parker, *Catalogue of Italian Drawings in the Ashmolean Museum* (Oxford, 1956), no. 755).

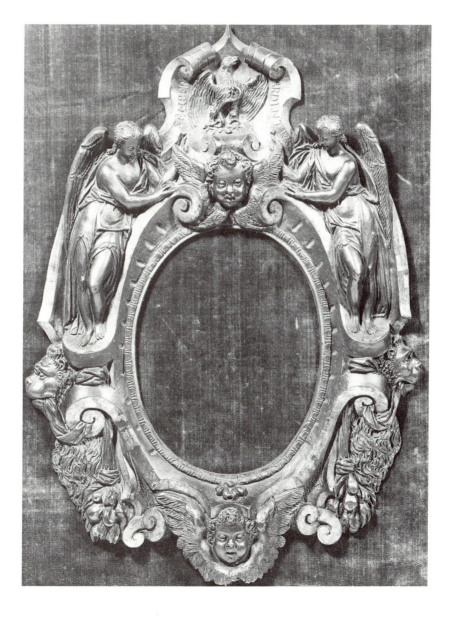

178. Door fixture in the form of a lion's head roaring, for the suspension of a handle or knocker

13 cms. (height); 12 cms. (width)

Bronze with a dull green and brown natural patina and patches of verdigris, rubbed in small areas at the edges to reveal a yellow metal. Hollow behind. 'B / —54/Œ' in white paint on interior with a small square paper label placed diagonally with blue printed border inscribed 'B / 1054' in ink.

Lent by C. D. E. Fortnum on 7 January 1888 and given later in the same year. B. 1054 in his catalogues. 'Bought in Rome' according to his notebook catalogue, with no date, but presumably after the compilation in 1857 of his preliminary catalogue, in which it is not included.

The handle or knocker would have taken the form of a ring passed through the loop joining the lion's lower jaw with the projection below. Fortnum catalogued this 'vigorously modelled' fixture as of the early sixteenth century, but it could easily be later in date. He noted that it was inspired by ancient Roman art and speculated that it might even be antique, describing the patina as that which comes from burial.

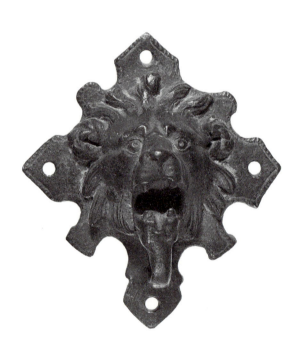

179. Door-knocker in the shape of a lyre, decorated with a half-length woman restraining two lions by their manes

28.5 cms. (height); 23.7 cms. (width); 15.3 cms. (width of scrolls at top); 4.1 cms. (nipple to nipple)

Bronze with a dark chocolate brown natural patina, palest where most handled. Very heavy, lost-wax, cast. The head and arms of the figure and the back legs of the lions are solid; the torsos of the figure and the lions are open behind. A square piece of iron, chamfered at the top, is inserted as the knocker's hammer. A small patch of metal has been inserted in the back of the lion to proper left. There have been many blows and dashes to the surface, but most detail has apparently been reproduced from the model. 'B / —96. /Œ' is painted in white on the inside of proper right scroll at the top.

Lent to the Museum by C. D. E. Fortnum on 20 March 1888 and given by him later in the same year. B. 1096 in his catalogues. Bought in 1876 'from the Late Miss Ellen Rigby' (cf. No. 181) according to the large catalogue, for £10 according to the notebook catalogue.

This type of door-knocker exists in many versions including the following: Bayerisches Nationalmuseum, Munich (see catalogue of that collection by H. R. Weihrauch (Munich, 1956), 108, no. 132); Bischoffsheim Collection, now untraced (W. Bode, *Italian Bronze Statuettes of the Renaissance*, ii (London 1908), no. CLXXV); Staatliche Museen, Berlin-Dahlem (5045; see L. Planiscig, *Venezianische Bildhauer der Renaissance* (Vienna, Berlin, 1921), 577, pl. 633); Victoria and Albert Museum, London (1592-1855); Meyer-Ilschen Collection, Stuttgart-Bad Cannstatt (cited by Weihrauch, loc. cit.). Another version was with the Arcade Gallery in 1962. Fortnum knew only of the Victoria and Albert version which he regarded as the 'fellow' of his own (that is as having originated on the other valve of the same palace door). There are many variations both in the general shape (if the models were taken from the same moulds they would have been rough and altered in each case) and in the handling which is in all cases bold. For instance, the Victoria and Albert Museum's version, that in Berlin, and that in Paris are all tighter in composition than the Ashmolean version with less space between the woman's shoulders and the arms of the lyre and with less space above her head. The scroll projecting at the figure's lower abdomen is rather more salient in the Ashmolean version than in the Munich or Victoria and Albert versions and it is different in form—there is a sort of flat strapwork in the Berlin version. The latter version also has an ornamental comb in the figure's hair and has a bearded bacchic mask at the top between the scrolls of the lyre concealing the ring hinge.

There exist nineteenth-century copies of this type of knocker: one is in the Walters Art Gallery, Baltimore (no. 54.4, bought from Seligmann, Rey and Co., New York, 1917), and another in the Art Institute, Chicago (1973.375). In both cases the detail, although in some respects clearer (especially the ornament on the scrolls which is at best smudged in some of the versions cited above), is not chiselled and the reverses are obviously sand-cast and much less crude than is typical of Renaissance knockers.

There is a related type of door-knocker also in the shape of a lyre and with lions climbing down each scroll arm, their tails curling around it, their front paws supporting a projecting shell handle, and their heads turned up—but with a whole-length figure standing between them and not touching them. The figure is a nude Hercules, his left hand on his hip, his right brandishing a club, in the examples in the Fitzwilliam Museum, Cambridge (M29-1917) and in the Rijksmuseum (J. Leeuwenberg, *Beeldhouwkunst in het Rijksmuseum* (Amsterdam, 1973), 387, no. 657), but is more commonly a draped female. Planiscig, illustrating two of the latter (one once in the Pierpont Morgan Collection, inscribed 'GIO . ANTO . TAVANI', now untraced, and one in the Kunstgewerbemuseum, Berlin, noted the close relationship in the figure style between these and the work of the Venetian sculptor Tiziano Aspetti (op. cit. above, 576–7, pls. 632–3). The figure in the Morgan version is indeed derived from a statuette of Judith (known in many versions, among the best being the cast in Sir Brinsley Ford's collection, that in the Museo Civico, Padua, and that sold at Christie's, London, 5 July 1988, lot 83), which is attributed to Aspetti on account of its resemblance to his signed statuettes of *Charity* and *Temperance* (dated 1593) on the rail of the high altar of the Santo in Padua. It is possible that Aspetti, having invented one figure, would then repeat it with little variation for a different purpose, but such an adaptation is also probable in a lesser artist, indeed an artisan founder such as were probably responsible for the design as well as the casting of all but the most extraordinary knockers. But if the design of this 'very harmonious and well-compacted model', as Fortnum justly described it, is by a leading sculptor then Aspetti is certainly a likely candidate.

This type of knocker may well have been traditional in Venice. The most important source for our knowledge of the knockers there is the set of forty-five drawings made by the Flemish artist Giovanni Grevembroch in 1758 of 'Battori, Batticoli e Battioli in Venezia' as it is headed—published in facsimile in G. B. Brusa as *Raccolta di Battitori a Venezia* in 1879 (the only copy in Britain is in the National Art Library, Pressmark 204.b.26). No. 5 in this series, located at Palazzo Longo ai Servi in Rio della Sensa, has a full-length figure of Hercules between a pair of downward climbing lions on lyre-formed scrolls. No. 26, located at the Monastero di S. Zaccaria, has similarly arranged lions but with less torsion in their poses, suggesting an older pattern. No. 27, located at the Monastero di S. Giuseppe, is similar to no. 5, but with a full-length standing female figure. No. 28, located at Levi dal Banco, has a nude boy between less twisted lions (and no shell handle). Nos. 29 and 30 'dei Belilios' and 'dei Bendana' are similar to no. 5, the latter with a Bacchus, as is no. 32, at Palazzo Garzoni a San Samuele, where the full-length figure is a personification of Hope, and no. 39 at Casa Loredan a 'S. Maria Nova' where it is a nude male hero. Half-length female figures are also found on Venetian knockers recorded by this source—for instance no. 16, at Casa Diedo

a S. Giovanni in Oleo, where, however, the figure is really a
mermaid whose split fish legs curl up to form the arms of the
lyre. There is, however, no reason to suppose that these types
of knocker were only made at Venice. A pair of lions on a
lyre-shaped knocker will be found, for instance, in an example
recorded on a palace in Bologna (see Gaetano Marchetti,
Antichi ferri e bronzi d'arte nelle porte degli edifici di Bologna
(Bologna, 1969), 21, fig. 16), although admittedly a
Bolognese knocker could have been made in Venice.

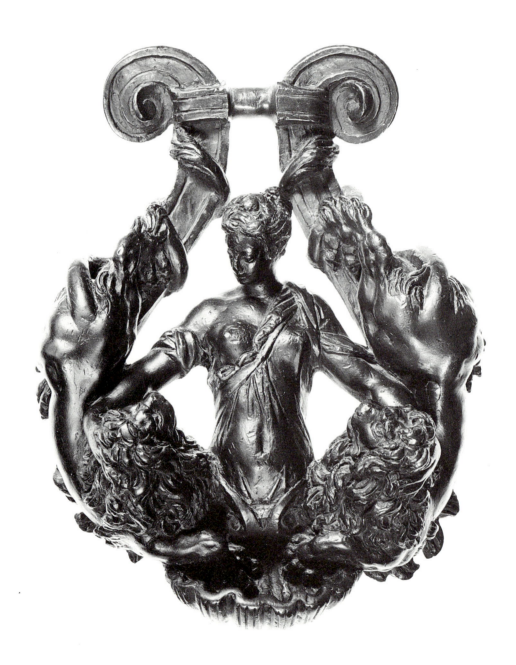

180. Door-knocker formed of winged monsters and a grotesque mask

24.2 cms. (height); 23.3 cms. (width, head to head)

Bronze with natural dark chocolate patina, paler in more salient parts (e.g. foliate beard and hair and noses of monsters). Heavy, lost-wax, cast, open behind. A circular piece of iron is inserted as the knocker's hammer. An iron cross-bar, concealed by the binding of the tails, is designed to fit a ring hinge. The linear detail of hair, furrowed brow, and feathers is reproduced from rough and rapid work in the wax model and retains much burr. 'B / —95 / Ⅎ' painted in white on the reverse. A blue-bordered square paper label inscribed 'B 1095' in ink is also attached to the reverse.

Lent by C. D. E. Fortnum on 7 January 1888, and presented later in the same year. B. 1095 in his catalogues. 'Bought in London in 1849', according to the large catalogue; 'at a Sale' there at that date and for 2 guineas, according to the earlier notebook catalogue; 'in London in 1850' according to the preliminary catalogue compiled in 1857 (p. 45); it is presumably the 'smaller bronze knocker' on which he spent 2 guineas before 1851 according to his 'Memorandum of prices paid'.

No other versions of this knocker have been recorded. The lack of rhythm in the composition and the awkward compilation of parts—wings, fish tails, lions' paws, human heads—is hard to match in other inventions of this sort, however grotesque. The basic scheme may be matched in at least one knocker known to have been on a Venetian Renaissance palace door by the mid-eighteenth century: no. 34 in the collection of drawings of such knockers made by Grevembroch (see No. 179) shows one at Palazzo Grimani a San Luca, composed of a pair of dolphins, their curling tails bound together at the top, and supporting below, between their heads, a grotesque mask with foliate projections. There is also some similarity with a type of knocker consisting of a mermaid and a triton curling round with a grimacing mask below (Metropolitan Museum, New York, 17-190-2096; Victoria and Albert Museum 555-1877; and K. Pechstein, *Bronzen und Plaketten, Staatliche Museen preußischer Kulturbesitz* (Berlin, 1968), 15, pl. 4).

Fortnum regarded this knocker as a 'fine vigorous model roughly but artistically executed and cast from the wax' and catalogued it as north Italian and of the late fifteenth or early sixteenth century—but in his notebook catalogue simply as of the first half of the sixteenth century. The grotesque ornament is more easily associated with work of the second half of the sixteenth century and could be of a still later date.

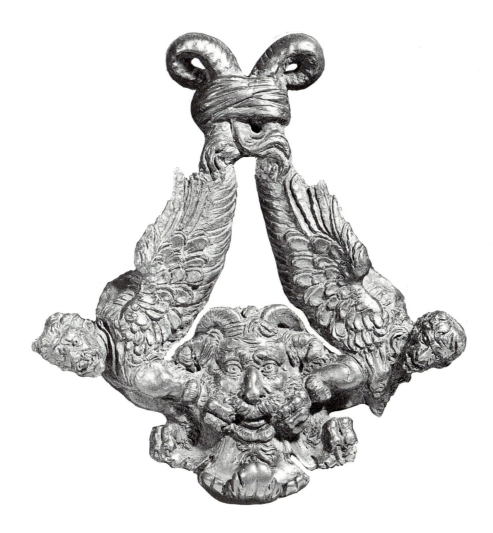

181. Door-knocker in the form of Neptune accompanied by a pair of hippocamps

45.5 cms. (height); 30.1 cms. (width)

Bronze with a dark brown natural patina worn to yellow on the noses of the hippocamps and on the shell handle. Heavy, lost-wax, cast, solid in the ends of the tails of the hippocamps, in the head and limbs of Neptune, but hollow in the god's chest which is open behind. A chaplet pin remains in his chest; there is a hole where the pin was passed through the metal on the other side. A piece of iron (4.5 cms. square) is inserted as the knocker's hammer. Much of the surface, and Neptune's flesh especially, has been extensively tooled with small scratchy lines, apparently in the metal, but the equine parts of the hippocamps are textured with small circles which look as if they have been impressed into the soft wax model with an anular punch (in a few areas the cleaning of the metal after casting has removed this texture). The bold lines defining wings, hair, mane, and the like also look as if they are cut into the soft model rather than the hard metal. There are small perforations in the chest of Neptune and above the nose of the hippocamp to proper left. There is a threaded insertion for a missing extension to the trident handle. 'B / — 97 / ⊕' painted in white on the reverse of the tail of the hippocamp to proper right.

Lent by C. D. E. Fortnum on 7 January 1888 and presented later in the same year. Numbered 1097. 'Bought from Miss Ellen Rigby' according to the large catalogue, for £10 in 1876 according to the notebook catalogue, having been bought in London 'about 1846' by her father George Rigby (see also No. 179).

Fortnum was aware of another version of this type of knocker. It was one said to have been on the door of Ca Pesaro in Venice, 'taken by Edward Cheney' and (in 1883 when Fortnum was compiling his catalogue entry) still in the possession of the Cheney family. According to Fortnum this was the same one that was reproduced by Matthew Digby Wyatt in his *Metal Work and its Artistic Design* (London, 1852), pl. 7, as from the Pisani Palace and 'regarded as the handsomest in Venice' (ibid. 73). When exhibited at the Burlington Fine Arts Club in 1879, however, the Cheney knocker was said to have come from the 'Corner palace'. Numerous other versions are now known, many of them modern. Fortnum observed, in tracing his back to about 1846, that this was 'long before the modern casts were fabricated for sale'. Consulting Grevembroch's drawings of old Venetian knockers made in the mid-eighteenth century (for which see No. 179) we find that examples were then to be seen on Palazzo Gradenigo at Santa Giustina and at Palazzo Lezze alla Misericordia (his nos. 1 and 2). He also illustrates one with hippocamps and shell handle at the Monastero della Celestia (no. 37) from which a Neptune had perhaps been detached.

The following list of versions of this type of knocker is certainly not complete, but is longer than the fullest previously published (J. Balogh, *Katalog der ausländischen Bildwerke des Museums der bildenden Künste in Budapest* (Budapest, 1975), i. 164–5, no. 213). It is arranged alphabetically by location. Alnwick Castle, Northumberland; Antwerp, van Beuningen Collection (*Phoenix*, 4 (1949), 171); Baltimore, Walters Art Gallery (514.3); formerly Berlin, Oscar Huldschinsky Collection (Berlin sale of 1928, lot 91, cited by Balogh, op. cit.); Boston, Gardner Museum (C. Vermeule, W. Cahn, and R. Hadley, *Sculpture of the Isabella Stewart Gardner Museum* (Boston, 1977), 155, no. 194); Budapest, Museum of Fine Art (Balogh, op. cit., no. 213); Budapest, Adolph Kohner Collection (Ernst Museum Aukciói, XLVIII, no. 313, cited by Balogh, op. cit.); Cambridge, Fogg Art Museum (1953.41, *Fogg Art Museum Annual Report* (1952–3), 14); Chicago, Art Institute (1950-1171; no. 34 in *Art of the Renaissance Craftsmen* (Fogg Art Museum, May 1937), when in Jellinek Collection, Buffalo); Detroit, Institute of Art (47.141; *Bulletin*, 32/1 (1952–3), 6); formerly Durham, N. Carolina, Duke University (sold Sotheby's, New York, 30 May 1987, lot 68); Edinburgh, Royal Scottish Museum (1877.20.41); London, British Museum (H. Weihrauch, *Europäische Bronzestatuetten* (Brunswick, 1967), pl. 184); Milan, Mylius Collection (A. Pettorelli, *Il bronzo e il rame nell'arte decorativa italiana* (Milan, 1926), fig. 181); formerly Munich, Marczell von Nemes Collection (Munich sale of 16–19 June 1931, vol. ii, lot 413, pl. 91, cited Balogh, op. cit.); Munich, Bayerisches Nationalmuseum (65.132, in reserve); formerly New York, William Randolph Hearst Collection (Hammer Galleries (1941), 58); Padua, Museo Civico (B. Candida, 'Un bronzo di Alessandro Vittoria', *Prospettiva*, 28 (1982), 79–82, fig. 4); Paris, formerly Bischoffsheim Collection, now untraced); formerly St Petersburg, Botkine Collection (catalogue of 1911, pl. 46, cited Balogh op. cit.); Trieste, Civici Musei di Storia e d'Arte (Candida, op. cit., fig. 5); formerly Venice, Antichità Pietro Scarpa (*Burlington Magazine*, Supplement (June 1972), pl. XX); Venice, Museo Civico Correr, version (*a*) (Candida, op. cit., fig. 2); version (*b*) (no. 215); version (*c*) (no. 1179, formerly Conte Cernazzi, Udine); Venice, Palazzo Loredan, Santo Stefano (Candida, op. cit., fig. 1); Venice, Palazzo Pisani (see Wyatt, op. cit., also L. Moretti in *I Pisani di Santo Stefano e la opera d'arte del loro Palazzo* (Venice, n.d.), 177, pl. 50); also two replicas of the same stolen about a decade ago from the Palazzo Pisani doors, one reproduced *Country Life* (12 July 1962), 90; Venice, Palazzo Clary, 1397 Zattere, Consulat Général de France (Candida, op. cit., fig. 6); formerly Vienna, private collection (auction of 1928 cited by Balogh, op. cit); formerly Vienna, Castiglioni Collection; Vienna, Kunsthistorisches Museum (no. 5973; Weihrauch, op. cit., pl. 183).

Modern casts were known to Fortnum, as we have seen, and the versions recently stolen from Palazzo Pisani were acknowledged as replicas. Among those listed above that I have seen, those in Boston, Detroit, and (formerly) Durham impressed me either as very inferior late casts or as poor nineteenth-century imitations, while that on Palazzo Clary, Venice, looks like a modern replica. Variations on the model are also known. In one of these Neptune, accompanied by lions like those in No. 179, is sticking his trident into the rump of one and stroking the other (an example, unnumbered, is displayed in the Museo Nazionale di Palazzo Venezia in Rome and another is illustrated in T. G. Jackson's *Dalmatia* (Oxford, 1884), 268).

Since at least the early years of this century knockers of this type have been associated with the name of the Venetian sculptor Alessandro Vittoria, but even the best of them (that in Palazzo Loredan, Venice) has some clumsiness which would be unlikely in a faithful reproduction of a model by him. Weihrauch (op. cit.) illustrates a terracotta Neptune in the British Museum attributing it to Vittoria. The head possesses a similar *terribilità* and the right arm is similarly raised, but the anatomy is more correct and the modelling more fluent than in the equivalent figures on the knockers. To describe the knockers as Style of Vittoria is not unreasonable but there is no evidence that he had assistants engaged in turning out door furniture, and we know that he did not cast his own figures (for the independent founders employed for his *St Sebastian* see *The Genius of Venice* (Royal Academy, 1983), 388, S. 37—entry by M. Leithe-Jasper).

The subject would seem to illustrate the *Quos ego* from Virgil's *Aeneid*—the moment when in Book One the irate god of the ocean calms the storm which, urged by Juno, the winds had stirred up to destroy the Trojan fleet. Neptune utters the words 'Quos Ego' ('Whom I') of a sentence he is too angry to complete. The subject was extremely popular in bronze sculpture of the late sixteenth and early seventeenth centuries both north and south of the Alps: among the most notable groups are that in the Cleveland Museum of Art (74.273) and those in the Walters Art Gallery, Baltimore, (54.49 and 54.2441—both reproduced in E. P. Bowron, *Renaissance Bronzes in the Walters Art Gallery, Baltimore* (Baltimore, Md., 1978), 47 and 55) and that sold at Sotheby's, London, 8–9 December 1988, lot 104, while the most famous of all is the superb bronze in the Victoria and Albert Museum (A. 99-1910), long attributed to Vittoria, but recently published by Anthony Radcliffe as perhaps by Vincenzo Danti and reflecting his competition design for the Neptune Fountain in the Palazzo della Signoria, Florence (*Burlington Magazine* (Dec 1988), 932).

The quality of the Neptune knockers varies greatly. The Ashmolean's is not one of the best—'the workmanship', Fortnum conceded, 'is rather coarse'. Indeed the modelling, especially of the hands, the lower abdomen, and breasts, one of which is oddly merged with the shoulder, is bad. Among the more visible of the versions listed those in the British Museum, the Correr (*a*), and Vienna are certainly far superior, although also full of faults. The type of finish also varies and I have found nothing like the texturing on the Ashmolean's bronze in any other version. There are numerous variations in the character of the trident (usually stumpy, often bent) and the position of the heads of the hippocamps. The wings of the hippocamps are unusually soft and rounded in the Ashmolean's version; they are usually spiky although those of the version in Palazzo Loredan, Venice, are unique in resembling spiney dorsal fins. Arms behind Neptune's head, as in the Ashmolean's version, are not unusual—cf. London, British Museum; Budapest; Correr (*a*). They never seem well integrated into the composition and are sometimes manifestly added after casting (as in the British Museum's version). The arms in the Ashmolean's version—(blank) three bends (blank), with a coronet with seven pearls and an ample

mantle—are hard to identify without tincture but could be, Fortnum observed, of the Bianchetti and Ghislieri of Bologna, or of the Bandini of Florence—but Michael Maclagan notes that there are numerous families using this shield, but relatively few with a right to a coronet.

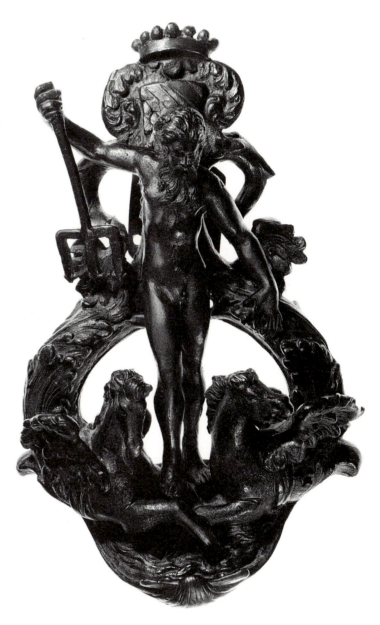

182 and 183. Pair of furniture handles in the form of scrolls, suspended from a lion mask, terminating in dogs, an eight-pointed star between their front paws

5.8 cms. (height of each handle); 5.7 cms. (width of each handle); 3.9 cms. (height of lion mask); 2.7 cms. (width of lion mask)

Bronze, fire-gilt. The gilding is tarnished in parts and in others is worn to expose a brown natural patina. Lost-wax casts, slightly hollowed behind. Fixed to the centres of the arched panels in the two doors of a small nineteenth-century cabinet of pale mahogany (68.6 cms. high; 43.1 cms. wide, 35 cms. broad).

Bequeathed by C. D. E. Fortnum in 1899. B. 1056 and B. 1057 in his catalogues. 'Bt. Florence'—presumably after 1857 when his preliminary catalogue, in which they are not included, was compiled. Attached by him to the cabinet in which he kept his collection of rings, which cabinet, by accident, has remained in the care of the Department of Antiquities.

The handles were catalogued by Fortnum as Italian of the sixteenth century—they are surely of the second half of the century and perhaps of the early seventeenth century and are likely to have been made in Florence (where they were acquired) in which city volutes of elegant form ornamented with overlapping scales or coins were much favoured. The dogs and star may well have been suggested by the *impresa* of the family for which they were made.

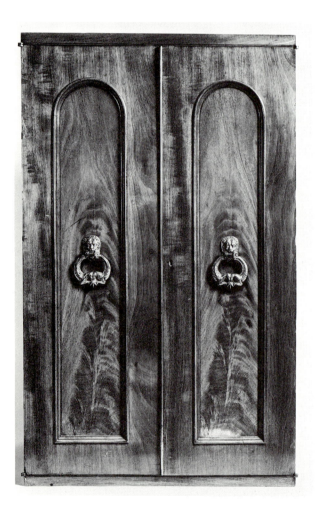

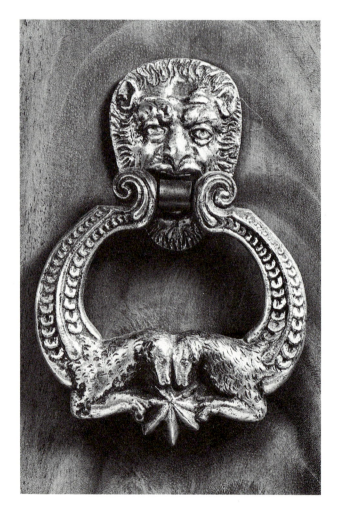

184 and 185. Pair of door-handles in the form of busts of Bacchus and Ariadne (*Bacchus* only traced)

12.8 cms. (height)

Bronze of a dark brown to black patina. Heavy, lost-wax, cast. Hollow behind but the head solid (or filled). An iron prong inserted into the rear of the chest has been broken off.

Given by C. D. E. Fortnum on 15 November 1889. Nos. 1062 and 1063 in his catalogues. 'Bought in Florence'.

Dated by Fortnum to the second half of the sixteenth century and described as 'coarse'—the coarseness is not untypical of much routine ancient Roman work and it is possible that the Ariadne has in the past been mistaken for a genuine Roman work. It is curious that in Fortnum's preliminary catalogue of 1857 he lists a male head handle without a companion and observes that it is of fine execution (47, no. 12), but there is no unpaired male head handle in his subsequent catalogues.

186 and 187. Pair of door-handles in the form of identical busts of laurel-crowned men in Roman armour

10.3 cms. (height)

Bronze of a brown natural patina with traces of black varnish. Lost-wax casts, hollow behind but the heads solid (or filled). Threaded iron prongs are inserted in the back of each neck. The surfaces have been roughly chiselled. In one case the bronze is dented on the nose. There is a firing crack across the lower neck of one and a portion of bronze is missing from the proper left shoulder of the other.

Given by C. D. E. Fortnum on 15 November 1889. Nos. 1073 and 1074 in his catalogues. Not in his preliminary catalogue of 1857, presumably acquired after that date.

Dated by Fortnum to the sixteenth century, they are 'coarse work', as he also observed, and could have been made at any time in the sixteenth, seventeenth, or eighteenth century.

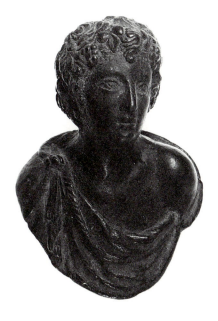

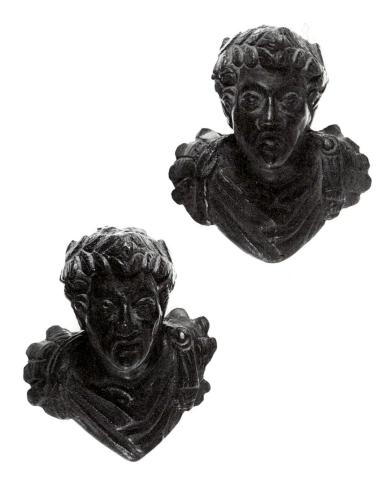

188 and 189. Pair of door-handles in the form of male and female bacchic busts

11.3 cms. (height of male); 11.4 cms. (height of female)

Bronze of light inferior alloy with a natural chocolate patina. Hollow, probably lost-wax, casts, open behind. Iron prongs are inserted in sockets behind the necks. Small screw holes at lower edges of chests (torn in one case). Small holes at both sides of both chests (possibly from chaplet pins). The hair on the back of the female head is unmodelled.

Given by C. D. E. Fortnum on 15 November 1889. B. 1071 and B. 1072 in his catalogues. Probably the 'Head of Bacchus' and 'Ariadne the companion' dated c.1570, nos. 10 and 11 on p. 47 of his preliminary catalogue compiled in 1857.

These handles were dated by Fortnum to the sixteenth century. The original models may well have been Venetian of the late sixteenth century since they resemble the curly-haired types much favoured in the decorative bronzework associated with Roccatagliata (see No. 82). However, these casts are 'coarsely executed', as Fortnum also observed, and could have been made at any time in the succeeding centuries. The male head is among the types of handle still made in Venice by the Valese Foundry (Madonna dell'Orto 3535) and retailed at their shop (793 Calle Fiubera, S. Marco) for

155,000 lire. This foundry commenced business in Venice in 1913 but no doubt took its models from earlier foundries. Modern examples may be seen on many doors in Venice (for example on those of the offices of Adriatica, Zattere 1413), but ancient ones are rare—those on the late sixteenth or early seventeenth-century vestment cupboards of the Sagrestia Grande of S. Stefano (of which seven were in place in 1989) appear to be original. An example of the male bust together with a similar female model are included in a display of such 'testine decorative' in the Museo Davia Bargellini in Bologna. (These are published in R. Grandi (ed.), *Museo Civico d'Arte Industriale e Galleria Davia Bargellini* (Bologna, 1987), 212–13, no. 163, entry by R. d'Amico, suggesting that they are of Bolognese manufacture: they are the fifth from left in the middle row of the upper illustration and third from right in the top row in the lower illustration.) What appears to be a version of the male bust is in the Heinz Schneider Collection (W. D. Wixom, *Renaissance Bronzes from Ohio Collections* (Cleveland Museum of Art, Cleveland, Ohio, 1975), no. 125). A slightly larger variant of this, but better modelled and more crisply finished, is in the Victoria and Albert Museum (reserve, A. 11-1944). Nos. 5735, 5736, 5737, 5738, 5739, and 5741-1859 in the same museum are of very similar character but with drapery in place of fruit swags, as is another handle in the Schneider Collection (Wixom, op. cit., no. 123). Such handles are also very common in the sale-rooms but are seldom illustrated.

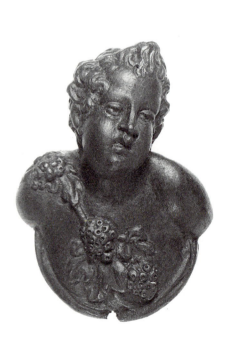

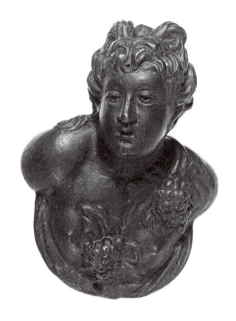

190 and 191. Pair of door-handles in the form of identical bald male Moorish heads, rising from chests cut in a scroll shape

8.7 cms. (height)

Bronze, with red varnish deteriorated to black and worn to reveal metal with a natural greeny-brown patina (much more worn in one case). Lost-wax cast, open behind, with projections, integrally cast, with threaded perforations.

Given by C. D. E. Fortnum on 15 November 1889. Nos. 1066 and 1067 in his catalogues. 'Bought in Italy', presumably after 1857 when the preliminary catalogue, in which they are not included, was compiled.

Fortnum dated these to the sixteenth century and commented that they were of 'good work'. The exotic taste is more suggestive of the seventeenth or eighteenth centuries. A somewhat similar bald Moor with big ears, a frown, and terminated at the neck with an undulating line serves as a handle to the front door of No. 67 Via degli Alfani in Florence (noted autumn of 1987).

192 and 193. Pair of door-handles in the form of identical, nearly bald, male heads with moustaches, rising from drapery

9.2 cms. (height)

Bronze, of natural pale greeny brown patina. Lost-wax cast, hollow behind, with integrally cast bars across back (one with a threaded brass prong attached to it). One handle (of slightly darker colour) had a patch inserted on top of the head. There are circular plugs in both necks.

Given by C. D. E. Fortnum on 15 November 1889. Nos 1064 and 1065 in his catalogues. 'Bought in Italy'. Not in his preliminary catalogue of 1857.

Fortnum dated these to the sixteenth century and commented that they were of 'good work'. The oriental features are more suggestive of the exotic fashions of the seventeenth or eighteenth centuries. A pair of moustached and pigtailed Chinamen of similar character but in rococo surrounds serve as handles to the doors of No. 29 Via Ricasoli in Florence (noted autumn 1987). Very similar handles are still cast by at least one Florentine foundry, that of Enzo and Renato Rafanelli, who sell them for 50,000 lire each at their showroom in Via del Sole. Similar but miniature heads sometimes serve as handles in ornate early eighteenth-century Italian cabinets.

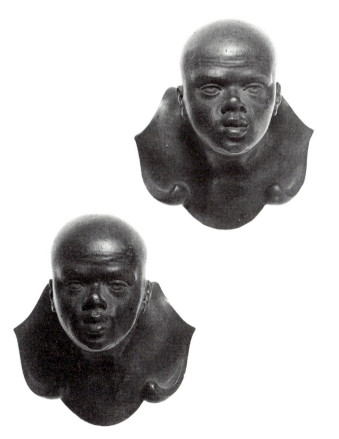

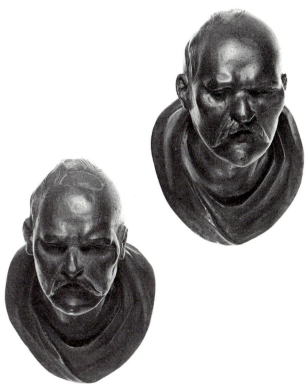

194 and 195. Pair of door-handles in the form of a male bust portrait 'en négligé', one the reverse of the other

9.8 cms. (height)

Bronze or brass, natural yellow patina with the remains of oil gilding. Lost-wax cast, open behind. Rusty iron prongs are fitted into the bronze at the back of each neck. 'B / —60 / 𝔉' and 'B / —61 / 𝔉', are painted in white on the reverses, also on one reverse there is a square blue bordered paper label placed diagonally inscribed in ink 'B / 1060'.

Given by C. D. E. Fortnum on 15 November 1889. Nos. 1060 and 1061 in his catalogues. Bought in Florence for £2, presumably after 1857 when his preliminary catalogue, in which they were not included, was compiled.

Fortnum dated these to the seventeenth century and noted the portrait-like character of the heads. Such open coats and nightcaps were especially typical of portraiture in the early eighteenth century. That door-handles could be based on portraits is not an absurd idea. The ornamental heads employed in the borders of the mid-sixteenth-century sacristy door of St Mark's in Venice by Jacopo Sansovino—and which serve as handles—were known to represent Sansovino, Titian, and Aretino (Ghiberti had of course earlier depicted himself in a similar location) and that the Aretino was copied for humbler situations is suggested by his boast that his effigy was so familiar that it even served as a door handle (see his *Lettere sull'arte*, ed. C. Cordie and F. Pertile (Milan, 1957–8), III, i. 67 and 211 n. 340—a reference I owe to Jennifer Fletcher).

196. Furniture handle in the form of two fishes, with crossed tails, respecting

11.7 cms. (height); 15.6 cms. (width)

Bronze with a natural dark brown patina and a few traces of gilding. Open behind. Hole in gills of fish head facing right (perhaps from a chaplet pin) imperfectly filled with a round plug. 'B / —55 . / 𝔉' painted in white in hollow.

Given by C. D. E. Fortnum on 15 November 1889. B. 1055 in his catalogues. 'Bought Florence', presumably after 1857 when his preliminary catalogue, in which it is not included, was compiled.

Catalogued by Fortnum as Italian of the sixteenth century, and certainly handles of this size and type were then employed in Italy, for example on the outsides of the arms of heavy chairs, as may be seen in portraits of the period, such as the seated woman by Pontormo in the Städelsches Kunstinstitut, Frankfurt. There are five handles involving similar fish in the Bardini Collection, Florence, but all are designed to hang from the tails. A similar design was employed for gold buckles in Paris in the last century.

197 and 198. Pair of small door-knockers or handles ornamented with rams' heads strapped together 'dos à dos'

12.6 cms. (height); 12.05 cms. (width)

Bronze, with a dark brown and pale green natural patina, rubbed to yellow at the six-sided moulded knocker, with iron ring suspenders on an iron cross-bar. Cast open at the back. 'B / . —58 / Ⅎ' and 'B / —59 / Ⅎ' is painted in white in the reverse hollows.

Given by C. D. E. Fortnum on 15 November 1889. B. 1058 and B. 1059 in his catalogues. 'Bought Florence', presumably after 1857 when his preliminary catalogue, in which they were not included, was compiled.

Catalogued by Fortnum as dating from the 'last half' of the sixteenth century. There is a similar handle/knocker in the Victoria and Albert Museum (15–1869, in reserve) which retains a bronze mask fitting from which the iron ring suspender issues, and another is in the Bardini Collection, Florence, also with such a mask. A Florentine origin is suggested by the pierced lyre-shaped stone supports of the balustrade on the façade of Palazzo Covoni-Daneo in Florence, nearly opposite Palazzo Medici-Ricardi, the scrolls of which terminate in cocks' heads in a manner reminiscent of these rams' head knockers. This Palazzo, it is worth pointing out, retains its original door fittings—knockers incorporating paired cocks and handles in the form of cocks' heads—presumably designed by the architect Gherado Silvani in the 1620s.

199. Small door-handle and knocker in the form of a finger ring with a bezel 'diamante in punta' issuing from the wolf's mouth

6.9 cms. (height); 5.3 cms. (width)

Bronze with a dark brown natural patina, yellow between masks and on the point of the diamond. Some verdigris. Solid cast. 'B.—53. Ⅎ' is painted in white on the inside of the ring.

Lent by C. D. E. Fortnum on 7 January 1888 and given later in the same year. B. 1053 in his catalogues. Purchased for £1 in Rome in 1865.

Fortnum considered this as Florentine of the fifteenth or early sixteenth century knowing that the 'diamante in punta' was an emblem of the Medici family favoured in that period. Two ring handles with diamond knockers are in the Victoria and Albert Museum (8876-1861—in reserve—and 7400-1860 on display). Another is in the Museo Bardini in Florence. What are certainly modern handles of a similar model with no connection with the Medici are fixed to doors in Corso dei Tintori and Via de' Conti. The 'diamante' remained in favour with the Medici as a subordinate family device throughout the sixteenth and seventeenth centuries as may be seen, for example, from the sides of the sarcophagi of the grand dukes in S. Lorenzo, and it was used for door-handles in both Palazzo Pitti and Palazzo Vecchio (Sala degli Elementi).

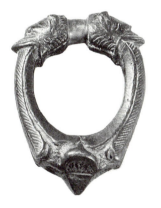

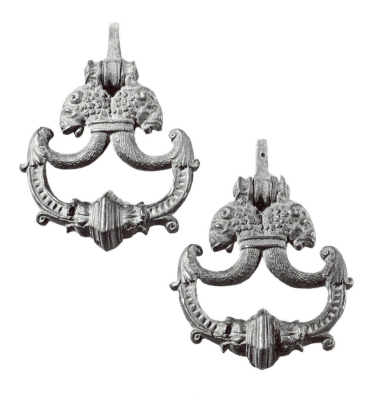

200. Lockplate for a portable chest decorated with trophies and captives, together with a hasp decorated with a woman bearing fruit and flowers

16.3 cms. (height of plate); 16.4 cms. (width of plate); 19 cms. (length of hasp); 3.8 cms. (width of hasp at hinge end); 2.6 cms. (width of hasp at lock end)

Bronze with a chocolate brown patina with some traces of a dark varnish in the hollows. Solid lost-wax cast. The modelling appears to be in the wax. A patch of bronze is inserted above the shoulder of the captive boy.

Bequeathed by J. R. Jones, 1951 (see below).

Over forty lockplates of this pattern and design are recorded. The best and most recent discussion of them and the fullest list will be found in Charles Avery, 'Fontainebleau, Milan or Rome? A Mannerist Bronze Lock-Plate and Hasp', in *Italian Plaquettes* (National Gallery of Art, Washington: Studies in the History of Art, 20, 1989), 291–307. Avery points out that they cannot have been fitted to heavy *cassoni* but were well adapted to lighter travelling chests and have survived on a couple of these.

The elongated figure on the hasp, the strapwork cartouches, and the elegant vases have suggested the School of Fontainebleau to some scholars but these motifs were popular outside France and are all of Italian origin. Connections have also been made with Milanese work. Avery remarks on the similarities with work by the Leoni and in particular on the affinity between the female figure on the hasp and the allegorical figure of Patience on the reverse of the medal of Ercole II d'Este by Pompeo Leoni (*c.* 1533–1608). The Leoni family of sculptors and medallists worked in Rome as well as in Milan and Madrid and there is armorial evidence, which far outweighs that of style, which points towards Rome as a city of origin for these lockplates.

Over half of the recorded examples have coats of arms. Some of these arms, like those on the hasp in the Ashmolean Museum's example, have not been identified and are, in any case, somewhat abbreviated in character and summary in execution. Others seem to be the arms of north Italian families and one even belongs to a Dutch family (ibid. 305, no. 40), but the majority are of Roman families, and these include those on some of the finest examples of the type, and on what is perhaps the most beautiful version of all, that in the Wallace Collection (ibid. 303, no. 14) which is larger than any other (22.8 cms. high) and of a very coppery metal, gilt. This example has on its hasp the arms of Mattei impaling Gongaza, presumably for the marriage of Marchese Asdrubale Mattei with Costanza, daughter of Alfonso Gonzaga, which, as Avery points out, could not have taken place much before 1585. Also of good quality is the version, again gilt, once in the Boston Athenaeum, recently given by Nereo Fioratti to the Museum of Fine Arts, Boston (1986.8), which has the

Orsini arms on one side, the Savelli arms on the other, and the two impaled on the hasp, which probably records the marriage of Ludovico Orsini with Giulia Savelli before 1585 when the former was put to death (ibid. 304, no. 25). Also apparently of good quality is the version once in the possession of the late John Hayward with the arms of the Colonna impaled with those of the Peretti on the hasp, probably recording the important marriage of 1589 between Marcantonio III Colonna with the niece of Pope Sixtus V, Felice Orsini Peretti (ibid. 304, no. 27). There are other versions with the Orsini and Savelli arms in the Hermitage and in the National Gallery of Art in Washington (ibid. 303–4, nos. 9 and 22).

The imagery seems curiously martial given these marital armorials, but it would be odd even for a soldier: female as well as male captives are not unexpected but both have been warriors, the breast plate in the trophy above the female having distinct projections for the bosom. This idiosyncrasy of the design seems to have excited no comment. It makes it even more surprising that it became standard for lockplates of this pattern.

Many of the surviving versions are good but obviously of lesser quality than those cited above. There are many minor variations to be observed of which the most obvious are the character of the masks in the square compartment in the centre of the lateral panels (a leonine satyr head in the Ashmolean version but more commonly a young female head) and the character of the ornament in the compartments below (a somewhat incoherent arrangement of scrolls and masks in the Ashmolean version but more commonly cartouches, sometimes containing arms). Avery notes that the Ashmolean version is identical with one of two examples in the Museo Nazionale di Palazzo Venezia, Rome (his no. 19, reproduced and discussed by P. Cannata, *Rilievi e placchette del XV al XVIII secolo* (catalogue of exhibition at Palazzo Venezia, 1982), 71–2, no. 68), and another in a private collection, Rome (his no. 32). He considers all three to be suspect. Examination of the Ashmolean bronze reinforces suspicions, for there is no sign of a lock ever having been fitted, or of the plate being subjected to any use. The plate would have been fixed to the carcass of the chest with nails in the four corners of the plate which would have had ornamental heads matching the mask ornaments in the square compartments, but if these nailheads were ever employed in this case they have left no dent or even scratch.

It is likely that the Ashmolean lockplate is a copy probably made towards the end of the last century when such items began to be eagerly collected. The detail is much sharper than is the case with one of the four versions in the Victoria and Albert Museum (4817. A) which is obviously an aftercast, but a wax cast might have been reworked prior to the bronze casting. In that case, or if the wax model was simply a measured copy, the bronze would be smaller than the prototype and indeed this is true of this bronze and the other two cited by Avery (the one in a private collection is said to be 16.5 × 16.5 cms., that in Palazzo Venezia 17 × 17 cms.) when compared with those of better quality. It remains to identify the prototype for these copies. A good candidate is the

example in Dallas Museum of Art (not in Avery's list but see *The Wendy and Emery Reves Collection* Dallas Museum of Art, 1985), 176, entry by D. T. Owsley). This is approximately 1 cm. larger than the Oxford version (the width is given as $6\frac{7}{8}$ inches). It is of the same design but gilt and considerably worn. Without being a work of the quality of the finest examples mentioned above, all details, whether the three birds in the arms, the fluttering ribbons above the helmet, or the wriggling contours of the ewer's handles, are far finer and more nervous than in the Ashmolean version. There are differences in the most minute details, such as the decoration on the bodies of the ewers or the loops of pattern beside the strapwork frame of the keyhole, which have been omitted or simplified, and in the framing mouldings, which are less numerous and thicker in the Ashmolean version.

Assistant Keepers in the Department recall that the bronze lockplate and hasp was among the items bequeathed by J. Reginald Jones, but it is not registered, does not appear on any of the lists, and is not mentioned in the papers related to that bequest. The list made in March 1951 after Jones's death seems likely to provide a complete and accurate guide to what was taken to the Museum on that occasion (see Nos. 277–9 for the circumstances) but after the death of his widow Edith Mary Jones on 18 June 1962 less precise records seem to have been made of the additional items which, in late July of that year, were taken to the Museum. Some of these additional items had not been included on earlier lists since Mrs Jones had a separate collection of her own from which the Museum was free to pick.

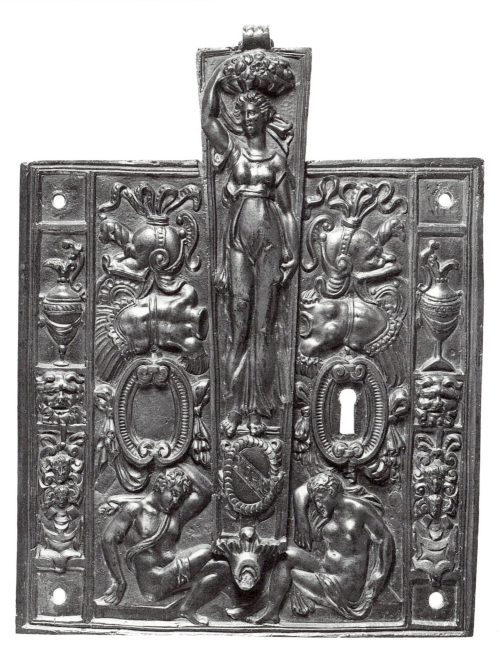

FITTINGS FOR PLUMBING

Unassociated with a Named Sculptor or Craftsman

201. Water spout in the form of a half-length armless monstrous winged satyr

18 cms. (length)

Bronze with a natural dark brown patina. Small patches of verdigris. Cast with the length of pipe, which has been broken off. Missing the tap.

Presented by Mr Henry J. Pfungst FSA in 1908 (*Annual Report* for that year, 8). See also Preliminary Essay and Nos. 203, 233, 234, 427.

There is a very similar spout in the Victoria and Albert Museum (1246-1888) which retains a tap in the form of a putto holding a staff. Bell, recording the acquisition in the *Annual Report,* noted that it was said to be north Italian of the Paduan School and of the late fifteenth or early sixteenth century. The type of satyr certainly is derived from the creatures favoured by founders in Padua and Ravenna. Such models were still in use later in the sixteenth century, but this piece may well date before 1550 and is included here for comparison with other items of this kind.

202. Tap handle in the form of the wolf suckling Romulus and Remus

7.7 cms. (height exclusive of screw 2 cms. in length)

Bronze with a very dark brown natural patina and some traces of black varnish. Heavy, probably solid, cast. The modern brass screw soldered into place.

Presented in 1908 by Mr Max Rosenheim (*Annual Report* (1908), 8).

Bell, recording this acquisition in the *Annual Report,* dated it to the sixteenth century. Conservatism in such items makes it hard to exclude a later date. Rome must be a possible place of origin, but Siena a more likely one, on account of the subject-matter—the badge of Siena being the Wolf and twins (legend having it that it was founded and takes its name from Senio, son of Remus).

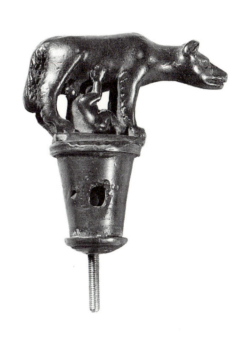

203. Water spout in the form of a monstrous head

15.7 cms. (length)

Bronze with a dark brown natural patina. Fitted with the length of copper pipe (sawn off). The threaded tap (missing its handle) is cast separately. The geometric pattern is chiselled in the metal. Inscribed in red paint on underside of spout between collar and tap 'Given / by / Mr Henry J. Pfungst / 1904'.

Presented by Mr Henry J. Pfungst FSA in 1904. For Pfungst see Preliminary Essay, and Nos. 201, 233, 234, and 427.

C. F. Bell, recording this acquisition in the *Annual Report* for 1904 (p. 1), described it as 'Venetian' and a valuable addition to the Renaissance collection. There seems no special reason to consider it as Venetian or indeed Renaissance, although it might be. The type of monster is not improbable as an ornament in the early eighteenth century.

204. Water spout in the form of a stylized fish head with a tap handle in the form of a lion supporting a shield

17.2 cms. (height of tap); 23.2 cms. (length of spout)

Bronze or brass with a dark brown natural patina worn to yellow in a few salient areas (e.g. the edge of the shield and leafy ornament over the fish's eyes). The handle is solid cast.

Given by Messrs. Durlacher of Bond Street in 1904.

It is perhaps no coincidence that the firm of Durlacher (which had been in business throughout the second half of the nineteenth century) had, together with Asher Wertheimer, purchased the collection of bronzes belonging to Henry Pfungst who also gave the Museum an item of old Italian plumbing in the same year (No. 203). Such pieces were probably not of much interest to American millionaires. C. F. Bell, recording this acquisition in the *Annual Report* of 1904 (p. 1), observed that it was 'Venetian' and made a 'valuable addition' to the Renaissance Collection. The crispness of this cast is quite different from any authentic Italian fitting of this kind dating from the sixteenth or seventeenth century but does suggest the sort of work found in mid-nineteenth-century Italian public fountains such as those in Piazza della Scala, Milan. There is a pair of very similar lion tap handles in the Museo Bardini, Florence.

FURNITURE

Unassociated with a Named Sculptor or Craftsman
(Cupboards, Cassoni, Caskets, Chairs, Pedestals)

205. Two-stage cupboard ornamented with terminal caryatids

146.5 cms. (height); 82.5 cms. (width, at base moulding); 49.5 cms. (height of upper caryatids); 7 cms. (length of upper caryatids); 4 cms. (width of upper caryatids including 'ground' of 0.5 cms.); 68.2 cms. (height of lower caryatids); 7 cms. (length of lower caryatids); 4 cms. (width of lower caryatids)

Walnut, with burr walnut. Many dents and scratches and much worm damage, on account of which the caryatid to proper right in the higher pair has lost much of her nose.

Bequeathed by A. G. B. Russell in 1958 (see also Nos. 339–40, 577). According to the card index of his collection it was bought by him on 19 May 1924 from 'Comm. Prof. Elia Volpi of Piazza Torino, Florence' for 8,000 lire (£81 12s. 8d).

The cupboard was regarded by Russell, and by the Museum on acquisition, as Florentine and of the sixteenth century; it resembles Italian work of the second half of this period and the terminal figures with small scroll arms, over which the drapery is hooked here, together with the scale ornament on the upper pair's piers, are found in ornamental Florentine work (most notably in the herms of Hercules in the great walnut desk in the Sala dell'Udienza in Palazzo Vecchio, Florence) and the motif of a tasselled swag overlapping the scaled tapering piers is closely paralleled in an 'Armadino pensile' in a Florentine private collection (*Palazzo Vecchio: Committenza e collezionismo medicei* (Florence, 1980), 208–9, no. 390).

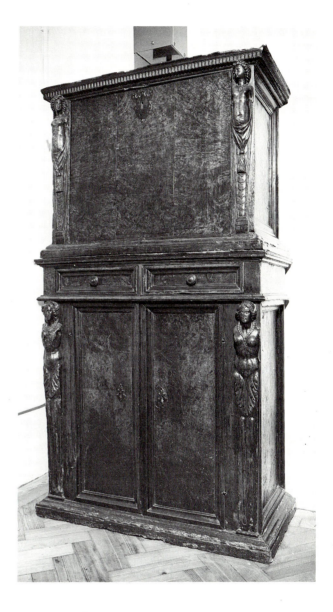

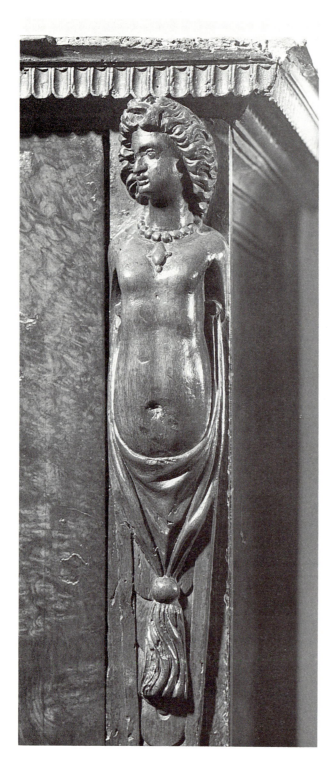
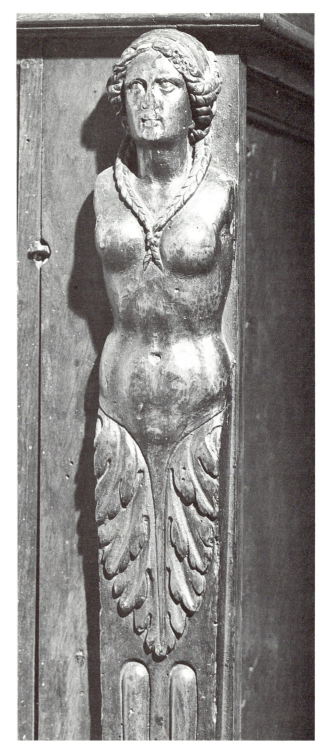

206. Cassone ornamented with shields and masks

60.8 cms. (height); 181.5 cms. (length); 58.5 cms. (width of lid); 18.5 cms. (height and width of the three panels containing masks, from the narrow mouldings outside the bead and reel ornament)

Walnut.

Lent by C. D. E. Fortnum in October 1894 and bequeathed in 1899. F. 10 in his catalogues. 'Bt. Florence' according to both catalogues, perhaps in 1875—see below.

Fortnum dated this Florentine *cassone* to the middle twenty years of the sixteenth century: it might however be later in date than 1560. Although he does not enter the date upon which he acquired it this is likely to be 1875 when he purchased the other Florentine furniture in his collection—a pair of seventeenth-century chairs, another sixteenth-century *cassone*, a sixteenth-century stool and table (F. 11, F. 12, F. 13, F. 14, F. 15). These purchases cannot have been unconnected with his rebuilding of the Hill House, Stanmore.

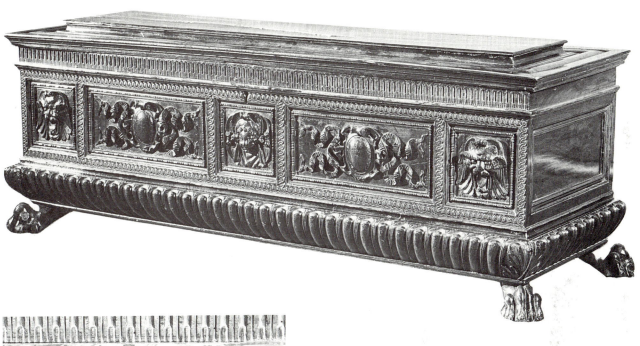

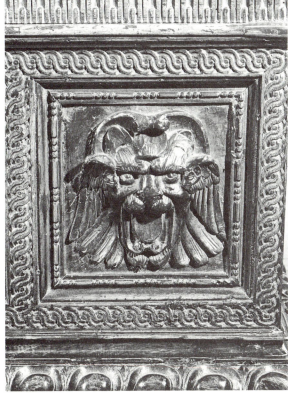

207. Cassone ornamented with acanthus leaves at the corners

62 cms. (height); 176 cms. (length cms. (length); 59 cms. (width)

Walnut with some inlay, perhaps of holly, for a thin string band framing the principal panel of each side, with an iron lock (old but not original) and evidence of original pin hinges.

Given by Mr and Mrs Edmund Houghton in 1937, together with No. 208.

The *cassone* is of similar size to No. 208 and has identical gadrooning, lion's paw feet, and raised central portion to the lid. Here too extra interest is provided by what are additions to the front corners although here they are acanthus leaves and extend from the lion's paw foot. The Houghtons also gave a roughly blocked-out wooden model purporting to be the model for the pedestal of one of the pair of marble holy water stoups in the Duomo at Siena made in the early 1460s by Antonio Federighi (1420–90) but surely the abandoned start of a modern copy of the same, also some alabaster and marble sculpture of dubious status (see the *Annual Report* (1937), 33). There is a facetious account of their dreadul collection and their generosity in bestowing items from it upon friends rash enough to express polite enthusiasm for them in the first volume of Kenneth Clark's autobiography.

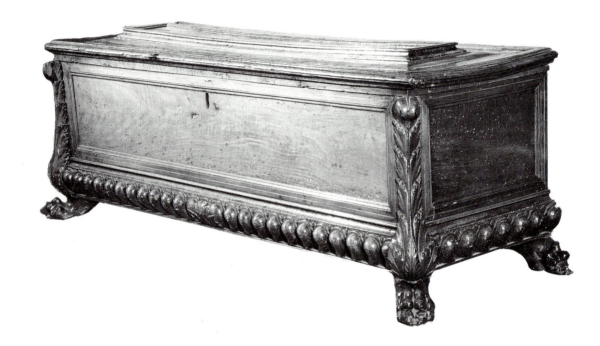

208. Cassone ornamented with harpies at the corners

61.7 cms. (height); 177 cms. (length); 56 cms. (width); 33.5 cms. (height of each harpy)

Walnut (bleached) with some inlay, with iron handles and lock. The shaped inlay for the cartouche of the central coat of arms and for the pair of boys restraining wolves (which are engraved in the wood) might be a nineteenth-century addition. The lid must be a replacement although it is made from old wood. The harpies are carved out of separate pieces of wood and although battered have none of the worm damage found in the corners behind them. The nose of the harpy to proper left has been broken off and one scrolled wing end has been broken off and reattached. The scrolled headdress

and some of the nose of the other harpy have been broken off as has the end of one scrolled wing.

Given by Mr and Mrs Edmund Houghton in 1937, together with No. 207. For their other gifts see the entry for No. 207.

The harpy to proper left has a moustache which is unusual. On acquisition the *cassone* was regarded as Italian and of the second half of the sixteenth century; it surely is Italian and if the engraved inlay is authentic it must date from the seventeenth century. A similar *cassone* with gadrooned base, applied harpies, and engraved inlay was acquired by the National Gallery of Scotland in 1989. Another is in the City Art Gallery and Museum, Birmingham.

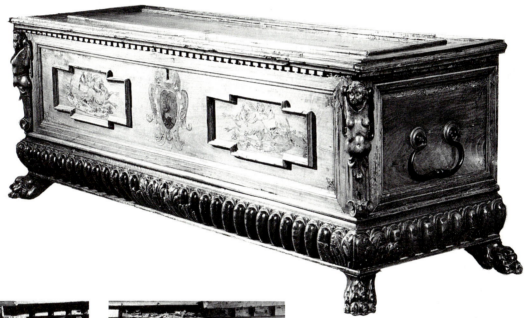

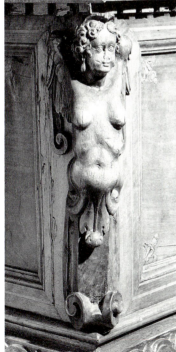 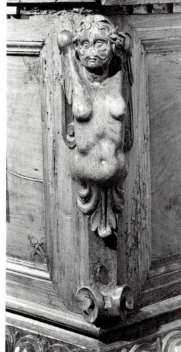

209. Cassone ornamented with gadrooning and fluting

53 cms. (height); 140.7 cms. (length of lid); 47.5 cms. (width of lid)

Walnut. The plinths beneath the lion's paw feet must be additions.

Bequeathed by C. D. E. Fortnum in 1899. F. 11 in his catalogues. 'Bt Florence 1875', according to large and notebook catalogues, for £20 according to the latter. Kept in the hall at the Hill House, Stanmore.

This *cassone* was dated by Fortnum 1530–40. The sarcophagus shape of the chest certainly became popular about then but this is densely ornamented with mouldings fashionable in Florentine wood carving of the second half of the sixteenth century. It is an excellent design: more varied in its contrasts of hollow and relief and more lively, on account of the radial pattern of its gadrooning, than the best-known *cassone* of this type which is now in the Museo Nazionale of the Bargello (*Palazzo Vecchio: Committenza e collezionismo medicei* (Florence, 1980), 209–10, no. 393; F. Schottmüller, *I mobili e l'abitazione del Rinascimento in Italia* (Stuttgart, 1928), 65, no. 153)). The ornamental style may be compared with that of the map cupboards in Palazzo Vecchio carved to Vasari's designs by Dionigi di Matteo in 1563 and with the stucco designed by Ammanati for the Loggia di Giunone in the same Palace. (Both comparisons are made by Maddalena Trionfi Honorati in the catalogue cited above.) But by comparison with genuine sixteenth-century carvings of this sort its execution appears mechanical and, despite the claims presumably made for it by the dealer from whom Fortnum bought it, it must have been made as a copy or imitation because it has modern hinges and no wear. When owned by Fortnum the *cassone* retained a crimson velvet cover on the raised slab of its lid.

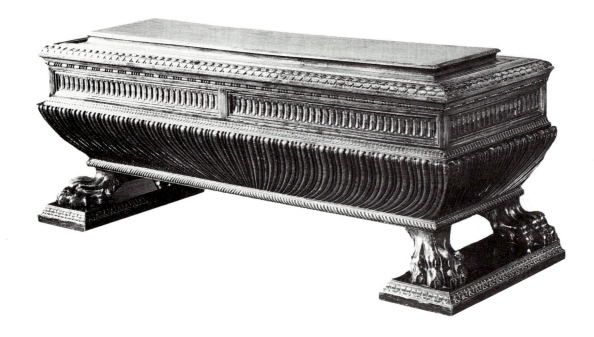

210. Casket with applied winged masks and sirens

26.3 cms. (height); 51 cms. (length); 28 cms. (width)

Poplar. The sirens, the winged masks, and the stud ornaments are all carved separately and applied. There is a separate compartment with a sliding top in the lid of the casket, but the top is missing. Mouldings at the back of the short side of the casket to proper

right are missing, as are one round small and one long stud. The base is riddled with woodworm. The lock and hinges, are original. The letter 'F' is carved twice on the outside of the plain back panel of the casket.

Probably the 'Italian casket 16th century' presented by Henry J. Pfungst in 1899.

The casket is probably Italian and the style of ornament suggests the late sixteenth or early seventeenth century.

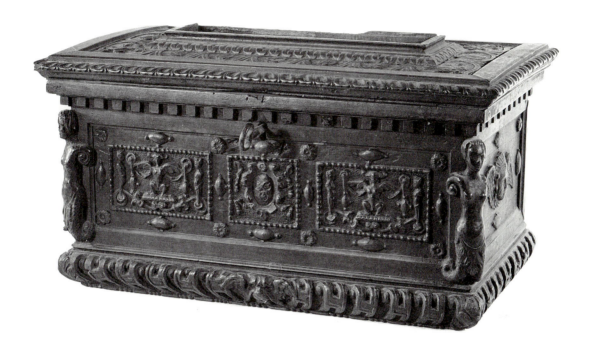

211. Casket with lion's paw feet, ornamented with curling strapwork

31.8 cms. (height); 46.3 cms. (length 32 cms. (width)

Walnut. The interior of the casket is lined with pine painted red. There is a separate compartment with a sliding top in the lid of the casket.

Bequeathed by C. D. E. Fortnum in 1899. F. 8 in his catalogues. Bought in Florence, 1875, for £2, at the same date, and possibly from the same source, as many of the other pieces of Italian furniture.

Fortnum catalogued this as Italian of *c.* 1550. It may be later in date. The curling strapwork, which graduates into scale ornament where the curled ends seem to overlap with others behind, is found on larger Florentine *cassoni*, as is the curious imitation of basketwork (anticipating the ripple mouldings of seventeenth-century ebony frames). Larger caskets of similar style but superior execution are displayed on a table in the Sala degli Elementi in Palazzo Vecchio, Florence, and on a table in the painted room in Palazzo Davanzati, Florence.

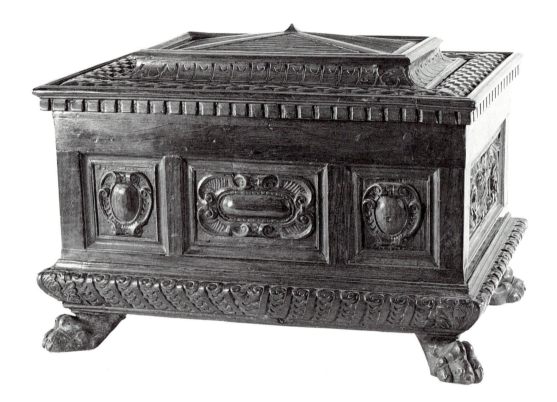

212. Casket with lion's paw feet, ornamented with scales and other ornament

21.5 cms. (height); 40.5 cms. (length); 29.5 cms. (width)

Walnut. The casket retains old, perhaps original, divisions inside. There is a separate compartment with a sliding top in the lid of the casket. The hinges are modern replacements. The original lock remains in place but is broken.

Provenance unrecorded, but possibly bequeathed in 1899 by C. D. E. Fortnum, for a manuscript list of 'Objects now at The Hill House Stanmore but to go to Oxford' made late in his life includes 'a casket of carved chestnut or walnut wood with sliding top lid at present in our bedroom' to which no number had been assigned. It was perhaps acquired with No. 211.

The casket is probably Italian and the style of ornament suggests the late sixteenth or early seventeenth century. The initials IHS, abbreviating the name of Jesus, with the Cross above the bar of the 'H' and three nails below it, carved in the cartouche of the central compartment of the front of the casket, below the keyhole, indicate an ecclesiastical origin.

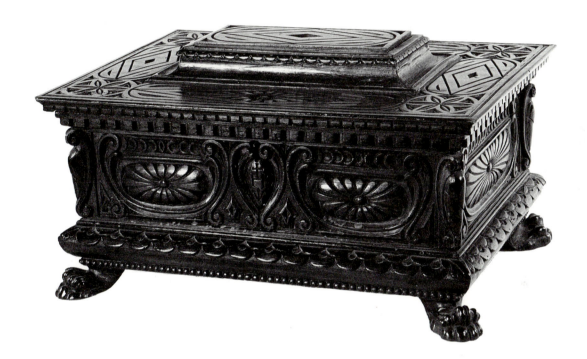

213. Casket with three compartments

18.5 cms. (height); 34 cms. (length); 27 cms. (depth)

Rosewood and ebony with silver. The mouldings are all of ebony. The silver is inlaid in lines forming geometrical patterns on the lid and side. The hinges are of brass, the lining is of red velvet, and the miniature knob on the drawer is of bronze—only the last of these three features looks original. The lower portion of the cabinet is a drawer. The main body of the cabinet opens as a chest. The raised portion of the lid forms a separate compartment opened by a sliding top. The catch to the drawer is broken and hangs down below the casket. There is a small catch which releases the sliding top in the mouldings on the short proper left side of the top. The lock in the front for the 'chest' is a modern addition and the wall of the casket has been thickened with mahogany to accommodate it. The inside part of the front foot to proper left has been lost.

Bequeathed by C. D. E. Fortnum in 1899. F. 9 in his catalogues. 'Bt. Florence' according to his notebook catalogue. 'Ebony Casket £1–18s–6d' is written under the year 1859 in his MS 'memorandum of prices paid'.

Fortnum dated this as 1530 in his notebook catalogue and as 1530–40 in his larger catalogue. C. F. Bell in a manuscript annotation to the larger catalogue speculated that it might be Tyrolese and of the eighteenth century. A casket of very similar form, a little larger in size, but with the inlaid lines said to be of brass and with brass scrolls on the feet, was lot 122 at Christie's, London, 4 May 1989, and catalogued as nineteenth century. The three compartments of such caskets were presumably intended for pens, stationery, and private correspondence respectively.

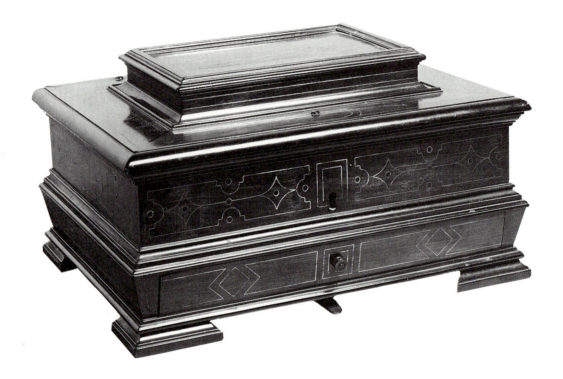

214. High-backed chair ornamented with dolphins and scrolling foliage

134.5 cms. (height); 47 cms. (length); 40.3 cms. (width)

Either maple or beech with some evidence of a red stain, with some additions in walnut. The cresting of the back together with the moulded framing at the top of the back is carved from a single piece; it is very roughly finished behind. Each post is carved from a single piece. The front legs and the stretchers are each carved from a single piece. The ornamental carving below the seat is carved from single piece: this has been broken and recently reglued. There is minor woodworm damage in several areas. Some pieces of wood have been lost from the proper right front leg where it is pierced. The panel of damask set in the back is modern: when removed, the traces of perforation for caning can be seen on one side. Such perforation is clearer when the damask-covered seat, which is also modern, is removed. The upper part of the frame of the seat carved with gadroon ornament partly covering the holes is modern. There are traces of a paper label behind the dolphin to proper left of the cresting inscribed in ink in French in a nineteenth-century hand: 'No. 17 / chaise / haut Oless . . . / Dauph . . .'

Bequeathed by C. D. E. Fortnum in 1899. F. 12 in his catalogues. Bought by him in Florence in 1875 for £6.

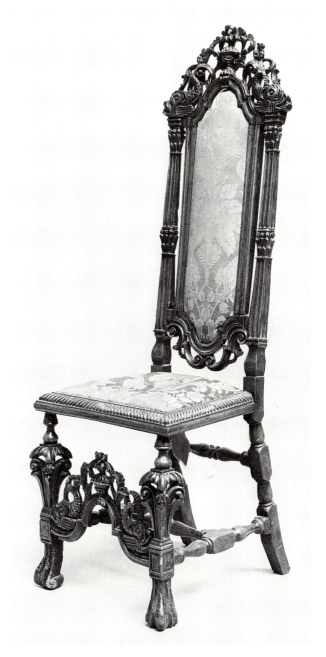

Fortnum considered this chair to be Florentine of the seventeenth century and he noted (it is added in the notebook catalogue as a footnote) that dolphins were armorials of the Pazzi (an eminent Florentine family). The gadrooning of the seat frame is very much in the style of one of the sarcophagi which Fortnum bought in Florence at the same date (see No. 209). The chair may well have been supplied by the same dealer. The whole chair has been dismissed (verbally, by curators in the museum and visitors to the museum) as of modern manufacture, and it is certain that this style of seventeenth-century furniture was reproduced in abundance in the last century, but the roughness of the carving behind, the eccentricity of the knees to the legs with their pierced scrolls meeting gadrooning, and the undisguised repairs all suggest that this might be an authentic seventeenth-century piece. It is perhaps Tuscan but unlikely to be connected with the Pazzi: dolphins were a common ornament in furniture. The label, which seems to refer to the dolphins, may date from the chair's period with a Florentine dealer—such dealers often traded in French. The chair has been identified (verbally) by several experts in the field of British furniture as British of the period of William and Mary. The posts in the form of superimposed Corinthian pilasters, the flattened dolphins on the broken arch of the crest, and the baluster stretchers can all be paralleled in the suite of gilded and japanned beech chairs sold at Christie's, 23 May 1969, lot 112, one of which is illustrated and discussed by Gervase Jackson-Stops in *The Treasure Houses of Great Britain*, (catalogue of the exhibition at the National Gallery of Art (Washington, DC, 1985), 164–5, no. 94). The chair could have been taken to Florence by an English resident only 25 or so years before Fortnum acquired it there.

215. High-backed chair ornamented with scrolls and cornucopia

128.5 cms. (height); 45 cms. (length); 38 cms. (width)

Probably maple. The cresting of the back, together with the moulded framing at the top of the back, is carved from a single piece; it is very roughly finished behind. Each post is carved from a single piece. The front legs and the stretchers are each carved from a single piece. The front proper right leg is certainly modern and has a modern turned dowel. The stretcher to proper right is of oak and probably also a replacement. The ornamental carving below the seat is carved from a single piece. The panel of damask set in the back is modern, and so too is the framework around it carved with leaves. At the sides this modern framework includes the bead moulding which makes it appear continuous with the older parts of the top and bottom of the chair back. The back was presumably originally caned. The damask-covered seat is also modern. When it is removed, perforation for caning can be seen. The upper part of the frame of the seat, which is carved with scale ornament and partly covers the holes, is modern.

Bequeathed by C. D. E. Fortnum in 1899. F. 13 in his catalogues. Bought by him in Florence in 1875 for £3.

Fortnum considered this chair to be Florentine of the seventeenth century. The scale ornament of the seat frame is very much in the style of one of the sarcophagi which Fortnum bought in Florence at the same date (see No. 209). The chair may well have been supplied by the same dealer. The whole chair has been dismissed (verbally both by curators in the museum and by visitors) as of modern manufacture, and it is certain that this style of seventeenth-century furniture was reproduced in abundance in the last century, but the roughness of the carving behind and the undisguised repairs suggest that this might be an authentic seventeenth-century piece. The chair was bought together with No. 214 but they are not a pair and when seen in a good light are not the same colour. As with No. 214 the chair has been thought to be British of the late seventeenth century.

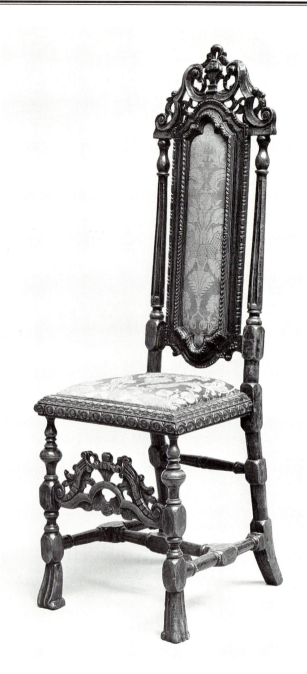

216, 217, and 218. Three side chairs decorated with cockle-shells, weedy fronds, and dolphins (only one illustrated)

105.4 cms. (height); 50.2 cms. (width); 59.7 cms. (length)

Beech, gilded on all visible surfaces. The water-gilding is not likely to be original. On No. 218 some of it is certainly a replacement. The gesso has not however been superimposed. The gilding is worn in some areas to expose the ruddy grey-brown bole preparation on the gesso; elsewhere the bole has flaked and the gesso chipped; varnish has been applied to tone the gilding and consolidate these losses and gold paint has been used since by the Museum workshop to cover some of the gesso. On all chairs each post is of a single piece of wood joined to the curved top rails below the eyes of the dolphins. These top rails, together with the cockle-shell crest, are of a single piece which is also joined to the top of the splat. Shrinkage has caused the joins to open conspicuously across the top of the splat (in a line passing through the eyes of the child's head) in all three

chairs. The joins between the front seat rail and the front legs have also opened. The bird's eye punchwork on the ground of styles, around the cartouche of the splat, on the chair rail, the lower part of the front legs, and the rear of the back legs is now very indistinct with the central dot not always legible. It appears to have been in the wood but it may have been obscured by the gesso in regilding. The lines in the petals of the flower-heads on the styles are similarly obscured. The chairs 216, 217, and 218 are incised on the inside of the back rail of the seat frame under the splat with the numbers I, III, IV; chairs 216 and 217 are also incised with II and IV on the insides of the stretchers of the drop-in seats and 218 is also incised with V on the inside of the front rail of the drop-in seat—these are more deeply cut than are the numbers on the seat frames. The Italian damask of the drop-in seat is a modern covering of about 1970.

Given by Mrs F. R. Weldon in 1934. Bought by 'Martin'—a dealer— as lot 134, Christie's, London, 5 November 1929, the sale of Colonel Claude Lowther, MP, JP, of Herstmonceux Castle (1872– 1929). A photograph in the catalogue shows the chairs in a room in the castle. Lowther purchased the castle unfurnished in 1913 and is likely to have bought the chairs after that date. No. 218 has been on loan to the Victoria and Albert Museum since 1964.

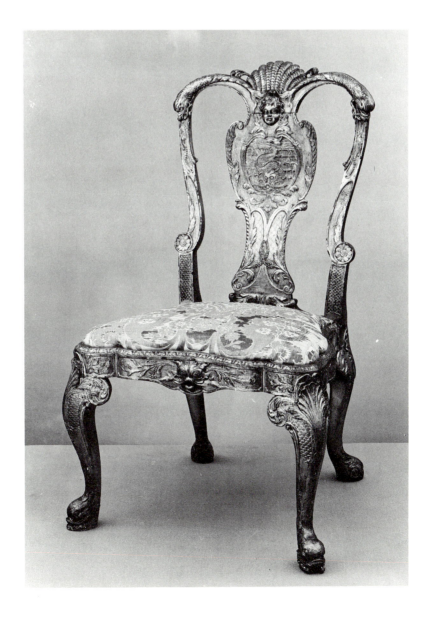

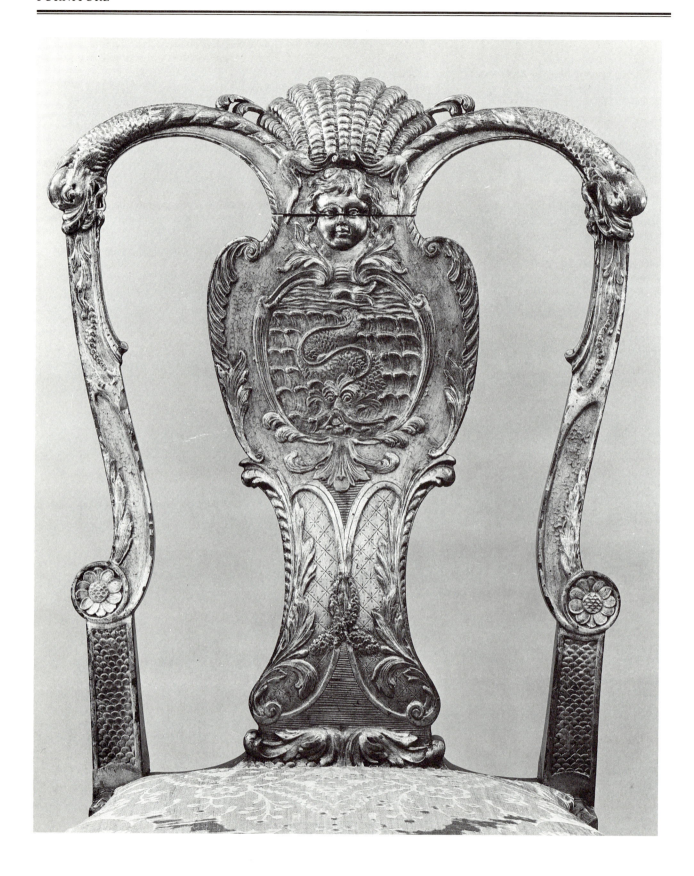

At least 17 chairs of this type, now generally dated to between 1725 and 1740, are recorded. As William Rieder was the first to point out when publishing a set of four in the Metropolitan Museum ('Eighteenth Century Chairs in the Untermyer Collection', *Apollo* (Mar. 1978), 181–5), these can be divided into at least two sets—the Ashmolean's three, together with two in the collection of Professor C. Truesdell of John Hopkins University, being different in construction and in detailing from the chairs in the Metropolitan Museum and in other collections. Professor Truesdell, who owns chairs from both sets, has examined these differences at length in 'A Puzzle Divided: English and Continental Chairs Following a Unique Design of the Early Eighteenth Century', *Furniture History*, 20 (1984), 57–60, pls. 76–80, pointing out that the heavier character of the Ashmolean set and the fact that in this set the shoe of the splat is not integral with the back rail of the seat frame indicate continental rather than English craftsmanship, whereas the other set appear to be entirely typical of English work. When the ornament is compared it will be found that the Ashmolean chairs possess more boldness, plasticity, and linear vitality, although the others are of remarkable quality and indeed greater delicacy. Particularly revealing is the greater concavity in the Ashmolean chairs of the shell-like forms springing from the knees of the cabriole legs and the more varied curvature of the fronds below, and the fish tail above, the child's head at the top of the splat.

The chairs have long been admired as among the finest of their period in existence. The cabriole legs and vasiform splat are characteristic of English chairs of the early eighteenth century but neither the character of the ornament, nor its wit—the top rails formed as of dolphin-like fishes biting the styles, echoed in the forms of the front feet; the fish head on the seat rail reappearing in the cartouche of the splat with a foreshortened body wriggling behind it in swirling waves—can be matched in other English furniture of this period. Nor indeed is the relationship between the double curves of splat and styles, which make the spaces between as beguilingly beautiful as the solid elements themselves, easy to parallel in English furniture design even at its most sophisticated.

The idea that Italian craftsmen were involved in the creation of these chairs seems to have been suggested by both John Hayward and Alvar González-Palacios before the alien construction of the Ashmolean chairs was emphasized by Truesdell. Various hypotheses could be advanced to explain the origins of these two sets: the most probably would seem to be that the Ashmolean set were made in Italy for the English market, or by Italian craftsmen in England, and the other set copied from them by some of the best native craftsmen.

The donor, Mrs Weldon, was the widow of the Linacre Professor of Comparative Anatomy (who died 1906). Among the works of art given by her between 1915 and her death in 1936, and those which she bequeathed, are many of the greatest paintings in the Museum (Claude's *Ascanius Shooting the Stag*, Watteau's *Le Repos gracieux*, Drost's, *Ruth and Naomi*, Corot's *Tuscan Hill Town*, Bonington's *Amy Robsart*, Camille Pissarro's *Jardin de Tuileries*, Orpen's *Chessplayers*) but no other items of furniture except a Georgian card table. Since she purchased these chairs at a time in her life when she must have wanted less rather than more furniture for her own home it is reasonable to suppose that she had the Museum—and indeed the new room named in her honour—in mind.

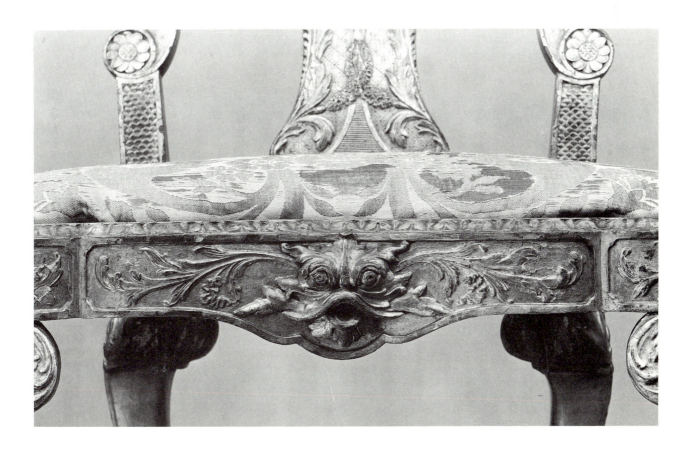

219, 220, 221, and 222. Set of four wall pedestals for statues
(only one illustrated)

112.7 cms. (height of each)

Marble cladding on a stone core. Each pedestal is constructed in four parts: the plinth is of *porto venere* (black marble from Genoa with yellow veins of a distinctive liquid form, known in Britain in the eighteenth century as 'gold vein'); the base mouldings are of slightly grey veined white Carrara statuary marble; the principle pier is of white Carrara statuary marble with panels of mottled pink, yellow, and white marble (probably a pale *rosso di Francia*); the uppermost mouldings of white Carrara statuary marble. The pedestals have obviously suffered from frequent reassembling and are chipped at the joins between the different parts, as well as being dirty and scratched.

Acquired in 1950 together with the busts of Popes Clement XII, Clement XIII, Innocent XIII, and Benedict XIV (which they still support)—see Nos. 22–5.

The pedestals are flat with no mouldings behind and were clearly intended to be placed against a wall. It is most unlikely that they were made for the busts by Claus which they now support, for the plinths of the socles of these busts seem too small and their square form contrasts unhappily with the concave shapes of the pedestals. This concavity and the chamfered angles derive from the inventions of Borromini but their less sharp edges, less dramatic curvature, and more orthodox mouldings are characteristic of Roman architecture in the first half of the eighteenth century. The use of *porto venere* also suggests this date, but it is hard not to suspect that the plinth, where this is employed, is an addition to increase the height of the pedestals for the busts. The lower height would have made them suitable for statues. To these arguments it may be objected that the socles of the busts by Claus might not be original, but it is impossible to imagine any style of socle which would mediate in an entirely happy manner between the busts and these pedestals. It was also very rare in this period for busts to be mounted on spreading pedestals. Straight columnar pedestals were used for busts in the second half of the eighteenth century: before that tapering term supports which compensate for and dramatize the pyramidal shape of the bust itself were favoured. On the other hand spreading pedestals are often found as supports for statues, especially small statues, in Roman palaces: those in wood in the gallery of Palazzo Doria Pamphili, those in travertine in the garden of Palazzo Borghese and on the staircase of Palazzo Barberini are examples.

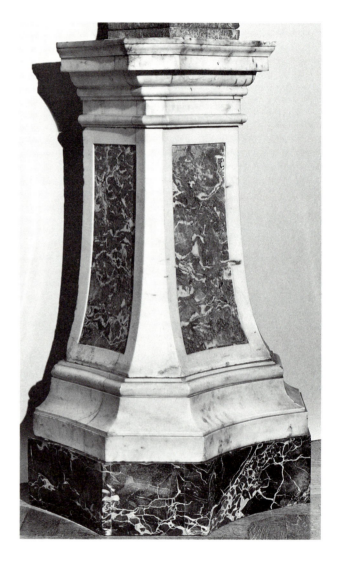

223. Pedestal ornamented with swags and the heads of lions and goats

17.8 cms. (height including corner finials); 23 cms. (length); 16.3 cms. (width)

Bronze with a ruddy chestnut patina darkened in parts. All the high relief ornament is separately cast and bolted to the main body of the plinth which is a hollow lost-wax cast with thin walls, open beneath. The majority of the bolts appear to be original. The swags are not now fixed in their original place behind the ears of the goats. There is a strip of fire-gilt bronze fixed, with modern solder, to the base moulding of the plinth. It has slipped on one side. This may not be an original feature. One of the fire-gilt bronze pomegranate finials on the corners of the upper surface of the plinth is missing. There are two attachment holes on the upper surface of the plinth 7 cms. apart.

This must be the 'beautiful pedestal of fine Cinque cento work bearing the arms of the Grand Duke of Tuscany' on which 'A Bison, an antique bronze found at L'Ariccia near Rome' was mounted when it was given to the University Galleries by Chambers Hall in 1855 (*University Galleries Donations Book*, 28). In 1888 when this little bronze was transferred from the Randolph Gallery (1888.1482 (76)) it was described as still with its pedestal but also as resting on a pedestal of polished porphyry $4\frac{7}{8}''$ by $2\frac{7}{8}''$ and $1\frac{5}{8}''$ high 'having a gilt metal border round the bottom'—this porphyry plinth must have been intermediary between the pedestal and the statuette or possibly a recent replacement for this pedestal. By that date the bronze's connection with Chambers Hall had been forgotten. There is no record of the transfer of this bronze 'Bison' to the Department of Western Art but it has for over twenty-five years been on display as a 'bull of Apis' upon an ebonized pedestal of the *Marcus Aurelius* type labelled in gold as fifteenth-century Italian and giving the provenance as 'Bodleian Collection'. After transfer the pedestal must have been removed. The porphyry plinth may have been recycled at the same date—its dimensions correspond exactly with those of the slab upon which the reclining nude woman attributed to Cellini (No. 21) is now mounted.

The pedestal cannot have been the original one for the little bronze *Bull*—it is too large and the *Bull* has a distinctive green patina which is quite different. Furthermore the *Bull* looks like an early Renaissance work whereas the pedestal, although hard to date for certain, does not. It is decorated with the arms not of the grand duke of Tuscany but of a prelate whose hat is on top with a bishop's six tassels hanging to either side of a shield quarterly, 1 and 4 a lion rampant, 2 and 3 on a bend between three fleur de lis three crooks (? perhaps hammers or shears).

INKSTANDS AND CANDLESTANDS

224. Inkstand in the form of three sphinxes (with a lid decorated with a group of a standing nymph and seated satyr)

16.2 cms. (height of each sphinx); 36.1 cms. (height of stand with groups on lid); 13.5 cms. (diameter of rim mouldings above heads of sphinxes)

Bronze with a natural rich red chestnut patina worn to a yellow tan on nails and nipples, with some traces of a darker varnish. Hollow, lost-wax, cast. There is a conical ink pot of pale green blown glass (presumably a replacement) suspended within an iron ring. There are perforations in the thin wall of bronze in the backs of the wings; the backs of the heads and wings and shoulders are not carefully finished, but the more visible areas very carefully tooled and polished. 'B/—76/F' is painted in white on the rim below the rumps of the sphinxes, and below that 'No. 600 1855', crossed out (the same marks appear under the base of the crowning group).

Lent by C. D. E. Fortnum in October 1894 and bequeathed by him in October 1899. No. 1076 in his catalogues. Purchased by him at the sale of the Uzielli Collection, Christie's, London, 17 April 1861, lot 666, for £42, using 'Whitehead' (presumably the dealer) as agent. 'It formerly belonged to Mr Bernal', that is Ralph Bernal, the great collector of glass, ceramics, enamels, arms, and armour and was lot no. 1280 on the eleventh day of his posthumous sale, 16 March 1855, where it fetched 30 guineas.

The inkstand was very highly regarded by Fortnum —and not only by him; he mentioned that 'the late sig. Alessandro Castellani offered me £1200 for it.' It had been illustrated in J. C. Robinson's *Catalogue of the Various Works of Art Forming the Collection of Matthew Uzielli, Esq. of Hanover Lodge, Regent's Park* ((London, 1860), pl. 8, no. 600) which was adopted as the sale catalogue after Uzielli's death in the following year. Robinson described it as 'splendid' and dated it to 'about 1530.' The integrity of the ensemble was questioned by Bode on a visit to the Museum on 6 March 1903 as recorded by C. F. Bell in an annotation to Fortnum's large catalogue. He considered that 'top and bottom had in the first instance nothing to do with one another', the lower part being 'Celliniesque' and 'perhaps a hundred years later in date'. Bell added 'It has long been my view that the thing as it stands is a *rifacimento* but in view of its fame & the great store set upon it by Mr Fortnum I should have hesitated to express it'. The group on the lid, generally now known as the *Chastisement of Pan*, exists in other versions, and is regarded as a product of the workshop of Severo da Ravenna. It must be an invention of the first years of the sixteenth century (if not of the last of the fifteenth century) and it will be considered separately in the catalogue of the Museum's Medieval and Renaissance sculpture.

There is evidence, however, that Severo's workshop was still active in the mid-sixteenth century (see No. 9), so it is not impossible that the lid is contemporary with the stand, and it certainly appears to have been originally cast with a heavy round base (and not subsequently fitted with such a base) to serve as a lid. Other versions of the sphinx stand

support an elegant spiral group of a female nude figure flogging a recumbent, cowering, howling male figure, a group, far better suited to it in style and in scale, which it would be hard to date before 1550. It is worth speculating that the Ashmolean bronze might be the consequence of something akin to a 'mail-order confusion', for both groups could be described as the 'punishment of vice' and a bronze founder familiar with this old model might have cast it to fit the base by mistake. The alternative explanation would be that the old group was fitted to the new base by a collector or a dealer just as a quattrocento painting might be given a cinquecento frame, at any time between the sixteenth and early nineteenth centuries. In any case there is no reason to doubt the antiquity of the stand, and Bell was correct to delete the word 'Modern' in Bode's description of it in *Italian Bronze Statuettes of the Renaissance*, i, (London, 1907), 28, as 'a modern copy of the Borghese inkstand by Cellini'.

'The Borghese inkstand' was the version of the stand together with the spiral flogging group with which Bode was familiar. It was then in the collection of Baron Alphonse von Rothschild in Vienna (Bode illustrated it, op. cit. ii, (1908), pl. CXLV) and was said to have come from Palazzo Borghese in Rome. Its whereabouts are now not known, but it was in 1955 in the collection of Mrs Max Epstein in Chicago (according to J. Draper's 1980 revision of Bode). Other versions are in the Louvre and the Speed Art Museum, Louisville. There is also a sphinx inkstand without any lid in the Victoria and Albert Museum (M. 358-1956) and a version of the spiral group designed as a lid, which might once have fitted over the stand in the Victoria and Albert Museum, is in the Frick Collection in New York (see J. Pope-Hennessy and A. F. Radcliffe, *The Frick Collection*, iii (New York, 1970), 234–9). By an extraordinary coincidence Fortnum's preliminary catalogue of 1857, pp. 55–7, reveals that he bought a version of this group in Rome in 1851 but on a different base consisting of kneeling tritons. He noted that it was very similar to the group in the private apartments of Palazzo Borghese attributed to 'John of Bologna'. It had been damaged in the siege of Rome in 1849. He had doubts of its antiquity and, probably for this reason, disposed of it.

There are also versions of the spiral group which are not designed as a lid, but they are generally of lower quality. In addition to Giambologna and Cellini, the following names have been advanced in the hunt for the creator of the spiral group and the base: Pierino da Vinci, Ammanati, Domenico Poggini, Rustici, Taddeo Landini. The fullest discussions of the problem are those by Ulrich Middeldorf in 'Eine seltene Bronze der Spätrenaissance', reprinted in *Raccolta di scritti*, ii (Florence, 1980), 303–8, and by Pope-Hennessy and Radcliffe (op. cit.). There has been little success in detecting other bronzes which might be by, or after, the same artist, but the youth on a seahorse in the Walters Art Gallery, Baltimore, attributed to Ammanati (54.465) seems to me to be a related work.

Were it not for their close association with the spiral flogging group, which must surely be Italian and has never been proposed as anything else, it would be tempting to suggest that the stands were made north of the Alps. The

version in the Victoria and Albert Museum is labelled as German or Flemish, but it is France that comes to mind. Sphinxes or harpies with a similarly sleek elasticity were popular with the school of Fontainebleau and can be found in works of art of all types from ornamental keys (see, for example, those in the Walters Art Gallery, Baltimore, 52.88 and 57.698, in the Victoria and Albert Museum 5610, 5613, 5616-1859, or in the Musée de la Renaissance, Écouen, CL. 20991 or CL. 22147) to elaborate carved wooden cabinets (see, above all, the *Dressoir aux harpies*, Écouen, CL. 20426, but also No. 323). The most familiar sphinxes in Italian bronzes of the sixteenth century are very different from these, but they are all made in Venice or the Veneto (see No. 226). If one looks to other centres and at works in other media, analogies may be detected. Middeldorf (op. cit. 307) cited the silver altar furnishings in St Peter's made by Andrea Gentile of Faenza for Cardinal Alessandro Farnese, which however are not sufficiently close to warrant an attribution.

It remains to point out the variations in the five recorded versions of the inkstand. The wings of the sphinxes are tied together in the Ashmolean and the Louisville versions, but in the latter are enriched with garlands. The Ashmolean, Louisville, and Victoria and Albert Museum versions all have a base supported by claw feet. In the untraced Borghese–Rothschild version, and those in the Louvre and Victoria and Albert, the wings of the sphinxes are hooked into projecting shells. There are other minor differences: for instance, in the Victoria and Albert version the wings are less feathery than those in the Ashmolean; the sphinxes there also have tails which are missing in the Ashmolean version.

Lastly, since the sphinxes in these stands are often described as harpies it should be pointed out that according to the standard authority of the period, Vincenzo Cartari's *Le imagini con la spositione de i dei de gli antichi* (Venice, 1556), 296, sphinxes had the face and breasts of a woman with great wings but were otherwise lions whereas (p. 293) harpies had the face of a beautiful but lean (*magra*) woman but in the rest of their bodies were birds with large wings and with hooked talons as they are described by Virgil in a passage admirably imitated by Ariosto.

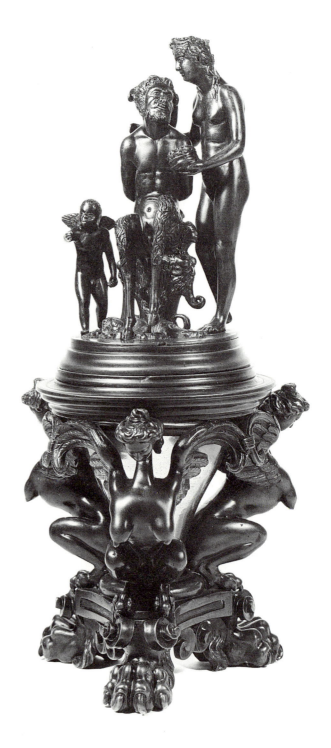

225. Inkstand supported by volutes adorned with lion heads and crowned by a cupid clutching flowers

21.6 cms. (total height); 10.6 cms. (height of vessel); 11 cms. (height of lid excluding part concealed by vessel);

Bronze with a dark brown patina and traces of black varnish. Hollow, lost-wax, cast. The vessel fitted with a lead lining now decaying. Chaplet holes beside the masks on the lid. Inscribed 'B. / —87 / ℰℱ' in white paint under one foot and 'B / —87 ℰℱ' on underside of lid.

Lent by C. D. E. Fortnum in October 1894 and bequeathed 1899. No. 1087 in his catalogue. Presumably purchased after the compilation in 1857 of his preliminary catalogue, in which it is not included.

In his notebook catalogue Fortnum dated the work to about 1580 but altered this to 1560. In his large catalogue he changed 1560 to 1540. C. F. Bell, annotating the latter, considered that it belonged to the period 1550–75 and to the 'School of Sansovino'. The decorative motifs, especially the female mask with drapery under her chin, are indeed characteristic of Venetian ornamental art of the second half of the sixteenth century and so too are the features of the Cupid. Fortnum was aware of the similarity between his inkstand and another in the Victoria and Albert Museum (567-1865, formerly Soulages Collection) in which the same pattern of vessel is supported by three free-standing heraldic lions and the same pattern of lid acts as a base for (or has been adapted as a base for) a standing personification of Hope. Neither the lions nor the Hope seem as well adapted to the design. There are connections also with another inkstand, in the same museum (5908-1859), also with a Hope, but this time with Cupid supporters, and a spreading scroll-work base like that in the Ashmolean Museum. Bode also illustrates an inkstand similar to this latter (*Italian Bronze Statuettes of the Renaissance* (London, 1907–12), ii, pl. clix—then in the collection of Otto Beit, London, now at Blessington in Ireland, collection of Sir Alfred Beit). On account of the character of Hope he was inclined to attribute it to Alessandro Vittoria. The statue must indeed be derived from an invention by Vittoria or a contemporary but it was surely an artisan not a leading sculptor who designed, or improvised, utensils of secondary quality such as these. A version of the inkstand in the Carrand Collection (no. 273), now in the Bargello, Florence, was noted by Bell as a replica of the version in the Ashmolean Museum but without a lid. A pair of seated putti clutching flowers, one very close to the putto here, the other in reverse, are included in an elaborate Italian inkstand and cover, dated 1566 in raised letters, which was lot 83 in William Newall's collection sold Christie's, London, 27–9 June 1922.

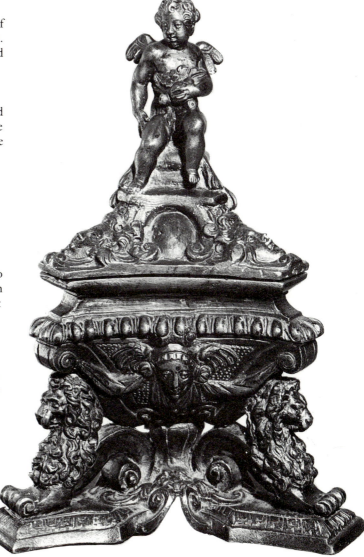

226. Inkwell (or basin) supported by three sphinxes

6.6 cms. (height)

Bronze with a dark chestnut patina. Brassy coloured metal is exposed where the undersides of the feet have been filed. The surface of the bowl has been textured with a punch. Much of the body of the bowl is missing but none of its rim. The body is of thin metal which is torn around the losses on the bowl. 'B. / —93 / Ⓕ' is painted in white on the interior of the bowl.

Lent by C. D. E. Fortnum in October 1894. Bequeathed in 1899. B. 1093 in his catalogues. The notebook catalogue leaves a blank after the word 'bought' but it was presumably acquired after 1857 in which year the preliminary catalogue, in which it is not mentioned, was compiled.

Fortnum regarded this, justly, as the 'wreck of a most elegant model'. He dated it to the early sixteenth century, but it was probably made later. He seems only to have decided that it was for ink when he came to classify his collection for the notebook catalogue, and in his large catalogue he felt the need to observe that it was 'well adapted for a salt cellar', which suggests a lingering doubt. Bowls of this type supported by sphinxes are not uncommon. A silver sugar bowl in the Wallace Collection (X11L—C202) which is dated 1580, and is decorated with three coats of arms one of which is possibly of the Vitale Rizzi family of Milan, is very close in design. A bronze bowl, 8 cms. high, in which the sphinxes have more wide-spread wings, pairs of lion feet (rather than one), and coiled serpent tails, is in the Louvre (OA. 2793). A vessel with very similar sphinxes to those in the Louvre, but with a bowl higher on their backs and of gadrooned form, is in Ravenna (*Piccoli bronzi e placchette del Museo Nazionale di Ravenna* (Ravenna, 1988), 37). While such bowls are usually described as inkwells some of them are equipped with an upper stage and described as perfume burners (an example, in the Castiglioni Collection, Vienna, is pl. 665 in L. Planiscig, *Venezianische Bildhauer der Renaissance* (Vienna, Berlin, 1921)). The same sphinxes as those on the Louvre, Ravenna, and Castiglioni bowls were sometimes employed to support the bases of urn-shaped candlesticks of which there are a pair in the Kress Collection attributed to Roccatagliata (J. Pope-Hennessy, *Renaissance bronzes from the Samuel H. Kress Collection* (London, 1965), no. 486, figs. 571–2, with a useful list of other versions). Sphinxes of a generally similar character but smaller serve as supporters for an octagonal inkstand with a conical cover surmounted with a horse which is on 'Mr. Morgan's desk' in the old library in the Pierpont Morgan Library, New York. It is decorated with the arms of notable Venetian families. Such sphinxes can also be firmly connected to Venice by their appearance on two important and dated works still in the city: the bronze support of the reliquary of the Scuola di San Teodoro (dated 1567) in the Accademia in Venice and the paschal candelabrum dated 1570 and cast by Andrea di Alessandro Bresciano for S. Spirito in Isola (now in S. Maria della Salute). Sphinxes which are particularly close to those on the Ashmolean's bowl (having one foot rather than two), but larger in size, support bowls which form a unit in Venetian andirons (such as the pair in the Altman bequest to the Metropolitan Museum, New York—14.40—694 and 695), and are sometimes found as independent pieces (for example Wernher Collection, Luton Hoo, no. 472).

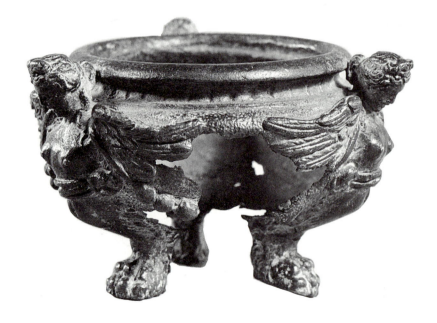

227. Inkstand supported by three helmeted sphinxes and crowned by a warrior

21 cms. (height); 9.3 cms. (height of warrior); 9.2 cms. (height of each foot—from paw to helmet)

Bronze, with a natural dark brown patina and a few traces of blackened varnish (on bellies of 'feet' especially). Hollow, lost-wax, cast. Traces of solder below the vessel. Inscribed 'B / 92 / ⴹ' in white paint inside the lid and 'B-92 ⴹ' along the back of one foot.

Lent by C. D. E. Fortnum in January 1888 and given later in the same year. No. 1092 in his catalogues. Bought in Florence in 1867 for £4, according to his notebook catalogue.

Although he esteemed it for its completeness and condition, Fortnum was aware that this inkstand was 'roughly executed'. He dated it simply as late sixteenth century. The vessel may be related to a number of other models in which the similarly punched basins are supported by sphinx-type supports, for example lot 121 at Sotheby's, London, 8–9 December 1988. The ornaments on these vessels may be decisively connected with those on documented and signed Venetian bronzes (above all the great candelabra in S. Maria della Salute and those of S. Stefano, repeated in S. Giovanni Crisostomo, where both scroll arms and scroll helmet may be found). The botched *contrapposto* of the warrior in the Ashmolean's inkstand appears also to be derived from slowly winding postures probable in a *Mars* (or *Minerva*!) of the late sixteenth-century Venetian School.

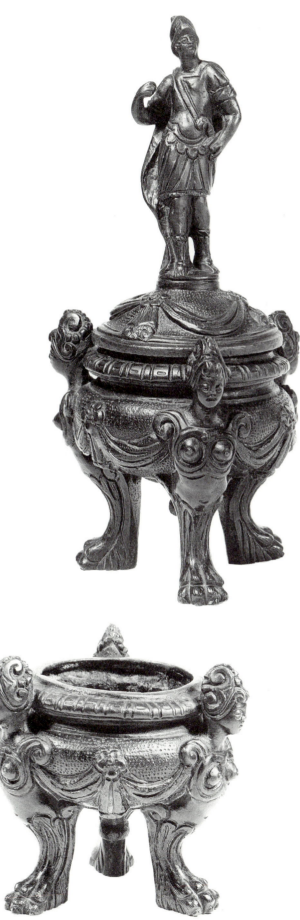

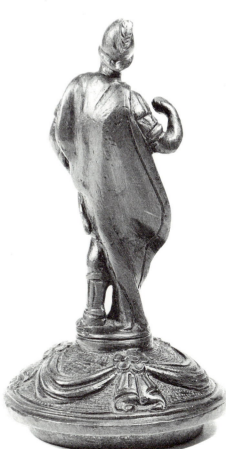

228. Inkstand supported by juvenile tritons with a cover crowned by Pomona

24.4 cms. (height); 15.6 cms. (height of figure from head to foot); 9.5 cms. (height of juvenile tritons)

Bronze of a slightly grey brown patina with traces of a blackened varnish. Hollow, lost-wax, cast, with thick walls, the tritons solid, or at least filled up with core, above the chest. Cast in two pieces (vessel with supporters; cover with Pomona). 'M.187' painted in white inside the cover where there is also an oval label printed with a black border and the initials 'E.G.R' above a line below which is inscribed in black ink '533'.

Bequeathed by J. F. Mallett in January 1947. Received in the Museum during the last week in May 1947. No. 187 in the inventory of his collection, valued at £60. 'Sotheby 1945. Ernest Raphael Collection', according to Mallett's notes.

The inkstand is well executed in some passages, especially the crisp grotesque masks and leaves in low flat relief contrasted with the punched ground of the cover—punching which appears to be executed in the wax model. But the figure, although clearly derived from an elegant model, had been modified by an insensitive craftsman. From behind (and it is an object designed to be seen in the round) the drapery falls behind the figure's right leg without folds in such a manner as to resemble a swollen leg. Mallett described the bronze, cautiously, as north Italian and of the second half of the sixteenth century. It is likely to have been made in Venice or the Veneto.

There is an inkstand in the Victoria and Albert Museum (561–1865, in reserve) with very similar tritons who however have hands on their chests and less well-formed tails. There is also a candlestand in the Museo Nazionale di Palazzo Venezia, Rome (displayed without a number), in which still more similar tritons have their right hand in the same position as those in the Ashmolean but hold their tails in their left. In general lobed or gadrooned vessels for perfume burners or inkstands supported by a trio of putti or half-animals seem to have been popular in the Veneto in the sixteenth and seventeenth centuries—see, among numerous examples, the perfume burner or inkwell from the Castiglioni Collection (L. Planiscig, *Venezianische Bildhauer der Renaissance* (Vienna, Berlin, 1921), pl. 665) and the inkstand in the Wallace Collection (S75), the former with sphinxes, the latter with putti. The way that the tritons' fins and tails have been cut through to form an irregular web-like foot may be matched in the no less disagreeable way in which sphinx supporters are often terminated. The figure of Pomona is also clearly related to Venetian sculpture. A statuette of a slightly larger size in the Museo Poldi-Pezzoli shows a figure with similar *contrapposto*, reversed, and without the raised arm but with one hand supported on a slim double-curved cornucopia behind the projecting knee, thin loops of drapery, and a band passing over the breast (FC. 1/68). There is a similar figure in the Musée de la Renaissance in the Château of Écouen (CL. 10931). These in turn may be related to larger sinuously posed figures of highly sophisticated execution possibly designed for andirons, most notably the personification of Peace, draped, but with a cornucopia of very similar character, in the Bayerisches Nationalmuseum, Munich, attributed to Alessandro Vittoria, and the Venus with a twisted dolphin in place of the cornucopia in the Metropolitan Museum, New York, signed 'I.C.' and generally given to Girolano Campana (Irwin Untermyer Collection, 68.141.19). Figures with those poses and supports may also be seen on the skyline of Sansovino's Marciana Library in Venice and in miniature on bronze utensils such as the salt in the Victoria and Albert Museum (625–1865).

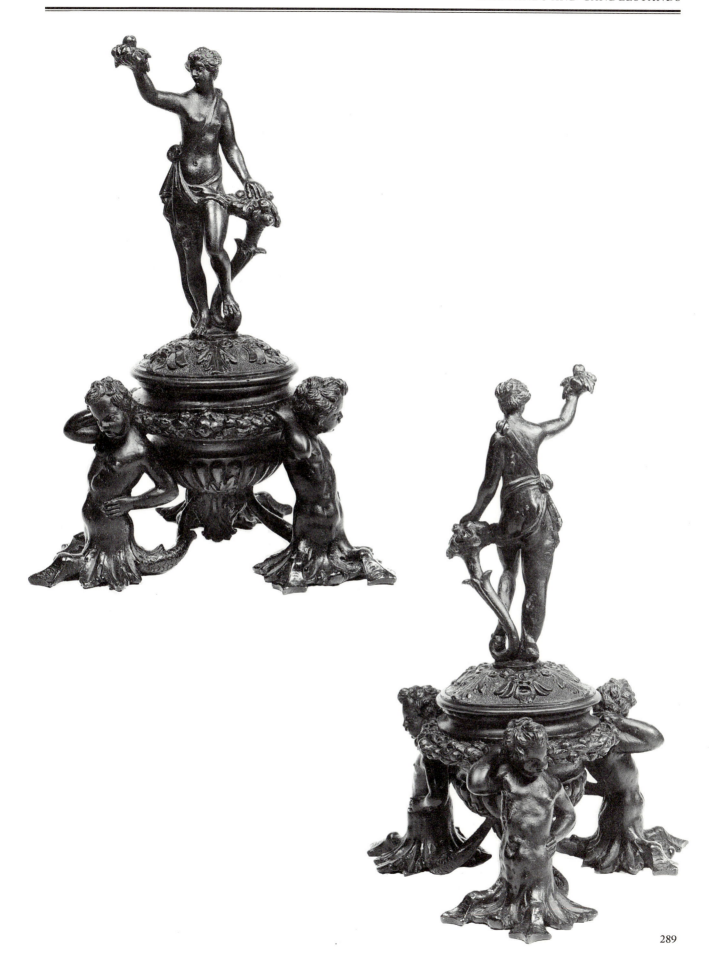

229. Inkstand with a female satyr bathing an infant

24.2 cms. (height); 14.8 cms. (height of figure); 22.8 cms. (length of base); 17.8 cms. (width of base)

Bronze with a dark brown natural patina and traces of black or blackened varnish. Hollow, lost-wax, cast. The figure is cast together with the platform designed to slide out of the base (now secured with pins). The pail is cast separately and soldered to the tray. There is a decayed lead lining in the pail. 'B / —89 / Œ' is painted in white on the side of the rear of the base, on the tray, and on the underside of the pail.

Lent by C. D. E. Fortnum on 20 March 1888 and given later in the same year. No. 1089 in his catalogues. Bought by him in Rome in 1865 from Augusto Castellani, 'with other bronzes', for £25 according to the notebook catalogue.

Fortnum in his notebook catalogue toyed with the idea that this inkstand dated from the first quarter or half of the seventeenth century and was perhaps Roman, suggesting, but they striking out, 'in the manner of Bernini'. In his large catalogue he regarded it as probably Florentine and from the second half of the sixteenth century. 'The influence of Michael Angelo is manifest in the figures and the general design, while the "giglio" at the sides probably refers it to Florence'. C. F. Bell, annotating the large catalogue, evidently agreed and assigned it to the School of Ammanati. Bode considered it as Venetian of c.1575 (*The Italian Bronze Statuette of the Renaissance*, i (London, 1908), 78, fig. 94). J. D. Draper in his 1980 revised edition of Bode considers it as 'probably nineteenth century'.

The inkstand has also recently been attributed by Charles Avery to Giuseppe de Levis, a founder of Verona whose name appears (with dates ranging from 1585 to 1600) on modest-sized bronzes, both domestic utensils such as bells and mortars, and items of more sculptural character (narrative reliefs, statuettes, elaborate inkstands, and a portrait bust). De Levis may never have aspired to be an artist, and may never have designed anything more than modest ornamental works, for whereas the bells and mortars bearing his name form a coherent group, the more ambitious items are less homogeneous in style and some of them certainly reproduce models made by other sculptors. (See the evidence admirably presented in C. Avery, 'Giuseppe de Levis of Verona: A Bronze Founder and Sculptor of the Late Sixteenth Century. 1. Bells and Mortars', *Connoisseur* (Nov. 1972), 179–88, and '2. Figure Style', *Connoisseur* (Feb. 1973), 87–97; but Avery does not consider the possibility that de Levis was only a founder.)

It is certainly true that Giuseppe de Levis's name appears on an inkstand with a narrative character—featuring Christ and the Samaritan woman beside a well, the well being adapted for the ink (Sir Leon Bagrit's collection, London, reproduced by Avery, op. cit. 87 and 96), but none of the ornamental features of the Ashmolean inkwell can be matched on this, or on any other piece associated with him. The two crudely modelled infants perched on the corner of the inkstand do resemble many on Venetian bronzes of the late sixteenth century and no doubt there was a vogue for narrative inkstands there in that period. The inkstand would certainly seem likely to be Italian, and possibly Venetian of the late sixteenth or early seventeenth century. The Florentine association of the 'giglio' pointed out by Fortnum should not be ignored and the grotesque mask incorporated, together with a cardinal's hat, in the cartouche framing the arms is of a type often found in Florentine ornament. On the other hand the volutes combined with inverted cornucopiae would seem to be a motif invented by Guglielmo della Porta for the tomb of Pope Paul III Farnese—this part of which had been executed before 1549. The lily, was a Farnese emblem and payments were made in 1551 for a 'Statua della Bacchessa'. belonging to the Farnese to be taken to the 'casa di fra Guglielmo Scultore' (A. Bertolotti, *Artisti lombardi a Roma*, 2 vols. (Milan, 1881), i. 133). There is also a connection with France which helps to suggest a date.

As was first pointed out by Anthony Radcliffe in a letter of 13 October 1971 two engravings showing a very similar satyr and child back and front on a naturalistic ground (presumably added by the engraver) were included in the *Antiquariae supellectilis portiuncula* by Paulus Petavius (Paul Petau) which seems to have been published in 1610, although some of the plates are dated 1609. Petau (1568–1614) was one of the ministers of King Henry IV of France and a keen antiquary and numismatist. This volume was perhaps the first set of illustrations ever made of the contents of a collection. (See J. Yvon, 'Petau numismate', *Gazette des beaux-arts* (Sept. 1966), LXVIII, no. 108, pp. 113–30.) This particular item was evidently regarded by Petau as an antique bronze. He may well have acquired it in, or from, Italy. It must have been well known in France for it was reproduced again—and more accurately—by Charles Patin (Carolus Patinus) in his *Imperatorum Romanorum: Numismata ex aere mediae et minimae formae* (Paris, 1697), opposite p. 129. Bernard de Montfaucon also reproduced and briefly discussed the sculpture in the supplement to vol. i of his *Antiquité expliquée* published in 1724 (160, pl. 61), still assuming it to be antique. It may be that the bronze of this group acquired by the Musée du Louvre in 1910 (OA. 6413) is from Petau's collection. It certainly corresponds closely to the engraving in Patin. There is another version of the faun in the Royal Scottish Museum, Edinburgh, which was acquired in London in 1883 (83-47-1). Both seem to have been known to Fortnum who observed in his large catalogue, 'I do not know another [inkstand] of this model, although I have seen other replicas of the female and her infant without the basement'. The bronze in the Louvre is 14.3 cms. high, and simpler and smoother than the figure in the inkstand, without for instance so many markings in the fur. It is also of a different alloy, with a high copper content, where the blackened varnish has been worn. The example in Edinburgh is 15.8 cms. high, coarser than the others and with different legs.

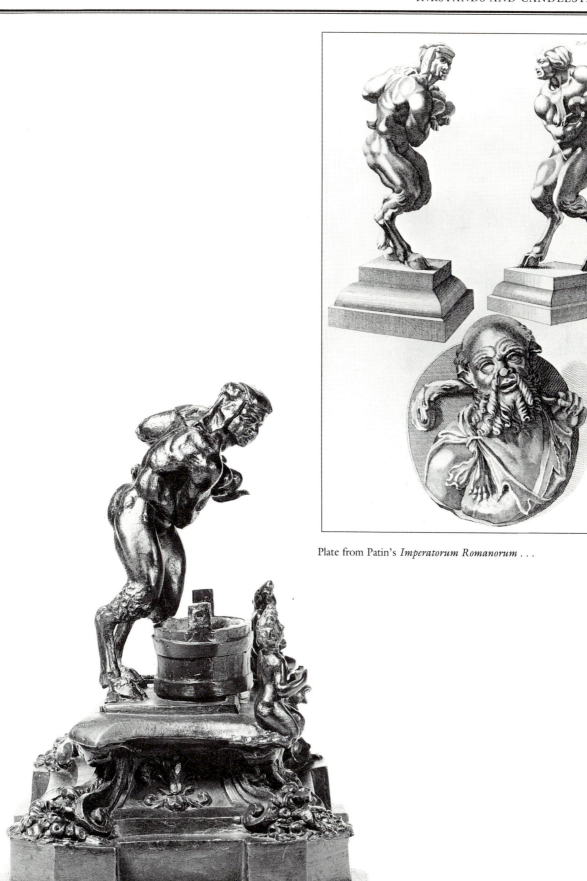

Plate from Patin's *Imperatorum Romanorum* . . .

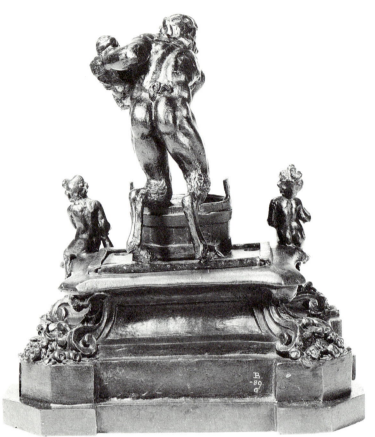

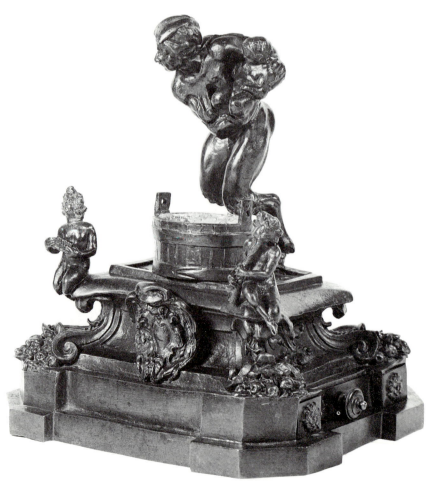

230. Inkstand with a seated draped female figure holding tablet and stylus

21.2 cms. (height); 16.2 cms. (height of figure)

Bronze with a pale brown natural patina, retaining traces of a red lacquer varnish in parts blackened. Hollow, lost-wax, cast. The figure, seat, and tablet are cast as one piece. Inside the upper section 'B / —90 / Œ' is painted in white and there is a lozenge-shaped paper label with blue border lines and 'B / 1090' inscribed in ink. On the underside of the wooden tray 'B / —90 / Œ' is also painted in white.

Lent by C. D. E. Fortnum on 20 March 1888 and given later in the same year. No. 1090 in his catalogues. Said in his notebook catalogue to have been 'bought in Paris' for the sum of £12.

Described by Fortnum as 'probably Florentine' and of the seventeenth century, but without reasons. He perhaps had in mind the 'exaggerated scroll work masks'—the mask element of which is only apparent at second glance—which support each corner of the stand, for they are of a grotesque design (ultimately dependent upon Michelangelo, cf. Nos. 62 and 63) popular in Florence. W. Bode (*Italian Bronze Statuette in the Renaissance*, (London, 1907–12), ii, CXLIV), describing a related inkwell in the Kaiser Friedrich Museum, Berlin (now Staatliche Museen, Berlin-Dahlem, 1997, reserve), interpreted the figure, reasonably, as a personification of Clio, Muse of History. He had previously published this bronze in *Pan*, 2 (1896), as Venetian from the circle of Jacopo Sansovino (p. 262). He regarded the Ashmolean version as an inferior replica, but it is of comparable if not superior, quality. The handling is remarkably similar—

for instance in the way that the fringed hem of the robe is caught up over the figure's left ankle and the sketchy rendering of its jagged disorder on the ground behind. There are many differences, however. The Berlin figure has a trumpet and carries (rather uncomfortably) a serpent biting its own tail together with the tablet (inscribed 'DEUS / INPRINCIPIO / FTC'); also, other tablets are placed on the base, one of which she may be imagined as reading. The corner feet of the Berlin stand are simpler scrolls with masks of male fauns sticking their tongues out. Such feet are found in ornamental bronzes made in Venice and Bode suggested the influence of Sansovino. The tight angularity of the pose does in fact recall in a general way the personification of *Sculpture* enthroned between the broken pediment of Alessandro Vittoria's wall tomb in S. Zaccaria, Venice (competed 1603 but designed as early as 1560)—reproduced L. Planiscig, *Venezianische Bildhauer der Renaissance* (Vienna, Berlin, 1921), pl. 570, and Francesco Cessi, *Alessandro Vittoria, architetto e stuccatore 1525–1608* (Trent, 1961), pl. 54. The fall of the drapery and its fringe on the base are reminiscent of that in the statuette of *Winter* attributed with good reasons to Vittoria (*Kunsthistorisches Museum*, Vienna, 5664). There is also a similarity between the figure and a standing statuette of *Hope* in the Victoria and Albert Museum (7875–1861) in type of garment, style of drapery, and sketchy modelling. For another instance of an inkstand ornamented by a very differently modelled female personification with a tablet see Yvonne Hackenbroch, *Bronzes, Other Metalwork and Sculpture in the Irwin Untermyer Collection* (London, 1962), p. xxx and fig. 69, now reserve collection Metropolitan Museum (64.101.1459B). J. D. Draper in his 1980 revised edition of Bode (op. cit.) describes the Berlin inkstand as 'possibly Roman and of the late sixteenth or early seventeenth century'.

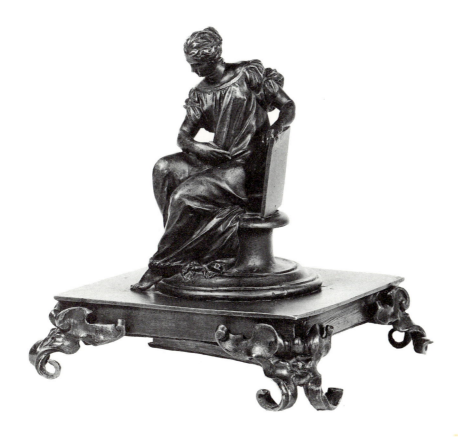

231. Inkstand (and perhaps candlestand) in the form of a putto with two masked horn-shaped containers

17.2 cms. (height)

Bronze with a chocolate to pale tan natural patina. Hollow, lost-wax, cast, apparently as a single unit. Wood jammed in the upper part of the interior. On proper left of the rock seat 'B. / —82 / ⊕' is painted in white. The detail appears to be almost all in the wax model—that of the hair is especially characteristic of a soft material easily tooled.

Lent by C. D. E. Fortnum in October 1894 and bequeathed by him in 1899. No. 1082 in his catalogues. 'Bought Bologna 1853 for a trifle.' But, according to his preliminary catalogue of 1857, it was bought there in 1851 (p. 45). Recorded by Fortnum as mounted on a black wood stand now untraced.

Fortnum described this in his large catalogue as 'a highly artistic and graceful model, the work of a masterly hand and probably unique as it is cast "a la cire perdue". The idea is doubtless derived from the antique figure of the young Hercules stangling the serpents, but greatly modified in expression and action and in the details.' He considered it as perhaps Florentine and of the late fifteenth or early sixteenth century. In his notebook catalogue he had speculated that one of the horns was for a vessel containing ink and the other for a candle or a vessel containing sand. C. F. Bell, in pencil additions to Fortnum's catalogue, noted that there was a similar figure in Berlin but with serpents (he was perhaps thinking of the figure in the Staatliche Museen, Berlin-Dahlem, inv. no. 2654), and also that there was an inferior replica of the inkstand but without the horn in the child's right hand in the Carrand Collection (G. Sangiorgi, *Collection Carrand au Bargello* (Rome, 1894), pl. 46, and no. 216 in the Bargello Catalogue of 1898 where it is said to be Venetian of the sixteenth century). The character of the pierced frieze of the base composed of masks and scrolls suggest a later date than Fortnum supposed and this is supported by comparison with a curious table utensil in the Walters Art Gallery, Baltimore (54.620). This consists of three nude putti seated on a round pierced base of identical design, each holding a masked horn vessel very similar to those in the Ashmolean inkstand. Balanced on top of their heads are the scrolled legs of a tripod, each terminating in a faun-atlantis holding, with both arms raised, the same ball. If, as seems likely, this piece was made by the same founder as the Ashmolean inkstand then the tripod handle would certainly suggest a date in the second half of the sixteenth century. I have not been able to trace the antique Hercules group which Fortnum had in mind, but the pose and expression of this boy must originally have had some such desperate pretext.

Attached to the sides of the high altar of the Duomo in Siena are a pair of bronze candlebrackets in the form of child angels emerging from acanthus and supporting pans upon their heads. They resemble the Ashmolean inkstand, both in

the modelling of the body, the treatment of the hair, and, most significantly, the motif of the leafy mask (used where the candlebrackets are attached to the altar). The Sienese angels are likely to date from between 1527 and 1536 when the present high altar was constructed. It has recently been proposed that they might be the work of the great Sienese painter Domenico Beccafumi, whose chief activity as a modeller and bronze founder belongs to the four years previous to his death in 1551 when he created the eight angels for the columns nearest to the same high altar (A. Bagnoli, 'La Scultura di Domenico Beccafumi', in *Domenico Beccafumi e il suo tempo*, ed. A. Bagnoli *et al.* (catalogue of the exhibition held in various locations in Siena, 1990), 531–5). In favour of this proposal is Beccafumi's fondness for leafy masks. They adorn the bronze consoles supporting six of the angels and are also found in his paintings—on the pedestal of the loom in the painting of *Penelope* in the Seminario Patriarcale, Venice, of *c.*1514 and in the pilasters of the temple in the fresco of the Marriage of the Virgin in the Oratorio of San Bernardino of *c.*1518 (ibid. 107, 610). The twisted pose of the Ashmolean putto is certainly reminiscent of the wriggling children in Beccafumi's paintings.

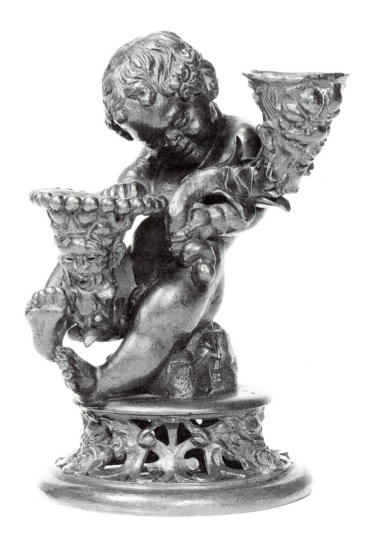

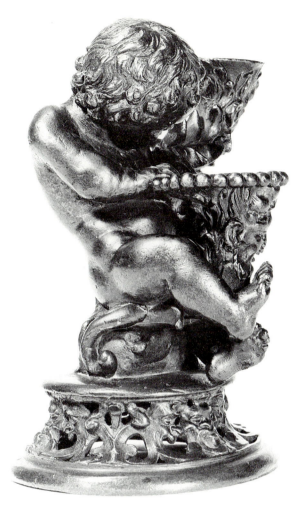

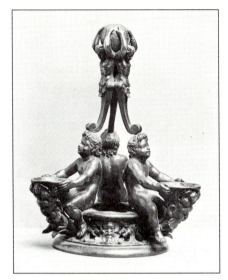

Table utensil. Walter's Art Gallery, Baltimore, Maryland

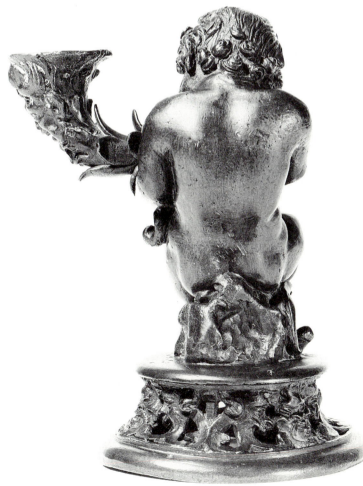

232. Inkstand in the form of a triton astride a tortoise carrying a whelk shell

15.2 cms. (height)

Bronze, of a high copper content, with warm chestnut natural patina and traces of black or blackened varnish in the hollows. Hollow, lost-wax, cast. The turtle's head with the attached tray were cast separately. No evidence of tooling. Two thin iron chaplets are visible in the interior of the cast, one across the triton's hips and the other across the triton's right 'leg'. There is a small hole beside his right 'leg' towards the tail. 'B / —83 / Ƌ' is painted in white at back of the tortoise to left of its tail.

Lent by C. D. E. Fortnum on 20 March 1888, given later in the same year. No. 1083 in his catlogues. 'I bought it of Augusto Castellani with other bronzes that had belonged to his father [Fortunato Pio Castellani, 1793–1865], in 1865.' The notebook manuscript contains the additional information that it cost £10.

The shells would, presumably, have been fitted with ink pots. The tortoise's head serves as a handle for a drawer which pulls out to reveal a tray for sand. Fortnum observed, justly, of this bronze that it was a 'bold vigorous work cast *à la cire*' and was a 'bold model suggestive of the manner of Bernini'. In his large manuscript catalogue he described it as 'perhaps Roman' and from the end of the sixteenth century or of the early seventeenth century. In the earlier notebook catalogue he had struck out sixteenth century and placed the bronze in the seventeenth, no doubt noticing the analogies with Bernini's tritons (and especially his Triton Fountain in Piazza Barberini of 1642–3). The rippling vitality of surface and complex plasticity do however seem possible in a sixteenth-century work on this scale, although if it were a larger work one might hesitate to date it before Bernini. Bode, who published the Ashmolean version in his *Italian Bronze Statuettes of the Renaissance*, (London, 1907–12) ii, pl. CLXXI, considered it to be Venetian of about 1575. Fortnum was aware that there were many modern copies— 'more or less varied in detail'. Noting that these had been made in Rome where his was acquired he supposed that his bronze might have served as the model for them. Five of these copies or fakes are identified below. Augusto Castellani might have made them. What Fortnum, and indeed subsequent scholars, failed to observe is that the Ashmolean bronze is related to a remarkable group of fanciful sketchy inkstands all of which must have come from the same workshop. One other bronze in the group seems to have consisted of a triton on a tortoise, but it was typically varied, with the shell held aloft by the triton pointing in another direction (illustrated in Bode, op. cit., as in Rodolphe Kann Collection, Paris, but present whereabouts unknown). The triton, however, is also included in an inkstand in the Philadelphia Museum of Art (30-1-26), riding a dolphin-like sea monster. The modelling of the chest and face is the same as the triton in the Ashmolean, so is the size, and he holds a very similar shell—but at a different angle and with his arms further back. This group can in turn be related to another in

which the same sea monster is ridden by a putto balancing the same type of shell upon the monster's head. There are examples of this model in the collection of the prince of Liechtenstein (no. 262; Bode, op. cit. ii, pl. CLXX, wrongly captioned as in the Benda Collection), in the Kunsthistorisches Museum, Vienna (9117), in the Victoria and Albert Museum (A. 7-1966), formerly in the Capel Cure Collection (see Sotheby, London, 10 December 1987, no. 35, illustrated), and with S. Franses of 82 Jermyn St., London. There are variations among all of these, in the attitude of the putti especially (who in the Vienna and Liechtenstein versions ride sideways). There is also a related model in the Fitzwilliam Museum, Cambridge (M5-1932; Bode, op. cit., iii, pl. CCLXI, wrongly captioned as in the Victoria and Albert Museum), in which the sea monster carries another sea monster which balances a shell on its tail. All these bronzes have the same very coppery metal, the same traces of black or blackened varnish, the same waxy quality, with no evidence of tooling (and occasional traces of very fine casting seams). The Ashmolean bronze has been examined beside that in the Victoria and Albert Museum: the treatment of the hair of the putto and that of the triton was found to be strikingly similar and the whelk shells of six spirals were the same size (10.15 cms. in length) and looked as if they came from the same mould (which incidentally may well have been taken from a real shell).

The riding putti inkstands have of course long been recognized as belonging to a group (what is new here is the extension of the group to include the Ashmolean, Philadelphia, and Kann bronzes). M. Leithe-Jasper has suggested that the putti might be the work of Adriaen de Vries or from his circle and has compared them and their 'dolphins' with those in the Hercules Fountain in Augsburg (see *Giambologna*, exhibition catalogue (Vienna, 1978), 310–11, and *Renaissance Master Bronzes from the Kunsthistorisches Museum, Vienna* (Washington, Los Angeles, Chicago, 1986), 229–30). A. Radcliffe has noted the similar figures (tritons as well as putti) and 'dolphins' adorning the fountain (designed by Carlo Maderno and Giovanni Fontana) in the Piazza della Madonna, Loreto. The casting of these by Tarquinio and Pietro Paolo Jacometti had been completed by 1622 (see entry in the catalogue for Sotheby's sale cited above). The inventions may well have been circulating in a diminutive form before they were executed on a large scale at Loreto. In style there is no close connection with the figures at Loreto, but still less with any bronzes by de Vries which are always distinguished by chiselling of a kind that is not found here.

It remains to describe the modern versions which Fortnum suspected were made in Rome (quite possibly under the auspices of the Castellani family who owned Fortnum's version). They differ from the Ashmolean group in that there is no smaller shell balanced on the tail, the shell above the head is of a different character and points another way, and there is a small infant triton riding in front of the large one. The surface is also different, having been extensively tooled after casting with punched and chiselled textures on the shells. They are heavy casts and of a brassy alloy. One of this type,

which passed in 1902 from the Propert Collection into that of W. Newall, was exhibited at the Royal Academy in the Winter of 1904 and again at the Burlington Fine Arts Club in 1912 (no. 7, pl. 32, in the illustrated catalogue of 1913). It had the initials 'B.C.' and the date 1545 on it, presumably intended to suggest the authorship of Cellini. It was sold as lot 40 at Christie's, London, 27–9 June 1922, and was then placed on loan in the Ashmolean Museum in 1951 by a collector in Stow-on-the-Wold. Another bronze of this type collection of R. Weininger in Berlin was published by L. Planiscig in 'Bronzi minori di Leone Leoni', *Dedalo*, 7 (1926–7), 554, and another was published, also with an attribution to Leoni (1509–90), by Y. Hackenbroch (*Bronzes, Other Metalwork and Sculpture in the Irwin Untermyer Collection* (London, 1962), p. xxx, pl. 63). The latter bronze was acquired by the Metropolitan Museum but deaccessioned in 1982. There is also a version in the reserve collection of the Walters Art Gallery, Baltimore (54.147), one was acquired by the Getty Museum *en bloc* with the Lederer Collection (85.SB.67—see the *J. Paul Getty Museum Journal*, 14 (1986), 264, no. 254), and another was lot 171 at Sotheby's, 8 December 1989. The distrust inspired by contact with these casts has perhaps influenced some scholars in their estimate of the Ashmolean bronze which J. D. Draper, for example, describes as 'probably nineteenth century' in his 1980 revised edition of Bode.

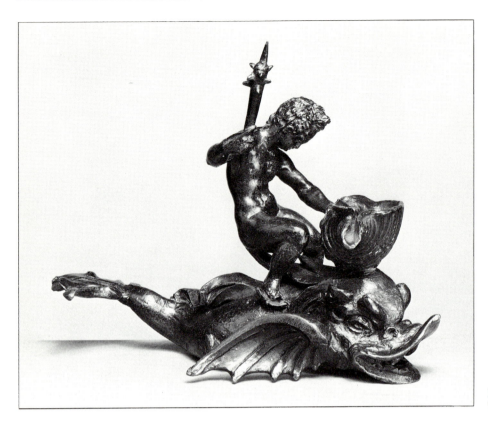

Inkstand.
Victoria and Albert Museum

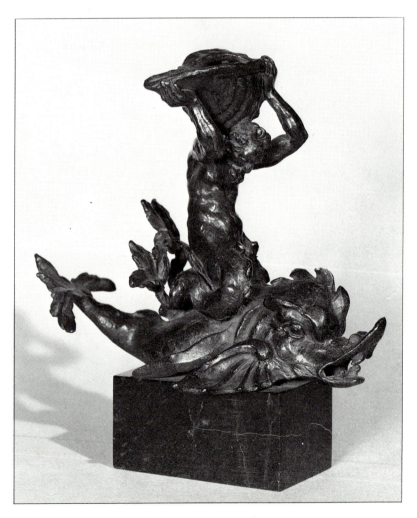

Inkstand.
Philadelphia Museum of Art

233. Inkstand in the form of a mermaid holding a receptacle for an inkwell

13.5 cms. (height); 7.8 cms. (width); 11.5 cms. (length)

Bronze with a green patina worn in parts to a pale brown natural patina. Hollow, lost-wax, cast, in one piece, perforated in the interior of the well. Some core remains in the interior of the mermaid where the metal has also severely oxidized (this was treated in 1987 by David Armitage of the Department of Eastern Art). For earlier treatment see below. 'B.—81 / Œ' is painted in white in the interior.

Lent by C. D. E. Fortnum on 7 January 1888 and given later in the same year. Bought by him in Florence in 1867 for £5. No. 1081 in his catalogues.

Fortnum owned another inkstand of an identical pattern which he had bought in Perugia in 1851 (preliminary catalogue, 46, no. 7)—no. 1080 in his catalogues. This he sold in the 1880s to Henry J. Pfungst. It was no. 36 in the *Descriptive Catalogue of a Small Collection Principally of XVth and XVIth Century Bronzes* (no date) and was sold to the dealers Durlacher and A. Wertheimer in 1900 and by them to Pierpont Morgan in whose collection it was catalogued by Bode. This version is now in the Metropolitan Museum, New York (32.100.191, in reserve). The only difference which Fortnum noted between the two inkstands was the absence

of any arms incised on the shield of no. 1080. His first view was that the inkstands were Italian and of *c*.1560 (preliminary catalogue), but he came to regard both as probably Venetian of the early sixteenth century, comparing them to the standard sockets of 1500–5 in the Piazza di San Marco signed by Alessandro Leopardi (thinking presumably of the sea creatures in the lowest band of frieze). Fortnum was also aware of a variant on the model in which the mermaid plays a stringed instrument. Among the versions of the two models are the following: Victoria and Albert Museum, Salting Bequest, M. 693-1910, with a stringed instrument—no doubt the version known to Fortnum; Philadelphia Museum of Art, 1930-1-32 from the Edmond Foulc Collection (W. Bode, *Bronze Statuettes*, ii (London, 1908), pl. CLXIX), also with an instrument and with arms in the shield; Wallace Collection (S. 87—J. G. Mann, *Wallace Collection Catalogues: Sculpture* (London, 1931), 35); Collection of Baron and Baroness Schröder and of Mr and Mrs Lippmann, the former exhibited Burlington Fine Arts Club 1928–9, the latter sold to them by Duveen 1932 (information from Wallace Collection files); Metropolitan Museum, New York (30.95.111), with an instrument. In addition C. F. Bell in a manuscript addition to Fortnum's large MS catalogue noted a version with an instrument in 'Museo Civico Bologna' and another there reproducing the lower part of the model but with the fish tails terminating in monster heads with the infant Hercules on top of them.

Bode was inclined to give a later date to these inkstands than Fortnum suggested, cataloguing the Morgan and

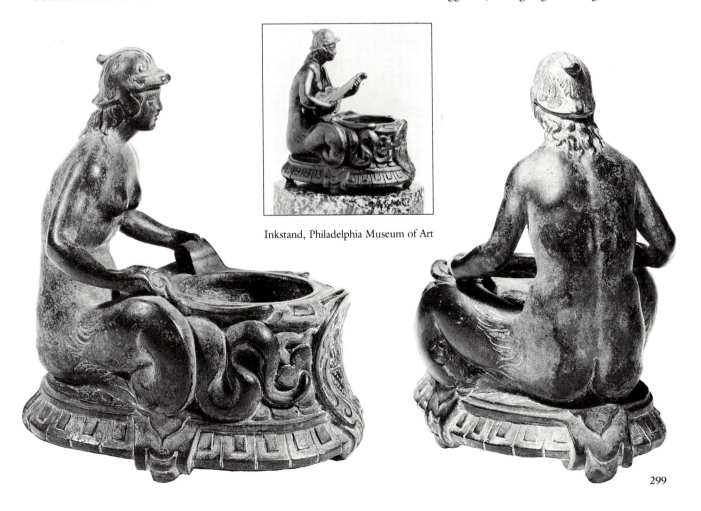

Inkstand, Philadelphia Museum of Art

another version as School of Jacopo Sansovino. J. D. Draper in his 1980 revision of Bode suggests 'possibly north Italian of the late sixteenth century'. The version in the Victoria and Albert Museum is currently labelled as 'German second half of the sixteenth century'. It is hard to find parallels in larger and better-documented sculpture, but the ornament around the base is suggestive of the late sixteenth century (compare the compartments of Venetian stucco or carved wooden ceilings of the lids of *cassoni*). An Italian origin is suggested by the provenance of Fortnum's pieces, and also by the evidence of the arms. Those on the Ashmolean's piece were identified by Fortnum as of the Malatesta family and he speculated whether the inkstand had belonged to either Sigismondo Pandolfo Malatesta (d. 1543) or his son Ercole (d. 1598). C. F. Bell, however, noted that the arms were those of a Sigismondo Malatesta who died in 1468, the quarters not being carried by later members of the family. Suspicions aroused by this anachronism were strengthened by the artificial appearance of the green patina and confirmed by the cleaning of the latter: the inkwell was removed from exhibition in September 1901. It should be pointed out that both false arms and a false patina can be added to a genuine bronze by an unscrupulous dealer and this piece has certainly not been proven a forgery. Moreover it is not certain that the arms are false. A connection with the Malatesta does seem possible. The chesquy bends seem to have been used more by the Bolognese branch of the family than by that of Rimini as Michael Maclagan has pointed out to me.

The musical instrument held by the mermaid in some versions might also help with assessing the date. David Green and Jeremy Montagu have pointed out to me that this must be some form of cittern 'since it has the characteristic "buckles" at the junction of neck and body, the appropriate shape of peg box, and it appears that there might be a slight "foot" at the end beneath the Mermaid's right forearm'. The oddity is the scalloped outline unusual in a cittern but found in a Paduan *lira da gamba* (Kunsthistorisches Museum, Vienna) of *c*.1590 and in a painting by Bartolommeo Passarotti of *King David* in Palazzo Spada of 1563–70. It seems likely to be a fanciful invention of the artist, but if so it is one which is inspired by instruments in fashion all over Europe in the late sixteenth century, especially in Italy where a revival of interest in the cittern seems to have begun in about 1574 when Paolo Virchi's *Il primo libro di tabolatura di citthara* was published.

Comparison with the version in the Wallace Collection reveals that the two are identical in size; the interior with residual core and perforations and the colour of metal are also very similar. The Ashmolean version has slightly more sharply cut mouldings around the base and cartouche, and the feathers on the helmet appear in the Wallace Collection version merely as flaps (this is also true of the version in Philadelphia). The version in the Victoria and Albert Museum differs in having minor variations in the lower ornamentation of the stand, and the mermaid there does not wear a helmet. The version with a musical instrument in the Metropolitan Museum has an entirely different treatment of the head with the hair standing up.

234. Inkstand in the form of a lion, a tree stump, and a fortress

14.2 cms. (height); 18.6 cms. (width)

Bronze with a chestnut brown natural patina, darker in the hollows. Hollow cast in three parts: the lion's head and the lower front portion of the fortress being separate, the former hinged as a lid, the latter serving as the front of a drawer. Small regular holes in the bronze (particularly evident in the tree stump but also, for example, below the lion's chin and beside his left rear paw) are from chaplet pins.

Presented by Mr Henry J. Pfungst FSA in 1908 (*Annual Report* (1908), 8–9). See also Preliminary Essay and Nos. 201, 203, 233, 427.

The stump of the tree is contrived to hold pens; the ink vessel would presumably have been in the lion's head and the sand in the castle drawer. C. F. Bell recorded the acquisition in the *Annual Report* as 'probably Venetian in the style of the school of Alessandro Vittoria, early seventeenth century'. It could be earlier, and certainly could be later, in date and there seems to us no very strong stylistic or technical grounds for considering it as Venetian.

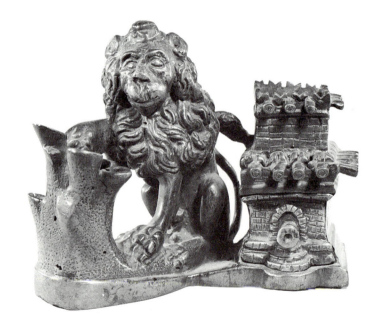

235 and 236. Pair of vase candlestands each supported by three kneeling putti

24.6 cms (height)

Bronze with a tan to dark brown natural patina. Hollow, lost-wax, cast. The vase foot, putti, and base are cast as a separate unit, the body of the vase is cast as another unit, in both cases. No. 235 is of a richer colour and has numerous holes where chaplets have fallen out, beside the masks in the vase and in the legs and chest of the putti. One of the putti in this piece has also lost a portion of the forehead. 'B / —22/ Œ' and 'B / —23 / Œ' painted in white on the bases.

Lent by C. D. E. Fortnum on 20 March 1888 and given later in the same year. Nos. 1022 and 1023 in his catalogues. Bought from 'Forest London'—for whom see Nos. 264–5. The date is given in the preliminary catalogue as 1856 (p. 46). The large catalogue mentions ebonized wooden stands from which the candlestands have since been detached.

As Fortnum noted, there is a very similar pair of candlestands, from the Soulages Collection, in the Victoria and Albert Museum (in reserve, 559 and 560-1865). Close examination

reveals slight differences: the swags in that pair seem to hang from the boys' hands whereas in the Ashmolean's pair they come from under the base. The vase handles are also more inelegant in the Ashmolean's pair. Another pair, equally close, are in the Museo Nazionale di Palazzo Venezia in Rome (displayed without numbers). The same three supporters are employed in an inkstand, supporting a lobed bowl with a cover crowned by a statuette of Fame (lot 74, Sotheby's, London, 7 July 1988, illustrated).

The separately cast upper part of the candlestands—the vase without its base—is found in other compositions where the supporters are sphinxes (see for examples the pair in the National Gallery of Art, Washington—illustrated in J. Pope-Hennessy, *Renaissance Bronzes from the Samuel H. Kress Collection* (London, 1965), no. 486, figs. 571, 572—where a list of other examples is also supplied). Very similar sphinx supports are found in a perfume burner in the Walker Art Gallery, Liverpool (no. 6236, illustrated in their *Foreign Catalogue* (1977), 471), where the upper register is supported by three kneeling boys not unlike those in the Ashmolean's candlestand but with one hand on hip and completely nude— see the entry by A. Radcliffe in the catalogue of the Arts Council exhibition of 1975, *Andrea Palladio*, 60, no. 108. This same type of sphinx, supplied with a scroll leg and lion paw, is a popular motif in inkstands and similar utensils (see

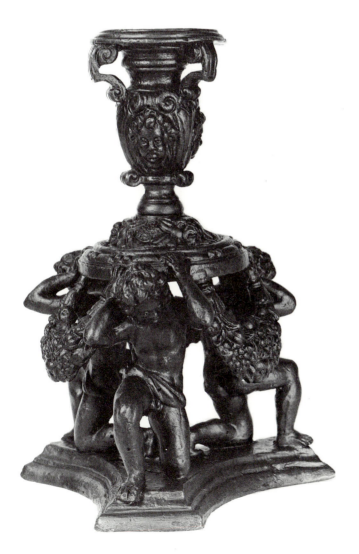
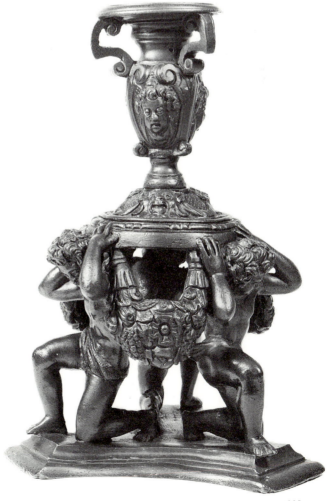

Nos. 226 and 227). Pope-Hennessy observes of the Washington candlestands that they 'are correctly ascribed by Valentiner to the Roccatagliata workshop'. Nothing is known of this workshop, and the few works certainly by Roccatagliata are of superior quality to any of the utensils surveyed here.

Fortnum's description 'north Italian, of about 1570–90' seems prudent, although Bell was right in his annotation of the catalogue to point to late sixteenth-century Venice, for the ornamental vocabulary in this group of bronzes is, as pointed out in No. 226, certainly Venetian.

Fortnum also cited the opinion of J. C. Robinson that this type of candlestand may be cast from models carved in wood (see Robinson's *Catalogue of the Soulages Collection . . . Exhibited to the Public at the Museum of Ornamental Art, Marlborough House* (London, 1856), 112, under no. 347 with reference also to no. 346, the pair of candlestands earlier referred to as now in the Victoria and Albert Museum). However, it should also be pointed out that the very popularity of trios of identical supporters reflects the relatively new ease with which (since the technical innovations associated with Antico) hollow wax models could be cast from the same model, assembled and then used for lost-wax bronze casts by the foundries of north-east Italy. From the account of variants given above, it will also be clear that the various components in an item such as this were valued by founders for their versatility. That these three boys were not originally designed for the purpose they are given here is strongly suggested by the meaningless truncated tail of drapery behind each one.

I owe to Anthony Radcliffe, the observation that candlestands in the Renaissance, being utensils for the writing table, not for the chimney-piece or dining table, do not in general exist in pairs. The different colour and the absence of equivalent chaplet holes in No. 236 suggests that it might be a pair made in the nineteenth century. If so, its accuracy must make connoisseurs despair.

SEALS, HANDLES, FEET, DOCUMENT HOLDERS

237. Seal with handle in the form of a nude terminal putto

9.05 cms. (height); 2.75 cms. (length of seal); 2.2 cms. (width of seal)

Bronze with a dark brown natural patina, palest where handled. Probably solid cast. Crudely chiselled. The plinth of the term is fixed to a brass seal. The boy's head is flattened as if for fixing to another seal. 'B. / 1148 / ₢' is painted in white on the upper surface of the seal behind the boy's feet.

Lent by C. D. E. Fortnum on 7 January 1888 and given later in the same year. No. 1123 in his catalogues. 'Bought in Florence', according to the notebook catalogue.

Considered by Fortnum, surely rightly, to be Italian and probably of a late sixteenth- or early seventeenth-century date. The seal is engraved with an oval shield of arms (barry of six) and the initial letters 'A' and 'M' above and below. A manuscript correction, perhaps by Bell, interprets the ornate 'M' as an 'AG'. But the 'A' and 'G' are not above and below but to either side in the strapwork of the frame. Although the last numeral of Fortnum's number is slightly broken it certainly reads '1148'. No less clearly the number in his catalogue is 1123. The error may have arisen from the fact that he catalogued it next to 1147. He may also have intended to change it to 1148, for he was not sure into which category to place his seals—the finest he in fact classified as plaquettes. A bronze seal handle in the form of an armless female herm is in the Kunstgewerbemuseum, W. Berlin (99.127), labelled as 'Venetian, late sixteenth century'. Michael Maclagan points out that the blazon on this shield was used by two Italian families, the Arrighi and Feranti.

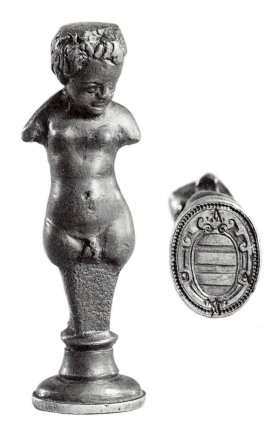

238. Double seal with a handle in the form of a nude putto standing on one seal and supporting the other

6.1 cms. (height); 2.7 cms. (length of upper seal); 2.05 cms. (width of upper seal); 2.2 cms. (length of lower seal); 1.7 cms. (width of lower seal)

Bronze with a dark brown natural patina. Probably solid cast. Crudely chiselled. There are some dents in the surface of the metal—most prominently in the boy's right leg. 'B 1147 Ⅎ' is painted in white on top of base (i.e. back of lower seal) by boy's heels.

From the collection of C. D. E. Fortnum, but it is uncertain when given or bequeathed. No. 1147 in his catalogue. Perhaps acquired after the compilation of the large manuscript catalogue in the 1880s—not recorded in the notebook catalogues.

Considered by Fortnum, surely rightly, to be Italian of the seventeenth century, but not impossibly of the sixteenth century. The seals are incised with a shield of arms bearing an ox passant above which are three stars of six points (estoiles) and the initials N. B. on the smaller (lower) seal and G. B. on the larger (upper) seal. C. F. Bell in a manuscript addition to Fortnum's large manuscript catalogue noted that the 'arms would appear to be of the Bossi family of Milan. Gules, an ox passant argent. Some members of the family seem to have borne differences, the three stars may perhaps be among them, in chief.' Michael Maclagan notes, 'This is all very well and most Bossi families bore an ox. But none of them in Renesse or in Scorza have stars as well. The initials would support letter B: but I don't think heraldically one can go further than "possibly for Bossi".'

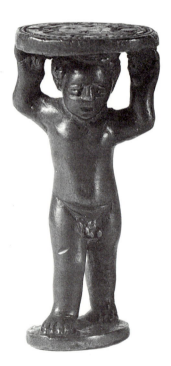
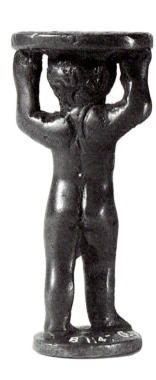

239. Handle in the form of a turbanned black boy wearing a quiver, emerging from a foliate base

9.05 cms. (height of bronze); 1 cm. (height of base); 3.5 cms. (length and width of base)

Bronze with a natural pale brown patina and traces of blackened varnish in the hollows. Hollow, probably lost-wax, cast, bronze with some perforations in the thin wall at the figure's back. There are holes of regular size in the turban and leaves apparently drilled out of the metal. Bolted to a block of porphyry. 'B-75 ℱ.' is painted in white on the quiver.

Given by C. D. E. Fortnum on 7 January 1888. No. 1075 in his catalogues. No note was made of where or when it was acquired but this was presumably after 1857 for it is not included in his preliminary catalogue compiled in that year.

Fortnum catalogued this as perhaps a handle for a knife—but it might also be for another implement—and as Italian, dating from the end of the sixteenth century, although it seems possible that it could be later in date.

240. Handle in the form of a putto, probably from an inkstand's lid

7.6 cms. (height including tang)

Bronze with a warm chestnut natural patina and traces of gilding mostly in the hollows. Brass partially threaded tang inserted in boy's upper right thigh. Hollow, lost-wax, cast. Small aperture behind boy's right knee; a plug apparent in his left breast. Traces of inscription in white paint on thigh near prong originally reading 'B.437 ℱ'. [Photographed with improvised support.]

Lent by C. D. E. Fortnum on 7 January 1888 and given later in the same year. B. 437 in his catalogues. 'Bought in Italy' according to notebook catalogue, with no date but presumably after the compilation in 1857 of his preliminary catalogue, in which it is not included.

Catalogued by Fortnum, surely correctly, as Italian of the end of the sixteenth century. He speculated that it might have served as a handle or 'may have surmounted an inkstand'. To this C. F. Bell added (in the large manuscript catalogue): 'probably; a fine inkstand with this cover, dated 1566 is in the collection of Mr William Newall'. This inkstand was exhibited at the Royal Academy Winter Exhibition of 1904 (Case 1, n. 3). Figures crowning the cover of an inkstand could however also be employed for other purposes.

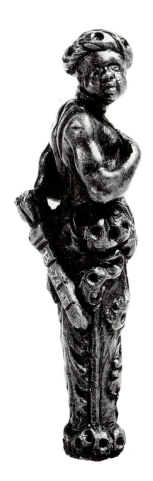

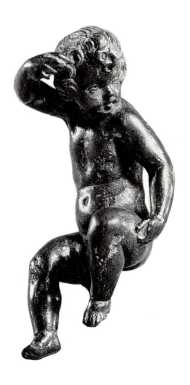

241. Ornamental foot in the form of a satyr

9 cms. (height)

Bronze with fire-gilding worn to reveal a warm chestnut natural patina, especially on the projecting thigh and elbow, the erect penis, and portions of the chest. Hollow, presumably lost-wax, cast. A groove is cut behind the head and below this a wedge of bronze has been inserted into the hollow back of the figure to form two wings (with two projections from each, perforated for screws) whereby it could be attached to the corner of a small casket or base of an item of miniature furniture. Inscribed 'B.418. ᚛' in black ink along figure's back to proper right.

Lent by C. D. E. Fortnum in October 1894 and bequeathed in 1899. No. 418 in his catalogues. No provenance given. Presumably acquired after the compilation, in 1857, of his preliminary catalogue, in which it is not included.

The figure might be designed to appear to support the lid of a casket as well as to serve as the foot of one. Fortnum supposed it to be Italian of the fifteenth century, but the second half of the sixteenth seems more likely. He pointed out that the satyr might represent Marsyas awaiting his gruesome death, but he does not appear apprehensive or unhappy and the arms are not tethered.

242. Cylindrical document holder decorated with trophies

24.8 cms. (length); 6.6 cms. (diameter of the base); 6.5 cms. (diameter of the lid)

'Cuir bouilli' (leather, soaked, heated, waxed, and shaped over a mould) over wood. The base is a piece of turned wood coloured black to match the leather. There are loops in the leather on both sides of the cylinder presumably for a suspension strap. The leather has been textured so that the relief ground is granular and the areas in relief are decorated with gold and with a red pigment—the latter less evident than the former. The leather has cracked in several places.

Provenance unknown.

The technique of 'cuir bouilli' was familiar in much of Europe well before 1500 but the style of this piece, with its cartouche and suspended trophies of three types (crossed quivers, crossed shields, and a helmet with weapons), suggests an origin in Italy in the second half of the sixteenth century.

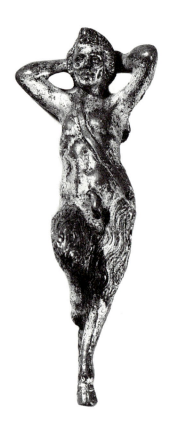

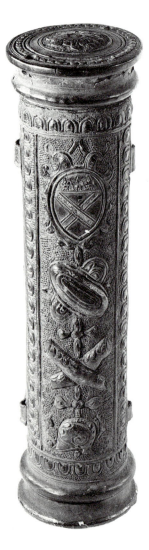

SALT-CELLARS, CENTREPIECES, BASINS, EWERS, SHIELDS

243. Salt-cellar in the form of a kneeling nude youth supporting a clam shell

27 cms. (height); 15 cms. (length); 12.5 cms. (width)

Bronze, with a rich chocolate natural patina and traces of a blackened varnish. There is some verdigris in the hair over the shoulders and on the underside of the shell, also in the youth's armpit. Hollow, lost-wax cast. The shell has been cast with the figure, the base is apparently integral but there is some solder smear below the figure's right knee and beside his left foot. The cast has been imperfectly cleaned around the back of the figure's head.

Lent in October 1894 by C. D. E. Fortnum and bequeathed by him in 1899. No. 1108 in his catalogues. Bought from the Avvocato Rusca in Florence in 1861—for £15 according to the notebook catalogue, but his 'memoranda of prices paid' has 'Bronze salt. Kneeling figure' by the year 1859 with the price £16.

See No. 244.

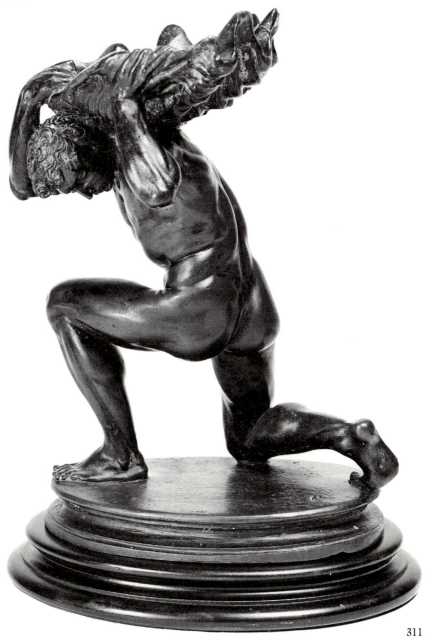

244. Salt-cellar in the form of a kneeling nude youth supporting a clam shell

25 cms. (height); 14.5 cms. (length); 12.5 cms. (width)

Bronze, fire-gilt, the gilding much worn to reveal a pale tan natural patina. Hollow, lost-wax cast. The shell and base are cast with the figure. Plugs in the bronze are now evident, as are chaplet pins (see for instance both sides of the figure's left ankle). There are firing cracks on the top of the figure's back and on his left forearm.

Lent by C. D. E. Fortnum on 20 March 1888 and given later in the same year. No. 1109 in his catalogues. Bought from Augusto Castellani in Rome in 1865 with other bronzes which had belonged to his father (see Nos. 232, 245), for £21 (according to notebook catalogue).

This bronze is apparently made from the same pattern as No. 243, although there are differences in the casting, the metal, and the finish—the underside of the shell in this case is also more perfunctory in modelling, but if the same moulds were used for the wax models these would have been rough and such a difference does not exclude this possibility. Fortnum believed that his ungilded version was 'the artist's original from which a series had been cast and gilded'. He knew also of the pair of figures in the Victoria and Albert Museum—nos. 629-1865 (formerly Soulages Collection) and 104-1910 (Salting Bequest). There are minor differences, in the wrinkling of the shells, and the musculature of the back, for instance, but again they are close enough for the wax models to have come from the same moulds. Fortnum also refers to a version sold in London in 1880 for over £100. Among other gilt bronze versions of the figures are those in the Museo Correr in Venice (Bronzi dorati no. 37), in the Staatliche Museen, Berlin-Dahlem (M 39/82), in the Kunsthistorisches Museum, Vienna (not on display, illustrated in L. Planiscig, Piccoli bronzi italiani del Rinascimento (Milan, 1930), 37, no. 292, pl. CLXIX), and in the collection of Dr A. von Frey, Berlin (L. Planiscig, Venezianische Bildhauer der Renaissance (Vienna, Berlin, 1921), 543, fig. 594). A number have been sold at auction (Christie's, London, 3 July 1985), lot no. 113; Sotheby's, London, 28 November 1968, lot no. 46—without the usual oval base). C. F. Bell also noted versions in the collections of Otto Beit and William Newall, the latter (acquired in 1891 from the Cavendish-Bentinck Collection) was exhibited at the Royal Academy in the winter of 1904 (when illustrated), and sold in 1922 (as lot 80, at Christie's 27–29 June). There is also a smaller variant on the same model in the Victoria and Albert Museum (631-1865, from the Soulages Collection) with the right, rather than the left, arm raised, perhaps devised as a companion for a figure with a beard and moustache (630-1865). There are variants in which a bearded and balding older man supports a shell of which an example is in the Museo Civico, Brescia; a pair were in the collection of Camillo Castiglioni (L. Planiscig, Collezione Camillo Castiglioni (Vienna, 1923), no. 50), and one was lot 133 at Christie's,

London, 4 July 1989. In addition there is a poorly modelled shell-bearing figure in the Ca d'Oro in Venice in which the boy's left knee does not touch the base, clumsily stylized water is pouring from the shell, and the oval base is adorned with vegetation. Finally, a related figure of a nude youth nearly standing upright, but still supporting a clam in the same position, was in the Cook Collection and in 1952 with the dealer Herbert Bier.

Fortnum regarded these figures as Florentine of 1550 and 1560 and 'worthy of and perhaps by Gugliel. or Giaco. Della Porta' and anyway 'clearly work of a masterly hand of the School of Michelangelo'. J. C. Robinson in his Catalogue of the Soulages Collection ((London, 1856, 124) considered the pair there as 'Florentine work circa 1560', which must be the origin of this idea. However, they have generally since been considered as Venetian—or at least associated with the followers in Venice of the Florentine Jacopo Sansovino. Bode, Italian Bronze Statuettes of the Renaissance (London, 1907–12), ii, pl. CLXII, illustrating the Ashmolean's No. 243, classified it as Venetian of about 1575, and J. D. Draper in his revision of 1980 classified it as probably Venetian of the late sixteenth century. Planiscig (ops. cit.) attributed the bronzes to Girolamo Campagna (1549–c. 1625) and the attribution has often been approved (notably by H. Weihrauch, Europäische Bronzestatuetten (Brunswick, 1967), 158). It is based on Campagna's liking for kneeling supporters such as those angels who support the altar of the sacrament in S. Giuliano, or his pair of angels carrying cornucopia candlesticks now on an altar of the church of the Carmini in Venice.

However, kneeling supporters were popular in Venice generally at this date—see the clumsy kneeling putti in No. 235 here, but also, and far more significantly, the paired ignudi supporting the great pair of andirons in the Museum of Fine Art, Budapest, and the similar triad supporting the hardly less splendid andirons in the Metropolian Museum (Kress Collection A. 1645 A and B). The youths in the Metropolitan Museum are sometimes supposed to be by Tiziano Aspetti because of the very similarly posed youth in his documented relief of St Daniel being nailed between boards (commissioned 1592 and completed by 1593), but have also been attributed to Campagna (see C. C. Wilson, Renaissance Small Bronze Sculpture ... at the National Gallery of Art (Washington, DC, 1983), 139–40). The upper portions of these latter andirons, including the kneeling supporters, exist in other casts (W. Bode, Bildwerke des Kaiser-Friederick Museums, ii: Bronzestatuetten... (Berlin and Leipzig, 1930), no. 247). The supporters are very close in character and also in size (18 cms. high) to those supporting the clam shells, the hair is similarly curled, the muscles are similarly emphasized and of similarly dubious anatomy but impressive elasticity, and the hands pressed against the thigh have the same long fingers with squared off ends that we see against the clam shells here—a motif reminiscent of Jacopo Sansovino.

The possibility of a much later date for these salt-cellars should also be entertained. The supporters recall the pair of atlantes who kneel upon the tower of the Dogana da Mar in Venice supporting the great gilded globe upon which Fortune

flies, the work of the founder Bernardo Falcone carrying out Giuseppe Benoni's prize-winning design of 1677. But the model must surely have been made by a great artist and probably one in the orbit of Sansovino.

It is also worth observing that some, perhaps many, of the casts listed in this entry are replicas or fakes made in the last century. The example in the Staatliche Museen, Berlin-Dahlem, which is slightly smaller than the Ashmolean's examples, appears to have been distressed and the defects of the cast especially in the shell while making it look old also make it impossible that it has ever been used.

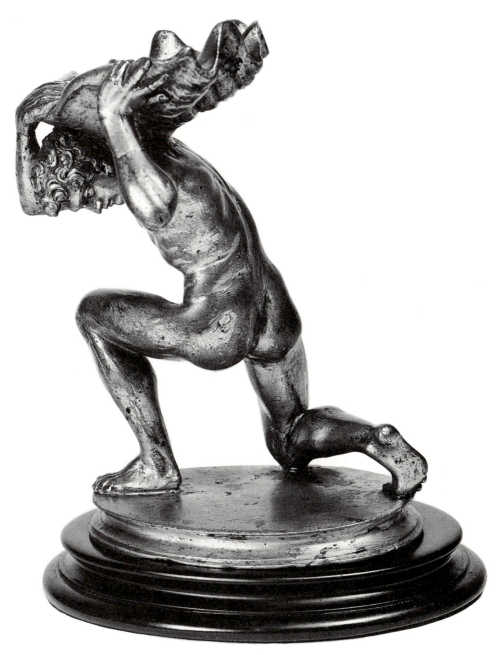

245. Salt-cellar in the form of a triton blowing on a conch, supporting a scallop shell, and riding a tortoise

13.8 cms. (height); 11.2 cms. (length); 13.2 cms. (width)

Bronze, fire-gilt, much worn to reveal a chocolate brown natural patina. Hollow, fairly thick-walled, lost-wax cast, all in one piece with the exception of the shell on the triton's back, which was cast separately, perhaps from nature. Little evidence of chasing. 'B-110-Ⅎ' painted in black on the hollow of the base moulding to proper left at the back.

Lent by C. D. E. Fortnum in October 1894 and bequeathed in 1899. No. 1110 in his catalogues. Bought from Augusto Castellani in Rome, 1865, for £21 (cf. Nos. 232, 244), according to the notebook catalogue.

Fortnum considered this as 'a most vigorous and admirable model full of artistic character and the work of a master hand'. He thought it probably Venetian and of about 1550. In his large catalogue there is a note that there was, in 1893, a replica of this bronze in the collection of Henry Pfungst (for whom see Nos. 201, 203, 233, 234, and 427) but without the shell on the triton's back. Pfungst must have disposed of it before 1900 when he sold his collection to the dealers Durlacher and A. Wertheimer (who then sold it to Pierpont Morgan) and it is not in the *Descriptive Catalogue of a Small Collection Principally of XVth and XVIth Century Bronzes* privately printed shortly before that transaction. The Pfungst version may be the one now in the Museum für Kunsthandwerk, Frankfurt on Main (no. 7436 displayed with an attribution to Alessandro Vittoria), which is very close to the Ashmolean version but has no shell and has a higher base (but of the same pattern). Another version of the figure, but without either arms or shell, was in Berlin. An ungilded version of this figure, also without the shell, but in this case with no base, was lot 78 at Sotheby's, London, 7 July 1988, with a companion in a reverse pose—these are possibly nineteenth-century casts modelled on the version now in Frankfurt. A similar pair of figures (perhaps the same pair) was illustrated by L. Planiscig in his *Venezianische Bildhauer der Renaissance* (Vienna, Berlin, 1921), 448, figs. 467-8. A variant, which looks like a nineteenth-century cast, in which the triton supports the shell with both hands, exists in several versions— see, for example, Kunstgewerbemuseum, West Berlin, no. 17–18, no. 107 in K. Pechstein, *Bronzen und Plaketten* (Berlin, 1968), with an attribution to Girolamo Campagna.

Tritons of this sort are not uncommonly employed in goldsmith's work, and one, in a pose very similar to that in the Ashmolean's salt-cellar, survives as a support for a nautilus goblet once in the collection of J. Pierpont Morgan (Wadsworth Athenaeum, 1917.269) by Georg Mond of Dresden (master before 1599, died after 1623) dated to about 1620—a group of silver gilt, the turtle resting upon amethyst crystals designed to simulate foam (no. 20 in the catalogue of the exhibition *J. Pierpont Morgan Collector*, held

at the Wadsworth Athenaeum, Hartford (Conn.), and elsewhere, in 1987). A figure in this pose is also possible in Italian ornamental art at any date in the seventeenth or eighteenth century—the magnificent stand made in Turin in about 1750 and today in the Victoria and Albert Museum (W. 34-1946) is a striking example. Fortnum noted that copies of his salt-cellar were made in silver by Augusto Castellani at Rome (from whom he bought his example). Castellani could also have made bronze versions as he may have done in other cases (see No. 232).

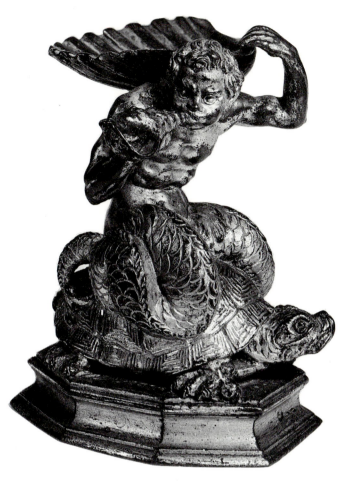

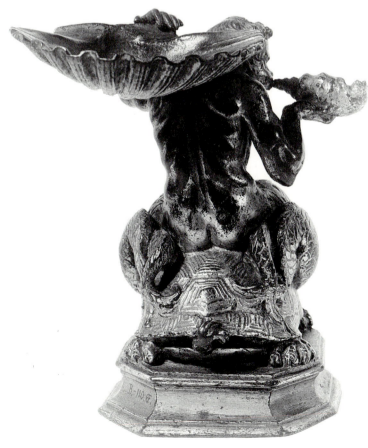

246. Three-sided centrepiece composed of shells, hippocamps, and marine creatures, crowned by Neptune

37.4 cms (height); 15.6 cms (height of Neptune including his base); 9.9 cms (height of each hippocamp); 20.6 cms (maximum width of base)

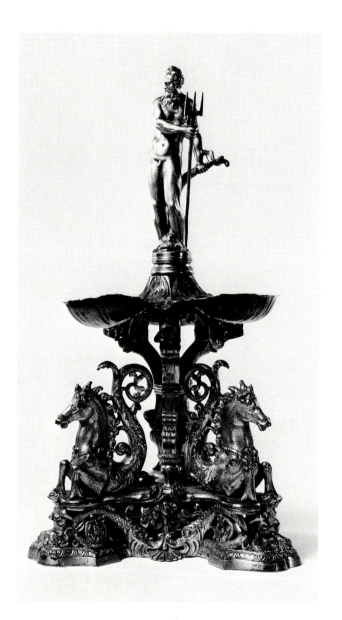

Bronze, fire-gilt, with some parts of silver. The three-sided base is cast in one piece in bronze by the lost-wax method as is evident from its hollowed interior where the metal has a pale brown natural patina. To this base, grotesque canine cherubs of cast silver are soldered (above the curling snouts of the confronted fish). The three gilt bronze hippocamps (each cast from the same mould and finely tooled) are bolted to the base, each in two places (three of the six nuts look original), and so is the central gilt bronze stem which divides into three strapwork branches. Three more or less identical fish, cast in silver, are screwed to the three projecting brackets of the strapwork. Above this are the three scallop-like shells each soldered to a leafy centre, all of thin embossed silver. The crowning gilt bronze figure of Neptune is cast in one piece, with the exception of his right hand (the join at the wrist is easily seen). The trident is separately cast. There are a few minor firing cracks and holes in the bronze. The silver of the minor ornaments is tarnished. The projecting shells retain much of what is probably an original lustrous black varnish. 'B / —107 / Ɛ' is painted in white on the interior of the base. For marks in the silver see below.

Lent by C. D. E. Fortnum in October 1894 and bequeathed in 1899. B. 1107 in his catalogues. Purchased by him using 'Whitehead' (presumably the dealer) as agent at the sale of the collection of Matthew Uzielli at Christie's, London, on 18 April 1861 (lot 721) for £27. 'It was previously in the Falcke Collection' (a fact not noted by Robinson).

Fortnum catalogued this as a salt-cellar or drageoir but J. C. Robinson in his *Catalogue of the Various Works of Art Forming the Collection of Matthew Uzielli, Esq. of Hanover Lodge, Regent's Park* (London, 1860), no. 678, wisely gave it the more general description of a centrepiece, as well. The high esteem in which it was held is revealed by the fact that it was one of the few pieces in the Uzielli Collection which were illustrated in this catalogue (pl. XI). Fortnum regarded it as 'perhaps the most elegant in design and as good in execution and condition as any of these larger salt cellars with which I am acquainted'.

As Fortnum must have realized, there are a pair of comparable gilt bronze and silver centrepieces—generally regarded as salt-cellars—in the Soulages Collection (Victoria and Albert Museum 624-1865), also involving shells, hippocamps, marine monsters, and scroll-work. They are crowned by statuettes of Jupiter and Venus, of similar size to the Neptune, but with a different base, with similar elegance of pose, somewhat clumsy extremities, and routine accessories. The Soulages pair have gilt bronze rather than silver shell containers, but do incorporate grotesque silver heads like those here, and the hippocamps are similar, although they are smaller and now serve to support the base. They

have no elements as precise in tooling or as spirited in character as the heads of the hippocamps in the Ashmolean centrepiece, but they are more consistent in quality and are simpler and more convincing in construction.

There are aspects of the Ashmolean centrepiece which make it certan that it is not in its original form. The hippocamps look as if they were designed to support shells with their heads and tails (as in the Soulages versions). More certainly the projecting brackets of strapwork were designed to support something, and yet they cannot be arranged to coincide with the undersides of the shells. The little silver fish on them now are crudely bolted into place each with an ugly tail stuck in the air—again as if meant as a support. These are also only roughly cast, as if intended to be only half visible. There are also tiny silver animal heads placed on the strapwork under the shells where they are completely invisible. In addition there is a rough hole in the central portion of the stage of silver shells for which there is no need.

Fortnum considered the centrepiece to be Venetian of 1550–70, here following Robinson who had catalogued it in the Uzielli Collection (op. cit.) as 'probably Venetian circa 1570'. One can see from Fortnum's notebook catalogue that he inserted '1550–' before '1570' as an afterthought, having at first simply transcribed Robinson. This dating seems sensible, although it could certainly be later in date than 1570. The figure type is very characteristic of Venice in the late sixteenth century (cf. Nos. 227, 228, 86). There are also parallels for the grotesque ornament in decorative work of Venetian origin, and, most significantly, the hippocamps look very like the ancestors of the flat brass creatures which still serve as ornaments on the sides of gondolas. C. F. Bell, however, deleted Fortnum's attribution in the large catalogue and wrote 'Southern German'. He had discerned the scarcely legible marks on the undersides of the three shells consisting, he thought, of the initials F. R.' with an object above. These initials, according to Marc Rosenberg's *Goldschmiede Merkzeichen* (Frankfurt on Main, 1922–8), belonged to an Augsburg maker, 'but the city's stamp—though not conclusively resembling either—looks more like the monk's head of Munich than any variant of the Augsburg pineapple'. This evidence is not conclusive: there are other ways of reading the smudged marks and in any case the silver shells, as has already been pointed out, may well be additions to the base, stem, and hippocamps of the original centrepiece.

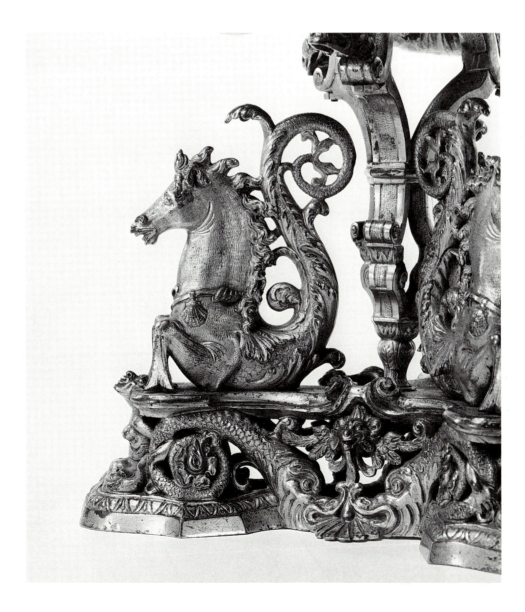

247 and 248. Basin, decorated with battling sea creatures and an allegory of Neptune, with a ewer, decorated with Neptune in triumph with Amphitrite

50.3–50.5 cms (diameter of the basin); 11.6 cms (diameter of central boss of basin); 46.1 cms (height of ewer)

Silver. The basin (No. 247) is embossed and chased. Some small cast elements are attached—notably, in the central boss, the crown held by the female figure, the coronet above the shield she also supports, and the trident of Neptune, and, in the frieze, the club and head of one of the tritons (at 11 o'clock) and the spear wielded by the rider (at 2 o'clock). The body of the ewer (No. 248) is composed of several cast pieces chased and soldered together. Some small cast elements are attached—notably the coronet on the shield of arms on the front of the ewer. The handle was cast in three principal parts (monster, acanthus leaves, and child) with lesser parts (club and tail) also cast and added. The date 1619 is chased on the shield held by the triton in the frieze of the basin at 11 o'clock. The reverse of the basin is engraved with the coat of arms of the 5th earl of Shrewsbury impaling those of Webb (for Barbara Webb daughter of Sir John Webb, Bt., whom he married in 1786) and the earl's crest appears faintly in the interior of the foot of the ewer. Some repairs are apparent to the arms of struggling figures at 3 o'clock on the frieze of the basin where the metal is also slightly perforated.

The plain base to the ewer appears to be an addition probably of the early nineteenth century.

Placed on loan in the Museum anonymously by Lord de Mauley on 13 July 1971 together with another set of identical design and a larger and more elaborate basin and ewer dated 1621 and 1622. All six pieces were cleaned by Kathleen Western in September and October 1971 to remove sulphide tarnishing: a thin coat of lacquer was also applied. Minor repairs—involving straightening the feet of the smaller ewers and soldering a loose coronet on the larger ewer—were carried out in the same period by a local silversmith, Anthony Hawksley.

All the loaned items were withdrawn from exhibition on 12 July 1973, removed on 26 July, and sold at Christie's, London, on 28 November. This basin and ewer together with its pair formed a single lot purchased by Artemis Ltd. for £44,000. The Reviewing Committee for the Export of Works of Art, at its meeting on 27 March 1974, stopped the granting of a licence for three months for one of the pair. By mid-June the Ashmolean had purchased this pair from Artemis for £30,000. (The other pair was bought by the City Museum and Art Gallery, Birmingham; the larger pair was bought by the Victoria and Albert Museum—M. 11 and A-1974.) £15,000 was contributed by the Regional Fund of the Victoria and Albert Museum, £5,000 by the National Art-Collections Fund, £2,000 by the Friends of the Ashmolean, £5,000 came from the France Bequest, £1,750 from the Central Purchase Fund of the Museum, and £1,250 from a special grant by the University Chest.

All six items belonged to the 5th earl of Shaftesbury (1761–1811) by 7 November 1807 when Samuel Rogers saw them, as he reported in a letter of 8 November, 'at Rundalls' (the royal goldsmith, Rundell, Bridge and Rundell, where they were perhaps being

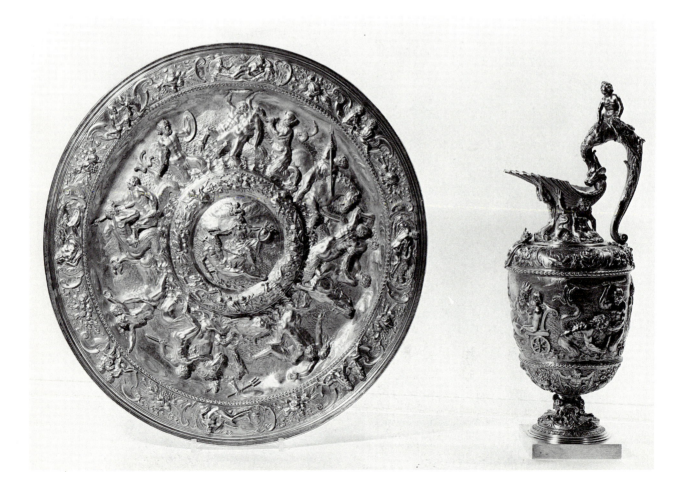

repaired). The earl had been in Italy twenty years before, but the reference suggests a more recent acquisition—the plate had been bought for £300 by 'Lord S.' at Naples (see Macandrew, cited below). Barbara, the daughter of the earl, married in 1814 the Hon. William Francis Spencer Ponsonby, third son of the 3rd earl of Bessborough, and he was created Baron de Mauley in 1838. Thence they passed by descent to the Lord de Mauley who loaned and sold them.

The basin and ewer together with their companions (see above) were published by Hugh Macandrew in the *Burlington Magazine* for September 1972 ('Genoese silver on loan to the Ashmolean Museum', 611–20). It was an article by Macandrew of the previous year, publishing a silver basin made after the oil sketch by Bernardo Strozzi recently purchased by the Museum ('A Silver Basin Designed by Strozzi', *Burlington Magazine*, (Jan. 1971), 4–11), which had prompted the owner to reveal that he had these examples of Genoese silver from the same period. The shields on all the pieces are decorated with arms which, being without tincture, cannot be assigned with certainty, but the exceedingly wealthy Lomellini is the most likely family and, Macandrew speculates, the most likely among them to have been the first owner is Giacomo Lomellini 'il Moro' (d. 1653–5), a prodigal patron of the arts. The pieces must have been made for a Genoese patron: the larger basin and ewer now in the Victoria and Albert Museum are decorated with the Battle of the Po, a great Genoese victory, peppered with allusions to the Grimaldi, the great Genoese dynasty, and given

Genoese marks, while in the boss of the Ashmolean's basin and its pair the Genoese landmark of the Torre di Faro is conspicuous.

Although all six pieces of plate have the same provenance the smaller sets of basin and ewer are earlier in date, different in style, and mythological and allegorical rather than historical in imagery. The ewers seem to be decorated with the Triumph of Neptune and Amphitrite. Their retinue of marine creatures appears already to have commenced the battle which is represented on the frieze of the basins—hippocamps and tritons are evidently quarrelling over the possession of nereids. The child with a club astride the monstrous handles has been identified as the infant Hercules, but might be intended for Cupid with the club of Hercules. The marginal bands of cartouches in the ewers are filled with a reclining Mars and a reclining Venus and Cupid, while around the basins these compartments are occupied by Danae, Olympias, Leda, and Semele. A marriage might have been the pretext for this imagery, but hardly explains the central episode on the basin in which a female personification, identified by Macandrew as Victory, is crowned by an angel or genius while she sets a crown upon the head of Neptune (or just possibly removes it from him), while with her other hand she holds the shield of the family for whom the plate is presumed to have been made.

The basin based on a sketch by Strozzi mentioned above which is now in the J. Paul Getty Museum, Malibu (85.DG.81) thought to be the work of a Dutch or Flemish

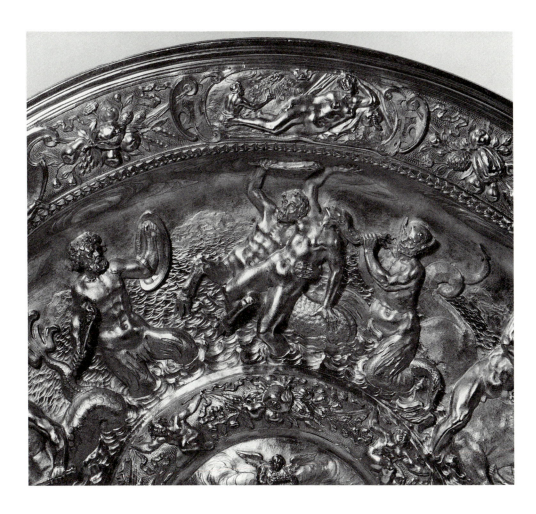

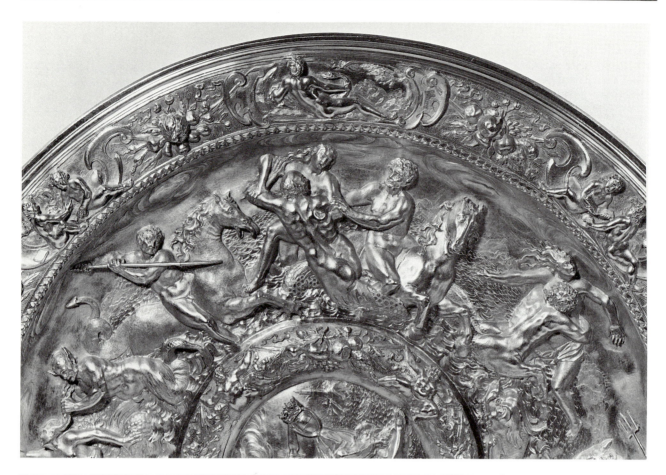

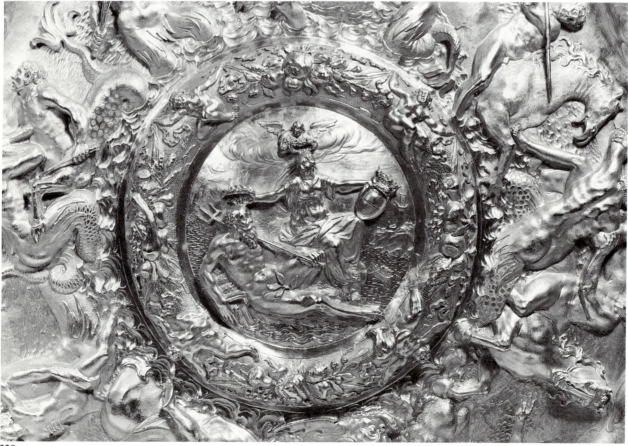

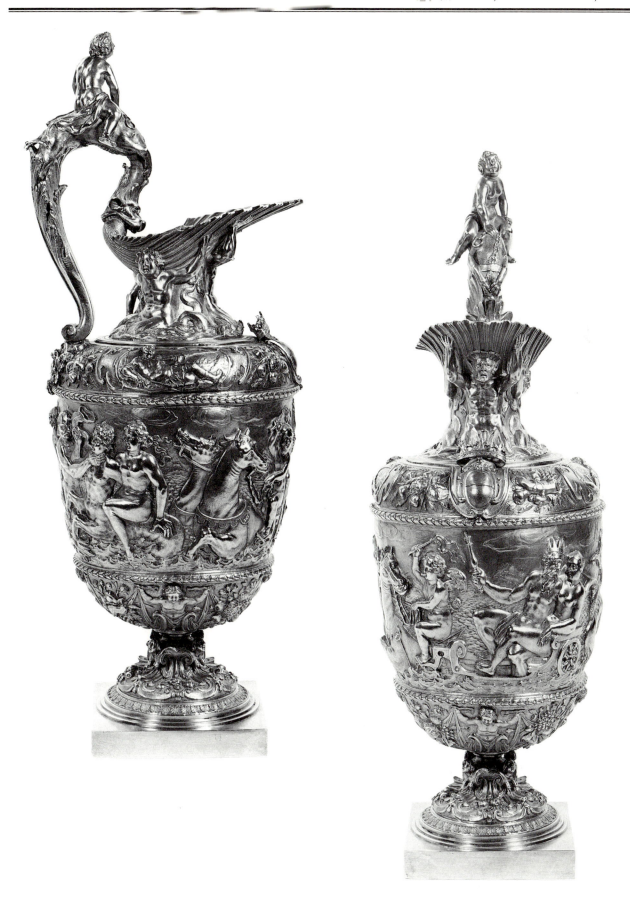

craftsman and the five silver reliefs depicting splendid episodes in the history of the Genoese Spinola family signed by Mathias Melin of Antwerp and dated 1636 (Rijksmuseum, Amsterdam, NM 603–607) are of similar style but superior quality. Arthur Grimwade, who first in recent decades realized the importance of the Ashmolean basin and ewer, suspected that they might be the work of a northern goldsmith. Macandrew considered that the style is

markedly Flemish in character, especially in the treatment of the figures on the basin. If in his mind's eye the beholder reduces their forms to an outline and sees them in terms of a pen and ink drawing, then he might well imagine the spirit of Van Dyck haunting their configurations. During this particular period nothing could be more likely than for them to have been designed either by one of the large colony of Flemish artists living in Genoa, or by a Fleming living in his native Antwerp.

The rendering of the fine textured hair of the sea horses, juxtaposed with the scales of tritons' tails and the rippling sea, the fine low relief of distant mountains and clouds, the variety of the fruit and vegetables in the swags, are remarkable, but the expressions of the figures are somewhat ludicrous, the actions are often unconvincingly desperate (see especially the way the nereid's hair is pulled by the triton on the basin at 12 o'clock, or the way the neck of the hippocamp is gripped on the ewer), the anatomy of the figures is intermittently clumsy, and their articulation never as consistently dynamic as intended. Either the skill of the chaser surpassed that of the designer of the figures, or the designer overestimated the chaser's ability to follow in the figurative part of his modello.

Knowledge of this silverwork was not confined to Genoa. Very similar basins and ewers feature in still lives by Meiffren Conte (*c.* 1630–1705)—see M. Faré, *La Nature morte en France*, 2 vols. (Geneva, 1962), ii, figs. 198, 199, 201, 204, 205, 208, and especially pl. VII. A very similar silver platter signed 'S.B.' and with the date mark of 1621 was lot 1139 at Sotheby's, Monaco, 6 December 1983.

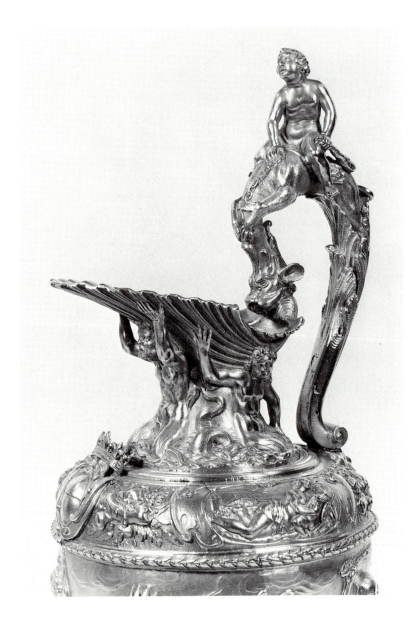

249. Parade shield decorated with a frieze of interlaced serpents and a boss in the form of the head of Medusa

67 cms (height of shield); 52 cms (width of shield); 34 cms (height of oval frame around Medusa head)

Iron. Sand-cast. There is no obvious evidence of chiselling. The border with the serpent frieze is fixed to the oval body by seven rose-head and eight pyramid-head studs (two studs are missing). There are six smaller rose-head studs on the outside edge of the border (seventeen are missing). There are traces of gilding on the serpents, and on the frame of the Medusa head outside the foliate band framing it, and remains of gold damascening in the arabesque frieze within this band.

Transferred from the Bodleian Library c. 1930.

The shield was attributed to Lucio Piccinino and dated to about 1550 by Sir Guy Laking (*Summary Guide* (1931, 25). It has more recently been described as a tournament shield and attributed to Antonio Piccinino, the famous late sixteenth-century Milanese armourer. It is in fact a parade shield and there is no very close parallel with the suit of armour made for Alessandro Farnese and today in the Old Imperial Armoury, Vienna (nos. A1132 and 1153), which has been (perhaps over-confidently) identified with that mentioned as made for Alessandro Farnese by Piccinino (Paolo Morigia, *La nobilità di Milano* (Milan, 1595), Book V, cap. XVII). In August 1987 A. V. B. Norman, then Master of the Royal Armouries, in addition to expressing scepticism concerning the attribution to Piccinino, pointed out that the shield was unusual in workmanship but 'as far as one can tell from a photograph, perfectly good'. He suggested a date of c. 1540–50.

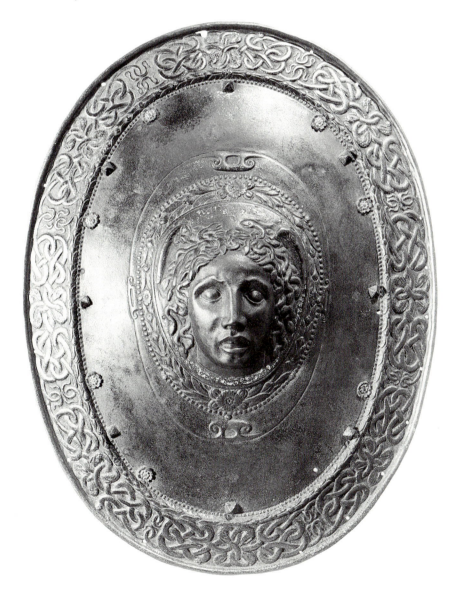

APPENDIX

Italian Furniture in the Ashmolean Museum

1. *Cassone* of walnut with four panels of blind Gothic tracery framed with bands of elaborate intarsia. Incised with the maker's cipher and decorated with arms said to be of the Bona and Baiamonte families of Verona. North Italian, second half of the fifteenth century. A. G. B. Russell Bequest, 1958. Bought by him from Rogers, Chapman and Thomas of 125 Gloucester Road, London SW7, on 27 November 1924 for £16. There is a similar *cassone*, presumably from the same workshop, in the Bayerisches National Museum, Munich (69/47).

2. Cupboard of walnut with two doors, crowned by a dentilled cornice, supported on bracket feet. The doors retain original wire hinges. Late fifteenth or early sixteenth century. A. G. B. Russell Bequest, 1958. Bought by him from G. Pallotti of Via Rondinelli, Florence, on 8 May 1924 for 2,000 lire (£20 8s. 8d.).

3. Chair of curule form of iron and brass. Italian, probably of the mid-sixteenth century. Purchased 1960. Other chairs of similar form are illustrated in F. Schottmüller, *I mobili e l'abitazione del Rinascimento in Italia* (Stuttgart, 1928), 174, *Burlington Magazine* (Sept. 1971), p. xlviii, and *Connoisseur* (Feb. 1981). The stamped pattern on the iron is typical of Florentine forges.

4. *Cassone* of walnut ornamented with shields and masks. Mid-sixteenth century. Cat. No. 206.

5. *Cassone* of walnut ornamented with acanthus at the corners. Mid- or late sixteenth century. Cat. No. 207.

6. Two-stage cupboard of walnut ornamented with terminal caryatids. Second half of the sixteenth century. Cat. No. 205.

7. Casket of walnut with lion's paw feet, ornamented with curling strapwork etc. Second half of the sixteenth century. Cat. No. 211.

8. Casket with lion's paw feet, ornamented with scales etc. Late sixteenth or early seventeenth century. Cat. No. 212.

9. Casket probably of poplar with applied winged masks and sirens. Late sixteenth or early seventeenth century. Cat. No. 210.

10. Stipo of rosewood, ivory, and ebony in the form of a miniature temple decorated with scenes from the New Testament and the Trojan War. Inscribed as by Theodore de Voghel and dated 1593. Cat. No. 105.

11. *Cassone* of walnut ornamented with harpies at the corners and with intarsia. Late sixteenth or seventeenth century. Cat. No. 208.

12. High-backed chair of maple or beech ornamented with dolphins and scrolling foliage. Cat. No. 214.

13. High-backed chair of maple ornamented with scrolls and cornucopia. Cat. No. 215.

14. Cabinet of ebony and *pietra dura* with ormolu mounts, some of them attributed to the workshop of G. B. Foggini. Florentine, sixteenth century (Heberden Coin Room). Cat. Nos. 35, 63.

15. Three side chairs of beech entirely gilded, carved with cockle-shells, weedy fronds, and dolpins. 1725–40. Cat. Nos. 216, 217, 218.

16. Large wall bracket (of pine?) previously gilded, with a rectangular top above complex stepped mouldings—egg and dart (of two sizes), vitruvian scroll, dentils, etc. Probably eighteenth century. At present employed to support the terracotta *Pietà*. (Cat. No. 93).

17. Wall bracket of pine, water gilded, with an approximately square top with curved front corners, breaking forward in the centre, above scrolls of complex form. At present employed to support the bust of a cardinal attributed to Legros (Cat. No. 53).

18. Writing desk in the form of a *bombé* chest of drawers with two large and two small drawers below a separate top with a slope dropping to reveal eight small and one large drawers and pigeonholes, the central one of which conceals a secret drawer. The carcass of pine, veneered with walnut, framed with walnut crossbanding, the slope of quarter-veneered figured walnut; with ormolu sabots and espagnolettes, also applied foliate ormolu ornament which forms handles for the chest of drawers. Mid-eighteenth century. Bought by C. D. E. Fortnum in Florence in 1875, and bequeathed by him 1899 (although his large catalogue is not annotated to this effect).

19. Masive rectangular mahogany bookcase of two stages bearing the gilt metal monogram of Maria Luisa di Borbone and incorporating four terminal busts of a bearded hero or deity in bronze. *c.* 1820 Lucca. Cat. No. 170 (Department of Antiquities).

20. Casket of rosewood, ebony, and silver with three compartments. Perhaps nineteenth century. Cat. No. 213.

21. *Cassone* of walnut ornamented with gadrooning and fluting. Florentine, third quarter of the nineteenth century, in the style of the second half of the sixteenth century. Cat. No. 209.

Concordances

Concordance of Registration numbers with numbers in this volume of the Catalogue.

1947–329	17	1959–65 (Bronzes iv)	70	1962–8	86	1966–50	148
1948–97	82	1959–65 (Bronzes v)	71	1962–10	14	1966–94	174
1950–22–25	62–65	1960–9	62	1962–29	93	1971–328	69
1952–27	142	1960–19	42	1962–32	157	1974–234	247
1952–111	12	1960–30	37	1963–53	171	1974–235	248
1953–107	143	1960–42	158	1963–137	88	1975–86	103
1953–108	144	1960–65	79	1964–11	130	1984–45	18
1953–109	41	1960–72	153 &	1964–41	156	1984–46	19
1953–110	94		154	1964–42	76	1986–10	48
1956–20	104	1960–74	36	1965–27	57 &	1987–279	38
1958–57 (Furniture iii)	205	1961–5	135		58	1988–302	32
1958–57 (Sculpture 1)	47	1961–38	129	1965–64 (i)	50	1989–38	33
1959–51	53	1961–57	134	1965–72	108	1989–39	34

Concordance of items inventoried in the Mallet bequest with numbers in this volume of the Catalogue.

171	145	177	118	215	132
176 (1 & 2)	1 & 2	187	228	232	49

Concordance of items catalogued by C.D.E. Fortnum and among his gift or bequest with numbers in this volume of the catalogue. (B = Bronzes C = Ceramics F = Furniture and S = Sculpture)

B402	155	B449	115	B1072	189	C470	107
B404	80	B450	29	B1073	186	C471	106
B405	81	B675	28	B1074	187		
B406	16	B684	30	B1075	239	F8	211
B407	15	B685	31	B1076	224	F9	213
B412	9	B687	55	B1081	233	F10	206
B416	44	B1022	235	B1082	231	F11	209
B417	123	B1023	236	B1083	232	F12	214
B418	241	B1050	177	B1084	96	F13	215
B420	39	B1053	199	B1087	225	F21	105
B421	74	B1054	178	B1088	4	F27	10
B422	89	B1055	196	B1089	229		
B423	95	B1056	182	B1090	230	S2	169
B425	136	B1057	183	B1092	227	S3	167
B426	46	B1058	197	B1093	226	S4	168
B428	146	B1059	198	B1095	180	S5	27
B429	99	B1060	194	B1096	179	S7	26
B433	121	B1061	195	B1097	181	S24	8
B434	60	B1062	184	B1106	176	S28	73
B437	240	B1063	185	B1107	246	S30	133
B440	164	B1064	192	B1108	243	S33	166
B441	61	B1065	193	B1109	244	S36	20
B443	162	B1066	190	B1110	245	S37	3
B444	87	B1067	191	B1114	175	S54	116
B445	45	B1068	90	B1123	237		
B446	112	B1069	91	B1124	110		
B447	113	B1070	92	B1125	111		
B448	114	B1071	188	B1147	238		

Index of Artists and Craftsmen